T0138244

Haeckel's Embryos

{ Haeckel's Embryos

IMAGES,
EVOLUTION,
AND
FRAUD

NICK HOPWOOD

}

The University of Chicago Press
Chicago and London

Published with the support of the Getty Foundation

NICK HOPWOOD is reader in history of science and medicine in the Department of History and Philosophy of Science at the University of Cambridge. He is the author of *Embryos in Wax*, coeditor of *Models: The Third Dimension of Science*, and cocurator of the online exhibition *Making Visible Embryos*.

The University of Chicago Press, Chicago 60637
The University of Chicago Press, Ltd., London
© 2015 by The University of Chicago
All rights reserved. Published 2015.
Printed in China

24 23 22 21 20 19 18 17 16 15 1 2 3 4 5

ISBN-13: 978-0-226-04694-5 (cloth)
ISBN-13: 978-0-226-04713-3 (e-book)
DOI: 10.7208/chicago/9780226047133.001.0001

Library of Congress Cataloging-in-Publication Data
Hopwood, Nick, author.
 Haeckel's embryos : images, evolution, and fraud / Nick Hopwood.
 pages cm
 Includes bibliographical references and index.
 ISBN 978-0-226-04694-5 (cloth : alk. paper) — ISBN 978-0-226-04713-3
(e-book) 1. Haeckel, Ernst, 1834–1919. 2. Evolution (Biology)—History.
3. Scientific illustration—History. 4. Embryos. I. Title.
 QH361.H67 2014
 576.8—dc23
 2014016887

♾ This paper meets the requirements of ANSI/NISO Z39.48–1992
(Permanence of Paper).

For my parents,

David and Joyce

CONTENTS

Figure 7.1
Illustration of von Baer's laws. Early vertebrate embryos exhibit features common to the entire subphylum. As development progresses, embryos become recognizable as members of their class, their order, their family, and finally their species. (After Romanes, 1901.)

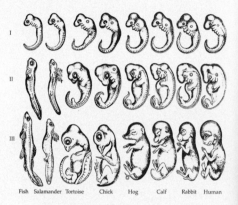

I

II

III

Fish Salamander Tortoise Chick Hog Calf Rabbit Human

opment and that their features become more and more characteristic of the species as development proceeds. Human embryos never pass through a stage equivalent to an adult fish or bird; rather, human embryos initially share characteristics in common with fish and avian embryos. Later, the mammalian and other embryos diverge, none of them passing through the stages of the other.

Von Baer also recognized that there is a common *pattern* to all vertebrate development: the three germ layers give rise to different organs, and this derivation of the organs is constant whether the organism is a fish, a frog, or a chick. **Ectoderm** forms skin and nerves; **endoderm** forms respiratory and digestive tubes; and **mesoderm** forms connective tissue, blood cells, the heart, the urogenital system, and parts of most internal organs. In this chapter, we follow the early development of ectoderm; this and the following chapter focus on the formation of the nervous system in vertebrates. Chapter 9 will follow the early development of endodermal and mesodermal organs.

■ FORMATION OF THE CENTRAL NERVOUS SYSTEM

Neurulation: An overview

"What is perhaps the most intriguing question of all is whether the brain is powerful enough to solve the problem of its own creation." So Gregor Eichele (1992) ended a recent review of research on mammalian brain development. The construction of an organ that perceives, thinks, loves, hates, remembers, changes, fools itself, and coordinates our conscious and unconscious bodily processes is undoubtedly the most challenging of all developmental enigmas. A combination of genetic, cellular, and organismal approaches is giving us a preliminary understanding of how the basic anatomy of the brain becomes ordered.

The action by which an embryo forms a **neural tube,** the rudiment of the central nervous system, is called **neurulation,** and an embryo undergo-

ing such changes is called a **neurula.** There are two major ways to form a neural tube. In **primary neurulation,** the chordamesoderm directs the ectoderm overlying it to proliferate, invaginate, and pinch off from the surface to form a hollow tube. In **secondary neurulation,** the neural tube arises from a solid cord of cells that sinks into the embryo and subsequently hollows out (cavitates) to form a neural tube (see Schoenwolf, 1991b). The extent to which these modes of construction are used depends on the class of vertebrate. Neurulation in fishes is exclusively secondary. In birds, the anterior portions of the neural tube are constructed by primary neurulation, while the neural tube caudal to the twenty-seventh somite pair (i.e., everything posterior to the hindlimbs) is made by secondary neurulation (Pasteels, 1937; Catala et al., 1996). In amphibians, such as *Xenopus,* most of the tadpole neural tube is made by primary neurulation, but the tail neural tube is derived from secondary neurulation (Gont et al., 1993). In mice (and probably humans, too), secondary neurulation begins at or around the level of somite 35 (Schoenwolf, 1984; Nievelstein et al., 1993).

Primary neurulation

In vertebrates, gastrulation creates an embryo with an internal endodermal layer, an intermediate mesodermal layer, and an external ectoderm. The interaction between the dorsal mesoderm and its overlying ectoderm is one of the most important interactions in all tetrapod development, for it initiates **organogenesis,** the creation of specific tissues and organs. In this interaction, the chordamesoderm directs the ectoderm above it to form the hollow neural tube, which will differentiate into the brain and spinal cord. The events of primary neurulation are diagrammed in Figure 7.2. During primary neurulation, the original ectoderm is divided into three sets of cells: (1)

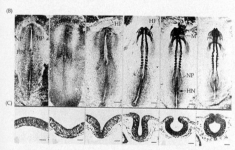

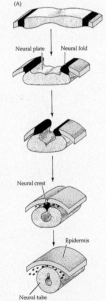

Figure 7.2
Neurulation in amphibians and amniotes. (A) Diagrammatic representation of neural tube formation. The ectodermal cells are represented either as precursors of the neural crest (black) or as precursors of the epidermis (color). The ectoderm folds in at the most dorsal point, forming an outer epidermis and an inner neural tube connected by neural crest cells. (B) Photomicrographs of neurulation in a 2-day chick embryo. (C) Neural tube formation seen in transverse cross sections of the chick embryo at the region of the future midbrain (arrowheads in B). Each photograph in (C) corresponds to the one above it. (HF, head fold; HP, head process; HN, Hensen's node; M, midbrain; NP, neural plate.) (Photomicrographs courtesy of R. Nagele.)

Fig. 1.1 Early vertebrate embryos, credited to a secondary source from 1901, in Scott Gilbert's developmental biology textbook, alongside photomicrographs and more recent diagrams. Gilbert 1997, 254–55, by permission of Sinauer Associates.

Icons of Knowledge

At the end of the twentieth century the leading textbook of developmental biology reproduced a figure first published over a hundred years before (fig. 1.1). With columns for species and rows for stages, the grid shows embryos of humans and other backboned animals beginning almost identical and diverging toward their adult forms. Images like this debuted in 1868 in the first accessible Darwinist system, an anticlerical gospel of progress by the combative German evolutionist Ernst Haeckel. For the first eight weeks of development, he roared, you cannot tell even an aristocrat from a dog. The church denied these pictures as "diabolical inventions of materialism," he said, yet that only testified to their power as evidence of common descent.[1] Schools initially banned Haeckel's books, but children sneaked them to read "with burning eyes and soul."[2] In the early 1900s his embryos entered American classrooms and were eventually reproduced worldwide. As the most influential illustration of the relations between evolution and development, they are still a reference point for research.

Old images shape current views. Look through websites, books, and TV programs, the main vehicles for communicating knowledge today. Among the flood of new pictures, copies represent a select few from the distant past. Their contemporaries fell by the wayside long ago, but the survivors have lasted for decades. Some are celebrities. The 1895 X-ray of Bertha Roentgen's "hand with rings" is hailed as a "photograph that changed the world," the atomic mushroom cloud held up as a "cultural icon" that encapsulates an era.[3] Since the 1960s the Apollo snapshots of Earth from space have portrayed the planet for environmentalists and advertisers. Antiabortionists and sex educators exploited Lennart Nilsson's fetal photographs from around the same time.[4] Such icons have exceptional reach and symbolic power, but far more images have played influential roles.

They have been textbook illustrations for students to learn or technical standards that define what researchers and practitioners see and hence know.[5] Map projections determine the apparent size and status of countries.[6] Anatomical atlases guide diagnosis, surgery, and expectations of body shape.[7] They channel attention in certain directions and close off others.

How do images become standard, canonical, classic, even iconic? Art historians debate what sanctified the *Mona Lisa* as the most famous masterpiece in the world. It was among the paintings selected to found the Louvre after the French Revolution, but was not the most celebrated in that group. Only the nineteenth-century making of the Leonardo cult and of the *femme fatale*, followed by the theft of the work in 1911, raised it to the highest level of fame.[8] The DNA double

helix benefited from aesthetic appeal and its status as "the secret of life," but was not an instant hit in 1953. Stardom came with recognition of the discovery, and the opportunities the structure offered designers to embody hope, hype, and fear as molecular biology took off.[9] Intrinsic qualities count, but users decide which images will make a splash and then sink without trace, while others achieve their greatest influence years or even centuries later.

Taking the visual dimensions seriously has enlarged and revised our histories of knowledge.[10] It has discovered the importance of nonverbal communication and of competition between different approaches to producing and using images. The emphasis has been on the more obvious novelties, but research has begun to illuminate the everyday routines of use. We can learn more about these and become sensitive to more subtle innovations by paying closer attention to long-term trajectories. The fate of a picture is sealed by whether and how it is reused. The pressures of didactic efficacy and accommodating data, of cost and aesthetics, of propriety and politics, of technique and the law converge on copying.[11] This is usually dismissed as derivative, but all successful images have stories of copying to tell.[12]

Histories include much-copied illustrations—and so help make them classic—but tend to miss their full significance by acknowledging their first appearances only. By contrast, investigations of afterlives show that consumption can matter as much as production and copying as much as design.[13] Stephen Jay Gould put the issue on the agenda by highlighting the power of icons that authors and publishers recycled through one textbook after another (fig. 1.2). He targeted primate series and trees that made evolution and progress look as though they marched hand in hand.[14] More recently, David Kaiser demonstrated in compelling detail how postwar physicists adopted Feynman diagrams, and stayed loyal through theory change, while seemingly more suitable alternatives failed to catch on.[15] But most studies of standard images remain sketches or

Fig. 1.2 A montage of Darwin icons on the cover of a biography published in the wake of the 1959 centennial celebrations, part of the Darwin revival following the modern evolutionary synthesis. The dog embryo had already been much reproduced, including by Haeckel, when it featured in *The Descent of Man* (here fig. 6.9). Design by Ellen Raskin reproduced from de Beer 1965 by permission of MM Literary Partners.

cameos; we need to paint on a larger canvas to realize the potential of the approach.

Keeping the spotlight on a single set of images, over the long term and as they addressed various users and viewers, brings out continuities and offers fresh perspectives on change.[16] It can also provide counterpoints to those tales of triumph that only ever go from strength to strength. Critiques accompany even the most dominant images, and different people, in different places or at different times, have rejected some of the most successful outright.[17] Success encompasses not just fame, but being taken for granted and becoming notorious too. Controversy is often part of the story and, by pushing participants to articulate their assumptions, helpfully makes decisions explicit.

To find out how pictures of knowledge succeed and fail, become accepted and cause trouble, this book focuses on Haeckel's embryos: textbook classic, icon of evolution—and the most fought-over images in the history of science. They have been so disputed because allegations of forgery—the most extreme threat to the integrity of an image and its maker—are almost as old as the pictures themselves. Within months of publication in 1868 colleagues accused Haeckel of playing fast and loose with the evidence for common descent. Six years later he aligned the most important battle in the history of embryology with modern Germany's principal confrontation between church and state, and charges of forgery grew legs. In that heyday of lithography and wood engraving for the middle class, critics pointed to several misdemeanors, including creating false identities by having the same blocks printed three times to represent three different species. This sharp practice was swiftly corrected and slowly admitted. They also said Haeckel had schematized tendentiously from well-known originals. These accusations, leveled at the comparative grids that are the subject of this book, were and remain more debatable.

Religious and political enemies reworked the charges on a larger scale in 1908–10, when Haeckel was Germany's most famous and notorious scientist, the world's greatest living evolutionist, and the best-known scientist-artist of the age (fig. 1.3). The first mass audience now followed the struggle over illustrations printed in photo relief. By 1914 the drawings had been denounced, though also defended, in hundreds, if not thousands, of magazine and newspaper articles. They were nevertheless copied into high-school and college textbooks and so survived to become some of the most widely seen embryo images of all time. But in 1997 an embryologist denied that vertebrates ever look so similar and, in ignorance of the earlier critiques, charged Haeckel with fraud. "Generations of biology students may have been misled," reported *Science* magazine.[18] Seizing the opportunity, the neo-creationist campaign for so-called intelligent design forced publishers to take the figures out. Drawings from the German Empire had become lightning rods for online controversy at the beginning of the twenty-first century.

Fig. 1.3 One of the postcards sold in Haeckel's hometown shows him painting watercolors in 1914. Though the Darwinist was frequently photographed with ape skeletons, many old-age portraits depict the visionary drawing, sketching, or painting nature (see also fig. 15.2). Sometimes he is immersed, as in these botanical landscapes; more often he looks up to reveal the fire still burning in his eyes. Postcard by Alfred Bischoff (Jena) stuck into the author's copy of the "physiognomical study" Haeckel's son edited for his eightieth birthday: W. Haeckel 1914.

Haeckel's embryos are exceptional, because over such a long period they have played so many of the different roles that images can play. That makes them broadly relevant. By reconstructing each significant process of production and reproduction, use and debate, this book tracks the triumphs and tribulations of one image that engaged specialists, teachers, students, and lay publics through massive transformations in the sciences and the communications industry. It thus offers histories that should shed light on other cases. To keep this feasible, I concentrate on the main sites of innovation and discussion, German-speaking Europe and then also Britain and especially the United States as it overtook Germany as the center of world science. Over two centuries, from the conditions that made the pictures possible to arguments about the rights and wrongs, I offer what I believe is the most comprehensive history of a scientific image. This will show how copying, the epitome of the unoriginal, has been creative, contested, and consequential.

A few historians were already familiar with parts of the story behind Haeckel's embryos when the news broke in 1997. I had come across them in textbooks at school and university, and then as a graduate student and postdoctoral fellow in developmental biology. Having retrained in history of science and medicine, I worked on German Darwinism and was starting a project on visualizing embryos, so knew enough to dismiss the fuss as old hat.[19] Then it dawned on me that the repetition, of the pictures and the charges, was the most exciting aspect of the whole affair. How could some of the most disputed images have been copied as textbook figures? And how, if they were so standard, could they have sparked three major controversies and countless small-scale debates? Trying to answer these questions made me realize how little I really knew, and how little the history of science could then say, not only about icons, but also about embryos—and how much these pictures might help. If doing justice to images changes the histories around them, tackling such challenging illustrations promised to transform understanding of embryology and of evolutionism.

The plates started in Haeckel's *Natürliche Schöpfungsgeschichte*, which went through a dozen editions and as many translations, including into English as *The History of Creation*. The most successful variant featured in another title that shaped the visual language of Darwinism, his more embryo-focused *Anthropogenie*, which managed two English translations as *The Evolution of Man*. When historians are only beginning to examine the finest embryological plates,[20] it might seem perverse to devote a whole book to dubious diagrams that Haeckel knocked off in a few hours for works that specialists have always given a bad press. Compared, however, with general-interest pamphlets and magazines, these tomes of five hundred to a thousand pages may appear too complex for many nonscientists to have read.[21] In fact, as prominent illustrations in the foremost syntheses, his grids could not have been more strategically placed.[22] They impressed and provoked pupils and teachers, the hacks who wrote the genuine bestsellers and the anatomists who tightened standards in response. Having mediated between popular science, academic investigations, classroom teaching, and media reports, Haeckel's drawings point the way from an intellectual history of embryologists to a social history of embryos still alert to the disciplinary politics of knowledge.[23] They give extraordinary access to the anatomical, graphic, and publishing practices that made development a process we can see.

Images of development, particularly of developing humans, are so familiar it is hard to believe that just 250 years ago they were almost nowhere to be found.[24] Only in the nineteenth century did developmental series picturing progressively more advanced stages become the dominant representations of the origins of human and animal life. Seeing development depended ultimately on encounters through which practitioners collected material—via hunters, breeders, and explorers from assorted animals, and via physicians from women patients—and reinterpreted it in embryological terms. Scientists and artists then derived vivid images which, with some difficulty, they selected and ordered into series. These were prepared for publication and distribution, with frequent interplay between research, teaching, and display to the lay audiences who eventually admitted embryos into their worlds. The series stood for the course of a pregnancy. Through Haeckel's dictum, "ontogeny recapitulates phylogeny"—we climb our evolutionary tree in the womb—they also represented the history of life on earth. Recent images of embryos and fetuses have been hotly disputed in struggles over reproduction. Controversy is not new, even in relation to abortion,[25]

but evolution once provided the main visual frame. The "first public embryo spectacle"[26] starred Haeckel's illustrations, which entered ordinary homes and stimulated influential research.

The clash between Haeckel and his chief critic, Wilhelm His, did not just pit phylogeny against physiology, and so define the options for embryology through the twentieth century. Professor His also founded the lines of research, little-studied by historians, that invested most in visualizing especially human development. Haeckel's pictures goaded His and others to produce the normal plates and stages that serve as the standards by which biologists divide embryogenesis today.[27] The grids survived in their own right as well, to become standard in the sense of much used, and so shaped the recent debate in evolutionary developmental biology over the existence of a stage when all vertebrates look the same. We should resist the false choice

between His's fine lithographs and Haeckel's dodgy diagrams. They need to be seen together.

Haeckel's Embryos thematizes the copying of the pictures and the repetition of the forgery charges, and the ways these did or did not intersect. On the one hand, it places the physical genesis and reproduction of the pictures in a history of copying, at times biased or creative, at others as faithful as anyone could desire or as derivative as can be. Copying was at issue as soon as a detractor said Haeckel had distorted already-standard illustrations. Since then, the individual figures on his plates have often been compared with their presumed sources. Paying attention to arrangements on pages and in books will divulge more. The biggest innovation was the invention of the grid, an aid to comparative seeing like the pairs, tableaus, series, arrays, and overlays which helped eyes detect similarities and differences, and so distinguish patterns (fig. 1.4).[28] Pre-

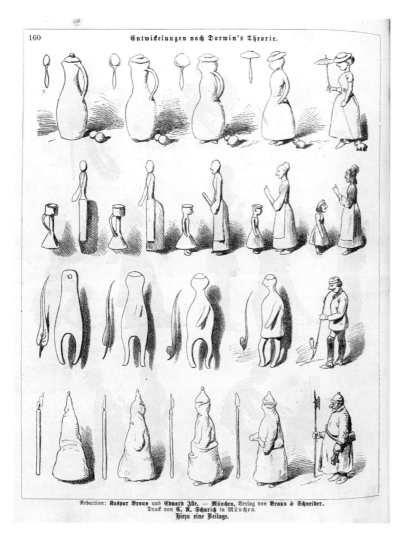

Fig. 1.4 "Development According to Darwin's Theory" in the *Fliegende Blätter*, the Bavarian *Punch*. In the progressive evolution of social types from everyday objects, additional humor comes from the simultaneous development, for example, of the lady from a coffee pot, her parasol from a carefully placed spoon, and her dog from a pair of balls. Four pseudoevolutionary series are aligned in a comparative array, as if to highlight the profusion, by the 1870s, of both evolutionary series and spoofs thereof (for example, fig. 5.1). "Entwickelungen nach Darwin's Theorie," a full-page wood engraving from *Fliegende Blätter* 56 (1872): 160. Niedersächsische Staats- und Universitätsbibliothek Göttingen (NSUB).

viously unexploited manuscripts, including the original drawings that had lain hidden since 1868,[29] let me reconstruct each step.

Even today, images may go only where networks run, databases have been set up, and permission given. In the nineteenth and twentieth centuries, when new methods facilitated copying for large audiences, technical difficulties and social hierarchies more obviously shaped content and distribution. The paradoxes of Haeckel's embryos highlight constraints and also choices. Why did most early copies pick out cells, columns, or rows, rather than reproducing the characteristic grid? How could the illustrations be present in schoolbooks adopted in the state of Tennessee in the aftermath of the 1925 trial of John Scopes for teaching human evolution, but absent from German and British texts published at the same time? Why, conversely, did almost no book dedicated to embryology copy the figures until as late as 1983? That certain groups repudiated them in certain places at certain times pushes us to explain how they could have been so warmly embraced or blithely taken for granted by others and elsewhere.

On the other hand, this book tracks the claims made with Haeckel's pictures and about them, especially the accusations of fraud. Alleging forgery in science is not just to distrust an individual, but to question the standards of a field. Yet fraud busting calls for systemic reform have tended to present as isolated rogues the historical scientists who have been accused.[30] As a big, polarizing figure Haeckel has invited this individualist, villains-and-heroes approach: was he "the scientific origins of National Socialism," as an American historian had it, or the "pioneer of scientific truth" lauded by the architect of East German Stalinism?[31] Most accounts use, and more often misuse, a tiny fraction of the available sources to try and retry him again and again. Influential recent interventions have juxtaposed drawings from 1874 with late twentieth-century photographs containing knowledge he could not have had.[32] More serious assessments have compared his illustrations with their supposed models and either picked on discrepancies to find him guilty or deployed arguments, such as the pedagogical value of schematics and the theory-ladenness of all effective drawings, to contextualize and so excuse his actions.[33] Recently, he has been placed within a code of representation oriented toward truth, which permitted some

manipulation, at odds with a new ideal of "mechanical objectivity."[34]

Each interpretation captures something important, but all are too general to explain why these particular pictures became controversial, and all are too focused on Haeckel to account for their fates in others' hands. Even a trial would have to consider the opponents' agendas and the negotiations that defined what would count as fraud. In a short but detailed and careful dissertation of 1981, Reinhard Gursch concluded that trouble came less from the images than from enemies' attempts to destroy Haeckel's credibility. The historian of biology Jan Sapp suggested, more radically, that since controversies serve to confirm or refute attributions of fraud, the verdict depended on biologists' overall assessment of Haeckel.[35] This risks underestimating the part played by his provocative behavior, but rightly shifts attention to the fight for his reputation that began in Germany and reverberated worldwide.[36]

Because Haeckel was accused early and often, the allegations have played a larger biographical role than those, long after the events, against Gregor Mendel, the "father of genetics," and Robert Millikan, the physicist who determined the charge on the electron.[37] They are a rich seam of commentary on the foibles of the Romantic genius and on scientists' morals.[38] But the link between maker and image often broke: debates over Haeckel the artist lost sight of specific pictures, and these flourished in part because they stopped being credited to him. Images are also no mere vehicles for ideas. Nothing would mislead more in this case than to assume that reproduction followed acquiescence in the doctrine of recapitulation. Use did not even always correlate with acceptance as accurate representations. In an irony of iconoclasm, Haeckel's figures were never more available, thanks to creationists and the Internet, than when most rejected as fakes.

Darwinism is no longer really at stake, and recent research on embryos demonstrates evolution better than Haeckel ever could.[39] Nor can history bridge the ideological chasm between creationism and mainstream biology across which the latest battle has been fought. It does seek to understand and explain actions on all sides as it recovers evidence that everyone should take into account. The adventures of this extraordinary icon more importantly direct attention to the ways scientific images become contested and

canonical, rejected and reproduced. They should help show why, when we open a textbook, turn on a science program, or visit a web page, we see certain illustrations and those alone.

Haeckel's Embryos proceeds roughly chronologically, but only roughly, because each short chapter develops a distinct theme, and some chapters cover different themes for the same periods. The pace changes according to the timescales on which the story unfolded. Some chapters linger to analyze the production of the primary images, explore local responses, or piece together month by month how the forgery charges caught fire. Others take a bird's-eye view to survey patterns of copying or accusation over many decades and between countries. To make the most of the pictures and charges as probes, the book also moves in toward and out from the main events, as it investigates medical teaching and conflicts over materialism, "imperial embryology," and the reactions of lay readers.

Most illustrations in the present work have never appeared beyond their original contexts before, though many were copies even there. They are of Haeckel's pictures, those he used, and those that reproduced, opposed, or spoofed his own. They put these icons back among their contemporaries and in various settings of production and viewing. The captions alert viewers to significant features and to huge differences of format and accessibility. The figures thus complement the text by sharing evidence and a sense of the research materials. They suggest connections and point to larger visual worlds.

The next three chapters (2–4) review the conditions of possibility of the pictures by introducing how developmental series came to be produced, how students and wider audiences were exposed to embryos, and how Haeckel became an artistic Darwinist. Four chapters (5–8) reconstruct the making of the illustrations in *Schöpfungsgeschichte* and *Anthropogenie*, and the debate, from the initial complaint to the first peak of controversy. Then five chapters (9–13), all moving from the 1870s to the early 1900s, explore his expansion of the grid through editions and translations, specialists' visual standards, nonscientists' encounters with these "forbidden fruits," copying into other evolutionary works, and the revival of the charges when Haeckel became an international celebrity. The last chapters tackle the "scandal for the people" of 1909, its effects on his twentieth-century reputation, copying into textbooks, and the paradoxes of iconoclasm since 1997. Chapter 2, about how embryologists made the serial images from which Haeckel would learn, opens with a story about a pair of embryos in a jar.

Two Small Embryos in Spirits of Wine

In the most famous embryological anecdote, the most distinguished practitioner admitted that he did not label a bottle and could not identify the specimens inside. In 1828, in a book so celebrated in the history of biology that its only nineteenth-century rival is the *Origin of Species*, the Estonian nobleman and Prussian professor Karl Ernst von Baer put sloppy labeling to good use.

> I possess two small embryos in spirits of wine, for which I neglected to note the names, and I am now quite unable to determine the class to which they belong. They could be lizards, small birds, or very young mammals. Head and trunk formation is so similar in these animals. Those embryos still lack extremities, but even if they were there, in the earliest stage of development it would teach us nothing, since the feet of lizards and mammals, the wings and feet of birds, and the hands and feet of humans develop from the same basic form. Thus the further we go back in the developmental history of the vertebrates, the more similar we find the embryos as wholes and in the individual parts.[1]

Charles Darwin reworked the story, while attributing it to someone else.[2] Haeckel deployed it as evidence from the highest authority that he had not drawn figures too alike, and his recent defenders have followed suit.[3] But critics around 1900, priding themselves on progress since Baer, poked fun at Haeckel's inability to distinguish classes as incompetence at best. "*Mix up all kinds of embryos in a pot,*" an anatomist boasted, "*and I will tell you the origin of every one.*"[4]

Baer's tale epitomizes the work on which Haeckel would build. Baer probably reviewed mental images, though he could also have consulted his own drawings or the few illustrations then available in books, as he tried to interpret

those specimens in relation to series of stages through development. Comparing series, a key operation of knowledge making, was central to the sciences of organic form. It linked fossils, adults, and embryos, or the history of life on earth, the classification of the animal kingdom, and the development of the manifold groups. Did these combine into a single series or several? Did the series run in parallel or diverge? Did all vertebrates, even all animals, ever really look the same? Histories of biology revel in these big questions about the shape of life, but tend to slip their moorings and float loose in an ethereal realm of ideas.[5] Baer's story grounds the high theory in the encounters with collections and images that constructed the developmental series on which comparative judgment could go to work.

Development is easily taken for granted now that schoolbooks, advice manuals, films, and the web offer elaborate sequences of progressively more advanced embryos and fetuses. Baer and Haeckel, by contrast, experienced developmental series as recent achievements and still a major challenge. Embryology was harder than adult anatomy because each animal needed not just one stage, but several, and these immature forms were tougher to find. Making series—by collecting, drawing, selecting, and ordering embryos in sequence for publication and debate—took up most of researchers' time.[6] So while they gave theory, even speculation, its due, they credited careful observation from nature for recent progress in the science.[7] They also knew how often the difficulty of obtaining comparable series brought soaring theoretical ambitions down to earth.

Developmental Series

Contrary to popular belief, eighteenth-century natural historians mostly did not arrange collections according to the great chain of being, an ascending sequence from the rocks below ground through plants and animals to humans and even angels above (fig. 2.1). Trees and other shapes figure too, while botanical gardens were laid out like maps.[8] Yet around 1800 scales did turn into ladders, and inventories into the results of development. Series came to express neither mere chronology nor endless cycles, but history and progress, the biggest story of nineteenth-century science. In hospitals as in art galleries, curators and

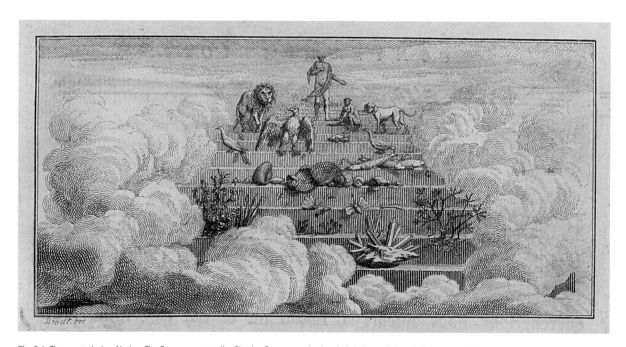

Fig. 2.1 The great chain of being. The Genevan naturalist Charles Bonnet posited an infinitely graded and all-encompassing chain that appeared only imperfectly to human understanding. In this header to his book on the contemplation of nature, the clouds have cleared to reveal a few representatives of the middle part, while the upper and lower reaches stay obscured. Engraving by Frederik Ludvig Bradt from Bonnet 1781, 1, by permission of the Syndics of Cambridge University Library.

professors placed collections in sequence to show the history of painting and the course of a disease. Books and, increasingly, journal articles displayed serial illustrations on the page. But as attention shifted from the external surfaces and visible characteristics of natural history to the internal organization and functions of comparative anatomy, leading naturalists split even the animal series. We feel the weight and length of the chain in their repeated efforts to break it up.[9]

Change was under way before the French Revolution of 1789, but with the eyes of the world on Paris, the reformed Museum of Natural History showed the path to the future. Writing two generations later, Haeckel celebrated one curator, Jean-Baptiste Lamarck, for pioneering evolutionism. Renovated versions of Lamarck's transformist ideas were popular in the 1820s, but his own speculative "zoological philosophy" had confined the earth and its inhabitants in a steady state of flux without real change. Haeckel praised a younger curator, Georges Cuvier, for having demonstrated the fact of extinction, thus establishing the otherness of "the former world" and giving the earth a true history.[10] But Haeckel regretted that Cuvier had posited the creation of fixed species after each of a series of catastrophes, and that his huge authority had ensured the long dominance of these ideas.

Cuvier powerfully divided the animal kingdom too. Refining the classification of Carl Linnaeus, which was convenient but "artificial" because based on single characters, he sought a more "natural" system. For Cuvier, structures depended on the functions demanded by different environments and could be understood only as organized wholes. The other parts were subordinated to the functionally most important elements, ultimately the nervous system. This justified theatrical reconstructions of entire extinct forms from single teeth or bones. Cuvier in this way distinguished four separate plans of organization, or *embranchements*. Reinterpreting the old distinction between animals with and without backbones, he placed the vertebrates on a par with three other divisions: articulates (largely arthropods and annelids), radiates (echinoderms and other groups), and molluscs.[11]

Embryology lacked institutional recognition and had little room in Cuvier's system, but offered a paradigm of progressive development from simple to complex that became influential elsewhere. The new science drew on three main areas of eighteenth-century knowledge. Anatomists and zoologists turned natural histories of monsters into teratology, a specialty devoted to malformations, which elucidated once-threatening anomalies as lawlike excesses, deficiencies, or arrests of development. As male surgeons muscled in on midwifery, interest in the pregnant uterus fed the making of human embryology. Above all, anatomists and physiologists reworked investigations into generation.[12]

While mechanical philosophers struggled with embryos, two groups of theories had aimed, with some difficulty, to account for the origin of organized beings. *Epigenesis*, the ancient view named by William Harvey in 1651, taught that organization arises progressively from unorganized matter. Its rival, *preexistence*, countered that, all appearances to the contrary, adult structures preexist, or are preformed, waiting to unfold. Most saw the egg as the site of preformation; a few favored the "animalcules" in the male semen. Enlightenment epigenesis reeked of materialism, while preexistence was orthodox in positing a passive nature determined by divine laws. But if an omnipotent and benevolent God had made all germs at the Creation, why were there monsters, and how could a polyp regenerate from its parts? Though additional assumptions explained these problems away, they contributed around 1800 to a victory for epigenesis—but epigenesis of a new kind.[13]

The medical dissertation that Caspar Friedrich Wolff wrote in Halle in 1759 had argued for epigenesis, but created order by a vital force. The Göttingen professor Johann Friedrich Blumenbach taught from 1790, with philosophical legitimation from Immanuel Kant, that rather than trying to explain the origin of organization mechanically, researchers must accept this fundamental feature of living things as given. That put questions about origins and the nature of the vital forces safely off-limits, but opened up a vast field within which to explore the relations of the plans of organization and discover the laws by which living animals, fossils, and embryos were not "developed" by God or some force, but developed themselves. In the German lands—the patchwork of princely states that were loosely held together in the Holy Roman Empire until this collapsed like a brittle husk when Napoleon defeated Prussia at the Battle of Jena in 1806—formation was the best guide to form. Studying embryos promised to show dynamically how stem forms had

generated series in an order corresponding to the natural system. As a static, mechanical universe gave way to a huge, organismic cosmos, adult anatomy seemed dead and artificial. The origin and development of embryos—embryogenesis—became the model for a nature pregnant with series on series of forms.

Cuvier's Stuttgart teacher Carl Friedrich Kielmeyer put forward the most potent view of the relations between series in a speech in 1793. He explored the possibility of a threefold parallel between the history of life on earth, the mature organisms surviving today, and the stages of embryogenesis. Though he found too many breaks and gaps, others (later including Haeckel) lacked his restraint. This doctrine of recapitulation, that higher animals develop through the forms of the lower, captivated the Romantic nature philosophers as they speculated beyond the bounds that Kant had marked out.[14]

The human fetus, Lorenz Oken pronounced, "is a representation of all animal classes in time." The animal kingdom was conversely a series of human abortions. The Romantics did not suppose that a human embryo ever looked exactly like a fish, only that one stage embodied the essentials, but their analogies struck critics as wild. Many were equally uneasy with the idea, popularized by the poet-philosopher Johann Wolfgang von Goethe, that a kind of intuitive perception of geometrical transformations could divine the underlying types from series and series from types. The other way to make series run in parallel for long distances was to follow the anatomist Johann Friedrich Meckel the Younger and base them on single organ systems, thus ignoring Cuvier's injunction to consider organisms as integrated, functioning wholes.[15]

By this means Cuvier's Paris colleague and former friend Étienne Geoffroy Saint-Hilaire challenged his approach. Geoffroy traced connections that revealed the equivalence of structures with different functions in different groups—for example, the bones of fish gill covers and the mammalian inner ear. While affinities among vertebrates were generally acknowledged, his disciples proposed that even vertebrates and molluscs shared a single plan. Some flirted with the material transformation of species, and the most extreme imagined a great progression from monad to man. In 1830 the latent controversy erupted in and around the Academy of Sciences to excite newspaper readers and transfix the learned world.[16]

These ideas are so grand, and the debates resonate so deeply, that histories of biology have taken for granted the making of the series on which everything rested, whether uninhibited speculation or solid research. To grasp the practical, everyday life of embryology and to bring its images into the picture, those rarefied discussions need to return to earth. People cared about theory, but worked with their hands. The Heidelberg professor Friedrich Tiedemann, who usually appears as a talking head advocating recapitulation, was once remembered "at his big, wide work-table, in the midst of preparations, copper plates [*Kupferwerken*], hand drawings, and wax models."[17]

Series were, and are, made by a set of linked procedures, which may seem trivial but have wrought profound changes. Collecting not only brought scarce items together; it also framed nondescript or differently interpreted objects as embryos in the first place. Fixation in alcohol turned transient forms permanent. Dissection, or preparation, cut away unwanted material to create clean *preparations* that displayed the structures of interest under the microscope. Collaboration with artists derived clear, magnified, and labeled figures and models from the tiny and unprepossessing stuff. Ordering these and selecting representatives contended with the uncertainties of timing, the effects of temperature and individual variation, and the possibility of abnormality. Published pictures defined standard *working objects*—though only for readers trained to recognize them as such. Development is thus not simply the process embryologists study; it is also an effect they have labored to produce.[18]

Images loom large, but it is still difficult to judge the relative contributions of words and pictures to constituting developing embryos as objects of knowledge around 1800. With so much changing and so little historical research, the sources of innovation remain obscure.[19] It is clear that, while some major works described more than they depicted, key projects invested in pictures that carried the main burden of conveying the results. Some earlier investigators had relied on existing images or shrunk from showing those they feared would mislead.[20] But by the mid-nineteenth century it was a commonplace that embryology had special need of "illustration through art."[21] "Mere words" now appeared inadequate to explain "complicated spatial relations" and were blamed for repeated

misunderstandings and complaints about not being understood.[22] Only new pictures could stake new claims.

Representing embryos in sequence was not itself new, and historians are just beginning to understand how series changed. Human embryology shows the most obvious shift and Haeckel's grids became some of its most influential displays. The extreme challenge of studying our own species also highlights the work of producing a developmental effect. Hidden in women's bodies, early human embryos were so hard for anatomists to obtain that they did not describe those from the first two weeks until the mid-twentieth century. Nor was access the only obstacle; to represent development took conceptual, practical, and aesthetic innovations.[23]

Beautiful Embryos

In premodern Europe pregnancy was uncertain even when a woman's monthly periods stopped and her belly swelled. It usually lasted nine months, but occasionally seven or eleven. Missed periods could mean illness or a false conception, though "quickening," when she felt a child move inside, was a fairly reliable sign. Artists did not depict the contents of the womb realistically either. Midwifery texts figured standard positions, while anatomical treatises showed symbols of children to come. Physicians procured miscarried and aborted objects from encounters with midwives or the women concerned, but the material may have diverged so far from an ideal of perfection based on adults that the doctors rejected it as malformed.

Surgeons promoted human embryology as they tightened their control over midwives' training and cornered the high-class end of the childbirth trade, while enlightened reformers invested in the unborn child as a future citizen. Trials over abortion, infanticide, and paternity, like "pleading the belly" to stay execution, demanded more certain and independent signs of pregnancy. Interest intensified in the later eighteenth century, and stages were fixed. Yet a celebrated atlas by the pioneering man-midwife William Hunter still focused on the uterus and the membranes connecting this to the "fruit." Grand tourists stopped at the wax models of embryos and fetuses in the great Italian collections, or the copies on show in Vienna, Paris, and London, but the most elaborate series in-

Fig. 2.2. A nondevelopmental series of models at the Royal Museum of Physics and Natural History (La Specola) in Florence. Around 1800 Clemente Susini and his school modeled human *feti* in wax and mounted them on six wooden panels. This, the first, runs from the fifteenth day to ninety days (bottom right to top right). At the beginning we see little development, mainly a progressive increase in size. Zoology Section, La Specola, Museum of Natural History, Florence (photograph by Saulo Bambi).

crease in size, while changing little in shape (fig. 2.2). For human embryos, at least, development still had to be produced.[24]

Only in 1799 did the German anatomist Samuel Thomas Soemmerring, known also as inventor of an early telegraph, have his artist mark out a space in which very young humans could be seen to change shape (fig. 2.3). With a little exaggeration, this engraving is regarded as the first series through human development.[25] Reviewing earlier drawings Soemmer-

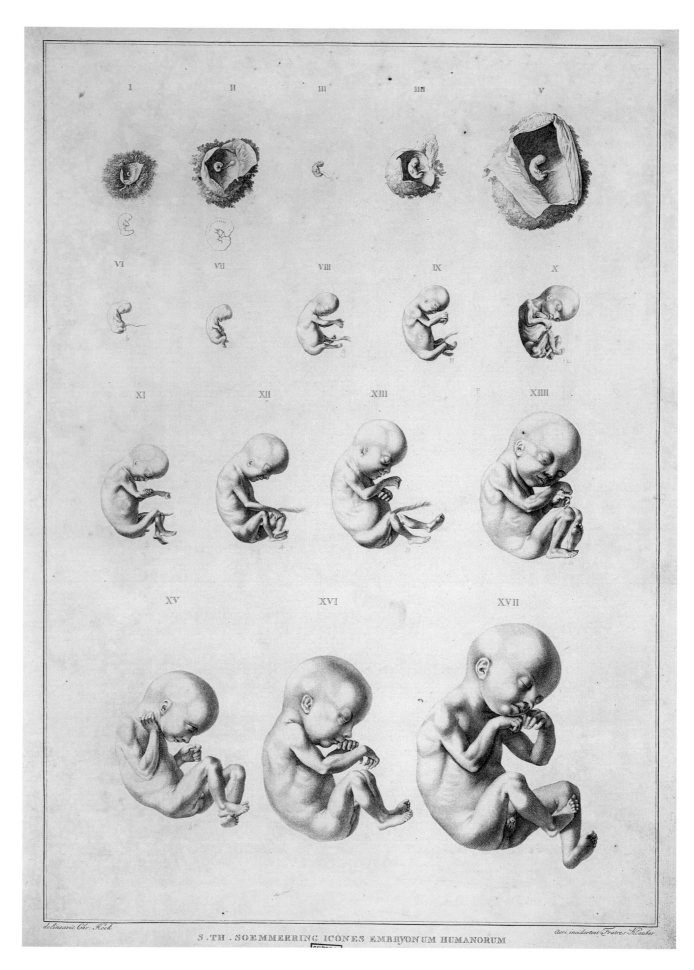

S.TH.SOEMMERRING ICONES EMBRYONUM HUMANORUM

ring complained that none showed "sufficient completeness and such progression of individual stages, that one can recognize without further ado the growth and transformation [*incrementum et metamorphosis*] of the human body from the third week after conception until the fifth or sixth month." Though he admired Hunter's series, the earliest specimens impressed him least, so he planned a supplement to demonstrate "stepwise development [*metamorphosin successivam*]" in the first five months.[26]

Having fled the French revolutionary army, Soemmerring was practicing medicine in Frankfurt, but the *Icones* used material from his time as a professor in Kassel and Mainz. In Kassel he had inherited a rich embryo collection and added to it via personal medical networks and the lying-in hospital. The main source was abortion, spontaneous or induced, but very occasionally anatomists carried out postmortems of women in early pregnancy, some of whom had committed suicide precisely because they feared a child. Other women thought in terms of waste they had to expel, or experienced an early miscarriage as just a delayed period. What few patients had interpreted in embryological terms anatomists now reframed in series of developing forms.

Soemmerring or his collectors opened the membranes to expose the fruits within. He then had the "best" preparations drawn.[27] From the eighteenth to the mid-nineteenth century all naturalists drew types, but in two contrasting ways. Hunter employed a Dutch illustrator to paint every vein and hair in a naturalistic effort to make individual preparations characteristic, while Soemmerring shared the idealism of most German anatomists. Strangely for us, they were committed to both accuracy and intervention to achieve perfection. Soemmerring's artist, Christian Koeck, set up grids to help him draw exactly in proportion, rather than in perspective, but also removed blemishes that obscured the essential form.[28]

Soemmerring ordered and selected the drawings, bringing the series "into a certain natural order" by arranging the preparations "according to age and also growth." Anatomists rarely trusted a woman's testimony about the time of her last period or intercourse. Different parts also grew at different rates, most noticeably as the rest of the body caught up with the relatively enormous head. So his "age" estimates included an assessment of shape or degree of "transformation." Constructing a representative series was complicated by the chronic problem that most of the material reached anatomists through the potentially pathological process of miscarriage. Embryos recovered from postmortems seemed more likely to be normal, but were few and far between. Trying to avoid preparations like "fruits" which drop early because they are "malformed or eaten by worms," Soemmerring selected as norms the "most perfect," that is, those distinguished by "beauty" for their age.[29]

Berlin engravers transferred Koeck's drawings to copper for printing. The effect was finer than woodcuts, but meant separate plates and the small run which suited a Latin work published for prosperous cognoscenti by a distinguished Frankfurt firm.[30] At the early and the latest stages we see the membranes, but—unlike in Hunter—the intermediate drawings at most hint at the umbilical cord. In a lastingly problematic habit, the focus on embryo and fetus had pushed the connections to the pregnant body out of the picture.

Soemmerring thus reworked an older tradition, and drew on established practices of collecting and comparing, but his first two rows show changes in shape that look forward to clearly developmental series more than they look back. Avoid setting up too rigid an ideal of development, take the shapes seriously, and allow for the case-by-case approach dictated by the scarcity of human specimens, and these images can be seen as a crucial step in the appearance of the developing embryo—and the disappearance of other forms miscarrying women had once produced. They are not the end of the story; they are the start of something new.

Soemmerring's sympathy for epigenesis may account for the innovation. Medico-legal interest in the course and duration of pregnancy also directed attention to the details of change. He highlighted aesthetics: even painters and sculptors came close to regarding the "perfect" embryo "with the greatest disgust as something malformed," because they judged by adult

Fig. 2.3 Samuel Thomas Soemmerring's images of human embryos between the third week and the fourth month in seventeen steps. Copper engraving by the Klauber brothers, after drawings by Christian Koeck, from Soemmerring 1799, plate I, by permission of the Syndics of Cambridge University Library. 64 × 46 cm.

standards and failed to appreciate the different criteria of beauty appropriate to each age.[31]

When the Countess of Kesselstadt saw the drawings before publication in the castle of the last prince of Mainz she could not look enough; "she had already had many children, but had never imagined their development [*Werden*] like this."[32] In tribunals, by contrast, such series would devalue the bodily experiences of plebeian women, not least in abortion trials.[33] Doctors admired the original, useful, and attractive plates that stimulated a medical tradition of studying human development by refining descriptions of preparations. By the 1830s, however, leading authorities considered many of Soemmerring's specimens abnormal.[34] They saw the reliance of human embryology on more or less chance discoveries—with no live material and the decisive early stages out of reach—as cutting it off from the spirit of direct observation that suffused the best work.[35] Sustained investigation of other species promised to reveal more, even about "the first genesis of the human embryo," than "isolated observations of mostly malformed early human eggs."[36] The new science was founded on accessible species, especially the classical object of investigations into generation, the development of the chick in the egg.

The Physiologist's Eye

Since hens could be bred in large numbers and development followed from the very start, philosophers and physicians had for millennia incubated eggs and opened them every few hours. Chronological sequences of engravings go back to the Paduan anatomist Fabricius ab Aquapendente in the early seventeenth century. Marcello Malpighi's more detailed drawings from 1672 were in use a hundred years later, and modern biologists admire them still.[37] So the shift around 1800 was more subtle for chick than human embryos, but by building on the existing tradition anatomists pushed further.

Caspar Friedrich Wolff, then at the St. Petersburg Academy of Sciences, gave the crucial stimulus with a treatise on the formation of the chick intestine, published in Latin in 1768. This tailor's son described, also with new images, how membranes formed, folded, and joined to create hollows, vesicles, grooves, and tubes, and how apparently dissimilar organs developed by deploying similar moves. In the early nineteenth cen-

tury, when Meckel brought out a German translation, Wolff inspired grand histories of chick development that consolidated the new embryology. These included finer illustrations and more thorough descriptions; they also introduced germ layers and cells as units of internal analysis.[38]

The German states were then satellites of France, and all the leading German researchers studied in Paris, but embryology was already more at home east of the Rhine. Although other institutions cultivated some medical and natural sciences, the universities, reformed to expect and not just allow research, were so dominant in this one that it is still hard to make out even the military surgeon or the director of a medical academy, let alone farmers or breeders who may have contributed to the debates.[39] After liberation from Napoleonic occupation in 1815, small networks of academic anatomists and physiologists consolidated the science.

The impetus came from Ignaz Döllinger of Würzburg, a teacher who had chosen empirical investigation over Romantic nature philosophy but still sought to understand form by penetrating to the dynamic, living core. He wished to complement Cuvier's static comparisons of adult structures with evidence of gradual transformation from simple to complex. That implied a huge program of work. On a walk one day in 1816 Döllinger made a start by enthusing two medical students from the German-speaking Baltic, Karl Ernst von Baer and Christian Pander, for a plan to reexamine the development of the chick.[40]

The noble but impoverished Baer had to leave the costly project to Pander, a banker's son, who worked where he was staying, in Döllinger's house. The main expense was to engage "the famous horse artist" Eduard d'Alton.[41] Instead of relying on brooding birds, Pander also paid a custodian to run two incubators, each of which accommodated up to forty eggs resting on cotton inside a container surrounded with warm water (fig. 2.4). Pander opened one as often as every fifteen minutes, using a special technique of Döllinger's, and over two thousand in all, viewing them under a compound microscope or magnifying glass and probing with fine needles.

Malpighi had ordered eggs by days and hours of incubation, though he knew that "Nature's powers … have … no fixed time of ripeness," but "now hasten, now delay the appearance of the fetus."[42] Pander found

that the rate of development varied with temperature so much that he divided the period into "ideal" hours and days.[43] Though variation remained "a real nuisance,"[44] he thus began to master a factor that could have prevented series becoming more detailed. His Latin dissertation summarized the changes until the fifth day, arguing in more direct language than before that development begins with the organization of "leaves" of tissue, the germ layers, and only then proceeds to organ formation.[45]

With monographs, not journal articles, still the main means of communication, the idea was to publish d'Alton's drawings with a German text. But so much was the project hatched in a clique of researchers that Pander planned a tiny luxury edition to give away. It took Lorenz Oken, as editor of a journal fostering exchange between disciplines, to object that this would disappoint the many friends of science Pander did not know. Even before the book came out, Oken hailed

the copper plates, to which he had advance access, as "completely new, newly seen, newly thought, newly drawn, newly engraved." While he still could not understand everything in the dissertation, he appreciated the coppers, "so finely and transparently engraved that one believes he could blow the figures away." Yet Oken wanted "not drawings only after nature (for these teach nothing), but ideal [ones]. In general every anatom[ical] artist should make it a rule to draw things not as they *appear*, but as they *are*. So-called drawing after nature is always only pretense; it is not the eye of the artist [*des Mahlers*] that sees, and should see, but the eye of the physiologist." If Pander and d'Alton managed a *connected* drawing of the origin of the main parts of the body, Oken promised to have it engraved on a commemorative medal in their honor.[46]

Haeckel would agree with Oken about drawing, but Pander responded that he and his friends had discovered a world so full of unexpected things happening at once that their figures could not give a joined-up account. They had to suspend judgment in favor of "the most *faithful* representation," never ascribing more importance to one part than another, and leaving the many unclear and indefinite features "shrouded in fog and faintly suggested." Otherwise—a dig at Romantic speculation—they would end up "caught in our own nets." Pander and d'Alton selected a "cycle of representations" for the plates (fig. 2.5A),[47] but avoided contaminating these facts by placing ideal drawings and labels on separate tracing-paper overlays (fig. 2.5B). The German description met another of Oken's requests by following the development of parts, rather than breaking this up by days.

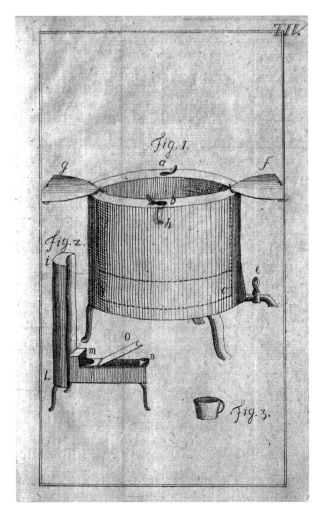

Fig. 2.4 Machine for incubating eggs, as used by Johann Friedrich Blumenbach and then Christian Pander. Figure 1 shows the machine itself, two nested metal cylinders with a space for water between them. The eggs were placed inside, the covers closed, and a thermometer was inserted through the hole between them. An oil lamp (fig. 2) gave heat from below, with the temperature in the chamber adjusted by regulating flame size and other variables. There was a special container (fig. 3) for removing, opening, and if necessary replacing individual eggs. The Göttingen professor who described the machine recommended it for general use as well as experiments, but acknowledged that a farmer with a good thermometer might still prefer to suspend the eggs in a basket in a barrel surrounded with horse manure. Hollmann 1783, plate IV. Thüringer Universitäts- und Landesbibliothek Jena.

Baer had looked on with interest as Pander proceeded "to wind a laurel wreath of egg-shells around his forehead,"[48] and as soon as Baer obtained a chair in Königsberg (now Kaliningrad), embarked on investigations to correct, extend, and generalize Pander's account. He could not afford an assistant, so minded the incubator himself until he could stand the sleepless nights no more and employed hens instead.[49] The research led in 1828 to the first part of *Über Entwickelungsgeschichte der Thiere* (On the developmental history of animals). Publication of the rest of the book was fraught, but both Haeckel and his archenemy Wilhelm His bowed down before what became a classic.[50] Subtitled *Beobachtung und Reflexion* (Observation and reflection), it is remembered for the latter, but began

with the practical difficulties of standardizing and dividing development.[51]

Because Baer was not a skilled artist and could not find one, he offered "ideal" instead of accurate figures.[52] The first two of just three plates show sections that each summarize observations on dozens of eggs (fig. 2.6). The complex third plate contains even more obviously schematic figures representing movements in the development of types (fig. 2.7). Baer followed Cuvier in approaching organisms as functional wholes with characteristic arrangements of parts; he also divided the animal kingdom into four. But Baer understood these types or schemata as governing modes of development. A homogeneous primary germ differentiated, perhaps by some electrochemical process,

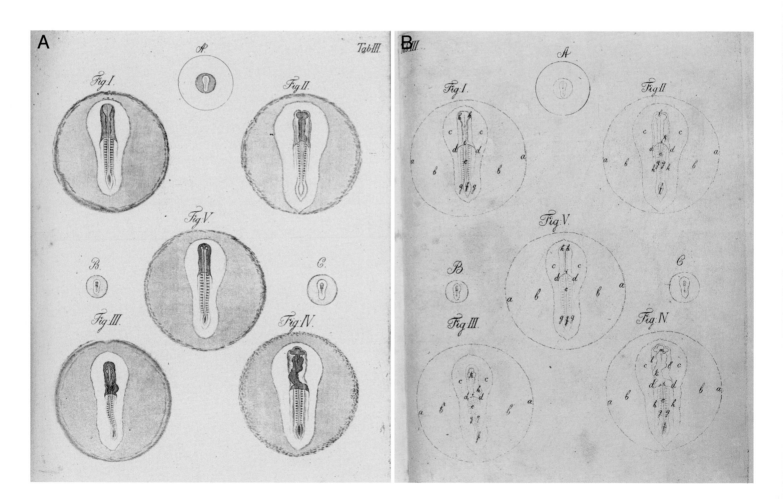

Fig. 2.5 Eduard d'Alton's drawings of the development of the chick in Christian Pander's book. Three "fetuses" of 2–3 days are shown: *A*, plate; *B*, overlay. Figures I and III show the dorsal aspects of the embryos seen in figures II and IV from the ventral side; in the original A, C, and B give the natural size of the three embryos magnified in figures I and II, III and IV, and V respectively. Each figure stands for the degree of development in an interval; Pander does not indicate how he selected them. Another plate aimed, exceptionally, to show "the variety of forms under which the embryo is accustomed to appear at the same stage of development [*Entwickelungsstufe*]." Copper engraving from Pander 1817, plate III, by permission of the Syndics of Cambridge University Library.

into a type characterized by distinctive arrangements of the fundamental organs formed from the germ layers. Further development of each type in various directions—to emphasize certain organs or others— produced a system of classes, families, and species, in which each form of organization developed to varying degrees.[53] Martin Barry, a British medic who had studied in Germany, emulated Baer in depicting the animal kingdom as a branching tree (fig. 2.8).[54]

Grades of development, Baer recognized, could "here and there form considerable series [*Reihen*] indeed," but these are "in no uninterrupted succession of development, and never equal through all grades."[55] Against the recapitulation theorists, Baer thus argued that embryos do not pass through the permanent structures of other animals, but deviate from shared forms; those unlabeled preparations were still fairly undifferentiated, but would diverge. Oken retorted that he had posited not a single ladder for the whole animal kingdom, but many, and that Baer's other objections were either unpersuasive or what he himself had always taught.[56]

Around the same time Baer announced the discovery of the mammalian egg in the ovary of a bitch. Earlier investigators had identified another structure, the Graafian follicle, as the egg, or claimed that the embryo formed from fluid that coagulated in the womb.[57] By the 1820s several microscopists were reporting having seen eggs, but Baer established his as the definitive account, in part through a demonstration to a group

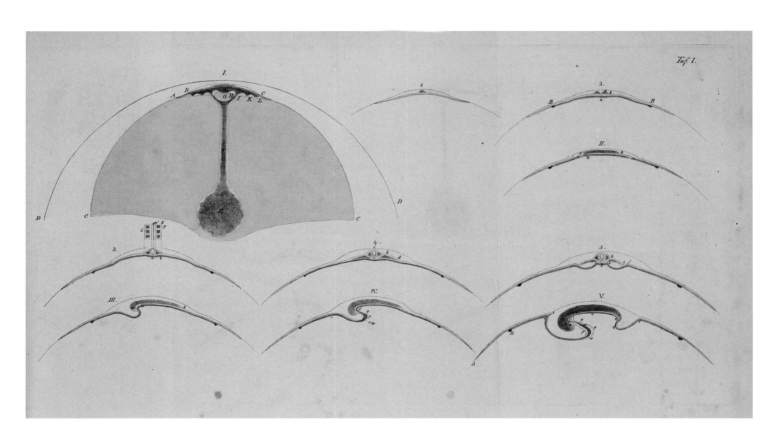

Fig. 2.6 Karl Ernst von Baer's idealized sections through chick embryos of the first two days. Arabic numerals indicate cross-sections and Roman the corresponding longitudinal sections, arranged in pairs to ease comparison. Figure I shows the position of the germ in relation to the yolk, while the other figures focus on the germinal membrane. The three germ layers are yellow (mucous layer), red (vessel layer), and black (serous layer). Foldout, colored copper engraving from Baer 1828, plate I, by permission of the Syndics of Cambridge University Library.

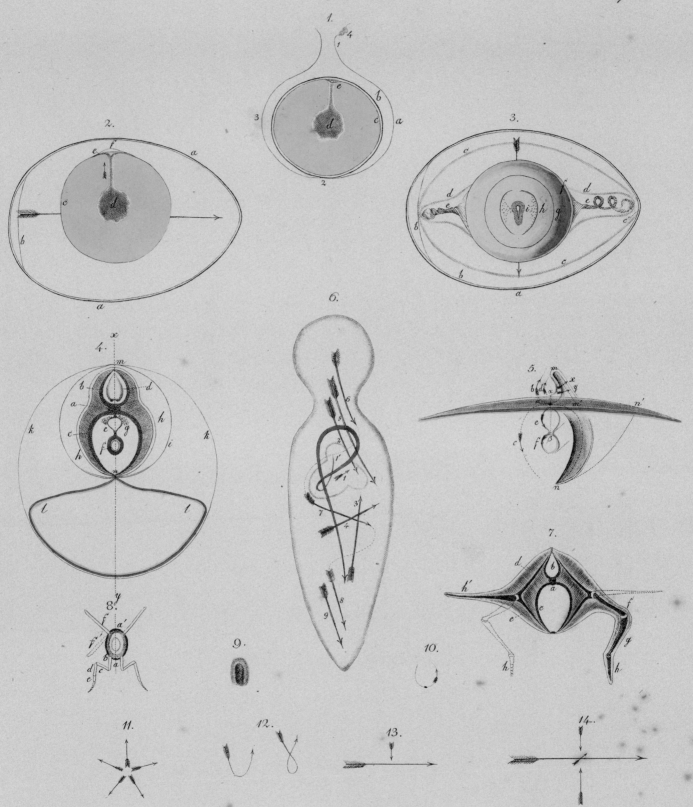

Fig. 2.7 Figures illustrating Karl Ernst von Baer's general propositions, mainly in relation to the four types of development: sections through a chick egg, (*1*) in the ovary, (*2*) at the start of incubation, and (*3*) after about 24 hours; (*4*) the much-reproduced "ideal vertical cross-section of the embryo of a vertebrate"; (*5*) the transformation of the embryo and (*6*) its movements; extremities of (*7*) vertebrates and (*8*) "articulates," that is, annelids and arthropods; (*9*) a jellyfish embryo; (*10*) the articulate scheme of development; the modes of development in each type: (*11*) radiates, (*12*) molluscs, (*13*) articulates, and (*14*) vertebrates. Colored copper engraving from Baer 1828, plate III, by permission of the Syndics of Cambridge University Library.

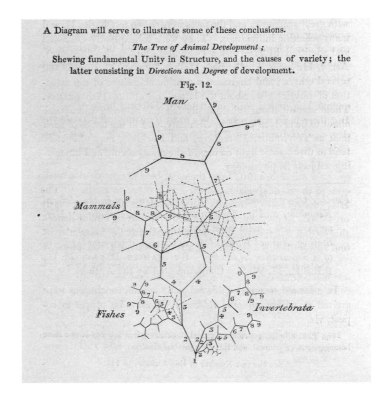

Fig. 2.8 Martin Barry's "Tree of Animal Development." Variety resulted from the direction of development (type) and its degree, from *1*, "No *appreciable* difference in the Germs of all *animals* (Fundamental Unity?)," through class, order, family, genus, species, variety, and sex to *9*, "The *Individual* character in its most special form." From Barry 1837, 346, by permission of the Syndics of Cambridge University Library.

of young anatomists and physiologists at a meeting of the Gesellschaft deutscher Naturforscher und Ärzte (Association of German Nature Researchers and Physicians). The radical democrat Oken had founded this peripatetic annual gathering in a spirit of liberal nationalism. Baer's performance impressed several of the key players who would take his program forward.[58]

Some of these researchers traced the development of organs in different species, some used the new achromatic microscopes to analyze embryos into germ layers and cells, and some concentrated on producing series through the development of little-studied groups. Baer's most important early follower of this kind was the Heidelberg and Giessen anatomist Theodor Bischoff, who pioneered work on mammals with monographs on the rabbit (1842) and the dog (1845). Reacting against the religious nature philosophy of a tyrannical father, Bischoff was a typical post-Romantic in shunning speculation and even reflection, though he never gave up belief in individual immortality. Confident in the significance of the subject, he rather immersed himself in demanding empirical toil. Buying and breeding the animals was time-consuming and costly. Searching the reproductive tracts for the tiny embryos required fiddly surgery and "an unutterable, truly mindless patience"[59] from a "strong, solid

man" known for throwing doors open with a bang.[60] The "diligence and care of exact, calm, and unprejudiced observation"[61] yielded thorough microscopical descriptions and indispensable figures.

"Lifting the veil" on "the puzzles of the development of the mammals and humans" was of "general interest," Bischoff assured his publisher, Eduard Vieweg of Braunschweig, but admitted that "such monographs" made "no great profit."[62] Far from it, even using lithography. This process of printing on a flat surface, invented in Bavaria at the end of the eighteenth century, relied on the repulsion of oil-based ink by wet limestone, except where previously drawn with oil or wax. Cheaper than the traditional copper engravings, and giving the artist more freedom, it was the major means of printing color during the nineteenth century. But even monochrome plates—sixteen for the rabbit, fifteen for the dog—cost so much that only by winning prizes could Bischoff fund the books.

Like the texts, the lithographs were arranged in developmental order, with extra figures to illustrate special points and often just four large drawings on a page. Most are black on white, but a few are reversed to mimic the effect of observation by reflected light (fig. 2.9); some show the same preparation in different views (fig. 2.10). The last plate in each volume gave

Tab.XIII.

Fig. 55. *Fig. 56.*

Fig. 57. *Fig. 58.*

Lith. u. Druck v. Henry & Cohen in Bonn.

Fig. 2.9 Lithograph from Theodor Bischoff's embryology of the rabbit, which won a prize from the Prussian Academy of Sciences and was dedicated to Karl Ernst von Baer. The plate shows two nine-day embryos, a few hours apart, within the germinal area, from dorsal (figs. 55 and 57) and ventral sides (56 and 58), lit from above. Bischoff was happy with this plate by Henry & Cohen of Bonn, because (unlike for some of the others) the excellent A. Schütter redrew his originals and transferred them to the stone. The leading textbook (Kölliker 1861) reprinted several figures from this book, and Haeckel adopted the reversed, white-on-black effect for his comparative plates. Bischoff 1842a, plate XIII, by permission of the Syndics of Cambridge University Library.

Tab.XI.

Fig. 42.
A.

Fig. 42.
B.

Fig. 42.
C.

Fig. 42.
D.

Fig. 2.10 Lithograph showing four views of a 25-day dog embryo. Theodor Bischoff had started work on the dog, but turned to the rabbit to obtain more material. The Soemmerring prize of the Frankfurt-based Senckenberg Society for Research into Nature provided the funds for the dog book. *A*, the "lemon-shaped" whole egg showing the position of the embryo and the membranes (magnified 2×); *B*, the embryo from the side (5×); *C*, the embryo stretched and from the front; *D*, the upper part of the intestinal system (10×). B and C would be much copied, including by Haeckel (fig. 5.6). Lithograph by A. Schütter after Bischoff's drawings, printed by Henry & Cohen of Bonn, from Bischoff 1845, plate XI, by permission of the Syndics of Cambridge University Library.

"schematic figures"—simple, color-coded line drawings of imagined sections—to explain the changing relations of embryo, membranes, and uterus. This was impeccable work, but low-key—unlike the books into which Haeckel would copy some of these illustrations. Bischoff, who had taken a lead in establishing special medical courses in embryology, hoped students might buy, but the runs of just three hundred sold so slowly he consoled the publisher with the hope that the prestige would bring in business that paid. Dedicated to building up the natural sciences, this was Vieweg's strategy precisely.[63]

These histories of development generated images Haeckel would use, as well as debates about modes of drawing, and distinctions between kinds of figure, in which he and his critics would intervene. Pander, Baer, and Bischoff also reinforced powerful conclusions about the vertebrate type.

Fragments of a Comparative Science

Luminous research on organ systems raised embryology to the comparative anatomist's "court of appeal."[64] Structures unintelligible in adults, such as the urogenital and respiratory systems and the skull, disclosed their true connections when traced from simple beginnings. Though hotly debated, not least between Cuvier and Geoffroy, this "higher" or "philosophical" anatomy, Goethe's *morphology*, won wide respect.[65] Arguments over the basis of mental capacity drove obsessive cataloguing of brains, and encouraged anatomists to align cerebral development through the animal kingdom and human embryogenesis (fig. 2.11).[66] Comparisons of whole embryos were far more limited, however.[67]

The keenest, most charismatic comparative embryologist—the man to whom Darwin attributed the unlabeled embryos—epitomizes the gap between theoretical ambition and empirical success. Louis Agassiz, a Swiss trained by Döllinger and Cuvier, combined the dominant French and German approaches. Claiming a threefold parallel between embryos, adults, and fossils, with development starting the same throughout the animal kingdom and then proceeding within distinct types, Agassiz looked forward to the day "we shall obtain from sketches of those embryonic forms more correct figures of fossil animals than have been acquired by actual restoration." He emigrated to the United States in 1846 and worked to establish the life sciences there. The essay that opened a splendid series of volumes on American natural history acknowledged that adult anatomy had led the way, but contended that by showing the grade of development of each species, embryology would add "definite standards of their relative standing, of their affinities, [and] of the correspondence of their organs in all their parts." Yet Agassiz offered only "important fragments" and lamented how little had been achieved.[68]

The major limitation was amassing material. Developmental series were hard to collect even from fish and amphibian spawn and chick eggs, not to mention rabbits and dogs; for human embryos anatomists had just begun. Malpighi had complained of the "well-nigh regal outlay" needed to research live-bearing animals, and Harvey's studies of deer depended on the patronage of the king.[69] Though hunters brought Bischoff does, he found them neither fresh nor abundant, except when the Revolution of 1848–49 gave general access to royal lands.[70] Slaughterhouses offered pig and cow, but it took decades to investigate these thoroughly. Heinrich Rathke, working on reptiles at the Estonian university in Dorpat (now Tartu), collected the indigenous adder and younger turtle embryos himself and obtained later stages and crocodiles from dealers and colleagues' museums.[71] In the early 1840s the young medic Carl Vogt described the development of salmon and midwife toad while laboring in a "scientific factory" that Agassiz had set up in his house in Neuchâtel.[72] After emigration Agassiz exploited his own proximity to American fishes and turtles (fig. 2.12). A science based in Paris or London might have made more use of imperial networks to gather exotics, but embryologists were few and the biological, geographical, and social obstacles were large.

Fig. 2.11 Types of nervous system in relation to the skeleton by the nature philosopher, Saxon court physician, and painter Carl Gustav Carus. In two comparative series this strongly idealist morphology went from the most primitive undifferentiated animal substance to the higher animals (figs. I–XVI) and from fish to human (figs. XVII–XXI). It is no coincidence that some of the most impressively serial illustrations are by a Romantic whose work would soon be rejected as ungrounded speculation (Kuhlmann-Hodick, Spitzer, and Maaz 2009a, 2009b). Copper engraving by Gottfried Wilhelm Hüllmann, after drawings by Carus, from Carus 1828, plate I. 42 × 29 cm. Universitätsbibliothek Tübingen: Bh 20.2.

Tab. I.

Fig. I. A.

Fig. I. C.

Fig. II.

Fig. III.

Fig. V. A.

Fig. VI.

Fig. VII.

Fig. VIII.

Fig. IX.

Fig. XII.

Fig. I. B.

B.

Fig. IV.

Fig. XII'.

A.

Fig. X.

Fig. XI.

Fig. XIII.

B.

C.

Fig. X'.

Fig. XV.

Fig. XIV.

Fig. XVI. a

Fig. XVI. b.

Fig. XXI.

Fig. XVII.

Fig. XVIII.

Fig. XIX. b.

Fig. XIX. a.

Fig. XX.

Carus del.

Hüllmann. sc.

Sonrel & Clark from nat. A. Sonrel on stone. L. H. Bradford & Co print.

VITELLINE AND ALLANTOIDIAN CIRCULATION.

Nor was scarcity the only problem; comparison also interested Agassiz's colleagues less than he would have liked. Similarity trumped difference as they concentrated on common features instead.[73] Rathke's sensational announcement of gills in mammals and birds confirmed the fundamental unity of vertebrate development, as expressed in Baer's anecdote and cross-section of the type (fig. 2.7).[74] The cell theory of the late 1830s sought to generalize the development of these fundamental organs to later structures and across the living world.[75] This took time. Though Bischoff presented development as all about cells, he did not see the egg as itself a cell (he thought the nucleus was) or the products of cleavage as cells.[76] But in the 1840s Robert Remak, as an unbaptized Jew having to work on the margins of the University of Berlin, argued that all cells arise from preexisting cells, from the egg through cleavage to the germ layers, tissues, and organs. He taught that each layer, endoderm, mesoderm, and ectoderm, gives rise to particular cell types, such as liver, muscle, and nerve.[77]

The anatomists who did most vertebrate embryology not only generalized; they also studied other animals with humans in mind. Given the dearth of early human embryos, they aimed to assemble—from the chick, domestic mammals, and a few abortuses—the best series that could stand for human development. As Vogt's teacher, the Bern anatomist and physiologist Gabriel Gustav Valentin, put it, "If ... the history of the bird embryo is ... the ground on which we march forward [einherschreiten], that of the mammalian fetus is the guiding star, which promises us safety on our path to human development." His pioneering *Handbuch der Entwickelungsgeschichte des Menschen* (Handbook of human embryology) mostly discussed the chick and domestic mammals.[78] For Bischoff, the chick was needed in the early stages, when—he optimistically deduced—human development proceeded "almost

in complete agreement"; later, when differences appeared, material was more readily to be had.[79]

Practical limitations, physiological generalizations, and anatomical interests thus converged on the unity of the vertebrate type, the point that Baer's spirit preparations had taught.[80] The identity of early vertebrates could have seemed uncontroversial to Haeckel. But for all the brilliant work on organ systems, comparative embryology had yet to fulfill any grander promise. Speculation about larger-scale relations ran riot, while cautious researchers shrank from ambitious claims. Baer had dreamed in vain of publishing "a work with numerous figures" to make it possible, "more or less like after Soemmerring's *Tabulae Embryonum* [Plates of embryos], to determine the age of any fruit he happened to receive," beginning with sheep and pigs and moving on to other animals.[81] A mixed bag of comparative books settled for much less. Collections of plates depicted select vertebrates with minimal general comment.[82] Some offered diverse forms, but with little prospect of testing bold declarations.[83] The few plates that included more than one species at a particular stage showed different views at different sizes (fig. 2.13), so did not allow the play of similarity and difference to pass in review.

Haeckel's arrays are usually seen through the forgery charges and contrasted individually to their presumed sources. Viewing them against previous developmental series reveals the novelty of columns displaying the development of various vertebrates down the page, and rows aligning equivalent stages across.[84] Pressure for change came from his evolutionary interests and the desire to reach a broad readership with aids to comparative seeing for minds less stocked with embryos than Baer's. They built on the interactions in the 1840s of lecturers and audiences who had already begun creating and demanding stronger images.

No one gave a more spellbinding lecture than Agassiz, with his expansive vision, charming French accent, free style, and easy way with the chalk (fig. 2.14). Later a notorious antievolutionist—the relations between species were, for him, not of blood but of thoughts in the mind of God—Agassiz may seem a surprising precedent. But he prefigured Haeckel's belief in recapitulation, vulnerability to the criticism that detailed empirical work lagged behind grand schemes, and need to address a general public that wanted vivid visual aids.[85] For lectures in Boston in 1849, Agassiz

Fig. 2.12 Louis Agassiz's embryology of the turtle: plate primarily showing the circulation to the yolk sac and allantois. The drawings aimed to picture individual expressions of divine thought (Blum 1993, 210–27). Haeckel appears to have used figures 1 and 4 (fig. 5.13). Lithograph by L. H. Bradford from drawings on the stone by Antoine Sonrel and Henry James Clark (fig. 1). Agassiz 1857, plate XIV, by permission of the Syndics of Cambridge University Library.

Tab. IX.

Fig. I.

Fig. II.

Capra ovis.

Fig. III.

Fig. IV.

Fig. V.

Fig. VI.

Fig. VII.

Fig. VIII.

Fig. IX.

Fig. X.

Mus musculus.

Didelphis virginiana.

Fig. XIII.

Fig. XIV.

Fig. XII.

Bos taurus.

Vespertilio murinus.

Fig. XI.

Canis familiaris.

Talpa europaea.

Fig. XVI.

Fig. XVII.

Fig. XV.

Bradypus tridactylus.

Carus ad nat. del.

Jul. Dietz sc.

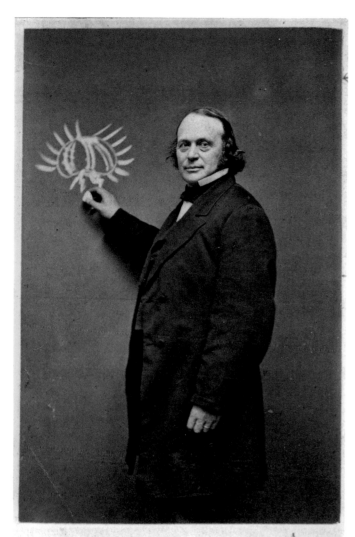

PROF. AGASSIZ.

Entered, according to Act of Congress, in the year 1861, by D. Appleton & Co., in the Clerk's Office of the United States for the Southern District of New York.

Fig. 2.14 Portrait photograph of Louis Agassiz drawing a sea urchin on a blackboard in 1861. He often appeared as a teacher of large audiences, illustrating his own performances as he went along, and in this year, launching his antievolution campaign, threw himself into lecturing again after a break. Archives, Ernst Mayr Library, Museum of Comparative Zoology, Harvard University.

Fig. 2.13 Various forms of mammalian development, depicted in a series in which Carl Gustav Carus made up for the dearth of comparative anatomical plates (Kuhlmann-Hodick, Spitzer, and Maaz 2009b, 260–62). Although united by paucity of yolk and the compensating development of special organs of exchange with the mother, mammal embryos were "extraordinarily diverse," and Carus offered mainly rare forms: sheep (I–II), bat (III–IV), marsupial (V–VIII), house mouse (IX–X), the mole and its eye (XI–XII), dog (kidneys and internal sex organs) (XIII), a similar preparation of a cow embryo (XIV), three-toed sloth (fairly mature) (XV), and placentas (XVI–XVII). Stages, ages, and views differ widely; Carus presented embryology as important for cultivating the mental flexibility necessary to recognize the higher unity in diversity. Copper engraving by Julius Dietz, after drawings by Carus, from Carus 1831, plate IX, by permission of the Syndics of Cambridge University Library.

assembled elaborate, schematic comparisons of vertebrate embryos. Based on colored drawings (fig. 2.15A), he drew series for snail, frog, chick, and rabbit on the blackboard, and these were included as wood engravings when newspaper interest led to publication (fig. 2.15B). To the untutored eye the figures are not as similar as Haeckel's, but the professor encouraged his listeners to see through the incidental differences with a strong statement of identity:

It is not only in these forms of the germ that we have an identical structure, an identical form, an identical process of the formation of the eggs, and the same

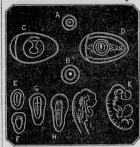

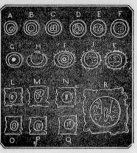

A

B

is as complete as it can be, though each of these types grows to a complication of structure, by which the young Mammal, for instance, leaving behind this low organization of the lower types, rises to a complicated structure, to higher and higher degrees, and to that eminence even which characterizes mankind.

As it is out of the question for me to introduce an illustration of all the phases of these changes, I will only introduce such points of the subject, as bear upon classification, and upon the succession of types in former geological ages, in order to show that the principle which I intend to introduce, as the fundamental principle of classification, is really of value, in all departments of Zoology.

In these diagrams you have representations of the changes which animals of the four classes of Vertebrata undergo. Here (Plate I, page 7) is the history of a Fish, (a White Fish from Lake Neufchatel), as represented by Dr. Vogt, from the egg (Fig. A) up to the period when the young Fish (Fig. F) is hatched. The close resemblance between this form (seen in fig. H) and other classes, is more striking. Here (Plate II, figs. F to O) we have the history of a Frog, (also from a paper of Dr. Vogt,) from the first moment of its formation (Fig. F.) up to the period when the young Tadpole (Fig. N) is hatched. In Plate II, figs A to E, are

[PLATE II—EGGS OF SNAIL AND FROG.]

the changes which a Snail undergoes, according to the illustrations of Rathke; and in this figure (Fig. B,) it is represented, as it appears, taken out of the egg, and deprived of its external envelope, in order to compare it with the form of the young Tadpole, (Plate II, fig. L,) or the form of the young Fish (Plate I, fig. H.) You see the Snail, in its early condition, resembles the young

Tadpole, closely, as you may ascertain by comparison of the figures. The resemblance with the Fish is not less striking, as you see on comparing also the figures of the young Fish.

[PLATE VII.—EGGS OF BIRDS AND HENS.]

And if we go on, we shall find the same agreement in Birds and Mammalia. We have here (in Plate VII) the Hen's egg. Here, (Figs. E to K) we have the different changes within the egg, as figured by Pander and Baer. We have here the different modifications of the young Chicken within the egg; and we have here (Fig. K) the young Chicken, already formed, at one of its earlier periods of growth, when it has yet undergone slight changes of form in its progressive development; and here, (Plate IX,) as we proceed further, we have the history of the changes of the embryo of a Rabbit, from the remarkable work of Prof. Bischoff. I have not figured the outlines of all peri-

[PLATE IX—EGGS OF RABBITS.]

Fig. 2.15 The schematic comparisons of snail, frog, chick, and rabbit "eggs" that Louis Agassiz produced for well-paid lectures at the Lowell Institute in Boston in 1849. *A,* ink and watercolor drawings; *B,* wood engraving of all but the tadpoles and mature frog, printed with the text, which was originally published in the *Boston Daily Evening Traveller. A,* 31 × 24 cm, Smithsonian Institution Libraries, Washington, DC: Agassiz Dibner MSS1B; *B,* Agassiz 1849, 97, Wellcome Library, London.

identical functions; we have the same modifications in the egg to bring about the formation of a germ; and this process by which the germ is formed is identical in Vertebrata with what we have observed in Radiata, in Mollusca, in Articulata. The resemblance does not go further [than, for example, plate VII, fig. I and plate IX, fig. Q], but here the identity is complete.[86]

This was a model for Haeckel's plates and claims, but less striking, harder to compare, and seemingly without a German equivalent.

The German-speaking universities produced the chief innovation, however: dedicated courses, occa-

sionally audited by laypeople. In Dorpat, Rathke's successor Carl Bogislaus Reichert gave some of the best-attended lectures, even though the delivery was as "muddled" as his publications. Not just medical students, professors, and general practitioners, but also "educated laypeople," "thronged" to "enjoy" his "vivid liveliness" and the "singular preparations" with which he "sought to explain the mysterious processes of generation and development." Out of those same "dark depths of embryology" Haeckel would bid to transform the communication of the science.[87]

{ **3** }

Like Flies on the Parlor Ceiling

Haeckel cast himself as a daring pioneer who freed pictures of embryos from "the very most difficult" medical lectures to enlighten an ignorant public:

> No other branch of the natural sciences has remained until the present so much the exclusive property of specialist scholars, and no branch has been so deliberately hidden with the mystical veil of an esoteric priestly secret as the germ history of man. If, even today, we say that every human individual develops from a simple egg, most so-called educated people reply only with an incredulous smile; and if we show them the series of embryonic forms which arises from this human egg, as a rule their doubt changes into defensive disgust. Most of the "educated" have no idea at all that these human embryos conceal a greater wealth of the most important truths, and form a more abundant source of knowledge than most other sciences and all so-called revelations put together.[1]

No one had ever claimed as much for embryology, or ever would, but Haeckel, here as elsewhere, only pushed an existing argument to the limit. Just as his pictures exaggerated standard images, so he embellished a prevailing medical discourse of lay ignorance, disbelief, and disgust.

Those illustrations were made possible, on the one hand, by the establishment of the German universities as centers not just for research, and the discipline wars in which Haeckel would enlist, but also and above all for training students to see microscopically.[2] Participating in a general embrace of visual aids, professors set up courses that, because embryos are scarce, small, and complex, relied on illustration to convey the complicated changes in shape.[3] Teachers drew on the blackboard and collaborated with artists, engravers, and publishers to

take the pictures into print.[4] Students still found the lectures hard, but some enjoyed the initiation and attained a powerful sense of their own expertise.

Haeckel's embryos depended, on the other hand, on the invention in the ferment around the 1848 Revolution of self-conscious genres of "popular science" that addressed laypeople but drew on and fed into university disciplines. While states built institutes for a privileged few, some researchers met a demand for knowledge frustrated by the denial of access to higher education.[5] They painted word pictures of nature and exploited cheaper techniques for printing illustrations.[6] Haeckel minimized the role of embryology in this tradition, and the science did count as arduous, abstruse, and awkward to handle politely. But embryos, made visible as developmental series, were already gaining a public profile. Battles over the materialist embryologist Carl Vogt shaped Haeckel's works and their readers, friend and foe. Vogt played on nonscientists' shock that humans "had arisen from eggs, just like the flies that walked around the parlor ceiling," to frame public recognition as an aesthetic challenge.[7]

Seeing for Ourselves

Memories of embryology teaching in the German universities are mainly visual. The pioneers had learned from Ignaz Döllinger while living with him, and in the early 1850s Robert Remak inspired their successors in classes at his apartment near the University of Berlin: "hecatombs of eggs and of crabs were sacrificed"—Remak cultured chick embryos in crab blood—"to give us a rich experience of seeing for ourselves [*Selbstanschauung*]."[8]

Since the late eighteenth century, educational reformers had made their watchword *Anschauung*, or seeing vividly, for oneself. They did not just show images to make points clear; they expected students actively to experience new knowledge. The French revolutionaries had called on doctors in training to "read little, see much, and do much,"[9] and the ideal of uniting teaching and research more moderately animated the German universities after the wars of liberation from Napoleonic occupation. Between 1830 and 1860, as these institutions ousted Paris as the mecca of medical education, pictureless monologues gave way to lecture-demonstrations and practical classes.[10]

To see for himself, a student paradoxically had to submit to strict disciplines, "for even seeing, especially seeing through a microscope, must be learned."[11] The *Gymnasien*, the grammar schools that prepared boys for university entrance—which in Germany was closed to women until around 1900—taught Latin and ancient Greek at the expense of the modern world. They ran drawing classes, but the little natural science was mostly natural history, often taught by theology graduates, and omitted topics as tricky as embryology.[12] Budding naturalists read and collected in their spare time, but all that rote-learning dulled their classmates' powers of independent observation. University professors worked to reawaken these. Haeckel would study embryos in Würzburg, Döllinger's old stamping ground and in the 1850s home to Germany's most dynamic medical faculty. One of the teachers, the firebrand pathologist Rudolf Virchow, set up a "microscopical railway" that combined two emblems of technological progress to transport histological specimens around the class.[13]

When lecturers showed students how to see, *discipline*, a regime controlling behavior, served a *discipline*, the subject acknowledged by the apparatus of professorship, institute, course, textbook, and examination.[14] The rise of the medical and natural sciences can be charted in the multiplication of subjects and the construction of laboratories to train not just an elite corps of researchers but every doctor, scientist, and science teacher. All were now supposed to distinguish tissues, cells, and germs through a microscope. Though embryology shared in the enthusiasm for microscopy, it rarely achieved independent status in the nineteenth century, but found niches within other disciplines instead. Medical students had learned about embryos in anatomy and especially physiology, two fields still represented by a single professor at each university. From the late 1840s, as a society in flux generated new approaches to the study of life, an expansive reorganization divided these chairs and launched the disciplinary struggle in which Haeckel would intervene.[15]

The "physics of the animal kingdom" once included vital forces, but in the debates leading to the 1848 Revolution a group of students of the Berlin anatomist and physiologist Johannes Müller resolved to root out these relics of Romantic nature philosophy that their teacher had left in play. Where Müller

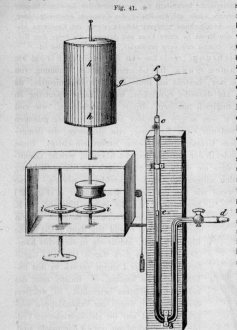

Fig. 3.1 Kymograph for measuring blood pressure, as depicted in a wood engraving in Carl Ludwig's reforming textbook. He had added a writing apparatus to a mercury manometer (*abc*). The two were linked by a rod floating on the mercury surface at one end (*e*) and attached at the other (*f*) to a pen (*g*). This wrote on paper surrounding a cylindrical drum (*h*) driven by clockwork (*i*). Ludwig 1856, 85. Wellcome Library, London.

Bestimmung des Blutdrucks. 85

des Blutdrucks überhaupt angegeben werden. — Hales, welcher den Blutdruck zuerst bestimmte, bediente sich des Verfahrens, welches die Hydrauliker bei Wasserströmen gewöhnlich anwenden, eine einfache, gerade Glasröhre. Diese etwas gröbliche Methode wurde von Poiseuille zuerst dahin verbessert, dass er die in das Gefäss eingefügte Glasröhre (*abc* Fig. 41.), deren Schenkel *ab* und *bc* gleichen Durchmesser besassen, heberförmig bog. In die Schenkel füllte er, etwa so weit der schwarz bezeichnete Inhalt des Rohres geht, Quecksilber, und auf dieses in dem kürzern, dessen Ende mit einem Messinghahn versehen ist, kohlensaures Natron. Darauf fügt er die Dille *d*, während der Hahn geschlossen ist, in das Blutgefäss, in dem er die Spannung messen will, stellt das Rohr senkrecht und öffnet nun den Hahn, so dass das Lumen des Gefässes und des gebogenen Rohres communiciren. In diesem Moment suchen sich auch die Spannungen der Flüssigkeiten in beiden Röhrensystemen in das Gleichgewicht zu setzen, so dass, wenn die Spannung des Blutes höher als die des Röhreninhaltes ist, Blut aus dem Gefäss in das gebogene Messrohr eindringt, und das Quecksilber aus dem kurzen in den langen

Fig. 41.

Schenkel eintreibt. Man erhält dann, mit Hilfe einiger Correcturen, aus dem Niveauunterschied des Quecksilbers in beiden Schenkeln den Druck, den das Blut ausübt. — Da nun aber der Blutdruck im Verlaufe der Zeit sehr beträchtliche Veränderungen erfährt, dass das Auge der auf- und absteigenden Quecksilbersäule nicht zu folgen vermag, so verband C. Ludwig mit den Messröhren eine Schreibvorrichtung, vermöge derer die in der Zeit veränderlichen Quecksilberdrücke sich selbst aufzeichneten. Diese Einrichtung beruht auf einem Prinzip, welches der berühmte Mechaniker Watt zuerst in Anwendung gebracht haben soll. Man setzt nemlich auf den Spiegel des im Schenkel *b c* vorhandenen Quecksilbers einen schwimmenden Stab *ef* auf, dessen freies Ende an einem Querholz einen Pinsel *g* trägt, der sich sanft gegen einen Cylinder *h h* anlegt; dieser wird mittelst des Uhrwerkes *i i* in gleichmässiger und bekannter Geschwindigkeit herumgedreht. Da der mit Papier überzogene Cylinder während des Umgangs fortlaufend andere Orte mit dem Pinsel in Berührung

had published across the whole field of what became anatomy, physiology, zoology, and pathology, they founded a specialized experimental physiology. Wielding "the fiery sword of physics," Hermann Helmholtz, Emil du Bois-Reymond, Ernst Brücke, and Carl Ludwig, a visitor from Marburg, swore to treat organisms like the machine models industrialists were exhibiting at meetings of the Physical Society. Anything not open to investigation by physical experiment or chemical analysis counted as either temporarily intractable, like reproduction, or utterly unscientific (fig. 3.1). That was their view of the science of form, morphology, which with its two pillars, comparative anatomy and embryology, most physiologists still treated as part of their field. Ludwig valued anatomy as a necessary subordinate, but disparaged Rudolf Leuckart's morphologically perspicuous systematics as "a scientific and artistic game." Until the elementary functions of animals were known, such books were best left unread.[16]

These "organic physicists" had high hopes of the revolution but were little involved, so when the forces of order won in 1849 Helmholtz and company could pursue conventional academic careers that tore anatomy and physiology apart. The promise of curing disease persuaded states to construct large, independent physiological institutes. To morphologists' horror, Ludwig moved into a "palace" in the Saxon university at Leipzig in 1869.[17]

Many anatomists gladly gave up the increasingly mathematical physiology. With the whole system growing, separate anatomy institutes began replacing the decaying buildings into which the preclinical sciences had crammed (fig. 3.2). These became vertebrate embryology's main home. It also thrived in the philosophy faculties, where zoologists were occupying independent chairs, though invertebrates attracted more attention here. From the late 1840s the comparative anatomists Albert Kölliker, Carl von Siebold, and Leuckart brought from the medical faculties the old search for the laws of form. Demarcating themselves

from plain taxonomy and mere utility, these "scientific zoologists" integrated anatomy, histology, life histories, and development.[18]

Embryology offered intellectual fascination and national pride, but did not set up institutes or societies of its own. With only a few practical uses, real or promised, in legal medicine, obstetrics, and fisheries, it neither chimed with the physicalist approach and demand for applications, nor could it compete for investment with voyages around the world. The main institutions, ignored by histories that track research, were courses in the "developmental history of man."[19]

The novelty of these lectures is attested by a student who, having been taught by the distinguished but

№ 1116. 19. November 1864.] Illustrirte Zeitung. 353

Das neue Anatomiegebäude in Berlin.

Fig. 3.2 "The New Anatomy Building in Berlin." Histories of medicine tend to give the impression that the mid-nineteenth century built only physiology institutes, and these were the most lavish temples of science, but Germany's leading illustrated magazine regularly reported new anatomy buildings and gave this one a whole page. The text explained how attention to "cleanliness and thorough ventilation" would prevent its becoming "an object of disgust and terror" for the general public. Wood engraving from "Das neue Anatomiegebäude in Berlin," *Illustrirte Zeitung* 43, no. 1116 (19 Nov. 1864): 353–54. 40 × 27 cm. NSUB.

boring Heinrich Rathke in Dorpat, claimed not to have seen a single preparation until he arrived in Königsberg in 1834 and found Baer busy investigating the sheep allantois, a membrane involved in embryonic nutrition.

> I had, of course, heard the name "allantois" countless times in Rathke's lectures, also often enough read about it in my notes, but I had never seen such a young mammalian embryo, also never seen an allantois as Baer now showed it to me…. I thus realized … that I needed above all to make my knowledge, until then gained only from books, into one based on things [*einem thatsächlichen*], and to normalize [*rectificiren*] the monstrous forms which my imagination

had worked up from my reading, through my own experience and sensory perception [*Anschauung*].[20]

Junior faculty, under pressure to lure fee-paying students, spearheaded change. As Müller's assistant in Berlin the anatomist Jacob Henle had annoyed his boss by poaching listeners with one of the first courses to allow students a microscope each.[21] When Henle was established as a full professor in Göttingen, Jacob Moleschott, then a young lecturer, boasted that his physiological experiments stole half Henle's class. "Those visually curious young fellows placed visual experience above the glittering fame of the teacher, what they could grasp with their hands above the intellect."[22]

Embryology courses go back most importantly to Theodor Bischoff, when an untenured lecturer in Heidelberg around the same time. "The incubator was always on, the lectures cost many female rabbits their lives, [and] with incomparable zeal he explained to us the processes in the incubated egg of the hen and the fertilized one of the mammal."[23] By the 1850s the courses were becoming small but standard parts of the medical curriculum, scheduled in the summer semester when it was too hot to dissect unpreserved cadavers.

These schools for sight trained young men to recognize, draw, and label unfamiliar objects. Motivated by Remak, Virchow's Würzburg colleague Kölliker taught vertebrate development almost every summer for three hours per week for forty-one years to an average of 50 students, sometimes as many as 110.[24] This Swiss "teacher of Germany" lacked Virchow's star quality, but earned praise as an "artist in word and picture" for his blackboard drawings in colored chalk.[25] Students copied down the emerging shapes, because "the pictures in the memory that have once made their way through the hand stick much more firmly in the head."[26] They viewed demonstrations of preparations in a fourth hour: "incubated hen's eggs," "embryos of all stages of mammals," "sections of embryos," and "above all also human embryos, whole and with all their organs [displayed], and pregnant uteri with the embryonic membranes and placentas."[27]

Learning how to see depended on learning what to see. Preparations had the advantages of authenticity and leading students toward research, but many early embryos were too rare, transient, translucent, and delicate to preserve, and fresh material was not always to be had. Interpretation of the tiny, complex, and unprepossessing objects came to rely on printed drawings, magnified and labeled, that fed into and derived from blackboard work.[28] The earliest free-standing survey, Gabriel Valentin's handbook of 1835, had no illustrations. The science, he had insisted, "can never be sufficiently explained through mere figures." "A few coppers … can dazzle the ignorant, but never satisfy the [student] eager to learn"; a "big atlas" would have raised the price too much.[29] A revolution in the production of printed matter now began to meet this demand, and generated the books on which Haeckel grew up.

Paintings of Nature and Illustrations of Embryos

In the German lands around 1800 numerous local associations already cultivated "natural science," giving this coalition of disciplines a unified identity. A heterogeneous "learned world" shared the results, also among the assorted groups with access to such works as Lorenz Oken's natural history. This addressed "all estates," but in seven volumes plus index and atlas was out of most people's reach.[30] At the same time, a "reading revolution" and the mechanization of book production, including cheaper paper, the steam press, and more efficient pictorial techniques, expanded the market for print. Professors and journalists joined publishers, developing affection for natural science through the encyclopedias that became fixtures in middle-class homes and newspapers that reported the latest research.[31]

Romantic writers inaugurated a long tradition in which understanding and aesthetic appreciation went hand in hand. In *Ansichten der Natur* (Aspects, or views, of nature) the explorer-researcher Alexander von Humboldt promoted the "painting of nature" as representing the characteristic external appearance of a landscape and its reflection within the human mind. For the Jena botanist and cell theorist Matthias Jakob Schleiden, in lectures to workingmen, only through the aesthetic appreciation of nature could educated people recover the primitive sense of the divine. Beauty might remain mysterious, but naturalists could analyze attractive objects, in particular by classifying plant forms and their associations.[32]

Ansichten der Natur was unillustrated, in common with many a vivid description likened to a "painting" seeking to give "pleasure."[33] The "popular science" that burgeoned from the early 1840s rarely depended on illustration. The discipline-builder Justus Liebig bid for public support with *Familiar Letters on Chemistry* (as they were translated), first published in the Augsburg *Allgemeine Zeitung* (General news), the closest thing to a German national paper. A few years later Humboldt's *Kosmos* combined the holistic cosmology of Romantic nature philosophy with fresh analytical research in appealing prose. The five volumes were more bought than read, but roused others to "popularize," as this was now called.[34]

The popular-science tradition would always value word pictures more than physical illustrations, but new printing methods allowed actual pictures to generate interest, in special graphic works and as an ever more routine addition to books and magazines. Cheaper and freer than copper, lithography was the main color technique. Steel engraving, introduced for banknotes in the 1820s, gave as much detail and tolerated very large runs. But the crucial invention was wood engraving, also dating to the turn of the nineteenth century and advancing in quantity and quality since then.[35]

Like the old woodcuts, drawings carved in relief did not need separate plates but could be printed with letterpress; the innovation was cutting into the end grain of boxwood to achieve results almost as fine as copper. Though costly, the blocks lasted well and could be electrotyped, that is, duplicated by depositing metal electrolytically in molds. Wood engravings became the dominant visual medium, including for reproducing photographs, from the 1840s until photomechanical methods took over from the 1880s. The technique made systematic visual coverage cheaper, as in zoologist Eduard Poeppig's four-volume translation of the *Pictorial Museum of Animated Nature* by the publisher of the *Penny Magazine* (fig. 3.3).[36] A frontispiece might attract readers to a book which ended with a handful of plates displaying key objects or scenes. Schleiden's plant lectures offered colored lithographs, with wood engravings as chapter vignettes (fig. 3.4). Six-hundred-

Fig. 3.3 Wood engravings of birds of prey in Eduard Poeppig's *Naturgeschichte*, the illustrations from which Haeckel copied and colored as a schoolboy. The German version expanded on the English original and presented the material more formally. In the lower left-hand corner of this page is the king vulture (fig. 1268), introduced as the dominant carrion-eater on the plains of tropical America, which Haeckel gave a prominent place in his "National Assembly of Birds" (fig. 4.1, fig. 7). Poeppig 1848, 41. 37 × 26 cm. Ernst-Haeckel-Haus, Jena (EHH).

Fig. 3.4 Illustrations in Matthias Schleiden's *Die Pflanze* (translated as *The Plant: A Biography*). A, frontispiece lithograph by J. G. Bach; B, wood-engraved vignette of a microscope. Haeckel knew the book by heart and adopted the practice of epigraphs from Goethe. Schleiden 1848, frontispiece and 35. Whipple Library, University of Cambridge.

page books now boasted two hundred wood engravings dispersed through the text.[37]

Wood engraving made the illustrated periodical too. From 1843 the weekly Leipzig *Illustrirte Zeitung* (Illustrated news) copied French and English models to bring into the drawing room everything "from the great deeds of princes to the result of the most hidden research."[38] The moderate liberalism was implicit in the celebration of progress and access to knowledge. On folio pages writers reported discoveries, new institutes, and the nature researchers' annual meetings (fig. 3.5). Geology, chemistry, astronomy, zoology, and botany made most of the running in this first great wave of science writing, and microscopy was prominent too.[39] The magazine admitted that pictures could pander to vulgar curiosity or poor taste, but argued that they should draw readers to the text and this enhance understanding of the pictures.[40]

Looking back from the twentieth and twenty-first centuries, such feasts for the eye stand out from a meager visual diet. Serial representations of progress, for example, were rare till around 1850, when sequences of paleontological scenes took off, "progressive and sequential," but at first "separate and distinct."[41] Looking forward from previous decades, however, stunning graphics became widely available, and the general trade reinvigorated academic publishing as techniques, books, images, and artists circulated between the two.

Embryologists continued to author expensive monographs, now with lithographs more often than coppers; journal articles only slowly took over as the main means of reporting research. In teaching, the prohibitive expense of illustrations reinforced warn-

Fig. 3.5 A spread of wood engravings in the *Illustrirte Zeitung*, representing demonstrations to the German nature researchers and physicians: a palaeo-therium skeleton, a fossilized human skull and butterfly, mucous-membrane cells, an instrument for recording the pulse on paper with a sample output, a preparation for explaining the digestive movements of the stomach, adjustments on the microscope, a foot with nails that regrew after amputation of the toes, and an animal group (owls and martens) by the Stuttgart taxidermist Hermann Ploucquet. "Die dreißigste Jahresversammlung deutscher Natur-forscher und Aerzte in Tübingen," *IZ* 21, no. 543 (26 Nov. 1853): 339–42, on 340–41. 40 × 54 cm. NSUB.

ings that this "most difficult" subject could not be acquired by reading, but "only through thorough and serious study."[42] That stayed a privilege of a medical education, and figures always caused some trouble, as when professors complained that students drew the drawing, not the preparation,[43] but the science came to rely on atlases and then on illustrated textbooks.

From the late 1830s teachers and publishers brought out collections of plates, still on copper or in one case steel. A physiology text by the Göttingen anatomist and physiologist Rudolph Wagner, discov-erer of the germinal vesicle (or nucleus) in the human egg, dealt with vertebrate sperm, eggs, genitalia, and the act of generation, and then development in chick and human, with observations of other mammals as necessary, but without illustrations.[44] So he supple-mented it with large-format copper plates from the same publisher, Leopold Voss of Leipzig. Described in Latin and German, these "physiological images" of his own specimens and those he could beg and borrow covered the morphological parts of physiology, includ-ing embryology (fig. 3.6). The plates were printed twice

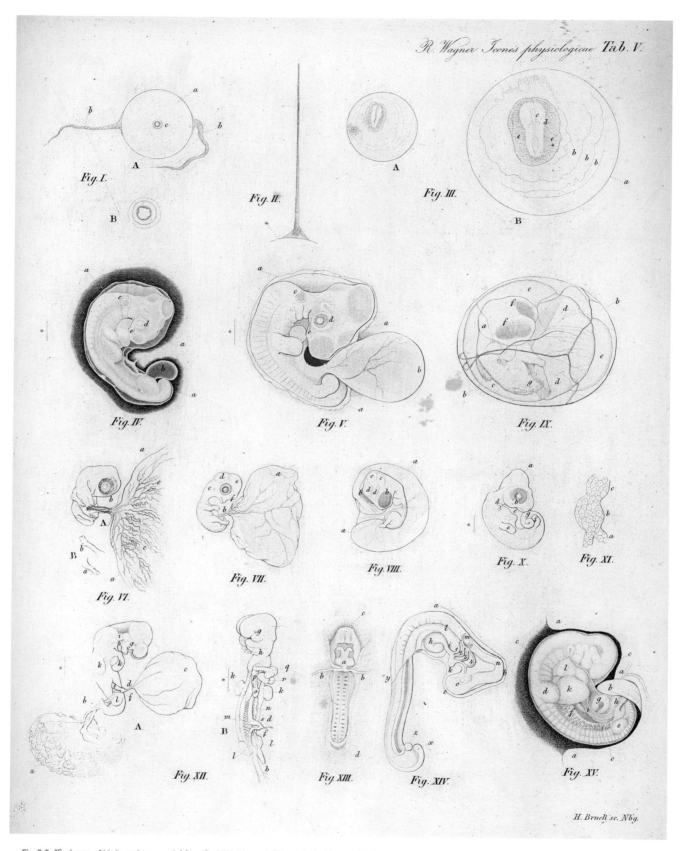

Fig. I. Fig. II. Fig. III. Fig. IV. Fig. V. Fig. IX. Fig. VI. Fig. VII. Fig. VIII. Fig. X. Fig. XI. Fig. XII. Fig. XIII. Fig. XIV. Fig. XV.

H. Bruch sc. Nbg.

Fig. 3.6 "Embryos of birds and mammals" from Rudolph Wagner's "physiological images." This is one of the most richly comparative plates in the literature before Haeckel (and see fig. 2.13). It shows, also for comparison with the chick and human plates that preceded and followed it, embryos of crow (I–V), chick (VI–VIII), falcon (IX), lizard (X), chick heart (XI), mole (XII), rabbit (XIII), dog (XIV), and sheep (XV). But there are various stages, sizes, and views, and typically the work does not really thematize comparative embryology. Under Wagner's supervision most of the drawings were done "with great faithfulness and elegance" by Harald Bagge, a student from Frankfurt am Main, whose engagement, talent, and diligence Wagner credited with keeping him going. Copper engraving by Bruch of Nuremberg, from R. Wagner 1839b, plate V. 28 × 23 cm. Whipple Library, University of Cambridge.

in runs of five hundred, then printed again and copied internationally, but Wagner fretted that he had allowed his friend Voss to sacrifice quality for speed and a low price; reusing the old coppers lost the "fine tones."[45]

Wagner recruited junior colleagues in south Germany to improve on his small and preliminary figures and author series with Voss. First Wagner persuaded Döllinger's last protégé, the young, pious Munich anatomist Michael Erdl, to produce loose-leaf plates of chick and human embryos with figures big enough to see in class (fig. 3.7).[46] Like Bischoff's lithographs of rabbit development, these are reversed, white on black, to imitate viewing against a dark background (fig. 2.9). The delicate, translucent structures stand out but are finely modeled and in part hand-colored within the outline. A little later Wagner arranged for Alexander Ecker, the new anatomist at Freiburg, Baden's second university, to update his images. Ecker judged Romantic nature philosophy fairly—his father taught Oken and he wrote a biography—while himself keeping interpretation on a tight leash. Prepared by exposure to malformations at the foundling hospital in Paris, training in microscopy in Vienna, and learning embryology as a colleague of Bischoff, during the 1850s Ecker turned Wagner's plates into a fresh work with sharper, more delicate, and in part colored figures (fig. 3.8).[47]

Visual aids in other media informed, drew on, and added to the drawings in Ecker's atlas. His physician assistant Adolf Ziegler, a modeler, helped him understand the three-dimensional forms and sold waxes that became indispensable in courses around the world (fig. 3.9).[48] Since the printed figures were mostly small and some were too complex to reproduce on the board during a lecture, Ecker also had them enlarged as wall charts (fig. 3.10).[49] But as books started to include wood engravings he worried that his expensive plates would suffer "dangerous competition."[50]

Wood engraving allowed the modern textbook, the type interspersed with captioned figures, to mimic the results of taking notes and copying blackboard drawings. If any single event consolidated embryology as an independent field it was not a new discovery or theory, but the first textbook, based on Kölliker's lectures, in 1861. Wilhelm Engelmann, who moved from publishing for schools into university texts in the 1840s, had already launched the *Zeitschrift für wissenschaftliche Zoologie* (Journal of scientific zoology) and

Kölliker's highly illustrated histology textbook, which refounded that subject as the study of the development of cells. The embryology text similarly recognized the science, while narrowing its scope compared with "generation" by excluding sexual and asexual reproduction. After a historical introduction, the lectures surveyed the general development of bodily form. The second part dealt, more originally, with organogenesis. The emphasis was on humans, but with recourse, especially for the early stages, to other mammals, chick, and frog.[51]

Würzburg medicine came together with the Leipzig publishing and printing industry as Kölliker collaborated, under Engelmann's direction, with a student transcriber, an artist, an engraver, and the big printer Breitkopf and Härtel on this landmark book. The lectures are short, because drawing took up so much time, and full of fine wood engravings (fig. 3.11), again because of "the great importance of figures."[52] Carl Lochow drew on the wood after originals and copies taken, with acknowledgment, from other works. Formerly of the *Illustrirte Zeitung*, he had somehow acquired expertise in anatomical illustration, so Engelmann had encouraged him to move to Würzburg and help Kölliker, where the book kept him busy for two years.[53] The engraver, Johann Gottfried Flegel, had done Kölliker's histology but was better known for prints after paintings by Wilhelm von Kaulbach. Together, Kölliker, Lochow, and Flegel set the standard for pedagogical pictures.

Medical students more interested in training for the profession than cultivation through science dreaded embryology as difficult and dull; fortunately for them, it did not usually loom large in exams.[54] Others experienced the lectures as so profound they affirmed or shook faith. Erdl intended his plates for all who, like the audience for translations of the Bridgewater treatises, would "worship and adore the omnipotence, wisdom and goodness of the Creator through the contemplation of His works." By contrast, a future surgeon recalled that "the very gradual development

Fig. 3.7 Colored steel engravings of chick embryos, from the sixth to the thirteenth day, from Michael Erdl's atlas, which he unusually engraved himself; a bit like Pander, he labeled the figures on separate sheets (not shown). Haeckel owned, admired, and had figures copied from the work. Erdl 1845, plate III. 23 × 17 cm. Whipple Library, University of Cambridge.

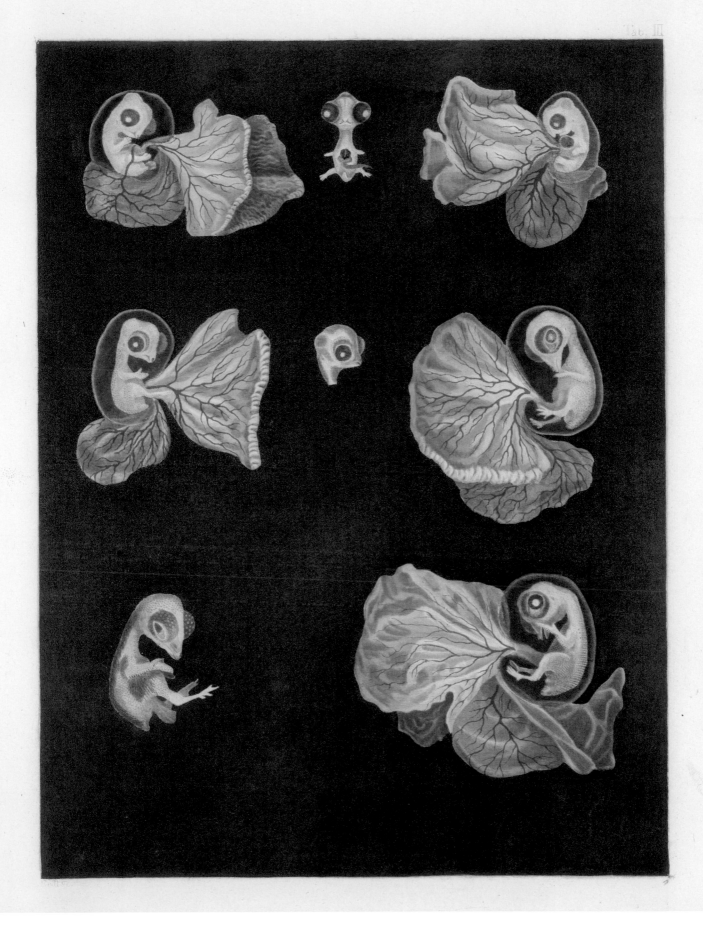

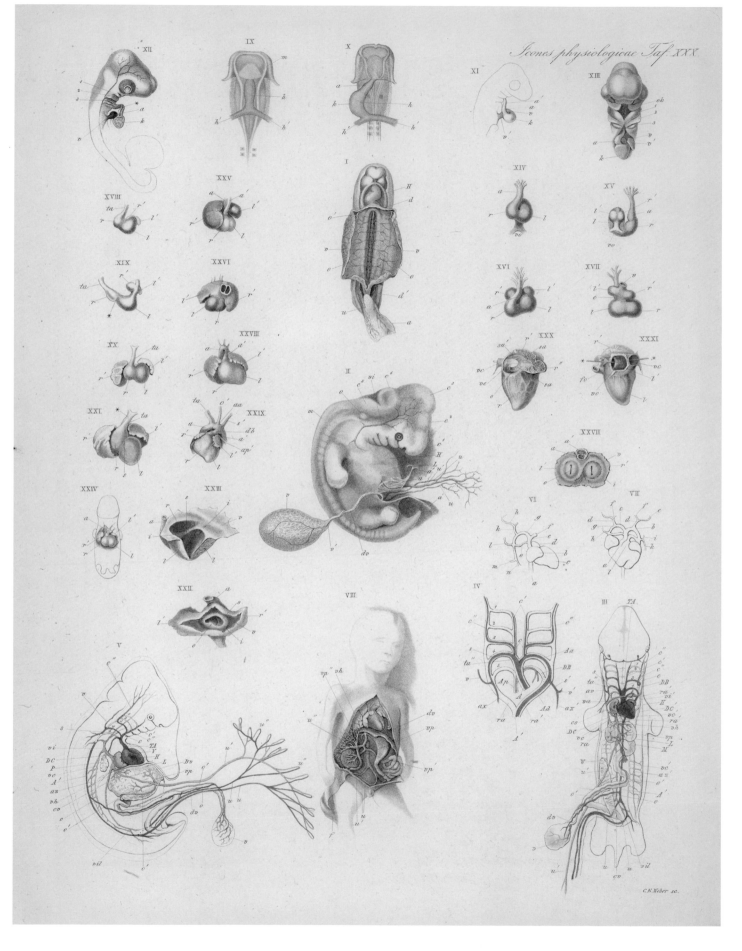

C.F. Weber sc.

A

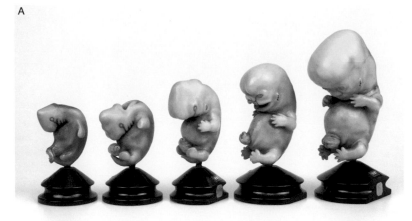

B

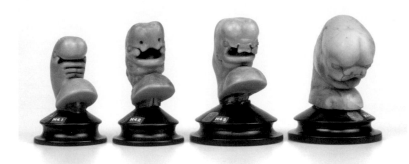

Fig. 3.9 "Wax preparations" of human embryos, first made by Adolf Ziegler in the late 1850s. A, external form from the third to the eighth week of pregnancy, magnified 8–9 times (model 1, 13 cm high with stand); B, development of the face, which the curvature of the whole embryo tends to obscure, magnified 20 times (model 1, 11.5 cm high with stand) and 11 times (models 2–4). Models 1, 3, and 4 are of the same embryos as models 1, 2, and 4 in A. Haeckel used such models in his teaching and made a provocative frontispiece of facial development (fig. 7.9). Department of Physiology, Development and Neuroscience, University of Cambridge.

Fig. 3.10 A wall chart from Haeckel's institute showing a highly enlarged blastoderm, possibly from around 1900. Haeckel's comparative embryological plates could have originated in, or been drafted for, a chart, but nothing similar appears to have survived. Institut für Spezielle Zoologie und Evolutionsbiologie mit Phyletischem Museum, Jena.

Fig. 3.8 Copper engravings of the development of the human vascular system in Alexander Ecker's atlas. The detail far exceeds that in Wagner's (fig. 3.6). The five-page legend, now in German only, explained that I–II show whole human embryos (II may have inspired Haeckel), III–V the development of the arterial and venous systems, partly schematically (and hand-colored), VI–VII a young pig heart, VIII an injected human embryo, IX–XVII hearts of chick, rabbit, and dog embryos, and XVIII–XXXI hearts of human embryos. Ecker 1859a, plate XXX, by C. E. Weber of Berlin after drawings by Josef Wilhelm Lerch.

A

Gestalt des älteren Säugethierembryo. 117

krümmung« belegen. Bezeichnen Sie die Axe des Embryo durch Hintere Kopf-Linien, so sehen Sie, dass die Axe des Rückens ungefähr unter einem krümmung. rechten Winkel in die des hinteren Kopftheiles übergeht, und dass dieser wiederum nahezu in einem rechten Winkel in die des vorde-ren Abschnittes sich fortsetzt. Eine ähnliche Krümmung erleidet der Embryo später auch an seinem hinteren Leibesende, welche wir »die Schwanzkrümmung« nennen wollen (Fig. 60). Zugleich Schwanzkrüm-mung.

Fig. 60.

krümmt sich auch der Rücken des Embryo mehr, so dass er etwas hinter der vorderen Extremität buckelartig vortritt und findet man in einem weiteren Stadium diesen Vorgang so weit gediehen (Fig. 60), dass das vordere und hintere Leibesende einander sehr nahe liegen und eine ziemlich geschlossene Bucht umfassen, in welcher das Herz, der sich entwickelnde Darmkanal und die hervorsprossenden Eingeweide überhaupt ihre Lage haben. Ausser der einfachen

Fig. 60. Derselbe Hundsembryo in der Seitenansicht, den die Fig. 51 darstellt. Nach Bischoff. *a* Vorderhirn, *b* Zwischenhirn, *c* Mittelhirn, *d* dritte Hirnblase, *e* Auge, *f* Gehörbläschen, *g* Unterkieferfortsatz, *h* Oberkieferfort-satz des ersten Kiemenbogens, zwischen beiden der Mund, *i* zweiter Kiemen-bogen, davor die erste Kiemenspalte, *k* rechtes Herzohr, *l* rechte, *m* linke Kammer, *n* Aorta, *o* Herzbeutel, *p* Leber, *q* Darm, *r* Dottergang mit den *Vasa omphalo-mesenterica*, *s* Dottersack, *t* Allantois, *u* Amnios, *v* vordere, *x* hintere Extremität, *z* Riechgrube.

B

94 Vierzehnte Vorlesung.

ein im Embryo gelegener centraler, aus dem das Epithel des Dar-mes sich gestaltet und ein ausserhalb desselben befindlicher peri-

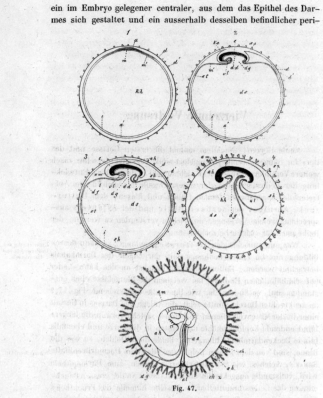

Fig. 47.

Fig. 47. Fünf schematische Figuren zur Darstellung der Entwicklung der fötalen Eihüllen, in denen in allen mit Ausnahme der letzten der Embryo im Längsschnitte dargestellt ist. 1. Ei mit *Zona pellucida*, Keimblase, Fruchthof und Embryonalanlage. 2. Ei mit in Bildung begriffenem Dottersacke und Amnios. 3. Ei mit sich schliessendem Amnios, hervorsprossender Allantois. 4. Ei mit zottentragender seröser Hülle, grösserer Allantois, Embryo mit Mund- und Anus-öffnung. 5. Ei, bei dem die Gefässschicht der Allantois sich rings an die seröse

Fig. 3.11 Pages from Albert Kölliker's textbook. *A*, the most authoritative reproduction of Bischoff's 25-day dog embryo seen from the side (fig. 2.10B); *B*, the most successful schematic, five figures "to represent the development of the fetal membranes." As the embryo (*e*) develops, we see the yolk sac (*ds*) form and atrophy, the allantois (*al*) grow out as a vesicle, and its vessel layer fuse with the serous membrane (*sh*) to form the true chorion (*ch*). Long controversial, the development of the allantois would prove contentious in the dispute over Haeckel's embryos. Wood engravings by Johann Gottfried Flegel after drawings by Carl Lochow, from Kölliker 1861, 117 and 94, by permission of the Syndics of Cambridge University Library.

of the embryo from the just fertilized egg affected me like a revelation" and contributed to his questioning of "much-loved dogmas."[55]

"Natural science" became a "rallying cry" as rivals competed more belligerently over its authority.[56] With censorship easing, the most visible knowledge joined the liberal, nationalist opposition to the despotism of the princely states and the rigid hierarchies of the established churches, but writers exploited nature for divergent agendas.[57] The political polarization after 1848 shaped Haeckel's pictures as much as did the dis-ciplinary struggles and the visual aids.

Seaside Materialism

While many "familiar letters" and published lectures showed worlds in waterdrops, "histories of creation," the genre in which Haeckel would intervene, offered epic surveys of the development of the earth and its inhabitants. The first, based on student lectures by the admirer of Humboldt and professor of zoology Hermann Burmeister, was published in seven editions from 1843. Burmeister rejected both divine creation and the transformation of species, which though popular among British radicals, smacked of outdated

nature philosophy and the much-ridiculed Lamarck. Typical of the liberal and democratic left in Germany, Burmeister rather narrated progress toward human beings through a series of catastrophes followed by mass spontaneous generations of flora and fauna. He cautiously discussed the origins of life and of humans, suggesting that matter had once been more capable of producing organisms, immature and in need of development perhaps, but organisms nevertheless. Laws of nature were nobler than arbitrary intervention, he argued. Humanity's status depended not on where we started but on how far we had come, and—by rejecting hierarchy and superstition and embracing freedom and science—would yet go.[58]

Burmeister was still indebted to Romanticism, but Carl Vogt—Haeckel's most important model—harked back to the mechanistic philosophies of the Enlightenment. Born to radical parents in Giessen, Vogt had studied chemistry with Liebig and then with his family escaped the repressive climate by moving to Bern, where Valentin won him for anatomy and physiology and he ended up working with Louis Agassiz. Irreligious and oppositional, a wit and raconteur, confident and self-ironizing, ravenous and portly, Vogt was larger than life. After Agassiz left for America, he carried on research in Paris and on the French coasts, wrote for the *Allgemeine Zeitung*, and, thanks to Liebig, was in 1847 called to a professorship of zoology in his natal town.[59]

Vogt copied Liebig in writing influential though not bestselling books. *Physiologische Briefe* (Physiological letters), which in a first run of twelve hundred introduced the functions and generation of the animal body, gained lasting notoriety for the admittedly "crude" comment, reminiscent of the medical revolutionary Pierre Cabanis around 1800, that "thoughts stand in the same relation to the brain as bile to the liver or urine to the kidneys." The idea of a directing soul was "pure nonsense."[60] Less well remembered though more significant for Haeckel was *Ocean und Mittelmeer* (Ocean and Mediterranean), Vogt's epistolary account of seaside sojourns in Brittany and Nice with the radical poet Georg Herwegh and the anarchist Mikhaïl Bakunin. This early attempt to win the public for lower life forms interspersed adventures at the beach with spicy observations about national, scientific, and artistic politics. Bakunin appeared as a "passionate angler," who came back from one outing amazed that "even nature had become Christian; the sea was observing its Sunday today and amusing itself with lively bell-ringing." Trying to catch the "bells," he burned his hands on these jellyfish.[61]

Vogt fought disgust based on ignorance and anthropomorphism, as he awakened aesthetic appreciation grounded in understanding marine life. A little like Soemmerring, he wanted readers to abandon the adult human as the measure of all things.[62] Since the sea was too complex and changeable for a "painting" of nature, he offered "a hundred small genre pictures" instead.[63] The single physical illustration was a composition parodying a work esteemed by the Nazarenes, a group of Christian Romantic artists Vogt despised (fig. 3.12).

Scientific revolutionaries stressed the connections, large and small. Reporting on a typhus epidemic among the oppressed Silesian weavers, Dr. Virchow prescribed "full and unlimited democracy" and "education, with her daughters, liberty and prosperity."[64] Reporting on how a sea cucumber shed body parts in response to dearth, Dr. Vogt opined that the weavers needed an inventor to help them do the same. They could then relieve themselves of legs that just got in the way, rumbling stomachs, suffering hearts, and heads that brooded on a remedy—leaving only arms with which to work and backsides on which to sit— and would still have all the body they could feed and all their subservient existence required.[65]

The revolution made Vogt a famous radical-democratic deputy in the National Assembly in Frankfurt, the first elected all-German parliament, and in the doomed final phase briefly a symbolic "imperial regent" in the "rump parliament" at Stuttgart (fig. 3.13). But a treason charge deprived him of his academic position as he fled back to Switzerland, where he wrote furiously and, thanks to his connections and Swiss citizenship, soon landed a chair in Geneva.[66] Though the German universities excluded many left-wingers during the revolution and the reaction that followed, the materialists produced their major writings as the flood from the political storm was diverted to science.[67] Only in 1850 did the critic of religion and of speculative philosophy Ludwig Feuerbach gloss Moleschott as arguing: "Man is what he eats" ("Der Mensch ist, was er isst").[68] And only in 1855 did the physician Ludwig Büchner bring out his bestselling *Kraft und Stoff* (Force and matter). This summary of materialism

TRANSFIGURATION.

B.II. Seite 112.

Lith.Anst.v.B.Dondorf.Frft."/M.

Fig. 3.12 *Transfiguration*, the frontispiece to Carl Vogt's *Ocean und Mittelmeer*, reinterpreted the last great work of the Renaissance master Raphael. Herwegh and Vogt aimed to expand the history painter's repertoire from humans, horses, and dogs, while excluding the Nazarenes' "deformed" angels, whose possession of arms and wings violated the principles of comparative anatomy. They intended to cleave close to nature, but not to risk taking "the first partisan natural scientific picture" too far beyond the favored painters and compositions of the day. The ethereal upper trinity is composed not of the transfigured Christ flanked by the prophets Moses and Elijah, but of a large jellyfish (representing the church) accompanied by a worm and a sea cucumber. This is not paired below with the apostles and the possessed boy Jesus will miraculously cure, but contrasted to various lower animals going about their business while responding to the "medusa shining with piety" above. A public used to still lifes of dead fish and polished shells would, the artists trusted, learn to appreciate a more natural style. Vogt 1848, vol. 2; explanation on 112–31.

Fig. 3.13 Caricature of Carl Vogt by Edward Jacob von Steinle, a painter close to the Nazarenes. The drawing of 29 August 1848 shows the "minister of the future," as Vogt was then tipped, as King Nebuchadnezzar of Babylon, who (according to the book of Daniel) was punished for his pride by seven years of madness, living as a clawed ox eating grass. The drawing circulated as a lithograph. Courtesy of Michael Venator.

and its implications paved the way for Haeckel by deploying as evidence of evolution the facts that no one could tell embryos apart and that comparative anatomical and embryological series ran in parallel.[69]

Materialism was not the only game in town, however, and famous names not the most-read. The most successful history of creation was neither of the two translations, one by Vogt, of *Vestiges of the Natural History of Creation*, which had caused such a stir in Britain and America,[70] but the pseudonymous *Die Wunder der Urwelt* (Wonders of the primordial world).[71] This compilation was condemned as stolen goods, repackaged in a speculator's factory like hack medical advice,[72]

but—hawked in cheap installments door-to-door—it clocked up twenty-eight editions in twenty-six years—better even than Büchner achieved. While other writers mediated between naturalists and theologians, or denounced these creations without a creator,[73] *Die Wunder* debated controversial questions, including the advent of life, but emulated Burmeister's prudence about species formation.

Vogt's big lecture tours of the 1860s allowed Friedrich Engels, a political enemy promoting his own dialectics of nature, to dismiss the "vulgar materialism of a traveling preacher."[74] For different reasons, historians today downplay Vogt's influence as they look

Nabuchodonosor — der Minister der Zukunft

beyond the narrow canon of popular science. Yet his books, journalism, and lectures mattered by engaging scientists, students, and laypeople simultaneously, transmitting politicized and aestheticized knowledge, and creating a public for Haeckel. By polarizing their audiences, the materialists marked out the field on which he would fight.

The German public, having rejected Vogt's politics, still bought his books.[75] His exile began with the *Vestiges* translation and two fat volumes of systematic, catastrophist *Zoologische Briefe* (Zoological letters). A genre that started as letters to a newspaper has been pigeonholed as "popular science," but these detailed tomes found readers in the universities too. Kölliker—politically cautious, but religiously indifferent—assigned the zoological letters in his comparative anatomy course.[76] In yet another book, however, Vogt provoked a huge confrontation by making fun of the conservative Rudolph Wagner's letters in the *Allgemeine Zeitung*.[77]

Wagner returned fire with a speech to the nature researchers and physicians, meeting on his doorstep in 1854, that defended two doctrines Vogt had attacked: the Christian view that all humans descended from a single pair, against which Vogt's "polygenism" posited separate origins for the different races, and the immortality of the soul. Wagner did not offer evidence so much as claim to have found nothing physiologically inconsistent with a position chosen to secure "*the moral foundations of the social order,*" the alliances of throne and altar on which the petty German despots relied.[78]

Responding to a blistering personal counterattack, Wagner protested that Vogt's "pack" of lying dogs could not always be ignored (even if some had been forced out of their posts), and then should feel the whip. "This irresponsible rabble wants to deceive the nation out of the most precious possessions." It "shamelessly blows the people stinking breath from the fermenting contents of its intestines and would

Fig. 3.14 Various kinds of cells. Virchow's *Cellularpathologie* (*Cellular Pathology*) reframed diseases in terms of the altered activities of these elementary parts. The first lecture demonstrated the constancy of nuclear structure through great variability in external form: *a*, liver cell; *b*, spindle cell of connective tissue; *c*, capillary vessel; *d*, larger star cell from a lymph gland; *e*, ganglion cell from the cerebellum. Haeckel would borrow from his teacher such social analogies as the cellular republic (Reynolds 2008) and such concepts as *heterochrony* and *heterotopy* (Hopwood 2005, 243). Wood engravings from Virchow 1859, 8, by permission of the Syndics of Cambridge University Library.

have them believe this be pure fragrance."[79] (Materialists had no monopoly on vulgarity.) Most physiologists found Wagner's intervention embarrassing and unhelpful, because if Vogt bore the brunt, it damaged Carl Ludwig too. Liberal spokesmen for the natural sciences rejected overconfident materialism and invocations of the supernatural alike; both placed unacceptable limits on research.[80] Going beyond the empiricist reaction against Romantic nature philosophy, Virchow developed the powerful generalization that all cells come from preexisting cells and that cellular change causes disease (fig. 3.14).

Though materialism remained a constant provocation, natural science chimed with various religious perspectives or appealed as an escape from theological controversy. Beyond the big debates, thwarted political ambitions found an outlet in writing, reading, and lecturing, engaging in clubs, and founding museums, magazines, zoological gardens, and workers' educational associations. High prices and restricted opening times limited participation, but popular science thrived because it offered the unified, harmonious view that the special sciences increasingly failed to provide.[81] Started by a former revolutionary, *Die Gartenlaube* (The bower) made the most of the need to evade the censor by creating and dominating a new genre of widely read family magazines which adapted natural science to the cozy tone. The more specialized *Die Natur* (Nature) sought a reenchanted world within the theological rationalism of the "German Catholics"

and Protestant "Friends of Light"—and joined the materialists in fighting the alliance of official Christianity and authoritarian monarchies. People of opposed convictions came together to pursue science, but promoted divergent syntheses in their own social milieus as these differentiated before and after the foundation of the empire in 1871. *Gartenlaube* had a conservative Protestant counterpart in *Daheim* (At home); the Catholic *Natur und Offenbarung* (Nature and revelation) battled *Die Natur*.[82] How was embryology presented?

Medical Experts and Lay Disbelief

Embryologists were painfully aware of the exclusion of their subject from a high-school system dominated by Latin and Greek. Baer had lamented that, while his listeners would all know cackling geese saved ancient Rome, only the medics would have examined a goose egg inside; a good German pedagogue would not even know fowl laid eggs, had he not read it in Pliny or Phaedrus.[83] Laypeople audited university courses, and some state collections opened to the public for a few hours a week,[84] but there was rarely more than the odd article or brief discussion in a larger work.[85]

Family magazines accepted anatomy without nudity or sex. Though not part of the aestheticized reconstructions of distant landscapes, sea creatures, and the primordial earth,[86] vertebrate embryos featured occasionally among the revelations of the submicroscopic

Negerkopf verglichen mit einem Löwenkopf von B. della Porta.

Hiervon sagt er: „Die Stirnen, so an der Figur viereckt, und der Proportion ihres Angesichts gemäß sind, sowie die Nasen, die rund und unten stumpf sind, bedeuten von wegen der Gleichheit, so sie mit dem Löwen haben, einen beherzten, großmüthigen, verständigen Menschen."

Ferner:

Kopf eines Windhundes verglichen mit einem Menschenkopf von B. della Porta.

„Welche eine heitere und heraus oder dargebotene Stirn haben, die werden vor Schmeichler und Flatterer gehalten — Welche kleine und gleichwie die Hunde ausgestreckte Ohren haben, das sind gemeiniglich närrische Leute — Deßgleichen welche länglichte Angesichter haben, die werden für unverschampte Leute gehalten. — Welche scharpfe und unten ausgespitzte Nasen haben, die lassen sich leichtlich aufbringen und zum Zorn bewegen. — Diese Zeichen alle sind den Hunden fast schein- und offenbar."

So hat er eine ziemlich bedeutende Anzahl Thier- und Menschenphysiognomien in seinem Buche verglichen.

Man sieht, daß auch hier noch ganz und gar der Begriff von der physiologischen Bedeutung des Hirns und der Schädelwirbel fehlte.

Es verging nach ihm wieder ein längerer Zeitraum, wo diese Wissenschaft, mit Ausnahme der Bemühungen von Lavater, größtentheils ruhte, bis im Jahre 1790 Dr. Gall mit seiner neuen, auf schon mehr wissenschaftliche Grundlagen gebauten Lehre auftrat. Leider waren jedoch damals fast alle Zweige der Naturwissenschaft noch so weit zurück, daß die Lehre, welche in die höchsten Gebiete des menschlichen Wissens, in die Beziehung von Seele und Leib, eingriff, eine wirklich dauerhafte Basis nicht gewinnen konnte, und so kam es denn auch, daß gerade das sogenannte System Gall's und Spurzheim's sich mehr und mehr auf Abwege verlor, und namentlich in Deutschland unter den Gelehrten nie wirklichen Anklang fand und finden konnte. Daß man sich denken sollte, gewisse sehr willkürlich gesonderte Seeleneigenschaften: Wohlwollen, Vergleichungsvermögen, Tonsinn, Verheimlichungstrieb, Bekämpfungstrieb und andere könnten an verschiedenen Stellen der Hirnoberfläche sich verfinden, und dadurch sich an der Schädelfläche ausdrücken, war zu unphysiologisch und zu unpsychologisch, als daß diese Vorstellungen ein Bürgerrecht in der Wissenschaft hätten gewinnen können! —

Im Jahre 1807 war es dann Oken, vielleicht früher schon Goethe, der den wichtigen Satz aufstellte: der Schädel sei ein höher entwickeltes Stück der Wirbelsäule, wodurch die allerdings geistreiche Wahrnehmung Gall's, daß das Gehirn ein höher entwickelter Theil des Rückenmarks sei, vervollständigt wurde.

Auf diesen wichtigen Grundsatz basirte nun die Geheime Medizinalrath Dr. Carus sein neues System der Cranioscopie, von welchem hier eine nähere Uebersicht gegeben werden soll, doch müssen wir hierbei einen Jeden, der noch

vertrauter mit Carus' System zu machen wünscht, auf seine Physiologie, III. Band, und seine „Grundzüge der Cranioscopie," Stuttgart 1841, verweisen.

Die wesentlichsten Grundsätze dieser Lehre möchten im Folgenden gegeben sein.

I. Das Hirn, bestehend aus Primitivfaserbögen und bläschen- oder zellenförmiger Belegungsmasse, ist das Centralorgan des Nervensystems, d. h. alle Primitivfaserbögen, deren peripherische Endumbiegungen durch alle Gebilde des Körpers verbreitet sind, finden ihre centrale Schließung nirgends anders, als zwischen der Belegungsmasse des Hirns.

II. Das Hirn, dessen Analogon in niederen Thieren ein einfacher kuglichter Nervenknoten ist, besteht in den vier höchsten Thierklassen und im Menschen nicht blos aus zwei, sondern aus drei Hirnmassen, so allerdings, daß bald die eine, bald die andere vorherrschend werden kann, und dadurch die andern mehr zurückgedrängt werden. Diese 3 Massen sind Vorhirn — die großen Hemisphären —, Mittelhirn — Vierhügel —, Nachhirn — kleines Gehirn —.

III. Der Schädel enthält, dem Hirn entsprechend, drei Wirbel: 1. den Hinterhauptwirbel, ursprünglich für das kleine Gehirn; 2. den Mittelhauptwirbel — Scheitelbeine und hintere Keilbeinhälfte —, ursprünglich für die Vierhügel; 3. den Vorderhauptwirbel — vordere Keilbeinhälfte und Stirnbein —, für die Hemisphären. In niederen Thieren und in der embryonischen Zeit des Menschen enthält jeder Wirbel seinen entsprechenden Hirntheil. Bei der weiteren Entwicklung des Schädels des Menschen ändert sich jedoch dieses Verhältniß dahin ab, daß zwar der Vorderhauptwirbel immer blos Hemisphärenmasse, Mittelhaupt- und Hinterhauptwirbel aber, neben Vierhügeln und kleinem Hirn, zugleich die Fortsetzung der großen Hemisphären enthalten.

IV. Hirn und Schädelwirbel bilden sich überall gleichzeitig und gleichmäßig, ohne daß eins durch das andere ausgedehnt oder gedrängt würde. Daher ist die Entwicklung jeder Schädelgegend nothwendig und immer ein Zeichen von dem Grade der Entwicklung des davon umschlossenen Nervengebildes.

V. Eine längere Fortsetzung der Primitivfasern im Hirn, wodurch auch eine weitere Ausdehnung einer Dimension im Hirn selbst, und folglich auch im Schädel bedingt ist, ergiebt auch höhere Innervationsströmung. Hieraus folgt auch, daß die größeren Dimensionen des Schädels zur Schädelbasis und der Austrittsstelle des Rückenmarks an, in verschiedenen Richtungen excentrisch gegen die Peripherie hin, als ein Maßstab für die größere Energie der in diesen Richtungen verlaufenden Primitivfasern anzuerkennen sind.

Versuchen wir nun, uns durch Hülfe einiger Schemata diese einzelnen Sätze noch etwas zu verdeutlichen. Was den ersten Satz anbetrifft, so dürfte uns folgende bildliche Darstellung denselben erläutern.

Centrifugale und centripetale Innervationsströmungen.

Stellen wir uns a als die Bläschenmasse des Gehirns dar, so sehen wir die centrifugale Innervationsströmung b — von dem Gehirn durch die Primitivfasern nach den verschiedenen Theilen ausgehend — und die centripetale — zum Gehirn zurückkehrend — c sich wieder in a schließend als Schlinge.

Der zweite Satz wird deutlicher werden, wenn wir die verschiedenen Entwicklungen des Gehirns in der Reihe der Thierklassen betrachten.

Bei den Thieren, wo das Seelenleben ein vollkommen unbewußtes ist, bei den Insecten, Mollusken und ähnlichen ist die Nervenmasse, welche das Gehirn vorstellt und aus

Insectengehirn.

welchen nur die Augennerven — b b — hervorgehen, ein einfacher rundlicher Nervenknoten — a —.

Bei den höher entwickelten Fischen dagegen finden wir schon eine Dreitheilung des Hirns, und hier ist die mittlere Hirnmasse II, aus welcher die Sehnerven entstehen, am meisten hervorragend; die dreigetheilte hintere Hirnmasse I, aus welcher die Hörnerven kommen, und die kleinere, paarig getheilte, vordere Hirnmasse III, woher die Riechnerven entspringen, sind hier untergeordnet.

Gehirn eines Fisches.

In der Reihe der Amphibien — z. B. bei einem Leguan-Gehirn — finden wir schon die vordere Hirnmasse — III — größer, die mittlere — II — jedoch immer noch sehr stark und der hintern — I — fast gleich.

Gehirn eines Leguan.

In der Reihe der Säugethiere fängt sich die Bildung an anders zu gestalten.

So finden wir hier in einem Schafsembryo schon die vordere Hemisphäre III etwas größer, doch immer noch die mittlere Hirnmasse II, die Vierhügel, sehr bedeutend. Am kleinen Hirn, der hintersten Hirnmasse I, beginnt eine Faltenbildung.

Gehirn eines Schafsembryo.

Endlich finden wir beim Menschen dieselben früheren Bildungsverhältnisse des Gehirns. Bei einem achtwöchigen Embryo stellt sich uns die Hirnbildung folgendermaßen dar. Das Rückenmark im Verhältniß zum Gehirn noch größer, das kleine Gehirn I und die Hemisphären III noch sehr klein, während die mittlere Hirnmasse II — die Vierhügel — verhältnißmäßig sehr groß ist und die erhabenste Stelle des Hirns einnimmt. a, b, c Hör-, Seh- und Riechnerven.

Gehirn eines achtwöchigen Embryo.

Im schon mehr ausgebildeten menschlichen Gehirne, bei einem zehn- bis elfwöchigen Embryo ist dann die mittlere Hirnmasse — das Centrum der Nerven wesentlich vegetativer Organe und des unbewußten Seelenlebens — Gemüth — noch immer von beträchtlicher Größe — II — doch entwickelt sich die vordere Hirnmasse — III — schon bedeutend. Die hintere Hirnmasse — I — ist noch die kleinste.

Gehirn eines zehn- bis elfwöchigen Embryo.

Das erwachsene menschliche Gehirn zeigt uns nun recht deutlich, wie außerordentlich sich die Verhältnisse der drei Hirnmassen geändert haben. Die vordere Hirnmasse III hat sich nicht nur über die mittlere II, sondern auch über die hintere I ausgebreitet.

Analog den frühern Bildungsverhältnissen von Rückenmark und Hirn entwickelt sich denn auch die Rückgrat- und Schädelwirbelsäule. Von unten nach oben zeigen sich die drei Schwanzwirbel, fünf Kreuzwirbel, fünf Lendenwirbel, zwölf Rücken-, sieben Halswirbel, auf Rückenmark und dessen Nervenpaar bezüglich, während am Kopfe analog den drei Hirn-

world. In an early article on phrenology the *Illustrirte Zeitung* compared embryonic brains (fig. 3.15); reproduction of fishes was also harmless enough.[87] Human embryos could be awkward to show,[88] but the new "history of development" anyway excluded genitalia and intercourse.

Embryos appeared in more titillating company in the commercial anatomical museums that mixed education and entertainment under the old banner "Know thyself." Vaunting the actually or potentially lewd, they displayed embryological models and specimens, normal and malformed, alongside naked and dissected statues, venereal diseases, and obstetrical operations.[89] In Munich, Paul Zeiller's more sedate anthropological museum included the development of the chick, the frog, and humans, this last series avoiding "anything offensive."[90] Struggling for respectability, other establishments confined embryos, with urogenital organs, to a special cabinet that men and women visited at different times. Books "in duodecimo or even smaller format," which Vogt denounced as products of "shameless charlatanry" and "the crassest ignorance," offered advice on family limitation, sex selection, and VD. A false "prudery" had kept the topic out of mainstream natural history and physiology for too long.[91]

The new embryology did not simply bring hidden secrets to light. That laypeople, especially women, did not know about eggs and embryos increased their relative ignorance of reproductive matters in medical eyes. As doctors rejected as vulgar superstitions the doctrine that terrible experiences during pregnancy could produce monsters, and the conviction that a woman's pleasure during intercourse was a precondition for procreation, Vogt mocked public incomprehension and resistance:

> I have often seen the strangest faces when I talked about these things with otherwise highly educated people, but who had devoted to the natural sciences no special study, when by chance I let drop expressions like "the human egg" [and] "the egg of mammals," which were familiar to me from my conversations with fellow specialists. These people stopped me then as if they had not heard properly, shook their heads disbelievingly, and it often took the greatest effort to make them grasp that they had arisen from eggs, just like the flies that walked around the parlor ceiling [*Stubendecke*], and that

their respectable wives rejoiced in the possession of ovaries. Some found this almost insulting.[92]

He implied that his interlocutors considered it demeaning to lower humans to the level of flies, and perhaps that association with sex made embryos unsuitable for mixed company. *Die Natur* praised his treatment as "tactful, attractive, and accessible."[93]

Vogt did not present embryology so explicitly as to compete with the advice books, but did set a precedent for Haeckel. A dozen of the physiological letters traced mammalian development. Mildly by Vogt's standards, he noted that humans, like other vertebrates, start out as "a longitudinal relief" in "the form of a biscuit or the sole of a shoe."[94] The copiously illustrated zoological letters concluded the description of each group with a look at its development, and so acknowledged the embryological approach to types and series which Vogt predicted the 1848 Revolution would favor as much as that of 1789 had boosted Cuvier's comparative anatomy.[95] One pair of drawings compared dog and human in the uterus (fig. 3.16). Vogt added figures to the physiological letters in the second edition. The third (1861) drew on the page proofs of Kölliker's textbook and reproduced a few of the wood engravings made available by "my friend in Würzburg and his publisher."[96]

Pictures were prized as democratizing, but risked bewildering nonmedical audiences. Zeiller had helped introduce embryological and obstetric drawings into midwives' training, but controversially promoted three-dimensional models as easier than flat figures. It was one thing for students to draw specimens in class; another to broach strange objects to less educated people using drawings based on unfamiliar conventions. But few lecturers questioned the possibility of simulating the experience of seeing for oneself.[97]

In the following decade, evolutionists would draw on their teachers' techniques for communicating

Fig. 3.16 Schematics of the embryonic membranes of dog (fig. 1338) and human (fig. 1339) in Carl Vogt's zoological letters. The uterine walls are shown black (*a*), the chorion as a zigzag line (*e*), the outline of the allantois solid (*g*), the umbilical vesicle dotted (*h*), and the amnion as the solid and dotted line (*f*). The caption stresses the greater development of the dog allantois and the human amnion. Vogt 1851, 2:422, by permission of the Syndics of Cambridge University Library.

mit derſelben, ſo daß nach dem Schluſſe der Schafhautfalten über
dem Rücken die äußere Eihaut durch eine innere Schicht verſtärkt
worden iſt, welche von der Faltung der Schafhaut herrührt. Man
nennt die ſo ausgebildete Haut, zu welcher ſelbſt noch eine Schicht
von im Eileiter umgebildetem Eiweiß kommen kann, das Chorion oder

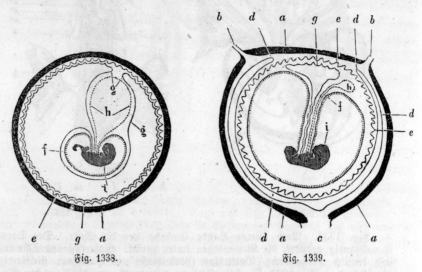

Fig. 1338. Fig. 1339.

Fig. 1338. Vom Hunde, Fig. 1339. vom Menſchen entnommen. In
beiden Figuren ſind die Gebärmutterwandungen ſchwarz, das Chorion zackig
dargeſtellt worden. Die Umriſſe der Harnhaut ſind durch eine einfache Linie,
die der Nabelblaſe durch Punkte, die der Schafhaut durch eine punktirte Linie
angegeben. Bei dem Hunde iſt die Harnhaut um das ganze Ei herumgewach=
ſen und hat ſich zur Bildung des gürtelförmigen Mutterkuchens überall in
die Zacken des Chorions hineingelegt. Beim Menſchen iſt ſie klein geblieben
und hat ſich nur an einer Stelle, der Stelle der ſcheibenförmigen Placenta, in
die Zotten des Chorions hineingebildet. Dafür iſt das Amnios, die Schafhaut,
um ſo größer und außerdem dem Ei von Außen her die hinfällige Haut (De=
cidua, durch eine zuſammenhängende Linie bezeichnet) umgebildet. a Wand
des Fruchthälters. b Einmündung der Eierſtöcke. c Muttermund. d Deci=
dua. e Chorion. f Schafhaut. g Harnhaut. h Nabelblaſe. i Embryo.

die Lederhaut; dieſelbe bleibt als äußere Hülle des Eies bis zu der
Geburt beſtehen. Sobald das Chorion durch die beſchriebene An=
einanderlagerung der äußeren Schafhautfalte und der urſprünglichen
Dotterhaut nebſt dem äußeren Eiweiße gebildet iſt, ſo entwickeln ſich
auf ſeiner ganzen Oberfläche eine Menge verzweigter Zotten, welche
ſich in die Oeffnungen der ſehr erweiterten Schleimdrüſen der Gebär=
mutter einſenken und auf dieſe Weiſe das Ei an einer beſtimmten
Stelle befeſtigen. Dieſe Zotten des Chorions entſtehen auf ſeiner ganzen
Oberfläche, verſchwinden aber alsbald wieder an denjenigen Stellen,
wo keine Befeſtigung an die Wände des Fruchthälters ſtattfindet. Die
Eier der meiſten Säugethiere erhalten auf dieſe Weiſe eine citronen=

knowledge and their simultaneous construction of difficulty and ignorance, which gave medics pride in their own privileged understanding and a dim view of laypeople as resisting the revelations of science. Haeckel would become the most ferocious critic, both of embryologists' failure to spread their discipline more widely, or even to recognize its full significance, and of public indifference to the embryological vision of life. His student initiation went back to a Würzburg classroom where, as always, the experience combined words and pictures, science and art.

Drawing and Darwinism

Science and art thread together through Haeckel's life. As a boy, he discovered nature by learning to draw. As a student, he copied organic structures from the blackboard while developing a vocation for zoology and attending a course on human development not once but twice; the material was so interesting, the lecturers so clear, and they drew so much.[1] Touring Italy, he almost stayed to paint landscapes on an enchanting island in the Gulf of Naples, but the intricate geometries of tiny marine organisms reconciled him to research. As a young professor, he sketched provocative comparisons of embryos and apes as well as the most controversial evolutionary trees. His plates of *Kunstformen der Natur* (*Art Forms in Nature*) capped a career of visual innovation, delighting laypeople and informing art nouveau design.

Yet art was never enough; Baer's "observation and reflection" had to combine. Haeckel drank in the world through his eyes, but theory, especially Darwin's theory, shaped what he saw as he searched for unity among the diversity of life. Haeckel framed his stance as radical reform—securing morphology against physiologists' attacks, revealing the laws connecting the ornate structures, and reinterpreting human culture in zoological terms—but critics heard echoes of Romantic nature philosophy. By the early 1900s, his drawings were often discussed as the schematic products of an overdeveloped fantasy that led him to show what he believed should be there. They expressed his Romantic, artistic nature, his yearning for an impossible synthesis of science and art.[2] Haeckel did conduct Romantic impulses across the nineteenth century, but *Romanticism* is too general and protean a term to explain a set of book illustrations. We should also be wary of projecting the famous scientist-artist onto his earlier self. To grasp what he brought to his embryo drawings it is important to work forward

not back, reviewing his training, respecting the variety of his earlier pictures, reconstructing their meanings, and so discovering how drawing and Darwinism coalesced.

Fig. 4.1 "National Assembly of Birds, consisting of one representative from every family, designed and painted by Ernst Haeckel, 1850." He traced and enlarged the originals (Wedekind 1976, 143), which tended to keep the poses in the book, but offered confident interpretations rather than slavish copies. 124 × 64 cm (with frame). EHH; Fotozentrum A. Günther.

Drawing Lessons

Haeckel grew up in a cultured, liberal middle-class home in Merseburg in the Prussian Province of Saxony. His father, legally trained and philosophically aware, was a senior civil servant in the ministry for educational and religious affairs and his mother an artistic soul committed to Friedrich Schleiermacher's enlightened Protestantism. They rejected a personal god and acts of creation as anthropomorphism, but accepted the contemplation of nature as a form of religious devotion. That made Haeckel devout indeed. Escaping the dead languages of the cathedral school, he wandered the region, enjoyed the "glorious," "marvelous" countryside, and collected plants. He also explored science through gifts of books. Humboldt and Charles Darwin's narrative of the *Beagle* voyage stimulated a desire to travel, while Schleiden's *Die Pflanze* nurtured his interest in the microscope.[3]

These activities were visual. Drawing and painting did not just cultivate habits of attention and accuracy while creating a record of things seen. Haeckel imbibed Humboldt's lesson that aesthetic appreciation and understanding went hand in hand. The most famous product of his schoolboy hobbies, a parliament of birds, represents two years spent coloring the four thousand wood engravings in Poeppig's natural history of animals and liberal enthusiasm for the National Assembly in Frankfurt where Vogt was strutting his stuff (fig. 4.1). Progress, in nature and society, formed a constant theme in Haeckel's reading, notably in Burmeister's history of creation, a birthday present from his brother.

Haeckel wanted to be a botanist, but given the uncertainties of an academic career, his parents typically insisted on the security of medicine. Terrified by disease, and initially squeamish about collecting animals, at least he could explore the science of life. Between 1852 and 1856 he spent three semesters in Berlin, where his family had moved when his father retired, and six semesters in Würzburg. Here he received much

the same advanced teaching as other future leaders of the medical and biological sciences, but processed the experience in his own inimitable way.

Haeckel learned to worship Johannes Müller, who inspired two generations of researchers, but no one seems to have taught him the physics-based science of animal function that some physiologists were hiving off.[4] A textbook by Carl Ludwig horrified morphologists by shrinking Müller's expansive endeavor to those processes amenable to physico-chemical experimentation and mathematico-physical analysis (fig. 3.1).[5] Haeckel's interests in the living world remained too broad for this ever to appeal. The "scientific zoology" of his most influential Würzburg teacher, Albert Kölliker, went in the opposite direction, an aesthetic quest for the laws of form. "The subject matter, the performance, Kölliker's whole approach is so enchant-

ingly beautiful that I just cannot tell you," he wrote home, "with what pleasure I and many others follow his lectures on anatomy"—despite the "barbaric" stench of "rotten flesh." Kölliker's wide knowledge and skilled observation left some students cold, but Haeckel admired the "extremely charming and interesting man; besides being such a perfectly handsome specimen of masculinity as I have rarely seen; in particular, his black eyes are quite splendid" (fig. 4.2).[6]

Würzburg gave Haeckel his first serious encounter with embryology in 1853, "nice lectures" by the young histologist Franz Leydig, with "a lot of drawing." Haeckel heard the subject a second time from Kölliker two years later. "Only the extraordinary interest of this incontestably most attractive and important of all organic natural sciences,... as well as Kölliker's extraordinarily clear and morphologically perspicuous deliv-

A

B

Fig. 4.2 Portraits of pupil and teacher. *A*, Ernst Haeckel as a Würzburg medical student, 1853, in silhouette, then a popular medium for portraits; *B*, Haeckel's own sketch of Albert Kölliker, 1852. EHH, *B* via Lerner 1959, Wellcome Library, London.

ery, accompanied by fine drawings, have moved me to listen again to the course on these matters, which I know almost by heart."[7] Haeckel thus distinguished himself from "most medical men," who endured microscopy as a chore. "The egg is just a simple cell. How incomprehensibly apathetically and indifferently most people behave toward this wonderful fact, the wonder of all wonders."[8]

Haeckel learned best from drawing and drawings. "There is in me some real, sensuous element that allows me to absorb and retain thoughts and facts much more easily, [and] these to imprint much more firmly, when they are represented by pictures, than when they are put down, dry and naked, only in words. I see this, e.g., very clearly in anatomy, where I have clean forgotten in a couple of days things I struggled to learn by heart, but that of which Kölliker gave us a drawing, however sketchy, I have fixed quite firmly and retain."[9]

Like other budding life scientists, Haeckel drew differently for different purposes. His notes from embryology lectures captured the essentials quickly in rough pencil outlines from the board (fig. 4.3). At leisure he sketched the surroundings of the city and drew bones and above all through the microscope. He began in class and, after saving up for a good instrument, continued in his room. Haeckel was a serious, sensitive student, shy with women and something of a loner even among men. So this "dearest inorganic treasure," the envy of his classmates, became "my true life companion," a "wife" he resolved never to leave.[10] It amazed Leydig that Haeckel could look through the microscope with the left eye while drawing with the right.[11]

Drawing was "almost my only real joy, which always drives out bad thoughts."[12] In a sketch that accompanied a dream report for his parents Haeckel portrayed himself, in the third person,

> precisely in his classical moment when he is drawing with his right hand and with his right eye precisely that which he sees through the microscope with his left eye (in front of which he holds his hand, in order to block out the light of the room). In front of him on the table there are also a galvanic battery, magnet, tweezers, coverslips, chemical test-tubes, and other household utensils of natural science. In the left background stands the nightmare of the future, a school blackboard with an interminable mathematical formula, which has yet to be solved. In the foreground [Heinrich] Berghaus's *Physikalischer Atlas* [designed to accompany Humboldt's *Kosmos*], which now forms the entire foreground of Ernst Haeckel himself!

Fig. 4.3 Haeckel's student lecture notes, including pencil sketches of human brain development. From a small notebook labeled, in his hand, "Kölliker. Embryologie. Würzburg 1853." Letters to Haeckel's parents refer, however, to courses by Leydig (1853) and Kölliker (1855). EHH: B286.

"As far as I can make out, medicine lies in the corner, hidden behind the tree. 'The golden tree of life,' however, is and will remain botany!"[13] Haeckel quoted Mephistopheles in Goethe's *Faust*: "All theory, dear friend, is gray, / And green life's golden tree."

Though immersed in drawing life—and death—Haeckel engaged with theory too: Kölliker's strict empiricism did not satisfy a young man on a heady diet of Humboldt and Goethe. Haeckel was an *Augenmensch*—he lived through his eyes—but sight was a means to an end. He acknowledged that he must avoid teleology and other sins of Romantic nature philosophy, but confessed that "a general natural philosophical view and survey of the whole field after researching the individual parts is especially congenial to me and is something I need."[14]

Kölliker introduced Haeckel to Carl Vogt's zoological letters, which intensified his interest in microscopical anatomy and fascination for invertebrate life. Extraordinary forms in unlikely places nourished his natural theological sensibility; whole, tiny marine organisms appealed more than human body parts.[15] Yet Vogt's "insane radicalism" and materialist condescension toward "the childish fairy tale of Christianity" still repelled Haeckel; over some passages he wanted to stick black paper.[16] Like many a liberal Protestant, Haeckel despised the Würzburg Catholicism as a superstitious cult, but with Vogt as model and caution he would steer a safer course, unifying matter and spirit, and putting God into a harmonious nature.[17]

From an interlude in Berlin Haeckel accompanied Müller on a journey to investigate invertebrates around the North Sea island of Helgoland. The prospect of further travel, to the tropics as a ship's doctor, reconciled Haeckel to his medical course. He returned to Würzburg for clinical training, studied with Virchow and experienced the microscopical railway.[18] Haeckel never warmed to the cold, stiff pathologist, whom he suspected of materialism and pitied as blind to the contemplation of nature, but nevertheless became his assistant in 1856 and undertook postmortems with a passion.

Virchow would attest to his pupil's "rare talent for the most rapid pictorial reproduction,"[19] but Haeckel admitted to his mother and father that "Virchow is not wrong to smile when he calls me an 'enthusiastic' instead of a 'matter-of-fact' observer." This was a charac-

ter issue, and Haeckel, knowing his tendency to exaggeration, explained that he owed his academic success to the "one-sided, extreme enthusiasm" that showed even in his drawing. He reassured his parents that "I am more protected than many others against the false steps which such oscillations from extreme to extreme only too easily bring, through the steady course of your consistent, moral and religious education."[20]

Virchow would have kept Haeckel on, but Müller had sounded the call of the sea, and Kölliker took Haeckel on a collecting trip that retraced Vogt's footsteps to Nice.[21] Haeckel gained a doctorate with a dissertation on crab histology in 1857. After the traditional ward experience in Vienna, he passed the state medical exam the following spring and set up a token practice in his parents' home while preparing to try for a research career. Müller's sudden death frustrated a scheme to join his institute,[22] but Haeckel, conquering his shyness, found comfort in engagement to his cousin Anna Sethe. An organic treasure, she promised companionship as true as his inseparable microscope. With Carl Gegenbaur, a young comparative anatomist from Würzburg, he planned a working tour of Italy, but in the end went alone. He was confident in his training and happy in a vocation of traveling to discover organic forms, drawing them, and reflecting on their relations.

Science and Art

Haeckel's most biographically prominent early artworks are the products of his Italian journey of 1859–60: the watercolors of landscapes that pulled him away from cold science and the stunning drawings of marine invertebrates that starred in his first major piece of research. On the beautiful island of Ischia, off Naples, Haeckel had met a fellow artist, the poet of the northwest German marshes Hermann Allmers, and almost become a landscape painter himself—except that he had to acknowledge a lack of real talent (fig. 4.4).[23] He knuckled down to serious science a few months later, having moved south to a "zoological El Dorado," the Sicilian city of Messina,[24] where he settled on the radiolaria: tiny, regularly shaped forms on the boundary between animal and vegetable life. This Müllerian topic allowed him to follow up the Bonn anatomist Max Schultze's claim that some organisms exist as protoplasm without organs.[25] These

Studio in Capri, August 1859.

Fig. 4.4 Haeckel's watercolor of his studio on Capri, with microscope and specimens on the table. He spent the month of August 1859 on this island, at the other end of the gulf from Ischia. 21 × 26 cm. EHH.

were joyous days. Thanking the sea gods for sending so many new species, Haeckel rededicated himself to nature and—as repelled by Italian Catholicism as he was moved by Italian nationalism—vowed to fight this "so-called Christianity" with its "despicable mockery of noble reason."[26]

Haeckel was later accused of confusing art and science, but back in Germany preparing this work for publication, suffered not because he let his artistic imagination run riot, but because he did not. "You won't believe what endless misery and what feeling of deep regret fill me when I enter a painter's atelier," he told Allmers. "Happy, happy people, I think, who can let their thoughts wander casually and freely to the splendid treasures of the South or wherever else their fantasy desires." His "pedantic scientific training"

inhibited his sketching: "Everywhere we feel hemmed in by scientific conscientiousness, and the portrayal becomes in the end just as much an anatomical picture as you also rightly criticized in my [landscape] drawings."[27]

Microscopy closed the rift that Haeckel felt opening between the beautiful and the true.[28] The deaths of close friends, and learning that respected teachers and classmates were to all intents and purposes materialists, had destroyed his faith.[29] He increasingly saw the natural world not as a creation separable from God, but as a divine wonder in itself. Morphology revealed unity in variety, and the fascinatingly symmetrical radiolaria, all derivable—soon he would say *descended*—from one original form, embodied the harmony and order he sought.

Taf. XXII.

1–9. Dorataspis. 1–5. D. Diodon, Hkl. 6–9. H. solidissima, Hkl. 10–13. Haliommatidium.
10–12. H. Mülleri, Hkl. 13. H. tetragonopum, Hkl. 14–16. Didymocyrtis Ceratospyris.

E. Haeckel del. Wagenschieber sc.

UNIVERSITY
LIBRARY
CAMBRIDGE

Fig. 4.5 Radiolaria discovered and drawn by Haeckel. A man shaped by the struggle against systematics as the goal of zoology went on to name thousands of new species. His major interest, and greatest success, was in the big divisions. Engraving by Wilhelm Wagenschieber, from Haeckel 1862, plate XXII, by permission of the Syndics of Cambridge University Library.

Work on thirty-five plates for a monograph let Haeckel put "my little bit of aesthetic feeling" to use.[30] As species multiplied, he fantasized that architects would take up the "ever more delicate, attractive, and fabulous forms," like "lanterns, flower baskets, bird cages, helmets, lances, shields, stars," and cast "even the best gothic" into the shade.[31] Allmers's cousin crocheted one of the radiolaria, and in 1900 another inspired the entrance to the universal exposition in Paris.[32] Nature gave the shapes authority. Introducing

his book as highly disciplined, Haeckel employed a camera lucida to draw "objective" figures with "almost mathematical exactitude," and the Berlin artist Wilhelm Wagenschieber transferred these expertly onto copper (fig. 4.5).[33]

Importantly, given later disparagement of Haeckel's drawing, eminent authorities lauded the plates without appearing to worry that the organisms might not match up. Schultze hailed "one of the greatest ornaments of the zoological literature of recent time"

and praised "exactness of presentation and the beauty of the figures." Rudolf Leuckart recognized the "sustained and conscientious research" and judged the result "equally perfect in form and content." Darwin found the drawings "admirably executed." On the recommendation of the president, Carl Gustav Carus, the monograph won the Leopoldina Academy's highest prize.[34] Carus was the Romantic philosopher-painter par excellence, but Leuckart a scientific zoologist, later a critic of Haeckel and coauthor of definitive wall charts.[35]

In the early 1860s, then, the radiolaria exemplified the very best scientific zoology. Haeckel had struggled privately with its empiricism, but his first research embodied its norms. Hindsight might pick out Virchow's comment about enthusiastic observation, but he had been keen to work with Haeckel, who acknowledged the need to keep himself in check. No one publicly criticized his drawing until 1869, when

Fig. 4.6 "How from his lectern the famous scientist Dr. Haeckel for the first time shows a radiolarian he discovered and a starfish to the astonished circle of long-haired Jena students, and thus opens their eyes. Sketch for a large wall painting, intended for the great hall in Jena," by Hermann Allmers, in a letter to Haeckel of 1 May 1861. Haeckel could be holding models, but Allmers seems to have had little sense of the microscopical size of the radiolaria. EHH.

the focus was on the *Natürliche Schöpfungsgeschichte*. "Romanticism" cannot fully explain attacks from colleagues who accepted his radiolarian work. Rather, it seems, the new figures would be censured as part of scolding the turn to nature philosophy in his general books, and then, as scientists' tolerance of idealization declined and Haeckel became more widely known as an artist, his status as a Romantic became an all-purpose explanation, accusation, and excuse—including for the radiolaria.[36] Romantic traits can be traced back, but were not a significant obstacle in his early career, even among colleagues committed to exact, empirical science.

Gegenbaur, now professor of anatomy at the University of Jena, a small institution that served the four Thuringian states, had begun scheming to create a position for his friend even before Haeckel left for Italy. The plan came to fruition in 1861. Jena offered the tradition of Goethe, Friedrich Schiller, and Oken, the beginnings of a renowned optical and glass industry, and a supportive administration in more relaxed surroundings than Berlin. Haeckel was in paradise, walking the woods and enjoying the liberal "spirit of freedom and equality" (fig. 4.6).[37] The radiolaria then won him promotion from "private lecturer" dependent on lecture fees to associate professor of comparative anatomy and director of the zoological museum. With this salaried position he could at last marry Anna.

In summer 1863 Haeckel used his advanced Würzburg training to begin to teach vertebrate embryology. For most of the thirty-three-lecture course he spoke from notes and drew on the blackboard from colored figures after Kölliker's lectures and textbook (fig. 4.7). He spent a half hour showing his six students chick embryos and "wax preparations" of humans, another half hour on fish, and a full hour demonstrating "human embryos and egg membranes in figures and preparations."[38] The waxes were presumably Ziegler's; the figures could have been plates or charts. These look

Fig. 4.7 The notebook from which Haeckel taught human embryology, beginning in summer 1863. Drawings in black pen, and blue and orange crayon, here show the overall organization of the mammalian embryo, including (F. 51B) the formation of the heart and embryonic circulation. EHH: B102.

to have been lectures much like any others and the pictures, for all the simplification compared with Flegel's wood engravings, give no hint of controversy to come.

Yet Haeckel continued to seek a grand synthesis not just consistent with the ethos of scientific zoology, but capable of defending that approach. Morphologists still smarted from Ludwig's dismissal of work like his on the radiolaria as a foolish game, easier than physiology, but failing to penetrate the secrets of life. This is where Darwin could help.

Darwin and the Laws of Form

Haeckel read *On the Origin of Species* in summer 1860 in a translation by the paleontologist Heinrich Georg Bronn that is fairer than usually thought.[39] He studied the book keenly over the next few years, and a foot-

note in the radiolarian monograph recorded his admiration.[40] The reading promised to resolve his personal quest for unity and save the science of form.

The *Origin* left Haeckel's favorite topics, classification and morphology, including embryology and rudimentary organs, for the last substantive chapter, but suggested that they proved evolution on their own. The embryology section began by observing that at early stages related animals often resemble each other more than do the adults. "A better proof of this cannot be given, than a circumstance mentioned by Agassiz, namely, that having forgotten to ticket the embryo of some vertebrate animal, he cannot now tell whether it be that of a mammal, bird, or reptile."[41] Darwin thus misattributed even as he revived the most potent account of similarity;[42] the third edition corrected the acknowledgment and gave a full quotation, while

Bronn's translation already credited and paraphrased Baer.[43] "Embryology rises greatly in interest," Darwin concluded, "when we thus look at the embryo as a picture, more or less obscured, of the common parent form of each great class of animals."[44]

Bursting into the ferment of German life and medical sciences, the *Origin* sparked debate in the universities and the press over *Darwinismus*, as people called it from as early as 1861. Responses varied with expertise, discipline—morphologists were some of the most engaged—religious commitment (if any), and, not least, age. Typical of older generations, Baer reacted against the denial of teleology and Kölliker also found the vision too accidental. Both could accept some transformism but wanted a single law of nature driving development from simple to complex. Their younger colleagues, especially the scientific zoologists Kölliker had trained, were more susceptible and had less to lose. Vogt and Ludwig Büchner embraced Darwinism fast, and it suited them—and their enemies—to assimilate it to the materialist worldview.[45]

Haeckel and Gegenbaur enlisted Darwin to shore up the claims of morphology to scientific status and align it better with scientific zoology. The search for developmental laws felt tainted by the Romantic interpretation of ideal types mysteriously directing development toward a goal, and invocations, such as Bronn's, of a "creative force." The experimental physiologists were succeeding in branding morphology "the old-fashioned approach of old men."[46] A mechanistic theory of evolution promised to refound the field on a more intellectually respectable cause.[47]

So the two friends formed a partnership of opposites to spread a German version of the good news from England. "Gegenbaur, about eight years older, [was] stiff and closed in on himself, slow and deliberate in everything that he did and that he wrote, a hard, inflexible character, but perhaps precisely for this reason avoiding many conflicts." Shunning publicity, he would concentrate on research in comparative vertebrate anatomy and the academic politics of publication, journal editing, and appointments. "Haeckel [was] lively, of bewitching kindness, quick in his decisions to the point of rashness, a cheerful fighter."[48] His research stayed loyal to marine invertebrates, but evolutionism gave him his synthesis and a politically congenial theory. Lecture notes from 1862–63 announce: "no miracle, no creation, no creator."[49]

Also in 1863 several books in German supported Darwin and human descent from apelike ancestors, including a translation of essays on "man's place in nature," the "question of questions for mankind," by the comparative anatomist Thomas Henry Huxley, the rising star of British biology.[50] In September Haeckel inaugurated the debate over evolution in the biggest pulpit of German science, a session of the congress of nature researchers and physicians open to laypeople of both sexes. Reading a fairly long manuscript, an approach frowned upon by the *Illustrirte Zeitung*, he gave the first public lecture in the "magnificently decorated" gymnasium of the Baltic port of Stettin (now Szczecin).[51]

Haeckel proclaimed that Darwin's theory was shaking an edifice that had lasted for centuries, and intervening deeply in the personal, scientific, and social views of every individual. "All the various animals and plants still living today, and all organisms that have ever lived on the earth were not, as we are used to assuming from early youth, each one independently created in its species, but have, despite their extraordinary diversity and variety, developed gradually in the course of many millions of years from some few, perhaps even from *one single stem form*, a highly simple anorganism." Humans had descended from ape-like mammals, kangaroo-like marsupials, lizard-like reptiles, and ultimately from lowly fish.[52]

Some wanted to restrict the theory to specialists, in part because transmutation had been rather risqué, but they were too late. "The whole great army of zoologists and botanists, of paleontologists and geologists, of physiologists and philosophers, is split into two diametrically opposed parties: on the flag of the progressive Darwinists stand the words, '*Development and progress!*' From the camp of the conservative opponents of Darwin rings the cry, '*Creation and species!*'" Promoting polarization—Haeckel ignored the liberal opponents and caricatured the teleologists—he claimed that the divide was growing every day, with ever wider circles drawn in. Expert judgment required long years of study, but none could remain aloof, and an open struggle would give everyone a good view.[53]

Haeckel explained that Darwin had purified the nature philosophers' transmutationist theories of the many errors and provided a wealth of facts in support. Evolution was too gradual to be observed, Haeckel admitted, but only this theory could explain whole se-

ries of the most significant phenomena. He said most about fossils, but referred to geographical distribution and rudimentary organs and drew special attention to embryology. Unlike Darwin, Haeckel evolutionized Agassiz by stressing "above all the highly important *threefold parallel between the embryological, the systematic, and the paleontological development of organisms.*" Haeckel acknowledged weaknesses and that much remained to be worked out. Darwin had overemphasized natural selection at the expense of the conditions of existence, but in Haeckel's vision, too, a "merciless and incessant *war of all against all*" ruled nature, no less than human society. The same natural *"law of progress"* acted everywhere, immune to "tyrants' weapons" and the "curses of priests."[54] This combative denunciation of tradition, superstition, and prejudice sounded revolutionary—while drawing on attitudes common in the liberal, educated, Protestant middle class.

The *Illustrirte Zeitung* noted that although listeners aired worries about the religious implications in small groups, the one direct public reply was from a geologist in the closing session who reckoned the fossil evidence more consistent with cycles of rise and fall than progressive development. The discussion began to come alive when Haeckel rebutted this argument, and Virchow backed up his contention that only those who mastered embryology were competent to assess

the theory. The meeting thus ended with the prospect of future debate.[55]

Back in Jena, Haeckel lectured, built up the museum, and plotted reform.[56] Filled with domestic bliss, recognition as a formidable microscopist and systematist, and Darwinism, these were the happiest months of his life. Then tragedy struck. On his thirtieth birthday, 16 February 1864, his radiolarian monograph won the prize, but Sethe, his irreplaceable first love, suddenly died. Three years later he married Agnes Huschke, a daughter of Gegenbaur's predecessor as anatomist, but Haeckel never fully recovered from an experience that left him harder and more reckless.[57] In 1865, with a call to Würzburg in prospect, he was appointed Jena's first full professor of zoology as an independent discipline and that winter founded a zoological institute (fig. 4.8). All the while he sought solace in intense work on a big, programmatic book, the *Generelle Morphologie*.

Planting the Tree

This "general morphology" combined observation and reflection to overcome the teleology and philosophical idealism that had ruined Goethe's science of form. "Dogma and authority, sworn to suppress every free thought and any direct knowledge of nature, have

Fig. 4.8 The Jena Zoological Institute in the old castle, where Haeckel worked from 1861 to 1869. He has marked the lecture hall and his own room. EHH.

erected a double and triple Great Wall of China of prejudices … around the fortress of organic morphology, into which," Haeckel imagined, "the belief in miracles, fought off everywhere else, has now retreated as if into its last citadel." Inside was a "great, wild heap of stones," the facts accumulated by the empiricists whom Romantic excess had frightened away from any general thought.[58] But if arrogant physiologists looked down on morphology as a mere maidservant, they mistook a temporary condition for the sister science she should become. Darwin would awaken her adepts, dreamily satisfied with the comfortable pleasures of describing organic forms, to serious insight, and show

the physiologists how much work of comparison and on origins they still had to do. Explaining form was as noble as explaining function, and justified an equal rank.[59]

Empiricism alone could never carry natural scientists' bids for authority, so like Virchow with his cellular pathology, Haeckel went after a generalization with which to claim a seat at the high table of power. "'*Common descent!*' is the 'word which happily solves the holy riddle, the secret law,' which Goethe discovered in the general opposition between the infinite variety and the undeniable similarity of organic forms."[60] Reconnecting with older ideas, Haeckel aimed through Darwinism to revive a philosophical approach to nature while avoiding the extravagances of the Romantics. Romanticism shaped even its harshest critics—Ludwig's self-registering devices appealed in part to a Romantic ideal of recording nature's dictation directly— and informed Haeckel's speculative system-building far more.[61] But it is misleading to harp on this aspect while ignoring the different and the new.

In two stout volumes, Haeckel offered the first Darwinist system in "as many lawlike proposals as the municipal code of a small city."[62] He considered the origins of life and compared and contrasted the properties of animals, plants, and the single-celled eukaryotes he called *protists*. The rest of volume 1, on general anatomy, set out six hierarchical levels of individuality and assigned fundamental structures to the whole animal kingdom. This organic crystallography, or *promorphology*, deduced from the external shapes and internal components of each group the "basic geometric forms" that lay behind and explained them (fig. 4.9).[63]

Volume 2 tackled the general history of development, beginning with a new classification system and reviewing modes of reproduction. Haeckel then discussed descent and the selection theory. He set up

Fig. 4.9 "Heteropolar Basic Forms" in the *Generelle Morphologie*. Schematic outlines of various pyramidal organisms. Solid lines represent the real outlines, dotted lines the stereometric basic forms (just the base of each pyramid) and the radial axes, while dashed lines indicate the interradial ones. Figure 1, for example, shows a carmarina (jellyfish) larva as a type of the "Hexactinota," "pyramidal basic forms with six antimers or paramers." Lithograph by Albert Schütze after drawings by Haeckel from Haeckel 1866, 1: plate I, by permission of the Syndics of Cambridge University Library.

inheritance as the conservative principle, with natural selection driving evolution by adaptation, the principle of change. Haeckel's most important law exploited Fritz Müller's *Für Darwin* (For Darwin, 1864) to develop the remarks on parallelism in Stettin: individual development rapidly and concisely repeats the evolutionary development of the species. Or, in the terms Haeckel invented and we still use, "ontogeny recapitulates phylogeny." He acknowledged, with Müller, that while additions at the end of development would leave embryonic forms intact, larval adaptation would distort, or as Müller put it, "falsify" these. Provided genuine recapitulation could be identified, however, embryos would make up for the scarcity of fossils.[64]

Following Darwin, Haeckel had evolutionized a long-standing image of the natural system in Stettin: "Every genealogical table may most vividly be represented by the picture of a richly branching tree." The "many thousand green leaves … which cover the younger, fresher branches" corresponded to the living species, the more perfect the further from the trunk; the dry leaves on the older, dead branches stood for extinct forms.[65] Bronn had depicted a notional tree. Darwin labeled the schematic branches on the diagram in the *Origin A*, *B*, and *C*, while keeping actual genealogies to himself. Haeckel's bold innovation was to push way beyond the facts to detailed phylogenies, the main illustrations in the *Generelle Morphologie*. He was informed in part by the Jena professor August Schleicher's trees of languages, and as determined as the Prussian chancellor Otto von Bismarck, in the wars then unifying Germany, to capture as much territory as possible by daring and rapid attack.[66]

These "stem trees," for the moment more like strange shrubs or kelp than any real trees, conveyed a branching view of evolution, not the single main line of advance to humans on which Haeckel would focus in the *Natürliche Schöpfungsgeschichte* and the *Anthropogenie*. They still inaugurated the problematic tradition of representing progress to higher forms and increasing diversity as climbing hand in hand up the trunk and out into an expanding cone. In 1866, people were more concerned about the many debatable decisions, and that Haeckel had included human beings (fig. 4.10).[67]

Haeckel outlined a cosmic synthesis. Anthropology, with psychology, was just a branch of zoology, and evolution would unify science and religion on a

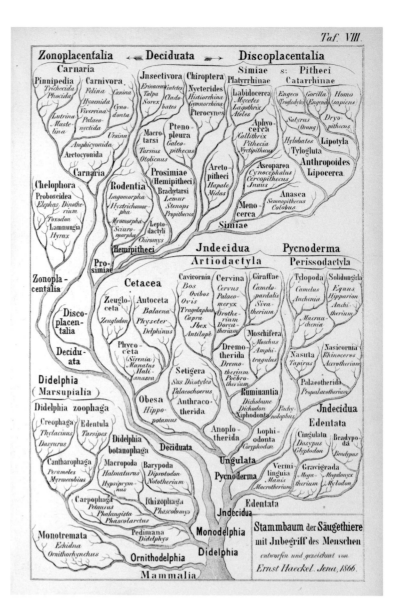

Fig. 4.10 "Stem Tree of the Mammals, Including Humans, designed and drawn by Ernst Haeckel," in the *Generelle Morphologie*. This, like his other trees, has been criticized for conflating low with primitive and few, and high with better and more. Carnivores (brave) and primates (clever, but a relatively small group) dominate the top tier, squeezing the more diverse rodents and relegating the diverse and specialized artiodactyls (cattle, sheep, deer, and so on) to the lower layer (S. Gould 1991a, 264–65). Lithograph from Haeckel 1866, 2: plate VIII, by permission of the Syndics of Cambridge University Library.

biological foundation. Following Schleicher in promoting an antidualist, or "monist," unity of matter and spirit, Haeckel placed God in nature; only crude anthropomorphism could lower him to the status of a "gaseous vertebrate" floating above.[68] The expected disagreement was handily explained: those who opposed evolution had not evolved far enough themselves. People who denied the fact, so easily demonstrated by observation, that the laws of thought are the same for humans and higher animals merely proved that their own wits lagged behind the undogmatic, unprejudiced intelligence of the cleverer elephants, dogs, and horses.[69]

The term *Darwinismus* has often implied the stifling of Darwin's originality by accommodation to Romantic biology. But Haeckel offered the core principles of descent with modification driven by the natural selection of hereditary adaptations. He at least claimed to reject teleology, and saw progress as an outcome of selection within a branching tree.[70] Darwin would follow Haeckel (and others) in applying the theory to humans. And yet, early German readers experienced the *Generelle Morphologie,* though brought out, like the radiolaria, by Virchow's "very solid" liberal publisher, Georg Reimer of Berlin,[71] as more alien than the *Origin of Species.* The problem was less the doctrine of descent, which several first endorsed in reviewing Haeckel,[72] than metaphysics that threw the scientific zoologists' caution to the winds. In the *Literarisches Centralblatt* (Central literary magazine), a general review journal for scholarly books, the hierarchical system struck the reviewer, sympathetic to the cause but not the execution, as dangerously close to Hegel's "purely abstract speculations." "Promorphology" similarly risked losing itself in pure thought, or was it productive to call echinoderms "half ten-sided amphitect pyramids"?[73] Theologians were even more hostile; a Protestant reviewer thanked the author for the "valuable and tasty fruits" of specialist science, but dismissed the approach as "nonsense."[74]

Colleagues praised the brilliance of the book, but criticized its harsh polemic, dogmatic and speculative "enthusiasm" reminiscent of Romanticism, and treating many issues as decided on which the jury was still out.[75] Haeckel rejected accusations of going too far—"As if one could ever go 'too far' in seeking the truth!"—but acknowledged the formal weaknesses of the long, digressive volumes. Polemic jostled with

dozens of new technical terms; *ecology* also eventually caught on. Huxley called it "not exactly a novel," and only a little over one-third of the one thousand copies had sold after two years. Reimer resisted a plea for a "*strictly scholarly* and *objective*" second edition; a mooted English translation never came off.[76] Haeckel mined the heavy tomes for the rest of his career, but they were not the vehicle to transport his science into the heart of German culture and establish its practitioners as leaders of the educated middle class.

A Natural History of Creation

In winter 1865–66, by contrast, Haeckel triumphantly held forth on Darwin's theory in the largest hall of the University of Jena to townsfolk and students from every faculty. Clad in a "plain gymnast's robe," but with "flashing eyes,"[77] he imagined the animated talk about his performance splitting his colleagues neatly into two camps, angry old theologians versus young lecturers and Gegenbaur, who wept "tears of joy." At the end the listeners broke with academic tradition to raise a storm of applause and shout "Bravo!"[78] Repeating the course to two hundred people two years later,[79] Haeckel made it the basis for a popular book. Having authored the least-read major evolutionary work, he now generated "perhaps the chief source of the world's knowledge of Darwinism."[80]

More than is usually appreciated the *Natürliche Schöpfungsgeschichte* (Natural history of creation) combined old and new.[81] The title identified with the genre Burmeister had established and Haeckel devoured as a boy. A long subtitle replaced Burmeister's approach by signaling that all true science must build on Darwin's "doctrine of development," while also crediting reconstructed versions of Goethe and Lamarck. By announcing application to "the origin of humans" and other "fundamental questions of natural science," it highlighted the most controversial implications. An opening series of historical chapters hailed the heroes who had fought the good fight against such stooges of the religious establishment as Cuvier and Agassiz. Then Darwin, whose "great intellectual deed" should become the pride of the nineteenth century, took the stage.[82] The next chapters presented evolution and natural selection, heredity and reproduction, adaptation and progress, ontogeny and phylogeny. The last part of the book reviewed the history of the universe and

Fig. **4.11** Haeckel and others taking their Darwinist manuscripts for printing. The illustration from a spoof of the *Anthropogenie* thematizes the flood of evolutionist literature, from which the *Schöpfungsgeschiece* would soon stand out. A song explains that after Huxley, Vogt, Friedrich Rolle, and Büchner, "Professor Haeckel then arrived / To finish it all he contrived / And with a quick one, two, three / worked out the whole pedigree." Wood engraving after a drawing by Fritz Steub from Reymond 1878, 84.

the earth, before tracing pedigrees of protists, plants, animals, and humans.

Though Darwinist literature was already pouring off the presses (fig. 4.11), this first accessible system demonstrated the transforming power of the theory on an unprecedented scale. Haeckel's "lectures" purported to be "popular" (*gemeinverständlich*) and "scholarly" (*wissenschaftlich*) at the same time. This combination was introduced to book titles by a series that, to encourage scientists to compete with professional popularizers, Virchow had cofounded only two years before.[83] "The highest triumph of the human mind, true knowledge of the most general laws of nature, ought not to remain the private possession of a privileged caste of scholars," Haeckel argued, "but must become the common property of the whole of humanity."[84] With more freedom to maneuver than professors in Berlin, he championed a view that few of his colleagues had yet recognized, let alone blessed for general consumption, but that he granted educated laypeople the right and ability to grasp.[85]

The *Schöpfungsgeschichte* also opened a fresh chapter in Haeckel's drawing. The 568 octavo pages contained a mere handful of illustrations, but these were so powerful and problematic that they stimulated huge interest and trouble. Haeckel adapted the pedigrees from the *Generelle Morphologie* as eight lithographs at the back and added a frontispiece showing heads of human races and apes, a double-page spread of embryos in the middle, and fourteen mostly embryological wood engravings. What shaped these pictures? His engagement with the Romantic legacy, his excitement about the new theory and his success as its advocate, the recklessness induced by Anna's death, and the desire to shake off the failure of his magnum opus: all surely guided his drawing hand. But the unleashing of enthusiasm cannot fully explain how a conventional embryology teacher, a zoologist renowned for the beauty and accuracy of his plates, drew embryos that divide biologists to this day. Beyond his attitudes and skills, those drawings resulted from collaboration on a book that reworked traditions to communicate Darwin's glad tidings about the history of the living world.

{ 5 }

Illustrating the Magic Word

"'Development,'" Haeckel intoned in the preface to his history of creation, "is from now on the magic word through which we shall solve all of the riddles around us, or can at least reach the path to their solution."[1] Were his pictures magical too?

Hostile scientists accused Haeckel of dabbling in dark arts. They said he falsified identities by having the eggs and embryos of three different species printed from single woodblocks and by tendentiously schematizing the embryo plate. These illustrations have been debated ever since, but no one has seriously investigated their genesis. Many discussions do not even acknowledge the differences between the eleven editions through which the *Natürliche Schöpfungsgeschichte* had expanded by World War I. To reconstruct the making of the figures, we need to go back to spring 1868 and retrace each step from planning and drawing through printing and publishing. Haeckel's correspondence with his publisher and the original drawings, hidden in his archive for 140 years, provide important evidence; the discovery of an early letter justifying his actions discloses their rationale.[2]

To read some accounts, this would catch a forger in the act, but even those convinced of his guilt should not expect this. Proving intent is notoriously difficult, and too many drawings are laden with theory for mere tendentiousness to be enough.[3] The majority of those who knew Haeckel, and in time even some of his fiercest opponents, denied any suggestion of bad faith.[4] It makes more sense to ask, first, if he drew in accordance with standard practice in and around the university courses where he learned and taught embryology, and second, if, however honest the intention, he recklessly produced a misleading effect. Uncovering how the grid was pieced together will also reveal alleged miscopying as a prime

example of the power of small, cumulative changes to create a new visual motif.[5]

Embryos for Evolution

To found a cultural revolution on his Darwinist zoology Haeckel had to make embryology better known. To render this vivid he had to learn from the visual mobilization for evolution that was already under way.

Among the earliest and most public pictorial responses to Darwin were caricatures in British magazines. Controlled laughter domesticated the theory for family viewing, but satire also exploited the suspicion that evolutionist series were more imagined than real.[6] In summer 1863 six cycles in the *Illustrated Times* renewed the French tradition of cartoons that had transformed King Louis Philippe into a pear. One turned a naughty boy into a monkey, his parrot into a commodore, and even the cage into a balloon (fig. 5.1). The target was Huxley's recent extension of evolutionism to human beings.[7]

Huxley converted three lectures to workingmen into *Evidence as to Man's Place in Nature*. Some British naturalists looked down on essays that the Darwinian botanist Joseph Dalton Hooker called a "coarse-looking little book.—not fit … for a gentlemans table," while an opponent sneered that he had seen it sold "amongst a crowd of *obscenities*" at Italian railway stations.[8] German Darwinists, used to strong meat, do not seem to have shared these British upper-middle-class reactions. Vogt found it "beautiful," and the arguments and images had a rapid effect.[9]

The frontispiece, a procession of primate skeletons, was "inspired visual propaganda" (fig. 5.2).[10] Collecting

NO. 5.—A MONKEY TRICK.—(DRAWN BY C. H. BENNETT.)

Fig. 5.1 "A Monkey Trick." Caricature by Charles Bennett, the fifth in a series, "Dedicated … to Dr. Charles Darwin." "Good little boys, and boys who would wish to be good, behold in our picture the sad fate of a young Monkey who played tricks with the Parrot." The "poor bird, tortured … till he could bear it no longer,… changed into a stern old Commodore." The boy "pushed out his Jaws and his Hippocampus major … the bend of his back and the length of his tail," and was captured. Even the cage "grew into an air Balloon, from which the young monkey is hanging; but how he will get down it is impossible to tell. Let this be a warning to you never to tease Parrots or any other bird, or beast, or brother." Wood engraving from *Illustrated Times*, no. 428 (30 May 1863): 381. Wellcome Library, London.

gibbon, orang, chimpanzee, gorilla, and human went beyond the available pairs. Presenting humans as one species among five bolstered the claim that human and gorilla were closer to each other than the gorilla was to the lower apes. Scaling the skeletons to similar sizes, arranged in the same poses, made them easy to compare, and the trend to an upright stance more than hinted at temporal progression. Darwin found "splendid" what the antievolutionist Duke of Argyll bemoaned as "a grim and grotesque procession."[11] Haeckel's embryos would imitate these techniques.

Paleontology and comparative anatomy had long provided the main resources for such discussions. Most of the thirty or so figures in Huxley's short book were of adult humans and apes; they redrew and superimposed contours to make similarities and differences clear. Embryology still played only a supporting

role, but its time was coming. Darwin had been disappointed by the lack of response: "Embryology is my pet bit in my book, & confound my friends not one has noticed this to me." Nor had any reviewer "alluded" to "by far [the] strongest single class of facts in favour of change of form."[12] Huxley now made good the omission by beginning his second chapter, "On the Relations of Man to the Lower Animals," with facts which "though ignored by many of the professed instructors of the public mind, are easy of demonstration and are universally agreed to by men of science; while their significance is so great, that whoso has duly pondered over them will, I think, find little to startle him in the other revelations of Biology."[13]

Drawing on Theodor Bischoff, Huxley discussed dog development and then explained that vertebrates pass through "a period in which the young of all these

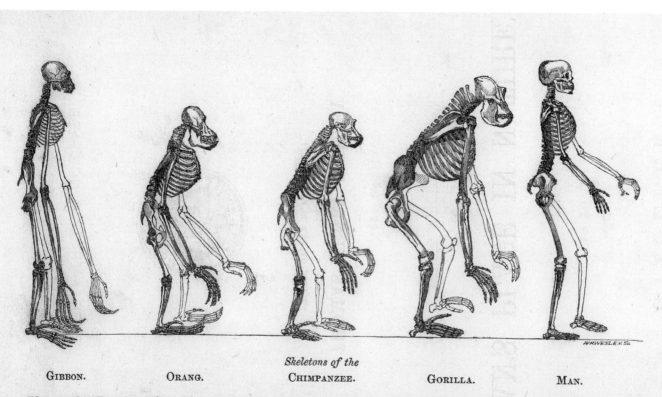

Skeletons of the

GIBBON. ORANG. CHIMPANZEE. GORILLA. MAN.

Photographically reduced from Diagrams of the natural size (except that of the Gibbon, which was twice as large as nature), drawn by Mr. Waterhouse Hawkins from specimens in the Museum of the Royal College of Surgeons.

Fig. 5.2 The frontispiece to Huxley's *Evidence as to Man's Place in Nature*, one of the most successful icons of evolution. Wood engraving from Huxley 1863a. Whipple Library, University of Cambridge.

animals resemble one another, not merely in outward form, but in all essentials of structure, so closely, that the differences between them are inconsiderable, while, in their subsequent course, they diverge more and more widely." What of humans? "Without question, the mode of origin and the early stages of the development of man are identical with those of the animals immediately below him in the scale."[14]

This chapter's first illustrations showed human and dog embryos. The "marvellous correspondence between the two … becom[es] apparent by the simple comparison of the figures," Huxley claimed (fig. 5.3).[15] The series were more striking than Vogt's schemata (fig. 3.16), but three pages apart and not strictly equivalent. It was harder than for skeletons to find the right preparations or to adjust existing drawings.

The other accessible, early Darwinist books in German were either short and sparsely illustrated or concentrated on paleontology and anthropology.[16] Advertised by lecture tours in Switzerland, France, and Germany, where he filled halls in an atmosphere of excitement and indignation, Vogt's course on human antiquity created the biggest stir—and salvaged his polygenism by postulating that different races descended from different species of ape.[17] In book illustration, the major event was an encyclopedia publisher's launch in

A

63

continuation of the walls of the groove; and from them, by and bye, grow out little buds which, by degrees, assume the shape of limbs. Watching the fashioning process stage by stage, one is forcibly reminded of the modeller in clay. Every part, every organ, is at first, as it were, pinched up rudely, and sketched out in the rough; then shaped more accurately; and only, at last, receives the touches which stamp its final character.

Thus, at length, the young puppy assumes such a form as is shewn in Fig. 14, C. In this condition it has a dispro-

Fig. 14.—A. Earliest rudiment of the Dog. B. Rudiment further advanced, showing the foundations of the head, tail, and vertebral column. C. The very young puppy, with attached ends of the yelk-sac and allantois, and invested in the amnion.

portionately large head, as dissimilar to that of a dog as the bud-like limbs are unlike his legs.

The remains of the yelk, which have not yet been applied to the nutrition and growth of the young animal, are contained in a sac attached to the rudimentary intestine, and termed the yelk sac, or 'umbilical vesicle.' Two membranous bags, intended to subserve respectively the protection and nutrition of the young creature, have been developed from the skin and from the under and hinder surface of the body;

B

66

structure. It leaves the organ in which it is formed in a similar fashion and enters the organic chamber prepared for its reception in the same way, the conditions of its development being in all respects the same. It has not yet been possible (and only by some rare chance can it ever be possible) to study the human ovum in so early a developmental stage as that of yelk division, but there is every reason to conclude that the changes it undergoes are identical with those exhibited by the ova of other vertebrated animals; for the formative materials of which the rudimentary human body is composed, in the earliest conditions in which it has been observed, are the same as those of other animals. Some of these earliest stages are figured below and, as will be seen, they are strictly comparable to the very early states of the Dog; the marvellous correspondence between the two which is kept up, even for some time, as development advances, becoming apparent by the simple comparison of the figures with those on page 63.

Fig. 15.—A. Human ovum (after Kölliker). a. germinal vesicle. b. germinal spot.
B. A very early condition of Man, with yelk-sac, allantois and amnion (original).
C. A more advanced stage (after Kölliker), compare fig. 14, C.

Indeed, it is very long before the body of the young human being can be readily discriminated from that of the young

1864 of a Darwinian natural history of animals by the explorer and zoo director Alfred Brehm. The striking wood engravings, more densely ecological and more about struggle than earlier pictures, provided rich resources for Darwin and Haeckel. The anthropomorphic stories and charismatic species made a family favorite of the multivolume work.[18]

Visually, embryology was still a world away. Darwinism was pushing up the agenda the similarity, or even identity, of human and other vertebrate germs. Ludwig Büchner's pictureless lectures mentioned the development of every organic being from an egg as "the best illustration of the whole theory."[19] But medical students reminded Haeckel that they found the subject difficult and dry. Huxley's embryos demonstrated the need to do better, and his primate skeletons showed how.

Following standard practice, Haeckel elaborated the text of the *Schöpfungsgeschichte* from a student transcript, adding explanations to make the lectures "as popular as possible."[20] Bit by bit he took the revised manuscript round to the printer. He also prepared the figures for reproduction.

Drawing Types

Haeckel's archive in Jena, one of the richest for the history of biology, was for a long time only partially open to Western scholars and still contains buried treasure. Hidden in a file mostly concerned with late editions, a small piece of paper is folded around three pairs of drawings of dog and human embryos from the fourth week, and then, all at roughly the same later stage, dog, human, turtle, and chick (fig. 5.4). These are surely the originals for the plates in the first edition: the forms are, in all contested respects, the same as in the lithograph, and the later abandoned figure numbers are on the back.[21] Since Haeckel never credited or blamed an artist for this work, and signed the analo-

gous plates in the *Anthropogenie*, it was always likely that he drew them all himself. These documents, with labels in his hand, put his authorship beyond doubt and confirm that he conceived the figures in pairs.

Haeckel cited no sources, which though common when addressing a general audience, gave his opponents a free hand to map his drawings onto the earlier literature in ways that he never specifically contradicted in public. Above all, they would accuse him of tendentiously copying the younger dog and human embryos respectively from Bischoff and Alexander Ecker (fig. 5.5A, C). They said he expanded the dog's head, while reducing that of the human, moving its eye forward and enlarging the tail.[22] The dog surely came, directly or indirectly, from Bischoff, but it has recently been proposed that, rather than distorting the human embryo chosen by the first accusers, Haeckel could have copied another of Ecker's illustrations fairly faithfully (fig. 5.5D).[23] That is plausible, yet assumes—with the critics and at least some friends—that each figure should have a single original. New evidence shows that Haeckel rejected this assumption.

With much bombast but little detail, Haeckel publicly discussed the making of these drawings only years and decades later. Fortunately, his archive also contains a full defense giving access to his understanding near the time, that figures and preparations did not necessarily map one-to-one. On 4 January 1869, a few months after publication, Haeckel told a sympathetic colleague that the human and dog embryos "are completely exact, partly copied from nature, partly assembled from all illustrations of these early stages that have been published hitherto."[24] In other words, he drew specimens in the Jena collections and synthesized his views of pictures in the literature to represent types. For some figures he may have copied both nature and drawings; for others he leant on one existing image.

Drawings, especially of humans, that embryologists prepared for printing did not generally blend peculiarities into a type. Even Soemmerring's had derived from particular preparations, and Haeckel's contemporaries more cautiously drew representative individuals.[25] An element of synthesis is not enough to place Haeckel with Goethe in the Neapolitan garden where in 1787 he imagined himself on the verge of intuiting the original plant.[26] But by mid-nineteenth-century standards, Haeckel's actions hardly

Fig. 5.3 Embryology as Huxley's prime evidence of "the relations of man to the lower animals." *A*, dog development, from the earliest rudiment to the "very young puppy," unattributed but indebted to Bischoff; *B*, human development, the first and last figures after Kölliker 1861, 23 and 130, the second "original." Wood engravings from Huxley 1863a, 63, 66. Whipple Library, University of Cambridge.

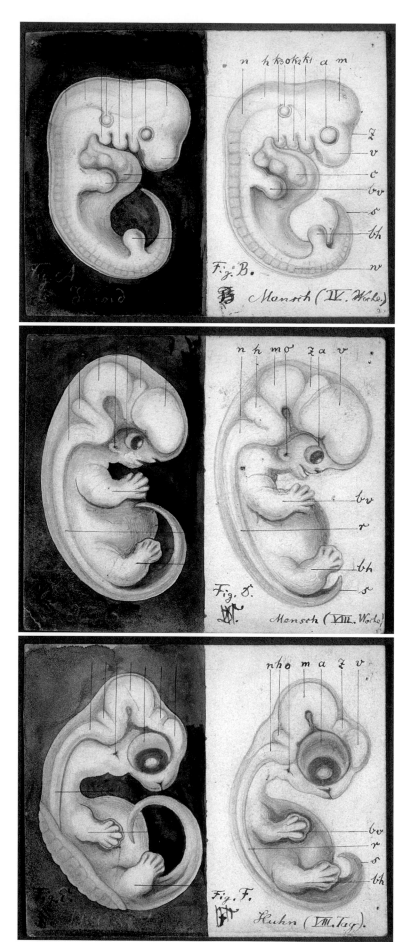

Fig. 5.4 Drawings presumed to be Haeckel's originals for the embryological plate in his *Natürliche Schöpfungs-geschichte* (fig. 5.12). *A–B*, dog and human embryos from the fourth week; *C–D*, six-week dog and eight-week human embryos; *E–F*, six-week turtle and eight-day chick embryos. The second drawings give the lettering. Pencil and ink on card, each pair 8 × 10 cm, in folder "*Nat. Schöpfgsg.* Tafel II u. III," EHH: B74.

Fig. 5.5 Pictures from monographs and atlases of the 1840s and 1850s that served Haeckel as part models. The whole pages shown in chapters 2 and 3 above give the original context; this selection, reproduced without differential magnification or changing orientation, highlights the work redrawing still had to do. *A,* lithograph of Bischoff's twenty-five-day dog embryo (in context in my fig. 2.10); *B,* steel engraving of a four-day chick embryo from Michael Erdl's atlas (my fig. 3.7 shows another plate from the same work); *C–D,* copper engravings of human embryos from Ecker's atlas: *C,* no age given, but about four weeks (see my fig. 3.8); *D,* five weeks. *A,* Bischoff 1845, fig. 42B on plate XI, by permission of the Syndics of Cambridge University Library; *B,* Erdl 1845, plate XI, fig. 6, Whipple Library, University of Cambridge; *C–D,* Ecker 1859a, plate XXX, fig. II and plate XXVI, fig. VIII.

sound "completely exact." Perhaps it depends what he meant by *exact*. He had already declared his opposition to "exact empiricism" without philosophical reflection, a false exactitude he criticized with the German word *exakt*. The letter used the older *genau*, with its links to *nah*, or near, to describe his own work.[27] The main clue to appropriate expectations, however, lies in Haeckel's later appeal to distinctions of genre and purpose: his pictures were "schematics" just like those he and his colleagues employed in teaching every day.[28]

Expository images are always in some sense schematic. Textbooks had particular specimens stand for whole domains of observation, and often suppressed details to help individuals represent all embryos of a species and stage. Vogt's less formal works simplified further, gave less circumstantial information, and dispensed with credits.[29] Blackboard drawings tended to remove all traces of individuality to depict types. But the term *schematic* then usually referred specifically to the small subset of simplified line drawings that gave the freedom to clarify relations between structures or speculate about others not yet observed. Baer had offered "ideal" drawings, and Rudolph Wagner's atlas included "several ideal and other half-schematic figures"; a plate of his "theory" of human development used these for the early stages no one had seen. When Ecker took over, he confined schematics to wood engravings printed with the legends. Kölliker's textbook carried only a few schematics, all labeled as such.[30] The first critic of Haeckel's embryos refused them in a research paper, because "if the text and the lettering of the figures … do not achieve the desired result, then nor will schemata,"[31] but most teachers valued clarifying simplifications.

Yet Haeckel's drawings went further than typical schematics, in either the wide or the narrow sense, and illustrations of early human preparations generally stayed closer to these rare materials. First, he silently downplayed or even removed esoteric structures that distracted from his point, and second, he worked hard for a vivid effect. The detail-rich remnants of the yolk sac and allantois in Bischoff's dog embryo (fig. 5.6A) still dominated the Kölliker wood engraving (fig. 5.6B), were much reduced in Huxley's (fig. 5.6C) and in Haeckel's drawing were suppressed (fig. 5.6D), thus eliminating membranes that distinguish higher vertebrates from lower. While the greater crudity of Huxley's copied illustrations fits their increased sche-

Fig. 5.6 Copying a dog embryo. *A*, lithograph in Bischoff's monograph; *B*, wood engraving in Kölliker's textbook; *C*, wood engraving in Huxley's essays; *D*, Haeckel's drawing. *A–B*, Bischoff 1845, plate XI, fig. 42B (in context in fig. 2.10 above), and Kölliker 1861, 117 (my fig. 3.11A), by permission of the Syndics of Cambridge University Library; *C*, Huxley 1863a, 63 (my fig. 5.3A), Whipple Library, University of Cambridge; *D*, EHH: B74 (fig. 5.4 above).

matization, Haeckel's were more schematic in form, but more finished, even dramatic, in style.

Following Bischoff and Michael Erdl, Haeckel mimicked illumination from below. He surrounded the first of each pair with a dark wash to show how all should be printed in white on black (figs. 5.4 and 5.5B). This made the outlines stand out, while allowing him to model the bodies with the "softness" and "delicacy" he valued.[32] He kept the embryos translucent to expose the central nervous systems and (at the early stages) the hearts and livers, and emphasized the features by shading. This style could be explained in part if he had wall charts scaled down or planned to blow the drawings up.[33] He also borrowed another trick from lecturing: the accent on structures with immediate appeal, such as the googly eyes that look out at us from the expressive faces of the older human and dog. Popular lecturers did this kind of thing to raise a laugh; Agassiz gave a whitefish hatchling "a leering eye and a toothy grin."[34] They rarely committed it to print.

The practice of generalization was linked to the question of individual variation. Baer had complained about this obstacle to understanding development, and the issue came up whenever evolutionists or their opponents argued over the gap between one group and another, often humans and apes. Haeckel's letter appealed to the widespread suspicion that many of the early human embryos in the literature were abnormal and poorly described. With the standard rhetorical move for those reducing gaps, he claimed that even Ecker's drawings of human preparations differed more among themselves than from dogs of the same age.[35] So it would have been misleading to pick one out. Nor would there have been any point in fussing over details that could not interest laypeople. Haeckel aimed to represent not problematic individual specimens, but the most likely true forms. This brought a charge of drawing to suit his theories, but he rejected the accusa-

Fig. 60.

tion as naïve: every schematic distorted the real form to give a scientist's view of its essence.[36]

Yet it is a mistake to suppose that because Haeckel is famous for "ontogeny recapitulates phylogeny" his pictures of vertebrate embryos were all and only about this; images and theories may have lives of their own. These pairs most obviously show mere similarity, or Baer's view that vertebrates begin the same because nature first lays out the general plan of the type. They also indicate how the different groups then start to diverge. Baer could not distinguish reptiles, birds, and mammals even with early limb buds. Haeckel took for granted in that same letter that humans and dogs start identical: "At a slightly earlier stage *absolutely no*

differences between human and dog can be present!" Bischoff had questioned this notion for some other mammals, but the earliest human stages were still unknown. For Haeckel, the only, rather esoteric, issue was the precise moment when that divergence could be detected.[37]

Above all, where Huxley made do with the embryological figures to hand, Haeckel treated the literature as raw material from which to draw four equivalent types. The letter explained that he "reduced both [dog and human] embryos ... to the same size, brought them into the same position, and executed them in the same manner."[38] Photographically assembling some of Haeckel's models shows how much more he did (fig.

5.5). Drawing at the same size entailed magnifying by different amounts. Drawing in the same position, unless the artist had access to a specimen, involved deducing how it looked from the other side. Drawing in the same manner imposed a style. All this had long been done for adult bodies (fig. 2.11), but anatomists with less control over embryos had not had the incentive to take this step. Such aggressive redrawing produced figures that readers did not have to discover, differently drawn, in different works or on different pages, but could compare at a glance.

These embryos vividly presented a conclusion and opened differences and similarities to scrutiny as never before. Haeckel may have transferred some secrets of the popular lecturer to print, but miscopying is harder to prove than is usually assumed, and there is no reason to suspect deliberate deception. The comparative frame is more significant. It began with the

heavily reworked pairs and—in the collaboration of publisher, printer, and lithographer—would become more striking on the printed page.

Printing Pairs and Grid

Haeckel's publisher, Georg Reimer, had inherited one of Germany's most important firms, politically and theologically liberal but loyal to the Prussian state and church (fig. 5.7A). Though lacking his father's entrepreneurial energy, he maintained an ethos of refined scholarship, while giving free rein to authors and the editors of his noted journals, including Virchow's *Archiv für pathologische Anatomie* (Archive of pathological anatomy), the *Preußische Jahrbücher* (Prussian yearbooks), and the *Protestantische Kirchenzeitung* (Protestant church news). Reimer was a friend of Haeckel's family, and his son Ernst, the company secretary, was

Fig. 5.7 Publisher and printer. *A*, Georg Reimer, a faithful godson of Schleiermacher, moderate liberal, and leading representative of the milieu in which Haeckel was raised. Wood engraving from S. W., "Deutsche Buchhändler, 5: Georg Reimer," *Illustrirte Zeitung* 49, no. 1266 (5 Oct. 1867): 225–26. NSUB. *B*, Friedrich Johannes Frommann of Jena. From a distinguished family—Goethe took tea at his father's house—his heart was in public life, and even the printing works run by his son did not come to life until an active scientific publisher, Gustav Fischer, started in Jena in 1878. But printing locally gave Haeckel control and will have gone down well in the town. Lithograph from *Buchhändler-Album* 1867, facing 27. Sächsische Landesbibliothek, Staats- und Universitätsbibliothek Dresden, Deutsche Fotothek.

Haeckel's brother-in-law and around the same age; he had trained with a Jena printer and married one of Agnes's sisters.[39] Devoted to Haeckel, the Reimers worried as they read the *Schöpfungsgeschichte* in proof that his "strong hint of godlessness" would only "incite" the "hypocritical rabble with its *sham belief*," and prejudice the "better people" against him. He would do better to recognize that "9 tenths of the educated public which is interested in science and thinks for itself" believed in God but had abandoned any literal belief in the Bible. The theology in the *Generelle Morphologie* had already been used to block his election to the Prussian Academy of Sciences.[40]

The Reimers did not really expect to influence Haeckel, and their letters are silent on the criticisms of his figures. They judged it wise as laymen and publishers to keep out of scientific disputes[41] and could have raised delicate issues face-to-face. Instead the correspondence gives access to the procedures by which the original drawings were turned into the wood engravings and lithograph and brought together with the text. Novel modes of scientific representation could go hand in hand with new printing technologies,[42] but the *Schöpfungsgeschichte* was, or should have been, technically undemanding.

In March 1868 Haeckel sent Georg Reimer twelve drawings, six for the comparative embryological plate (fig. 5.4), and six (which do not seem to have survived) for the fourteen wood engravings in the text. Of these, only the last, a radiolarian copied from one of Haeckel's articles, appears just once; a moner—a single-celled organism without nucleus and organelles—and an amoeba crop up twice each, a mammalian egg four times, its cleavage twice, and a vertebrate embryo three times. Textbooks and popular works commonly repeated figures to save page-turning and make blocks go further. But it was hardly usual for one block to represent different objects, in one case the "egg of a mammal" as well as those of human, ape, and dog (fig. 5.8), and in another the embryos of dog, chick, and turtle (fig. 5.9).[43] Wood engravings were often printed via electrotyped metal copies, or *clichés*, in the still only literal sense of that term. Extra electrotypes would have allowed a single printing to reproduce each figure three times on one page. The repetition was reckless but evident from close inspection of incidental details, so it is almost inconceivable that Haeckel intended to deceive. He removed those false comparisons from the

Mischung, in der molekularen Zusammensetzung der eiweißartigen Kohlenstoffverbindung, aus welcher das Ei wesentlich besteht. Diese feinen individuellen Unterschiede aller Eier, welche auf der indirecten oder potentiellen Anpassung (und zwar speciell auf dem Gesetze der individuellen Anpassung) beruhen, sind zwar für die außerordentlich groben Erkenntnißmittel des Menschen nicht direct sinnlich wahrnehmbar, aber durch indirecte Schlüsse als die ersten Ursachen des Unterschiedes aller Individuen erkennbar.

Fig. 5.

Fig. 6.

Fig. 7.

Fig. 5. Das Ei des Menschen. Fig. 6. Das Ei des Affen. Fig. 7. Das Ei des Hundes. Alle drei Eier sind hundertmal vergrößert. Die Buchstaben bedeuten in allen drei Figuren dasselbe: *a* Kernkörperchen oder Nucleolus (sogenannter Keimfleck des Eies); *b* Kern oder Nucleus (sogenanntes Keimbläschen des Eies); *c* Zellstoff oder Protoplasma (sogenannter Dotter des Eies); *d* Zellhaut oder Membrana (Dotterhaut des Eies, beim Säugethier wegen ihrer Durchsichtigkeit Zona pellucida genannt). Bei sehr starker Vergrößerung erscheint die Dotterhaut des Säugethiereies von sehr feinen und zahlreichen Kanälen in radialer oder strahliger Richtung durchsetzt.

Das Ei des Menschen ist, wie das aller anderen Säugethiere, ein kugeliges Bläschen, welches alle wesentlichen Bestandtheile einer einfachen organischen Zelle enthält (Fig. 5—7). Der wesentlichste Theil desselben ist der schleimartige Zellstoff oder das Protoplasma (c), welches beim Ei „Dotter" genannt wird, und der davon umschlossene Zellenkern oder Nucleus (b), welcher hier den besonderen Namen des „Keimbläschens" führt. Der letztere ist ein zartes, glashelles Eiweißkügelchen von ungefähr $\frac{1}{50}$''' Durchmesser, und umschließt noch ein viel kleineres, scharf abgegrenztes rundes Körnchen (a), das Kernkörper-

Fig. 5.8 The eggs of human, ape, and dog. Wood engraving by Johann Gottfried Flegel after a drawing, probably by Haeckel, printed three times. Like the cleavage stages (not shown), the form may ultimately derive from Bischoff 1845, but Kölliker 1861, 23, appears a more direct model for the egg. Key: *a*, nucleolus; *b*, nucleus; *c*, protoplasm or yolk; *d*, membrane or zona pellucida. Haeckel 1868, 242.

next edition and eventually excused this "extremely rash *foolishness*" as committed in undue haste but "*bona fide*."[44]

Haeckel may have been in a hurry, but he and the Reimers took trouble to have the wood engravings cut

Fig. 9. Fig. 10. Fig. 11.

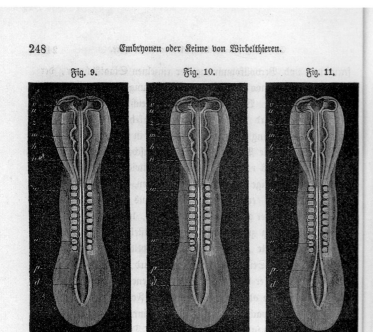

Fig. 9. Embryo des Hundes. Fig. 10. Embryo des Huhns. Fig. 11. Embryo der Schildkröte. Alle drei Embryonen sind genau aus demselben Entwickelungsstadium genommen, in dem soeben die fünf Hirnblasen angelegt sind. Die Buchstaben bedeuten in allen drei Figuren dasselbe: *v* Vorderhirn. *z* Zwischenhirn. *m* Mittelhirn. *h* Hinterhirn. *n* Nachhirn. *p* Rückenmark. *a* Augenblasen. *w* Urwirbel. *d* Rückenstrang oder Chorda.

Die erste Blase, das Vorderhirn (*v*) ist insofern die wichtigste, als sie vorzugsweise die sogenannten großen Hemisphären, oder die Halbkugeln des großen Gehirns bildet, desjenigen Theiles, welcher der Sitz der höheren Geistesthätigkeiten ist. Je höher diese letzteren sich bei dem Wirbelthier entwickeln, desto mehr wachsen die beiden Seitenhälften des Vorderhirns oder die großen Hemisphären auf Kosten der vier übrigen Blasen und legen sich von vorn und oben her über die anderen herüber. Beim Menschen, wo sie verhältnißmäßig am stärksten entwickelt sind, entsprechend der höheren Geistesentwickelung, bedecken sie später die übrigen Theile von oben her fast ganz.

Fig. 5.9 Embryos of dog, chick, and turtle "taken from exactly the same stage of development, in which the five brain-bladders have just begun to form." Perhaps modeled mainly, though not only, on Bischoff 1845, fig. 36A on plate VII. Wood engraving by Flegel after a drawing, probably by Haeckel, printed three times. Key: *v*, forebrain; *z*, twixtbrain; *c*, midbrain; *h*, hindbrain; *n*, afterbrain; *p*, spinal cord; *a*, optic vesicles; *w*, somites; *d*, notochord. The right-hand side is a little out of focus here because it is close to the original gutter. Haeckel 1868, 248.

Fig. 5.10 Woodblock, presumably by Flegel. How it came to be preserved is unknown, but likely because of the controversy over its multiple use. EHH; Fotozentrum A. Günther.

Fig. 5.11 Haeckel's sketch, in a letter to Georg Reimer, of the arrangement of drawings for the double embryo plate in the *Schöpfungsgeschichte*. The six figures (A–F in fig. 5.4 but here still numbered 4–9 in one series with the future wood engravings) were to be arranged "in order to be able to compare them all with each other" on two facing pages. From Haeckel to Reimer, 26 Mar. 1868, Staatsbibliothek zu Berlin, Preussischer Kulturbesitz: Dep. 42 (Archiv Walter de Gruyter), R1: Haeckel, Ernst, fol. 50r.

well. Fearing that not all their artists would deliver "softness and delicacy," he asked for Kölliker's wood engraver, and was delighted with Flegel's "very good," even "excellent," proofs (fig. 5.10).[45] The only problem came from entrusting the "not difficult" printing job to Friedrich Johannes Frommann, the printer with whom Ernst Reimer had worked (fig. 5.7B).[46] Though Frommann played a leading role in organizing the book trade, his contempt for innovation visited a steady decline on his own business, and he had not printed a wood engraving for twenty or thirty years.[47] Looking at the first cuts, Reimer told Haeckel it would be "a crying shame" if the printer were "to smear" the rest "beyond recognition" too. Haeckel took "old Frommann" Flegel's proofs with the new blocks and asked him to match the quality. Frommann blamed the paper (supplied through the Reimers), but finer ink improved the rest.[48]

Haeckel had planned to have the plate engraved on wood, but Frommann and the local lithographer, Eduard Giltsch, persuaded him that this would "never achieve the *softness* of the forms and shading." Since these figures were to be printed larger—and in a run of just one thousand—lithography would be *"better and cheaper."* Georg Reimer agreed—while insisting on thicker paper, blank on the back—and returned the drawings.[49] Giltsch or his son Adolf now brought the pairs together on a double plate in the arrangement Haeckel had sketched (fig. 5.11).[50] They converted lines to stipples, making the shading more even and the outlines sharper, but the rendition is more faithful than any wood engraving (fig. 5.12). This prototype is not, however, a grid, and so does not share the special properties of that aid to comparative viewing.

The drawings and this rarely reproduced lithograph show that it took several steps to build up the

Fig. A. Keim des Hundes, 5‴ lang (aus der vierten Woche). Fig. B. Keim des Menschen, 5‴ lang (aus der vierten Woche). Fig. C. Keim des Hundes, 8½‴ lang (aus der sechsten Woche). Fig. D. Keim des Menschen, 8½‴ lang (aus der achten Woche). Fig. E. Keim der Schildkröte, 7‴ lang (aus der sechsten Woche). Fig. F. Keim des Huhns, 7‴ lang (acht Tage alt). Fig. A und B sind 5mal, Fig. C—F 4mal vergrössert. Die Buchstaben haben in allen sechs Figuren dieselbe Bedeutung. v Vorderhirn. z Zwischenhirn. m Mittelhirn. h Hinterhirn. n Nachhirn. r Rückenmark. a Auge. o Ohr. k1, k2, k3 erster, zweiter und dritter Kiemenbogen. w Wirbel. c Herz. bv Vorderbein. bh Hinterbein. s Schwanz.

Fig. 5.12 Embryo plates from the *Schöpfungsgeschichte*. The panels show, in Haeckel's terms, *A*, germ of the dog (from the fourth week); *B*, germ of the human (from the fourth week); *C*, germ of the dog (from the sixth week); *D*, germ of the human (from the eighth week); *E*, germ of the turtle (from the sixth week); and *F*, germ of the chick (eight days old). Haeckel states that on his plates A–B are five times and C–F four times enlarged. Panel A–B is 8.5 × 10 cm. Lithograph, Haeckel 1868, 240b–c.

definitive arrangement. For this first (1868) edition of the *Schöpfungsgeschichte* Haeckel drew pairs of embryos like Vogt and Huxley, except that he drew three, rendered them more easily comparable, and had them printed together. Only in the next (1870) edition did he add a fourth pair to fill the space left by moving the legends to the end of the book and so create rows that correspond to developmental stages (fig. 5.13). And only the *Anthropogenie* (1874) eliminated the horizontal divisions across the pages, adding species labels

to unify the columns while suppressing the (conspicuously various) age information (fig. 7.11 below).[51] So Haeckel did not have some obvious model for rows and columns ready to import; he and his collaborators took the opportunity of a layout shift to change the design.

Related images in other domains could still have informed this innovation. Geological books had occasionally laid out scenes of epochs in panels in ascending columns.[52] A closer parallel, with its multiple col-

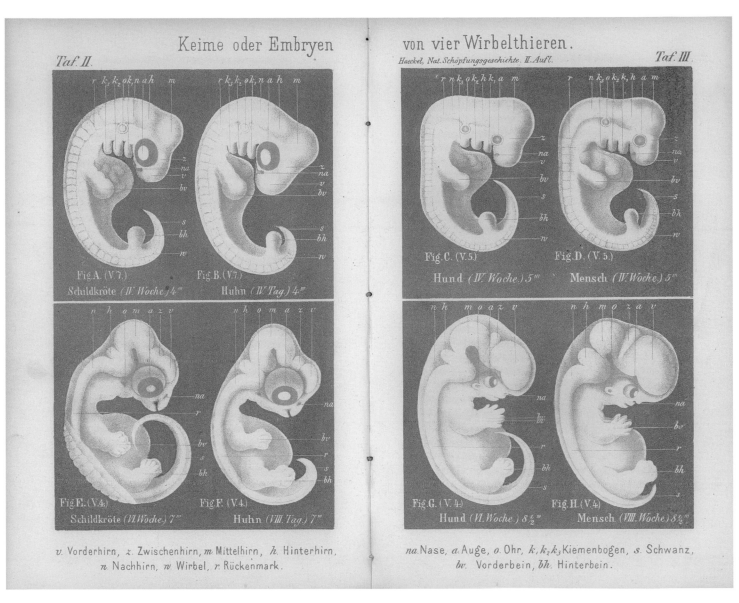

Fig. 5.13 "Germs or Embryos of Four Vertebrates" in the second edition of the *Schöpfungsgeschichte*. In the first of many grids, turtle, chick, dog, and human embryos are shown from left to right at an earlier stage (first row) and a later stage (second row). Small differences from the first edition suggest that the figures were redrawn with essentially the same forms; the contrast is reduced and the detail less. Panel A–B is 8.3 × 10 cm. Lithograph, Haeckel 1870, plates II–III.

umns and zoological consideration of human beings, is the foldout tableau of allegedly primordial human species that accompanied Louis Agassiz's essay in an influential manifesto for human inequality and racial separatism that pleased his slave-owning friends in the American South. Agassiz rejected development from a single origin in favor of the special creation of each race in a "zoological province."[53] Eight columns showed racial heads, skulls, and characteristic animals (fig. 5.14). The first and last columns did not fully read across—the last was even condensed to accommodate two extra cells—but Agassiz tried to line up equivalent animals, and the heads and skulls can all be compared across the page. Physiognomy had long employed similar though not identical pairs and grids (fig. 3.15).[54] More directly perhaps, Haeckel combined the single-species developmental series with the arrays of adult anatomies, such as later editions of the *Schöpfungsgeschichte* and the *Anthropogenie* also used. This is the power of his grids: they did not just display

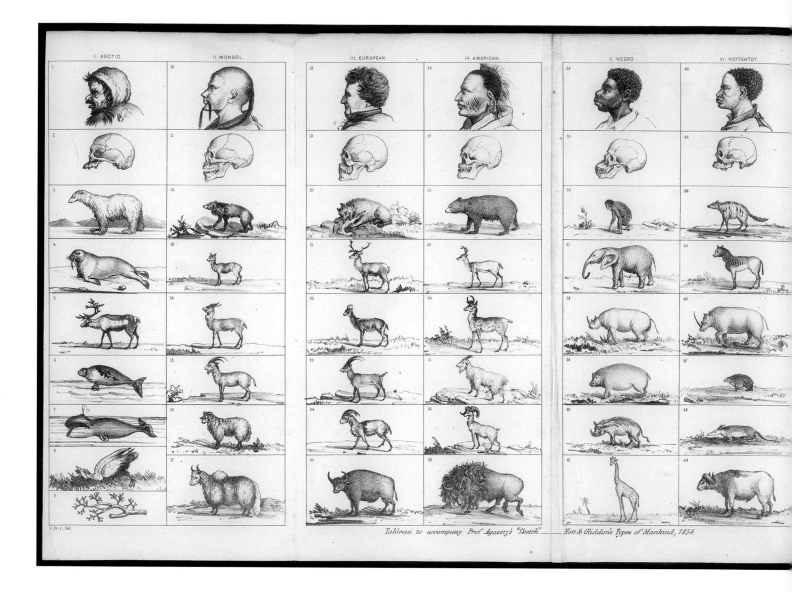

Tableau to accompany Prof. Agassiz's "Sketch." _____ *Nott & Gliddon's Types of Mankind, 1854.*

taxonomic variety; they traced it back to development from a common ancestral stage.

Even the four-by-two grid differs significantly from the initial three pairs. Those offered two species at an earlier stage above the legend, and four at a later stage on the facing page (fig. 5.12). They were pivoted around the C-D pair, with one comparison to less developed embryos of the same species (A-B) and another to additional species at the same stage (E-F). Turning the arrangement into a grid did far more than complete the set, so that all species were represented at both stages (fig. 5.13). It gave the array a unified logic: in the standard direction of reading, look across what are not yet quite columns for complexity, though not necessarily phylogenetic order, and look down the

rows for stage. The emphasis is still on similarity, as in the pairs; the later embryos have only begun to diverge. Awkwardly for those who present all Haeckel's embryo plates as readouts of the recapitulation theory,[55] the main message is less specific. But we can see recapitulation at work in the common ancestral stage of the first row, and perhaps in the human differentiation of the paddle-like limb and loss of the tail retained for longer by the turtle.

In trees of descent Haeckel filled an existing format with new knowledge; this array was new—at least to embryology—but the knowledge old. For that reason, and because critics narrowed the focus to individual figures before the first grid was even published, the innovation went unremarked. Yet here, it

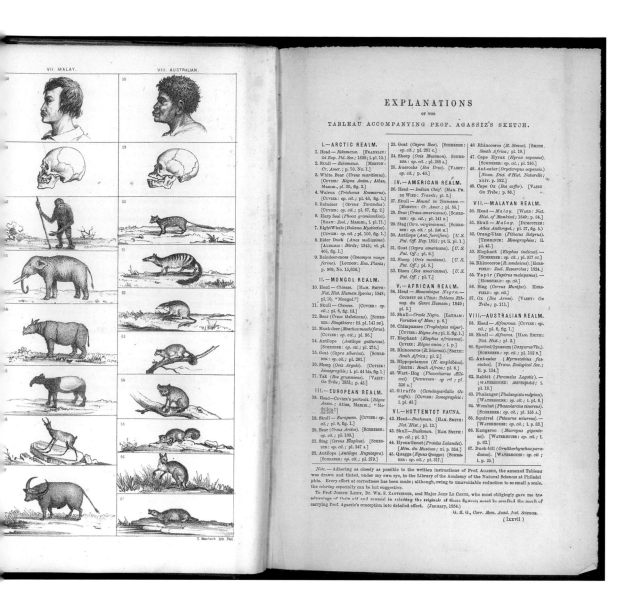

Fig. 5.14 The tableau in Louis Agassiz's "Sketch of the Natural Provinces of the Animal World and Their Relation to the Different Types of Man" in Josiah Nott and George Gliddon's *Types of Mankind*. The columns show Arctic, Mongol (Asiatic), European, American, African, Hottentot, Malayan, and Australian realms. The first contains "Esquimaux" head and skull, white bear, walrus, reindeer, harp seal, right whale, eider duck, and reindeer moss. Lithograph by Thomas Sinclair, after drawings by A. Frey, from Agassiz 1854. 22 × 47 cm.

is worth stressing lest the history of development be written off as mere repetition after Soemmerring or Baer, was a novel space for comparing different series. It embodied problematic assumptions. Aesthetic appeal may have strengthened Haeckel's commitment to initial sameness; the design certainly encouraged him to fill cells he might wisely have left blank. But all this lay in the future. In 1868 there was no grid, and he anticipated "great interest" from putting just six figures together.[56]

The Grandest Fact

How did the illustrations work in the finished volume, and what arguments did Haeckel make with them? He intended the *Schöpfungsgeschichte* to take a Darwinist history of creation to the whole of humanity, or at least, given the bulk and two-and-a-half-thaler price tag, to a general middle-class audience. Let us turn the pages, concentrating on the pictures, just as the first critic feared lay readers would.[57]

Haeckel sought confrontation by having the illustrations express the most provocative claims. Ernst Reimer refused his request for a special color cover to "excite attention" by depicting "the fundamental idea of the whole stem tree" as too hard for provincial lithographers and "no longer *at all* in fashion for works of quality (even if popular)." Conscious of the balance to be struck and safeguarding the firm's reputation, Reimer explained that colorful covers had be-

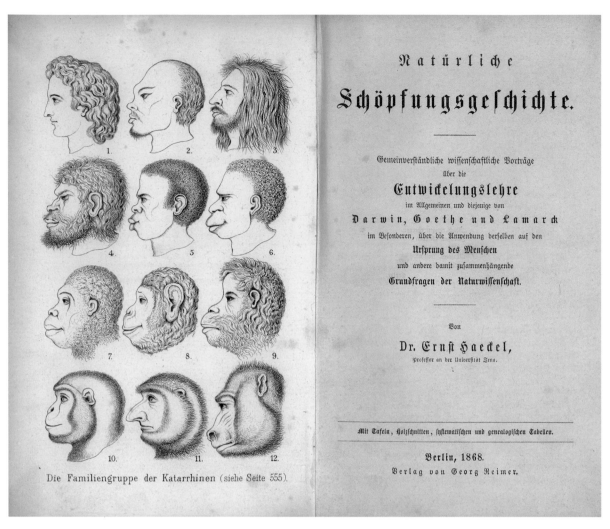

Die Familiengruppe der Katarrhinen (siehe Seite 555).

Fig. 5.15 Frontispiece and title page of the *Schöpfungsgeschichte*. "The Family Group of the Catarrhines," or narrow-nosed apes, was notoriously supposed to demonstrate "the highly important fact" that the "lowest humans" (figs. 4–6, "Australian Negro," "African Negro," and "Tasmanian") stood "much nearer" to the "highest apes" (figs. 7–9, gorilla, chimpanzee, and orang) than to the "highest human" (fig. 1, "Indo-German") (p. 555). The lithograph also shows "Chinese" (fig. 2), "Fuegian" (fig. 3), gibbon (fig. 10), proboscis monkey (fig. 11), and mandrill (fig. 12). Writing from a holiday in the Tyrol, Haeckel was unhappy that the proof by the lithographer, Gustav Müller, strayed too far from his original. He asked Agnes to have especially figure 1 corrected and the eyes made "more expressive throughout." She and Müller judged the plate "in general quite successful," but she agreed that the eyes were "too expressionless" and checked a revision (Ernst Haeckel to Agnes Haeckel, 31 Aug., and Agnes Haeckel to Ernst Haeckel, 6 Sept. 1868, in Huschke 1950, 49, 50–51). The frontispiece appears to have been the last item finished; Haeckel checked the embryo plates in Jena himself (Haeckel to Ernst Reimer, 22 June 1868, Staatsbibliothek zu Berlin). Haeckel 1868.

come "an unmistakable characteristic of light railway reading."[58] Instead Haeckel grabbed interest with an inflammatory frontispiece that constructed a hierarchical series of heads from apes through human races (fig. 5.15).[59] He saw humans as ultimately sharing a common origin in an apelike ancestor, but based on linguistic differences treated races as distinct species likely to have evolved independently.[60] The plate hints at pairs of races and apes, but at a time when much had been written about how to measure heads would

offend mainly for appearing to lower humans and raise apes.

Thanks to the thicker paper, the book then falls open at the double embryo plate with its key evidence of human descent from lower forms. No history of creation had ever said so much about embryology, and no book had offered such an illustration before. Adding a liberal twist to von Baer's criticism of the humanistic bias of the schools, Haeckel scolded "our so-called educated circles" and even most zoologists. They either

knew nothing of "these invaluable facts of human on-
togeny" or failed to realize that they were "sufficient
to solve the question of man's position in nature and
thus the highest of all problems." "Contemplate at-
tentively and compare the six figures which are re-
produced on the following plates [fig. 5.12], and you
will recognize that the philosophical importance of
embryology cannot be rated highly enough." These
facts would displease those committed to fundamen-
tal differences between man and the rest of nature,
and ruling castes would find them most unpleasant.
"What," Haeckel roared, were hereditary nobles to
"think of the thoroughbred blood which flows in their
privileged veins, when they learn that all human em-
bryos, those of nobles as well as commoners, during
the first two months of development, are scarcely
distinguishable from the tailed embryos of the dog and
other mammals?"[61]

Haeckel used the wood engravings and lithograph
mainly to present laws of differentiation and progress
from similar beginnings. Eggs developed into embryos
by ever-increasing differentiation of the parts and di-
vision of labor of the cells, and this process was at first
extremely similar in all vertebrates. "The mammalian
egg illustrated in fig. 3 ... could just as well stem from
man as from the ape, the dog, or any other placental
mammal." And again, "Compare the human egg (fig.
5) with that of the ape (fig. 6) and the dog (fig. 7) [here
fig. 5.8], and you will not be able to perceive any kind
of difference." The first dissimilarities were in molec-
ular composition alone.[62]

Huxley had qualified his claim: "Ordinary in-
spection would hardly distinguish" early vertebrate
embryos that were alike "in all essentials." More of a
showman, Haeckel went on to declare, of the figures
derived from a single block: "If you compare the young
embryos of the dog, the chick, and the turtle in figs.
9, 10, and 11 [here fig. 5.9], you will not be able to per-
ceive a difference."[63] Haeckel explained that the parts
initially differentiated in similar ways to produce, for
example, the divisions of the brain and the extremi-
ties. Then he pointed out how the later embryos (fig.
5.12C-F) had begun to display differences that would
become more marked in the adults. Rudimentary or-
gans showed that differentiation and progress do not
always go together; tailed human embryos were an
"irrefutable witness for the undeniable fact" of our de-
scent from ancestors with tails.[64]

Haeckel drew out the standard transformist anal-
ogy: ontogeny was more remarkable than phylogeny,
yet occurred every day. "Most people even now do not
wish to acknowledge the most important conclusion
of the theory of descent, the paleontological devel-
opment of man from apelike and through them from
lower mammals, and hold such a transformation of
organic form to be impossible. I ask you, however, are
the phenomena of the individual development of man
... any less wonderful?" Not least, but last, Darwin's
theory also explained why the two forms of develop-
ment ran more or less in parallel: "*Ontogenesis, or the
development of the individual*, is *a short and rapid repe-
tition (recapitulation) of phylogenesis, or the development
of the tribe to which it belongs, determined by the laws of
inheritance and adaptation.*"[65] This causal connection,
which Haeckel introduced in the first chapter, licensed
his use of embryological evidence in the construction
of the systematic tables and trees, but was not the
main frame for the embryo plate.

Different illustrations had different status. The
trees were an "approximate hypothesis" of organisms'
genealogical relations that contained most of Hae-
ckel's original thought. If the general theory of evolu-
tion was true, he argued, it had to be possible to work
out how it applied in specific cases, and this demanded
hypotheses that "can have only temporary and condi-
tional value."[66] By contrast, deploying the word *fact*
eleven times in four pages of text around the embryos,
he treated them as providing established knowledge
ripe for evolutionary reinterpretation.[67]

For Haeckel, "mere" or "naked" facts were never
more than "unfinished stones" waiting to be enlivened
by the theory that would work them into the edifice of
true science.[68] Yet he repeatedly drew readers' atten-
tion to "extremely important" and "remarkable," and
of course also "undeniable," facts that pointed irre-
sistibly to the theory of descent because only it could
explain them.[69] Chief among these were the "facts of
ontogeny," the existence of rudimentary organs, and
the "highly interesting and significant fact" of recapit-
ulation, which encompassed the serried observations
of several sciences. "These most important biological
facts," "invaluable" and "clear [*handgreiflich*],"[70] were
like Darwin's "grand facts" and "wonderful facts": suf-
ficient to prove the theory by themselves.[71] For Darwin
too, "the resemblance of Embryos" was "the grandest
of all facts in ... Zoology."[72]

Judgment Day?

Asking for trouble by tackling contentious issues for scientists and laypeople at the same time, the *Schöpfungsgeschichte* traded on Haeckel's boldness in tracing human evolution. The illustrations just as recklessly served his truth, but it was less the specific forms of the embryos that courted controversy than the comparative frame, the schematic and dramatic style, and the exaggerated claims. Embryos had never been compared so vividly before, offering powerful evidence of common descent and weak points for attack, but had the text not treated the plate as proof it might still have passed as an unusual schematic.

Haeckel pushed acceptable practice to the limit, with liberties not taken by other professors addressing lay audiences at the time. He would admit that a few of his pictures were bad. He schematized to suit himself. But only in the cases of the three clichés did he undoubtedly, indefensibly, and, for his argument, unnecessarily sin against the standards of his day.

There is no evidence of dishonest intent, and it is implausible that he sought to deceive. The repetition of the blocks was too easily detected and too little rode on the exact forms: irreproachable illustrations could have shown the similarity of vertebrate embryos. This judgment takes full advantage of hindsight, including manuscript testimony that has only recently come to light. But why judge Haeckel, whom no one holds up as a paragon of propriety today?[73] It is more productive to ask how, where, and for whom forgery became the issue. This does not mean letting him off the hook, but involves examining his role in provoking the charges, the accusers' agendas, and the negotiations through which, over time, various groups tried to make sense of it all.

In early autumn 1868 no one had yet raised the possibility of fraud, and the word *forgery* would not be heard for years. Controversy was inevitable, but the future of the illustrations was wide open. Readers would decide their fate.

{ 6 }

Professors and Progress

Some of the earliest notices of the *Schöpfungsgeschichte* came in from London. The liberal conservative *Saturday Review* pronounced it "an excellent book," but lamented that Haeckel "deals fluently in ingenious speculations on the conformity of development to right reason, without seeming to suspect that ... one authentic instance of a periwinkle developing into an oyster, not to say an otter, would be more to the purpose than the very best of them."[1] Even Huxley, in the inaugural issue of the intellectually ambitious *Academy*, criticized so much that he felt obliged to end by stressing his "entire concurrence with the general tenor and spirit of the work, and ... high estimate of its value."[2] Schleiden wrote for many German scientists in a monthly from Brockhaus, when he praised the "brilliant" Haeckel for "the most significant attempts to extend Darwinism," but worried that "his enthusiasm at times leads him too far, and lets him regard things as certain and decided, for the scientific treatment of which a much larger sum of facts still has to be collected."[3] A theological critic welcomed the way Haeckel had taken Darwin's not entirely unjustified theory to its logical conclusion, because this exposed the deficiencies and defects for all to see—all, that is, who were able to wade through the jargon and willing to overlook the materialist manure that passed for jokes.[4] With so much to fault, especially in the phylogeny in the second half of the book, no one could have predicted that the embryological illustrations would cause most trouble.

The *Schöpfungsgeschichte* owed general readers its success in an expanding market for knowledge, but laypeople were initially involved in controversy over the embryo pictures mainly through scientists' concerns about how Haeckel presented science to the untrained. This is because his peers, the professors of anatomy and of zoology who taught embryology in the German-speaking

universities, monopolized expertise. For forgery to become an issue these most competent readers had to experience a clash between what they saw and what they knew, take the big step of accusing a colleague of dishonesty, and have the charge publicized effectively. Every history of the case cites Ludwig Rütimeyer and Wilhelm His as the first critics, but they tend to remain mere names, while the stances of the other professors have not been explored at all. Recovering agendas and audiences, local and disciplinary, will explain why only Rütimeyer and His protested and to what effect.[5]

Accounts that jump years at the turn of a page have also taken the reception of the charges for granted. It is as if a few talking heads could have decided everything as they floated free of time and space, connecting instantly in a way people do not always achieve today and certainly did not in the mid-nineteenth century. The accusations need instead to be placed in the reading, talking, and reviewing that carried the controversies over the *Schöpfungsgeschichte* and the larger debates over Darwinism.[6] Embryologists were already criticizing Haeckel privately, in marginalia, conversations, and letters, when Rütimeyer publicly alleged something approaching forgery in 1869. But most colleagues, though sharing worries about Hae-

ckel, appeared unconcerned about the embryos. As his gospel of nature became a set text in a culture of progress founded on natural science,[7] other illustrations had to be removed, but criticisms of the embryo plates failed to gain traction. Reconstructing the discussions will show why.

Drawn Rather Freely?

Visiting Munich in August 1868, Haeckel preferred the intellectual climate of the south German center of art and science to the Berlin air (fig. 6.1).[8] "Everyone here is reading your history of creation," he was told a few months later; every last copy had sold.[9] Zeiller's anthropological museum prepared the ground: "Your whole title copper (the catarrhines) was modeled in wax, but much more richly and in part in even more graphic examples."[10] A report from the university contrasted the reactions of the anatomist, Theodor Bischoff, and the zoologist, Carl von Siebold. Both were "Northern lights," distinguished non-Bavarians appointed in the 1850s to revive the institution,[11] and their testimony is telling.

Coeditor of the leading zoological journal, Siebold made a name by championing his observation of parthenogenesis in bees against the newly dominant

Fig. 6.1 Munich's University Square, built in the late 1830s under Ludwig I of Bavaria in early Renaissance style. The fountains were added in 1840–44; the victory gate in the distance was finished in 1852. Steel engraving after his own drawing by Karl Gunkel from an album of plates published by Max Ravizza in the mid-1860s. Münchner Stadtmuseum, Munich.

theory that demanded the action of (male) semen. Though he complained about Haeckel's dogmatism and advised his young friend to learn from criticism, he acknowledged a kindred spirit. Writing in late December 1868 with thanks for the "splendid book," he chided Haeckel only for giving up on the older generation, many of whom were lukewarm toward Darwinism, or even, like Baer, would come out in opposition. For "although I must already count myself among the older zoologists," Siebold agreed "with all my heart." To prove his commitment he reported "tak[ing] up the cudgels for you against Bischoff," who had "mentioned your [embryo] plates [fig. 5.12], which for me so clearly reveal the kinship of all vertebrates, including man. Bischoff said you had drawn the human embryos rather freely, so that they came closer to the dog embryos. I do not believe this. Can you possibly tell me which figures you copied? I would be glad if I could show my colleague these original illustrations."[12] Though an invertebrate specialist, Siebold had grown up with embryology: the son and brother of obstetricians, he had taught midwifery and lectured on human generation. He went into the conversation defending the plates, but may have left worried that he no longer mastered the literature, perhaps with doubts of his own.

Not yet rooted in Jena, Haeckel hoped to succeed to Siebold's chair, and devoted a whole page of his grateful response to the explanation of his drawing quoted in the previous chapter. Siebold acted as though satisfied. Silent on the pictures, the next letter reported his successful proposal of Haeckel for membership in the Bavarian Academy of Sciences, an important source of research funds. The two men soon moved to the familiar *Du* and Siebold expressed childlike delight on discovering that he had been born on the same day as "the reformer of the zoological sciences," thirty years before.[13] He continued to praise the *Schöpfungsgeschichte*, writing of the third edition: "I do not feel myself in the least disturbed; on the contrary, almost everything about which other people may be upset expresses what I feel."[14]

Bischoff, better known today for his hostility to women's medical education, fought the application of Darwinism to human beings and disputed the similarity of human and ape brains. Though he assented to natural selection and the struggle for existence and saw nothing demeaning in human descent, "either for man or for his creator," he denied Darwin's flawed doctrine the status of a theory based on general principles. He rejected the "enthusiasm" that led Huxley, Haeckel, and Vogt to deny the qualitative differences that made apes such unlikely ancestors, and insisted instead on the empirical method of Darwin's own research.[15]

The pioneer of mammalian embryology was the most authoritative possible critic of Haeckel's pictures, but around 1840 he had himself presented the early embryos of humans and other vertebrates as "extraordinarily similar." A decade later, startled by extreme differences between hamster development and that of rabbit and dog, he had inveighed against hasty generalization.[16] The comment to Siebold may signal an interest in deploying diversity against the enthusiasts. Yet Bischoff seems to have let pass the dog that Haeckel would be accused of miscopying from him. Nor did Siebold report any criticism of the woodcuts. Did their elderly eyes not notice the repetition,[17] or was it too embarrassing to point out?

The other greatest authority was Louis Agassiz at Harvard, whose turtle illustrations Haeckel would be presumed to have copied. As Stephen Jay Gould put it: "In 1868 Agassiz, age 61 and physically broken by an arduous expedition to Brazil, felt old, feeble, and bypassed, especially in the light of his continued opposition to evolution.... He particularly disliked Haeckel for his crass materialism, his scientifically irrelevant and vicious swipes at religion, and his haughty dismissal of earlier work." Having discovered Agassiz's annotated copy of the *Schöpfungsgeschichte*, Gould reported his private battle, measured until he exploded at the embryological plate: "Where copied from? Contrived similarity combined with inaccuracy" (fig. 6.2). The younger embryos were worse: "Where were these figures taken from? There is nothing like this in the entire literature. *This* identity is not true." Under Haeckel's claim that he would detect no difference, Agassiz wrote: "Naturally, since these figures were not drawn from nature, but rather one is copied from the other! Atrocious."[18]

Criticism from such connoisseurs as Bischoff and Agassiz might suggest (as Gould assumed) that Haeckel's peers regarded his actions as obviously beyond the pale. But (as Gould recognized) these heroes of the previous generation also opposed at least Haeckel's brand of evolutionism. Moreover, a quarter century earlier (as Gould may not have realized), Bischoff and Agassiz had themselves highlighted the similarity of

Fig. A. Keim des Hundes, 5''' lang (aus der vierten Woche). Fig. B. Keim des Menschen, 5''' lang (aus der vierten Woche). Fig. C. Keim des Hundes, 8½''' lang (aus der sechsten Woche). Fig. D. Keim des Menschen, 8½''' lang (aus der achten Woche). Fig. E. Keim der Schildkröte, 7''' lang (aus der sechsten Woche). Fig. F. Keim des Huhns, 7''' lang (acht Tage alt). Fig. A und B sind 5mal, Fig. C—F 4mal vergrössert. Die Buchstaben haben in allen sechs Figuren dieselbe Bedeutung. v Vorderhirn. z Zwischenhirn. m Mittelhirn. h Hinterhirn. n Nachhirn. r Rückenmark. a Auge. o Ohr. k 1, k 2, k 3 erster, zweiter und dritter Kiemenbogen. w Wirbel. c Herz. bv Vorderbein. bh Hinterbein. s Schwanz.

Fig. 6.2 Louis Agassiz's marginalia in the *Schöpfungsgeschichte*, objecting to the figures of the younger dog and human embryos on the double embryo plate. As examples he named "coloboma," that is, abnormal eye development, and the missing "umbilicus." Ernst Mayr Library, Museum of Comparative Zoology, Harvard University.

Fig. 6.3 Rütimeyer on fossil ungulate teeth. *A*, lithograph showing molars of extinct *Anoplotherium* and *Palaeotherium* found in the canton of Solothurn, and of red deer. *B*, table based on tooth analysis, a tentatively presented attempt to achieve a more natural grouping. Rütimeyer sympathetically considered the possibility that morphological relations were based on "physiological truth" (642), and nodded to Darwin, but avoided discussing his views in a specialized work. Rütimeyer 1863, plate II and 640.

vertebrate embryos. Haeckel could have lifted his rhetoric of identity from Agassiz, whose own drawing for public lectures was not above reproach. Now it suited Agassiz and Bischoff to stress difference. By contrast, Siebold, less knowledgeable but competent, broadly supported Haeckel and saw no reason to fuss. A physiologist drew attention to "a series of instructive illustrations to demonstrate the similarity of young embryos of various vertebrates." Darwin simply noted, with reference to Haeckel's plate: "I must [k]no[w] about embryology."[19]

Many medical and life scientists looked at the pictures as confirming what they already knew or should have known. Others experienced a worrying clash with their greater knowledge, but for a long time they kept doubts more or less to themselves. Only one directly accused Haeckel of foul play in print.

To Spare the Reading?

Histories state that a certain Ludwig Rütimeyer leveled the first forgery charges in late 1868—it was in fact not before mid-1869—in the *Archiv für Anthropologie*. But this professor of zoology and comparative anatomy at the University of Basel was Darwin's most expert champion in Switzerland. To understand why he moved against Haeckel we need to reconstruct his allegiances, and above all to read his review.

From a long line of Bernese pastors, Rütimeyer had studied theology and then medicine before turning to the geological and paleontological investigations that in 1855 gained him his Basel chair. He cofounded the German Anthropological Society, which owned the *Archiv* and would become a bastion of empiricist resistance to Darwinist speculation. Not unusually, he rejected natural selection as too mechanistic, and his antimaterialist view of the history of nature as a progressive striving for consciousness left the natural sciences only a modest place in the order of knowledge. He ranked breeding experiments, fossils, and biogeography above embryology as evidence of evolution, but accepted human descent. In the early 1860s, by comparing teeth, he had placed fossil mammals in some of the first evolutionary lineages (fig. 6.3). Darwin commented in 1865: "I think Rütimeyer, for whom I have the greatest respect, is also with us."[20] Haeckel asked the Reimers to send Rütimeyer the *Schöpfungsgeschichte* "on behalf of the author."[21]

A

Tab. II.

Maxilla dextra. 13. 14. Anoplotherium. 15. Cervus. **Mandibula dextra.** 16. 17. Palaeotherium. 18. 23. 24. 25. Anoplotherium. 19. 20. Alces. 21. Tarandus. 22. 26. 27. Elaphus.

B

Coryphodon.	Lophiodon.				Listriodon.	**Tapirus.**	
					Aceratherium.	**Rhinoceros** etc.	
				Titanotherium.			
	Anchilophus?	Propalæotherium.	**Palæotherium.**		*Anchitherium.*	**Equina.**	
					Hipparion.		
					Oreodon?	**Camelina.**	
			Anoplotherium.	*Chalicotherium.*		**Cavicornia.**	
			Xiphodon.			**Cervina.**	
					Amphitragulus.		
		Dichobune.	Dichodon.	Microtherium.	**Moschina.**		
				Pæbrotherium etc.			
			Hyopotamus.	*Agriochœrus?*	**Dicotylina.**		
				Anthracotherium.			
	Lophiotherium.			Archæotherium.	**Suina.**		
	Pachynolophus.	Chœropotamus.	Entelodon.	Palæochœrus.			
Pliolophus.	Hyracotherium.						
	Rhagatherium etc.			Hippohyus.	**Hippopotamus.**		
					(Mastodon?)		

Reviewing the book and a slim volume by Haeckel in Virchow's series of "popular scientific lectures," Rütimeyer concentrated on the difficulty of classifying the works. "The author has called them popular and scholarly," a novel and evidently puzzling combination. "No one will dispute the correctness of the first predicate"—professors readily inferred this even of rather taxing books—"but he will himself hardly lay serious claim to the second." The most generous assessment might be as "schemata, [of] how the author imagines our present knowledge arranged in the future; they thus form a kind of … fantasy literature, which … in science recalls a far distant past, when observations still served only as mortar for the stones delivered by fantasy, while we are used today to demand the reverse relationship."[22]

Rütimeyer was horrified that public discussion of man's place in nature would allow the uneducated to take the unripe fruits of zoological research and foment (perhaps even ferment) atheism and materialism. But he reassured listeners in Basel: "The work itself is much too difficult, and requires much too much the concerted exercise of all the powers of our mind, for it to be able to be performed in any other place than the quiet room—closed against the incompetent—of the sharp observer and the deep thinker."[23]

Just as elitist about figures he would have preferred under lock and key, Rütimeyer wondered if they were "intended to secure the book, alongside the readers who read the text and then if necessary make their own such illustrations, a second [audience] whom one wanted … to spare the reading." Extraordinarily, by later standards, he assumed a main readership skilled enough to draw figures from the books on their shelves or from specimens. The comment brings home the way sparse illustrations had presupposed experience and highlights the perceived risks of pictures that others celebrated as democratizing knowledge.

Rütimeyer seems to have objected to the figures' summary character—by doing so much work they tempted readers to skip the text—as well as to their makeshift appearance and lack of honest originality. They "neither create the impression of being intended to last, nor are they altogether new." Rütimeyer deplored the publication of the frontispiece, a kind of drawing "well enough known in convivial circles of friends," and of the evolutionary trees, hypothetical "sketches" such as had long existed "for private

orientation" where they should have stayed, "in desk drawers."[24]

Against the embryological drawings, which were "really new in a certain sense," the distinct charge was that Haeckel had taken two kinds of liberty with established truth. No more than Siebold did Rütimeyer insist on illustrations directly after specimens.[25] But knowing that "drawings in no other field … demand greater scrupulosity and conscientiousness," it could have been expected that Haeckel "not arbitrarily model or generalize his originals for speculative purposes." Comparison of the lithograph with plates by Bischoff, Ecker, and Agassiz proved Haeckel's guilt, Rütimeyer claimed, and these identifications stuck, even without further details.

Worse, Rütimeyer went on, "one and the same, moreover incorrectly interpreted woodcut, is presented to the reader three times in a row and with three different captions as [the] embryo of the dog, the chick, [and] the turtle." This sort of thing could be disregarded in "sixth- and seventh-hand compilations," but not in a "'scientific' history of creation … by a microscopist," especially when he "does not describe these drawings as crude schemata," but states that "you will not be able to perceive a difference." Rütimeyer did not write of *forgery*, let alone *fraud*, but of "playing fast and loose with the public and with science." Yet he protested clearly enough that Haeckel had failed to meet the "obligation" to the "truth" that should live "in the heart of every serious researcher."[26]

Anthropology was more cultivated outside the universities than within, but this journal will have reached only hundreds of people. As difficult to negotiate as an Alpine torrent, Rütimeyer's prose restricted his comments to the few. His immediate audience lived right on his doorstep in Basel, a city-republic ruled by an oligarchy "of millionaires and pietists,"[27] whose presence may explain why the first attack came from there. Haeckel saw Rütimeyer as truckling to religion for money: "Since his excellent works have earned him the reputation of being half Darwinist," he "slander[s] other Darwinists" so that his "very devoutly pious" Basel countrymen still "pay his salary."[28] That is too crude, for Rütimeyer gave *The Descent of Man* a positive review, and scholars in Basel, where he fitted in well and had been made an honorary citizen the previous year, valued authenticity above all else. But the city did encourage critical intellectual engagement with the

modernizing world. For the humanities, the literature historian Lionel Gossman has characterized the small university as a haven for "unseasonable ideas," "a sanctuary for intellectual practices that ran counter to the reigning orthodoxies of German scholarship."[29] The argument extends to the natural sciences: a society rather uninterested in science popularization credited Rütimeyer for his courage in resisting a rising orthodoxy perceived as artificial, populist, and gratuitously offensive to religion.

Protecting Embryology

That winter Rütimeyer had attended an embryology course taught by his close colleague Wilhelm His, who had the strongest interest of any scientist in opposing Haeckel in this field.[30] The anglophone literature knows His for a rival, physiological program for the study of development and as Haeckel's most effective critic, but has characterized him too sketchily. Often taken for a "German anatomist," he in fact had a strong Swiss identity and held one of the last undivided chairs of anatomy and physiology. Reconstructing his stance will explain his hostility better.[31] He appears now, because although he did not attack Haeckel's pictures directly until 1874, the ground was laid by his public defiance of Haeckel's approach in 1869 and Haeckel's rude rebuttal in 1872.

Brought up among the Basel patricians whose legendary wealth derived from the silk-ribbon industry, His had in the 1850s studied medicine in Berlin and Würzburg, where he shared teachers with Haeckel, most importantly Virchow. He first read Carl Ludwig's textbook "only with constant internal opposition," finding this applied physics "thin and impoverished." But unlike the morphologists who remained of this view, His was soon engaged in a kind of histology that, in dialogue with Ludwig's physiology, addressed questions such as the mechanism of lymph formation.[32] Doctoral research on the structure of the cornea and powerful local connections secured him that full professorship in his hometown at the tender age of twenty-six (fig. 6.4).

Having taught embryology for several years, His began to research chick development in the mid-1860s. While trying to perfect his teacher Robert Remak's attempt to derive each cell type from a specific germ layer, he ended up revising the doctrine completely. He controversially (and in the end unsuccessfully) proposed that much of the mesoderm—which gives rise to connective tissue, cartilage, bone, and blood vessels—originates not from the main embryo but by ingrowth from an auxiliary germ, or *parablast*. The monograph that presented this theory, *Die erste Entwickelung des Hühnchens im Ei* (The early development of the chick in the egg, 1868), used an effective

Fig. 6.4 View of Basel over the Rhine in 1870. In the center is the Blue House, the splendid late Baroque palace where His was born, adjoining on the left the White House, and in front on the right the university where he and Rütimeyer worked. Photograph from an album of Dr. Carl Friedrich Meyer-Müller, Staatsarchiv Basel-Stadt: AL 45, 1–5.

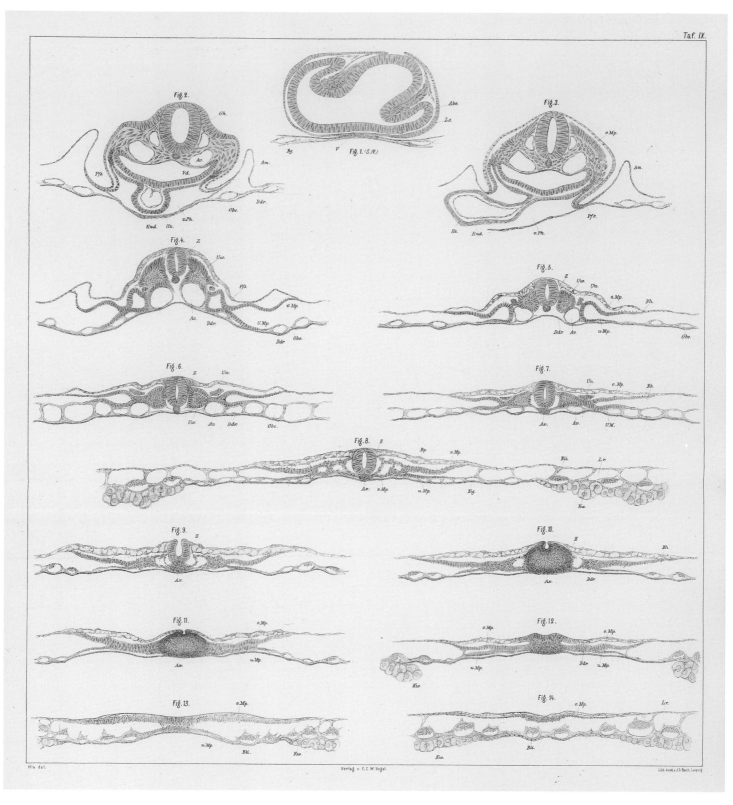

Fig. 6.5 Transverse sections of a two- to three-day (stage-7) chick embryo after drawings by Wilhelm His. Lithograph by J. G. Bach from W. His 1868, plate IX. Whipple Library, University of Cambridge.

Fig. 6.6 Wax models of the early development of the chick by Adolf Ziegler after Wilhelm His. These are the stage 7 models from a twenty-three-piece series first made in 1868: *A*, dorsal view; *B*, ventral view with facial surface of head and heart exposed; *C*, endoderm with vessels forming on it; *D*, sagittal section; *E*, brain; *F*, heart. All magnified forty times, but variously enlarged here; the frame in *A* is 33 cm high; *E* is 9 cm long. For the full series: Hopwood 2002, 96–97, 148. Anatomisches Museum Basel.

microtome for the first time fully to convert embryos into serial sections (fig. 6.5). But His did not stop at sections or even graphical reconstructions. Building magnified models in wax or clay gave him unprecedented access to microscopic internal structure and recovered three-dimensional views from the slices (fig. 6.6). Unfortunately for Haeckel, he was thus massively invested in the accuracy and completeness of representations.[33] As if that was not bad enough, His also dared to apply the mechanical approach of the physiologists Haeckel hated to the embryos Haeckel loved.

On simple premises His built a grand vision. He modeled the germinal disc on an imperfectly elastic plate, of which the different regions grow at different rates and have different elasticities, and so create pressures that force changes in shape. Thus the slower-growing periphery resists the expansion of the faster-growing central region, causing the surplus material to be thrown up into the system of criss-crossing folds which divide the embryo into the major anatomical regions and thence into organs. The distribution of growth for each species or even individual was described by a law which could in principle be expressed as a function dependent on space, time, and external conditions. Though he had the local mathematician derive a growth equation, His recognized that he was far from a solution for a chick, let alone a human being (fig. 6.7). He nevertheless declared his conviction that "the formulae of the growth laws for all living beings in creation stand in wonderfully simple relations to each other." He supposed that the female body was more juvenile than the male because the temporal gradient of the law of growth was steeper. If of two individuals one had a higher maxi-

Biegungen Elasticitätskräfte entwickelt sein, welche, wenn keine äusseren Kräfte auf die Platte ein wirken, sich gegenseitig im Gleichgewichte halten müssen.

3. An einzelnen Stellen wird die Gränze der vollkommenen Elasticität und unter Umständen auch die Festigkeit überschritten sein; die Folge davon sind bleibende Veränderungen in der gegenseitigen Lage der Elemente und zuweilen auch Risse.

4. Die Platte wird nicht mehr eine Ebene darstellen, sondern eine gekrümmte Fläche mit verschieden geformten Hebungen und Faltungen, wobei die Form sowohl eine Folge des Wachsthumsgesetzes, als auch der den einzelnen Theilen innewohnenden Elasticitätskräfte sein muss.

5. Die Dicke der Platte wird an den verschiedenen Stellen auf eine der Wachsthumsfunktion entsprechende Weise zugenommen haben.

Um den ausgesprochenen Sätzen etwas mehr Anschaulichkeit zu geben, wollen wir beispielshalber den Funktionen W und $\varphi\,(x, y)$ bestimmte einfache Formen geben, damit die angedeuteten Rechnungsoperationen ausgeführt werden können. Wir nehmen an es sei:

$$W = \left(\frac{99}{y^2 + 100} + \frac{1}{x^2 + 100}\right);$$

es ist dies eine Funktion, welche den oben ausgesprochenen Bedingungen genügt, und bei welcher die Form und die Constanten so gewählt wurden, dass die Ausführung der Rechnung wenig Mühe verlangt. Ferner sei $\varphi\,(x, y)$ die Gleichung eines Kreises vom Radius 100; also

$$x^2 + y^2 = 10000 .$$

Wir erhalten nun durch Ausführung der oben angedeuteten Operationen

$$W_{mx} = \frac{99}{10100 - x^2} + \frac{1}{x^2 + 100}$$

$$W_{my} = \frac{99}{y^2 + 100} + \frac{1}{10100 - y^2}$$

und ferner:

$$\varDelta x = t.\left(\frac{1}{10}.\ arc.\ tg\ \frac{x}{10} + \frac{99}{2.\sqrt{10100}}\ .\ lg_n\ \frac{\sqrt{10100} + x}{\sqrt{10100} - x}\right)$$

$$\varDelta y = t.\left(9{,}9.\ arc.\ tg\ \frac{y}{10} + \frac{1}{2.\sqrt{10100}}\ .\ lg_n\ \frac{\sqrt{10100} + y}{\sqrt{10100} - y}\right).$$

Für t nehmen wir 10 und berechnen für angenommene Werthe von x und y die entsprechenden Werthe der neuen Randcoordinaten X und Y. Die beistehende Figur giebt das Resultat der Rechnung. Wir sehen daraus, wie die ursprüngliche kreisförmig eGestalt des Randes $ABCD$ in eine, mehr einer Ellipse ähnliche Gestalt $EFGH$ übergegangen ist. Dass es nicht eine mathemathisch richtige Ellipse ist, ergiebt sich sowohl aus der Gleichung, als aus der Zeichnung.

Um nun ferner über die Werfungen der Platte im Inneren uns einige Rechenschaft zu geben, machen wir folgende Betrachtung:

Wir berechnen die Länge, welche die Linie OC erhalten sollte, wenn die geringere Ausdehnung des Randes die Verlängerung nicht hinderte. Diese Grösse hat offenbar den Werth:

$$100 + 10 \int_0^{100}\left(\frac{99}{100} + \frac{1}{x^2 + 100}\right) dx$$
$$= 1091{,}5 .$$

Die Linie OG ist nur gleich 131; der Rand gestattet somit der Linie OG sich etwa nur auf $^1/_8$ der Längenzunahme auszudehnen; die anderen $^7/_8$ werden somit zur Entwickelung der Elasticitätskräfte, der Verschiebungen, Ausbiegungen u. s. w. dienen.

His.

Fig. 6.7 "Change in Form of a Thin, Incompletely Elastic Plate, of Which Different Parts Grow Unequally." Page from the essay by the Basel mathematician Eduard Hagenbach that accompanied His's monograph. Some medical students hated the mathematics in his lectures (Johann Rüedy to Haeckel, 14 Oct. 1875, EHH), and no embryological work had ever contained such things before. W. His 1868, 193. Whipple Library, University of Cambridge.

mum and thus a steeper decline of the function, then, he reckoned, it would have more nervous system and be cleverer but weak, the other more musculature and be less intelligent but strong.[34] This "fundamental law of growth" (*Grundgesetz des Wachsthums*) thus underwrote a vision of the organization of the animal kingdom and bourgeois society as sweeping as the "biogenetic law" (*Biogenetisches Grundgesetz*), the name Haeckel gave the evolutionary doctrine of recapitulation in a monograph on calcareous sponges in 1872.

But this was speculation; all His could do was establish the relevance of mechanical forces by mimicking shape changes with "simple experiments" in everyday materials. So he compared the closing of the body to folding an old-fashioned letter. The closure was incomplete, like when trying to fold the letter around a larger piece of stiff card; alternatively, it could be demonstrated on a leather "embryo" containing a wire frame. The extremities were produced where folds crossed. Upper and lower germ layers separated like two pieces of paper loosely stuck by their flat surfaces when light pressure was applied to the edges.[35] The development of the central nervous system paralleled the shapes produced by slitting and bending a rubber tube.[36] These crude forms, His argued, were similar enough to the developing embryo that the same basic mechanical processes must be involved. In this view, organs then without a physiological role, such as the hypophysis and the thymus, appeared as "embryological residues, comparable to the waste that in cutting out a dress cannot be entirely avoided even if the material is used as economically as possible."[37]

This approach was consistent with common descent; His embraced Rütimeyer's teleological evolutionism and the growth laws included the environment. But His gave this such a minimal role, and paid so little attention to change over geological time, that the whole scheme might as well have been preordained.[38] He had set it up without reference to evolution and worked to preserve for embryology a phylogeny-free zone.

Addressing the University of Basel as its elected head, His sought "to protect the rights of the individual history of development from the overweening power of Darwinian views."[39] The speech of late 1869, published the following year, presented embryology as largely irrelevant to evolution and assigned the science to physiology instead. Reviewers complained

of an uncollegial proposal that physiology take over the scientific parts of morphology,[40] but by deferring to Rütimeyer on Darwinism His was in no danger of stepping on local toes.[41] He also sniped at claims about identity, doubting the "absolute correctness" of recapitulation and rejecting it as an explanation. In a departure from the usual reading of Baer, he stated that "complete identity of forms is not found even at very early stages of development or for closely related embryos. The more practiced an observer is, the earlier he will know to assign a doubtful object to its appropriate place."[42]

This response was even more overdetermined than Rütimeyer's. In addition to the embryological agenda, His was on the board of the *Archiv für Anthropologie* and had collaborated with Rütimeyer to classify Swiss skulls. In dedicating the speech to his devout brother-in-law and mentor, the pathologist and physician Friedrich Miescher-His, His also followed Rütimeyer in opposing a religiously inflected humility to Haeckel's hubris.[43] Though some conservatives remembered with displeasure His's grandfather's role in founding the revolutionary Helvetic Republic, he was deeply rooted in Basel,[44] where the stand against Haeckel would go down well.[45] But for the moment His did not explicitly target the pictures—or even name Haeckel—and this coded academic speech could not stem his competitor's success. By the time it was published, a German journal in New York had offered, as a prize for signing subscribers, "'*either* Haeckel's *Natürliche Schöpfungsgeschichte or* [the eighteenth-century dramatist Gottfried Ephraim] Lessing's complete works'!!—Agnes [Haeckel] nearly died laughing!"[46]

Well Worth Studying

Most biologists now accepted evolution in some form, even if they did not buy the whole Darwinian or Haeckelian package,[47] and Haeckel was galvanizing young zoologists. With the end of the Franco-Prussian War and the foundation of the Second German Empire, his fat tome started to epitomize the "culture of progress," the optimistic, nationalist, anticlerical cultivation of science, especially in the booming newspaper and magazine industry, which stretched from left liberals to moderate conservatives (fig. 6.8). A group of journalists and editors softened and simplified Haeckel's

Fig. 6.8 The culture of progress, as represented by "the man with the encyclopedia." Caricature by Fritz Steub in a spoof of Haeckel's *Anthropogenie*. Wood engraving from Reymond 1878, 118. 4 × 6 cm.

messages for family consumption. He fed them books, biographical material, and illustrations, cultivating the sense that they were mediating between Darwin's vicar and his flock.[48]

For the second edition, published in 1870 in the higher run of fifteen hundred,[49] Haeckel revised and expanded the chapters of pedigrees. Though he signed the new preface in early May 1870, late enough to have answered Rütimeyer and likely also His, he avoided for the moment publicizing accusations that had acquired little momentum, and took on more general charges instead. He denied being "hyper-Darwinistic"; if the theory of evolution was true, it must be possible to sketch the special applications using hypotheses which should then be improved. Nor was his approach materialistic and atheist, but rather monistic and pantheist: unifying matter and spirit and placing God in nature. A natural religion was higher than belief in a personal god.[50]

The book gained in visual interest too. Setting a pattern in which a new frontispiece to each edition relegated the old one to the inside, a tamer view of zoophytes and coelenterates in the Mediterranean replaced the heads, which had "flattered" "the monkeys" and "caricatured" "the men."[51] Haeckel challenged a private complaint by Charles Lyell, the geologist and expert on human antiquity, that he had drawn at least the Australian, African, and Tasmanian "too '*pithecoid*.'" In older travel books, Haeckel replied, "one often finds *even more* apelike faces."[52] But since he had never liked the lithographer's work,[53] he had a trusted

artist revise and double the primate gallery for a new engraving. To help laypeople he added some "urgently desired" figures of invertebrate ancestors.[54] The plates of vertebrate embryos were redone, probably because the stones had been cleaned, but the low-circulation objections of the Basel professors made no difference to their forms. He expanded the arrays to include the earlier stages of turtle and chick, and gave them the definitive arrangement in a grid (fig. 5.13).

Haeckel did respond, silently, to Rütimeyer's only incontestable charge, that of using the same blocks for different objects. Haeckel now labeled a single figure "the human egg," but noted that it "could just as well stem from … any other mammal"; the same block still also stood for the "egg of a mammal." He continued to claim that early embryos of reptiles, birds, and mammals were indistinguishable, but now presented just one of the woodcuts as "a mammal or bird."[55]

"Powerful support" from "alarmingly similar" embryos was noted in *Das Ausland* (Foreign countries), the magazine of ethnography, geography, and natural science that Friedrich von Hellwald—an apologist for the "right of the stronger"—made a chief organ of Darwinism in Germany. The reviewer repeated a slightly garbled version of Baer's story, while accepting that only paleontology could prove common descent.[56] Even critics praised the embryo plates.

In *Nature* Michael Foster, who lectured on chick development at Cambridge and inspired Britain's first important embryological research school, saw the book as a new *Vestiges*. He regretted that "the heads

of men and monkeys,... at once absurdly horrible and theatrically grotesque, without any redeeming feature either artistic or scientific[,]... have been increased from twelve to twenty-four, but their quality remains the same." Yet he lauded some "really beautiful and very instructive plates" of the development of various animals and "a large comparative view, well worth studying, of the embryos of the four vertebrate classes." Foster was just back from a German tour, which included "a very pleasant interview" with Haeckel; he also had "a long chat with His and saw many of his preparations and photographs." Did he miss Rütimeyer's criticisms or did he discount them?[57]

This approval chimed with vindication from the major Darwinian event for years. "As I drink my morning coffee the postman brings me ... Darwin 'On the Descent of Man,'" Haeckel told his favorite students, Richard and Oscar Hertwig, in 1871. "This book has been anticipated with great excitement from all sides, and not only my scientific opponents, but also many supposed Darwinists had prophesied as certain that the calm, moderate, and mild Darwin would decisively disavow the passionate, radical, and hyper-Darwinistic Haeckel and his application of the theory of evolution to man!" Not a bit of it. "The most famous scientist of the century" corroborated everything Haeckel had argued, and acknowledged the *Schöpfungsgeschichte* in the most flattering terms: "If this work had appeared before my essay had been written, I should probably never have completed it." Haeckel celebrated his "greatest scientific triumph," while others saw him as leading Darwin astray.[58]

Having brushed up on embryology and borrowed Bischoff's and Ecker's books from Huxley,[59] Darwin made his first figure a full-page comparison (fig. 6.9). "As some of my readers may never have seen a drawing of an embryo, I have given one of man and another of a dog, at about the same early stage of development." Darwin noted Haeckel's "analogous drawings," but pointed up how "carefully" his own had been "copied from two works of undoubted accuracy," recording magnifications and the omission of "internal viscera" and "uterine appendages."[60] He may have been distancing himself from Haeckel's practice, but confirmed great similarity. "What," Haeckel asked him, "will Mr. Rütimeyer [have to say], the left half of whose brain is Darwinist, and the right one (along with the entire choroid plexus) orthodox-clerical?"[61] Haeckel would soon feel confident enough to retaliate.

A Dogmatist of the Worst Sort

Haeckel's comprehensive gospel of evolution now stood out from the flood of Darwin literature as one of the handful of works any self-respecting progressive had to have read. New editions came out in quick succession in 1872 (1,500 copies), 1873 (2,500), and 1874

Fig. 1. Upper figure human embryo, from Ecker. Lower figure that of a dog, from Bischoff.

a. Fore-brain, cerebral hemispheres, &c.
b. Mid-brain, corpora quadrigemina.
c. Hind-brain, cerebellum, medulla oblongata.
d. Eye.
e. Ear.
f. First visceral arch.
g. Second visceral arch.
H. Vertebral columns and muscles in process of development.
i. Anterior ⎫ extremities.
K. Posterior ⎭
L. Tail or os coccyx.

Fig. 6.9 Darwin's human and dog embryos as "evidence of the descent of man from some lower form." Compare figures 5.6 and 5.12, above. Wood engravings from Darwin 1871, 1:15. Whipple Library, University of Cambridge.

(2,500).[62] The "unusual commercial success" of this heavy tome counted as the "most eloquent" testimony to mounting public interest in science,[63] and would more than compensate the Reimers for any loss on the *Generelle Morphologie*.

Haeckel kept on adding illustrations and using new prefaces to respond to criticisms, provoke opponents, and keep the book in the news.[64] For the lightly revised third edition he capitulated to the continued attacks and removed the "ape plate," even though it had been a selling point.[65] The embryos, harder to criticize and

newly praised, were redone for a long haul. Wilhelm Grohmann of Berlin replaced the lithograph, suitable only for low runs, with a copper engraving strengthened by steel facing, that is, electroplating with iron (fig. 6.10). By repeating the procedure it lasted until the eighth (1889) edition.[66]

Emboldened by Darwin, Haeckel now took on his Basel critics. He mocked Rütimeyer and travestied his attack as denying "the identity of form of the eggs and the young embryos of humans and the most closely related mammals," when the point had been to de-

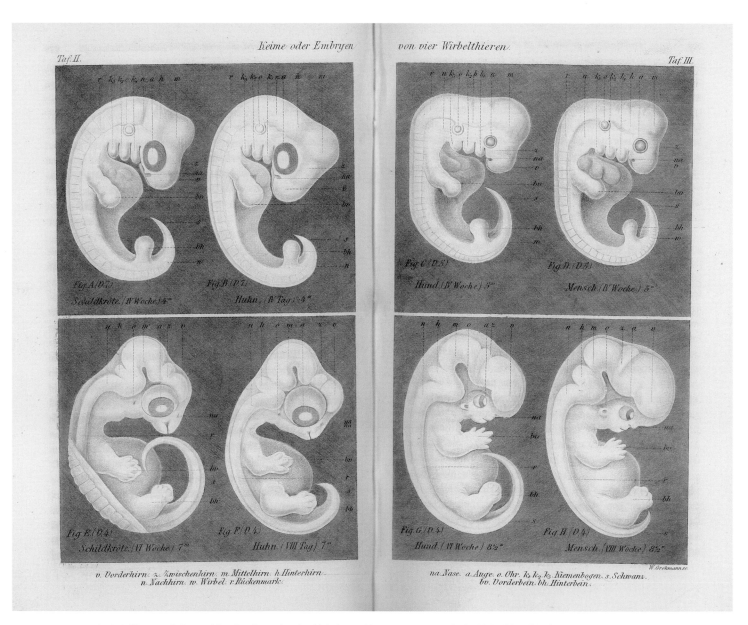

Fig. 6.10 "Germs or Embryos of Four Vertebrates," turtle, chick, dog, and human, at two stages in the third edition of the *Schöpfungsgeschichte*. This was the definitive form of the first embryological grid. Essentially the same as the lithograph (fig. 5.13), it is sharper, finer, and lower contrast on the gray background. Panel A–B is 8.3 × 10 cm. Steel-faced copper plate by Wilhelm Grohmann from Haeckel 1872, plates II–III.

nounce the means by which Haeckel had achieved it. He quoted Huxley's comments from *Man's Place in Nature*, and then—perhaps reminded by the *Ausland* reviewer—wheeled out Baer's tale of the unlabeled preparations as evidence of how long "these embryological facts denied by Rütimeyer" had been known. Wilhelm His had questioned the extent of the identity, but Haeckel used him rather to illustrate the "astonishing misunderstanding" of a specialist who had "pursued ontogenetic investigations with great diligence (if also unfortunately without morphological judgment)." He had set up a "supposedly 'mechanical' theory ... which every zoologist of clear judgment and knowledge of the facts of *comparative anatomy and ontogeny* can regard only with a smile."[67]

For good measure, Haeckel also targeted other anthropologists and ethnographers as half-educated dilettantes who failed to appreciate that their science was really a branch of zoology. The leading light of the Berlin Anthropological Society, Adolf Bastian, earned his pet insult, that people who opposed evolution had not evolved far enough themselves.[68] Fortifying Haeckel in his stance by diplomatically stressing agreement, Darwin wrote that he was "particularly glad to hear ... your criticisms." Rütimeyer's review had "grieved" him; "I am sorry that he is so retrograde, as I feel much respect."[69]

Haeckel's academic star was still rising: he turned down calls to Vienna (1871–72), Strasbourg (1872), and Bonn (1874),[70] and continued to publish apace. Based on his sponge work, he grandly refounded the doctrine of types by deriving all multilayered animals from a hypothetical common ancestor. This he based on the observation that all *metazoans*, as he called them, pass through an early developmental stage that he christened the *gastrula*, or "stomach larva," a two-layered, hollow body with an opening on one side. According to the biogenetic law, all of these phyla must have descended from an equivalent ancestor, the *gastraea* (fig. 6.11).[71]

Yet opposition was growing among the increasingly dominant physiologists, as power also shifted toward a few rapidly expanding universities, including Berlin and Leipzig. From nearby Jena, freer politically but still waiting for a railway station, Haeckel nervously defended small institutes as his enemies circled.[72] Ludwig had His called to a chair of anat-

Fig. 6.11 "Development of a Calcareous Sponge (*Olynthus*)." Haeckel made no major changes to the fourth edition of the *Schöpfungsgeschichte*, but did highlight this research as demonstrating the productivity of a theory often decried as speculation. A new frontispiece—seen here as an internal plate in the fifth edition—showed the development of the common ancestral form, which he hailed as a living representative of one of the oldest and most important human ancestors: *1*, egg; *2*, two-cell; *3*, morula; *4*, planula; *5–6*, gastrula; *7–8*, ascula; *9*, adult *Olynthus*; *10*, *Ascometra*, one of the strangest forms to develop from it. Lithograph by Eduard Giltsch from Haeckel 1874b, plate XVI.

omy at Leipzig in 1872, and when the German nature researchers and physicians met there that August, the leading National Liberal physiologist Emil du Bois-Reymond moved against Haeckel with a speech, "Über die Grenzen des Naturerkennens" ("On the Limits of Our Knowledge of Nature"). Scientists such as Virchow had long distanced themselves from the excesses of materialism, even as they pushed forward the frontiers of science. Scientific mandarins seeking accommodation with the new Prusso-German Empire now wanted unity under the nation and in approach, demanding autonomy in exchange for a pledge to stay out of politics and religion. Haeckel's historical causation challenged the dominance of mechanistic science, and he rode roughshod over the limits by replacing religious with scientific metaphysics.

So in Leipzig du Bois made the temporary limits absolute: "With regard to the riddles of the physical world the investigator of nature has long been wont to utter his *Ignoramus* [we do not know] with manly resignation.... With regard to the riddle of what matter and force are, and how they are able to think, however, he must once and for all resolve upon the far more difficult verdict: *Ignorabimus* [we shall not know]." This aggressive agnosticism bid for a powerful neutrality; where science could not go, du Bois saw little to be known. But soldiers of science and guardians of Christianity took him to be giving up vast territories he might have claimed.[73]

Meanwhile several specialists expressed grave reservations about the gastrula research: Haeckel theorized beyond the evidence, treated other researchers roughly, and ignored inconvenient facts. Some zoologists censured his disregard for their values of skeptical empiricism, intellectual openness, and modesty. Historians have stressed the criticisms, but shared interests tempered concern. The newly independent discipline's most famous professor and best recruiting officer had stuck his neck out to defend morphology and promote evolutionism. Public opposition would risk common causes as well as the critic's honor, fan the flames, and allow lay enemies to exploit divisions. Rütimeyer may also have lacked the specific authority to pronounce on embryology. Was it worth contesting illustrations that represented no discovery but merely exaggerated into identity a point about similarity that no one disputed, whatever his stance in the Darwinian debates?[74]

Testifying to a level of celebrity approaching that enjoyed by Vogt or even Liebig, so many people asked Haeckel for his photograph that he had a portrait engraved as the frontispiece to the fifth (1874) edition (fig. 6.12).[75] He was also unhappy with a "terrifying counterfeit" that had appeared with an early biographical sketch in *Die Gartenlaube*, the liberal family magazine and prototype of a mass press, which now circulated in a huge run of nearly 400,000 and was read by many times more.[76] Understanding the embryo plates as representing types, Haeckel would shrug off specialist objections that the figures differed from specific originals. But scientific authorship was individual and he expected a portrait to capture the character known to his family and now central to German Darwinism.

In the *Illustrirte Zeitung*, more expensive because of the many pictures but prominent all the same, a biography began: "Haeckel's name gains more in popularity every day. Even the less educated person" knew that he occupied a chair in Jena and had written the *Natürliche Schöpfungsgeschichte*. Haeckel had given the biographer, newspaper editor Otto Zacharias, information and photographs. Zacharias scorned the "legion of adversaries": "Haeckel is man enough not to let himself be diverted … from the path he has taken. He is not only an eminent scholar, but also a scientific character, a man of moral courage and of uncompromising single-mindedness."[77]

Single-minded to his friends, to his enemies Haeckel was a zealot. In Germany's leading daily, the *Allgemeine Zeitung*, a theologian described him as "witty and skillful in his presentation, but all the same a dogmatist of the worst sort," a latter-day nature philosopher who would take whatever "stone" fitted his "edifice" without checking it too carefully first. The critic, Johannes Huber, was one of the "Old" Catholics who had broken with Rome over the declaration of papal infallibility in matters of faith and morals. He was not about to embrace an equivalent doctrine in science. Huber quoted Rütimeyer's criticism of the *Schöpfungsgeschichte* as a work of fantasy, but left out the comments on the figures.[78] The Basel professors maintained a dignified silence, while Bastian, the anthropologist Haeckel had insulted, let rip. Known for his convoluted and pompous style as Don Bombastian, he accused "the fanatical crusade-preacher of a new faith" of throwing immature "products" out into the "rough and tumble of the market bustle," where,

Ernst Haeckel.
1874.

Fig. 6.12 Haeckel's first author portrait. The Reimers paid the renowned August Andorff 120 marks for this copper engraving, but had to admit that, though revision achieved a good enough likeness, the work was hardly up to his earlier standard; he had become, "to put it mildly, very thirsty" or, to put it bluntly, a drunk (G. Reimer to Haeckel, 26 Aug. 1874, EHH). Haeckel 1874b. Universitätsbibliothek Tübingen: Bg 97 ak.

"misinterpreted and misunderstood," they "will degenerate into malformations." The teratological metaphor notwithstanding, Bastian did not mention embryos, but demanded that the public be protected from such "forgeries [*Fälschungen*]" as "on the plate of racial heads."[79]

A Jury of His Peers?

Haeckel later fancied that his colleagues were sitting in judgment on his embryos, but only one specimen ever went before such a court. A jury of his peers might seem a nice quick way of writing history. We could pretend that they met in the early months or years to adjudicate without risk of anachronism in the light of then-current knowledge and practice. But would they ever agree? The critics were all both expert in embryology—Rütimeyer had easy access to such

expertise—and hostile, for disciplinary, political, and religious reasons, to Haeckel, if not to evolution itself. By contrast, those who either welcomed the pictures, or passed up opportunities to criticize them, tended to be only generally competent and favorably disposed toward him; no established vertebrate embryologist gave support. The professors also divided over whether and how to draw for laypeople. The dearth of common ground bodes poorly for a definitive verdict, let alone a snap judgment. There is nothing for it but to follow the real, engaging, and instructive debate.

In autumn 1874 pictures already figured in fierce arguments over the character of the leading German Darwinist. Haeckel had had to remove the ape plate and the illicitly repeated woodcuts, but the latter were a minor issue, and he was not under enough pressure to alter the embryological arrays, which no one had called *forgeries* yet. Close colleagues and distant sup-

porters found nothing wrong, those in the middle kept their heads down, and opponents rejected so much they could be dismissed. Rütimeyer's criticisms had little initial effect, even when the experts agreed, because he addressed a small readership in elitist terms and neither he nor, for the moment, anyone else followed up. Most life scientists had no interest in joining the attack, and Haeckel, riding high in the culture of progress, drew some of the sting by suppressing the repeats. New editions of the *Schöpfungsgeschichte* misrepresented the criticisms while establishing

early vertebrate similarity as a fact. For the audience that mattered most, not the specialists but the larger group who taught embryology in the universities, his embryos still had to be made problematic. Nonscientists had even less chance of assessing representations the likes of which few had ever seen.

So Haeckel could well have imagined that he had foiled this challenge. But the issue remained unresolved, he was more controversial than ever, and "popular scientific lectures" devoted to embryology were about to appear.

{ 7 }

Visual Strategies

Burning with a slow fuse, Rütimeyer's indictment finally detonated in a battle for embryology between Haeckel and Wilhelm His in 1875. For the nineteenth-century sciences of form and function, this confrontation compares in importance only with the standoff between Georges Cuvier and Étienne Geoffroy Saint-Hilaire at the Paris Academy of Sciences in 1830. Cuvier's functionalism then opposed Geoffroy's morphology; embranchements resisted the unity of plan; and the fact-driven, establishment science of the austere Protestant competed with the broad speculation and alliances of the Romantic deist.[1] Now Haeckel's evolutionary morphology fought His's physiology, and populist Darwinism faced off against anatomical exactitude.[2] The two men disagreed about similarity and difference—for Haeckel, vertebrates began essentially identical, proof of their common descent, while His argued that skilled observers would eventually tell even the earliest embryos apart—but their sharpest exchanges concerned picturing practice. The great debates over the progress and limits of science, the courage to speculate and the nobility of restraint, focused on how a scientist should draw.

Noticing the moral charge of His's accusations, Lorraine Daston and Peter Galison have interpreted the episode as a clash of representational ideals.[3] In this view, Haeckel worked within a code of truth to nature, which permitted manipulation to portray types, while His operated according to a code of "mechanical objectivity" committed to self-denial and the unvarnished depiction of individuals. Some of the rhetoric and practice do exemplify such a conflict, but it was not the main issue, just as mechanical objectivity played little role in the sciences of organic form; morphologists valued their full intellectual participation in drawing too highly. Haeckel more obviously blasted His's quantitative approach

to anatomy and physiology, and did not critique the mild mechanical objectivity until sixteen years later, when His was no longer directly involved. Limits and restraint were in the 1870s a major theme of reflection in German science and specifically of anxiety about Haeckel,[4] but the pictorial strand of the Haeckel-His debate is not well captured as a collision of truth and objectivity. The quarrel was not about scientific illustration in general, or specialist "atlases" primarily, but proper conduct in presenting visual evidence to lay readers in books.

Haeckel and His authored two of the most influential works on embryos: the major statement of the once so important relations between ontogeny and phylogeny, and the manifesto for the physiological approach that dominated in the twentieth century. These also contain the most widely copied grids and the main counterimages with the most authoritative critique. Yet the combatants communicated scientific agendas and moral stances as much through putting pictures on the page, and making them work with words, as through high-flown invective. Since books do not simply project drawings, let alone ideals, the practicalities of printing and publishing refracted authorial aims to generate what should be recognized as daring experiments with genre and illustration.[5] Haeckel's *Anthropogenie* adapted academic lectures for general readers in a textbook laced with political and religious polemic. Hundreds of figures, most of them borrowed, introduced the variety of embryonic-ancestral forms. His's *Unsere Körperform und das physiologische Problem ihrer Entstehung* (The form of our body and the physiological problem of its development) broached an unusual topic in familiar letters. Dozens of specially commissioned wood engravings encouraged readers to engage physically and explore.

Heavy Artillery

By reordering the animal kingdom according to the doctrine of recapitulation, the gastraea theory made embryology matter so much to Haeckel that he planned a "second part" of the *Schöpfungsgeschichte* on human generation. When the Reimers warned him off a commercially naïve plan to tack on an extra volume, this turned into the *Anthropogenie*, supposedly "popular scientific lectures on the principal points of human germ and tribal history" in 732 pages.[6]

Haeckel had lectured on embryology in Jena since 1863, at first using Kölliker's scheme: a little history of science, then the development of the body plan and of the organ systems. In 1869 Haeckel added "tribal history" to "germ history" to give four roughly equal parts—history, ontogeny, phylogeny, and organogeny—a structure he kept in the *Anthropogenie*.[7] The ontogenetic chapters showed how humans develop by passing through the same stages as all other vertebrates and then diverge. The phylogenetic part assembled "an approximate overall picture of the ancestral series of man."[8] The last chapters tackled the development of the skin and nervous system, the sense organs and those of locomotion, and the digestive, vascular, and urogenital apparatus.

While Kölliker dealt with other vertebrates as surrogates for humans, Haeckel moved throughout between embryology and its "powerful ally," comparative anatomy. The biogenetic law suffered from exceptions due to the inevitable omission of steps and to "falsification" by adaptation, but was his "Ariadne's thread" in the "complicated labyrinth of forms." "Only through phylogeny can ontogeny really be understood. The history of the tribe lays bare the true causes of the history of the germ!"[9]

Physiologists might look down on such claims, Haeckel warned, but had contributed nothing themselves. Only His, that "industrious but uncritical worker," had tried to apply physiology to embryos, with ludicrous results. Though His did not oppose evolution, Haeckel derided his "great law of development" as an antievolutionary pseudo-explanation, and the analogies as ridiculous. Playing on readers' snobbery, Haeckel mocked His for reducing nature to the level of a seamstress: "he conceives form-constructing '*Mother Nature*' merely as a kind of clever *dressmaker*." Phylogeny recognized rudimentary organs as the atrophied remains of parts of the body that evolution had taken out of service; His saw them as waste rags. "In the literature of embryology" the 1868 monograph on chick development occupied "the lowest level."[10]

Riding a wave of liberal nationalist optimism and continuing the tradition of Protestant Catholic-baiting, Haeckel enlisted in Otto von Bismarck's "struggle of civilizations" (fig. 7.1). The iron chancellor, fearing the growth of the Catholic Center Party under the transnational authority of an allegedly infallible pope, sought to unite the German Empire against perceived enemies

Fig. 7.1 "Between Berlin and Rome." In a cartoon from the satirical Berlin weekly *Kladderadatsch* (Crash-bang-wallop) Bismarck and Pius IX are playing chess with figures representing issues in the *Kulturkampf*. Following the magazine's nationalist line, Bismarck is confident he will soon win. Copied and recopied, in 1890 into a Bismarck album assembled by the magazine itself, this has long been the stock image of the conflict, but looks different in context, with a joke below about butchers fattened after the lifting of the slaughter tax. *Kladderadatsch* 28, no. 22–23 (16 May 1875): 92. NSUB.

within. Virchow had coined the term *Kulturkampf*, and other liberals followed Bismarck in this self-defeating campaign of anti-Catholic discrimination that in the mid-1870s entered its most repressive phase.[11] Church property was seized and the army clashed with resisting crowds; Haeckel enjoyed seeing bishops and Jesuits in prison or exiled. He policed the battle lines and rooted the compromisers out, chief among them Emil "We Shall Not Know" du Bois-Reymond.

Du Bois was antireligious and hostile to metaphysics, and claimed to have lectured on Darwin before Haeckel, but Haeckel made his play of humility hide a de facto alliance of "Berlin biology" with the Vatican. In this struggle "intellectual freedom and truth, reason and culture, development and progress" stood "under the bright banner of *science*," while "under the black flag of *hierarchy*" were marshaled "intellectual servitude and falsehood, unreason and barbarism, superstition and retrogression." In this crusade "*embryology [Entwickelungsgeschichte] is the heavy artillery in the 'struggle for truth.'*" That the "church militant" damned "the naked *facts* of human *germ history*" as "diabolical inventions of materialism" testified to their power.[12]

To become a weapon, embryology would have to appeal. Haeckel's preface warned readers of "the great difficulties and dangers" attending "the first attempt to render the facts of human germ history accessible to

a wider circle of educated people, and to explain these facts by human tribal history." "The comprehension of precisely those form-phenomena with which human germ history deals is among the most difficult of morphological tasks; and the academical lectures on 'developmental history of man' are rightly considered even by medical men, who are previously acquainted with the anatomical features of the human body, as the very most difficult." Haeckel had "taken pains" to achieve "as 'popular' a form as possible." He moved faster than Vogt, underlining a few key points while stripping out technical terms, complexities, and equivocations. But having begun with student lectures Haeckel still overestimated how much detail laypeople could use. The pages were almost as wordy as Kölliker's and carried fewer illustrations. Perhaps he felt constrained by the

wish "to convince some of those specialists, who indeed deal daily with the *facts* of germ history, but who neither know nor wish to know anything about [their] true *causes*."[13]

Haeckel laced the heavy material with political and disciplinary polemic, and his critique of classical education added the allure of forbidden knowledge. It is worth reading again that extraordinary opening passage in which he drew on Baer and Vogt to claim more for embryology than ever before or since:

No other branch of the natural sciences has remained until the present so much the exclusive property of specialist scholars, and no branch has been so deliberately hidden with the mystical veil of an esoteric priestly secret as the germ history of man. If, even today, we say that every human individual develops from a simple egg, most so-called educated people reply only with an incredulous smile; and if we show them the series of embryonic forms which arises from this human egg, as a rule their doubt changes into defensive disgust. Most of the "educated" have no idea at all that these human embryos conceal a greater wealth of the most important truths, and form a more abundant source of knowledge than most other sciences and all so-called revelations put together.[14]

Haeckel styled himself as a hero liberating secrets from a learned caste who failed to recognize their true meaning. If popular physiologies hooked readers with sex (fig. 7.2), his selling points were academic authority, explicit politics—and the richest illustrations of strange forms.

223

A. Der Gebärmuttermund.
B. Die Gebärmutterwände.
C. Der Gebärmuttergrund.
D. Die Mündung der Fallopischen Röhren.
E. Das menschliche Ei, eingebettet in
F. Die hinfällige oder Siebhaut.
G. Die zurückgeschlagene Haut.

Fig. 42. Das menschliche Ei in den ersten vier Wochen der Schwangerschaft.

Finger erreicht. Im dritten Monat beginnt es wieder höher zu steigen, obgleich seine Schwere fortwährend zunimmt. Die Ursache dieses Emporsteigens, welches fast bis zur Geburt fortdauert, liegt in seiner immer zunehmenden Vergrößerung, vermöge welcher es im kleinen Becken nicht mehr Raum genug findet. Nur kurze Zeit (8—14 Tage) vor der Geburt nimmt es wieder einen tieferen Stand im Becken ein, wenn anders das Kind gut liegt und das Fruchtwasser sich regelmäßig vermindert. Nach diesem zweiten Senken fühlt sich die Schwangere in der Herzgrube erleichtert und beim Einathmen weniger beengt, weil der Grund des Uterus von da an das Zwerchfell weniger in die Brusthöhle hinauf drängt. Größtentheils legt sich der Grund der Gebärmutter, wenn er bis über den Nabel hinaufgestiegen ist, mehr in die rechte Seite der Schwangeren, wölbt dort den Leib derselben mehr hervorstehend, und bildet auf diese Weise, weil gleichzeitig der Mutterhals mehr in die linke Hälfte des Beckeneinganges gestellt wird, eine schiefe Lage der Gebärmutter, welche, wenn sie einen mäßigen Grad nicht übersteigt, zur Norm gehört, und bei den allermeisten Schwangeren beobachtet werden kann.

Fig. 7.2 "The Human Egg in the First Four Weeks of Pregnancy" in a wood engraving from *Die Geheimnisse der Zeugung und das Geschlechtsleben des Menschen* [The secrets of generation and the sexual life of human beings] by Dr. Otto Kreß. *E* represents the egg implanted in the uterus. Such compilations, disparaged by Vogt and Rütimeyer, presented eggs, embryos, and fetuses in the sexual and reproductive context that Haeckel avoided. This undated edition of 830 pages contained many drawings, crude and inaccurate even by Haeckel's standards, in text figures and color plates. Nor was it the only mid-nineteenth-century work of this kind to remain in print in revised form, with many of the original illustrations, into the Weimar Republic (for another example: Hopwood 2007, 295). Kreß [c. 1860], 223.

In My Image

In Haeckel's epigraph from Goethe's *Prometheus* the fallen Titan models humans in clay and pities Zeus, the Greek king of the gods, the other immortals, and by implication the Judaeo-Christian God:

> Here I sit, forming humans
> In my image;
> A race to resemble me:
> To suffer, to weep,
> To enjoy and delight themselves,
> And never to heed you—
> Like me![15]

Haeckel formed his humans from drawings.

Joining the frantic building of monuments to construct a past for the young German Empire,[16] the *Anthropogenie* proudly traced humanity back a few million years, to amoeba, amphioxus, axolotl, Australian lungfish, and ape. Haeckel may have taken a branching view of life,[17] but his most influential works sketched the trunk route to human beings. A portrait gallery of ancestors progressed "from moner to gastraea," "primordial worm to craniate," "primordial fish to amniote," "primordial mammal to ape." Echoing the plate in the *Schöpfungsgeschichte*, a tendentious "catarrhine quartet" showed the last links (fig. 7.3). Let "ignorant theologians" and "anthropocentric" philosophers object that he insulted the "dignity of man." If amphioxus lacked "skull, brain, and limbs," this "flesh of our flesh and blood of our blood" still deserved more respect

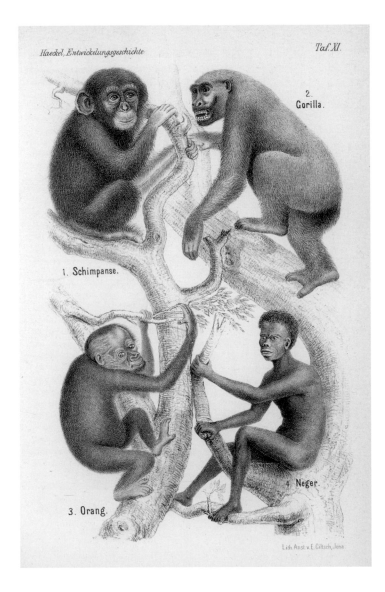

Fig. 7.3 "A Catarrhine Quartet" in the *Anthropogenie*. These drawings of chimpansee, gorilla, orangutan, and "negro" provoked protests about anthropomorphic apes, but then so did Brehm's standard illustrations. Haeckel revised especially the orang in the third (1877) edition. Lithograph by Eduard Giltsch from Haeckel 1874a, plate XI.

Fig. 7.4 "Human Pedigree." Haeckel's widely reproduced German oak was the first really tree-like phylogenetic tree. Stephen Jay Gould criticized a late version for speading the few mammals over the whole cone, while cramming a million insect species onto one twig (S. Gould 1997, 64–66). Haeckel had explained that because he was tracing human relatives he would pay no further attention to arthropods, molluscs, and echinoderms (Haeckel 1874a, 174), and here made those branches end as unfinished stumps, but the effect is much as Gould said. Lithograph by J. G. Bach from Haeckel 1874a, plate XII.

"than all the useless rabble of so-called *saints* to whom our 'highly civilized' nations build temples and dedicate processions!"[18] Liberals still minded only how far a person had come and could go. He offered them secular icons that summarized the ascent (fig. 7.4).

This phylogeny relied, especially for the more distant ancestors, on ontogeny to show the path. The amoeba corresponded to the single-celled egg, allegedly of the same form and about the same size "in the elephant and whale as in the mouse and in the cat." Then came a ball of primordial slime and the swimming stomach or gastrula, from which Haeckel derived the gastraea, "the most important develop-

mental condition in the entire animal kingdom." There followed an embryo that looked, as Vogt had put it, like the "sole of a shoe."[19] Pictures would make household gods of these potentially disgusting forms.

To save time and money on the illustrations, Haeckel abandoned the Reimers for the leading zoological publisher and friend of the Jena Darwinists, Wilhelm Engelmann of Leipzig (fig. 7.5). Engelmann, who also paid better, owned a wealth of wood engravings from his textbooks, chiefly Kölliker's embryology.[20] For most of the 210 text figures, Haeckel compiled lists of the blocks from which electrotypes were to be prepared (fig. 7.6).[21] Since he gave only short captions, un-

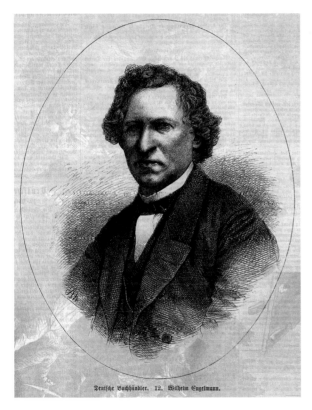

Fig. 7.5 Portrait of Wilhelm Engelmann. Zoologists' main publisher was on good terms with Gegenbaur and Haeckel, with whom his son, the physiologist Theodor Wilhelm, had studied. Engelmann senior published university textbooks and "popular lectures" by the same authors, notably Schleiden, but the *Anthropogenie* uncomfortably straddled this divide. Wood engraving from ––r, "Deutsche Buchhändler, 12: Wilhelm Engelmann," *Illustrirte Zeitung* 52, no. 1349 (8 May 1869): 347–48. NSUB.

Fig. 7.6 "List of wood engravings" for the *Anthropogenie*. The right-hand numbers indicated the blocks from Engelmann's textbooks ("K," Kölliker) from which to make clichés for figures 51 to 72, covering the end of lectures 10 and 11; "54 × 47" meant that Haeckel's fig. 54 should repeat fig. 47. "Verzeichniss der Holzschnitte. Ontogenie," in folder "Holzschnitte," EHH: B63, fol. 123.

200　　Der sohlenförmige oder leierförmige Urkeim.　　X.

Fig. 41.

Fig. 42.

lich der Betrachtung von Quer-
schnitten, welche man in der
Richtung von rechts nach links
senkrecht durch die dünne
Scheibe des Urkeims legt. Nur
indem man diese Querschnitte
auf das Sorgfältigste Schritt
für Schritt in jedem Stadium
der Entwickelung untersucht,
kommt man zum vollen Ver-
ständniss der Vorgänge, durch
welche sich aus der einfachen
blattförmigen Körperanlage der
so ausserordentlich complicirte
Wirbelthierkörper entwickelt.

Wenn wir nun jetzt durch unseren
sohlenförmigen Urkeim (Fig. 41 b, 42)
einen senkrechten Querschnitt legen,
so bemerken wir zunächst die Ver-
schiedenheit der drei über einander
liegenden Keimblätter (Fig. 43). Der
Urkeim oder die Embryonal-Anlage
besteht gewissermaassen aus drei
über einander liegenden Schuhsoh-
len. Die unterste von diesen (das
Darmdrüsenblatt) ist die dünnste
Schicht und besteht bloss aus einer
einzigen Lage von Zellen (Fig. 43 d).
Die mittlere Sohle (das Mesoderm)
ist beträchtlich dicker und erscheint
mehr oder weniger deutlich aus zwei
eng verbundenen Schichten zusam-
mengesetzt, von denen die untere (f)

Fig. 41. Fruchthof oder Keimscheibe des Kaninchens
mit sohlenförmigem Urkeim, ungefähr 10mal vergrössert. Das
helle kreisrunde Feld (d) ist der dunkle Fruchthof. Der helle Frucht-
hof (c) ist leierförmig, wie der Urkeim selbst (b). In dessen Axe ist
die Rückenfurche oder Markfurche sichtbar (a). Nach BISCHOFF.

Fig. 42. Urkeim des Menschen von Gestalt einer Schuh-

Fig. 7.7　Page including borrowed and new wood engravings of early embryos in the *Anthropogenie*: fig. 41, "Germinal Disc of the Rabbit," from Kölliker's textbook after Bischoff; fig. 42, Haeckel's rougher, higher-contrast "Original Human Germ in the Form of a Shoe Sole" in the second week. Haeckel 1874a, 200.

explained labels litter the *Anthropogenie*, but the savings were huge and the sources unimpeachable.[22] What he could not borrow he had artists copy or drew himself, but took less trouble than before: an unidentified engraver cut fewer than sixty mostly crude blocks.[23]

Haeckel wanted a new figure to begin to fill the gap in knowledge of human development that, with two unimpressive exceptions, Kölliker had left between the unfertilized egg and the three-week embryo (fig. 7.7).[24] Figures at three and six weeks were original too (fig. 7.8), perhaps mainly to show the allantois, which Kölliker had highlighted in a schematic (fig. 3.11B). This structure shaped like a sausage skin was known in birds and some mammals to grow out of the hindgut into a nutritive link between the embryo proper and the external membrane, with which it fused to form the true chorion; in the mammals it made a major contribution to the umbilical cord. Only higher ver-

hat (Fig. 78, 5, *al*), bald in ein sehr wichtiges Organ, das die Ernährung des Embryokörpers durch das Blut der Mutter vermittelt. Dies Organ ist der sogenannte Aderkuchen oder Mutterkuchen (*Placenta*) (Fig. 83, Fig. 84, *pl*). Die Blutgefässe, welche sich in dem Darmfaserblatte auf diesem Sacke ausbreiten, wachsen sehr stark, und entwickeln sich besonders mächtig an der Stelle, wo der Sack die innere Fläche der

Fig. 82.

Fig. 83.

der Dottersack sind auf die rechte Seite herübergeschlagen. Der Dottersack tritt zwischen beiden Urnieren vor und ist oben abgerissen. *a* Vorderbein. *c* erster und *d* zweiter Kiemenbogen. *e* Gehörbläschen (darunter dritter und vierter Kiemenbogen). (Nach Bischoff.)

Fig. 81. Hunde-Embryo, von der rechten Seite (älter als Fig. 80). *a* erste, *b* zweite, *c* dritte, *d* vierte Hirnblase. *e* Auge. *f* Gehörbläs-

Fig. 7.8 Wood engravings of human embryos with their membranes. Figure 82 is described as showing a preparation from the third week, figure 83 a preparation six weeks old. Wilhelm His would make it especially controversial that Haeckel pictured and described the allantois as still "an impressive vesicle" at this stage. Haeckel 1874a, 272.

tebrates had one at all, Haeckel argued, and only in higher mammals did it develop into a true placenta.[25]

Haeckel put more effort into twelve striking plates, beginning with a provocative frontispiece on the development of the face (fig. 7.9). Adapting his grids, three-part panels show two early stages and adult in humans, represented by Zeus, a ram, a cat, and a bat. The different visages all arise from similar embryonic heads. Haeckel also offered explicitly schematic cross- and longitudinal sections in orange, blue, red, and green to help readers through the most difficult rearrangements, and fine figures of ascidian and amphioxus, based on the *Schöpfungsgeschichte*, to bridge the invertebrate-vertebrate divide.

This is the context for the comparative embryological arrays. Haeckel added fish and salamander to turtle and chick to include all five vertebrate classes, omitted the controversial dog, but inserted pig, cow,

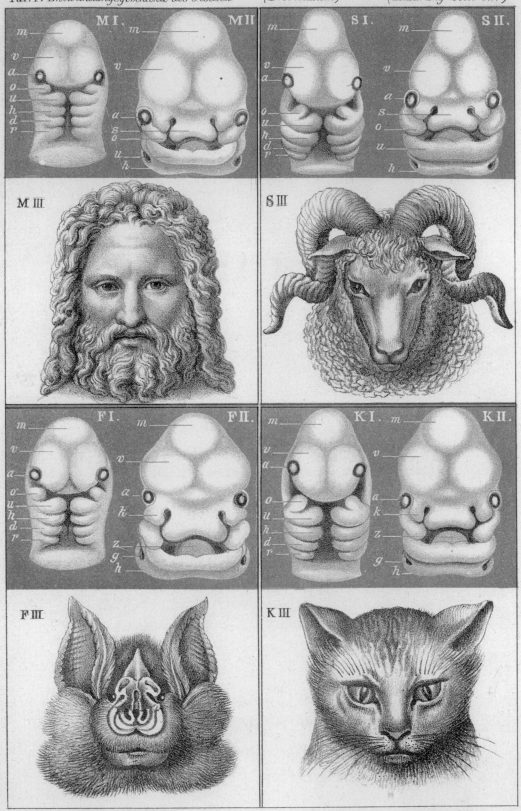

Taf. I. *Entwickelungsgeschichte des Gesichts* (Drei Stadien) (Erklärung Seite 621)

M. Mensch. F. Fledermaus. K. Katze. S. Schaaf.

E.Haeckel, del. Lith.Anst.v. J. G.Bach, Leipzig.

and rabbit to stress similarity among the mammals. Having drawn in pencil, he inked over structures such as the eyes to heighten definition and deepen shadows (fig. 7.10). He redrew turtle, chick, and human, but did not change his procedures in response to criticism, though he did explain that he had left the membranes out. He even stated that his human embryos were "drawn after very well preserved preparations in spirits. Most figures of human embryos from the first month are represented after spoilt or damaged preparations."[26] It was cheeky to introduce new specimens in such a work, cheekier still to claim they were better.

By showing each species at three stages that covered more of development, the expanded plates dramatized the play of similarity versus divergence (fig. 7.11). They displayed in all its glory the advantage of embryology as evidence of evolution, that it traced variety back to a common ancestral stage. They allowed more detailed discussion of what stayed the same and for how long.

Fig. 7.9 Comparative embryology of the face as the frontispiece to the *Anthropogenie*. "The three different stages of development are in all four mammals chosen to correspond as much as possible, reduced to approximately the same size, and seen from the front." The original drawings make clear that Haeckel drew the embryos first, then stuck on the adult faces (EHH: B65, fol. 36). A later version more obviously plays on the "ages of (wo)man" tradition (Haeckel 1891, 1: plate I). Lithograph by J. G. Bach from Haeckel 1874a, plate I.

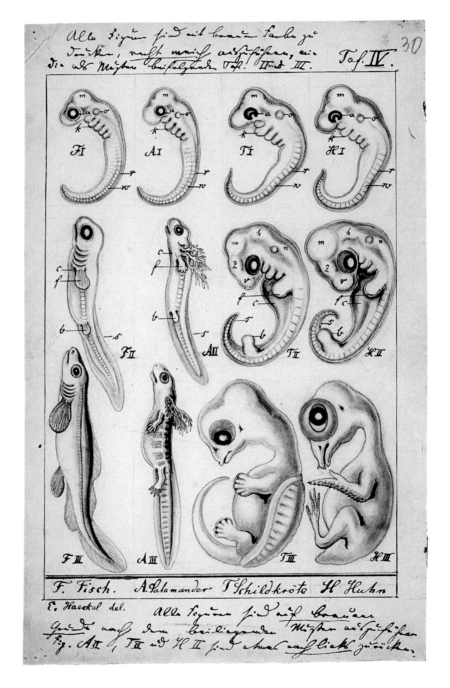

Fig. 7.10 Haeckel's drawing for the first embryo plate in the *Anthropogenie*. He instructed the lithographer—for this and most other plates, J. G. Bach's large Leipzig firm—that "all figures are to be printed with brown ink, to be executed *really softly*, like pl[ate]s II and III [of the *Schöpfungsgeschichte*] enclosed as a pattern" and "*on a brown background*." Haeckel approved a test print and the reproduction is faithful (fig. 7.11). EHH: B64, fol. 30.

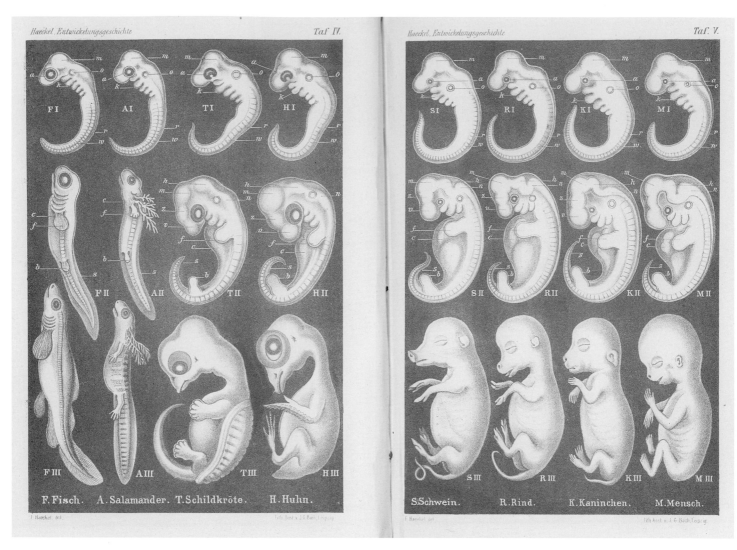

Fig. 7.11 Comparison of vertebrate embryos at three different stages of development, from the *Anthropogenie*. The double plate, which established columns by removing the divisions between rows and giving full species labels only at the foot of the page, shows fish (*F*), salamander (*A*), turtle (*T*), chick (*H*), pig (*S*), cow (*R*), rabbit (*K*), and human (*M*) embryos at "very early" (*I*), "somewhat later" (*II*), and "still later" (*III*) stages. It was "meant to represent [*versinnlichen*] the more or less complete agreement, as regards the most important relations of form, between the embryo of man and the embryo of other vertebrates in early periods of individual development. This agreement is the more complete, the earlier the periods of development at which human embryos are compared with those of the other vertebrates. It is retained for longer, the more nearly related in descent the respective mature animals are." Each panel is 18 × 12 cm. Lithograph by J. G. Bach after drawings by Haeckel, from Haeckel 1874a, plates IV–V.

Haeckel took readers several times from top to bottom and bottom to top. The introduction had alluded to the denials of embryonic identity from Basel, again without making the substance of Rütimeyer's accusations clear. But at the third or fourth week, Haeckel still asserted, "the human embryo, even if we investigate it most exactly with the sharpest microscope, is absolutely indistinguishable from the embryo of the same age of an ape, dog, horse, cow, etc."[27] In the first row (with a three-week human embryo) no difference was detectable between higher and lower vertebrates;

in the second row, mammals, including the (four-week) human with its "highly respectable tail," were still only subtly different from birds and reptiles; and even in the third row the human (at eight weeks) remained in "complete agreement" with the other mammals. In this second month a whole set of finer differences appeared between humans and dogs, as shown separately in Kölliker's wood engravings after Bischoff. But only in the fourth or fifth month could humans—in two figures copied from Erdl—be told apart from higher apes. Development began essentially the same

in every group and diverged less the more related they were.[28]

Haeckel's frame was recapitulationist; the first stage pointed to an ancestor as limbless as the jawless fish.[29] Comparing the human embryo across the first row, we can also see ancestral features which will be lost. The gill arches are initially shared with the early fish embryo, and the fish retains these at late stages of its short and simple development (a diagonal comparison from MI to FIII), but in the human they are reworked. The fish fin remains closer to the paddle-like limb bud (FIII and MII), which the human embryo transforms into a hand (MIII). All the early embryos have tails, but human and chick lose or largely lose theirs. Haeckel discussed these issues elsewhere, but presented the plates in terms of how long animals look the same before diverging. The emphasis was on evolutionizing Baer in frank illustrations that might elucidate the dry material and inspire ancestor worship, but were vulnerable to attack.

Physical Engagement

Wilhelm His agreed with Haeckel that studying embryos was important and hard, but about almost nothing else. Embryology should not be mined for phylogenetic evidence; this "physiological science" must rather explain "every developmental stage" as "a necessary result of that immediately preceding."[30] He also wished to foster a research ethos and attitude to visual evidence to counter the populist system-building of the *Anthropogenie*. So His abandoned the stage descriptions of his 1868 monograph and the lofty restraint of the rectoral speech in favor of familiar letters with bold wood engravings. Committed to analogies with everyday materials, he made not just his models but also these drawings into physical proxies that readers could measure, manipulate, and compare.

Haeckel still taught at a small local rival, while His had moved from the periphery of the German-speaking university system to Leipzig, one of the largest institutions. But it was His who struggled to promote mechanical views buried in the dry, costly treatise. Physiologists welcomed his approach, but did little embryo research. Senior zoologists opposed a physiological takeover of embryology, and younger ones used Haeckel's framework to extract significance from detailed studies. Even for the friendly Kölliker, His

overestimated larger mechanical forces at the expense of the activities of the cells. The subject already tended to put medical students off and then he added mathematics.[31] Finally, as natural science rode a wave of liberal enthusiasm, Haeckel painted His, scientifically innovative and politically middle-of-the-road,[32] as a reactionary dyed in the wool.

Yet by creating an audience, Haeckel gave His a chance to press his case. Planned before but written after the *Anthropogenie* appeared, *Unsere Körperform* was brought out in early 1875 by His's regular Leipzig publisher, where the owner was related to his wife and busy expanding the medical list.[33] A family member and local professor surely had a high level of control, and he could have subsidized the illustrations.

Haeckel had adapted the lecture form from textbooks, with its formal address to "Gentlemen" and expectation of comprehensive coverage. Even Vogt's zoological letters ended up as two fat, systematic volumes, with a chatty narrator who played on his status as a controversial personality but did not talk to his audience directly. In only 215 small octavo pages His wrote seventeen pithy letters to a "scientist friend," his nephew Friedrich (Fritz) Miescher-Rüsch, and so, like Vogt in *Ocean und Mittelmeer*, used the familiar *Du*. Miescher, His's own mentor's son, had studied with Ludwig in Leipzig and then succeeded to the chair of physiology in Basel; posterity knows him as the discoverer of nucleic acid. In early 1874 he persuaded "Uncle Willi" to write the book, which they dedicated to Ludwig. That summer His worked on the drawings and they exchanged the letters the following autumn and winter, with a real correspondence about how to improve them.[34] More realistic than Haeckel and avoiding populism, His anticipated readers with scientific training and stamina. He came across as an expert researcher with a literally avuncular but relentlessly analytical style, advising a young investigator how to assess evidence and frame theories without the worldly cynicism of fellow neuroanatomist Santiago Ramón y Cajal.[35]

The *Anthropogenie* mixed mostly secondhand pictures plus some coarse woodcuts and a few arresting plates. *Unsere Körperform* is unified by 140 (100 different) specially commissioned large wood engravings, the vast majority illustrating embryos and organs that His had studied deeply. Haeckel discussed his first figure a hundred pages into the *Anthropogenie*. "To begin

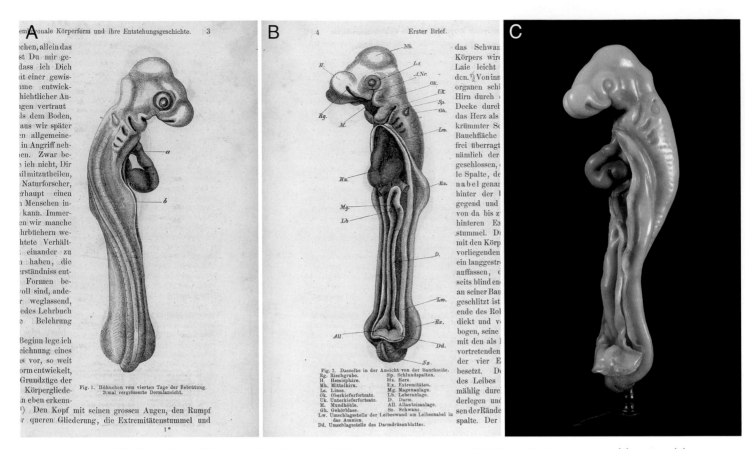

Fig. 7.12 The fourth-day chick embryo in three dimensions. *A–B*, the opening wood engravings in His's letters on the form of our body in (*A*) dorsal and (*B*) ventral views; *C*, Ziegler model, of which the wax is 26 cm tall. *A–B*, W. His 1874, 3–4; *C*, Anatomisches Museum Basel.

with," His stated on page 3, "I show you the drawing of a chick" (fig. 7.12A). The wood engravings focus more tightly on essentials than Kölliker's—His favored "striking, sharply outlined line drawings"[36]—but he stressed their precision.

With a drawing prism His traced contours after nature at exactly fortyfold magnification and based the shading on the way light struck his and Ziegler's "exact as possible" wax models (fig. 7.12C).[37] Representing a physical, anatomical approach, not abstract morphology, the figures convey a sense of depth that makes the earlier (and much of the later) literature look flat. A first pair of dorsal and ventral views were printed on opposite sides and toward the edge of a page, almost as if the paper stood for the body (fig. 7.12A-B). Most figures are of sections, which His pushed his audience to relate to the whole embryos; the few schematics are clearly identified as such.

Inviting readers to imagine manipulating the layers, His taught them to see the embryo mechanically.

Introducing successively younger stages, he showed how to run development backward by grasping the edges of the germ and pulling them apart, cutting open each tube and smoothing out the walls; this set up the argument that the germinal disc normally develops by similar movements in reverse. Encouraging investigation of his claim that folding was driven by the pressures consequent on differential growth, especially the resistance of the slower-growing periphery to central expansion, he offered a schematic to trace and fold up.[38] Fending off Haeckel's objection that since the disc was inelastic the whole analogy was unrealistic, His presented tests indicating resistance to deformation. Measuring thicknesses demonstrated differential growth. Everything from the initial divisions through the separation of the germ layers to the origin and development of the organs was thus, he argued, a function of the law that determined the expansion of the disc.[39]

To sharpen readers' appreciation of mechanics His

The figure reproduces a two-page spread (pages 98–99) of Wilhelm His's monograph, headed on the left "98 · Achter Brief." and on the right "Formen einer sich biegenden elastischen Röhre. · 99". The German text and the figure labels (Fig. 87, Fig. 88, Fig. 89, Fig. 90) are part of the reproduced historical image.

Fig. 7.13 "Forms of a bending elastic tube" as analogies for mechanical moments in the development of the central nervous system. Wilhelm His took his reader through the shapes adopted by a wide-bored rubber tube, for example, when slit and given a concave (fig. 87) or convex bend (fig. 88), or pushed together from the ends (fig. 89). These invoked various embryonic structures; here he showed the dorsal surface of a two-day chick embryo (fig. 90) and compared the spindle-shaped widening to the tube in figure 88. 21.5 × 27.5 cm. W. His 1874, 98–99.

selected "simple experiments" from the monograph. Drawings now made these vivid and invited, or substituted for, imitation at home. For example, he modeled the development of the nervous system on a rubber tube, obtaining the characteristic spindle-shaped gaping of the neural plate behind the just-formed somites by slitting the rubber along part of its length and applying a convex bend (fig. 7.13).[40]

After nine anatomical chapters His moved to general questions and critique. Haeckel should not treat morphological evidence of evolution as decisive when only paleontology and biogeography were direct. Conversely, even the most perfect tree would not explain individual development; biologists would still have to derive form from the fertilized egg. In any case, Fritz Müller—who pioneered the evolutionized recapitulation theory—had admitted that embryos "*blurred*" and "*falsified*" the historical evidence. "Now, if it is worrying enough to add to a hypothesis an auxiliary hypothesis speaking of forgery, it flies in the face of all rules of natural scientific language first, as Haeckel does, to set up a 'fundamental law' and then to speak of its 'falsifications' occurring in nature."[41]

Though asserting an anatomist's right to study mechanisms in a single species, His did compare patterns of growth. Much like Bischoff discussing the hamster, he concluded that the early development of amphioxus, the jawless lamprey, and salmon was too diverse for any general scheme. The question was how, from such different beginnings, these embryos con-

Fig. 132. Menschlicher Embryo, 8mal vergrössert.

Fig. 133. Embryo des Schweines, 8mal vergrössert.

Fig. 134. Embryo des Rehes, 8mal vergrössert.

nahezu die Hälfte, beim Schweinsembryo ein sol‑ etwas über ein Viertheil von der Gesammtkonfil‑ st charakteristische Eigenthümlichkeiten entgegen. er ist schlanker als bei sämmtlichen, oben betracht

tiv mächtige Entwicklung des Gesichtsschädels beim Sch‑ viel günstiger liegen als beim Menschen, und Du‑

eutendere Breite von den übrigen ab. Dass der Sch

Cm. 1·864 Grammes wogen) aufgezeichnet, ausges‑ und aus dem Gewicht der ausgeschnittenen Figu‑ chenraum der Profilansicht im Ganzen, derjenige des Ko‑ ie des Rückentheiles und des von den Extremitäte

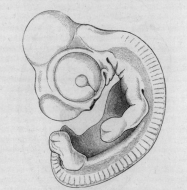

Fig. 135. Embryo des Kaninchens (14 Tage p. foec.) 8mal vergrössert.

Fig. 136. Embryo des Meerschweinchens, 8mal vergrössert.

Fig. 137. Embryo eines Hühnchens (5 Tage bebrütet) 8mal vergrössert.

ryonen, und wenn wir das Verhältniss des Kopfes er nur im Allgemeinen betrachten, so steht der Hül

filansicht, sehr unbedeutend, und wie beim menschli‑ ryo ist von einem äusseren Ohre nur eine leichte

ckten Bauchtheiles des Rumpfes berechnet. Die Gr‑ Kopfes zog ich von der Einknickungsstelle hinter

Die specifische Physiognomie jüngerer Embryonen. 201

Flächeninhalt des Umrisses in Quadr.-Centimetern.	Kopf.	Rückentheil des Rumpfes und Extremitäten.	Unbedeckter Bauchtheil.	Total.	Kopf.	Rückentheil des Rumpfes und Extremitäten.	Unbedeckter Bauchtheil.
Mensch	17,86	16,47	2,52	36,85	48,4%	44,7%	6,9%
Schwein	7,46	14,86	12,82	35,14	21,2	42,3	36,5
Reh	10,68	15,77	9,17	35,62	30,0	44,3	25,7
Meerschweinchen . .	14,59	18,35	4,56	37,50	38,9	48,9	12,2
Kaninchen	14,32	18,62	3,17	36,11	39,6	51,6	8,8
Hühnchen	14,06	13,19	2,79	30,04	46,7	44,0	9,4

Abtheilung der Tabelle tritt eine bestimmte Gruppirung der Säugethierembryonen hervor. Die Embryonen vom Reh und vom Schwein stehen einander näher, als denen der Nager und als dem menschlichen. Beim Schweins- wie beim Rehembryo wird der schwächere Kopfantheil durch den stärkeren Bauchtheil compensirt. Die geringsten Schwankungen zeigt die Columne, die die procentischen Zahlen des Rückentheils des Rumpfes umfasst.

Fig. 7.14 "The specific physiognomies of young embryos" by Wilhelm His. Wood engravings of (A) human, (B) pig, (C) deer, (D) rabbit, (E) hamster, and (F) chick. Like Haeckel's figures, these are drawn at the same size and in the same orientation, but each is printed on a single page, with detailed discussions of the differences in the text above and below. These were the main nineteenth-century counterimages to Haeckel's grids. W. His 1874, 194–200.

Fig. 7.15 Table of surface areas of drawings of human, pig, deer, hamster, rabbit, and chick embryos, in square centimeters and as percentages, for head, dorsal trunk and extremities, and the ventral part of the trunk not covered by the extremities. Wilhelm His determined the areas by weighing the paper. W. His 1874, 201.

verged.[42] Higher vertebrates were more similar, but Haeckel was wrong to pretend an identity the recapitulation theory did not need.[43]

"Specific physiognomies" countered Haeckel's figures by highlighting differences that would be amplified, for example, to give pigs large snouts and humans large brains (fig. 7.14). Just as an architect imagines the building from the plan, His explained, "so one day the experienced embryologist will also be able, at the appearance of the first perceptible divisions of the embryo, to recognize what is to arise from the developing form." He approached "differential diagnosis" as a problem to be tackled by exact measurement, for the moment by cutting out and weighing drawings on stiff paper (fig. 7.15).[44]

Tools as well as evidence, these three-dimensional illustrations were supposed to turn readers into experimenters and shake their faith in Haeckel's visual claims. The letters also "subject some of the figures [Haeckel] presents as the strongest proof to a more exact inspection."[45]

Denunciation, Renunciation

To edify young scientists, His made an example of Haeckel that warned against dogmatism, smoothing over gaps in knowledge, writing about topics not mastered, and worse. These faults may have loomed larger with the recent expansion of the field, intensified competition, and a boom in popular science.[46] Haeckel's Darwinism, the disciplinary target, was also the worst offender on every other count.

First His developed Rütimeyer's criticisms of the *Schöpfungsgeschichte*, beginning with the identical eggs and embryos (figs. 5.8–5.9). "Surely," His sneered, "it was a stroke of luck for science that we cannot rate highly enough which brought three so exactly equivalent embryos into Haeckel's hands." Unfortunately, the identity did not stop at the precise shape of the somites in the embryos and the grains in the eggs, but extended to the position and form of the lettering and dotted lines. "In other words, Haeckel has served us up three clichés of the same woodblock with three different titles!"

This procedure was a bit much, and it was immediately chastised by Prof. Rütimeyer, a man who stands equally high for the breadth, depth, and conscientiousness of his research, as such a sin against scientific truth as to damage deeply a researcher's reputation. After that, we were entitled to expect at least a retraction and apology for the error committed. Instead, in the preface to his later editions Haeckel heaped grave abuse on Prof. Rütimeyer, as untrue as regards its content as ignoble in its form. At the same time, and this should be mentioned, as a result the woodblock of each of the two series was printed only once, one provided with a single, the other with a collective caption.[47]

Haeckel, His implied, thus acknowledged the guilt he lacked the courage to admit.

Having prepared readers to judge less blatant misdemeanors, His confronted the comparative plate— enlarged but with the initial six figures unchanged in the fifth edition (fig. 6.10)—and specified the originals precisely.

Of these figures some are copies, others also constructed [*componirt*]. In addition to the turtle figure, the figures of the allegedly 4-week dog (see Bischoff, pl[ate] XI, [fig.] 42B, dog embryo of 25 days) and that of an allegedly 4-week human (see Ecker, *Icones physiol[ogicae]*, pl[ate] XXX, [fig.] 2, without information on age) are copies. [See fig. 5.5A, C.] Only they are free copies, and the freedoms taken are such that they serve the desired identity. Or is it an oversight of the lithographer that in Haeckel's dog embryo the brow of the head, of all structures, has come out 3½ mm longer than in Bischoff, but in the human embryo the brow is 2 mm shorter than Ecker's, and at the same time by moving the eye forward is narrowed by a full 5 mm, and that to make up for it the tail of the latter soars upward to double its original length?[48]

General criteria of fair play sufficed to appreciate these finer points.

Turning to the *Anthropogenie*, His charged that those embryological illustrations not reprinted from irreproachable sources were "in part highly unfaithful, in part nothing short of invented." He took particular exception to the three new wood engravings of human embryos, beginning with the shoe-sole form (fig. 7.7): "No observer has seen this stage until now, and from the material available so far I maintain with

confidence that it cannot look like this or have the dimensions given." Haeckel seemed to have constructed it from Bischoff's dog and rabbit.[49]

Then His denounced the two figures depicting a prominent free allantois (fig. 7.8), a structure "in humans well known never to be visible in the form of a vesicle." In fact, when Kölliker's textbook doubted the many sightings of a free human allantois, it implied that no one had found an embryo of just the stage when the allantois had formed but was still free. Haeckel made the "not seen" but expected into a drawing; His made it "never visible." He also criticized as "invented … the majority of the figures of the embryo plates IV and V [fig. 7.11], on which, to name only a gross example, fish and frog embryos display a cephalic flexure [the large bend in the midbrain] … as casually as the embryos of the turtle, the chick, and the mammals."[50]

This was dangerous because, while Haeckel's "word games" "fall to the criticism of any reasonable thinker," only "the specialist" could see through his "irresponsible game with facts." Laypeople might spot weak arguments, but had to trust an expert's evidence. Accepting that scientists drew differently for different purposes, His insisted that Haeckel's figures could not be "schematic" when the text used them as proof;[51] his own were bold and exact.

His's investment in sectioning and modeling increased his interest in challenging Haeckel, and he highlighted the exactitude of his techniques. Haeckel knew how to draw, His argued, and had previously availed himself of the prisms so readily available in Jena, seat of the Carl Zeiss optical works.[52] But drawing aids were old, and from the previous generation Agassiz and Bischoff had raised similar objections. The stress on methods was not to push mechanical objectivity but to sharpen the issues and raise the stakes.

Scientific polemicists often accused opponents of ignoring inconvenient facts, but His had identified active distortion too. Amplifying Rütimeyer's comment about the researcher's obligations, he hit hard:

> I myself grew up in the belief that among all qualifications of a scientist reliability and unconditional respect for the factual truth is the only one that we cannot manage without. Even today I am of the opinion that with the loss of this one qualification all the others pale, however brilliant they may be.

Thus let others honor in Mr. Haeckel the active and daring party leader; in my judgment he has, through the manner in which he has led the struggle, himself relinquished the right to count as an equal in the company of serious researchers.

Even without the words *forgery* or *fraud* the meaning was clear: Haeckel represented the bad politicization of science.[53]

Darwin's theory, with which His denied any quarrel, "freed" "our intellect from barriers which had limited it for centuries." Nor need "solid phylogenetic research" (Rütimeyer's kind) fear anything from "a physiological theory of forms." But open research questions did threaten Haeckel's finished system. Teachers had to gloss over gaps in knowledge, but for His, who never wrote a textbook, "producing smooth presentations for use in school is not the researcher's highest task." As Baer had written: "Science is eternal in its source, immeasurable in its extent, endless in its task, unreachable in its goal." Methods for determining growth laws remained to be invented and the prospect of a formula lay "in the endless distance."

> It is a hard for the researcher who remains true to his nature to be forced to admit that the ultimate goals, in the pursuit of which he has invested his whole effort, here, as in all areas of research, recede into more remote distance the further he advances on the path that leads in their direction. In the invigorating work itself, in the consciousness of certain progress, and in the rich fruits that await him on the path he finds full recompense for all this renunciation.

Joining the calls for restraint, His recommended "resignation"—a form of scientific devotion that would hardly tempt Haeckel.[54]

Having confronted Haeckel's approach so thoroughly, and impugned his honor so prominently, His risked being defined by what he was against. But at least this challenge could not be ignored.

Schematics

Haeckel responded in November 1875 with a polemic, *Ziele und Wege der heutigen Entwickelungsgeschichte* (Aims and approaches of embryology today). The hundred-page supplement to the journal of the Jena Med-

ical and Natural Scientific Society appeared also as a pamphlet dedicated to a horrified Baer.[55] Throwing caution to the wind, Haeckel let rip at assorted opponents, including Alexander Goette, the zoologist at the Imperial University of Strasbourg in German-occupied Alsace. But Goette's book on toad development—an "enormously voluminous, beautifully colored, but spongy and tasteless watermelon"[56]—was never likely to be influential. The main quarry was His.

Haeckel lampooned His for trying to explain ontogeny in its own terms, like Baron Münchhausen pulling himself out of the swamp by his own hair. Ludwig had deluded His into thinking that a specialized investigation into the physiology of generation could elucidate organic forms when Rudolf Leuckart had long ago unmasked the arrogant folly of this approach. Only a fool would revise the germ-layer doctrine to suit the chick, a species with exceptionally falsified development. It was as if General Helmuth von Moltke had tried to interpret the world-historical significance of his victory at Sedan, the decisive battle of the Franco-Prussian War, by calculating the trajectories of all the bullets. His's analogies were hopelessly inadequate to the "infinitely fine and complex" problem, but even the most sophisticated account of ontogeny would need phylogeny to explain the origin of the unequal growth.[57]

Seven years on, Haeckel also finally addressed "the serious accusations of untruth and forgery" directly.[58] Making these seem more unreasonable by expressing them more radically, the accused introduced the word *forgery* into the discussion himself, unusually in the annals of fraud in science. He still did not acknowledge the charge of repeating blocks, but responded to the denunciations of invention and tendentious copying as a side issue that His had despicably blown out of all proportion.

Figures His said were "invented" Haeckel justified as deductions to fill gaps. But it was one thing to forecast an unknown form or missing link, another to im-

ply the result was already known. Haeckel glossed over this difficulty by picking a case which seemed—for the moment—to prove him right. An associate professor of anatomy, Wilhelm Krause of Göttingen, perhaps wanting to make the most of an item in his collection, had just described a preparation as showing the free human allantois that His had announced could never be seen. A brief article presented an 8 mm human embryo that Krause estimated as toward the end of the fourth week of pregnancy (fig. 7.16). "One can recognize," he wrote, "the surrounding amnion, the budding upper and lower extremities, three gill arches, the heart, the torn yolk sac, and the allantois." Haeckel

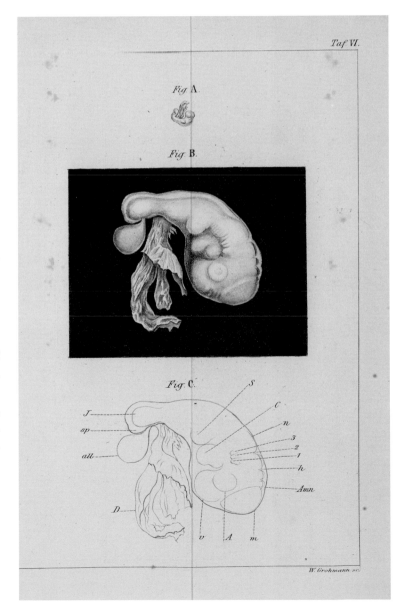

Fig. 7.16 "On the Human Allantois." Wilhelm Krause's embryo with a free allantois (*all*) next to remains of the yolk sac (*D*): *A*, actual size; *B*, magnified; *C*, labeled. Lithograph from Krause 1875, plate VI, a short article in a prestigious (and hardly Haeckel-friendly) journal, by permission of the Syndics of Cambridge University Library.

paraded this confirmation of morphology's predictive power.[59]

Haeckel had been told he could not use pictures as evidence and call them schematic. He treated them as merely illustrating claims and so did just that.[60]

> For *didactic* purposes (especially for a wider audience) I hold simple schematic figures to be far more effective and instructive than pictures executed as truly to nature and as carefully as possible. For the former reproduce the essence of the series of ideas [*Vorstellungsreihe*] that is to be explained through the figure, and leave out everything inessential, while the latter leave the clear (and often very difficult) distinction of what is important and unimportant in the picture to the reader alone. From the few and simple schematic figures which Baer gave in his classical *Entwickelungsgeschichte der Thiere* morphology has gained infinitely more instruction and knowledge than it ever will from all the numerous and most carefully executed pictures of His and Goette put together![61]

Baer's drawings showed that the best researchers did not mistake the trees for the wood.

Ironically, though the plates in His's monograph were soft and rich, his letters were more boldly illustrated than the *Anthropogenie*. But by conflating His's play of exactitude with excessive detail, Haeckel portrayed his opponent as a blinkered pedant and himself as doing nothing more controversial than using simplified drawings in teaching: "In all hand- and textbooks schematic figures ... find the widest application, and when His accuses me, as a most serious crime, that my schematic figures are *invented*, then this accusation applies to all of those in just the same way. *All schematic figures are invented as such*.... They all represent an ideal abstraction at the expense of the concrete facts which in the process are necessarily more or less distorted."[62] While His had objected to unfaithfulness to other drawings and to nature, not to the omission of inessential features, Haeckel made his watchword *schematic*. The difficulty is that although applicable to all expository images, the term usually referred to more simplified, often clarifying or speculative line drawings. These could not count as evidence and Haeckel's drawings look nothing like them. He enjoyed the freedom of the specific sense of *schematic* only to exploit the wide meaning in his defense.[63]

Haeckel admitted "now and then" going "too far in the use of schematic figures," and regretted that, "in part through the fault of the wood engraver," some had turned out "quite badly." But a whole approach did not depend on such "trivial weaknesses" as a few "bad figures." If His wished to exclude him from the ranks of "*serious*" researchers, he would join the "*jocular*," and with His's theories around, they would have a good laugh.[64]

Hilarity and indignation—directed more at Haeckel's pictures and arguments than those of His—would follow their books and this pamphlet as they circulated and were read. Haeckel's appeal to schematics picked up a category that not just His but also lay reviewers had already begun to contest. As the debate over the *Anthropogenie* heated up, failure to discipline one's drawing was very much at stake, though less in terms of a clash of representational codes than as a controversy over schematics and expertise. Everyone was talking about those extraordinary illustrations, sometimes persuasive, sometimes mysterious, and sometimes betraying their bias by preconceived ideas.

{ 8 }

Schematics, Forgery, and the So-Called Educated

While many advanced under Haeckel's "bright banner," he also addressed "the so-called educated," his term for the self-satisfied grammar-school and university graduates he imagined smiling incredulously at the human egg and recoiling from pictures of embryos in disgust. But lay critics of the *Anthropogenie* voiced rather different concerns about schematics such as those one commentary assembled on the plate reproduced in figure 8.1. They worried that Haeckel's surface views of early vertebrate embryos and sections through later stages were hard to follow and nigh on impossible to challenge. The plate is from a spoof, discussed below, that thematized these problems as it turned his fat lectures into short songs. So the last figure displayed an excess of artistic license that deflated the whole show: representing a remedy for a spinning head, the squiggles end in outlines labeled "beer," "sausage," and "bread roll."

When the *Anthropogenie* joined the newspapers, magazines, pamphlets, and books that shaped public opinion during the *Kulturkampf* and the debate over Darwinism, schematic figures became the visual analogue of unfounded speculation—low politics masquerading as fancy drawing—that some readers refused to take on trust.[1] Yet Haeckel's enemies did not prominently exploit the Basel allegations against his pictures until late 1875, six years after Rütimeyer's review of the *Schöpfungsgeschichte*, one year after the *Anthropogenie,* and six months after His's letters appeared. To see how his critique was amplified as charges of forgery, and why only then, it is necessary to reconstruct a greater than usual density of response, and to mark smaller units of time.[2] This will reveal the effects of reviewers' decisions to pass over His's condemnation in silence or to pass it on, and of publicists and theologians who then relayed, neutralized, or exaggerated it for different groups. As leading scientists accepted limits to secure the

127

Fig. 8.1 Illustrations of early embryos and colored schematics in a parody of the *Anthropogenie*. To the tune of "Nach Italien, nach Italien" [To Italy, to Italy] a song explains the attractions of each image as a destination until, dizzy from all the sections, the singer repairs to the pub. Lithograph by Fritz Steub from Reymond 1877, following 72. 13 × 19 cm.

freedom of research, Haeckel led the militants in sub-suming all of human culture into zoology, provoking orthodox Christians and seeming to play into socialist hands.[3] Liberal spokesmen made an example of him as they exchanged public trust for restraint, while the so-called educated lampooned his vision as fantasy or worse.

Ad oculos Even to the Blind?

The publisher's son Theodor Wilhelm Engelmann, a grateful student and rare physiologist friend, read the first sheets of the *Anthropogenie* hot off the press. "How lively and gripping all knowledge becomes as soon as the heartbeat of a great a[nd] healthy theory is work-ing within it," he told Haeckel, and stressed the visual effect. "With this book you have demonstrated that *ad oculos* [to the eyes] even to the blind."[4]

A bankable name made publication in September 1874 a big event. Orders received by early August showed that the first 2,000 copies would not last a couple of months, and Engelmann senior set about printing 2,500 more.[5] The liberal publicity machine went into action, with the *Illustrirte Zeitung* plugging the book in its biography, and in early 1875 running a four-part review. Darwinism was no "fashion," Otto Zacharias informed the "layman," but a "scientific" theory supported by the similarity between embryos of different species which only the biogenetic law could explain. Zacharias introduced ascidians and

amphioxus as our ancestors, then tackled the development of humans and other vertebrates from eggs. Above all, he countered "aesthetic reservations": "we should as little be ashamed of our descent from apes, or from lowly organisms in general, as of the fact that every human being has to pass through developmental forms in the maternal body which very vividly recall the permanent forms of certain lower animals." "If a person wishes to take a step toward self-knowledge, he must study comparative embryology."[6]

The many big pictures set the *Illustrirte Zeitung* apart from newspapers, magazines, and books that were still mostly plain text. Sounding like Haeckel defending schematics, the editor made a virtue of the limitations of wood engravings. These drove "cultural progress" for the many not by reproducing "the impressive size and splendor of the building," or "the brilliant colors of the painting," but rather "the essential, namely the *thought* that expresses itself in the drawing, the pure content of the artistic idea freed from the captivating brilliance of surface technique."[7] Haeckel's plates were too dry for *Gartenlaube*; science writers found it hard to meet the illustrative demands of "these family magazines." "All figures which have a didactic character, which are reminiscent of systematic textbooks, are rejected by the editors.... The picture should appear accidental, form a group, stand out as a whole."[8] By contrast, with a circulation of twelve thousand, some thirty times lower than *Gartenlaube*, the *Illustrirte Zeitung* presented itself as like "textbooks … for the people" and carried drier pictures provided they made news.[9] The vertebrate embryos occupied a large half page (fig. 8.2).

Embryology, Zacharias explained in the review, is "for the more general public as good as nonexistent, since the layman is only in rare cases granted the opportunity to convince himself with his own eyes of these wonderful processes." "These plates," possibly the first to show, let alone compare, whole human embryos since the foundation of the paper in 1843, opened "a wholly new perspective." They made clear—he repeated the controversial claim—that "the best microscope" can discover "no significant difference … between the egg of man, that of the ape, of the dog." Though concluding merely that humans should be content with their lot, Zacharias commended the pictures for making "graspable and vivid" that "man is no exceptional being."[10]

People assumed the *Anthropogenie* would repeat the success of the *Schöpfungsgeschichte*. "Every 'popular' book by Professor Ernst Haeckel of Jena is an exciting event for the 'educated,'" an anonymous "layman" complained in the *Allgemeine Zeitung*, the national daily that had become an important venue for debating Darwinism. "However fat it may be,… as soon as the publisher's announcement of the first edition appears, the printer need only ensure that the next are already under the press. These swell up fatter again, while in the meantime copies of its mysterious woodcuts in the *Illustrirte Zeitung* inflame the general demand for the book to an epidemic."[11]

The attention amazed those who had had to learn a not always popular science. Friedrich Miescher, His's nephew, told Swiss doctors:

> Until a few years ago books about embryology were exclusively in the hands of us medics and perhaps also of zoologists; beyond that this discipline was regarded as one of the more inaccessible corners of our science, and, let us be frank, when we were students not all of us enjoyed finding our way in the labyrinth of germ layers and sheets that were unfolded before us in colored chalk drawings.
>
> Quite different nowadays, when the *Natürliche Schöpfungsgeschichte* is read in thousands of copies by the widest circles. Every educated man who progresses with the spirit of his century is today expected to know what a four-week dog embryo looks like.[12]

Haeckel was promoting visual education in embryology on a previously unimagined scale. Could it really succeed?

Engelmann already knew that sales had slackened after the "first storm."[13] Surprised to have received so few English orders, he blamed religion. Even in Leipzig "words of misgiving sometimes fall, especially among the women, because it is just too painful to have to part from the nice biblical creation story!"[14] Friedrich Michelis, the Old Catholic theologian, philosopher, and commentator on science, branded the *Anthropogenie* "a humiliation and disgrace for Germany," not because Haeckel had had "the courage" to denigrate "eternal truth," but because the weakness of his thought, a symptom of "scientific hallucination and senile marasmus," signaled the decline into

Ein kastanienschüttelnder Hirsch. Nach der Skizze eines Jagdfreundes gezeichnet von Arthur Thiele.
Aus dem „Waidmann. Blätter für Jäger und Jagdfreunde" (Verlag von P. Wolff in Gohlis-Leipzig).

eine scheibenförmige Verdickung, der sogenannte Fruchthof oder die Keimscheibe, die nun den eigentlichen Herd aller embryonalen Entwickelung darstellt. Der übrige Inhalt der Keimblase dient nur zur Ernährung. Von der Structur dieser Keimscheibe haben wir schon oben eine genaue Beschreibung gegeben. Die beiden Blätter, aus

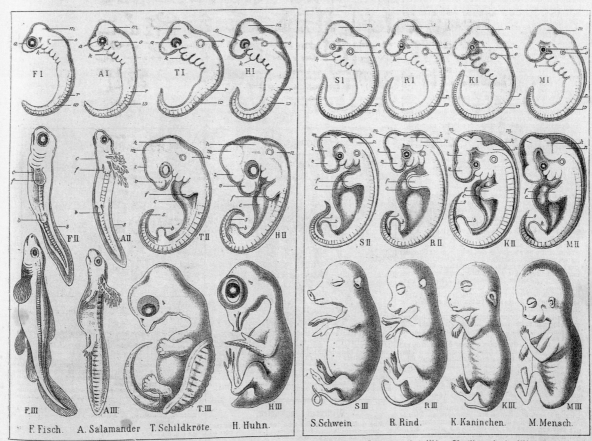

Taf. I. Vergleichung der Embryonen eines Fisches, eines Amphibiums, eines Reptils und eines Vogels auf drei verschiedenen Entwickelungsstufen.

Taf. II. Vergleichung der Embryonen von vier verschiedenen Säugethieren auf drei verschiedenen Entwickelungsstufen.

F. Fisch. A. Salamander T. Schildkröte H. Huhn.

S. Schwein. R. Rind. K. Kaninchen. M. Mensch.

Aus Ernst Häckel's „Anthropogenie": Vergleichende Embryologie.

"impotence" of the nation of Leibniz and Kant.[15] Yet challenging religion and provoking Christian philosophers could sell.

The technicalities were the real problem. Professors, like the Guy's Hospital physician Philip Henry Pye-Smith in *Nature*, might find the exposition "an excellent example of how a very complicated subject may be explained and illustrated."[16] But Friedrich von Hellwald, a soldier turned editor, abandoned a review he was writing for *Ausland*, so Zacharias, a private tutor turned editor, had to do this one as well.[17] A liberal business newspaper admitted that, "numerous illustrations" notwithstanding, the book "still needs to be studied more than read."[18] Even physicians found it demanding,[19] and Haeckel doubted that embryology would ever reach "educated lay society." "The subject is so dry and so tough to master that it will hardly become popular" (fig. 8.3).[20]

The other big worry was experts telling the public not to trust Haeckel. Carl Vogt, now only the second most famous German Darwinist but still a darling of the liberal press, took an influential stand in the *Frankfurter Zeitung* in February 1875. It was "positively raining histories of creation and stem trees," he had noticed, but the public could not judge the work. "For laypeople the facts … must appear to be just as much matters of faith and the conclusions drawn from them as much dogmas as those of the Bible and the Quran for the believing Christian or Muslim." The trees had their uses in indicating possible paths, but these lineages were "just as full of gaps, just as mythical, I would say, as the pedigrees of princely and noble families that were so popular in antiquity and the Middle Ages, which one moment were traced to some hero of the Trojan War and the next to a Biblical patriarch." It would do evolutionism no harm if scientists emulated Rütimeyer and immersed themselves in detailed investigations. Now that Darwinism had become a religion, complete with prophets and high priests, researchers

could safely mimic the historical critics who had left so little of the Bible intact—and the people would still believe.[21]

In the *Allgemeine Zeitung* that April the same anonymous reviewer who objected to the publicity exploited these "doubts of a Darwinist" in refusing to take the difficulty of the *Anthropogenie* as given. Writing "from the lay perspective," he presented the esoteric material and exclusive jargon as a strategy to construct ignorance. Mimicking some churches in wanting docile recruits, Haeckel intoned a fashionable dogma that party members must copy. The "ultra-Darwinist" method instilled fear of exclusion from the cultural struggle, of remaining "at a lower animal stage of development." If the 36 mostly phylogenetic tables did not do the trick, then the 12 lithographs and 210 woodcuts, the "schematically constructed, schematically reduced, schematically adjusted visualizations of theoretical idealism," would show the path to the truth. Unable to check the facts, what could a layperson do but parrot Haeckel-Darwinism "blindly"? Well, the reviewer explained, the black arts of Darwinist propaganda—"lofty dismissal, regretful or scornful disparagement, hushing up, and related tricks"—could not entirely bury "specialist reservations about, objections to, and refutations of the infallibility … of the mas-

Fig. 8.2 Haeckel's comparative embryology in the *Illustrirte Zeitung*. This first copy of the plates from the *Anthropogenie* was for a long time the most widely distributed. Faithful and full-size, the wood engraving looks flatter than the lithograph and the part labels are unexplained. The deer above are after a picture in a hunting book. Otto Zacharias, "Ernst Häckel's 'Anthropogenie,'" *IZ* 64, no. 1651 (20 Feb. 1875): 140–42, on 141. 41 × 29 cm. NSUB.

Fig. 8.3 A bewildered listener flees Haeckel's lecture. In Fritz Steub's illustration for Moritz Reymond's spoof of the *Anthropogenie* some of the more controversial embryological illustrations appear on wall charts. A skeleton looks on, alarmed, as a man whose mind Haeckel has blown with the images shown in figure 8.1 rushes out to an inn. Wood engraving from Reymond [1882], 1:102.

ters." So inexpert readers should play hostile scientists off against Haeckel. The reviewer triumphantly quoted Vogt's comments on Haeckel's trees and criticized the ideal sections as schematic—yet cited no authority against the embryological illustrations. He adopted Rütimeyer's label, "fantasy literature," but was presumably still unaware of his charges or those in the book by His that had come out about a fortnight before, at the end of March.[22]

By this time commentators had debated for six months whether or not the *Anthropogenie* could and should convince laypeople. Would the schematics persuade even the blind, or did they mandate blind obedience to schematized science? But the *Illustrirte Zeitung* reproduced embryo plates that expanded those Rütimeyer had attacked, and no early reviewer so much as hinted at foul play. Compared with the phylogeny, *Nature* judged the ontogeny "unexceptionable and somewhat commonplace."[23] Haeckel had made embryology the next great battleground over Darwinism, but opponents could not criticize particulars until experts broke ranks.

Warning the Public

The *Anthropogenie* "filled" one medical student "with the greatest enthusiasm" and "the most fruitful ideas" for a career as an invertebrate embryologist, and many youngsters were every bit as excited.[24] They had no reason to oppose Haeckel and could not fault the pictures. Established anatomists and zoologists faced tougher decisions about what to tell the public—and the author.

Würzburg-trained morphologists privately welcomed the book as soon as it came out. The sober, publicity-shunning Gegenbaur found it "excellent," though he was concerned that Haeckel now prioritized grand schemes over detailed research. Another comparative anatomist, Carl Hasse of Breslau (now Wrocław), appreciated the "clear, lucid, and convincing" presentation, telling Haeckel: "The large number of schematic figures gave me real pleasure, all the more because I know from my own experience the high pedagogical value of similar ones drawn by me for my lectures."[25] Yet even Gegenbaur and Hasse, aware that Haeckel had burnt his fingers before, warned him about illustrations they saw as crude, inaccurate, provocative, or requiring labeling as schematic.

Writing from Heidelberg, where he had taken over the anatomical institute, Gegenbaur told his "dearest friend," "I'll talk to you about the woodcuts at our next meeting. For the 2nd edition you really must change a good many." It was too late to alter the proboscis monkey's "aquiline nose" (fig. 8.4), but Haeckel, already thinking of the third edition, asked for details, and "Carlo" told "Ernesto" what to revise.

> Fig[ure] 4[2] [here fig. 7.7] is quite strange to me, and is presumably supposed to be only a schema, but you have not indicated this, so that readers could believe it be observed. In addition the woodcut looks very crude. Fig[ure] 83 [here fig. 7.8] presents the brain shaped like a Liebig *Kaliapparat* [the five-bulb apparatus containing potassium hydroxide solution that made organic analysis simple and reliable] and a mammalian brain *never* looks like that. Where is the opossum from? Aren't the young much too big still to seek out the pouch[?] The drawing of other woodcuts seems very crude to me too. Just compare and look at the execution of … those taken from Köll[iker's] *Entw[icklungsgeschichte]* or Bischoff. I think the book is worth also taking care with the illustrations, and Engelmann'll do it.

Gegenbaur thus picked out two of the same wood engravings as His, but let pass several illustrations His would attack. Hasse focused on the "superfluous" faces and catarrhine quartet, which would only fuel enemies' "cheap jokes" (figs. 7.3 and 7.9).[26] Morphologists helping Haeckel did not foresee the trouble the embryo grids would cause.

A few months later *Unsere Körperform* gave Haeckel's critics top-grade ammunition against these pictures, but only scientists could deliver it. The exclusive *Westermanns Monatshefte* (Westermann's monthly magazine) might disapprove of His's "personal tone" and *Nature* brand it "a sign of weakness when a scientific combatant brings his quarrel before a general public."[27] But his sole attempt to reach a wider audience was not for the hoi polloi. Though advertised as "important … for owners of Haeckel's *Anthropogenie*," and smaller, cheaper, and more informal than its target, the book addressed readers literate in science.[28] Even fewer capable reviewers were available, and fear of damaging the cause, and themselves, still inhibited the evolutionist majority from speaking out.

Fig. 76. Fig. 77.

Fig. 8.4 "Head of the proboscis monkey (*Semnopithecus nasicus*) from Borneo" and "Head of Miss Julia Pastrana" from the *Anthropogenie*. The nose, as the most characteristic part of the human countenance, was so important to Haeckel that he showed the monkey twice. In discussing ontogeny, he argued that its nose developed more than in "especially ape-like humans," such as "the notorious" Miss Pastrana, a Mexican dancer Darwin described as having "a gorilla-like appearance." If the face were truly made in the "*image of God*," Haeckel gave the monkey more claim to this title (Haeckel 1874a, 267). In the phylogenetic part of the book, he used the nose to divide the apes and assign humans to the catarrhines or "narrow noses" (485–86). Wood engravings, after Brehm and a photograph by Hintze, from Haeckel 1874a, 267.

Prominent national publications initially reported just the substantive dispute, and avoided fanning the flames. Vogt's fairly positive early notice in the *Frankfurter Zeitung* claimed to find in the critique of Haeckel, "alongside much that is true," an echo of battles between Leipzig and Jena fraternity students, but even he did not mention the charges. Generally criticizing stem trees was one thing; repeating allegations of malpractice quite another. In the scholarly *Literarisches Centralblatt* that summer the Strasbourg anatomist and ovary expert Wilhelm Waldeyer assessed His's approach as important though one-sided, but did not even name His's adversary.[29]

There are signs of discretion even in strongholds of resistance to Haeckel. In Basel the liberal paper repeated the accusations of tendentious copying and invention as it warned the public against the system that "a highly imaginative [*phantasiereichen*] zoologist" was passing off as "the epitome of modern biology." Their "esteemed fellow citizen" His had separated the "chaff" of "swindle" that passed for "popular" Darwinism from the "wheat" of Professor Rütimeyer's "solid" research. In June the bryologist Karl Müller, an editor of the leading anti-Darwinist science magazine *Die Natur*, hailed His as a "real researcher," if unfortunately also an evolutionist. Müller did not specify the allegations, but gave the page reference and made their gravity clear.[30]

In October 1875 a late notice of the *Anthropogenie* in the *Centralblatt* less coyly told Haeckel off for mixing hypotheses and facts, including in the illustrations. The reviewer, the evolutionist entomologist Hinrich Nitsche, was an associate professor of zoology in Leipzig and a colleague of His; he had trained with Leuckart and sent Darwin photographs of his own atavistically pointed ears.[31] Nitsche found Haeckel's coloring of the germ layers of "high didactic use," but regarded other figures as too schematic and "often really too tendentious." "Much worse," His, "one of the most competent judges," had shown "the factual incorrectness of a whole series of the embryonic representations."[32]

This review could have sparked trouble even with a circulation of around a thousand, but Haeckel's own *Ziele und Wege*, which appeared in a run of two thousand the following month, was more potent and then itself attracted reviews.[33] The spicy pamphlet signposted the battlefront for supporters grappling with

the *Anthropogenie* and administered an antidote before the poison could work. Most admirers read His only through Haeckel and the Darwinist press.[34] The journalist Ernst Krause imbibed Haeckel's vicious polemic "like a refreshing draft," but, writing as Carus Sterne in *Gartenlaube,* showed the conciliatory face women were said to like when he gently dismissed what in *Ausland* Zacharias blasted as His's "nonsense." Both hushed up the complaints against the illustrations.[35]

Yet *Ziele und Wege* was a double-edged sword. For all the gratitude toward Haeckel for fighting the fight,[36] the intemperate attacks stirred up trouble. The pamphlet confirmed such liberties as covert "deductions" and introduced the term *forgery* into the debate. No biologist doubted the need for interpretation, but evidence that was so hard to question demanded special care not to break the bond of trust. The supposed advantage of pictures, that they display proof directly, made tampering a serious crime. In autumn and winter 1875–76 several experts joined His in taking a stand. Theodor Bischoff showed the Bavarian Academy exact drawings of mammalian eggs with significant size differences, and explained that no one had seen elephants' or whales'. Using the camera lucida on young mammalian embryos gave the lie to the comparative plates. Photographs of ape heads exposed that "notorious" frontispiece. But the terse published report reproduced none of this evidence, and comments in other learned journals had similarly little reach.[37]

The charges finally spread beyond scholarly periodicals and hostile subcultures, in part through reviews of *Ziele und Wege*, in part when the Würzburg professor of zoology and comparative anatomy, Carl Semper, moved—at some cost to his own reputation—"to make the general educated public aware of the errors and hypotheses on which *Haeckel's teachings* are . . . founded."[38] Haeckel and Gegenbaur had for some time taken a dim view of this specialist in sea cucumbers, and he had broken with Haeckel over the gastraea. Semper now turned a public lecture into a pamphlet that in early 1876 placed "Haeckelism in zoology" in the debate over the freedom and limits of science. Zoologists owed Darwinism attention and funding, Semper acknowledged, but risked everything by overstepping the bounds. In the struggle over the border regions Haeckel had sadly deceived himself into the same dogmatism and credulity he rejected in

the church. A note quoted His on the "forgeries" and added examples.[39]

The accusations now escaped scientists' control. Liberals still tended to admiration; a new entry in Meyer's encyclopedia presented Haeckel as the "most outstanding" Darwinist researcher, while admitting he had many opponents.[40] To the left, among social democrats, he became a freedom fighter of science, a champion of free thought against the alliance of throne and altar.[41] On the Protestant right and among Catholics, however, the charges offered a potent weapon. A dispute among scientists over how to draw for laypeople, in which the leading critics were committed to evolution and saw the pictures as irrelevant to its validity, thus handed their clerical enemies an opportunity.

Church and Police

Most German theologians ignored the rising tide of natural science, leaving a few to respond with alarm. These commentators exploited divisions among scientists, either to condemn the whole enterprise or to make space for goal-directedness and divine intervention in human evolution. While the Catholics generally equated modern knowledge and materialism, moderate Protestants displayed conciliatory attitudes even in the debate over Haeckel—only these consisted at most in separating his own freethinking scientism from "true science."[42] He thus appears as the most diabolical threat and, once attacks from his own colleagues began to rain down, as heaven-sent.

The German Protestant reception of Darwin began early, and in earnest with *The Descent of Man* in 1871. The orthodox used Semper to discredit Haeckel as the most exposed representative of an unscientific movement, its success explicable solely by affinity for the materialistic, egotistical age.[43] Georg Reimer's liberal *Protestantische Kirchenzeitung* liked him little better. Semper had exposed the morally dubious tricks with illustrations and "destroyed the magic" that had protected popular science. Now that a scientist had protested, liberal theologians could more confidently combat Darwinist excess—while accepting much of evolutionism.[44] The devout botanist Albert Wigand of Marburg rejected such compromise. A member of the Catholic Apostolic Church, a millenarian movement from Britain, Wigand penned a massive historical

critique of Darwinism that touched on the "immoral procedure" by which Haeckel "represents *invented* facts by *figures* in order to *prove* a theory." The man, "richly talented and without doubt from the beginning filled with the noblest enthusiasm for the truth" had gone "ever more astray." But "the pseudo-philosophical veneer, the scholastic schematism, and the forgery of facts" mattered less than the whole approach. By revealing where that led, Haeckel was "our most useful ally in the fight against Darwinism"; if only His and Semper had had the courage to complete the break. Few biologists took Wigand seriously, but he inspired later anti-Darwinists.[45]

Orthodox Catholics argued from the same evidence that Haeckel was speeding the eventual triumph of Christianity over modern thought. When his influence became seriously worrying around 1874,[46] Michelis and other Old Catholics who had broken with Rome were first in the ring, but all Catholic writers opposed him. Several developed a standard rebuttal that worked even if the embryos really looked the same: since dogs produce only dogs, the significant differences must simply be hidden.[47] Dr. Carl Scheidemacher, author of antimaterialist tracts, curate at Aachen cathedral, and teacher at its school, accounts for much of the detailed Catholic interest.[48] In a journal of orthodox apologetics, in *Natur und Offenbarung*, the more liberal science magazine founded by Michelis, and in the Catholic counterpart to *Gartenlaube*, he used His (apparently enlisted via *Ziele und Wege*) to challenge the claim to identity. It was, Scheidemacher asserted, "long agreed … that even … an uneducated layman" could "immediately discover the differences of a human embryo from that of an ape and dog," just as "our doctors" could say whether or not the blood on a knife was human.[49] (For His, only specialists could tell early embryos apart.)

Scheidemacher further drew on His and Semper to allege "*deliberate falsification*," which put Haeckel as far beyond the pale of serious science as the materialists, traditionally paid no more attention than dogs barking at the moon. Haeckel's response proved—Scheidemacher reversed Haeckel's favorite insult—"that at least he is descended from the apes, and of the most impudent kind." He "is and remains a charlatan strayed onto the chair of a German university, who with his bragging combines the crudity of the gutter and the knavish dishonesty of the swindler."[50] Scheidemacher wondered which was worse, "the depravity of those forgeries or the hypocrisy" of the defense. "Haeckel has obviously … *damaged* Darwinism immensely. For a doctrine which on the most important point has to reach for the cheap means of forgeries … must be built on very shaky ground."[51]

By exploiting Haeckel's colleagues' attacks, Wigand, Scheidemacher, and others launched the forgery charges as a standard element in Christian anti-Darwinism and so shaped all future debates. Haeckel helped by telling even casual readers of the third (1877) edition of the *Anthropogenie* that "specialist embryologists" had accused him of invention and "forgery," while again failing fully to address the charges.[52] He was not under enough pressure. So although he used Gegenbaur's comments to improve or eliminate figures he accepted were poor (fig. 8.5),[53] he left the comparative plates which allies had passed.

The forgery story lacked the autonomy and momentum of later set pieces: writers who opposed even the morally exemplary Darwin had other reasons to attack, and critics could barely keep up as Haeckel sparked one new controversy after another. He was rebuked for distorting Goethe into an evolutionist, disrespect toward the recently deceased Agassiz, and—for many scientists the last straw—a theory of heredity that invoked atomic souls and speculated on memories propagated by "the perigenesis of the plastidules," wave movements of hypothetical elementary particles of life.[54] Haeckel also appeared to scorn facts by refusing new evidence that the primordial ocean organism Huxley had named *Bathybius haeckelii* was really an inorganic precipitate.[55] Forgery was the most serious charge, but it is hard to isolate the damage it did.

The preface to the third edition excommunicated from Haeckel's faith not just Semper and Kölliker, but—as punishment for the comments on pedigrees—even Vogt, who in the *Frankfurter Zeitung* defended himself against the "apostle" turned "prophet" turned "oracle." Fearing for the reputation of science, Vogt demanded an end to "schematic caricatures and nebulous elucubrations" and a return to the facts Haeckel ignored, distorted, even "falsified." The most important questions remained to be researched, and "will not be solved by drawing exercises on paper with half a dozen different colors, but by true and unceasing

Fig. 86. Fig 87 (neben 85)

(H 38) (H 39)

Fig. (41.) 85

Fig. 42.

lich der Betrachtung von Quer-
schnitten, welche man in der
Richtung von rechts nach links
senkrecht durch die dünne
Scheibe des Urkeims legt. Nur
indem man diese Querschnitte
auf das Sorgfältigste Schritt
für Schritt in jedem Stadium
der Entwickelung untersucht,
kommt man zum vollen Ver-
ständniss der Vorgänge, durch
welche sich aus dem einfachen
blattförmigen Körperanlage der
ausserordentlich complicirte
Wirbelthierkörper entwickelt.

Wenn wir nun jetzt durch unseren
sohlenförmigen Urkeim (Fig. 41, 42)
einen senkrechten Querschnitt legen,
so bemerken wir zunächst die Ver-
schiedenheit der drei übereinander
liegenden Keimblätter (Fig. V. Der
Urkeim oder die Embryonal-Anlage
besteht gewissermaassen aus drei
über einander liegenden Schuhsoh-
len. Die unterste von diesen (das
Darmdrüsenblatt) ist die dünnste
Schicht und besteht bloss aus einer
einzigen Lage von Zellen Fig. V d).
Die mittlere Sohle (das Mesoderm)
ist beträchtlich dicker und erscheint
mehr oder weniger deutlich aus zwei
eng verbundenen Schichten zusam-
mengesetzt, von denen die untere (

Fig. (41.) Fruchthof oder Keimscheibe des Kaninchens
mit sohlenförmigem Urkeim ungefähr 10mal vergrössert. Das
helle kreisrunde Feld (d) ist der dunkle Fruchthof. Der helle Frucht-
hof (c) ist leierförmig, wie der Urkeim selbst (b). In dessen Axe ist
die Rückenfurche oder Markfurche sichtbar (a). Nach BISCHOFF.

Fig. 42. Urkeim des Menschen von Gestalt einer Schuh-

observation of the facts."[56] These widely shared concerns—Haeckel was called to no more chairs—fed a major confrontation at the fiftieth-anniversary congress of nature researchers and physicians in Munich in September 1877.

Haeckel told the first general session that the theory of evolution, so firmly established that anyone who still asked for evidence proved only his own ignorance, should link the natural sciences and the humanities, including in the schools. But he overreached. Virchow, who had campaigned for science lessons and supported him in Stettin in 1863, felt compelled to answer. Later in the meeting the leading left-liberal reminded scientists of the fragility of their liberty in the face of orthodox Protestant and ultramontane Catholic threats. He advocated restraint, lest the immoderate propagation of "personal speculations" subvert "that favorable feeling of the nation which we enjoy." They could expect freedom of research, but not to ground intellectual life in uncertain results. Virchow blamed theories like evolution for the Paris Commune and warned of socialist appropriation of such ideas. He had easy sport with Haeckel's plastidule souls, but himself saw evolution, especially the origin of life and human descent, as too hypothetical to teach. Having long urged caution while pushing forward the frontiers of science, Virchow joined du Bois-Reymond in exchanging limits for autonomy within them and His in urging "resignation."[57]

The speech delighted the religious right; secular liberals and the left could not believe the betrayal. Did Virchow really mean that the Bible was better grounded than evolution? How could he smear Darwinism as socialist? Haeckel responded with a pamphlet, *Freie Wissenschaft und freie Lehre* (*Freedom in Science and Teaching*), which suggested in passing that, if anything, Darwinism was *aristocratic* because "all are called, but few are chosen," while also stressing his own want of political talent or ambition as a contrast to Virchow's career. Haeckel gave thanks for the Arch-

Fig. 8.5 Haeckel improves wood engravings for the third edition of the *Anthropogenie*. On this page from a wide-margined copy of the unchanged second edition he revised the text and tipped in prints of dog and chick to replace the human embryo that Gegenbaur had criticized as crude and His as invented (compare fig. 7.7). EHH: B63.

duke of Saxe-Weimar's enlightened patronage of the Thuringian university. If Berlin's watchword was now "*Restringamur*" (Let us exercise restraint), then "the cry must go out from Jena, as from a hundred other seats of learning": "*Impavidi progrediamur!*" (Let us march fearlessly on!) Vogt had little time for either man, but sided with "prophet" Haeckel because "schoolmaster" Virchow played into Bismarck's hands by calling "church and police."[58] A short book by Wigand blamed Darwinism for assassination attempts on the emperor.[59]

In 1878 Bismarck broke with the National Liberals, abandoning the *Kulturkampf*, allying himself with the Catholic Center Party and the Conservatives, and using the failed assassinations as an excuse to outlaw social-democrat organizations, meetings, and literature. With evolutionists having to dissociate themselves from socialism, the conservative climate now closed down the whole middle-class debate. Having reached the general and the confessional press, the charges against Haeckel did not go away; Wigand repeated those too, as would many others. But the allegations did lose the impetus that might have brought the issue if not to a resolution, then to a head.

Only the most blatant frauds in science—Piltdown Man or some recent gross fabrications—have led to clear-cut verdicts, and who perpetrated the Piltdown hoax is still debated, sixty years after it was unmasked and a century after a modern human skull with an orangutan jawbone was passed off as a missing link.[60] The more that is at stake for research, the more pressure on scientists to decide. Experts might be offended by Haeckel's pictures but could tolerate them more easily than, for example, early twentieth-century geneticists could accept the Viennese biologist Paul Kammerer's experiments supporting the inheritance of acquired characteristics. Kammerer's sweeping assertions based on sketchy evidence had already been criticized when in 1926 a visiting herpetologist reported that the sole preserved midwife toad had been injected with ink to make it look as though it had inherited nuptial pads from parents forced to breed in water. The revelation, followed by Kammerer's suicide a few weeks later, vindicated the rising view, but he had been on the defensive already and still had backers decades later.[61]

Haeckel claimed no discovery, no one doubted significant similarity, and the character implications

were less severe. Anyone who looked closely could see that he had repeated the blocks, but no consensus would ever be achieved on the other pictures or the implications. No one needed it enough, and large, independent power bases sustained rival interpretations. For religious conservatives Haeckel's trickery showed the bankruptcy of evolutionism, while liberals divided over his transgressions. Almost all competent scientists subscribed to the fact of evolution, and it was looking unprofitable to debate other issues with him. Parody would more elegantly express support and reservations, thematizing the fraught relations between prophet-showman and the so-called educated, the arbitrariness of his visual evidence, and the role of fantasy in generating it.

"I Shan't Ask What an Egg Might Be"

Nature researchers in the German lands had long sung together to foster male camaraderie and cultural nationalism, validate specialized knowledge, and share the humor in songs such as Joseph Victor Scheffel's mock-tragic lament from the last ichthyosaur. Moritz Reymond, who became the most successful setter of science to folk and student tunes, had served as an Austrian army officer and railway administrator, journalist, and editor of a liberal Viennese paper until his political satire led to a trial and he gave up the civil service to work as an editor in Bern. When a commission for the annual banquet of the local scientific society spurred him to author a series of humorous little books on liberal intellectual fashions, such as the *Kulturkampf* and medical advice, he made Haeckelism his greatest theme. He also engaged sympathetically with the anti-Semite Wilhelm Marr, arguing against "Jewish liberalism," as Reymond called National Liberalism, and the crass materialism it spawned. He opposed "scientific pessimism," an antireligious mishmash of secondhand snippets from Schopenhauer, Haeckel, and others, calling instead for Germany to fulfill its cultural mission as a world power.[62]

With a title referring to Catholic books of daily prayers and the like for non-priests, and a focus on the Old Testament, *Das neue Laienbrevier des Haeckelismus* (The new lay breviary of Haeckelism) eventually ran to five books. Reymond prepared the first, *Genesis, oder die Entwickelung des Menschengeschlechts* (Genesis, or the development of the human race), for Christmas

1876. By shrinking the octavo lectures of the *Anthropogenie* chapter by chapter to a 178-page sextodecimo of songs he aimed, as himself one of "the so-called educated," to acquaint others painlessly with its positive and negative features. Engaging deeply with the book and its reception, the satire played on the symmetry between Haeckel's charges of ignorance and the exclusivity of his own neologisms, on the one hand, and the irony of his attacking church dogma while setting himself up as "the apostle of a new faith," on the other. Fritz Steub, a caricaturist in the style of Wilhelm Busch, drew illustrations. Since a controversy about pictures had so far used them little, with His's counterimages still not reproduced and Bischoff's unpublished, Steub's visual engagement stands out.

The breviary opened with a frontispiece portrait staring out like a prophet from the sun (fig. 8.6). Haeckel declaimed, after the lines from *Prometheus* at the start of the *Anthropogenie* (fig. 8.7):

> Here I sit, forming humans
> In my image;
> The race that I need,
> To prove most clearly,
> What was required to be proved.

Dedicating the "dainty little rhymes" to "the so-called educated," Reymond moved on to a parody of Haeckel's prefatory remarks about the person who "Greets with a skeptic's 'Oho' / Even his own embryo!"

> I shan't ask what an egg might be
> In its essence and destiny;
> For you would only answer, I bet:
> "The material for an omelette!"
> A man pretends to high education
> And flatters himself on cultivation,
> But of the egg he knows only:
> You buy it from the egg lady!
> Learn therefore from these lips of mine
> The grave tidings for the first time:
> The egg is just a simple cell,
> Of life the most primitive well;
> From the egg, humans like beasts spring,
> And children the stork does not bring![63]

Haeckel's long-suffering audience was to acquire sophistication.

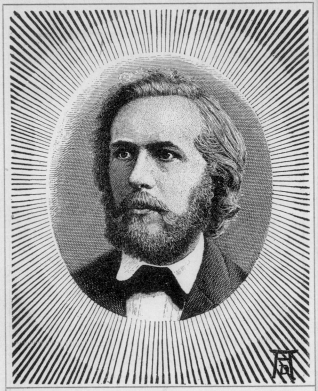

Hier ſitz' ich, forme Menſchen nach meinem Bilde,
ein Geſchlecht, das mir gleich ſei.

Prometheus, Act III, Vers 17.

Das neue Laienbrevier

des

Häckelismus.

———

Genesis

oder die Entwickelung des Menschengeschlechts.

Nach Häckel's Anthropogenie in zierliche Reimlein gebracht

von

M. Reymond.

Bern.
Georg Frobeen & Cie.
1877.

Fig. 8.6 Frontispiece and title page of "The New Lay Breviary of Haeckelism." The portrait is based on that introduced into the fifth (1874) edition of the *Schöpfungsgeschichte* (fig. 6.12). Wood engraving after drawing by Fritz Steub, with Albrecht Dürer's monogram, from Reymond 1877. 13 × 19 cm.

Fig. 8.7 Haeckel as a Promethean sculptor. Wood engraving after a drawing by Fritz Steub from Reymond 1878, 44.

Prometheus.

Hier ſitz' ich, forme Menſchen
Nach meinem Bilde,
Ein Geſchlecht, wie ich's brauche,
Zu beweiſen auf's Klarſte,
Was zu beweiſen war.

Frei nach Göthe.

44

Reymond tackled the Haeckel-His dispute several times, mentioned the forgery charges,[64] and commented more extensively and variously on Haeckel's use of pictures. Michelis had likened Haeckel to a minstrel showing his murder story, and Steub now mimicked the carnival tradition, especially at *Fasnacht* in Basel, of *Schnitzelbänke*, humorous cartoon posters with a sting in the tale. A song about "the main branches of biogeny" started with Haeckel literally cutting an evolutionary tree to shape—a *Schnitzelbank* (usually *Schnitzbank*) is also a woodworker's bench (fig. 8.8). The monist carpenter trimmed the dead wood of materialism and the leafy branches of idealism, ready to redecorate the bare trunk.[65] Then, accompanying

Reymond's introduction of germ history and tribal history, Steub's *Schnitzelbänke* drew on the pseudo-developmental tradition (figs. 1.4 and 5.1) to send up the ontogenetic and phylogenetic series by having them culminate in underwhelming stereotypes that mocked Haeckel's pretensions and displayed the scope for drawing to suit the theory.

In the style of the frontispiece to the *Anthropogenie* (fig. 7.9) an embryonic face developed into a depressed man wearing a floppy hat and glasses (fig. 8.9). This was Michel, the personification of the German national character who had figured in series lamenting his decline from dangerous Jacobin of spring 1848 through bourgeois conservative in the summer to pa-

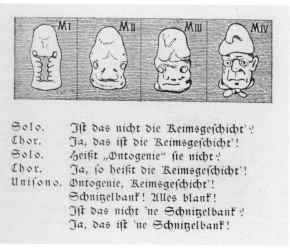

Fig. 8.8 The apostle Haeckel carving the human stem tree. Wood engraving after a drawing by Fritz Steub, from Reymond 1877, 24.

Fig. 8.9 Pseudodevelopmental series of facial development. Wood engraving after drawings by Fritz Steub, from Reymond 1877, 25.

thetic figure of total resignation in the autumn (fig. 8.10).[66] The animal series proceeded from amoeba through tortoise and bear to "Homo philist." or "philistine," as the student fraternities disparaged ex-members for their stolid conformity to the world of work and loss of a sense of bibulous fun (fig. 8.11). Even the amoeba prefigured the outstretched limbs.

Later books of the breviary cast the apostle as a conjurer and a high priest. Haeckel had appealed to Johannes Müller—"Fantasy is an indispensable possession; for it is through her that new conjectures which stimulate important discoveries are made"—while ignoring his warning not to daydream.[67] In book 2, or *Exodus*, a play about the writing and publication of

the *Schöpfungsgeschichte*, Haeckel's servant Psyche persuaded him to use fantasy to help himself over gaps in his knowledge. No one would follow, she urged, unless he adapted some tried and tested tricks of the church. A red gas in a peep box represented the primordial chaos, from which with a bit of magic his two servants appeared (fig. 8.12).

Books 3 and 4 imagined the establishment of Haeckelism as the state religion. In *Leviticus* Haeckel set up a cult of amphioxus, while *Numbers* explained how to feign infallibility:

A little picture, though not quite true,
Looks impressive in the layman's view;

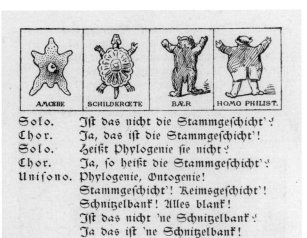

Fig. 8.10 "Michel and His Cap in the Year '48" in *Eulenspiegel*, a weekly of political satire for democratic revolution edited from Stuttgart by the anarchist Ludwig Pfau with drawings mostly by Julius Nisle. The series "spring," "summer," and "autumn" reads down one column and then the next, and is followed by a plaintive "Song of a German Proletarian," his family dead of hunger and exhaustion, who questions the promised "comfort of eternity" as coming too late. *Eulenspiegel*, no. 13 (24 Mar. 1849): 51. 29.5 × 22 cm. Universitätsbibliothek Tübingen: L I 85.4.

Fig. 8.11 Pseudodevelopmental series from amoeba to "philistine." Wood engraving after drawings by Fritz Steub, from Reymond 1877, 26.

Fig. 8.12 "We see nothing." An unconvinced "audience of small minds"—their title expressing Haeckel's contempt for unpersuaded readers—viewing his peep show of the origin of life. By Fritz Steub from Reymond [1882], 2:208.

Fig. 8.13 Fantasy directing a microscopist to the promised land. By Fritz Steub from Reymond [1882], 4:91.

Cut line by line into wood,
He believes it right and good [unbestritten].[68]

A ditty after Mignon's song from Goethe's *Wilhelm Meister* thematized the opposition between Haeckel and the "exact." The prophet was leading the chosen people to the promised land, when at the border du Bois-Reymond blocked the path with the warning that miracles lay ahead. Fantasy helped Haeckel press on undeterred into "the El Dorado of development."

There fantasy weaves from theory gray
A picture in all colors bright and gay,
And light and clear to the view it appears,
As if we'd gone back millions of years.
Know'st thou the scene? Let us fly,
That it may parade before our eye![69]

Steub showed Fantasy guiding the microscopist's gaze (fig. 8.13). Supporters admitted that Haeckel did not always have the balance right, but credited her with his most original insights.[70]

Admirers and critics received Reymond's work "with great glee."[71] Pleased to see Darwinism's true colors exposed, a Catholic reviewer regretted only that the anatomical subject matter precluded its recommendation to all.[72] Some said the satire would hurt but Haeckel would have to live with it;[73] others that humor had always been part of the national scientific tradition. The "German scholar" had complained about educated ignorance and "German humor" had replied: "Give me the results of your science for a trial and—what do you bet?—I'll take them in verses and rhymes to the general public so clearly ... that every proletarian will know his series of phylogenetic ancestors better than the proudest baron the branches of his thousand-year pedigree!"[74]

A zoology student found everyone in Jena laughing. "Since Haeckel was always a friend of healthy humor and sharp satire ... some of the best parts ... were read out before the ... zoology practical." Rumored to have kept a copy in his jacket pocket, he recommended Reymond to students too busy drinking and fencing to attend lectures. As Auguste Forel, the Swiss psychia-

trist, ant researcher, and monist, put it: "The layman can get to know the doctrine of evolution as he laughs; for the author has understood how at the same time to lampoon the dogmatic and hypothetical exaggerations and to preserve and crack open the kernel inside."[75] Enemies saw Haeckel's transgressions as representative; evolutionists separated his excesses from the sound core. All could reflect on the problem of evidence and fantasy in visual communication and would in future often discuss the use and abuse of schematics with his pictures in mind.

Afterlives

Joking apart, large groups now saw the German Darwin as a forger. How had it come to this? The bad news about the deep-sea slime had embarrassed Huxley, but his reputation was not dragged as far into that mud. Haeckel's striking designs, provocative rhetoric, and dual audience of scientists and laypeople all courted controversy, and the Basel anatomists' attitudes and interests led them to sound the alarm. But the fate of the embryo plates depended on what users could and would do, as we can see by comparing these with the other illustrations Rütimeyer singled out: the repeated blocks, the ape plate, and the stem trees.

Haeckel suppressed the blocks, and the repetition, however discrediting, was not publicly toxic in the first six years; later too, in-print images mattered more. The ape plate was criticized as a forgery, and succumbed because too many people could judge it. By contrast, the trees, to some extent protected as hypothetical, were generally criticized only as speculative and dogmatic, and so grew on. The more esoteric embryo plates initially escaped scot-free. An early apology might have defused the issue, but Haeckel goaded his critics and then intensified the struggle just as concern mounted over his approach. By 1875 his character was so contested that a host of enemies took even the most honest error as a sign of bad faith.

The flawed hero of German Darwinism lived to fight another day, though as a man better at lighting fires than putting them out he never shook the charges off. The embryo plates also survived their first controversy because scrutiny never became concerted enough. Among scientists only hostile experts had faulted comparisons that vividly, if approximately, conveyed what many accepted as an established fact. So when the first phases of production and debate ended in the late 1870s, the pictures and the charges still had most of their lives before them. Though specialists tightened standards, the embryos gained influence as ever more people saw them, in Haeckel's books and as copies with greater reach. This eventually prepared the ground for the larger contest that followed the rewarming of the accusations for an expanded audience around 1900. Haeckel delivered the *casus belli* by drawing ever more ambitious grids.

Imperial Grids

The growth of Haeckel's embryo arrays was a wonder to behold. From that initial grid of four columns (species) and two rows (stages) in the *Schöpfungsgeschichte*, the display enlarged in the *Anthropogenie* from eight columns and three rows in 1874 to twenty imposing columns, now over six plates, in the fifth edition of 1903. Species changed more remarkably still. The first hailed largely from the German forest, heath, and farmyard, with their salamanders, chicks, pigs, cows, dogs, and rabbits.[1] On the last, tuatara, river turtle, kiwi, spiny anteater, dolphin, and gibbon represented a global empire. Gaps remained, however, and the way Haeckel filled them exhibits his personal blend of thinking and seeing, and the power of the grid, as he worked within its frame and it worked with him.[2]

The many editions and translations of Haeckel's books are often mentioned as evidence of success, and their growth as a sign of improvement,[3] but changes such as this rise of imperial embryology have hardly been explored.[4] Originality is so strongly associated with first editions that revised illustrations are typically either ignored or captioned as if present from the start.[5] Yet the earliest grid appeared in the second edition of the *Schöpfungsgeschichte,* and one of the biggest controversies targeted figures Haeckel only introduced in the fifth edition of the *Anthropogenie.*[6] Translation, similarly, is usually understood in terms of loss of text and meanings, and it is easy to see images and their quality in the same way. If viewed side by side with the German originals, Haeckel's English plates do look worse—and some are comically mislabeled—but in this new context their authority increased.[7] By cutting illustrations, an English translation also showed what then proved true in German: as the market for evolutionism grew in the early twentieth century, the *Anthropogenie* and its plates did better apart.

The point is more generally about innovation away from the cutting edge. In the history of visual culture the years around 1900 are commonly associated with X-rays, the cinema, and the adoption of photo-relief printing, especially of halftones.[8] Histories of popular science follow publications for the first mass audience, and biographies of Haeckel move on to one of the most prominent, his *Welträtsel* (Riddles of the world).[9] Staying with *Schöpfungsgeschichte* and *Anthropogenie* shows how the resulting celebrity fed back, creating the conditions for the halftone process to take new versions of the old plates to fresh audiences and put them center stage.

A New Lease of Life

Research in the 1880s entrenched evolutionism in academic zoology, while public discussion in Germany was subdued. The middle-class reaction had ebbed and few proletarians had access to Haeckel's books, so after the first rush neither *Schöpfungsgeschichte* nor *Anthropogenie* was reprinted. Around 1890 low stocks and a rising tide of debate justified new editions. Haeckel presented himself as the prophet in the promised land, still hitting out at hostile specialists, but mainly synthesizing the results of "the industrious diligence of numerous excellent workers."[10]

For the *Schöpfungsgeschichte* excessive length was always a worry, though since the plates multiplied with the lectures, expansion was also a selling point. Even the thorough updating for the eighth (1889) edition focused on the taxonomic system; the embryology did not change much. Repeated steel facing kept the embryo plates going,[11] and in lieu of revision Haeckel referred to the *Anthropogenie* for a "more exact representation … of eight different vertebrates … at *three* different stages of development" (fig. 7.11).[12] He thus justified retaining his first grid and advertised the more specialized book. For the ninth (1898) edition he went over the pedigrees again, replaced old plates, and added ten more; the press gave the option of binding in two parts.

Only a complete overhaul could save the *Anthropogenie*.[13] It had always been too academic for general readers, and Haeckel now pitched it "more strictly scientifically," cutting "popular" from the title "in the hope … of interesting my specialist colleagues … and of drawing attention to the *many new thoughts*."[14] Re-

vision for the fourth (1891) edition meant "*hard* work, after the colossal progress of the last decade," but also a handsome honorarium.[15] With his student Oscar Hertwig's new embryology text open as he altered and added to a wide-margined copy of the third edition, he still had to ransack the literature, begging and borrowing books and drawings from allies.[16] The *Anthropogenie*, Haeckel insisted, was about the big picture, not details. It still grew to 900 pages, with 20 plates, 440 woodcuts, and 52 genetic tables, and split into two volumes. Wilhelm Engelmann and his eldest son had died, so Haeckel dealt with the former company secretary, now partner and director, Emanuel Reinicke, who gave this star author and friend of the founding family a "completely free hand" with the illustrations. Reinicke saw these as crucial to any wider appeal the book might achieve, but reduced the print run, raised the price, and relied on biologists to buy.[17]

Those might have been the last editions, at least of the *Anthropogenie*, had the bestselling *Welträtsel* of 1899 not raised the writer's profile to dizzying heights of international celebrity. This fluent synthesis of monist philosophy, empirical science, and anticlerical argument responded to a gulf Haeckel perceived between the progress of natural science and the social limitations imposed by the churches and an outdated education system. The title referred to du Bois-Reymond's enumeration of seven riddles, from the nature of matter and force to the origin of rational thought. Du Bois had regarded three as insoluble and three as very hard, and left open the question of free will. Haeckel declared free will mere dogma and that between them his doctrines of development and substance (conservation of matter and energy) solved the other six. They also put paid to the immortal soul and other Christian myths. (Heaven, for example, though psychologically understandable, would soon get boring, and, he stereotyped, "many men" would on reflection rather forego its pleasures than share them "'*eternally*' with their 'better half' or even their mother-in-law.")

Fig. 9.1 The boxfish, or *Ostraciidae*, from Haeckel's *Kunstformen der Natur*, emphasizing the hexagonal patterns of the armored scales. Though most plates showed invertebrates, a few depicted vertebrates and plants. Vertebrate embryos were not included and did not play a significant role in art nouveau. Haeckel 1904a, plate 42, by permission of the Syndics of Cambridge University Library.

Ostraciontes. — Kofferfische.

Sensitive to the religious needs of humanity, however, and having placed God within Nature, Haeckel invited modern readers to contemplate the "true, beautiful, and good" in the "church" built by Nature herself. Change had no need of a political revolution, he wrote; the particular system of government mattered far less than separating church and state, and teaching more science in school.[18]

Raising a storm of praise and protest that dwarfed everything written for and against Haeckel before, the book drew the scorn and ire of philosophers and theologians as appalled by the scholarship as by the proposals. Accused of such offenses as lifting his history of Christianity from a forged source, he was disqualified in the eyes of many academics.[19] Even Gegenbaur broke off relations.[20] But with some 400,000 copies sold in German and translations into thirty languages, many more people discovered something they could use.[21] Diverse readers shared Haeckel's opposition to hierarchy founded on superstition; for Lenin, famously, the book became "a weapon in the class struggle."[22]

It was not all struggle around Haeckel. In these same years, *Kunstformen der Natur* (*Art Forms in Nature*) celebrated the beauty and symmetry of organic structures, delighting families and serving as patterns for art nouveau design (fig. 9.1).[23] Including only a few vertebrates, and omitting their development, these plates mattered to the old embryos mainly because they raised Haeckel's profile as an artist. They may also have helped the *Welträtsel* bring fresh readers to the works on which it built.[24] A new edition of the *Schöpfungsgeschichte* came out in 1902 and of the *Anthropogenie* the following year.

Haeckel changed the *Schöpfungsgeschichte* little—the *Kunstformen* excused the dearth of illustrations[25]—but the *Anthropogenie* was harder to leave alone. Nearly seventy and complaining all the while,[26] he reworked it again. Hurt that his colleagues had ignored the fourth edition, he turned back to the "wider circles" who wrote him "several *Welträtsel* letters *every day*" and he reckoned needed the *Anthropogenie* as the only accessible survey of human development and evolution.[27] He reinstated the "popular" and designed an attractive cover (fig. 9.2), but the fifth edition ran to almost a thousand pages and addressed the generally educated after "teachers, doctors, and students."[28]

Some plates were now done in photogravure, a technique for etching photographs on copper, and the

Fig. 9.2 The fifth edition of the *Anthropogenie*, with the cover featuring a human fetus and an ape surrounded by a developmental series from fertilization to gastrula. Haeckel's sketch showed an earlier embryo instead of the fetus (folder "35 Tafeln V. Aufl.," EHH: B63). Haeckel 1903.

Fig. 9.3 "Four Comparative Plates of Amniote Embryos, from Twelve Different Orders," in the fourth edition of the *Anthropogenie*. The species shown at "very early," "somewhat later," and "even later" stages are six sauropsids (reptiles and birds): lizard (*E*), snake (*A*), crocodile (*K*), turtle (*T*), chick (*G*), and ostrich (*Z*); and eight mammals: opossum (*B*), pig (*S*), deer (*C*), cow (*R*), dog (*H*), bat (*F*), rabbit (*L*), and human (*M*). Contrary to an early plan to put mammals first ("*Anthropogenie*. IV. Aufl. Tafeln. 1891," EHH: B64, fol. 24v.), order across the page largely corresponds to the systematic tables, though less obviously so for the mammals. Drawn by Haeckel and lithographed by Adolf Giltsch, from Haeckel 1891, 1: plates VI–IX.

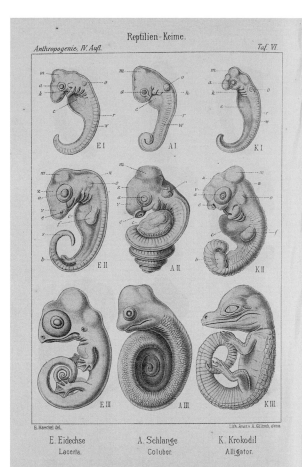

E I　　A I　　K I

E II　　A II　　K II

E III　　A III　　K III

E. Haeckel del.　　Lith. Anst. v. A. Giltsch, Jena.

E. Eidechse　　A. Schlange　　K. Krokodil
Lacerta.　　Coluber.　　Alligator.

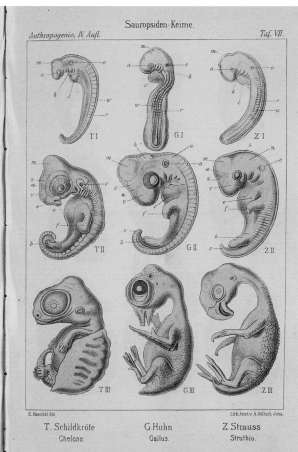

T I　　G I　　Z I

T II　　G II　　Z II

T III　　G III　　Z III

E. Haeckel del.　　Lith. Anst. v. A. Giltsch, Jena.

T. Schildkröte　　G. Huhn　　Z. Strauss
Chelone.　　Gallus.　　Struthio.

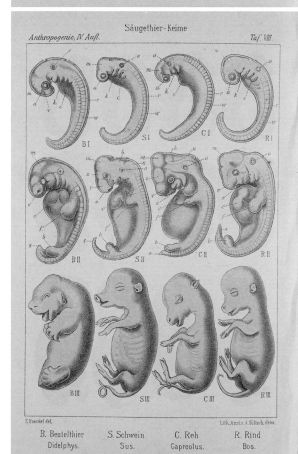

B I　　S I　　C I　　R I

B II　　S II　　C II　　R II

B III　　S III　　C III　　R III

E. Haeckel del.　　Lith. Anst. v. A. Giltsch, Jena.

B. Beutelthier　　S. Schwein　　C. Reh　　R. Rind
Didelphys.　　Sus.　　Capreolus.　　Bos.

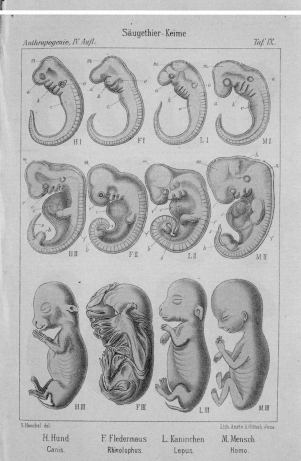

H I　　F I　　L I　　M I

H II　　F II　　L II　　M II

H III　　F III　　L III　　M III

E. Haeckel del.　　Lith. Anst. v. A. Giltsch, Jena.

H. Hund　　F. Fledermaus　　L. Kaninchen　　M. Mensch
Canis.　　Rhinolophus.　　Lepus.　　Homo.

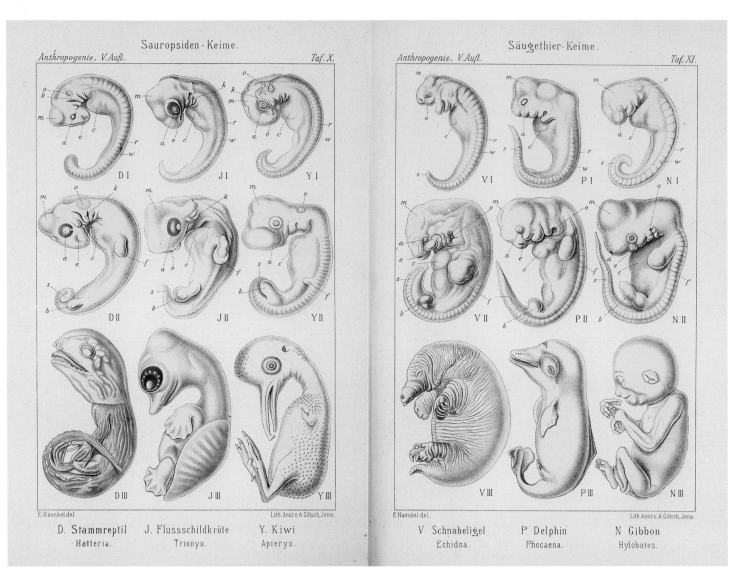

D I J I Y I

D II J II Y II

E.Haeckel del. Lith.Anst.v.A.Giltsch,Jena.

D III J III Y III

D. Stammreptil J. Flussschildkröte Y. Kiwi
Hatteria. Trionyx. Apteryx.

V I P I N I

V II P II N II

E.Haeckel del. Lith.Anst.v.A.Giltsch,Jena.

V III P III N III

V Schnabeligel P Delphin N Gibbon
Echidna. Phocaena. Hylobates.

Fig. 9.4 Two new comparative embryological plates in the fifth edition of the *Anthropogenie*. Tuatara (*D*), river turtle (*J*), kiwi (*Y*), spiny anteater or echidna (*V*), dolphin (*P*), and gibbon (*N*) form a synopsis of exotic amniotes, in systematic order. Drawn by Haeckel and lithographed by Adolf Giltsch, from Haeckel 1903, 1: plates X–XI.

text figures—including copies of sixty-year-old wood engravings—were reproduced photomechanically too. Haeckel kept Erdl's terribly dated human embryos, while an adjacent plate borrowed from an authoritative recent lithograph by Wilhelm His (fig. 10.5 below). Adolf Giltsch lithographed the comparisons to match (figs. 9.3–9.4). Printed on one side of thick paper, four plates in the fourth edition and six in the fifth stood out, stylish and fresh.

Exotic Orders

Haeckel increased columns, or genera, from the un-

changed eight over two pages in the third (1877) edition of the *Anthropogenie* through fourteen over four in the fourth (1891) to twenty over six in the fifth (1903). When updating and expanding the ninth (1898) edition of the *Schöpfungsgeschichte* he also finally replaced the old four-by-two with a six-by-three double spread that accumulated rapidly in the more successful book (fig. 9.5). (Table 9.1 summarizes the publication history of the plates.) He enjoyed displaying the triumphant growth of comparative embryology, confirming the biogenetic law and its (rather nonspecific) corollary, that more closely related species resemble each other for longer,[29] and defying his critics.

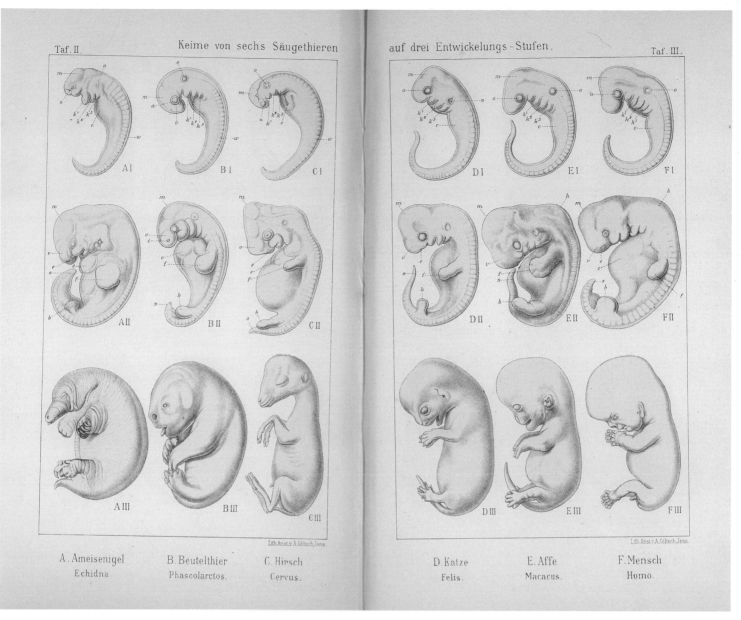

Taf. II. Keime von sechs Säugethieren auf drei Entwickelungs-Stufen. Taf. III.

A. Ameisenigel
Echidna.

B. Beutelthier
Phascolarctos.

C. Hirsch
Cervus.

D. Katze
Felis.

E. Affe
Macacus.

F. Mensch
Homo.

Fig. 9.5 "Germs of Six Mammals at Three Stages of Development," a double plate from the ninth edition of the *Schöpfungsgeschichte*: spiny anteater (A), marsupial (koala) (B), deer (C), cat (D), ape (macaque) (E), and human (F). The legend explains that from a nearly identical fish-like stage the embryos develop so that the later character of each mammalian group is more or less recognizable, especially from limbs and heads. Lithograph by Adolf Giltsch from Haeckel 1898a, plates II–III.

Haeckel amplified his adult arrays too, but the embryos multiplied more because they were present early, occupied a thematically central position, and resisted criticism better than the heads. Mammalian forelimbs supplanted those, and later editions of *Schöpfungsgeschichte* and *Anthropogenie* introduced pigeon varieties and hind-leg bones, primate skulls and skeletons of mammalian hands and feet, mammal brains and ears of humans and apes (fig. 9.6). The

"fairly large number of related forms" was supposed "to stimulate the reader to the most important and fruitful method of *critical comparison*."[30]

The later embryo plates sought completeness within a reduced taxonomic range, cutting fish and salamander and proliferating reptiles, birds, and mammals to emphasize the groups closest to humans (fig. 9.3). The Latin generic names in the fourth edition of the *Anthropogenie* and reference to "twelve different

TABLE 9.1 Publication history of Haeckel's comparative embryological plates in his own books

Plate	Animals	Edition	Year	Print run	Cumulative total	Comments	English translation
Schöpfungsgeschichte 1868	Turtle, chick, dog, human	1	1868	1,000	**1,000**	3 pairs	
Schöpfungsgeschichte 1870	Turtle, chick, dog, human	2	1870	1,500	1,500	2 rows, lithograph	
		3	1872	1,500	3,000	Engraving	
		4	1873	2,500	5,500		1876
		5	1874	2,500	8,000		
		6	1875	2,500	10,500		
		7	1879	2,500	13,000	Printing of 500 plates delayed till Nov. 1884	
		8	1889	2,500	15,500	Printing of 1,000 plates delayed	1892
Anthropogenie 1874	Fish, salamander, turtle, chick, pig, cow, rabbit, human	1	Sept. 1874	2,000	2,000	3 rows	
		2	Oct. 1874	2,500	4,500		
		3	1877	2,000	**6,500**	Issued 28 Nov. 1876, when *c.* 400 of 2nd ed. still unsold	1879
Anthropogenie 1891	Lizard, snake, crocodile, turtle, chick, ostrich, opossum, pig, deer, cow, dog, bat, rabbit, human	4	1891	1,500	1,500		
		5	1903	1,500	3,000		1905
		6	1910	[1,500?]	**[4,500?]**		
Schöpfungsgeschichte 1898	Echidna, koala, deer, cat, macaque, human	9	1898	[2,500?]	[2,500?]		
		10	1902	[4,000?]	[6,500?]		
		11	1909	4,000	[10,500?]	A cheaper edition [1911] used at least 500	
		12	1920	[3,000?]	[13,500?]		
			1923			Reprint	
		VA	1926			People's edition	
Anthropogenie 1903	Tuatara, river turtle, kiwi, echidna, dolphin, gibbon	5	1903	1,500	1,500		1905
		6	1910	[1,500?]	**[3,000?]**		
Sandal germs in *Anthropogenie* 1903	Lizard, turtle, chick, pig, rabbit, human	5	1903	1,500	1,500		1905
		6	1910	[1,500?]	**[3,000?]**		
Der Kampf um den Entwicklungsgedanken 1905	Bat, gibbon, human	1	1905	10,000	10,000	Columns adapted from *Anthropogenie* 1891 and 1903	1906
		1	1907	8,000	**18,000**	*Das Menschen-Problem*	
Sandal germs in *Das Menschen-Problem*	Pig, rabbit, human	1	1907	8,000	**8,000**	Columns adapted from *Anthropogenie* 1903	
Unsere Ahnenreihe	9 mammals	1	1908			Three stages per cell	

Notes: Plates are identified by the book and date of first publication, with the second (lithographed) and third (engraved) editions of the *Schöpfungsgeschichte* treated as the same. Data gleaned from correspondence confirm the figures in Krauße 2002, 137, 139–40, except for three editions of the *Schöpfungsgeschichte*. Figures in square brackets are estimates. Cumulative totals (plotted for most of the plates in fig. 9.18) make no allowance for unsold copies, loss, or destruction. The many reprints of the English translations are not shown.

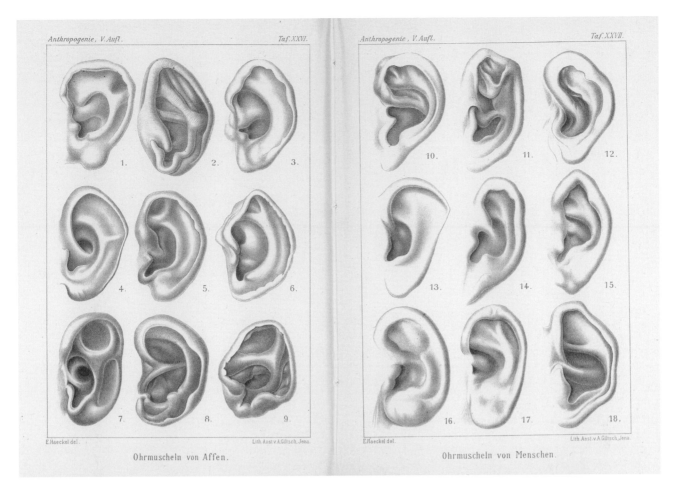

1. 2. 3.

4. 5. 6.

7. 8. 9.

10. 11. 12.

13. 14. 15.

16. 17. 18.

E.Haeckel del. Lith.Anst.v.A.Giltsch.Jena.

E.Haeckel del. Lith.Anst.v.A.Giltsch.Jena.

Ohrmuscheln von Affen.

Ohrmuscheln von Menschen.

Fig. 9.6 Lithographs of "the left external ears of eighteen anthropomorphic persons" in the fifth edition of the *Anthropogenie*. Figures *1–9*, apes; *10–18*, humans: *1–3*, gorilla; *4–6*, chimpansee; *7–8*, orang; *9*, gibbon; *10*, bushman; *11–18*, various Europeans, including the composers Engelbert Humperdinck (*16*) and Richard Strauss (*17*). Haeckel explained that the variation is so great because the shape or even loss of this rudimentary organ hardly affects the conduction of sound, and drew attention to the atavistic remains of the point in the examples shown in figures 12 and 15. He recommended, as an improving recreation for large, boring meetings, that one compare ears (Haeckel 1903, 2:759–60). Darwin had used the same unthreatening example early in *The Descent of Man* (Dawson 2007, 29), though after the embryo pair. Drawn by Haeckel, reduced to the same size, and lithographed by Adolf Giltsch, from Haeckel 1903, 2: plates XXVI–XXVII.

orders," the level below class, marked the turn to a narrower audience and implied an ambition one day to match the trees and tables in detail (fig. 9.7). Adding a lizard, a snake, and a crocodile to the turtle gave Haeckel all four main orders of reptiles, and ostrich plus chick bagged both orders of living birds. More mammals covered less of this more diverse class.[31] The opossum represented marsupials for the first time. Of twenty placental orders, Haeckel already had pig and cow (ungulates), rabbit (a rodent), and human, and he now put in a deer (another even-toed ungulate), the dog (a carnivore), and a bat, for visual interest as much as taxonomic variety. Covering its optic vesicles, the bat appeared as "see no evil," the first of the three wise

monkeys, and possibly "hear no evil" too. The limbless snake varied the reptiles. Ostrich and chick created the opposite effect: well-known differences were not manifest even at the last stage.

In the fifth edition, Haeckel inserted exciting orders (fig. 9.4): the spiny anteater or echidna, the first monotreme or egg-laying mammal; the gibbon, the closest great ape to humans; and the tuatara, a living member of the most primitive reptilian order, which completed that set. He gained less from the kiwi, a second flightless bird, and another turtle, this one freshwater and from Japan, but sheer numbers counted too. "When we see that fully [*tatsächlich*] twenty such different amniote species develop from one and the same

Fig. 9.8 Cleavage and gastrulation in "holoblastic" eggs, that is, those with total cleavage (amphioxus, frog, human), and the "meroblastic" (partially cleaving) eggs of fish and crab, in the *Anthropogenie*. Vertical median sections coded gray for the "animal" half of the egg (ectoderm) and red for the "vegetative" half: endoderm (stippled) and yolk (vertical lines). From the allegedly primitive amphioxus it was easy to derive amphibians and mammals; Haeckel claimed more credit for bringing partial cleavage within the same frame, whether it was discoid at one pole (fish) or, as in many invertebrates including the crab, superficial but all round. Expressly schematic lithograph by Eduard Giltsch after Haeckel's pen and watercolor drawings (EHH: B63, fol. 157–58), from Haeckel 1877a, plates II–III, by permission of the Syndics of Cambridge University Library.

Achtundzwanzigste Tabelle.

Uebersicht über das phylogenetische System der Säugethiere.

Unterklassen der Mammalien	Legionen der Säugethiere	Ordnungen der Säugethiere	Systematischer Ordnungs-Name
I. Subklasse: Monotrema (Ornithodelphia).	I. Gabelthiere Prototheria	1. Ursäuger	Promammalia
		2. Schnabelthiere	Ornithostoma
II. Subklasse Marsupialia (Didelphia)	II. Beutelthiere Metatheria	3. Aeltere Beutelthiere	Polyprotodontia (Generalista)
		4. Jüngere Beutelthiere	Diprotodontia (Specialista)
III. Subklasse: Placental-Thiere Placentalia (Monodelphia) oder Epitheria. (III—V: Niedere Placentalien, meist ohne Decidua). VI—VIII: Höhere Placentalien, meist mit Decidua.)	III. Zahnarme Edentata	5. Scharrthiere	Effodientia
		6. Faulthiere	Bradypoda
	IV. Walthiere Cetomorpha	7. Walfische	Cetacea
		8. Seerinder	Sirenia
	V. Hufthiere Ungulata	9. Urhufthiere	Condylarthra
		10. Unpaarhufer	Perissodactyla
		11. Paarhufer	Artiodactyla
		12. Rüsselhufer	Proboscidea
		13. Platthufer	Hyracea
	VI. Nagethiere Trogotheria	14. Hufnager	Tillodontia
		15. Pfeilnager	Toxodontia
		16. Schneidenager	Rodentia
	VII. Raubthiere Sarcotheria	17. Urraubthiere	Creodontia
		18. Insectenfresser	Insectivora
		19. Fleischfresser	Carnivora
		20. Robben	Pinnipedia
	VIII. Herrenthiere Primates	21. Flederthiere	Chiroptera
		22. Halbaffen	Prosimiae
		23. Affen	Simiae
		24. Menschen	Anthropi

Fig. 9.7 Evolutionary table of the mammals from the *Anthropogenie*, with divisions into subclasses (monotremes, marsupials, and placental mammals), legions, and orders. Haeckel 1891, 2:576.

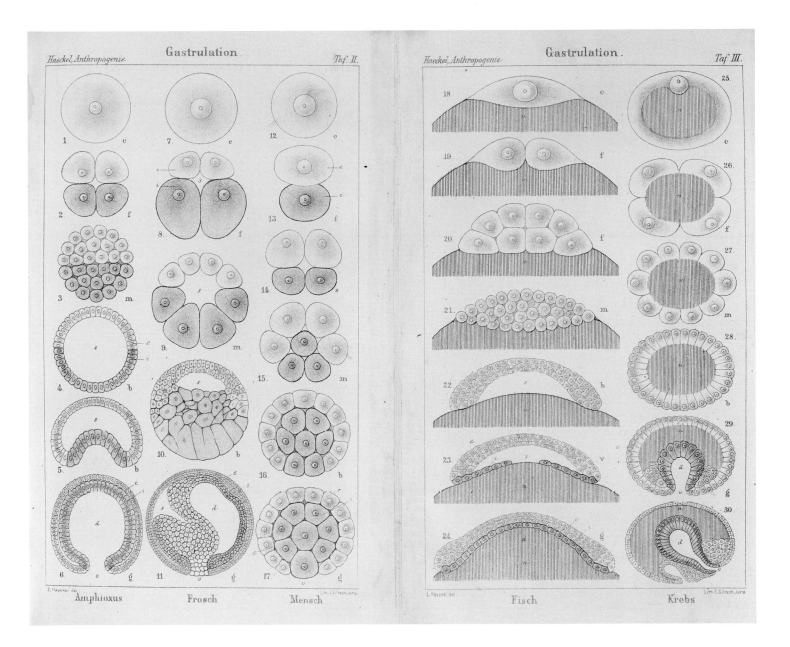

Amphioxus Frosch Mensch

Fisch Krebs

germinal form, we also grasp that these originally de-scend[ed] from a common stem form."[32] Growth cele-brated the Darwinian stimulus to the field.

Additional rows, or stages, made a stronger state-ment than extra columns about similarity and differ-ence through development. In 1877 two new plates in the *Anthropogenie* had adapted the design to earlier stages. Summarizing the gastraea theory, they showed cleavage—the cell divisions following fertilization—and gastrulation—the rearrangement that produces the layered body of the Metazoa (fig. 9.8). Four main types were derived from a primordial form (fig. 6.11)

according to the amount of nutritive yolk. Haeckel's more mature view thus acknowledged early differ-ences: very similar eggs developed into rather varied gastrulae which then converged on the stage in the first row of the main embryo plates, before diverging again.[33] His headline affirmations and most prominent pictures still implied initial identity. Haeckel more di-rectly extended the grids a quarter century later, when the fifth edition of the *Anthropogenie* put in some "san-dal germs," of which the first row looks less alike (fig. 9.9).[34] But he mainly added species as new ones came in.

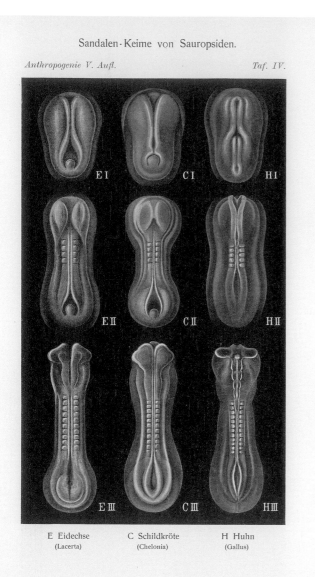

E I C I H I'

E II C II H II

E III C III H III

E Eidechse C Schildkröte H Huhn
(Lacerta) (Chelonia) (Gallus)

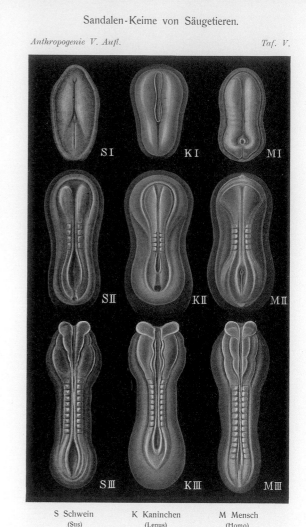

S I K I M I

S II K II M II

S III K III M III

S Schwein K Kaninchen M Mensch
(Sus) (Lepus) (Homo)

Fig. 9.9 "Sandal germs of six different amniotes," lizard (*E*), turtle (*C*), chick (*H*), pig (*S*), rabbit (*K*), and human (*M*), at three different stages, in the fifth edition of the *Anthropogenie*. Halftones of drawings from Haeckel 1903, 1: plates IV–V.

Transformative Collecting

Collecting did not just bring biologically, geographically, and socially diverse materials together. It also transformed meanings by taking diversely interpreted objects and framing them all as equivalent embryos. This was very challenging for non-European species and for mammals.[35]

Having begun with indigenous animals, Haeckel inspired zoologists to look further afield, with a premium on illuminating vertebrate and human origins. To exploit marine diversity, one of his students founded the Naples Zoological Station, the most prestigious of a string of seaside laboratories, in 1872.[36] The British Empire—German colonies played little role—gave stay-at-home naturalists access to a global network of dealers and zoo owners. But in 1881 a major survey by Francis Balfour of Cambridge was still full of gaps.[37] Led by Haeckel's students and friends, intrepid zoologists set sail to bring home living fossils and missing links.

The revised plates exploited these efforts. The 1891

additions were not just lizard, snake (Rathke's adder), deer (mostly Bischoff's),[38] and bat, but also crocodile, ostrich, possum, and new turtle figures. Haeckel's partial borrowings from published illustrations indicate their journeys. He owed his older turtles and some crocodilians to articles on skull development by William Kitchen Parker, Hunterian professor of comparative anatomy at the Royal College of Surgeons in London. A rambling writer but careful observer, Parker had received turtles collected from Ascension Island in the South Atlantic during the Royal Society's *Challenger* expedition of 1872–76, alligators from a former student of Balfour at Princeton, and crocodiles from the principal civil medical officer in Colombo, Ceylon (now Sri Lanka).[39]

Haeckel's two older possum figures derived from the description by the staunch Erlangen Darwinist Emil Selenka, who raised them in captivity (fig. 9.10B). Having missed the breeding season on a visit to Brazil, he bought a large number of North American animals from the Hamburg zoo director and dealer Carl Hagenbeck and bred them in Bavaria. Selenka kept a colony through the winter, fed mostly on horse meat in a warm shed, well ventilated and cleaned out daily to keep down the stench. Each female usually came into heat just once a year, an event signaled by her liveliness and, through her scent he supposed, the males' readiness to try to "conquer" her.[40]

After another decade of exploration, all but one of the new genera in the *Anthropogenie* of 1903 and half those in the *Schöpfungsgeschichte* of 1898 were exotic. Academic biologists on New Zealand's South Island described two. The development of the kiwi was the work of T. Jeffery Parker, William's son, Huxley's student, and a professor at the University of Otago in Dunedin. With support from the Royal Society, he relied on Richard Henry, a collector and "excellent" "field-naturalist," for material from Lake Te Anau. Arthur Dendy, the British-trained professor of biology at Canterbury College in Christchurch, had a lighthouse keeper amass a "magnificent supply" of eggs of the already endangered tuatara from shallow holes in the earth of an island reserve (fig. 9.10A).[41] Though closer to Jena, the dolphin embryos were more arduous to obtain: Haeckel's student Willy Kükenthal accompanied whaling ships in the northern seas (fig. 9.10C). In the most ambitious expeditions a Jena colleague Richard Semon collected echidnas on a journey to

Australia, while Selenka founded ape embryology on two safaris, the first in 1889 to the East Indies, especially Java, the second in 1892 to Ceylon, Borneo, Sumatra, and Japan (fig. 9.10D).[42]

Collecting depended on cultivating people with access to eggs, embryos, and pregnant females: dealers, hunters, colonial officials, trackers, whalers, farmers, knackers, and clinicians. Embryologists who used existing chains of command, or paid for otherwise worthless material, easily met their needs. Parker senior reordered others' priorities more deeply by having a state-funded expedition collect from the turtle pond that provided meat for the navy at Ascension, and when he missed some stages convincing the admiralty to take more.[43]

A foundation through which the philanthropist Paul von Ritter supported phylogeny in Jena funded Kükenthal and Semon.[44] But Kükenthal could not organize his own whaling trip and found it hard to intervene during the freezing storms on the ships. He did better at the processing stations on Spitsbergen, but owed the original of Haeckel's latest stage—Kükenthal had none as early as Haeckel's first two—to the Indian Ocean via the Hamburg natural history museum.[45] Letters of recommendation to colonial officials and settler farmers gave a luckier Semon access to echidna country and helped recruit indigenous Australians who staffed his camp and collected some four hundred anteaters (fig. 9.11A). Many settlers had never seen one, because the echidnas were nocturnal, shy, and quiet, and lived in the most inaccessible bush (fig. 9.11B). Only the "incomparable nose and hawk's eye" of "the blacks" could follow the slight and complex tracks over difficult terrain to the hollows where the animals slept by day. So the hunters were cross when, after hours of tracking, Semon paid little or nothing for the more numerous males.[46]

Ideally, diverse embryos were to be analyzed into comparable developmental series, but collecting difficulties imposed major constraints. Flaunting their derring-do and excusing the holes in their collections, the explorers portrayed work on domestic mammals and humans as tame. Semon pointed out that controlled rabbit matings produced plenty of embryos to fix in comfort, while echidnas, rare and hidden even in their distant homeland, generated one offspring every few years. He sacrificed many females in vain because they turned out not to be pregnant, and since the Ab-

und wenn sich hiergegen vielleicht auch manches einwenden läßt, darf andererseits doch nicht verkannt werden, daß ihm eine Stellung gebührt, welche die zwischen ihm und den ihm anscheinend so nahe verwandten wirklichen Schuppenechsen bestehenden Unterschiede zum Ausdrucke bringt.

Die Brückenechse (Hatteria punctata), welche wir als Urbild einer besonderen Familie betrachten müssen und als Vertreterin einer eigenen, von allen übrigen gleichwerthigen Abtheilungen

Brückenechse (Hatteria punctata). ¼ natürl. Größe.

wesentlich verschiedenen Unterordnung (Rhynchocephalia) ansehen mögen, ist eine sehr große, etwas plumpe Schuppenechse. Ihr Kopf ist vierseitig, der Leib gedrungen, der Gliederbau kräftig, der etwa der Länge des Rumpfes gleichkommende Schwanz zusammengedrückt dreieckig; die Vorder- und Hinterfüße haben fünf kräftige, kurze, runde Zehen, welche kleine Spannhäute zeigen und mit kurzen Krallen bewehrt sind. Schenkelporen fehlen. An der Brust bemerkt man hinten eine Querfalte; im Nacken, längs der Rückenmitte und ebenso längs der Mitte des Schwanzes erhebt sich ein aus zusammengedrückten Dornen gebildeter, in der Schulter- und Lendengegend unterbrochener Kamm. Kleine Schuppen decken den Kopf, kleinere und größere den Leib, große, viereckige, flache, gekielte, in Querreihen angeordnete Schilder die Unterseite, kleine Schuppen den

10*

Sommer am benachbarten Meierhofe eine Güte that. Höchst vorsichtig jedoch rückt es vor und birgt sich endlich im Hühnerhaus selbst.

„Biederer Bauer! warum hast du vorigen Winter so viele Krähen weggeschossen und Raben dazu? Nun, du hast deinen Spaß gehabt: jetzt aber eile ins nahe Dorf und verschaffe dir hinreichenden Schießvorrath, putze deinen rostigen Kuhfuß, stelle deine Fallen auf und lehre deine trägen Köter, um dem Opossum aufzulauern. Dort kommt es! Die Sonne ist kaum schlafen gegangen, aber des Strolches Hunger ist längst wach. Hörst du das Kreischen deiner besten Henne, welche es gepackt hat? Das listige Thier ist auf und davon mit ihr. Jetzt ist nichts weiter zu thun; höchstens kannst du dich hinstellen und auch noch auf Füchse und Eulen anstellen, welche bei dem Gedanken frohlocken, daß du ihren Feind und deinen Freund, die arme Krähe, weggeputzt hast. Die werthvolle Henne, welcher du vorher so gegen ein Dutzend Eier untergelegt hast, ist diese jetzt glücklich losgeworden.

Opossum (Didelphys virginiana). ⅓ natürl. Größe.

Trotz all ihres ängstlichen Geschreies, trotz ihrer gesträubten Federn hat das Opossum die Eier verspeist, eins nach dem andern. Das kommt also von deinem Krähenschießen her. Wärst du barmherziger und gescheiter gewesen, so wäre das Opossum wohl im Walde geblieben und hätte sich mit einem Eichhörnchen begnügt oder mit einem Häslein, mit den Eiern des Truthahns oder mit den Trauben, welche so reichlich die Zweige unserer Waldbäume schmücken: aber ich rede dir vergeblich vor!

„Doch auch angenommen, der Bauer hätte das Opossum über der That ertappt, — dann spornt ihn sein Aerger an, das arme Thier mit Fußtritten zu mißhandeln. Dieses aber, wohlbewußt seiner Widerstandsunfähigkeit, rollt sich zusammen wie eine Kugel. Je mehr der Bauer rast, desto weniger läßt sich das Thier etwas von seiner Empfindung merken. Zuletzt liegt es da, nicht todt, aber erschöpft, die Kinnladen geöffnet, die Zunge heraushängend, die Augen getrübt, und so würde es daliegen, bis die Schmeißfliege ihre Eier auf den Pelz legte, wenn nicht sein Quälgeist fortginge. „„Sicherlich"", sagt der Bauer, „„das Vieh muß todt sein."" Bewahre, Leser, es „„opossumt"" nur etwas vor. Und kaum ist sein Feind davon, so macht es sich auf die Beine und trollt sich wieder in den Wald."

Das Opossum ist, wie seine ganze Ausrüstung beweist, ein Baumthier, auf dem Boden dagegen ziemlich langsam und unbehülflich. Es tritt beim Gehen mit ganzer Sohle auf. Alle

„Der Delphin wirt billich genennt und geachtet der König und Regent deß Meers und Wassers, von wegen seiner anmutung, geschwindigkeit, stercke, listigkeit und schnelle, auß welcher ursach die König von Franckreich auch etliche andere Fürsten und Regenten die Delphin zu einem wappen führen, und sein gestalt auff mancherley gülden silberin müntz geschlagen, erzeigen, in dem gemähl, fanen und paneren führen. Es bekompt auch zu aller zeit der erstgeborne son deß königs von Franckreich den Namen Delphin, führt auch solchen zu einem wappen. Auff mancherley müntz der Keyser werden sie geschlagen, als Augusti, Tyberij, Rusti, Domitiani, Vitellij, Item der Griechen, der mehrertheil Königen, welche sie in jrem schimpffwerck treiben, so sie spielen, springen oder geilen, welcher Müntz eine oben gesetzt ist, welche beyder seiten gestalt erzeigt."

Delfin (Delphinus Delphis). ⅟₁₀ natürl. Größe.

„Item in des Keysers Titi Vespasiani müntz wirt gesehen ein Ancker mit eim umbgeschlagenen Delphin, welches geschwindigkeit und staumnung, thun und lassen, nach gestalt der sach bedeuten wil, dann sonst bedeutet er auch der mehrertheil, das Meer, herrschung der Wasser, anmutung gegen den jungen Kinden, einbrünftigkeit, art der liebe und der gleichen."

Der Delfin vertritt mit einigen ihm sehr nahe stehenden Arten eine besondere Sippe (Delphinus) und eigene Unterfamilie (Delphinina). Die Merkmale der letzteren sind folgende. Der verhältnißmäßig kleine Kopf spitzt sich nach vorn in eine schnabelförmig verlängerte, die Gehirntheile an Länge gleichkommende oder noch übertreffende Schnauze zu, deren Kiefer mit außerordentlich zahlreichen, kegelförmigen und bleibenden Zähnen besetzt sind; die Brustflossen stehen ganz seitlich, etwa im ersten Fünftel des Leibes; die Rückenfinne erhebt sich fast von der Mitte der Oberseite; die Schwanzflosse ist verhältnismäßig sehr groß und beinahe rein halbmondförmig gestaltet. Die Merkmale der Sippe sind die des Thieres selbst.

Band I, S. 126.

Makak.

Fig. 9.10 Haeckel depicted embryos of exotic vertebrates known to the public through illustrations in Brehm's *Thierleben* (Animal life), some of which he borrowed. *A*, tuatara, as used in the *Anthropogenie*; *B*, opossum; *C*, dolphin; *D*, macaque. Wood engravings by C. Wendt (*B–C*) and Richard Illner (*D*), after drawings by Gustav Mützel (*A, B, D*), and Robert Kretschmer (*C*), from Brehm 1876–79, 7:147, 2:559, 3:704, 1: facing 126, by permission of the Syndics of Cambridge University Library.

Ada und Jimmy.

Australischer Ameisenigel, Echidna aculeata var. typica.

Fig. 9.11 Semon's echidna hunters and their prey. *A*, his "particular friends," Ada and her husband Jimmy, in the camp on the River Boyne, a tributary of the Burnett, in Queensland. Though Semon regarded the aborigines as "one of the lowest human races," he admired their skill in the noble art of hunting. Jimmy, once a famous warrior, was Semon's "best huntsman" and a fine raconteur (166–68). The bottles on the table were likely for preserving and staining the embryos. *B*, an adult echidna. Semon 1896, facing 166 and 172, by permission of the Syndics of Cambridge University Library.

origines returned to the camp at dusk, he frequently had only "flickering candlelight" by which to dissect any embryos out of their tight-fitting shells.[47] For Selenka, chance supplied the lucky human embryologist "without sacrifice of time and health," while heroic searches for ape embryos often went unrewarded. Having hunted apes in Borneo, he lost his rare treasures in a boat collision and was so sick with malaria that his wife Lenore had to lead an expedition to make good the loss. She "brought some valuable anthropomorph material from the darkness of the forests … to her husband's scalpel and microscope."[48]

Embryologists presented themselves as bringing light. Framing as embryos materials that had been interpreted differently, if at all, was the crucial first step in constructing their working objects. The Aborigines knew how to track the echidna, or "cauara," a prized delicacy; they also told Semon of its origin from a bad man who was filled with spears. Semon impressed the "bushmen" by showing that the young are not "conceived on the teat," as they had believed, but begin, like other mammals, in the womb.[49] By contrast, the tuatara was not an important Māori food; they treated it with respect, even reverence, and used the animals as a kind of cold-water bottle when hunting the muttonbirds that nested nearby.[50]

Some of the most profound transformations went on closest to home. Even women who realized they were pregnant—and in the early stages, many did not—still rarely explained the blood clots they passed in embryological terms. Anatomists appropriated bleeds that had been experienced variously as unre-

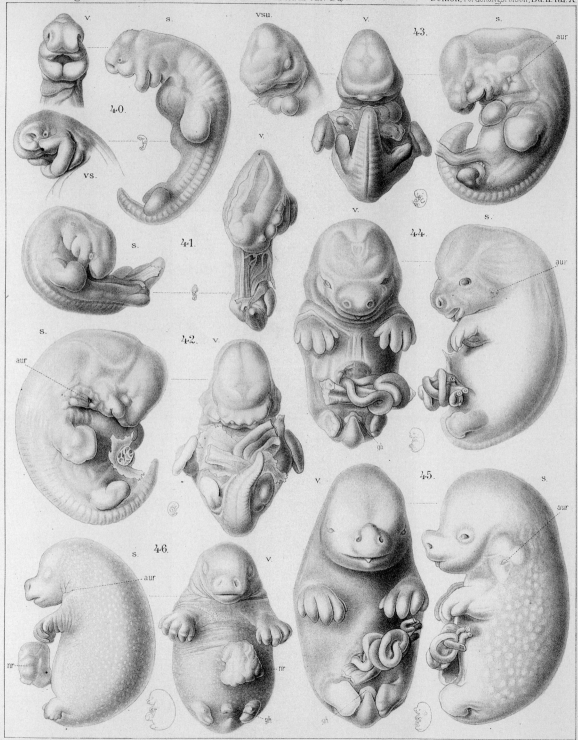

markable late periods, distressing miscarriages, or desired restorations of menstrual flow. They discovered embryos in the bodies of patients who had not known they were expecting or tragically committed suicide because they did. Haeckel and other medical writers dismissed women as ignorant. Many did remain miserably or respectably unaware even as the potentially available information increased, but nonembryological views could also make sense. Those desiring a baby might think in terms of an unborn child, while those fearing a pregnancy focused on menstrual regulation.[51]

Specimen preparation and drawing were more standardized than collecting. Authors collaborated with artists to arrange embryos into developmental series and select representatives for printing, usually by high-quality lithography. Well-funded expeditions generated prestigious volumes about one group each (fig. 9.12). Haeckel's grids assembled the booty of imperial embryology and so also confronted the many gaps.

Thinking, Not Seeing

Haeckel was later insulted as a "*desk* embryologist," as someone, that is, who manipulated figures without first-hand knowledge.[52] This underestimated his experience with vertebrate material, and the work any embryologist had to do at the desk. But it captured the charge that he rode roughshod over the evidence, inventing or altering figures to suit his ideas.[53] Some laughed at the suggestion that there were any originals behind his drawings at all, yet most critics alleged misuse of sources. How did the desk-work for the later editions relate to his earlier drawing and others', and how could it have seemed reasonable to him?

Fig. 9.12 Highly magnified drawings of echidna embryos from pouch eggs after removal of the membranes (figs. 40–45); so-called puggle just hatched from the eggshell (fig. 46). The contour drawings give the natural sizes. Views from the side (s), front (v), between front and side (vs), and from the front and below (vsu). The text thematized the development of the external ear (aur) and the first signs of the spines (figs. 45–46). Adolf Giltsch made this lithograph and some of the drawings for Semon, then Haeckel or Giltsch copied, and Giltsch lithographed, figures 40 and 43 for the *Anthropogenie* (here fig. 9.4). Lithograph from Semon 1894, plate X, by permission of the Syndics of Cambridge University Library.

Haeckel drew after nature and published figures. For the *Anthropogenie* in 1891 he "sought to dispose of the accusations against some of my original illustrations … by executing them anew and as faithfully to nature as possible from the best objects available to me."[54] Haeckel implied that these objects were "a larger number of better preserved embryos,"[55] but also relied on drawings. The embryologist Carl Rabl, a former student, sent a generous selection, many unpublished (fig. 9.13).[56] Haeckel thus had access to more embryos than had been described in print—but also fewer, because so many were lost in a vast literature that even specialists found ever harder to survey. In the 1880s travel and thousands of *Challenger* invertebrates left him little time to keep up.[57] So he had Gegenbaur's senior student Max Fürbringer send His's study of human embryos and recent large tomes by Selenka, his student Albert Fleischmann, and Parker senior, as well as a fat human embryology by the Boston Brahmin Charles Sedgwick Minot.[58]

Haeckel worked in much the same way from his first embryo plates to the last, but refined his account of his procedures. By the mid-1870s he had developed an opposition between bad and good exactitude, *Exaktheit* and *Genauigkeit*, which justified a liberal view of schematics and let him claim to represent nature truly at the same time. In a "concluding apologia" to the 1891 *Anthropogenie* he placed himself with "all *thinking* morphologists" as showing the essentials of an object "not as they really *see* it, but as they *think* it."[59] This need not have implied anything so formal as theory, but could have meant basing an interpretation on knowledge of other forms. He wrote later that equivalent illustrations were "for the larger part exact [*genaue*] copies after the best available original figures of reliable authors, for the smaller part drawn faithfully [*naturgetreu*] by Mr. Adolf Giltsch after original embryos of my own collection."[60] Haeckel referred to similar drawings as *schematic figures* and now also as *diagrams*, a term long employed in astronomy and geometry and of clearly theoretical line drawings, but fairly new for simplified representations of organic form.[61]

Haeckel still drew his embryos at the same size, and in the same orientation and style, which his "tried and tested collaborator" Giltsch had internalized (fig. 9.14).[62] Redrawing aggressively, Haeckel removed extraembryonic membranes, and now noted that he had

Fig. 9.13 Preparatory drawings. *A*, sketches of embryos and their brains; *B*, finished drawing of a cat embryo, likely from Carl Rabl (used for DIII in the revised plate for the *Schöpfungsgeschichte*, here fig. 9.5). EHH: *A*, B63, fol. 196; *B*, B65, fol. 98.

Fig. 9.14 "Adolf Giltsch, on the left his son, on the right [the zoologist] Professor [Heinrich] Ernst Ziegler, photographed by Ernst Haeckel. In the garden of the zoolog[ical] institute in Jena, July 1900." Students called the popular Giltsch "Doctor" (Haeckel, "Adolf Giltsch. Ein Nachruf," *Altes und Neues aus der Heimat. Beilage zum Jenaer Volksblatt* 1911, no. 11). Photograph, EHH.

done so, and restored symmetry that he believed accidents of preparation had disturbed.[63] Even His allowed himself to repair damage.[64] But figures that map imperfectly onto the most likely originals suggest that Haeckel sometimes went further, suppressing limb buds, for example, from the youngest echidna embryo (compare figs. 9.4 and 9.12) and altering somite numbers at will.[65] For most colleagues that was too much thinking and not enough seeing, especially for figures used as evidence and not labeled as schematic. He had toned down the rhetoric, but critics still saw a viciously circular argument from doctored data.

Haeckel did recognize constraints: it was hard to obtain the youngest embryos at "exactly the same age," and fixatives distorted their "tender" and "soft bodies." "One and the same object is also often represented differently by different observers, according to the chance illumination under the microscope."[66] An "exact" embryologist might thus have excused incidental differences that remained; he justified the effort to see through appearances to the underlying types.

Empty cells could have stimulated further research. Haeckel's vivid descriptions of a speechless ape-man, the hypothetical *Pithecanthropus alalus*, inspired a Dutch military doctor to dig up Java Man,[67] but the embryo plates were supposed to summarize established knowledge. Trees could grow higgledy-piggledy and maps be adapted to the terrain, but the lattice imposed a fixed order.[68] Haeckel confessed that for "perhaps 6 or 8 percent" of his "pictures of embryos," "the available observational material is so incomplete or insufficient that in constructing a continuous developmental series one is *forced* to fill the gaps with *hypotheses* and to reconstruct the missing members by *comparative synthesis*."[69]

Haeckel gave sources for borrowed figures, but not for the embryo plates, which he treated as original. They mixed recognizable copies with drawings either of new specimens or from his imagination. Take the "crocodiles" (fig. 9.3): the second and third closely resemble an alligator and a crocodile in Parker's article, but the first has no obvious precedent.[70] Haeckel may have drawn his own preparations and drawings; he had some late-stage crocodile embryos.[71] For the bat and the gibbon he admitted silently substituting a related group for a missing middle stage. Unexceptionable as a hypothesis or with an explanation,[72] this was difficult to stomach as fact.

If Haeckel rejected textbook standards, by his own lights he did not invent so much as adapt and supplement with best estimates based on extensive knowledge. Yet he accorded these figures the same status as copies from authoritative works. The formal properties of the grids thus combined fatefully with empirical limitations and his drawing style. The design could have shown that some stages were yet to be found, but instead appealed to his drive to prefigure evolutionary science, encouraging him to fill cells and exaggerate initial similarities. He defended the drawings as schematic, even diagrammatic, and admitted that he bridged gaps with hypotheses, while presenting the plates as exact and faithful to nature—an assertion more likely to be accepted abroad.

Englished and Abridged

Translation distanced the plates from Haeckel and had several other effects. Illustrating a work in a new language demands negotiation between publishers, and poses special problems, not least of labeling. Subject to different pressures, though often freer from an author's control, translations not only revise, abridge, or comment on texts, but also alter, cut, or add figures.[73]

The *Schöpfungsgeschichte* went into a dozen tongues, beginning with Polish and then a major scientific language, French;[74] the *Anthropogenie* managed a few. The histories of the books, and hence the plates, have differed between linguistic communities, but since the twentieth century legacy of the pictures is dominantly American, English would matter most.[75] Anglophone translations selectively amplified the older plates, while subtly changing form and context and revealing the burden they placed on the *Anthropogenie*.

British and American companies jointly produced translations of two editions each of the *Schöpfungsgeschichte* and the *Anthropogenie*. The new London firm of entrepreneur Henry S. King and his successor, the freethinking former vicar Charles Kegan Paul, joined forces with Appleton in New York. These serious publishers had recently acquired a high profile in natural science through the International Scientific Series that pioneered global copyright against the American system of pirate reprinting. Appleton did Darwin's *Origin* and founded the *Popular Science Monthly*, again to trump the pirates.[76]

The first English translation of the *Schöpfungs-geschichte* (1876) was organized from the fourth German edition following its phenomenal success and before the forgery charges grew legs. As translator Haeckel selected his former student, the zoologist, freethinker, and campaigner for professional science, E. Ray Lankester, who in fact revised a draft by a family friend, L. Dora Schmitz. To create a less radical impression Lankester cut "natural" from the title and had Haeckel write a milder preface, but the addition of his own name to the title page hardly signaled moderation.[77] Appleton and King (then Kegan Paul) had the *Anthropogenie* translated anonymously in New York. German books could be "Englished, printed, and pub-lished in a matter of days,"[78] but this one, planned in 1874, appeared as *The Evolution of Man* only in 1879. It took so long it ended up following the third German edition of 1877, with delays for the extra figures and revision of the text because the translator, Gustav Van Rhyn, "is not completely English."[79] It cost thirty-two shillings and *The History of Creation* the same.

Translation changed form. With smaller pages, thicker paper, and so two volumes from the start, *The History of Creation* and *The Evolution of Man* are literally heavier than their German originals, but the lower-quality plates look more schematic, if not as degraded as some of the wood engravings (figs. 9.15–9.16). Printing used electrotypes and stereotypes sup-

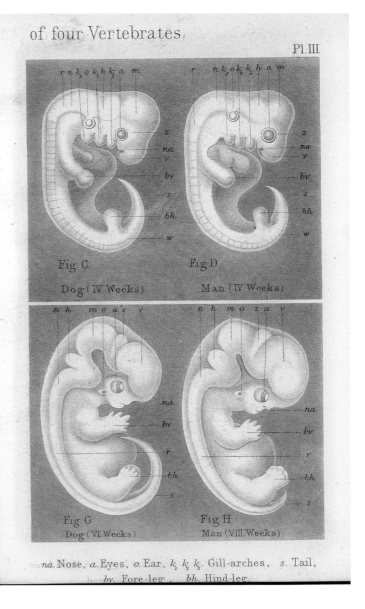

Germs or Embryos of four Vertebrates

Pl. II.

Fig. A.
Tortoise (IV Weeks)

Fig. B.
Chick (IV Days)

Fig. E.
Tortoise (VI Weeks)

Fig. F.
Chick (VIII Days)

Pl. III.

Fig. C.
Dog (IV Weeks)

Fig. D
Man (IV Weeks)

Fig. G
Dog (VI Weeks)

Fig. H
Man (VIII Weeks)

v. Fore-brain, *z*. Twixt-brain, *m*. Mid-brain, *h*. Hind-brain, *n*. After-brain, *w*. Spine, *r*. Spinal-cord.

na. Nose, *a*. Eyes, *o*. Ear, k_1 k_2 k_3. Gill-arches, *s*. Tail, *bv*. Fore-leg, *bh*. Hind-leg.

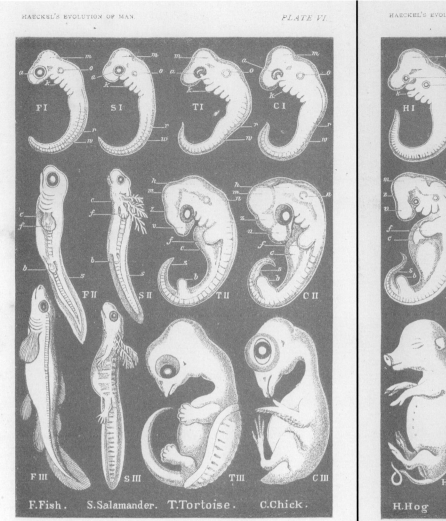

FI SI TI CI

FII SII TII CII

FIII SIII TIII CIII

F.Fish. S.Salamander. T.Tortoise. C.Chick.

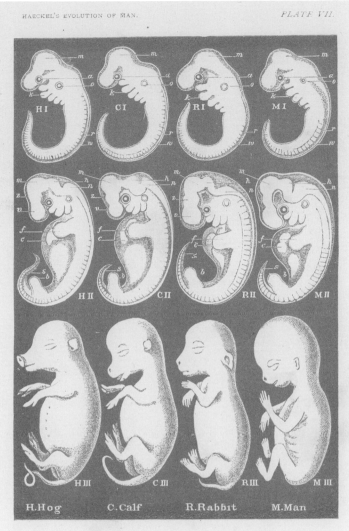

HI CI RI MI

HII CII RII MII

HIII CIII RIII MIII

H.Hog C.Calf R.Rabbit M.Man

Fig. 9.16 The embryo plates in *The Evolution of Man*, on a brown-green background rather like the original, but reduced in size by two-thirds. A tissue-paper separator (here removed) made it harder to compare across all columns at a glance. Haeckel 1879b, 1: plates VI–VII.

Fig. 9.15 The embryo plates in *The History of Creation* (1876). The figures appear washed out and monochrome next to the originals (fig. 6.10), the lettering bright and black against the gray. Printing at the same size on smaller pages gives a cramped effect. Haeckel 1876b, 1: plates II–III.

plied inexpensively by Reimer and Engelmann, relettered but with only the more easily altered column and row labels translated, so that the more inclusive *Mensch* became *man*.[80] Pye-Smith still judged them "excellently reproduced," and the *Examiner*, a radical weekly on its last legs, praised "the beautifully executed plates which supply the reader, in a sense, at first hand, with some of these facts [of embryology]," and "add considerably to the interest of the exposition."[81]

The English-language publishers selected German editions containing the early plates. The first *History of Creation* was reprinted a few times before 1892, when the same team brought out a "fourth" edition from the eighth German one. This stayed in print into the twen-

tieth century,[82] so no English version ever took the replacement plate from the ninth German edition. Similarly, *The Evolution of Man* (initial run, one thousand) was reprinted twice in Britain in runs of five hundred and several times in the United States,[83] including by Paul E. Werner, the prolific pirate of Akron, Ohio,[84] but the greatly revised fourth German edition was not translated, so neither, initially, were the new plates.[85]

These losses of quality and variety should not obscure what was "gained in translation."[86] The embryo plates acquired authority from the nontranslation of the apologia that this edition alone contained and the other main documents of the disputes with His and Semper.[87] Although German natural science was im-

Fig. 9.17 Cover of the RPA paperback *Evolution of Man*. Though sold on the illustrations, as well as the author's fame and the low price, this edition excluded the plates. Haeckel 1906a.

ported to the United States, with its large immigrant communities, and much translated,[88] the accusations were hardly reported in English. Biologists discussed them, but only a rare specialist sounded the alarm. In 1877 Minot, a stickler for "absolute accuracy," and a "fearless" and "emphatic" critic schooled in anti-Haeckelism by study in Leipzig and with Semper in Würzburg,[89] listed criticisms in the *American Naturalist* magazine, with translations from His and references to many other authorities. But the editor, the Christian, neo-Lamarckian entomologist Alpheus S. Packard Jr., pleaded that readers "not lose sight of the fact that Haeckel stands as an original investigator far above some of his critics.... His [specialist] works ..., besides his masterly drawings and elegant literary style, should be taken into account in judging of his influence on the progress of zoology." These books traveled better than occasional pieces for general audiences. So the criticisms do not seem to have sparked any great debate; the row with Virchow over Darwinism in school overshadowed the issue more even than in Germany.[90]

In Britain and America *The History of Creation* was not the one indispensable work of the leading native Darwinist, but an important survey by a distinguished and controversial foreigner. "That work had only penetrated into the first circle beyond the sacred academic enclosure, and was still unknown to the crowd." But with *The Riddle of the Universe*, as *Die Welträtsel* was translated, Haeckel "blew a blast that would reach the far-off shop and factory."[91] This international sensation was the first big success of the Rationalist Press Association (RPA) and its publisher Watts: the sixpenny reprint sold 30,000 in 1902 alone; over 250,000 English copies had been printed by 1914. The translator, the Catholic priest turned freethinker Joseph McCabe, claimed that "I saw it pass from hand to hand among the simple fishermen of the Orkney Isles—that *ultima thule* [farthest northern point] of European civilization—I found it among the mountain people of Scotland and Wales, in Catholic cities in Ireland, among the sheep-shearers of Australia and even with the Maoris of New Zealand."[92] Fame drove competition for the fifth (1903) edition of the *Anthropogenie*. As an honorary associate of the RPA, Haeckel cheered when they beat Kegan Paul.[93] Watts (and G. P. Putnam's Sons in New York) brought out a fine edition on heavy paper with good plates, but McCabe's work

so "bristles with mistakes" that he labeled the spiny anteater (echidna) a sea urchin (*Echinus*).[94]

Though reprinted beyond the initial run of one thousand, sales at twenty-one shillings were limited; then a people's edition at sixpence a volume (a shilling for both) made "Haeckel's greatest work" "one of the cheapest scientific books ever published" (fig. 9.17).[95] Admittedly "very technical and difficult" in parts, "the previous success of the 'Riddle,' the interest of the subject, and the hundreds of illustrations gave it a large circulation."[96] But, abridged and printed in two columns on thin paper, in its most widely read form the *Anthropogenie* cut all the plates.[97]

Second Wind

An encouraged Haeckel wanted a German people's edition, but did not appreciate this precondition of the British success. While the faraway RPA was free to adapt the book to the market, the plan for a shorter *Menschenkeime* (Human embryos) foundered on the expense of the plates he could not imagine doing without.[98] The full-size *Anthropogenie* soldiered on into a sixth (1910) edition that largely reprinted the fifth. At a hefty twenty marks it was squeezed by competition from above and below: more reliable and current embryology texts and the many cheap, short, and easy Darwinist books. In 1912 Haeckel let Reclam, the publisher of cheap reprints, include the gastrula chapter from the *Anthropogenie*, with illustrations but not the embryo plates, in a selection from his works for their twenty-pfennig "universal library," newly available also from slot machines in that year.[99] By contrast, Reinecke sent the copper for the cover of the parent book to be melted down for the war effort, and remaindered several hundred copies in a Berlin department store.[100]

Though the *Schöpfungsgeschichte* sometimes faltered, buyers kept coming decade after decade. An essentially unchanged eleventh (1909) edition, with some of the stock issued as a single half-price volume two years later,[101] was followed by a posthumous twelfth (1920) edition celebrating "one of the classical books of the theory of evolution ... which shaped the thought of a whole generation." To maintain this "living monument" in difficult times, it was set more compactly, with all the illustrations though lower quality, and in 1926 was finally reprinted as the long-desired

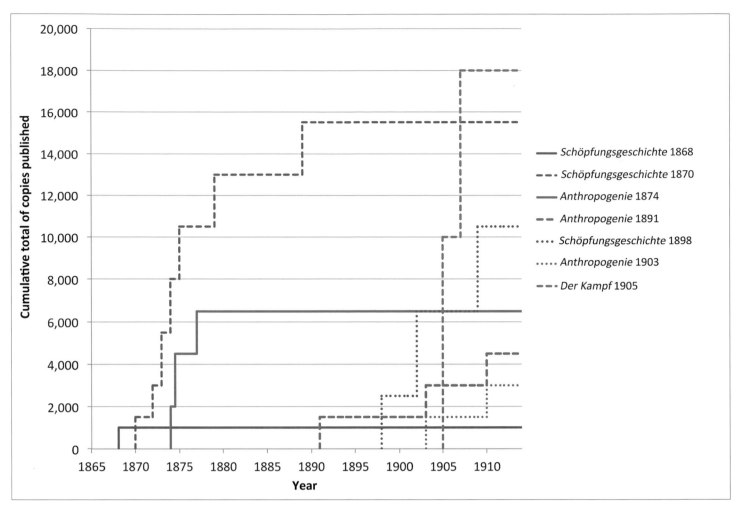

Legend (right of chart):
— *Schöpfungsgeschichte* 1868
–·– *Schöpfungsgeschichte* 1870
— *Anthropogenie* 1874
– – *Anthropogenie* 1891
···· *Schöpfungsgeschichte* 1898
····· *Anthropogenie* 1903
–·– *Der Kampf* 1905

Y-axis: Cumulative total of copies published
X-axis: Year

Fig. 9.18 The accumulation of copies of the main comparative embryological plates in the German editions of Haeckel's books. Early versions dominate (*Schöpfungsgeschichte* 1870 and *Anthropogenie* 1874) until the revised plate in the *Schopfungsgeschichte* (1898) took off, and cheap pamphlets of lectures in 1905 and 1907 suddenly flooded the market with plates based on later editions of the *Anthropogenie*. If copies in other works were shown, it would magnify the dominance of the early plates. Data, some estimated, are from table 9.1, but plates of sandal germs are not included here.

Fig. 9.19 Embryos of nine different mammals at three similar stages, from *Unsere Ahnenreihe* (Our ancestral series), Haeckel's *Festschrift* for the 350th anniversary of the University of Jena and the linked handover of his Phyletic Museum to the university in 1908. The forms are almost all copied from the *Anthropogenie* and *Schöpfungsgeschichte*—only the tarsier is new—but the arrangement is fresh and the presentation more academic. Halftone after drawings by Adolf Giltsch from Haeckel 1908, plate VI, by permission of the Syndics of Cambridge University Library.

Embryonen von neun verschiedenen Säugetieren auf drei ähnlichen Entwickelungsstufen.

A. Giltsch, phot. Verlag von **Gustav Fischer** in Jena.

"people's edition."[102] It had already featured—unillustrated—among Haeckel's collected "popular works," but—admitting failure—the *Anthropogenie* did not.[103]

For a long time the expanded grids did not seem to matter much; Haeckel barely commented on the increased detail. More of the early versions were printed, with more publicity and longer working lives (fig. 9.18), precisely the bias amplified by translation into English.[104] A variation on the column design in an occasional academic publication is merely an interesting curiosity (fig. 9.19).[105] But in 1905 and 1907, as the imperial columns symbolized the indulgent overspecialization that killed the *Anthropogenie*, cheap German pamphlets of public lectures reprinted plates derived from them (figs. 14.4–14.5 below). These quickly sold eighteen thousand altogether, making their embryos the most prominent and accessible of any in Haeckel's books (fig. 9.18).[106] In 1908–9 the second major forgery debate targeted revisions of the gibbon figures, and thus turned parts of the enlarged grids into some of the most widely discussed. The huge audience for the *Welträtsel*, and photo-relief printing, had given them a second wind.

In the absence of a hostile consensus, German colleagues had allowed Haeckel to expand the plates, or at least been unable to stop him. Yet specialists shunned his work and then set standards for vertebrate embryology that pushed his practice and his pictures ever further beyond the pale. Wilhelm His regained the initiative by making such an example of Haeckel's trump card, Wilhelm Krause's human embryo with a free allantois, that it would stand as a warning for decades to come.

{ **10** }

Setting Standards

Haeckel's polemic over aims and methods had defended the "evolutionary deductions" in the *Anthropogenie* by recalling his conclusion that because human and ape placentas were essentially the same, their development could not differ. "Since, however, the vesicular form of the allantois had not then been observed directly in humans, I was most ceremoniously accused of 'scientific forgery' by Wilhelm His." Fortunately for Haeckel, or so it seemed, Professor Krause of Göttingen observed the allegedly "never visible" structure that very year, 1875. But His had the last laugh when he made the preparation the most dramatic casualty of demanding new standards for human embryology. He reinterpreted it so outrageously his colleagues consented only after a formal viewing ended two more years of debate.[1]

The His reforms put studies of the rarest specimens of the most challenging species on a new basis. A *normal plate* ordered human embryos, and his sectioning and modeling generated detailed internal descriptions. The next generation extended the methods across the vertebrates, discrediting the simple doctrine of recapitulation with its equivalent phylogenetic stages, such as a fish stage through which all mammals must pass. Concern about variation between individuals even threatened to prevent the setting up of stages within species. But rather than abandon evolutionary questions, some anatomists adopted His's techniques to recover the more complicated evidence of phylogeny from ontogeny. Around 1900 they organized an international project to publish *Normal Plates on the Development of the Vertebrates* that effectively turned each of Haeckel's species columns into a complex monograph. Mid-twentieth-century experimenters simplified these into the staging systems that developmental biologists still use today.[2]

Normal plates, like *normal stages*, are visual standards. Achieving and maintaining scientific standardization has taken large resources when it has been necessary to coordinate activity across institutions or respond to public pressure.[3] Research in nineteenth-century embryology was mostly confined to the universities, and weakly disciplined within them, so its standards stayed informal and local. Norms became practically binding only in the work of His and his successors—the human and comparative vertebrate studies that histories of experimental biology ignored in favor of a somewhat misnamed "revolt from morphology."[4] From the 1880s investigators began to manipulate living embryos, especially of amphibians and sea urchins, to control development and so gain a more powerful understanding of its physiology. Research on humans seemed too limited and medical to

have any fundamental significance, and comparative studies appeared to represent a degenerating research program that experimentalists disparaged as merely "descriptive." A closer, less partisan look uncovers how deeply the renewal of these fields shaped embryological practices and institutions. This history also gives the lie to the assumption that Haeckel's pictures were "popular" and "downstream" of all research: anatomists created the most authoritative images in part in reaction against these, the most contested—and then used their new standards to assess his grids.[5]

Reforming Human Embryology

In the third (1877) edition of the *Anthropogenie* Haeckel put Wilhelm Krause's drawing of the embryo with a vesicular allantois next to his own deduction (fig. 10.1)

Fig. 10.1 Wilhelm Krause's embryo (fig. 7.16) tipped in for the third edition of the *Anthropogenie* (1877). Page from the wide-margined copy of the second edition that Haeckel revised. EHH: B63.

and sent the book to the editor of the Darwinists' new party paper, *Kosmos*. Ernst Krause (no relation) compared Haeckel to Alexander the Great—both dared and won—and His to Zoilus, Homer's bigoted and carping critic. Haeckel had called on "the genius of comparative anatomy" "to make the never-before-seen show itself in the mirror of science." The result was "great excitement among the waiting enemies," who thought they had caught him out, and from "Prof. His, chairman of the holy secret court [*Vehme*]," a "most serious charge."

> Fortuna, however, does not abandon the brave. At the time of greatest need she sends Prof. Krause in Göttingen the never-seen to inspect, and behold, it appears in exactly the form which Haeckel had sketched. The accusers now take their stand on an old paragraph of the holy penal code, in which is written that prophecy [*Wahrsagen*] is forbidden. However, it appears that this is a slip of the pen, and that in science it is rather false prophecy [*Unwahrsagen*] which produces a bad reputation.[6]

Krause's embryo allowed Haeckel a rare victory on facts.

Unimpressed, embryologists complained that they could not place the preparation in developmental series. Kölliker argued that an 8 mm human embryo from the fourth week of pregnancy with limb rudiments, head curvature, "gill slits," eyes, and a developed heart could not still lack an umbilical cord, which should develop *from* the allantois, when three-week embryos were known to have one already. For the moment, he interpreted what Krause called the allantois as in fact the yolk sac, and what Krause labeled the yolk sac, but was in his view too large, as the umbilical cord with remnants of the amnion attached. (Figure 3.11B labels the parts.) When Krause rejected this proposal as "unanatomical," and swore that age estimates were not so exact, Kölliker suggested abnormality.[7] Other experts expressed misgivings too.[8] Haeckel's faith looked rash, but the field was still too open to exclude even this object from the discussion.

Though His never replied to Haeckel's counterattack, he had not given up; like his enemy Gegenbaur, he put his energy into research. Having privately told Krause that he suspected another species was involved,[9] in 1878 His embarked on an unprecedentedly

systematic study of human embryos from the first two months. Haeckel played no further direct role and the strength of the relationship between their confrontation and this new research is a matter of conjecture. It was an obvious move for an anatomist to apply to humans the sectioning and modeling methods developed on the chick. By making the degrees of vertebrate similarity and difference so controversial, Haeckel had destabilized human embryology—vulnerable with its scarce early preparations, widely used surrogates, and diverse observers—and this surely gave His an added incentive. The resulting *Anatomie menschlicher Embryonen* (Anatomy of human embryos), issued in three parts between 1880 and 1885, certainly stood for the specificity of human development and the independence from comparative questions of specialists able to analyze preparations comprehensively with the latest techniques. Professor His directed his reforms to taking human embryos out of the hands of clinicians and of those he dismissed as "embryological amateurs."[10]

To begin with, His collected the earliest embryos he could find. Placing himself at the center of a supply network of scientists and physicians, he amassed seventy-nine in all, the vast majority from miscarriages and abortions. The first were the fruit of face-to-face interactions among Basel doctors. Stick and carrot induced others to give up "their rare finds." He criticized gynecologists for ruining or wasting "precious objects" by failing to deliver them to an anatomist's microtome.[11] But he rewarded doctors who agreed "to collect material" for "sacrifice … on the altar of science"[12] by calling the embryos by the initial letters of the donors' surnames—the physicians', that is, not those of the women from whose bodies they came.[13] Naming symbolized the embryologist's taking possession. It took these items out of stories of waste removal, illness, and pregnancy loss, and inserted them into a scientific narrative of development.[14]

Not just reframing his specimens as embryos, His physically reconstructed them too. Photographing the opened but still whole ova recorded the external details; at meetings he projected a set of ten photographs that his institute photographer sold (fig. 10.2A). Then His or his artist drew the contents, often from the photographs (fig. 10.2B). Drawing required and benefited from judgment, His reckoned, a widely shared conviction that explains why it took decades, even after photographs became easier to reproduce in print, for them

Fig. 10.2 Successive representations of embryo A, donated by the Leipzig gynecologist Friedrich Ahlfeld to Wilhelm His. *A*, glass photograph by Th. Honikel; *B*, lithograph after drawing by C. Pausch (in which the tear between head und rump has been filled in); *C*, detail of lithograph after His's drawings of cross-sections; *D*, "original model by Wilhelm His" in black wax; *E*, Friedrich Ziegler's wax reproduction of His's model; *F*, Ziegler's "dissection." *A, D–F*, Anatomisches Museum Basel; *B–C*, W. His 1885, plate I* and 1880a, plate V, by permission of the Syndics of Cambridge University Library.

Fig. 10.3 An embryograph designed by Wilhelm His to replace the standard combination of microscope and camera lucida for work at low magnifications (5–20 ×). Edmund Hartnack of Paris and Potsdam sold the apparatus from the early 1880s. We see a drawing prism, objective lens, and stage, all freely movable on a graduated retort stand, above a mirror; the image was projected onto a drawing table. Instrument, height *c.* 45 cm, acquired from a Dr. M. Abraham in 1942, Historical Collections, National Museum of Health and Medicine, Washington, DC.

to play much role in journals. But he made drawing more mechanical with an apparatus adapted for low magnifications and later marketed as an *embryograph* (fig. 10.3).[15]

This work introduced serial sectioning and plastic reconstruction into human embryology. Thin slices on microscope slides gave greater access to internal anatomy (fig. 10.2C), but alienated the microscopist from the experience of bodily form. So His insisted that the sectioned preparations be reconstructed in wax (fig. 10.2D). Only in this way, he argued, could an anatomist fully grasp complex microscopic structures and communicate that understanding to others. He modeled freehand, correcting the shapes by measuring with calipers against drawings in different planes. This converted the nondescript objects he had received into enormously magnified, solid embryos, which the Ziegler studio reproduced and sold (fig. 10.2E-F).[16]

It was hard to achieve a truly developmental order. Distrusting women's estimates of days since their last period, and given uncertainty about the timing of ovu-lation relative to menstruation—the dominant view still had them coincide—His used criteria in the embryos themselves.[17] Other vertebrates provided general orientation, but the whole point of taking the trouble to study humans was to discover how similar or different they were. In the end he arranged them by length, but since they curl up to varying degrees through development, he first took pains to define a standard measure.[18] For the earliest he still relied on judgment.

Where Soemmerring had sought perfection, His claimed to show probably normal, well-analyzed individuals. He tried to derive stages from them,[19] but went back to the seriation of particular specimens, a more cautious approach suited to a field that proceeded from one rarity to the next.[20] Setting aside the obvious abnormalities,[21] he scoured case histories and states of tissue preservation for further clues, alert to any mismatch in development between embryo proper and the surrounding membranes. But what was to count as normal would emerge only from comparing well-studied preparations of clear provenance. Unsparing criticism promulgated new standards for embryonic material, its analysis, and its investigators, and excluded much as abnormal or poorly described.[22] The targets included a spate of recent reports by clinicians. Brutal judgments pressured others to hand specimens over and gradually established a series based on steadily increasing length and degree of development.

This review paid Krause's embryo special attention. The anatomical section of the congress of German nature researchers and physicians heard the shocking verdict in September 1879: the preparation their colleagues had debated for four years was not human at all, but a bird.[23]

Sitting in Judgment

In the first (1880) installment of the *Anatomie* His compared Krause's figures with "good illustrations of human embryos of the same stage" to identify a series of major differences, in all of which, His said, Krause's embryo looked birdlike (fig. 10.4). The midbrain was too small to be human and the diameter of the eye about three times too large; the pharyngeal arches were too short; there was no trace of the liver; the posterior end was a short stump instead of a substantial forward-curling structure; the whole body was too little curved.

A **Fig. 5.** Menschl. Embryo (B.) 7 mal vergrössert.

B recht ansehnliche Leberanschwellung, von welcher an KRAUSE'S

Fig. 6. KRAUSE'S Embryo 7 mal vergrössert. **Fig. 7.** Hühnerembryo 7 mal vergrössert.

Zeichnung keine Spur zu sehen ist. Ferner ist beim menschlichen Embryo der nach vorn umgeschlagene Theil des hinteren Leibes-

Fig. 10.4 Drawings comparing *A*, His's human embryo B; and *B*, Krause's embryo and that of a chick. W. His 1880a, 70–71.

Krause had told His the embryo came from "a doctor friend." "The error may have been caused by a chance mistake, but it may rest on actual deception [*Mystification*]. On that, of course, only Krause himself can shed light, after he has first consulted with his source."[24] Professor His went on to develop the hypothesis that in humans the embryo never separated from the chorion, but remained linked to it through a "belly stalk." The tiny allantois at no stage projected as a free vesicle into the chorionic cavity, but grew as a duct along the already present connection: a free allantois was not merely "not visible," it never existed.[25]

Rejecting or ignoring His's reforms, Krause defended his preparation for another two years. He provided no more information on provenance, and refused, until he secured agreement on external morphology, not only to section the embryo, but even to remove the amnion or let it travel; all were too risky, he claimed. He released new drawings and used these to contest or dismiss as trivial all of the features His reckoned avian. To solve the most worrying problem, that much younger embryos had been described with fully formed umbilical cords, Krause posited that a disturbance of the yolk circulation had led the allantois to form too early to compensate for the hydraulic imbalance, and that as a consequence the embryos died. Early adhesion with the chorion—the basis of His's theory of belly-stalk formation—was abnormal.[26]

Other embryologists remained skeptical, but continued to suggest ways in which the embryo might represent a human abnormality.[27] Perhaps they were reluctant to associate themselves with an embarrassing suggestion. But no specialist either leapt to endorse His's view or declined to discuss the specimen until it was better documented. How could he promote norms while a professor of anatomy remained free to defend as exemplary an embryo that His placed in another vertebrate class? This shows how far he still had to push his colleagues to accept his reforms; it also gave him a golden opportunity to drive them home.

In late 1880, His reasserted his standards. First, he demanded again that Krause provide information on provenance and original condition. "It is imperative," His insisted, "formally to notarize every new document properly before introducing it into the discussion … especially … when …, like yours, [it] flatly contradicts every other, including the best authenticated." Second, His disputed Krause's defense; only removing the amnion and sectioning at least the head could resolve the matter. Third, Krause had explained

Fig. 10.5 *Normentafel*, or normal plate, of human embryos by Wilhelm His. While ordering and selecting, His had worked on his own sharp outline drawings, but for this survey his closely supervised artist C. Pausch drew the delicate forms. Lithograph from W. His 1885, plate X, by permission of the Syndics of Cambridge University Library.

W. His gez. Verlag von F.C.W. Vogel in Leipzig. C. Pausch lith.

Druck v. J.G. Bach, Leipzig.

away the lack of a connection to the chorion by branding all such cases abnormal. "It is a brave advance into enemy territory that you have undertaken there," His mocked. Krause seemed to be arguing that "there is just nothing else for it but to break with the previous human embryology, and, beginning with yours as the youngest normal human embryo known until now, to make a fresh start." Doubting that specialists would follow, His stressed that only thorough analyses could protect the field from "uncritical or … overcritical gusts of wind."[28]

Krause fought on through 1881.[29] If he could not stem the criticism, neither could His decisively discredit the embryo. Krause refused to put the unique object at risk by sending it on the train or bringing it to a conference, but he confidently invited embryologists to Göttingen to see it, and His declared himself willing to participate in a meeting to "sit in judgment on your embryo."[30] The opportunity came in April 1882 at a celebration of the fiftieth anniversary of Jacob Henle's doctorate, a lavish occasion honoring the grand old man of German anatomy. Former students, friends, and official delegations descended, tributes and congratulations flooded in, and the celebrants ate, drank, and speechified.[31] In some spare time the local zoologist showed the anatomists "the famous object." Krause and His were absent, but in open letters Kölliker and Carl Hasse declared it a bird. They saved faces by focusing on features not apparent in Krause's drawings: the huge size of the yolk sac implied by its remains and the massive vessels it contained. That the embryo was a chick they could not say; it might just as well have been a duck, a goose—or a turkey.[32]

These declarations closed the debate. Haeckel silently removed the figure of Krause's embryo from the fourth edition of the *Anthropogenie*, but used Selenka's recent extension of His's belly-stalk theory to the anthropoid apes to claim this peculiarity as proof of their closeness to human beings.[33] Krause may never have been reconciled, but could not challenge the verdict publicly,[34] while His had turned resistance to advantage. The new methods had not been needed, but he had dismissed a specimen that failed to meet his standards, and seared into memories the risks of dabbling with human embryos.

In 1885 His produced a summary *Normentafel*; anglophone authors used the German word or trans-lated it as *normal plate*. Twenty-five embryos develop from the end of the second week of pregnancy—as he estimated the earliest specimen—until the end of the second month (fig. 10.5).[35] Putting them all on a single plate in sequence, in side view, nearly all from the left, and at the same magnification vividly conveyed the effect of development and made it easy to classify new specimens with respect to his own.

The exclusion of Krause's embryo should be recognized as the founding event of modern human embryology. Early human specimens had once been almost an afterthought in textbooks ostensibly devoted to the topic, but now anatomists left gaps rather than present surrogate material. The resolution of the case also contrasts with the stalemate over Haeckel's pictures. The figure he borrowed from Krause depicted a particular object and was first published in a specialist journal. A clear target was easier to hit and the claim to broad significance increased the pressure to do so— but this still took much argument over seven years. Haeckel's syntheses would be far more difficult to stop, even as His's concerns spread to comparative research.

A Crisis of Staging

Evolution continued to motivate embryology—none more extreme than collecting emperor penguin eggs during the fateful "winter journey" of Robert Falcon Scott's Antarctic expedition in 1911 (fig. 10.6).[36] But Darwinist morphology had entered a long crisis in the 1880s, when biologists found it ever harder to agree about recapitulation. Though usually understood in terms of ideas, their predicament may be grasped practically and pictorially as a crisis of staging, not just between species, but also within them. Haeckel's embryos were a frequent, if generally implicit, reference point.

According to the biogenetic law, the development of all animals marches in parallel, so that ontogeny repeats phylogeny. Haeckel admitted that they never correspond exactly. Just as transmission and translation corrupted texts, so ontogeny "falsified" the ancestral record. He distinguished the faithful *palingenesis* from the corrupting *cenogenesis*, with its major mechanisms, *heterochrony* and *heterotopy*. Heterochronies are changes in the timing of development; for example, in vertebrates the heart appears earlier in relation to the other organs than it did in evolution. Heterotopies

FIG. 10. EMPEROR PENGUIN AND CHICK.

To face p. 16.

Fig. 10.6 "Emperor Penguin and Chick" at the Cape Crozier rookery on Ross Island, where the British National Antarctic (Discovery) Expedition landed in 1902. Biologist Edward A. Wilson's contribution to the report attached "the greatest possible importance" to working out the embryology of this "nearest approach to a primitive form not only of a penguin but of a bird" (E. Wilson 1907, 31). The search for the eggs inspired the "worst journey" of the Terra Nova Expedition of 1910–13. Wilson froze to death with Scott, while Apsley Cherry-Garrard survived to present three eggs to an underwhelmed British Museum. E. Wilson 1907, fig. 10.

are changes in place, especially shifts of cells from one germ layer to another: the sex glands arose in the mesoderm, but must originally have developed from one of the primary germ layers.[37] This made the evidence of evolution tougher to interpret, but as long as the cenogenetic chaff could be separated from the palingenetic grain, the doctrine of recapitulation accommodated exceptions so readily it could never be disproved.[38]

Embryologists' conflicting choices nevertheless made the theory seem arbitrary and left them vulnerable to attack. Embryology and adult anatomy had been supposed to cooperate in establishing phylogenies, but Gegenbaur rejected Haeckel's exaggerated claims for ontogeny. By the late 1880s he was arguing from Heidelberg that cenogeneses could be identified only from knowledge of animals' completed, active states. With more fossils unearthed, paleontologists asserted their own privileged access to the only direct evidence. By the 1890s bitter, inconclusive turf wars were driving young scientists away.[39]

Embryology had prospered under Darwinism, but its institutions were still weak, or at least diverse, and riven by competing approaches. The most successful was the developmental mechanics of the Jena-trained anatomist Wilhelm Roux, which went beyond His's

modeling to investigate development experimentally. Roux and his followers manipulated living embryos. For example, they discovered the awesome power of *regulation* by shaking apart the first two cells of a sea urchin embryo and producing not two half embryos, but two half-sized normal larvae.[40] Histories written to trace the origins of mid-twentieth-century biology shift to these experiments from the 1880s and present "descriptive embryology" as an older, less powerful approach. But although increasingly on the defensive, the field against which experimentalists demarcated their own endeavors was not really older, in part because they applied the label in a new way. The term *descriptive* had once meant anatomical as opposed to comparative studies. Haeckel expanded the category to disparage work not informed by phylogenetic concerns, and the experimenters enlarged it still further to include phylogeny too. *Descriptive embryology*, in this sense of nonexperimental work, was new also because human and comparative embryologists reformed techniques and institutions.[41]

During the 1870s His was isolated from morphologist-embryologists, and young zoologists found rich pickings by following Haeckel, but during the 1880s His gained clout. Many were casting around for new approaches, and the anatomists were under pressure

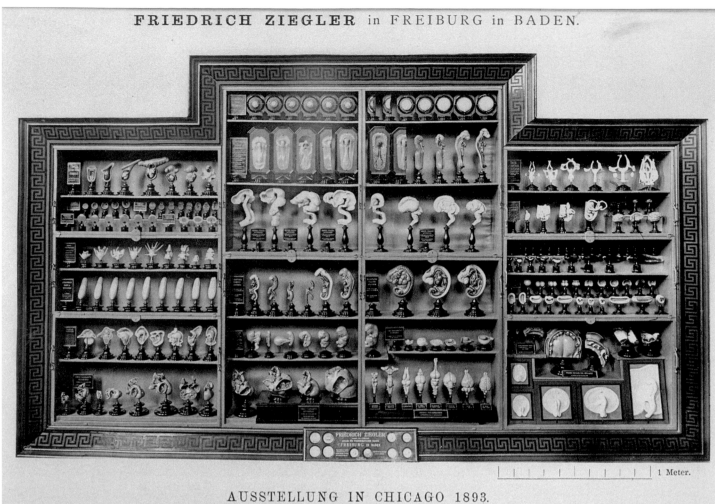

FRIEDRICH ZIEGLER in FREIBURG in BADEN.

AUSSTELLUNG IN CHICAGO 1893.

Fig. 10.7 Friedrich Ziegler's stand at the World's Columbian Exposition in Chicago, 1893. Rivaled only by Haeckel's plates, this is the most impressive visual synopsis of human and comparative embryology in their heyday around 1900. Photograph from Ziegler 1893. Division of Rare and Manuscript Collections, Cornell University Library.

to study the then experimentally inaccessible mammalian embryos. His's normal plate provided a framework for new specimens, and the models displayed internal detail. Modeling became feasible when anatomists adopted the simpler method of transferring magnified sectional drawings to wax plates, which they cut out and stacked up. Monographs and articles described models, which Adolf's son Friedrich Ziegler "published" in parallel and sold to institutes worldwide (fig. 10.7).[42]

All this made mastering development so time-consuming that individual investigators could tackle specific problems only. The wealth of detail combined with the diversity of approaches to spread "fragmentation and confusion." So in 1886 His proposed the establishment of central institutions to collect and prepare specimens, and produce drawings, photographs, and models. He had in mind the Naples Zoological Station, which offered researchers from around the world bench space and organisms. The plan was to do for embryology what the botanical gardens and observatories, geographical and geological surveys, meteorological institutes and statistical bureaus were already doing, and the Imperial Physical-Technical Institute then promised.[43]

While serving a standardizing agenda, enlarging the empirical commons was a nonpartisan enough goal to spur collaboration and institution-building, but this took many years. Meanwhile, the greater attention to individual specimens was making comparison across species harder still. Continuing to stress the connections, Haeckel made light of such difficul-

Nr.	Material	Länge	Alter	Körperform	Keimscheibe	Urwirbel	Chorda	Nerven-system	Auge	Ohr	Nase	Epiphyse Hypophyse	Mund	Verdauungs-tractus	Kiemen-spalten	Urogenital-system	Herz und Gefäße	Integument und Skelett	Extremi-täten	Amnion	Allantois	Bemerkungen
18	Gasser 38					7—8 Urw.							Kopfdarm-höhle ge-wachsen				Verschmel-zung der beiden Herz-hälften					
19	Gasser 37					circa 8 Urw.										Wolffscher Gang im Ent-stehen						
20	Kupffer 50 Fig. 49	5,1 mm				8 Urw., Bil-dung des 9. angedeutet		Schluß des Vorderhirns ist erfolgt. Schlußstelle 2 Knöpfchen														Blut und Gefäße im Gefäßhof. Anlage des Sinus terminalis
21	Gasser 47					8 Urw.	Läuft nach vorn in eine dicke Zell-masse aus	Gehirn-nerven														
22	Gasser 47					9 Urw.																Pleuroperi-cardialhöhle vorhanden
23	Gasser 38					10—11 Urw.											Blutkörper-chen im Herz und in den Aorten					
24	Janosik 115					11 Urw.										Erster An-fang des Wolffschen Ganges						
25	Gasser 47			Primitiv-rinne noch vorhanden		12 Urw.		Medullar-rohr klafft nur hinten noch ein wenig														
26	Braun 46	5 mm				13 Urw.																
27	Gasser 37					circa 14 Urw.										Wolffscher Gang, solider Strang						
28	Kupffer 50 Fig. 60		30 St.	Drehung des Kopfteils. Linke Seite gegen den Dotter		14 Urw.		Ganglion acustico-faciale	Beginnende Abschnürung der Augen-blasen	Grube	nicht deutlich											
29	Gasser 47					14—15 Urw.		Medullar-rohr voll-ständig ge-schlossen														
30	Gasser 07					16 Urw.										Wolffscher Gang zeigt deutliches Lumen						
31	M.			Embryo liegt auf der lin-ken Seite		20 Urw.	Ch. im Vorderkopf. Verbindung mit den Mesoderm-flügeln	Hinterhirn segmentiert auch das Me-dullarrohr	Beginnende Bildung der sek. Augen-blase. Linse: seichte Grube	Tiefe noch offene Grube			Rachenhaut nicht durch-brochen	Enddarm noch nicht geschlossen	1. u. 2. Kie-menspalte mit Ver-schluss-platte.					Niederes Kopfh. reicht nicht bis zum Mittelhirn	Nicht vor-handen	
32	Janosik 115					22 Urw.										W. G. reicht weiter cau-dalwärts als Urwirbel ge-bildet sind						
33	Hoff-mann 68					24 Urw.								Schwanz-darm ge-schlossen							In der An-lage be-griffen	
34	Janosik 115			.		30 Urw.										Primäre Ur-nierenkanäl-chen						
35	Janosik 115							Sek. Augen-blase, Linsen-anlage noch nicht abge-schnürt								W. G. hat im hinteren Ab-schnitt noch kein Lumen						Ist nach Janosik älter als No. 34

Fig. 10.8 Table of development by Albert Oppel. The rows represent specimens, the columns length, age, body form, germinal disc, somites, and so forth. This is part of a table for the chick, of which several were needed because authors had described their material in incompatible ways, as either individual specimens (shown here) or stages. Oppel 1891, 122–23.

ties, but railed as "the most blinkered *specialism* everywhere achieves great success."[44] The situation was especially difficult for younger anatomists who accepted His's techniques as the state of the art but saw the troubled relations between ontogeny and phylogeny as the big challenge. Research and discussion concentrated in the anatomical institutes of the German southwest: Freiburg and Heidelberg in Baden and the Imperial University at Strasbourg.

In 1891 a systematic review made the major difficulty of setting up ancestral stages between species overlap with a minor crisis of staging within them. Having set out to compare the development of organs in different vertebrates, the histologist Albert Oppel despaired of the literature. Some authors gave age or length as if these had any general significance. Many set up stages on the basis of somite number or whatever organ they happened to be studying and aggregated features observed in different embryos. But variation in the relative development of different organs within species made this unreliable and the addition of new material difficult. That left Oppel's survey inconclusive, but he provided his successors with a format for comparing and extending internal analyses: tables in which columns represent dimensions and organs, and rows the progress of development (fig. 10.8).[45]

Embryology was participating in an anthropologically informed movement to investigate normal variation. In Strasbourg Ernst Mehnert sharpened Oppel's critique of staging. Impressed by variations in bird and turtle embryos, he censored the assumption "that embryos of the same species belonging to the same

stage are absolutely the same as each other and that as a result more or less any embryo may serve as norm for the relevant stage." Embryologists who troubled to investigate many objects found considerable variation. They avoided giving specific times for the appearance of a structure and speaking of "stages," but rather described development within a certain period and evaluated the individual deviations.[46]

Oppel's Freiburg colleague, Franz Keibel, took an equally bleak view. Early evolutionist enthusiasm had generated (Haeckel's) synoptic but superficial works, while the new methods had been applied only to particular periods or organs. Standards had changed so much that after several generations of research the field seemed without a complete embryology of any animal. It was time to go back to detailed studies of individual species. Keibel presented his own of the pig as a test of that "premature generalization," the biogenetic law. Unable to fit the material into ancestral stages, he concluded that the temporal "jumblings up" (*Durcheinanderschiebungen*)—"displacements" was too mild—were such that, for mammals at least, the law was false. One could not distinguish a fish stage, let alone a "land-animal stage," and it made no sense to salvage the law for individual organs alone. "Temporal separation is inherent in the concept of *stage*," he argued; "it appears impossible to speak of stages temporally displaced through or over one another."[47]

Keibel stayed loyal to embryology. Gegenbaur wanted adult anatomy as the appeal court, but Keibel planned to unlock the more complex ontogenetic evidence by turning heterochronies from problems into topics of research.[48] In October 1895 he called for collaborators on *Normal Plates on the Development of the Vertebrates*.[49] Implicitly, these harked back to Haeckel's grids, which served as an inspiration and a warning, flawed icons that Keibel aimed to supersede. Explicitly, His's *Normentafel* and Oppel's tables provided models for comparisons that would respect the differences between species and even individuals. By February 1896 the anatomists' house publisher Gustav Fischer, savior of the scientific book trade in Jena, had agreed to bring out the normal plates, in runs of three hundred each.[50]

The crisis of evolutionary embryology may thus be reinterpreted as a crisis of staging within species as well as between them. Critiques of the biogenetic law made it impossible to line up ontogenetic and phylogenetic stages. Critiques of casually identifying specimens with stages highlighted individual variation. Normal plates offered a way out.

Every Column a Volume

Keibel turned each column of Haeckel's comparative plates into a complex monograph that would explore the "jumblings up" that prevented specialists from arranging embryos in phylogenetic order. The new genre combined His's and Oppel's designs; Keibel's own republished work on the pig set the pattern for quarto volumes of plates and tables with a terse text and long bibliography (fig. 10.9).[51] The tables indicated the overall degree of development and, based on serial sections, that of primitive streak, somites, notochord, nervous system, and other parts (fig. 10.10). Keibel began with the wish to reinvestigate ontogeny and phylogeny and his local need to respond to Mehnert's critique of staging. Then a consensus formed on the desirability of the plates as laboratory tools for ordering jars, microscope slides, drawings, and models.

An international team covered fourteen species before World War I temporarily halted the project. Keibel, his collaborators, and other German-speaking anatomists did most of the work. The United States contributed through Minot at Harvard, Chicago zoologist Charles O. Whitman, and their junior colleagues. The zoological explorers did the rest: Richard Semon, John Graham Kerr from Francis Balfour's Cambridge school, and Selenka's student Ambrosius Hubrecht of Utrecht. Semon, Kerr, and his companion John Samuel Budgett went after lungfishes on three continents because of the status of these animals as (relatives of the) links between fish and land vertebrates. Like Semon in Australia, Kerr and Budgett fished the South American lungfish in the swamps of the Gran Chaco in Paraguay.[52] Budgett then independently collected the African one in the Gambia, and handed the embryos to Kerr before dying as a result of an expedition to observe the development of another primitive fish.[53] In

Fig. 10.9 Normal plate of the spectral tarsier, *Tarsius spectrum*, by Franz Keibel, using material collected by Ambrosius Hubrecht, who placed this species at the root of the primate line. Haeckel copied figure 18a and two figures showing earlier stages (fig. 9.19 above). Lithograph by Adolf Giltsch after drawings by the Freiburg artist Richard Schilling, from Hubrecht and Keibel 1907, plate III.

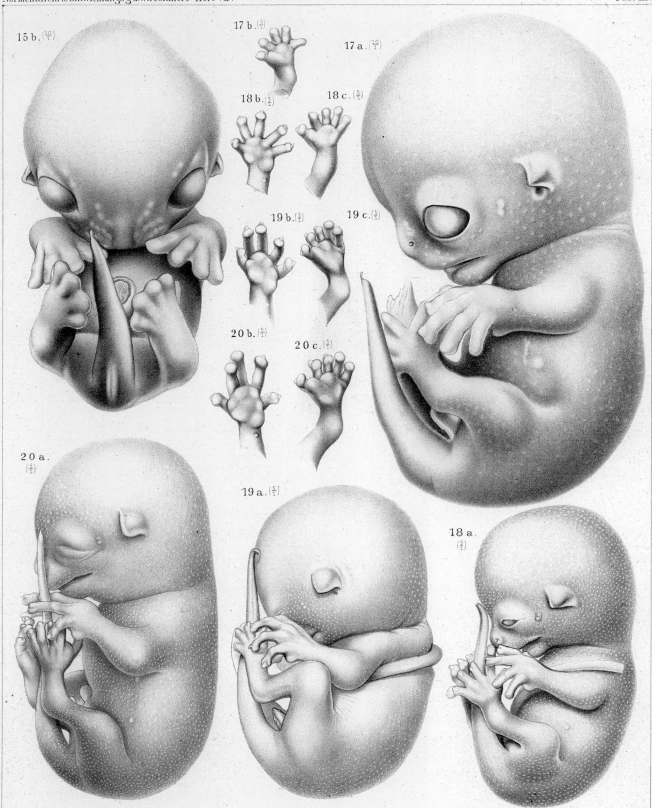

15 b. $\left(\frac{10}{7}\right)$

17 b. $\left(\frac{5}{1}\right)$

17 a. $\left(\frac{10}{7}\right)$

18 b. $\left(\frac{5}{1}\right)$

18 c. $\left(\frac{5}{1}\right)$

19 b. $\left(\frac{5}{1}\right)$

19 c. $\left(\frac{5}{1}\right)$

20 b. $\left(\frac{5}{1}\right)$

20 c. $\left(\frac{5}{1}\right)$

20 a. $\left(\frac{5}{1}\right)$

19 a. $\left(\frac{5}{1}\right)$

18 a. $\left(\frac{5}{1}\right)$

R. Schilling gez.　　　　　Verl. v. Gustav Fischer, Jena.　　　　　Lith.Anst.v.A.Giltsch, Jena.

Bez.	Maasse	Körperform	Primitiv-streifen	Urwirbel	Chorda	Nervensystem	Auge	Ohr	Nase	Hypophyse	Mund	Verdauungstractus, Leber und Pankreas	Kiementaschen, Thyreoidea, Thymus, Trachea und Lungen	Urogenitalsystem	Herz und Gefässe	Integument	Skelet	Extremitäten	Amnion	Allantois	Bemerkungen
33 Tarsius 285. N.T. Fig. 17 a u. 17 b.	Gr. L. 16,2 mm.											Anus offen. Ziemlich langer Darm mit medianer Leiste.		Hoden.	Herzsepta geschlossen.	Haare über den ganzen Körper.		Die Finger ganz getrennt.			Fix.: Pikrinschwefelsäure. Zool. Mus. Utrecht.
34 Tarsius 72. N.T. Fig. 18 a bis 18 c.	Gr. L. 20 mm.	N.T. Fig. 18 a bis 18 c.										Noch keine deutlichen Darmzotten.		Hoden. Conus inguinalis.			Etwas weiter als Tab. 33.				Fix.: Pikrinschwefelsäure. Zool. Mus. Utrecht.
35 Tarsius 735. N.T. Fig. 19 a bis 19 c.	Gr. L. 20,8 mm.	N.T. Fig. 19 c.										Kein Darm mehr im Nabelstranggebiet.		Ovarium.			Etwas weiter als Tab. 33.				Fix.: Pikrinschwefelsäure. Zool. Mus. Utrecht.
36 Tarsius 492. N.T. Fig. 20 a bis 20 c.	Gr. L. 24 mm.	N.T. Fig. 20 a bis 20 c.												Hoden. Müller'scher Gang in Rückbildung.			Sehr ähnlich den vorigen.				Fix.: Pikrinschwefelsäure. Zool. Mus. Utrecht.

Fig. 10.10 Part of the table of tarsier development from Keibel's normal plate. He described not stages, but individual specimens, and included sixteen not illustrated on the plates. Hubrecht and Keibel 1907, 26–27.

Indonesia Hubrecht hunted lorises and tarsiers as human ancestors.[54]

These diverse specimens were all to be analyzed in the same way, but limitations—Hubrecht had just ten loris embryos—combined with local styles. Authors differed less in microscopical and graphic procedures than in how they selected representatives and what they took these to represent. Informed by criticisms of naïve staging within species, Keibel and his direct collaborators offered selections of mere individuals; others made particular objects stand for stages. Intending the tables to provide materials for the study of variation, Keibel included as many additional individuals as he could; Kerr described only the lungfish depicted.

Celebrating progress since the Krause affair, Keibel allowed himself to express satisfaction. "A confusion of human embryos with those of sauropsids [birds and reptiles], as could still happen to an expert thirty years ago and at that time led to a rather lengthy discussion, may be regarded as impossible today." As His had predicted, "in all sufficiently well known forms the differences are so striking that one glance is enough to make the differential diagnosis."[55] Yet the normal plates will have disappointed anyone looking for a handy visual summary.

For gross comparisons Keibel referred to a handbook chapter which more typically emphasized not progress since Haeckel began showing embryos around, but how much harder the task had become. "The external forms of vertebrate embryos in the various stages of their development are, of course, determined by their whole internal development and cannot be understood in detail if we do not know this internal structure quite exactly. It is today, however, barely possible to analyze the external form of a very few older embryos in this way, let alone the form series of the embryos of the main types of all vertebrates." So Keibel presented one developmental series after

Fig. 10.11 The Central Embryological Collection when still at the Hubrecht Laboratory, Utrecht. *A*, whole embryos of the macaque monkey *Macaca irus*; *B*, sections of the embryos on microscope slides. (The collection is now at the Museum für Naturkunde, Berlin.) Courtesy of Jenny Narraway; *A*, reproduced with permission from Richardson and Narraway 1999.

another, from amphioxus to human beings, but did not align them and so avoided commenting on stage relations.[56]

In concluding, or rather failing to conclude, Keibel admitted that he should have tried to explain the similarities and differences, but pronounced this impossible. He offered little more than a review of His's attempts to deal with the problem since he had weighed drawings on card, measurements that, for Keibel, would have needed statistically significant numbers. He emerged from a maze of detail only to explain that the bigger problem of mechanical explanation remained intractable and to reiterate that the biogenetic law was invalid. Unable fully to embrace either His's or Haeckel's broad views, the field appeared empirically overwhelmed.[57]

The collection of heterochronies produced no new synthesis.[58] The plates succeeded rather as standard laboratory tools that also facilitated the creation of the first research institutes and specialist society dedicated to embryology. Keibel worked with His's student, the American anatomist Franklin Paine Mall, to establish human studies at a department funded from 1914 by the Carnegie Institution of Washington at the Johns Hopkins University in Baltimore, which became the leader in that field.[59] His's plan for a central institution eventually led to the foundation in 1911 of the International Institute of Embryology, today the International Society of Developmental Biologists, which promoted collection from endangered colonial mammals. A laboratory established in Hubrecht's memory at Utrecht housed a central collection (fig. 10.11).[60]

World War I ended the modest revival of comparative embryology—research on human embryos continued apace—and halted the normal plates. Restarted in the 1920s and 1930s, they shared in the mid-twentieth-century marginalization of comparative work, but nevertheless impelled others to adapt the *Normentafel* design. The increasingly dominant experimentalists transformed Keibel's complex, bulky tomes to suit their own needs. Now using microsurgery to transplant tissue within and between individuals of different species and degrees of development, they sought convenient tools for rapidly staging living embryos. In developmental biology after World War II normal stages—often reduced to a few journal pages—helped domesticate model organisms (fig. 10.12). With embryology still fairly weakly institutionalized, and the

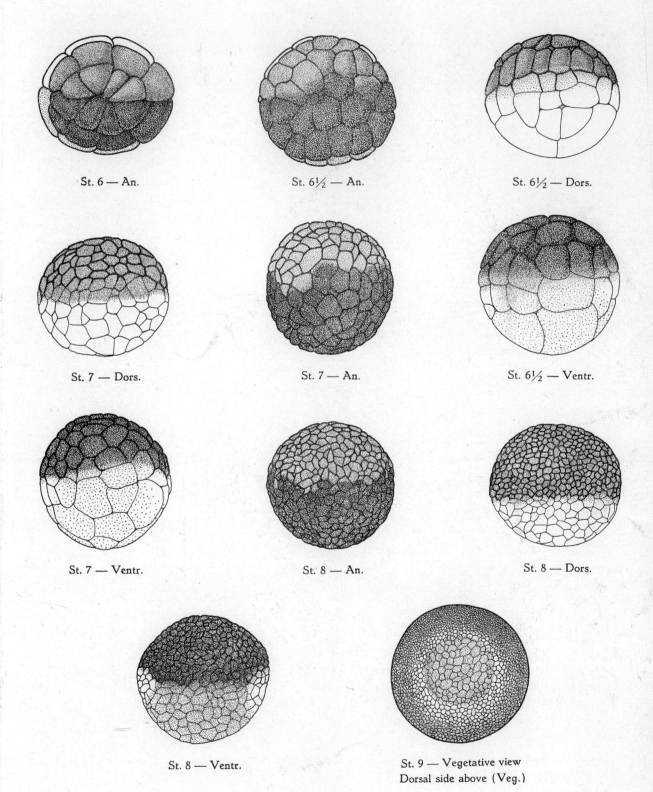

St. 6 — An.

St. 6½ — An.

St. 6½ — Dors.

St. 7 — Dors.

St. 7 — An.

St. 6½ — Ventr.

St. 7 — Ventr.

St. 8 — An.

St. 8 — Dors.

St. 8 — Ventr.

St. 9 — Vegetative view
Dorsal side above (Veg.)

stakes low, scientists in strategic positions proposed divisions of development that others usually accepted for their convenience in research. Staging systems had emerged from discussions that questioned the very possibility of assigning an embryo to a stage.[61]

Visual Standards

Visual standards go back to the briefly most famous and soon most notorious human specimen of the decades around 1900. Wilhelm Krause's embryo links His's critique of Haeckel to the foundation of a vertebrate embryology that went beyond his "premature generalization" and comparative plates. Pictures that might seem merely popular had goaded the invention of a new genre of standard, and experts would now judge them by its lights.[62] Haeckel attacked excessive exactitude, but welcomed and copied from these columns-turned-monographs nevertheless.[63]

The normal plates did not replace Haeckel's. Anatomist-embryologists who dared not venture any more

rigorous visual synopsis also did not move decisively against his. Krause's embryo had to be eliminated, but figments of Haeckel's imagination did not. Keibel avoided commenting on the grids until forced to take a stand.[64] Even then, he did not criticize the practice of staging across classes. With just three stages and many gross distortions, subtleties were presumably beside the point.

The lack of either alternatives or any resonant expert intervention left the field to Haeckel's plates. Even as specialists adopted technical standards in reaction to the destabilization of human embryology by his pictures, these became standard in the sense of generally used. Embryologists had unique authority, but were just one audience among many. By holding back they left teachers and priests, freethinkers and theologians, mothers and schoolchildren free, with their own skills and interests, to respond to the plates in very different ways. Let His and Keibel sneer; those embryos would unlock the mysteries of life.

Fig. 10.12 Normal stages of the South African clawed frog, *Xenopus laevis*. After World War II, this amphibian, introduced into the world's laboratories for pregnancy testing, was favored for experimental embryology and biochemistry. An international project based at the Hubrecht Laboratory produced *normal tables* that are still in use (Gurdon and Hopwood 2000). Stages for relatively early embryos, from 32-cell to fine-cell blastula, are shown. Reprinted from Nieuwkoop and Faber 1956, plate II, © 1956.

Forbidden Fruit

In the mid-1870s some grammar-school boys took time out from confirmation classes to form "a secret league." Meeting in the "hidden back room" of "a fairly disreputable" Cologne pub, they drank that first illicit glass of beer and read "'the book' ... with its pictures of embryos ..., its boldness against heaven and church." One of them, Wilhelm Bölsche, progressed to a career as the most successful science writer in German history, and Haeckel's *Schöpfungsgeschichte* unlocked an "endless kingdom of ideas" for thousands more.[1] They told of youthful inspiration, often after a more agonizing crisis of faith than this son of a freethinking newspaper editor ever went through. Shaping worldviews and recruiting biologists, *Schöpfungsgeschichte* and *Anthropogenie* aided "self-development," and the embryo plates played a prominent part.[2] Responses to specific illustrations are more challenging for historians to recover than experiences of reading whole books, but there is enough evidence to explore the power of Haeckel's embryos beyond the set-piece national debates. What obstacles did critics erect and viewers overcome, and how did the images change lives?[3]

The controversies of the late 1870s led to a ban from German schools that gave Darwinism the appeal of "forbidden fruit."[4] Rare figures of *Leibesfrüchte*, or "fruits of the body" as embryos and fetuses were called in law, promised initiation into the enigmas of life and compensated readers for the difficulty of the *Anthropogenie*. But embryos could be tricky to show. Though Haeckel avoided anything sexually explicit, the proximity to sex of those "diabolical inventions of materialism" fed the continuing culture clash.[5] The milieus of imperial Germany—including the landed aristocracy, the Protestant middle class, workers, and Catholics—cultivated opposing views of Darwinism and what was appropriate for young people. In the ferment of social reform and reaction around 1900,

Haeckel stirred progressives to link evolutionism and sex education, while the orthodox Christians most agitated about evolution tended also to be least comfortable presenting frank information about the body.[6] This concern combined with the forgery charges to make his embryos flashpoints in fights across the generations and milieus. The pictures pitted enthralled schoolchildren against outraged priests, student Darwinists against expert professors, young women against prudish parents, and itinerant freethinkers against defenders of Christian faith.

Worldview

Pressure was building for better science teaching, but natural history still had a low status in the classical *Gymnasien* (grammar schools) that dominated the education system. The *Realschulen*, which foregrounded factual knowledge of the world, offered only a little more. With a move in the late 1880s to include moral lessons drawn from "living communities" modeled on the village pond, children might study frogspawn, but not human and comparative embryology (fig. 11.1).[7] Pupils interested in nature complained that the

282 Froschlurche.

1. Ihre Gestalt ist fast die eines Fisches (s. das.). Der Kopf geht unmittelbar in den fußlosen Rumpf über. Letzterer setzt sich in
2. einen mehr denn körperlangen, seitlich zusammengedrückten Ruderschwanz fort, der rings von einem breiten Flossensaume umgeben ist. Durch Hin- und Herschlagen des Schwanzes unter schraubenförmiger Drehung der Flossensäume bewegt sich die Larve fort. (Vgl. mit der Schiffsschraube; s. Grönlandwal und Fische!)
3. Die Atmung erfolgt durch Kiemen (s. Fische), die wie kleine Bäumchen am Halse hervorsprossen. Bald verschwinden diese äußeren Kiemen; denn unterdes haben sich innere

1. Soeben abgelegte Eier.
2. Eier mit aufgequollenen Gallerthüllen.
3.—8. Die einzelnen Stadien der Entwicklung.
K. Kiemenöffnung.
Oben ein Männchen mit den Schallblasen; darunter ein Weibchen, ein Insekt fangend.

Der grüne Wasserfrosch und seine Entwicklung.

Fig. 11.1 Drawing of stages in the development of the green water frog from Otto Schmeil's successful, reforming textbook of zoology. Though systematically organized, this included much information relevant to evolution. Amphibian development allowed discussion of reproduction without reference to human beings, but progressives could make it lead on, as also to the vertebrates' conquest of land. By Albert Kull (1898), halftone from Schmeil 1907, 282.

dull lessons were designed to discourage.[8] Struggling to find a worldview, short-changed by the orthodox Christianity and useless cramming, middle-class youngsters had the resources to amass collections at home and discuss books that were off-limits at school. Some encountered Haeckel then, others later; many owed him the rest of their intellectual lives.

Few began with Haeckel. *Kraft und Stoff*, Ludwig Büchner's materialist classic, was shorter, easier, cheaper, more radical, and in print into the twentieth century.[9] But the *Schöpfungsgeschichte* became the main general treatment of Darwinism. Children raided their parents' or library shelves or dared to ask for it as a present;[10] libraries gave some workers and peasants access.[11] If readers had enough preparation but not too much,[12] this gospel of nature could elicit a conversion experience. In 1870, at the *Gymnasium* of the Benedictine monastery of Kremsmünster in Upper Austria, the doctor's son Carl Rabl defied the ban on such works. He "read the book with true devotion day and night and was convinced that there could be no better on the great, important problems with which it dealt." A priest told him not to believe it, but "from then on the concept of development governed everything I did and thought." He studied in Jena and became the embryologist who sent Haeckel drawings with which to revise the *Anthropogenie*.[13]

Young people debated Darwin and Haeckel with friends, classmates, and teachers.[14] A few progressive schoolteachers even began to teach evolution, and one gained national notoriety. Hermann Müller, the botanist and science master at the distinguished *Realschule* in Lippstadt, Westphalia, lent pupils Haeckel's books and discussed them. In 1876 he announced that "the history of the origin of man will be explained according to wall charts prepared after Haeckel's *Anthropogenie*." Müller may not have had the chance to teach much evolution, but Wilhelm Breitenbach recalled that "after the plates and figures in this book Müller himself prepared (or had prepared by us *Primaner* [seventeen- to eighteen-year-olds]) large teaching charts, on which human embryology and our probable evolution was explained, always, of course, with a strong emphasis on how hypothetical the whole conception was."[15]

This provoked opposition at the height of the *Kulturkampf* and as left-wing Darwinism spread. Evolutionism would rival Marxism in the ideology of German social democracy, which grew through illegality in the 1880s to reemerge as the largest socialist movement in the world before 1914. Darwin plus Marx convinced social democrats that the struggle for existence in nature, continued in the class struggles of human history, would deliver the future to them. Friedrich Engels used the *Schöpfungsgeschichte*, and the party leader August Bebel, having read the book in prison, quoted it in his bestselling *Die Frau und der Sozialismus* (Woman and socialism).[16] *Die Neue Welt* (The new world), the weekly "entertainment magazine" founded by fellow prisoner Wilhelm Liebknecht in 1876, promoted Darwinism and embryology. It reported "utterly amazing things" about the initial similarity of vertebrate development from eggs, citing Haeckel also for embryonic tails and gills and defending his evolutionary trees. A biography presented him as "learned, eloquent, and charming," stressed his research contribution, and praised his works as "full of fire," mentioning neither the pictures of embryos nor the charges against them.[17] His response to Virchow impressed socialists less, but Haeckel remained a hero.[18]

Local Catholic anger forced the Prussian government to investigate Müller, but the *Kulturkampf* minister was satisfied he had not taught human evolution. Then a report circulated that his pupils had corrected the religion teacher's "In the beginning was the Word" from St. John's Gospel with catcalls of "Carbon!" (This was triggered by a classroom reading of a passage from Carus Sterne, which in fact played off Goethe's *Faust*.) In the Prussian House of Lords a Conservative warned that "Haeckel-Darwinism" would raise "a generation whose confessions are atheism and nihilism and whose political philosophy is communism." The Müller affair was widely, if slightly unfairly, blamed for a biology ban. The 1882 curriculum excluded the subject from the last three years of secondary school and warned against teaching unproven hypotheses. The other German states followed suit and marginalized biology, not prominent before, until the early 1900s. Haeckel's campaign had backfired.[19]

Some managed to teach evolution,[20] and young people still read Haeckel. A sensitive pupil at a Catholic *Gymnasium* entered a deep depression when the priest preparing the class for first communion convinced him he was unworthy and would be terribly punished. He recovered only some eighteen months later, having made a borrowed *Schöpfungsgeschichte* his

"bible" and Haeckel his "guardian angel."[21]

Haeckel's critique of religious orthodoxy offered a new unity for a fragmented age. Bölsche reviewed the *Anthropogenie* as editor of the main organ of literary naturalism, the *Freie Bühne für modernes Leben* (The free stage for modern life), which represented social problems without pretense but romanticized the effect of the book:

> I see it working silently among laypeople.... I see it in the homes of the thousands of lonely, intellectually lonely, brooders, who also ask the question: Where from? Where to? What is man? Where does he come from? And who then from this book at least for *their* life, for *their* small span of existence, gain consolation and sustenance ... the momentary mastery of the *whole*, the satisfied, knowledge-sated floating above the world, the inner feeling of pleasure at the harmony, which, without great separating question marks, unrolls its colored tapestry before us, half seen, half intuited.[22]

This was science as ersatz religion, the thread that held facts and figures together, a bridge between beauty and truth.

Haeckel became "an intellectual leader to thousands and thousands,"[23] and religion teachers responded with alarm. In 1889 one caught Carl Neumann with the "moral contraband" of an ancient *Schöpfungsgeschichte*. When he confessed that other boys had also "secretly eaten of this fruit of knowledge" the teacher spent the next few lessons driving the "harmful poison" out of their heads. "The 'ape professor' and 'ape fanatic' was branded a bit of an idiot. There was talk of 'wild fantasies,' 'baseless hypotheses,' and 'outrageous forgeries.'" But the book still gave off "something like a flame," its "magical power" keeping Neumann true. He edited the Haeckel anthology for Reclam.[24]

The legislative consequences of Hermann Müller's teaching may have been exaggerated, but his classroom symbolized the struggle for souls and the clash of parental attitudes with Haeckelian views. The son of a Protestant theologian, Eberhard Dennert, respected the scientist Müller, but observed with horror how he "inoculated" fifteen- to eighteen-year-olds with Darwinism, how "immature minds devoured" Haeckel's books "with delight, and then ... threw all faith

as unnecessary ballast overboard." Müller encouraged them to study in Jena and, instead of taking over his father's engineering works, Breitenbach became a leading monist. Dennert "was among the few, who despite the strong influence of a beloved and very significant teacher did not trek to Jena" to train with "the Darwinist-monist saviors of the world."[25] "When I took my farewell from Müller his voice rang coldly in my ear: 'And so you will go to [the anti-Darwinist botanist Alfred] Wigand in Marburg?' That was the last word he said to me."[26]

University Impressions

The official university curriculum generally excluded Haeckel's pictures. For many decades no German embryology, anatomy, or zoology textbook copied his embryo plates.[27] Professors occasionally recommended the *Anthropogenie*,[28] but Oscar Hertwig's text, launched by Gustav Fischer in 1886, soon superseded Kölliker's as the multiedition market leader (fig. 11.2).[29] When Haeckel disarmingly admitted in 1891 that the revised *Anthropogenie* must be full of mistakes, British experts agreed. In *Nature* the otherwise sympathetic Cambridge-trained Manchester zoologist Arthur Milnes Marshall criticized the "entirely erroneous" account of the "development of the human embryo." "Prof. Haeckel has ... many hard things to say of Prof. His, but is indebted to him for [his] only really good figures of human embryos ... , and would have materially improved his book had he studied more carefully the admirable descriptions of the Leipzig Professor."[30] *Nature* acknowledged the fifth and sixth editions as historic, classic—and out of date.[31] German biologists were gentler, in part to avoid trouble, in part because they took a "popular" book less seriously.[32]

Schöpfungsgeschichte and *Anthropogenie* were read in the universities nevertheless. While evolutionary theory drove much research, standard courses did not tackle Darwinism head-on and rarely explored the most radical implications. These books, like lecture series on evolution to students of all faculties, added that thrill, as they mediated between dry studies and urgent questions of philosophy and religion. So even students not taking medicine or zoology picked up some embryology, and this resonated for a minority of enthusiasts just as it had for Haeckel. One remembered "the deep and transformative impression that

Fig. 11.2 Illustration from the soon-standard embryology textbook by Oscar Hertwig. Schematics, here mostly of chick development, still played a crucial role and could now be more easily and cheaply printed in color. Haeckel's own artist Adolf Giltsch did this lithograph, and the book contained a wealth of photomechanically reproduced figures in the text. Hertwig became more critical of Haeckel after moving from Jena to a chair of anatomy in Berlin. O. Hertwig 1888, plate I.

[Haeckel's] presentation of human germ history made on us young people ... and how it became fundamental for our worldview."[33]

Readers copied the illustrations. The theology student Gustav Tschirn, a mill owner's son studying the *Schöpfungsgeschichte* at age twenty-two in about 1887, was impressed by "the facts ... of reproduction and the development of the mammalian egg. In eight drawings under my notes I preserved for myself the pictures of cell division and multiplication, as well as of the animal and human fetus." In this way, "embryology proved to me that the developing human soul does not travel down from God on high into the body of the child, but that from the depths of nature it originates from the simple cell, exactly like in animal and plant."[34]

Haeckel's embryos caused trouble here because concerns about accuracy and honesty were traded across the ideological divide and as a matter of disciplinary pride. When dropping "the well-known

name" was enough to "split" a class "at once into two demonstrative sections,"[35] professors and fellow students tested followers' faith.[36] Already skeptical, Dennert took an embryology course with the refined anatomist Nathanael Lieberkühn in Marburg in summer 1881 and remembered his comments. "Professor Haeckel in Jena maintains in his popular writings that the embryos of humans and animals cannot be distinguished at early stages," Lieberkühn had announced. Some distrusted Haeckel—he must know that experts could now tell the embryos apart—but Lieberkühn, an embryologist with an extensive collection, questioned only his competence. "Gentlemen, *I do not doubt at all that Professor Haeckel is unable to distinguish these embryos*. But from this it does not follow that other people also cannot." In a sign of how confidence had grown since Baer's day, he wagered: "*Mix up all kinds of embryos in a pot and I will tell you the origin of every one*." Lieberkühn "did not say anything he could not back up. The trust-inspiring, calm way in which he dealt with Haeckel ... made a great impression on me," Dennert recalled, "and alongside Wigand's influence contributed much to curing me thoroughly of Darwinism."[37]

When Wilhelm Krause visited the following year Lieberkühn and his colleagues enjoyed seeing him identify his allegedly human embryo with one they revealed to have come from a canary.[38] Some biologists saw the case as confirming Haeckel's opportunism and ignorance. But the anatomist Julius Kollmann, attempting to reconcile the positions of Haeckel and his own Basel predecessor His, cited the confusion in Haeckel's support. "Who does not remember that only a few years ago the embryo of a bird was declared and described as that of a human being, and it took some effort to determine the error. After such an event a claim of Haeckel's ... about the similarity of vertebrate embryos among themselves appears in another, less unfavorable light, and the bad faith of which he was accused was surely not present."[39] Progress made his plates look poorer, but could excuse them as having been adequate at the time.

Sex Education?

Beyond high schools and universities the *Schöpfungsgeschichte* and *Anthropogenie* could promote the very perception of embryology as repugnant that Haeckel professed to challenge. The *New York Times* reviewed *The Evolution of Man* in 1879 as "Science Militant" with illustrations to match.

> There are pictures of the stages along the whole route, from a one-celled animalcule to a pickled baby.... People who object to an ape-like being for a remote ancestor will be far more horrified to look at the comparative series of embryos which the ferocious Haeckel has laid down carefully on colored plates. [They] will there see the embryonic man not merely in close relationship as to form with the embryonic rabbit, calf, and hog, but to such creatures as the tortoise, salamander, and fish. But nowadays nobody can afford to be squeamish in such matters. Science is having her innings.

When the new translation came out a quarter century later, the paper again warned that "the subject is rather gruesome and ... not best adapted for public discussion."[40] The forms were shocking and their association with sexual anatomy made matters worse.

The founder of experimental psychology, Wilhelm Wundt, recalled as an associate professor having talked on "Darwin's theory" to an off-season audience in the spa town of Baden-Baden in the late 1860s. "When I was in the lecture hall ... unpacking various pictures of embryos, including some of the early stages of life of apes and humans, in order to hang them up as demonstration objects on the wall, the director of the Baden winter entertainments, who was accompanying me, started back in disgust. Decency forbade such pictures, he opined, especially in the presence of ladies. I could do nothing and had to pack up my figures again and limit myself to indicating their content orally in the lecture."[41]

The imperial German universities excluded women until around 1900; Haeckel's lecture-based chapters addressed "Gentlemen." Opponents of women's medical education regarded the prospect of their examining the sex organs and learning about procreation and development, particularly in male company, as what Theodor Bischoff called "a gross offense against decency and good manners and ... a shameless abandonment of all feminine delicacy of feeling."[42] Separate admission times to anatomy museums limited viewing, and women rarely wrote on embryology until the twentieth century, when scientific careers be-

Fig. 11.3 Header to *Daheim*, a domestic middle-class scene in which the paterfamilias reads aloud to all ages and both sexes. In this year the magazine had a circulation of 44,000, an order of magnitude below *Gartenlaube*, then at its peak. Many readers were military men, for whom the family ideal served as a substitute (Graf 2003, 435–37). From *Daheim* 11, no. 5 (31 Oct. 1874): 65. Universitätsbibliothek Erlangen.

gan to open up and advice books by women for women came in.[43] Revising Dora Schmitz's translation of the *Schöpfungsgeschichte*, Ray Lankester felt misgivings: "Nice things for a young lady to turn from German into English!"[44]

To women seeking escape from the straitjacket of bourgeois convention the book soon symbolized forbidden knowledge. In Gabriele Reuter's bestselling novel about the psychological suffering induced by long and stifling preparation for a marriage that never happens, the protagonist finally opens a book she had often dusted in her father's bookcase. Reading the *Schöpfungsgeschichte* is, for Agathe Heidling, like a "journey around the world with sublime vistas back to immense pasts and clear views to a future filled with the forces of development." She forgets herself but gains "astonishing knowledge of her own becoming through countless ancestral series," loses her "luggage" but acquires "unimagined riches." The intellectual jailbreak displeases her parents. "Young

girls often take works of that kind in quite the wrong way," her father says, and her mother adds: "The book with the terrible illustrations? … But Agathe, I should not wish to read anything like that." Instead of the recommendations from Haeckel that Agathe had put on her Christmas list, she receives a local flora "for our daughters" and a flower press.[45] This road to freedom was closed.

Women took responsibility for religion and early learning in Christian families, which was reckoned to make them suspicious of Darwinism but allowed those of advanced views to put it to use. Wilhelm Engelmann complained about religiously motivated female resistance, but told Haeckel that an Austrian newspaper recommended the *Anthropogenie* "to the *Viennese ladies*."[46] The young Karl Kautsky, later "Pope of Marxism" as the leading theoretician of the Second International, then a student in Vienna, studied the *Schöpfungsgeschichte* with his mother, a former actor and future novelist.[47] The dramatist and freethinker Hed-

wig Henrich-Wilhelmi made it "the gospel" on which she based "the education of our children."[48] Women did not so visibly participate in the big debates or as reviewers in the mainstream press, but around 1900 hosted "heated discussion[s] of Haeckel and Darwin" at salons and clubs in Berlin and Vienna.[49]

Magazines had long since domesticated Darwinism for family viewing. Only a few years after Wundt was forbidden to hang his pictures, books by Huxley, Darwin, and Haeckel made illustrations of embryos acceptable. Even before wood engravings of Haeckel's plates entered liberal homes with the *Illustrirte Zeitung*, a piece by the orthodox theologian Otto Zöckler in *Daheim* (At home), the conservative Protestant competitor to *Gartenlaube*, had reproduced Darwin's human-dog pair (fig. 11.3). The multipart article presented the case for the defense fairly enough to provide a useful introduction to Darwinism, but by the end Zöckler had rejected natural selection and everything else that conflicted with traditional religion and morals. The figure supported Haeckel's claim about similarity, but proved nothing, Zöckler interjected, because deep down species were not the same.[50]

Darwin's embryos were suitable for family viewing because detached from pregnancy, reproduction, and sexual organs, just as Haeckel's were little discussed as the "fruit of the body" in the language of the anti-abortion law of 1871.[51] Working out what the pictures showed was part of the fun. The ghoulishness of the skeletons in Zöckler's article and "the terrifyingly distorted face of an old man" from Darwin's *Expression of the Emotions* fascinated an army captain's son leafing through his widowed mother's bound volumes. He imagined an ascidian as a carrot and interpreted the embryos as "human ears."[52]

"I believe," Bölsche wrote in the *Freie Bühne*, "that the number of laypeople is nothing short of legion, who for the very first time in their lives got to know their own wonderful becoming as a little germ from the very contested, somewhat popularly schematized embryo plates in Haeckel's *Schöpfungsgeschichte* and *Anthropogenie*."[53] These, "the most instructive figures, which most encourage one to read, that probably any recent physiological work contains,"[54] entered some encyclopedias in the 1890s, but were too compromised to benefit fully from his promotion of the subject.

For Bölsche, embryos attracted controversy because teaching Darwinism meant discussing sex, beginning with fertilization in higher plants and the development of frog and chick. Reeling off evidences risked reducing evolution to safely isolated facts, but monism stressed the connections. Sexual enlightenment was a vital theme of the Bohemian, lifestyle-reforming literary naturalists who congregated in Friedrichshagen near Berlin, and specifically of Bölsche's "erotic monism" (fig. 11.4). Conservatives might lament as moral decline that well brought-up girls no longer blushed at the mention of sexual matters, but frankness was better all round.[55]

Catholics policed illustrations which might excite young minds. During the Müller dispute "a physician was disgusted to encounter a sixteen-year-old boy eagerly [looking] over a 'scientific' work covered with detailed figures of the male and female body."[56] In 1908 a two-mark *Der Mensch* (The human body) by a reformist priest and writer on anthropology took care to represent embryos only by cell division. Modern in its focus on cellular processes and experiments, the approach ensured, as one Catholic reviewer noted with satisfaction, that "even the chapter" on embryology "contains nothing to stimulate the senses, so that the book can be given to grown-up youths."[57] As the debate over sex education heated up,[58] the Austrian novelist and Haeckel admirer Marie Eugenie delle Grazie, who herself grew up on his gospel of Darwinism, staged the opening scene of a novel in a convent school for upper-class Roman and Neapolitan girls. Asking about lizards, the teacher is embarrassed even by the prospect of the word *egg*, and a model pupil lands in trouble for repeating information about the tuatara and quadruped evolution from her freethinking uncle's *Schöpfungsgeschichte*. Her punishment is to write out the first chapter of *Genesis* several times.[59]

An incident at a Berlin school shows the undiminished potency of Haeckel's pictures in real classrooms and introduces lantern slides as a means of group viewing. Spoilt by a widowed mother and educated at home for a long time, Max Hodann collected plants and animals, kept frogs and fish, visited the Museum of Natural History, and devoured popular science. A chance meeting with Haeckel had strengthened a desire to become a biologist and this survived the dull natural history lessons at a new *Gymnasium* in the comfortable suburb of Friedenau. Shortly after his twelfth birthday, in 1906, Hodann staged a provocative performance there.

Wir haben von Heringen, Stichlingen, Eintagsfliegen geredet, vom Seestern und vom Bandwurm, von der Spinne und von der Bienenkönigin. Eine große Menagerie der Liebe. Jetzt erscheint ein ganz neues Bild. Unser Glas, mit dem wir beobachtet haben, wird zum Spiegel. Und im Spiegel stehst du selbst. Endlich bloß noch du. Du allerdings in deinem größten Sinne. Du in deiner tief geheimnisvoll zerspaltenen Zweiheit, die gerade durch die Liebe erst Einheit wird, — als Mann und Weib. Du im Stammbaum deiner Jahrtausende, als ungeheurer Organismus, der Völker treibt, wie ein Birnbaum grüne Blätter, und Kulturen wie Blütenschnee. Von dem diese Völker wieder herabregnen wie gelbes Laub und die Kulturen fallen wie ausgelebte weiße Blütenblättchen, deren Liebesdienst erfüllt. Und der dann beide wieder neu treibt auf einem höheren Ast.

Hat dich der Gedanke schon einmal bis ins Innerste durchschauert: der Mensch steht vor dir?

Denke dich auf einen Moment hinab in die grüne Meerestiefe. Da wimmelt und glotzt und schwimmt all jenes krause Tierzeug, von dem wir gesprochen haben. In seine Höhle gewühlt der schwarzblaue Seeigel. Rote Seesterne in dicken

— 8 —

Fig. 11.4 Page from Wilhelm Bölsche's best-selling *Das Liebesleben in der Natur* [*Love-Life in Nature*], first published in 1898, opening a chapter with the words "We have talked of herrings, sticklebacks, mayflies, of starfish and tapeworm, of spider and queen bee. A great menagerie of love. Now a quite new picture appears. The glass with which we have been observing becomes a mirror. And in the mirror you stand yourself." Header by Wilhelm Müller-Schönefeld from Bölsche 1907, 2:8.

I was beginning to take stock of my knowledge of evolution and drew among other things animal and human embryos of various developmental stages with Chinese ink on glass plates. Then I appeared in the natural science club of our school, in which twelve-year-olds usually had no business. Without asking, I announced I would give a slide lecture on the phylogenetic law. The *Tertianer* [thirteen- to fourteen-year-olds] and *Sekundaner* [fifteen- to sixteen-year-olds] left their chemical solutions and electrophorus [an instrument for generating static electricity] and collected expectantly on the benches. Werner Grüner worked the slide projector. I demonstrated on the screen the sandal germ and gill stage of man and linked the most radical Haeckelian conclusions to the presentation.

Though the school warned parents against the cinema and a boy was expelled for joining a football club, "the physics teacher who was present that evening accepted the matter, against which there was from a natural scientific point of view nothing to say. It got around, however, that 'a *Quartaner* [twelve-year-old] had shown pictures of embryos'; that *Gymnasium* must be in a fine mess! My first collision with the type of the enraged ignorant petit bourgeois led to a lively school scan-

dal."[60] Nearly forty years after Haeckel's pictures were first published, official exclusion still added to their allure and failed to stop demonstration and debate.

Culture Clash

A leading Jesuit claimed that the illustrations mattered because "the tremendous impression, which few readers of Haeckel's work can escape, rests precisely on the irresistibly persuasive power of these drawings"—and then resisted that power.[61] Orthodox Catholics tended to discuss Haeckel, the embryos, and the forgery charges together, as they damned "modern culture as the enemy of religion and the Church,"[62] and Darwinism as fit only for the liberals' shallow world of *Stammtisch* newspaper reading over beer and tobacco.[63] Darwinists relied on unproven assertions, while Christianity solved "the mystery of life": "It is a creation of God.... God created man in His image, to resemble Him."[64] Commentators made a bogeyman of the scientist whose icons competed with the divine.

Carl Scheidemacher's vigorous rejection had dominated the early Catholic counterattack in conservative theological journals, the more liberal *Natur und Offenbarung* (Nature and revelation), as well as *Deutscher Hausschatz* (German household treasury), the Catholic *Gartenlaube* (fig. 11.5). The neoscholastic philosopher Tilmann Pesch, driven from his chair at the Jesuits' base in the abbey of Maria Laach, later quoted His and Semper against Haeckel's forgeries and concluded that the similarity was no greater than in any progression from simple to complex. Moderates, though tolerant of evolutionism if it allowed supernatural creations for the origin of life and human beings, showed little more charity toward a man who, himself spurning compromise, turned culture, morals, and religion into a subdepartment of zoology.[65]

The most competent Protestant theologians promoted Christian engagement with science as they worked out stances on evolution. Natural selection, or Darwinism in the narrow sense in which people increasingly used the term, found minimal support, and many scientists rejected it too, but there was a wide spectrum of theist positions.[66] For traditionalists, led by Zöckler and his apologetic *Der Beweis des Glaubens* (Proof of faith), Christianity could never make peace with the cultural pathology of evolutionism even were this purged of Haeckelism. By contrast, a maga-zine founded to expand the middle ground reconciled mechanism with teleology, and argued that, provided scientists granted an initial creation and divine intervention in the transition to humans from beasts, many would embrace development as the more noble view.[67] On the left, the *Protestantische Kirchenzeitung* treated the theory of evolution as a permanent achievement—provided spiritual and material factors were understood as working hand in hand. Their job was "to show ... that that which is really true in the new view is perfectly consistent with religion, while that which ... is essentially contrary to it is also proving itself more and more untenable scientifically."[68] Attitudes to Haeckel's pictures thus varied in the strength of the condemnation, with Zöckler railing against "deliberate distortions," while an influential moderate regretted that they were "unfortunately not exact, but modified, after the manner of stencil plates, in favor of greater similarity," which he still accepted as "truly great."[69]

Beyond theological monographs and journals, Haeckel's embryos and character figured in cheap books,[70] sermons, newspaper articles, and the small change of ideological conflict in personal, local, and regional clashes between representatives of the different socio-moral milieus. In 1890 in Saulgau in Upper Swabia, for example, the Center Party fought a liberal-democratic People's Party proposal to replace religion classes by scientific instruction in ethics and morals. The local paper expressed horror that children would then learn that human beings were "not God's image, not an immortal spirit called to eternal happiness" but, following Darwin, "just a beast, a higher species of ape." Though "unbelievers and materialists" had welcomed Darwinism "with Bacchanalian jubilation ... it is nothing but an *unproven supposition*.... E. Haeckel in Jena did not even shrink from *deception and forgery*. The forgery was, however, *proved* and he could not deny it."[71]

Lectures and sermons provided opportunities for public combat face to face. In and beyond the independent Catholic and Protestant congregations, itinerant lecturers campaigned against the established churches and Christian burial and for free thought and cremation (fig. 11.6). Haeckel's embryos, one of their strongest cards, could leave them exposed. The former theology student Gustav Tschirn was now chairman of the German League of Independent Congregations—for a period he also led the German Freethinkers' League—

Fig. 11.5 Magazines present contrasting images of nature. *A*, cover of the Catholic "Nature and Revelation" for February 1879. Science and religion harmonized in a static world; the gently smoking volcano represented no threat. Compare *B*, the dynamic header to the same month's *Die Natur*, in which the volcano had transposed the political ambitions of 1848 into the natural realm. Even here the magazine stressed harmony, however, and later covers of this organ of anti-Darwinism express it more strongly still ("Zum Titelbild," *Die Natur* 1, no. 1 [3 Jan. 1852], 1; Daum 1998, 352). *A*, by permission of the Syndics of Cambridge University Library; *B*, NSUB.

Fig. 11.6 Freethinkers campaigning in the Weimar Republic. "Religion is opium for the people. No higher being will save us, no god, no emperor, nor tribune." The small middle-class movement for cremation and quitting the churches had grown by this time into mass organizations of *proletarian freethinkers*, in large part based on the provision of funeral services to organized workers. The misquotation of Marx's "opium *of* the people" is typical. From Winkler 1988, 157, courtesy of Dietz-Verlag.

and would travel from his Breslau base to preach. Once a priest interrupted a sermon in nearby Görlitz with "the shameful objection that Haeckel had 'forged pictures'" and lent Tschirn a brochure that referred to Semper and His. Tschirn had relied on Haeckel. Could the drawings he had copied as a student, that his fellow lecturers were showing all over the country, really be frauds?[72]

Obstacles as Invitations

Passive obstructions and defensive strategies combined to prevent contact, repel viewers, or at least qualify the messages that Haeckel's embryos could convey. Yet obstacles were also invitations. Those plates impressed schoolchildren and students as one of the best bits in his books, even if, or precisely because, they first had to learn not to see them as ears. The official ban limited access and ensured excited discussion. Descriptions as "gruesome" and not for the "squeamish" might attract as much as repel. Priests risked reinforcing pupils' pride in illicit knowledge. University professors' deflations were harder to overcome, but—as Tschirn would discover—Haeckel had a rebuttal of specialist nit-picking ready.

These forbidden fruits could be shockingly evolutionist, but as sexual enlightenment were fairly tame. They presented embryology, which in academic courses in anatomy and zoology already tended to exclude reproduction, as evidence for common descent separable from bodies with genitalia. That a conservative family magazine reproduced Darwin's embryos in an article by an orthodox theologian shows not open discussion of the sexual facts of life, but just how sanitized evolutionary embryology could be. Nevertheless, around 1911, when a middle-class Jewish boy, Edward Elkan, requested and received for his birthday "a large

and beautifully illustrated book on evolution," Haeckel-style images struck his mother as improper. She "discovered with horror that there was on the last page a column showing the development of vertebrate embryos including those of the genus *Homo*. To her, this was pure pornography! '... and you are not showing this to anybody! Particularly not to your cousin Gertrud (who was one year older than I).' There was to be a little birthday party that day but my main present was confiscated and only released when the house was again free of poor children who might have been contaminated by the sight of such a horror as a human child yet unborn."[73]

If viewing was always in some sense both individual and collective, it mattered who else was in the room. Bölsche read the *Schöpfungsgeschichte* with his male friends; the younger Elkan was not allowed to look at embryos in a mixed group; Heidling was discouraged from seeing them at all. Tschirn and Hodann made private copies, then displayed the pictures to audiences, among whom many will first have seen them in a public place. The fraud charges could come into play at any time. Often they were there before a viewer saw the illustrations, if he or she ever did; in orthodox circles, many accepted the forgery story sight unseen. Or, as in Tschirn's case, the objection might be heard only long after an encounter, and taken as a ruse to rumble or a lesson that all that glitters is not gold. On the most memorable occasions opponents clashed in the presence of the offending images as the spark.

Copying multiplied opportunities for confrontation and consensus. Transferring the embryos onto charts or lantern slides or into other books released them from Haeckel's works, easing access and also shaping the forms that would endure. One of the most striking copies appeared in Bölsche's "story of the evolution of love."[74]

{ **12** }

Creative Copying

"Give me your hand." The chapter opens with an invitation to descend with Bölsche and some yet-to-be-invented endoscopic technology into the depths of a young woman's body. Here, in a fantasy of postcoital visual penetration, "an artificial light of extraordinary power" would illuminate the mystery of fertilization, and egg and sperm appear enlarged as if in a fairy tale. *Das Liebesleben in der Natur* (*Love-Life in Nature*) caused a fin-de-siècle sensation with lyrical prose that aestheticized and eroticized Darwinism. Published in a fine edition, in the tradition of William Morris's Kelmscott Press, it also sported art nouveau motifs based on "correct natural historical objects." That chapter was headed by "six embryos or germs in the mother's body, on the left three of the cat, on the right, strikingly similar, three equivalents of humans." Columns from the *Schöpfungsgeschichte* mirrored each other across the page (fig. 12.1).[1]

By loosening their association with Haeckel's books, his diagrams took the first step toward becoming iconic. A surge in the volume and accessibility of printed matter between the 1870s and World War I brought the first mass audience a richly visual science. But few people grew familiar with embryos, bacteria, and X-rays by reading Darwin and Haeckel directly, let alone Robert Koch and Wilhelm Roentgen.[2] These new objects gained visibility as copies: *Liebesleben* sold some eighty thousand, one edition of a big encyclopedia three times that. Nor did copying just recognize images or determine where they would appear; it also settled how they would look. Today, Haeckel's embryos are a grid based on the first edition of the *Anthropogenie*, but only after decades of ringing the variations was this established as the canonical form.

Copying depended on decisions by publishers, illustrators, and authors faced with economic imperatives, technical possibilities, and audience expectations.

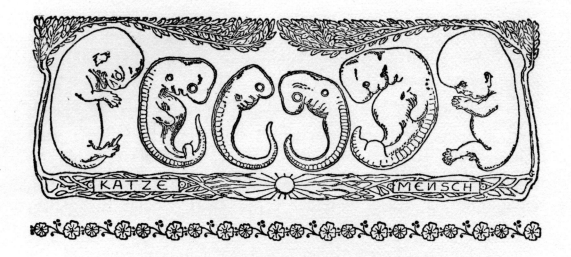

Und nun komm ganz in die Tiefe unten zurück.
Laß uns beim Anfang beginnen, soweit es einen giebt.
Laß uns behaglich plaudern und schauen. Ohne Hast. Wo
uns gerade Licht scheint und ein Stück Wurzelwerk erhellt.

Fig. 12.1 Header in Wilhelm Bölsche's *Das Liebesleben in der Natur*. Haeckel's embryos are "framed by a plant whose roots seem to begin as sunbeams" and so convey the intertwining of nature (Kelly 1981, 55). The first words of the chapter are "And now come"; "Give me your hand" are the next after those shown. The book was the first big success of the Jena publisher Eugen Diederichs, who though sometimes seen simply as an agent of conservative revolution, initially collected various initiatives for cultural renewal (Hübinger 1996; Ulbricht and Werner 1999). Some reviewers praised the decorations by Wilhelm Müller-Schönefeld (Heidler 1998, 672); others rejected objects "neither represented scientifically correctly and exactly, nor wittily stylized and filled with fantasy" (Grautoff 1901, 137). From Bölsche 1907, 1:44, after Haeckel 1898a, plates II–III (here fig. 9.5).

Early-modern woodcuts were expensive, and authoritative depictions of remarkable phenomena scarce, so long-term reuse was common and savants fought printers for control.[3] By the 1870s, when Haeckel's embryos began to be copied, authors and publishers had far greater freedom to reproduce illustrations: printing was easier and cheaper, and the copyright law fairly permissive and much flouted.[4] But only wood engraving could put pictures with text, so until photomechanical processes allowed more direct printing, these lithographs or steel engravings still had to be re-engraved in relief.[5] Not that everyone deploying embryos for evolution wished to reproduce Haeckel's figures directly.

Copying mattered most in German, the language of the most advanced science and the primary debates, and English; anglophone copies and controversies would dominate after World War I. Though imitations spread widely, an exhausting, if hardly exhaustive, survey of German, British, and American books discloses significant avoidance, even among Darwinists.[6] Authors rarely gave reasons, and manuscript evidence is sparse, but users' likely knowledge of and stances toward the forgery charges, the appeal and availability of competitors, and the constraints of cost and technique can explain the patterns.[7] The same considerations account for the diverse reworkings of Haeckel's grids before one became the norm.

Patterns of Use and Avoidance

Borrowing began as early as 1872, stimulated by the success of the *Schöpfungsgeschichte*, the prominence of the recapitulationist argument, and visual appeal. Haeckel complained to Georg Reimer about "the *circa* 6 dozen works on Darwinism which have appeared in

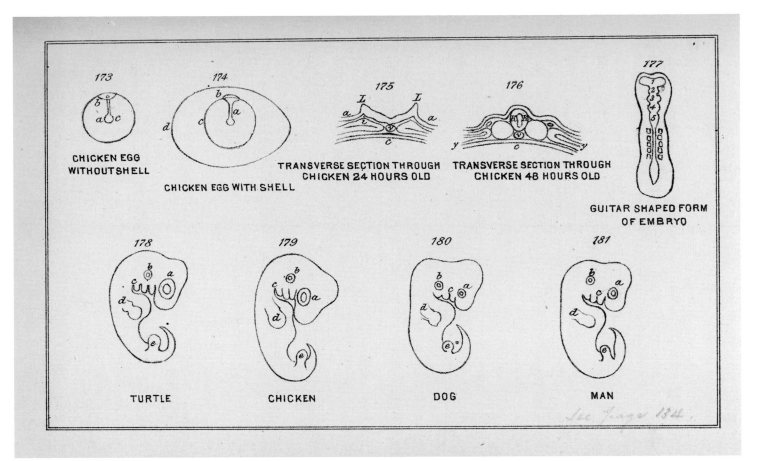

Fig. 12.2 The earliest known copies of Haeckel's embryos, in Henry Chapman's *Evolution of Life*. Having visited centers of European science, Chapman placed the four earlier stages from the *Schöpfungsgeschichte* on a lithograph with diagrams after Baer and Kölliker. Chapman 1873, facing 127.

the last half year. Among these are quite a few which have stolen liberally from the *Natürl[iche] Schöpfungs[g]esch[ichte]*. One American has even printed all of the plates as well!"[8] That was the Philadelphia doctor Henry C. Chapman, whose *Evolution of Life* sold as "popular," not new (fig. 12.2).[9] Haeckel here alluded to his property rights but helped supporters with pictures.[10] German copyright law allowed unrestricted reproduction, with acknowledgment, of single illustrations,[11] and publishers did a lively trade in electrotypes.

The embryos were copied into some of the most successful evolutionary epics and a handful of other books that took recapitulationism or more summary proofs of organic evolution to large audiences.[12] Rarely crediting sources, works of this kind usually presented the figures as facts long known, not a controversial theory attached to Haeckel's name. More advanced treatments qualified the biogenetic law, mostly in his own terms.

Encyclopedias, which already had entries for *embryo*, responded to Haeckel by recognizing embryology as standard knowledge at the same time as they were adding plates and figures in earnest. His embryos never entered the veteran *Brockhaus*, which gave the science short shrift, had fewer pictures, and ignored him for a long time. The rival *Meyers Konversations-Lexikon*, of which his geographer son-in-law happens to have owned the publisher, inserted them in 1894 into 233,000 copies of a thoroughly Haeckelian article which already reproduced his gastrula plate (fig. 12.3).[13] They featured in an encyclopedia for women, but not in Dennert's conservative alternative, which alluded to unworthy behavior instead.[14] In Britain, the more scholarly, establishment *Britannica* never let the drawings in; for Balfour's Cambridge successor

bei den Tieren der verschiedensten Klassen derselbe, so-lange die Larven freilebend sind, wie die hier abgebilde-ten Korallenlarven, ändert sich dagegen, wenn die Ent-wickelung in einer durch eine Schale eingeschlossenen, mit Bildungs- u. Nahrungsdotter versehenen Eihülle erfolgt (s. Ei), wie bei vielen höhern Tieren. Diese Ent-wickelung ist aber der ebengeschilderten typischen Form gegenüber als eine abgeleitete, sekundäre Form zu betrachten, durch die Notwendigkeiten des Lebens-, Element- und Jahreszeitenwechsels hervorgerufene, denn die primäre oben geschilderte Entwickelung konnte nur bei Tieren erhalten bleiben, die das feuchte Element

A Schildkröte. B Huhn. C Kaninchen.

I I I

II II II

III III III

Fig. 2. Wirbeltierembryonen in drei vergleichbaren Entwickelungsstufen (schematisch).

niemals verließen. Da indessen auch bei der Ent-wickelung ähnliche Furchungen und Stadien und na-mentlich der Gastrula ähnliche Stufen auftreten, so schloß Häckel daraus nach seinem oben erwähnten »biogenetischen Grundgesetz«, daß die Gastrula-Larve das Nachbild einer gemeinsamen Ahnenstufe aller höhern Tiere sei, der sogen. Gasträa, von der noch heute zu den Pflanzentieren gerechnete Verwandte (»Gasträaden der Gegenwart«) leben, deren Körper zeitlebens nur aus einer doppelten Zellenschicht besteht. Es ist dies die vielgenannte Häckelsche Gasträathe-orie, die von mehreren Zoologen verworfen wird, in-dem sie annehmen, es seien einzig tektonische Ursachen, welche einen derartigen gleichmäßigen Verlauf der ersten Entwickelung aller Tiere bedingen.

Auf diese Weise sind zwei deutlich unterschiedene Zellenschichten entstanden, welche den schon von Pan-der entdeckten primären Keimblättern entsprechen, das die Innenwand der Gastrula auskleidende Ma-

gen- oder Innenblatt, auch unteres Keimblatt (Entoderm) genannt, und das sie bedeckende Haut-blatt oder äußere Keimblatt (Exo- oder Ektoderm), welche die Grundlage aller fernern Entwickelung der Tiere bilden und zwar so, daß stets aus dem Haut-blatt die Körperbedeckungen, das Nervensystem und die Sinnesorgane hervorgehen, weshalb es auch Haut-sinnesblatt genannt wird, während sich aus dem In-nen- oder Magenblatt hauptsächlich Eingeweideteile bilden. Die Höhlung des innern Sackes der Larve heißt Urdarm oder Urmagen, seine Öffnung Ur-mund, wohl zu unterscheiden von dem sich später an andrer Stelle öffnenden Nachmund.

Huxley wies 1849 die sogen. Homologie der Keimblätter, d. h. ihre Gleichwertigkeit durch alle Tierklassen nach und zeigte, daß der Körper der meisten Pflanzentiere zeitlebens nur aus diesen beiden Zellen-schichten und deren Bildungen besteht. Bei höhern Tieren bildet sich indessen zwischen beiden Keimblät-tern bald noch ein mittleres, sekundäres Keimblatt, das Mittelblatt (Mesoderm), oder auch zwei se-kundäre Keimblätter, woraus das Muskelsystem her-vorgeht. Über den Ursprung und die Beziehungen sowie die weitern Umbildungen der Keimblätter haben Remak, Kowalewsky, Häckel, van Beneden, Balfour, Ray Lankester und namentlich die Gebrüder Hertwig aufklärend gearbeitet. Die Mannigfaltigkeit der Wei-terbildungen in den verschiedenen Tierklassen entzieht sich einer zusammenfassenden Betrachtung um so mehr, als bei vielen Tieren einem Generationswechsel ähn-liche Vorgänge schon im Larvenleben auftreten, und es läßt sich im allgemeinen nur sagen, daß die unähn-lichsten Endformen aus ähnlichen Anfangsformen hervorgehen, z. B. die verschiedenen Krebsformen, die Sterntiere, die naheverwandten, aber in ihren Formen so verschiedenen Haie und Rochen (s. Tafel). Die im ausgewachsenen Zustande von den übrigen symme-trischen Fischen so abweichenden unsymmetrischen Platt-fische oder Seitenschwimmer sehen in ihrer Jugend jenen ähnlich, und die Augen stehen wie gewöhnlich auf den beiden Seiten des Kopfes, bis dann die eine (rechte oder linke) Seite sich zur Oberseite ausbildet, und das Auge der andern Seite zu ihr hinüber wan-dert (s. Tafel). Auch Vertreter der verschiedenen Klas-sen höherer Wirbeltiere sind auf niedern Stufen so ähn-lich, daß man junge Schildkröten, Vögel und Säuge-tiere kaum unterscheiden kann (Textfig. 2). Über die weitere E. der höhern Wirbeltiere s. Embryo und über die E. der eierlegenden Tiere s. Ei. Vgl. Wolff, Theoria generationis (Halle 1759); v. Baer, E. der Tiere (Königsb. 1828—37, 2 Bde.); Remak, Unter-suchungen über die Entwickelung der Wirbeltiere (Berl. 1850—55); Rathke, E. der Wirbeltiere (Leipz. 1861); Balfour, Handbuch der vergleichenden Embryologie (deutsch, Jena 1880—81, 2 Bde.); Korschelt und Heider, Lehrbuch der vergleichenden E. der wirbel-losen Tiere (das. 1892); Marshall, Vertebrate em-bryology (Lond. 1893); O. Hertwig, Lehrbuch der E. des Menschen und der Wirbeltiere (4. Aufl., Jena 1893); Häckel, Anthropogenie, E. des Menschen (4. Aufl., Leipz. 1891); Kölliker, E. des Menschen (2. Aufl., das. 1879); Derselbe, Grundriß der E. des Menschen und der höhern Tiere (2. Aufl. das. 1884); His, Unsre Körperform (das. 1874); Derselbe, Ana-tomie menschlicher Embryonen (das. 1880—85, 3 Tle.).

Entwickelungskrankheiten, s. Krankheit.

Entwickelungsperioden (Entwickelungs-stufen), die Zeiträume, in welchen die Entwickelung

Fig. 12.3 One of the highest-circulation copies, in the fifth edition of *Meyers Konversations-Lexikon*. Columns for tortoise, chick, and rabbit are labeled "schematic." The pictures remained through the sixth edition (1908) of 240,000 and the seventh (1925). As with Chambers's encyclopedia, they were then not specifically cut but fell victim to the commissioning of embryology articles that ignored evolution altogether. From "Entwicklungsgeschichte," in *Meyers Konversations-Lexikon*, 5th ed., vol. 5 (1894): 824–26.

Adam Sedgwick, who revised the embryology entry in 1902, a "blind man could distinguish" the embryos of different vertebrates.[15] But the Edinburgh lecturer J. Arthur Thomson, just back from Jena, put Haeckel's in *Chambers's Encyclopaedia* in 1889 and thence in a book from a university extension course that stayed in print for thirty years. A Christian vitalist, he had learned to love his teacher nevertheless.[16]

All in all, one to two million copies of Haeckel's plates could have been printed before World War I, but in a welter of life- and medical-science titles the overwhelming majority of illustrated books did not reproduce them. The major restriction was by topic: his embryos appeared in evolutionist works that appealed to comparative embryology. Even in this great age of Darwinism, most textbooks, primers, and manuals of zoology, physiology, anatomy, and natural history for pupils, students, and laypeople made little, if any, space to treat evolution explicitly. Paragraphs on ontogeny were often distributed among separate descriptions of types. Embryology also figured without evolution in the accessible books that focused on humans,[17] and in the small sections on the subject in works of midwifery, obstetrics, gynecology, marital advice, and sex education. Conversely, the Darwinist literature did not always include embryos. Introductions might begin gently with everyday objects or concentrate on behavior and ecology; paleontology boasted the longest pedigree and spectacular new discoveries. But many surveys did make Haeckelian embryology their most compelling evidence; they just did not all use his plates.[18]

General constraints acted independently of suspicions of forgery and inaccuracy. The rate of illustration was increasing, but even by 1914 there was nothing like today's pressure for a picture per point.[19] Darwinism began by taking over earlier representations of scenes from deep time, fossils, strata, adult anatomies, and embryos. Haeckel gave such time-honored drawings as Bischoff's cleaving mammal eggs a new lease of life and helped innovations, notably Huxley's skeletal procession, become canonical fast. Smaller, simpler figures, such as Huxley's or Darwin's embryo pairs, were cheaper to copy—even to redraw and re-engrave—and it was often enough to show that early humans resemble dogs. The gill slits in the same figures exemplified the unexpected byways of development for which evolution could account. References to a wider range of animals evoked Haeckel's plates without reproducing them.[20] Detailed expositions might favor aortic arches, fish tails, or brains; Müller's crustacea could stand for the biogenetic law.[21]

Controversy did not necessarily impede copying, because supporters enjoyed nailing Haeckel's colors to their masts; his chalk-sponge gastrula (fig. 6.11) was a great hit. Yet only the charges can explain big differences patterned by country, scientific status, and stance toward Haeckel. Copying was more extensive in Britain and the United States than Germany, where the plates were more available in better quality but more numerous critics deployed the allegations more. Almost no research scientist reproduced the pictures, even the few who wrote surveys of the right kind.[22] Nor, until 1909, did hostile writers replicate what they criticized. A contribution to a big installment-based natural history upheld the "traditions of exact anthropology" and chose His's visual critiques to highlight specific differences as well as similarities.[23]

Close allies offer the most telling evidence of inhibition. In the mid-1870s the journalists Ernst Krause and Otto Zacharias had competed to spread Darwinism and dismiss His. Writing as Carus Sterne around this time, the uncritical Krause dedicated to Haeckel a book that gently introduced evolution, from the formation of the world to its eventual end. *Werden und Vergehen* (Coming into being and passing away) was narrative-driven and illustration an afterthought.[24] Krause tacked on the argument from embryology with the grid from the *Schöpfungsgeschichte* (fig. 12.4). By contrast, when Zacharias prepared an "illustrated catechism" of Darwinism some fifteen years later, the man who had interpreted the embryo plates for the *Illustrirte Zeitung* chose not Haeckel's pictures, but His's. He nevertheless discussed the biogenetic law, cited not His but Haeckel, and implied criticism only in the suggestion that setting up a complete human pedigree was premature.[25] What had changed?

Zacharias took more distance from Haeckel after his patron favored Krause's *Kosmos* over his own project for a Darwinist magazine.[26] Zacharias had also acquired skill and status. While still a journalist, he followed Haeckel's advice to train in science and build a research profile. Practical classes in Leipzig taught him to make preparations and, as he told Haeckel in 1882, "how many nonsensical figures of embryological phenomena are truly a scandal a[nd] how little the representations correspond to the facts." This was probably

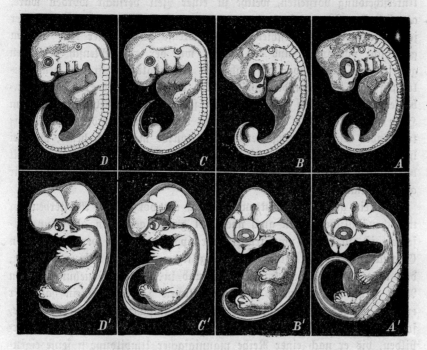

Fig. 12.4 The plate from Haeckel's *Schöpfungsgeschichte* as a wood engraving in *Werden und Vergehen* by Carus Sterne. *D*, human; *C*, dog; *B*, chick; *A*, turtle. The order has been reversed, but the copying is not so faithful as to suggest much reliance on photographic transfer or tracing. The figure survived into the posthumous, twice-reprinted sixth (1905–6) edition, which Bölsche edited lightly while recognizing that it needed more thorough revision (Bölsche to Haeckel, 25 Dec. 1903, in Nöthlich 2002, 157–58). Sterne 1876, 336.

Fig. 12.5 Wilhelm Bölsche's bestselling "Descent of Man." *A*, caveperson having slain a mammoth; *B*, an alternative to Haeckel's embryos: human from Rabl, ape from Selenka, echidna from Semon. Illustrations by Willy Planck from Bölsche 1904, cover and 69.

not a specific dig—the context is histological—but relates the use of His to his own hard-won expertise. He signed the preface as founding director of Germany's first freshwater research station.[27]

Wilhelm Bölsche is the strongest case. He borrowed those embryos for the *Liebesleben* (fig. 12.1) from the plate in the new *Schöpfungsgeschichte* that Haeckel had sent the previous Christmas and that Bölsche had admired for the "splendid" illustrations.[28] But then Haeckel's friend, biographer, most effective popularizer, and stalwart defender steered clear of the pictures in books that sold over one and a half million. Take his opening contribution to *Kosmos*, the first commercial

natural scientific book club, started in 1904. The name harked back to Krause's journal, which had failed with *Die Natur* and other ventures from the mid-nineteenth century, while the business model succeeded by exploiting the new pictorial technologies and a network of clubs. Based around a magazine with four or five book supplements a year, *Kosmos* sponsored traveling lecturers too. Dominating the market, it was Haeckelian enough to interest his many fans and sufficiently general to attract a broad spectrum of authors and readers.[29] In the first supplement, *Die Abstammung des Menschen* (The descent of man, 1904), which sold some 125,000 and *Kosmos* readers voted the best book

A

B

Der Embryo (Keim im Mutter-
leibe) des Menschen aus der Mitte
der fünften Woche. Er ist stark ver-
größert, denn die wahre Größe be-
trägt auf dieser Stufe noch nicht
ganz einen Zentimeter. Man be-
achte die Kiemenspalten am Halse,
die flossenartigen Gliedmaßen und
den deutlich entwickelten Schwanz.
(Nach Rabl.)

Der Embryo des Land-
Schnabeltiers (Echidna).
Man beachte die auffallende
Ähnlichkeit mit den ungefähr
auf gleicher Stufe der Reise
stehenden Embryonen von
Mensch und Affe. (Nach
Richard Semon.)

Der Embryo eines Affen auf ähn-
licher Stufe wie der obenstehend ab-
gebildete Embryo des Menschen. Man
beachte die frappante Ähnlichkeit.
(Nach Selenka.)

on natural science in 1921,[30] Bölsche defended the sim-
ilarity of vertebrate embryos. That humans also went
through a fish stage, with gills and fins, was as certain
as that the earth circled the sun. Those who denied as
"forgery" what the state required every medic to learn
placed themselves beyond the moral pale. But though
Bölsche took several illustrations from Haeckel, this
one went back to the sources (fig. 12.5). The compari-
son occupied a whole page, so money was not the issue;
the aim was to stop opponents scoring easy points.[31]

In evolutionary surveys and encyclopedias Hae-
ckel's defiant pictures enlivened once-imageless pre-
sentations and replaced earlier comparisons. But a
new title adopted them only a few times per decade
with little momentum building up. Especially in Ger-
many, the charges and the availability of alternatives
excluded them from many a Darwinist work. Where
used, they were rarely copied whole.

Raiding the Grids

While Haeckel's unlimited budget permitted ever
larger series, borrowers favored the first plates in
the more general and successful *Schöpfungsgeschichte*
and the earlier, most criticized editions of the *Anthro-
pogenie*.[32] These less specialized arrays, which had the

Fig. 12.6 Andrew Wilson's *Chapters on Evolution* broke up the plates in *The Evolution of Man*: *A*, the first two chick figures as a pair of "embryo-vertebrates"; *B*, the fish column as a horizontal series; *C*, the top row as "embryos of quadrupeds." From A. Wilson 1883, 181, 187, and 188, by permission of the Syndics of Cambridge University Library.

longest active lives and most translations (fig. 9.18), were often further simplified. Treating the "German Darwin," a professor with a major research reputation, as an authoritative source, evolutionists typically plundered his grids for figures, columns, and rows.[33]

Chapman had selected some of Haeckel's embryos for the same page as diagrams credited to Kölliker and Baer (fig. 12.2). Books by two of the best-traveled itinerant lecturers split Haeckel's plates too. The American William Gunning's *Life-History of Our Planet* adopted all eight figures from the *Schöpfungsgeschichte*, but as two sets of two pairs.[34] *Chapters on Evolution*, by Andrew Wilson of Edinburgh, broke up the plates from *The Evolution of Man* to match his small wood engravings (fig. 12.6). The text then brought pair, column, and row together to argue that "no more convincing proof of the community of development … could be adduced."[35] Less impressive than the grid, the effect was in some respects more persuasive, since figures were introduced independently and then compared.

Removing columns (classes or orders) could be a major or minor change, depending on which was cut. A pamphlet by an antiquarian doctor and *Meyers Konversations-Lexikon* both copied three columns from the *Anthropogenie*. The pamphlet thematized human evolution by displaying fish, rabbit, and "man" on a foldout frontispiece, for a long time the most blatant use of the embryos in any book.[36] The encyclopedia, though it showed human embryos elsewhere, gave only turtle, chick, and rabbit, and so lost the main point (fig. 12.3).[37]

Borrowers more commonly picked rows showing early identity. The agnostic banker Edward Clodd's *Story of Creation* (1888), which spawned an abridged *Primer of Evolution* and was still in print in the 1920s, put the top row from the *Anthropogenie* in one chapter (on embryology) and the three younger tortoise, dog, and human embryos from the *Schöpfungsgeschichte* in another (as the first proof).[38] For *Chambers's Encyclopaedia* Thomson took fowl, dog, and "man" from the first row.[39] Basic arguments about the similarity and detours of development thus almost reverted to human-dog pairs. To highlight the gill arches, a schoolmaster's *Problems of Evolution* pictured one human embryo of Haeckel's alone.[40]

Economics drove selection. Since most reproductions had to be printed with texts, but the figures originally appeared on separate plates, it was impossible to order a copy from Reimer or Engelmann. The price of wood engraving rose sharply with size and complexity, but keeping the striking, white-on-black style of the lithographs cost less than cutting away most of the wood to create black lines on white.[41] Photography was already used to copy drawings onto the wood, but by the 1890s hand engraving had largely given way to photographic processes for transferring the originals to metal plates that were then etched into relief. The line process handled only lines; in the halftone pro-

cess a screen converted continuous tones into dots that mimicked the gradations of light and shade. Though price still went up with size, and blocks were often finished by hand, it was now cheaper to include more of the original.[42] This did not immediately transform reproductions—that lone embryo was a line block of a figure redrawn in ink—but it did shape things to come.

By borrowing a small number of modules, publishers not only reduced expense; they also adapted complex plates to simpler house styles; Wilson's unassuming line drawings suited his book. The sharper outlines of unshaded lithographs, white-on-black wood engravings, or black-on-white line blocks rendered the figures more diagrammatic and so often a better match. The wish to harmonize helps explain why, even once they had been engraved on wood, publishers worked independently rather than selling electrotypes of the blocks;[43] production was also too competitive and dispersed.

Haeckel's earliest, simplest, and most available plates were thus most copied. Picking out individual elements preserved controversial similarities, but lost the special features of the grid.

Expert Arrays

Evolutionists confident in embryology, though not specialists, took the opposite tack and appropriated the grid. Some changed a few columns and rows, others every single cell. A century before *Science* magazine printed photographs to counter Haeckel's plates,[44] experts redrew these to support largely Haeckelian conclusions. Extra rows already addressed the issue of convergence and divergence in development.

Timing suggests that photo-relief methods eased the decision to redraw, but competence was an essential prerequisite. Zoologist Richard Hesse's cheap adult education lectures on evolution and Darwinism of 1902 argued, with most German professors, for descent and against natural selection. The first and largest figure in a chapter on embryological proofs was a three-row, four-column grid containing new drawings of shark, snake, chick, and human (fig. 12.7). Without criticism or play of accuracy Hesse avoided Haeckel's figures, while using the design to draw the usual conclusion from the resemblance and indirectness of development.[45]

That may be the earliest German example. A more elaborate (double-page, three-row) grid entered the country from a "popular" two-volume Swedish zoology of 1899 by the Uppsala professor Axel Wirén. The halftone reproduction of detailed drawings gives a photographic quality, and text and legend are thorough too. The Gegenbaur-school comparative anatomist and socialist Wilhelm Leche of Stockholm put this array in an approachable book on human origins and evolution which came out in German in 1911. Leche explained that His had expended much effort to prove what no serious biologist had ever denied, that the embryos of different types were alike, not identical. Leche used His's own figures to evidence the greater similarity between embryos than adults, and Wirén's to show that only evolution from a nonhuman animal could explain human development.[46]

The most lavish, effective, authoritative, and exhaustively interpreted embryo grid was by another critical Haeckel adherent writing for a general audience. In Freiburg in Baden, a center of academic Darwinism, a zoology lecturer included this in a large-format two-volume atlas, *Vom Urtier zum Menschen* (From the primordial animal to man). Signaling the respectability of evolution in 1909, the hundredth anniversary of Darwin's birth, the Deutsche Verlags-Anstalt in nearby Stuttgart had commissioned Konrad Guenther—the future pioneer of nature conservation, not the racial theorist—to address educated nonspecialists in a prestige book that offered "the *real scientific research work itself*." Readers approaching Guenther's double plate were supposed to have accepted embryology as the most convincing evidence of human descent and be ready to review the main stages. "In the same way a hiker will understand more clearly the heights of different mountains, if from one viewpoint he contemplates those that rise from the plain, than if he climbs them individually one after the other. The latter size estimation will be more exact, but the former will be handier and perhaps also more easily recalled" (fig. 12.8).[47]

Guenther borrowed figures of almost the same animals as in the early *Anthropogenie* from his expert colleague Keibel. Ordering the rows by extremities gave comparable body forms because, Guenther argued, limb development agreed approximately with that of most other organs. The earliest primate stages would have been indistinguishable in more closely matched

kurze Zeit wirklich zu einem engen Durchbruch, der jedoch wieder verwächst. Zwischen je zwei Furchen der gleichen Seite ist

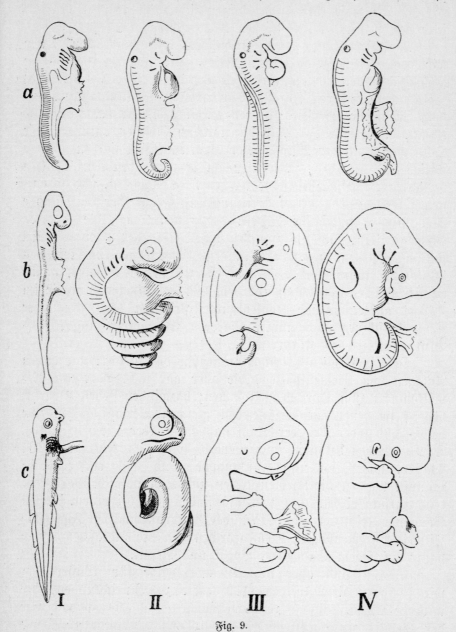

Fig. 9.

Keimlinge von Haifisch (I), Ringelnatter (II), Huhn (III) und Mensch (IV), jeder in drei verschiedenen Altersstufen (a—c).
Bei der ersten und zweiten Stufe sind die Kiemenspalten am Halse deutlich zu sehen.

Fig. 12.7 Embryo grid in Tübingen professor Richard Hesse's evolution lectures. The *School Review* lamented that America had no equivalent of Teubner's little volumes "From nature and the world of thought," which "afford to the Germans inexpensive material of high grade" (18 [1910]: 570). With an eighth edition (1942) and copies in several other German books, this was one of the most successful alternative grids. Hesse 1902, 21. 18 × 12 cm.

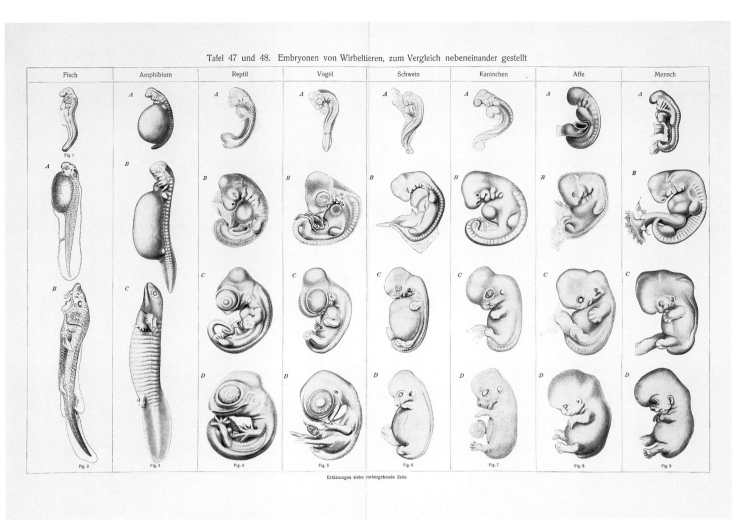

Tafel 47 und 48. Embryonen von Wirbeltieren, zum Vergleich nebeneinander gestellt

Fig. 12.8 Plates in Konrad Guenther's atlas of evolution, *Vom Urtier zum Menschen*. The columns show fish and amphibian at three stages, and reptile (lizard), bird (chick), pig, rabbit, ape, and human at four; a few columns mix species. Calling each column a "figure" echoes Wirén. Halftone of drawings from Guenther 1909, 1: plates 47–48. 34 × 49 cm.

specimens, but even in ideal individuals not all organs kept pace across species. The conditions of life affected embryonic nutrition, the membranes, and hence the embryo itself. More importantly, the most significant organs developed first, the eyes early in reptiles and especially birds, the brain in humans and apes. "Nevertheless, despite all of these disturbing conditions, the double plate convincingly teaches us the kinship relations," visible in the first row for all vertebrates, the second for amniotes, the third for mammals, and the fourth for primates. Development ran in parallel for longer, Guenther concluded, the closer the groups—just as the biogenetic principle dictated.[48] Haeckel's spirit suffused faultless figures.[49]

In a Catholic newspaper a Jesuit biologist could object only that, although the atlas appeared more objective than the *Anthropogenie*, the bias was just better hidden, and noted that lack of "reserve in the treatment of the sexual aspects" made it unsuitable for the general public, families, or young people.[50] He singled out descriptions and depictions of human genital development, but others took a broader view of the sexual. This book contained the embryos that horrified Mrs. Elkan as pornography.[51]

By adding rows, or stages, illustrators took a bolder stand on the shape of vertebrate development than when they put in extra columns. In the 1930s the headquarters of evolutionism in the United States, the

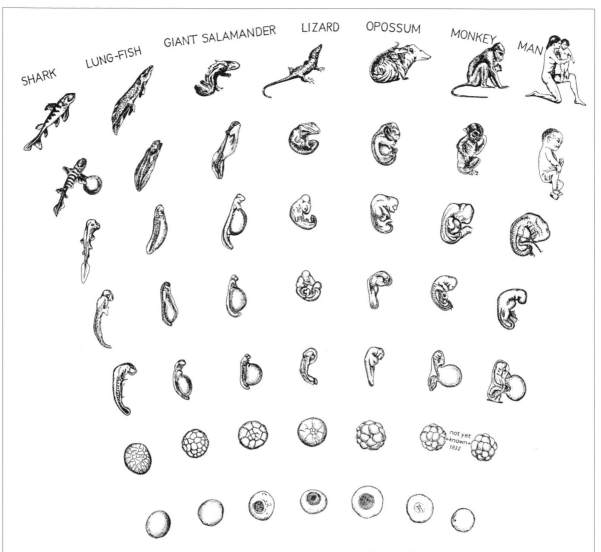

SHARK LUNG-FISH GIANT SALAMANDER LIZARD OPOSSUM MONKEY MAN

not yet known 1932

Dept. of Comparative and Human Anatomy 1932

Fig. 14. Comparative embryology from fish to man (Wall Chart 5).

Man, like other vertebrates, develops from a zygote or fertilized egg, which divides and subdivides as it grows until it eventually gives rise to the millions of cells in the adult body.

In order to facilitate comparison the corresponding stages in the different lines of development have been enlarged to about the same size, regardless of 'scale.' Thus the human egg, which measures only about 1/250 of an inch in diameter, is here shown nearly as big as the egg of the Port Jackson shark, which measures about two inches (bottom row).

The picture shows seven out of the innumerable stages of development.

The second row illustrates late cleavage stages. In the third row note the beginning of somites (body segments); in the fourth row gill slits and the beginning of the fore limbs are indicated; the fifth row shows late embryos with fore and hind limb buds; sixth row, late foetal, newly hatched, or new-born stages; top row, adults.

42

Fig. 12.9 A redrawn grid with additional rows, from a wall chart at the American Museum of Natural History. This unusual series hung in the Hall of the Natural History of Man for its August 1932 opening at the Third International Congress of Eugenics. The paleontologist William King Gregory presumably oversaw the drawing, which makes explicit a Haeckel-style "deduction" by labeling the cleavage stages of monkey and "man" "not yet known 1932"; mother and child represent the adult human. The guidebook warned about mixed magnifications, but gave no sources. From W. Gregory and Roigneau 1934, 42, by permission of the American Museum of Natural History.

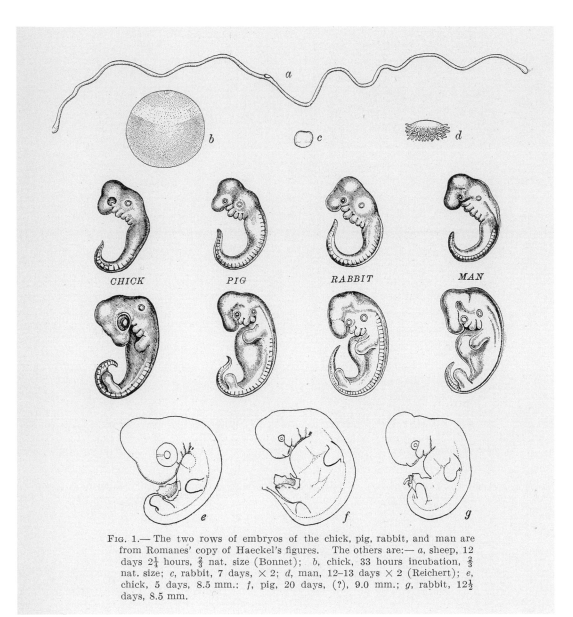

Fig. 1.— The two rows of embryos of the chick, pig, rabbit, and man are from Romanes' copy of Haeckel's figures. The others are:— *a*, sheep, 12 days 2¼ hours, ⅔ nat. size (Bonnet); *b*, chick, 33 hours incubation, ⅔ nat. size; *c*, rabbit, 7 days, × 2; *d*, man, 12–13 days × 2 (Reichert); *e*, chick, 5 days, 8.5 mm.: *f*, pig, 20 days, (?), 9.0 mm.; *g*, rabbit, 12½ days, 8.5 mm.

Fig. 12.10 A critique that incorporated part of Romanes's versions of Haeckel's rows (fig. 12.11). Developmental biologists would similarly modify Haeckel's plate in the late 1980s (fig. 12.3). F. L[ewis] 1907, 591.

American Museum of Natural History in New York, extended the design to seven rows (fig. 12.9).[52] This chart included three stages before Haeckel's first two, a newborn replaced his third, and an adult completed the series.[53] The fan effect heightened the message of divergence, while the early similarity was more Haeckelian than Haeckel, who sometimes acknowledged differences in stages before his first row.

Embryologists had questioned initial resemblance at least since the mid-nineteenth century, when some argued that vertebrates begin differently and converge before diverging again. Bischoff's observations of hamster embryos implied as much, and His highlighted convergence as the truly remarkable fact.[54] In a note in the *American Naturalist* the editor, Minot's Harvard student and successor, Frederic T. Lewis, tore into Haeckel's "totally valueless" drawings, which had "wholly overlooked" "the characteristic features." Lewis nevertheless reproduced Haeckel's top two rows with accurate drawings below and very various eggs above (fig. 12.10).[55]

The expert reworkings fed minor copying traditions, especially in textbooks,[56] but by the 1890s the huge runs of *Meyers Konversations-Lexikon* were squelching the initial variety. Then came the first signs of the big shift to Haeckel's whole plates.

Before 1900 few books reproduced entire grids, but the copy after the *Anthropogenie* in George John Romanes's *Darwin and After Darwin* (1892) proved the most influential of all.[57] In early twentieth-century Britain and the United States most of the new uses of Haeckel's embryos in evolution books neither picked out parts nor substituted more accurate drawings, but copied his double plates, many of them via Romanes.[58]

This wealthy, Canadian-born, Cambridge-trained physiologist and Darwin disciple was elected Fellow of the Royal Society for research on the nerves and muscles of jellyfish and sea urchins and later studied mental evolution. The second and third volumes of *Darwin and After Darwin* were for specialists, but the first was "a merely educational exposition of Darwinian teaching ... adapted to the requirements of a general reader, or biology student." These included copious large illustrations, which "have been drawn either direct from nature or from a comparative study of the best authorities."[59] Among other "evidences," Romanes gave a Haeckelian embryology, qualified only by a warning that embryos resemble embryos and not necessarily adults.

Of some thirty figures in the embryology chapter, a third came from Haeckel. The comparative plates were the last and among the most conspicuous, even at the end of a six-page logjam of images. Taking for granted the work that had gone into the grid, Romanes commented that "the similarity of all vertebrated embryos at comparable stages of development admits of being strikingly shown, if we merely place the embryos one beside the other" (fig. 12.11). No "wonder that evolutionists ... now regard the science of comparative embryology as the principal witness to their theory."[60] Though his discussion of heredity was up to date, the embryology thus stayed faithful to the original spirit of the Cambridge school and lagged behind critical German research. As a compound figure like those that Romanes elsewhere assembled from separate elements,[61] Haeckel's array may, however, have seemed visually advanced.

The artist likely redrew the embryos from the degraded English translation: no aspect present only in the German original (fig. 7.11) is preserved, and several characteristics of the English plate (fig. 9.16) are visible that do not simply reflect the loss of detail. Look, for example, at the more anterior start of the somites in Tortoise II. Shading restored volume, but various features took the wood engraving further from the lithographs, notably the more prominent, detailed limbs in row III. Suppressing the (German) part labels and identifying the figures more economically, with more space between the rows, cleaned everything up.

By the early twentieth century the majority of new anglophone uses of Haeckel's embryos lifted whole plates from *The Evolution of Man*, mostly via *Darwin and After Darwin*.[62] So at the very moment when his lithographs could be reproduced as halftones, Romanes's grid took off instead. Uncluttered line drawings suited most books better and gained credibility from their place in "the best single volume on the general subject that has appeared since Darwin's time." "Fully illustrated with new figures that largely increase its value," it was expected "to be for years to come the one book to which general readers will turn for a concise statement of his ideas."[63] Romanes died in 1894, but at least three British and four American printings followed before World War I. His "generous love of fair play and hatred of personal controversy" may have reassured people Haeckel put off, and he had not "returned to Christian faith" so obviously as to repel nonbelievers.[64] Since he and most other borrowers acknowledged Haeckel[65]—some praised "perhaps the greatest living ... Evolutionist"[66]—they must have been unaware of the forgery charges or discounted them.

Haeckel's embryos now occupied a peculiar position in English. The socialist educator Dennis Hird, founding principal of Ruskin College, the independent institution for working-class education in Oxford, had had one whole plate from *The Evolution of Man* reproduced in *An Easy Outline of Evolution* for the RPA in 1903, light on dark as in the original for the first time.[67] But for a simpler and more successful *Picture Book of Evolution* (1906–7), "for young people and ... those who have not much time to read," he borrowed the double plate and many other figures from Romanes. Hird may have preferred the line drawings, Mrs. Romanes gave permission, and perhaps it was convenient to take as much as possible from one book.[68] The RPA then brought out *The Evolution of Man* in the abridged edition without the plates. Hird had Haeckel's comparisons, while the cheap Haeckel did not.[69] This may seem strange, but reproductions had long been the major source.

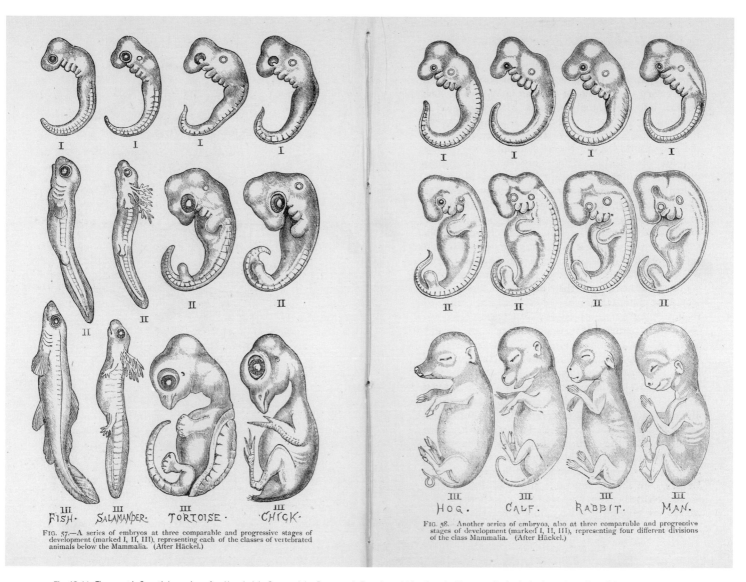

FIG. 57.—A series of embryos at three comparable and progressive stages of development (marked I, II, III), representing each of the classes of vertebrated animals below the Mammalia. (After Häckel.)

FIG. 58. Another series of embryos, also at three comparable and progressive stages of development (marked I, II, III), representing four different divisions of the class Mammalia. (After Häckel.)

Fig. 12.11 The most influential copying after Haeckel, in George John Romanes's *Darwin and After Darwin*. Romanes invited a horizontal reading of the series, stage by stage, from "very little difference" through "further differentiation" to "distinctive characters … well marked." The similar lettering hints that Robert E. Holding, who drew the elaborate illustrations of the products of artificial selection, also copied these. Romanes 1892, 152–53. Whipple Library, University of Cambridge.

Contested, Creative, Consequential

Copying the embryos sometimes sparked controversy in schools and lectures; patterns of use and avoidance reveal implicit contests over books. Though encyclopedias alone distributed some half-million copies in Germany before World War I, these images would enjoy their widest circulation away from the center of debate, in Britain and especially the United States.

Copying was creative. From plundering just a few figures to keeping the grid but changing every drawing, from deleting columns to adding rows, the variations adapted the illustration to genre, printing technique, expertise, and stance on the relations of evolution and development. The cost of wood engraving and the demand for simplicity limited many copies to just one or two figures. Photomechanical reproduction might have made expert arrays available across the full price range, but a clean drawing in an impeccable source established Haeckel's grid of 1874 as the Anglo-American standard. Copying was thus also consequential.

After World War I ended the first great age of evolutionism, reissues of existing works outnumbered new titles, and cheaper surveys had fewer illustrations, if often higher runs. The main publishing action was in experimental and in some ways anti-Haeckelian biology.[70] The burgeoning health and sex education literature is part of Haeckel's late-Enlightenment world, but rarely included these pictures.[71] And yet, neither the topic nor the figures disappeared. They retained a place in evolutionary epics and this once-forbidden fruit became official knowledge in the United States. Copied into a high-school text by 1900, the embryos would thrive through textbooks in the twentieth century.

This is remarkable given that forgery charges against new grids exploded into a major, internationally reported controversy in 1909 while the old grids continued to be attacked. From the early 1890s hostile colleagues and student traitors had joined religious enemies in rewarming the accusations as they contested Haeckel's reputation and the *Welträtsel* elevated him to extraordinary fame.[72] In an age hungrier than ever for news, he made more than most. At a time of growing ambivalence about science, few practitioners so mixed infamy with renown. Again and again, Germany's most controversial scientist, the world's most notorious evolutionist, stood trial.

{ **13** }

Trials and Tributes

Contrary to rumor, no real tribunal ever heard the case. When the forgery story broke in 1997, Terry Hamblin, a hematologist from Bournemouth on the English south coast, protested in the *Times* that it "tells us nothing new": Haeckel had long ago been "tried and convicted of scientific fraud by a university court in Jena."[1] Hamblin did not mention his own creationism, and the source of this fabrication emerged only later as an unreferenced antievolutionist tract.[2] No judge or jury delivered a verdict, though Haeckel, a jurist's son, more than once imagined bringing "this literary affair of honor" before the courts,[3] and it figured when he and a disgruntled student sued each other for libel. So was there nothing new? In the 1870s a leading embryologist had accused Haeckel in an agenda-setting debate. In Germany over the next thirty years a crowd of lesser figures repeated those allegations during one derivative dispute or another, with no fresh charges or big public row.[4]

Yet repetition mattered because it kept the issue alive and shaped it too, by focusing attention on the actions of 1868 and 1874 rather than more recent plates, and by forcing Haeckel into a fuller defense. Though he was often simply abused as a forger, some commentators expanded on themes only broached before. Haeckel's schematics were contrasted to photographs for the first time and, as popularizers grew in confidence, considered in relation to the general limitations of pictures for communicating science. But the main issue, now more than ever, was character. The young reformer had grown into the grand old man of evolutionism, but was he too morally compromised to base a worldview on his science? The substantive issues counted for less and less when critics, focusing on the alleged cover-up, found Haeckel and his allies guilty of "falsify[ing] the history of [his] forgery."[5] Even as supporters honored him on a massive scale, charge

followed charge and countercharge, and the hostile histories grew and grew.[6]

Fighting Nature?

A dispute over how to respond to the advancing social democrats led the new emperor Wilhelm II to dismiss Bismarck in 1890. (Haeckel invited the ex-chancellor to Jena and declared him a "doctor of phylogeny" for uniting the German tribes.) Wilhelm would rule personally over a polarized era in which mass politics began and the battle over Darwinism was rejoined. Failing to adapt, the liberals declined further while the right regrouped to compete with the socialists for working-class votes and other interest groups pressed their claims.[7] As Christian conservatives boosted clerical influence in the schools, Haeckel attacked superstition and backed campaigns against legislation that limited free speech.[8] The reaction from the religious right shored up his base; colleagues' disapproval was a more serious threat.

Most university biologists let this sleeping dog lie. For his scientist foes, His had said it all. Why dignify Haeckel with further attention, provoke a counterattack, or aid those who would restrict the freedom of teaching and research?[9] For his devotees, he had courageously pioneered the theory of evolution, making trouble but also taking the flak; one embryologist was "eternally grateful" and so were "all who belong to the same generation."[10] The pictures of embryos could be excused, if not always defended, and Haeckel, who in person was almost universally described as delightful and unaffected, had paid for his mistakes.[11] And yet, he still had an undiminished capacity to provoke.

Haeckel targeted a high-ranking researcher of his own age who, like His, pitted quantitative physiology against evolutionary morphology. Victor Hensen, professor of physiology at the University of Kiel, the main German naval base, was the most active scientist in a fisheries improvement commission he had promoted when a liberal member of the Prussian parliament. Engaged in measuring the fish catch relative to the total biological yield of the sea, he moved from using egg numbers to estimate laying fish to include the tiny free-floating organisms he christened *plankton*. A more efficient net exhaustively fished columns of water and indicated a roughly even distribution over large areas of open sea. Was the dominant view, that these drifters clustered unpredictably in swarms, an artifact of casual fishing in complex coastal regions where yield varied wildly with depth? Hensen mobilized the economic importance of the issue and his contacts in Berlin to finance a lavish Atlantic expedition in the summer of 1890 (figs. 13.1–13.2). The widely reported preliminary results supported uniformity, but also showed, unexpectedly, that tropical seas were poorest in plankton. Hensen was hailed for opening a new era in marine research.[12]

Haeckel, the leading plankton researcher, could not take this. Fresh from classifying over 3,500 new radiolarian and other species from the *Challenger* voyage, he had received nothing from an expedition, resourced to a level he would never enjoy and based on methods he opposed, that questioned the most basic presupposition in the field. He fired off a polemic that branded Hensen's method "utterly worthless" and his "incautious" conclusions misleading. Morphology and parts of physiology were too complicated for mathematics, but like His, Hensen had applied inappropriately simple (and mind-numbingly boring) techniques. In the nationalist *Tägliche Rundschau* (Daily news) Ernst Krause criticized the waste of public funds.[13]

Hensen's own pamphlet defended the project and took the fight to Haeckel, despite the "aggravating circumstances." No one would wish to move against someone "personally so fresh, charming, and heart-gladdening, a very brilliant writer, highly gifted," productive, and much respected abroad. But "such serious and deliberate offenses against science have been incontrovertibly proven against Haeckel that though forbearance is possible in personal interactions, in scientific discussion the situation really becomes very difficult." Quoting His, Hensen returned the forgery accusations to a research debate after a lull of fifteen years. He suggested that "workers in science who proceed like Haeckel stand in relation to the normal researchers as if they had originated *diphyletically*." Since "true facts have no weight for *him* who does not shrink from bending them to his will," he wrote "not for Haeckel, but for readers who belong to my phylum."[14]

Hensen accepted evolution as probable, and Darwinism as a "highly interesting and instructive" hypothesis but not the complete explanation it pretended to be. He rejected the biogenetic law and the declara-

Fig. 13.1 The plankton expedition: journey of the steamer *National*. "The ordinates on the line of travel give the volume of the plankton catches," with ⅓ mm equivalent to one cc per m² of sea area. Hensen 1890, plate I.

Fig. 13.2 The plankton expedition: vignette of sailors with a net. Halftone from the cover of Victor Hensen's polemic against Haeckel, Hensen 1890.

tion of one mode of development as the norm. Every embryologist had considered recapitulation, but then recognized that it did not work. Haeckel had decided it must. When he "encountered a certain recalcitrance in the material," he concluded that *nature just forged a little now and again.* "Because nature falsified his biogenetic law, Haeckel cenogeneticized nature back in the manner described by His" to create a world as compromised as himself.[15]

Developing His's critique of the "party leader," Hensen complained that Haeckel had "form[ed] parties in … science as in a parliament, and his party has been carried high by a lay public … which he wooed. In science, however, we can tolerate no party rule; it may make one strong in the *fight*, but *who* then are we supposed to be fighting? Not *nature*, surely? She who never falsifies, but always speaks the truth to her true friends!" People had warned Hensen he would make "too many enemies" by attacking Haeckel. He comforted himself that the next generation was breaking free, if not from lip service, then in research.[16]

Physiology here faced morphology, and Hensen was also a noted embryologist after whom the node in the chick embryo is named.[17] A larger political or religious agenda seems unlikely. An anti-Catholic liberal himself, Hensen ridiculed the destruction of received views for Haeckel's barren monism, but gave no other hint of religious conviction.[18] Hensen shared His's commitment to exactitude,[19] and disdain for popularization,[20] but had let himself be provoked into a character assassination not directly related to the issue at hand. The *Tägliche Rundschau* objected to the "personal insults, accusations, and bad manners," while the conservative *Leipziger Zeitung* seized on the confirmation that Haeckel was finished.[21] The main effect was to force him into a more detailed defense against the forgery charges, the "concluding apologia" to the fourth (1891) edition of the *Anthropogenie*. This did not really engage with Hensen, but assembled arguments against attacks presented as petty and themselves dishonest.

Foolishness, Photographs, and Popular Pictures

Haeckel explained that His's denunciation had been so widely reported that "friends concerned about my personal honor" advised him to sue for libel and defamation. Judges might find him guilty "on purely formal spurious grounds," he feared, but a jury of "informed, impartial, and honest colleagues would very surely unanimously find me innocent." Even His's "close friend" Kollmann—a closet monist—had exonerated Haeckel, but Hensen still "warmed up" the allegations.[22] Two decades later Haeckel would give up on a unanimous verdict. Embryologists' divisions meant that an "impartial and competent court … simply cannot be found." "The exact embryographer" might condemn him, but "the comparative embryologist" would find his "'forgery' fully justified and useful for … teaching."[23]

The apologia reheated arguments about genre and audience. Developing his broad view of "schematics," Haeckel insisted that the "great majority" of figures in the *Anthropogenie*—most of them electrotype prints from other works—were "so-called *diagrams* or *schematic figures*." "The nature researcher who uses a schematic figure to illustrate a fact *thinks* something when he does this; he alters the true form of his object according to the view that he forms of its *essence* and leaves all unnecessary and distracting details out." Since this was standard classroom practice, His could have saved himself the trouble of "denouncing me as a liar and a cheat" because Baer, Müller, Gegenbaur, and Huxley deserved the same honor.[24]

Harking back to supposedly long-standard practice, Haeckel articulated a new reaction against the imagined excesses of "exact" physiology and "mechanical objectivity."[25] Objectivity rhetoric hardly figured in 1875, when His defended truth, which Haeckel qualified in defining his pictures as schematics.[26] Now that Haeckel stood accused of bending facts to his will, he added to the war between physiology and morphology a skirmish over objectivity featuring photography as a foil. "Completely free of blame and virtuous, according to His (and many other 'exact' pedants), is thus only the *photographer* or that 'physiographer' who like the latter copies nature *without thinking*." Haeckel claimed that His used "diagrams" too, calling them "*constructed pictures*," but failed to recognize the role of thought (fig. 13.3). Yet His was not the automaton Haeckel pretended. He had developed a drawing apparatus, but accepted subjectivity as the advantage and disadvantage of drawing over photography. He let drawings mend tears in specimens and defended freehand modeling against a more mechanical and "objective" method because he valued the mental labor involved.[27]

Cardiocoel nennen.

Das Cardiocoel oder Kopfcoelom dehnt sich bei den Amnioten bald unverhältnissmässig aus, indem der einfache Herzschlauch frühzeitig sehr stark wächst und sich in mehrere Windungen legt. Dadurch wird die Bauchwand des Amnioten-Keimes zwischen Kopf und Nabel bruchsackartig nach aussen vorgetrieben (vergl. Fig. 170 *h*, S. 359, und Taf. VI—IX, *c*). Eine Querfalte der Bauchwand, welche sämmtliche in das Herz einmündenden Venenstämme aufnimmt, wächst von unten zwischen Herzbeutel und Magen hinein und bildet als dünne Querscheidewand (*Septum transversum*) die Anlage des primären Zwerchfells (*Diaphragma*, Fig. 407 *d*). Diese wichtige muskulöse Scheidewand, welche nur bei den Säugethieren Brusthöhle und Bauchhöhle vollständig trennt, ist auch hier noch anfangs unvollständig; beide später ganz

Fig. 407. **Frontal-Schnitt durch einen menschlichen Embryo** von 2,15 mm Nackenlänge, 40mal vergrössert; „erfunden" von WILHELM HIS. Ansicht von der Bauchseite. *mb* Mundbucht, umgeben von den Kieferfortsätzen. *ab* Aortenbulbus. *hm* Mittheil der Herzkammer, *hl* linker Seiten-Theil derselben. *ho* Herzohr (der Vorkammer). *d* Zwerchfell oder Diaphragma, *vc* Obere Hohlvene. *vn* Nabelvene. *vo* Dotterraum. *lb* Leber. *lg* Lebergang.

getrennte Höhlen hängen hier eine Zeitlang noch durch zwei enge Canäle zusammen, die „Brustfortsätze der Rumpfhöhle" von HIS. Diese beiden, zum Dorsaltheil des Kopf-Coeloms gehörigen Canäle

Fig. 13.3 "Frontal Section Through a Human Embryo of 2.15 mm Nape Length, magnified 40 times; 'invented' by Wilhelm His." This was Haeckel's sarcastic description of a His "construction" borrowed for the discussion of diaphragm (*d*) development in the *Anthropogenie*. Haeckel 1891, 2:779.

Haeckel also finally addressed the repeated blocks, or "*story of the three clichés,*" as he named it after the parable of religious tolerance in Lessing's *Nathan the Wise*, in which a judge could not distinguish three rings that symbolized the monotheistic religions. The reality was banal: "Expert colleagues know that the issue is an act of extremely rash *foolishness* which I committed *bona fide* in the rushed production of the few illustrations for the *first* edition of the *Natürliche Schöpfungsgeschichte* (1868). I illustrated with three *identical* figures three *extremely similar* objects, so similar that as is well known"—but specialists disputed—"*no* embryologist is able to distinguish them." "Already in the second edition I corrected this formal error, which gave me the superficial *appearance* of knowingly false depiction." Twenty-three years later Hensen was still bringing up the mistake. How "*pathetic* and *contemptible* is my opponents' approach, always (*bona fide*??) to gnaw away at a hundred weak points of my works with trivial and spurious arguments, criticism of small errors, and suspicion of scientific forgery, when the *fundamental concepts* of my theories carried through to their conclusions offer them numerous much more important and worthier objects of attack."[28]

Like *Ziele und Wege* in 1875, this antidote reassured supporters, such as the freethinker Gustav Tschirn, who "read up" His and Semper "and—as a nonspecialist, since I simply could not explain this incredible thing to myself—turned without further ado directly to the man so incomprehensibly accused." Haeckel recommended borrowing the fourth edition of the *Anthropogenie* from Willy Kükenthal in Breslau, and this rearmed Tschirn, who just needed a confident explanation, for the road.[29]

Wilhelm Bölsche engaged with the charges as a self-styled "popularizer," for whom Haeckel's books caused trouble because of their "position on the boundary of popular literature and specialist work." The tale of the "forgeries" spread because scholars failed to appreciate the limitations of popularization. Even the three clichés represented "a small excess of zeal," of a kind common in the best popular geology and astronomy, and had to be judged in context: "in a popular book … for a schematic outline drawing … with the strongly emphasized admission … that the chemical composition … is in each of them *despite this* individually different."[30] The illustrations in the *Schöpfungsgeschichte* were "improvised," but calling this "forgery" was unfair, "as if he had wanted deliberately

to dupe his readers with false figures!"[31] In 1891, when Bölsche was cultivating Haeckel, he regarded even the admission of "foolishness" as "too severe." After his friend's death he accepted that inexperience led Haeckel into "all kinds of naïvely stupid actions" in illustrating the book "as crudely as a calendar."[32]

Bölsche's deeper point was that Haeckel might better have avoided drawings altogether when the danger of misunderstanding was so great.[33] "For if the layman already tends to consider … a scientist's text holy and eternally true, of a figure he will think that … he now holds in his hand the palladium that vouchsafes him … the sight of the absolutely correct." Yet theory shaped even specialist figures, while the most effective popular pictures were more generalized, exaggerated, and stylized. Any calm assessment of where someone might have gone too far had to recognize this.[34]

Peace and Reconciliation

Most biologists preferred to forgive and forget, dealing with Haeckel by praising what they could. Thank-you letters for liberally distributed new editions show what other professors could applaud. "You possess the tremendous ability … to summarize the almost endless fields of knowledge," Kollmann wrote, and

"have always … stressed the connections. Even with Darwin, without you we would probably have groped around in the fog for a long time."[35] Revision gave the *Anthropogenie* a double identity, as a relic of the early editions and a contemporary work, with the contrast a tribute to the research Haeckel had inspired. Friends and students recalled how the *Schöpfungsgeschichte* had awakened their interest in biology, and assured him it remained "the best book" on "these important general questions,"[36] while publicly celebrating the German Darwin more safely as a historical figure.

This strategy culminated in a sixtieth-birthday jamboree in 1894. Support poured in, because "he who pays homage to Haeckel … pays homage to the theory of evolution."[37] Nationalism played a role—"the German professor is above all a German"[38]—but the cause was international. Seven hundred nineteen subscribers, including scores of European academics and the Ernst Haeckel Club in Louisville, Kentucky, contributed over fourteen thousand marks, double the cost of a party for two hundred and a marble bust (fig. 13.4). Haeckel also received memberships in scientific societies, biographical tributes, and a street named after him in Jena.[39]

As chairman of the organizing committee, Gegenbaur's eldest student and successor as Jena anatomist,

Fig. 13.4 Photograph of Haeckel, a practiced sitter, with a later bust, this one by Cipri Adolf Bermann, in summer 1905. EHH.

Max Fürbringer, rejoiced that "even colleagues, with whom [Haeckel] has stood in hard, sharp conflict because of this question or that (and he is sometimes a rough opponent),... told us that they wished to honor him too." Hensen, His, Goette, and many others were still absent—Semper had died—but among the perhaps surprising names are Albert Kölliker, Oscar Hertwig (who had become critical of Haeckel since moving to a chair in Berlin), Franz Keibel, Wilhelm Roux, and, from Cambridge, Adam Sedgwick, today known one-sidedly as a critic of the biogenetic law and Haeckel's illustrations. In all, just over half the full professors of zoology at the imperial German universities, few of them directly his students, contributed to the bust. Though a less controversial major figure might have expected close to a full house, this was quite an achievement, and a similar proportion of the anatomical *Ordinarien* signed up. "Thus," Fürbringer concluded, "a celebration of adoration and admiration has become also a celebration of peace and reconciliation, and here too the old great saying is true: unity in great things; liberty in doubtful things; charity in all things!"[40]

Haeckel's own senior student, Richard Hertwig, who had realized his teacher's dream of the Munich chair, showed how to exercise charity by invoking the spirit of the whole. "In the life of every science there come times in which calm, rational work is not enough, but that demand the researcher's entire personality, times in which the energy of a character inhibited by no kind of incidental, petty considerations must join with the power of clear judgment." Hertwig credited Haeckel's "most brilliant discoveries" to his "inspired intuition" and Goethe-like "combination of artist and researcher." "Where others sought in vain to tear her secret from nature equipped with complicated apparatus and rich material, a few observations were enough to lead you to the right path of research. You understood in high measure how to think in accord with nature because you possessed much of the artist's gift of sight, which without tedious analysis knew how to grasp the significant in the phenomena and to express it."[41] In other words, Haeckel had been the right man for an unusual job, but solid work with the latest techniques was now the order of the day.

It helped that Haeckel, though in print intolerant of dissent, had founded a "flexible," "divergent" school.[42] But if his church was broad, that it was a church amplified the damage when a few abandoned the faith. While Rütimeyer and His attacked a rising approach, and Hensen claimed to fight an orthodoxy that had overreached, the next two scientist accusers, like Huxley's turncoat student St. George Jackson Mivart in Britain, were apostates from the creed in which they had been raised.[43]

Apostates Enter the Lists

Otto Hamann, a "faithful, obedient disciple," had sent Haeckel an expensive plant or flower for every birthday.[44] But in 1889, when Haeckel declined to nominate this former student and assistant, an echinoderm specialist, for the Ritter chair in phylogeny, Hamann came out against Darwinism (but still accepted evolution as a mere hypothesis). As Haeckel joined the Protestant middle-class protest that would derail the 1892 elementary-school bill (fig. 13.5), Hamann appears to have ingratiated himself with influential circles in Berlin and been rewarded with a job at the Royal Library and a professorial title. He even wrote for a conservative Catholic journal in Vienna. An overtly political book argued that no evidence supported the derivation of one type from another, and that internal causes and ultimately the Creator directed any development toward a goal. Sarcastic about Haeckel, Hamann quoted His's denunciation and reproduced his pictures.[45]

Betrayed and furious, Haeckel lashed out in a footnote to a landmark speech on "monism as connecting religion and science." Hamann had embraced "orthodox mysticism" to suck up to the powerful when, as the weakest candidate, he lost out on the chair. The book was "*from beginning to end a huge lie*" and honest enemies of evolution should beware of such an "*unscrupulous renegade*; for it needs only the chink of coins to bring him back into the Darwinist camp."[46] Hamann sued for libel, and Haeckel countersued. In the nervous atmosphere surrounding the bill to increase church influence in school, the liberal press reported a threat to intellectual freedom from putting "Darwinism on trial."[47]

This was not the tribunal Haeckel had envisaged. The court considered just the personal insults, and only a confession could have proved his plausible defense that he had written the truth. So both were fined, though Haeckel much more, and ordered to strike the offending passages from any future editions. Ha-

Fig. 13.5 *"Zedlitztrütschleria papalis*, Haeckel," sketches of male and female forms of a new mammal that Haeckel claimed had been found in an "ultramontane swamp" in Posen (now Poznań) by the Jesuit Father Filucius in company with Pious Helene, two characters by the satirist Wilhelm Busch. Haeckel named the creature after the Prussian minister of culture, Robert von Zedlitz-Trütschler, author of the hated elementary-school bill. From a copy of Haeckel's "Mammale novum incredibile," in a "beer newspaper" celebrating the twelfth anniversary of the Natural Scientific Association of Students of the University of Jena, 30 Jan. 1892. EHH.

mann's behavior appalled most biologists, who were unimpressed by a book that from supposed weak points in the evidence moved, with even less warrant, beyond science to God. Haeckel—seen, unusually, as the victim of an unprovoked attack—was widely accorded the moral victory.[48] Hamann authored a pamphlet on Haeckel's dishonesty in dealings with Rütimeyer, His, Hensen, Bastian, Semper, and Robby Kossmann (who denied Goethe's alleged evolutionism), and himself.[49]

The second apostate held a full professorship that made him the most senior antievolutionist zoologist.[50] Selenka's student Albert Fleischmann, also known mainly for mammalian embryology, succeeded to his teacher's Erlangen chair in 1898. Just before, he brought out a textbook that rejected evolution as a fairy tale. Smelling another Hamann, Haeckel all but accused him of changing sides to please Bavarian Ca-

tholicism and steal Selenka's old job.[51] Some did want an antievolutionist, but Fleischmann, who claimed to have expressed the same views in 1891–92, appears to have benefited from the faculty's debt to him for running the institute during Selenka's long absences.[52]

Though Fleischmann is often called a creationist and certainly helped that cause, he offered only a cult of the directly observable based on extreme skepticism toward theory. Lectures published in 1901 suggested that belief in evolution satisfied a longing for impossible knowledge of the distant past. Haeckel's spurious mixing of science (descent) and theology (creation) had chimed with the anticlerical mood, but—Fleischmann made much of a few dissenters—evolution was losing ground. He argued, for one key transition after another, that transformation of types could not be proved.[53] To introduce the debate over Darwinism, he quoted the forgery charges after His, Semper, and Hensen.[54]

Fig. 13.6 Cover of "Darwinism and Social Democracy; or, Haeckel and the Putsch," "by a thinking scientist" (1895). Pamphlets in this series, published by the press of the leading Catholic newspaper, were very widely distributed. Carl Leonhard Becker's design shows sunlit cherubs singing against the evil dragon. 13.5 × 9.8 cm. Universitätsbibliothek Tübingen: Gd 514.

For all this, religious opposition remained more important as social-democratic progress increased the pressure on Darwinists to prove they were not fellow-travelers. When Haeckel resisted the 1895 sedition bill, which the Center Party made so restrictive of criticism of Catholicism that Protestant conservatives let it drop, a ten-pfennig pamphlet presented him as an intellectual anarchist whose science was fantasy and his "religion" atheism barely disguised (fig. 13.6). His, Semper, Rütimeyer, Hensen, and especially Hamann were lined up to testify to Haeckel's dishonesty, while his defense was dismissed as like a thief pretending he reached for the wrong pocket in a hurry.[55]

The growing rosters of accusers flattened status, inviting readers to put Hamann on a par with His.

Taken at face value, they would mislead about historical impact too. A trial engaged the general public more than a textbook, while this affordable religious attack may have reached more people but largely within its own milieu. On the one hand, repetition kept the charges current and raised the chance of sparking something bigger. On the other, and from such predictable challengers, it risked confirming that forgery was no longer news.

Notoriety and History

Everything would change not with one more scientist critic or yet another clerical denunciation, but in the first place with Haeckel's own role through

Quo vadis?

Haeckel, der Führer des Mo^{nismus}: Herr, wohin gehst du?
Giordano Bruno: Nach Rom.^e Zeit, mich wieder einmal verbrennen zu laffen!

Fig. 13.7 "Quo vadis?" In front of St. Peter's Cathedral Haeckel asks Giordano Bruno, burned at the stake on the Campo de' Fiori in 1600 and a hero of nineteenth-century free thought, where he is going. "To Rome. It is time to have myself burned again." The reference is to the apocryphal encounter between Peter and the risen Christ, south of Rome, which reconciled Peter to his martyrdom. The occasion was a papal encyclical on the errors of modernism. This double-page spread took advantage of cheaper color printing to create a stark image, in which Haeckel and Bruno are foregrounded as individual leaders against the hordes of black-habited clerics, and the church seems more threatened by the flames. From a drawing by Wilhelm Adolph Wellner after a design by Paul Kraemer, *Lustige Blätter* 22, no. 44 (29 Oct. 1907): double page preceding 10. 31 × 46 cm. Stadtbibliothek Hannover: Zs 212.

the *Welträtsel* (1899) in creating a mass audience for science. He was not unknown a year earlier, when Bölsche was commissioned to write the first book-length biography for a series including composer Franz Liszt, philosopher Friedrich Nietzsche, arms manufacturer Alfred Krupp, and explorer Fridtjof Nansen,[56] but magazines appear to have run caricatures only from 1900 (fig. 13.7).[57] For about a decade the last representative of the heroic age of evolutionism was more newsworthy than Darwin. He fed the new mass-media machine with the most controversial science book, and then gave interviews, responded to

critics, wrote a sequel, and staged public events. An international celebrity, he was so distant from research that specifics were no longer at stake. He stood for a whole worldview.

The *Welträtsel* carried no illustrations but claimed the similarity of vertebrate embryos as a *"fact of the first order."* With reference to the plates in *Schöpfungsgeschichte* and *Anthropogenie* Haeckel argued as usual, but for ten or even a hundred times more readers, that only evolution could explain why "at a certain stage the germs of man and of the ape, the dog and the rabbit, the pig and the sheep are recognizable as higher

vertebrates, but otherwise cannot be distinguished."[58] So he took the embryos with him as he returned to the center of a larger stage. Opponents amplified the character questions as they scrambled to take him down.

Hermann Müller's former pupil Eberhard Dennert tabled the forgery charges most potently. Historians of biology know his *Vom Sterbelager des Darwinismus*, a pamphlet of 1903 translated in the United States as *At the Deathbed of Darwinism*.[59] Dennert rejected natural selection, but accepted common descent as a probable hypothesis while insisting on a divine act of creation for human beings. Yet *Deathbed* has sometimes been cited almost neutrally to represent a somewhat exaggerated "eclipse of Darwinism" around 1900, when a host of competing evolutionary theories challenged natural selection, but evolutionism in many ways thrived.[60] The book, by an academic outsider with minimal support among German biologists but a base in apologetics, was in fact his second in a series of interventions promoting conservative Protestant science.

Having taken a doctorate in botany from Marburg, Dennert taught at a Protestant boarding school in Godesberg near Bonn. He was impressed by the controversial former court chaplain Adolf Stoecker, founder in the early 1880s of the populist Christian Social Party, which when it failed to compete for working-class votes made anti-Semitism central to a program directed to the lower-middle class. The party never attracted many votes, but played a part in hounding Haeckel. From 1897 Dennert led the working group on apologetics and natural science in Stoecker's Independent Church Social Conference, a conservative splinter group from the Protestant Social Congress, which combated the rise of socialism by addressing social problems from a Christian perspective. Dennert joined the debate over the *Welträtsel* in 1901 with a slim book promising *Die Wahrheit über Ernst Haeckel*, or "The truth about Ernst Haeckel … in the judgment of his colleagues," the largest compilation of fraud accusations to date.[61]

In German *Die Wahrheit* outsold *Vom Sterbelager*— with thirteen thousand printed by 1908—as it explored Haeckel's evasions, excuses, and dishonesty one critic at a time. But attention had so shifted to the succession of charge and countercharge that Dennert judged him "more careful" now.[62] Since recent plates had escaped criticism, Dennert could object only that "he and his people … continue to falsify the history of Haeckel's forgery."[63] The past mattered in the battle over a man whose status depended on his role as a pioneer, but it was harder for history to make news.

Haeckel tried to defuse the issue by cutting the apologia from the fifth (1903) edition of the *Anthropogenie*, and he still had plenty of backing. His seventieth birthday was much celebrated in 1904, though he avoided another party by escaping to the Ligurian riviera. The rash of book-length lives that followed Bölsche's quasi-official biography dealt sympathetically with the allegations,[64] and *Kosmos* expanded the audience for Haeckelian science. But this also provoked opposition as the charges were repeated into the years of Haeckel's greatest fame and notoriety, with more readers to shock and clashes more likely. Then some new pamphlets carried provocative pictures, and Dennert and the Christian Socials ensured that the controversy spiraled out of control.

Scandal for the People

"Haeckel admits the forgeries," screamed the right-wing Berlin newspaper *Das Reich* (The empire) as the scandal hit the headlines in early January 1909. "Haeckel is condemned, condemned once and for all. Whoever still seeks to save him now, makes himself complicit." The organ of the Christian Socials thus fed a media storm over an article by Haeckel which a week previously had taken up almost the whole front page of the *Berliner Volks-Zeitung* (Berlin people's news). The optimistic editor of that left-liberal paper had claimed that this "show[ed] once and for all that the most nasty accusations against him are groundless."[1]

The hopeless symmetry of those "once and for alls" surprised no one. This row was remarkable for its scale. News of "forgeries" had once reached a middle-class audience through paragraphs in difficult books and mostly rather serious periodicals. When a concerted controversy over "Haeckel's pictures of embryos" broke out in 1908–9, the views of millions of newspaper readers were at stake.[2] Professors, teachers, and journalists still played the main roles, but as educated-middle-class authority eroded and mass politics marched through an expanded and diversified press, an ideological struggle over science produced a debate so broad contemporaries gave up trying to track every contribution.[3] The old charges were recently aired; cheap books published after big public lectures contained revised embryo plates; and rival leagues had just been founded to propagate and eradicate Haeckel's nature-religion. The trigger might not seem anything special—a garbled local newspaper report of a lecture—but as an account of a Christian Social Party meeting, it represented a populist challenge to the left and the establishment, and so announced a new constituency for science.

The politics of evolution changed slowly. A more aggressive selectionism was opening Darwinism up for the right; Haeckel's own rightward shift is well known. But eugenics, or racial hygiene, which Haeckel helped promote around 1900, drew support also from left-wing professionals, and Darwinism remained first and foremost a major plank of social-democratic ideology.[4] In the debate over his pictures, the highest-profile controversy over evolution of the years before World War I, reactionary Protestants and Catholics still loudly opposed liberals and the left. Christians were engaging more closely with natural science, however, and so were more interested not just in countering a threat, but also in providing versions the faithful could use. At the same time, right-wingers challenged scientists' autonomy on a widening range of issues, such as vivisection, cadaver dissection, the antisyphilitic drug Salvarsan, and later relativity.[5] Haeckel had once lampooned "the so-called educated" as he broke the National Liberal consensus on the limits of science. Now an academic outsider on the Protestant right invoked "the German people" to force reluctant specialists to take a stand.[6]

Lectures and Leagues

In 1904 Haeckel rallied followers to create a campaigning organization for social reform based on his nature philosophy, chiefly through propaganda for an evolutionist worldview, fighting church influence in the schools and encouraging the replacement of Christianity with a rational religion of nature. Though the international congress of freethinkers in Rome declared him "anti-pope," many worried about his metaphysical commitments and doubted that yet another forum would help a minority interest break into the mainstream. But in Jena in January 1906 admirers formed the German Monist League under his honorary presidency and with his personal assistant as general secretary. One of Wilhelmine Germany's numerous middle-class protest movements, the league claimed 2,500 members within a year, mostly from the free professions, but still only 6,000 in 1914, in forty-two local branches. The monists published magazines and pamphlets, put on lectures, and arranged solstice festivals and secular confirmations. Some scientists joined, but many regarded monism as illegitimate scientism, an institutionalized rejection of limits, that mixed

questionable doctrine with uncongenial ideology. The league was politically diverse and split in the early years between promoting science and developing new religious practices, but Haeckel dominated and big lectures kept his profile high.[7]

Haeckel had resolved to speak in public no more, but friends, a fee of 2,500 marks,[8] and perhaps a wish to settle accounts with Berlin science now that Virchow was safely dead, persuaded him to intervene personally again. In April 1905 in the Sing-Akademie, the capital's oldest, largest, and most distinguished concert hall, three talks tackled the German churches' co-option of evolutionary biology (fig. 14.1). Taking as his title "Der Kampf um den Entwickelungs-Gedanken" (The struggle for the theory of development), Haeckel welcomed the increasing adaptation of science for Christian readers as a sign of the impending "victory of pure reason," but worried that it muddied the waters. So he targeted the Jesuit scientist Erich Wasmann, a competent researcher who accepted evolution for ants, but not humans, and posited special creations for the origin of life and the human soul.[9]

Orthodox Protestants doled out leaflets at the doors and complained that Haeckel had "desecrated" the room. He responded that even if the authorities followed the pope, who had the churches of Rome disinfected after the freethinkers' congress, they would never eradicate the *bacillus of truth.*[10] Wasmann rejected Haeckel's monism as a prop for socialism and anarchism, referred to the story of the three clichés, dismissed embryonic identity as an *argumentum ex ignorantia*[11]—and was invited to lecture in February 1907 (fig. 14.2). A few months later the vitalist botanist Johannes Reinke, a Kiel colleague of Hensen, assailed Haeckel in the Prussian House of Lords. Accepting evolution but not human descent, he painted monists as barbarians driving young people into socialist arms. Where once conservatives had restricted biology teaching to prevent socialism, Reinke now prescribed the science to inoculate pupils against social democracy.[12]

Haeckel took on this echo of Virchow's forty-year-old "calls for the police" in a lecture in Jena that he called "Das Menschen-Problem" (The problem of humans) or "the question of man's place in nature and his relations to the totality of things." Among friends and marking the Linnaeus bicentenary, Haeckel adopted a milder tone, playing up his own international

Haeckel in Berlin.

„Sie, kommen Sie mit Ihrer verdammten Fackel nicht unsern heiligsten Gütern zu nahe!"

No. 18 LUSTIGE BLÄTTER. 5

Fig. 14.1 "Haeckel in Berlin." He holds the *Welträtsel* and a torch of Enlightenment that is shedding sparks. Against the background of the new cathedral—just across the Spree Canal from the Sing-Akademie—a policeman shouts, "You, don't get too close to our holiest cultural possessions with your damned torch!" Though not as large as it is pictured here, the book began as a tome of nearly 500 pages, which Haeckel abridged for a "pocket edition." Halftone after Franz Jüttner, *Lustige Blätter* 20, no. 18 (3 May 1905): 5 (usually misdated to 1900). 31 × 23 cm. Stadtbibliothek Hannover: Zs 212.

Fig. 14.2 "Haeckel and Wasmann" (here, unusually, Waßmann). "H[aeckel]: Yes, my dear fellow, if you use *that* glass the cross is always going to get in your way." From *Kladderadatsch* 60, no. 10 (10 Mar. 1907): 38. NSUB.

Häckel und Waßmann

H. Ja, Verehrtester, bei Gebrauch dieser Lupe wird Ihnen das Kreuz wohl immer hinderlich sein.

Fig. 14.3 Photograph of exhibits for Haeckel's 1907 lecture "Das Menschen-Problem." "The Zoological Institute supplied its treasures of visual aids, which offered rich opportunity for partly serious, partly humorous reflections" (Heinrich Schmidt, "Ernst Haeckel über das Menschenproblem," *Jenaer Volksblatt* 18, no. 141 [19 June 1907].) Haeckel more than filled the 1,400 places in the great hall of the Jena *Volkshaus*, or "House of the People," an initiative of the physicist and social reformer Ernst Abbe completed in 1903. At the back of the stage the large charts show ape and human skeletons after Huxley (top), vertebrate embryos, a systematic table, and a mammalian evolutionary tree. The grid of "sandal germs" on our left is much like a plate in the pamphlet (fig. 14.4); the adjacent later embryos are based on columns for marsupial, dog, bat, and human in the *Anthropogenie*. The frieze below them includes the development of the face. At the front are stuffed apes, skeletons, and charts showing brains, apes, and ethnographic portraits. To our right, below Erich Kuithan's balcony decorations, is a strip of vertebrate embryos and a large chart showing development of the gastraea. EHH.

reputation, local contributions, and the freedom of the smaller German states, where "it is still permitted, not just to research, but also to teach the truth." The government had awarded him the title "Excellency," the first time a zoologist achieved this rank. He looked forward to the completion of the Phyletic Museum, "a temple for the 'religion of pure reason,' for the cult of the 'true, good, and beautiful,'" that was going up "at the gates of paradise"—on the edge, that is, of Jena's Paradise Park.[13]

Haeckel had charts and specimens arranged like elaborate altarpieces around the stage and gave embryos star billing (fig. 14.3). The published text highlighted the argument from embryonic similarity, and rejoiced that people could now speak about the eggs of humans with as little inhibition as about those of chicks.[14] Since a cheap pamphlet could not be illustrated so lushly,[15] Haeckel made do with a figure of a human egg cell plus three glossy halftones. One showed Huxley's primate skeletons and two were em-

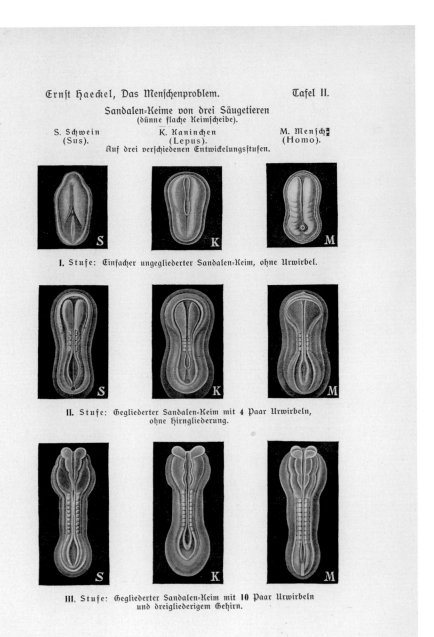

Ernſt Haeckel, Das Menſchenproblem. Tafel II.

Sandalen=Keime von drei Säugetieren
(dünne flache Keimſcheibe).

S. Schwein K. Kaninchen M. Menſch
(Sus). (Lepus). (Homo).

Auf drei verſchiedenen Entwickelungsſtufen.

I. Stufe: Einfacher ungegliederter Sandalen=Keim, ohne Urwirbel.

II. Stufe: Gegliederter Sandalen=Keim mit 4 Paar Urwirbeln,
ohne Hirngliederung.

III. Stufe: Gegliederter Sandalen=Keim mit 10 Paar Urwirbeln
und dreigliederigem Gehirn.

Fig. 14.4 "Sandal Germs of Three Mammals (thin, flat germinal disc)," pig (*S*), rabbit (*K*), and human (*M*). Halftone of drawings from Haeckel's 1907 pamphlet, *Das Menschen-Problem*, plate II.

bryo grids: "sandal germs" (fig. 14.4) and older stages shared with a booklet from the Berlin lectures (fig. 14.5). Only a sharp eye would have spotted differences in the forms compared with the plates in the *Anthropogenie*; many would have seen that such pictures were accessible in works by Haeckel as never before.[16]

The Christian right perceived a threat to morals and the state, and even liberal Protestants were concerned. In November 1907 Eberhard Dennert went public with a rival Kepler League to combat "atheis-

tic monism" and promote science as compatible with Christianity. Against the specter of schoolchildren lured by Haeckel, and *Kosmos* lecturers touring the country with "striking slides in part based on fantasy," this league would fight monism with its own weapons: cheap literature and traveling speakers.[17] Dennert and Wilhelm Teudt, until then a priest and head of the Inner (or Home) Mission in Frankfurt, became scientific and executive directors respectively, backed by a committee of professors and teachers, mostly physical sci-

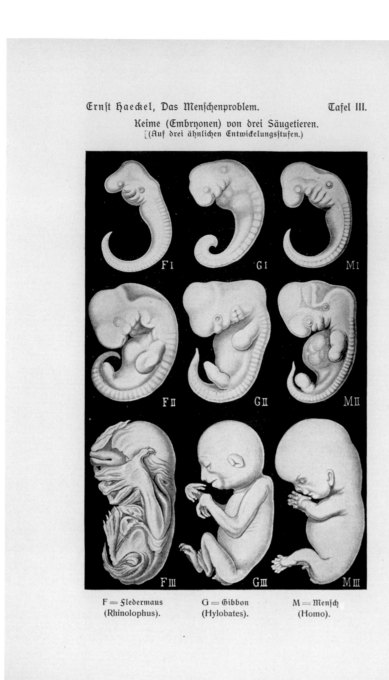

Ernst Haeckel, Das Menschenproblem. Tafel III.

Keime (Embryonen) von drei Säugetieren.
[(Auf drei ähnlichen Entwickelungsstufen.)]

F I G I M I

F II G II M II

F III G III M III

F = Fledermaus
(Rhinolophus).

G = Gibbon
(Hylobates).

M = Mensch
(Homo).

Fig. 14.5 "Germs (Embryos) of Three Mammals. (At three similar stages of development.)" Bat (*F*), gibbon (*G*), and human (*M*) are mostly taken unchanged from the *Anthropogenie*; but MIII is the oldest human embryo from the revised plate in the *Schöpfungsgeschichte* [after His], FII is different, and GII has a longer tail (see figs. 9.3–9.5). Halftone of drawings from Haeckel's 1907 pamphlet, *Das Menschen-Problem*, plate III.

entists plus a few medics, but (deliberately) few theologians (fig. 14.6). A theist, antisocialist, and nominally ecumenical, though overwhelmingly Protestant, framework kept specific commitments light.

The league claimed to defend scientific freedom against monist misuse. For Dennert, science could not conflict with religion because the one dealt with the how, the world picture, the other the why, the worldview. True science must be in "harmony" with true religion, as it had been for the seventeenth-century astronomer Johannes Kepler (fig. 14.7). But how, critics asked, were they supposed to interact three hundred years later, and what did harmony mean unless it implied religious constraints? Was the league not taking popular science "out of the cradle of materialism" and putting it to bed "in the crib of Christian faith"?[18] The more left-wing Protestants worried that the orthodox Dennert risked both faith and science by treating them

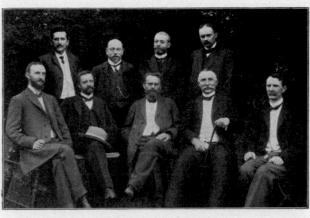

einungen, insoweit auch der sogenannte
ffekt, die glänzendste Bestätigung der Jonen-
rz besprochen. Zum Schluß wurde ein all-
berblick über das bisher in der Frage nach
n der
rreichte
Man
innere
haft der
ließen.
ribt das
sel der
.Wenn
tation
Theorie
werden
n wür-
rie sich
kungen
Die
lesung
h aufs
mit der
or Dr.
: die ra-
Stoffe.
G r u-
er Uni-
n) führ-
n drei-
Kursus
ium und die Radioaktivität" vor. An-
i die Röntgenstrahlen und deren Wirkungs-
n die Entdeckungen Berquerels und Herrn und
s (Uran, Polonium, Radium) dargelegt und die
en der β-, α- und γ-Strahlen besprochen,

Dinge im Geist allein. Der Psychomonismus,
worin in Göttingen vertritt, leugnet den Gegen-
schen Seele und Körper, denn die Körper existi
als Empfindungen der Seele. „Es gibt nur
ist der r
halt der
Der konfi
lismus
manns ir
ter dem
seinsinh
Träger
wußtsei
nennt er
bewußte
wirkt in i
ganischen
ganischen
baut der
und trägt
wußtsein.
Der B
de ging i
ren darau
die Bez
Monism
„Monist"
unseren
wenigsten
breiten
unserer G
und unseres Volkes, allmählich festlege auf
Haeckel und dem Monistenbunde vertretene
die sich kritischer Monismus nenne und einer
lichen philosophischen Grundlage entbehre. Die
Vertreter des Monismus würden sich daher n

Dr. Serauer, Dr. Hauser, Dr. Riem, Oberl. Grewe.
Oberl. Dr. Bavink, Univ.-Prof. Dr. Gruner, Prof. Dr. Dennert, Direktor Teudt, Dr. Braß.

Fig. 14.6 Group photograph at the Kepler League's third natural scientific course in August 1909, including (the three men seated to our right) Dennert, Teudt, and Brass, and (seated far left) Dennert's successor Bernhard Bavink. The courses were modeled on *Kosmos* events. *Der Keplerbund*, no. 10 (1909): vi.

Fig. 14.7 Page from the Kepler League members' newsletter, a supplement to *Unsere Welt* (Our world), their rival to *Kosmos*. It represents Johannes Kepler by a silhouette of the monument in his birthplace, and shows the cultivation of modern laboratory science in the setting for the league's fourteenth natural scientific and natural philosophical course. *Keplerbund-Mitteilungen*, no. 57 (Sept. 1913): 1–2.

Keplerbund-Mitteilungen
für Mitglieder und Freunde

№ 57. Godesberg bei Bonn September 1913.

**Der 14. naturwissenschaftlich-naturphilo-
sophische Kursus des Keplerbundes**

fand in den Tagen vom 5. bis 12. August im Bundes-
hause zu Godesberg bei Bonn, Rheinallee 26,
statt und war zahlreich besucht. Er hatte sich die Auf-
gabe gesetzt: E i n f ü h r u n g i n d i e e x a k t e n
N a t u r w i s s e n s c h a f t e n auf geschichtlicher
Grundlage. Mit den Vorlesungen, die bis zu den
allerneuesten Entdeckungen und Ergebnissen der be-
handelten Disziplinen hinführten, waren chemische La-
boratoriumsübungen und Handfertigkeitsübungen zur
Herstellung einfacher physikalischer Apparate verbun-
den, für die ebenso wie für die Vorträge über Chemie

und Physik in dankenswerter Weise die Räume des
Evang. Pädagogiums zur Verfügung gestellt waren.
Das untenstehende Bild gibt eine Vorstellung von der
mustergültig eingerichteten, mit Werkzeugen, Arbeits-
maschinen und Materialien aller Art ausgestatteten
p h y s i k a l i s c h e n W e r k s t ä t t e , in der ein ansehn-
licher Teil der diesmaligen Kursusteilnehmer unter der
Anleitung des Oberlehrers G r e w e - Godesberg mit
großer Befriedigung gearbeitet hat.
Dr. M o r é - Elberfeld gab in sechs Vorlesungen
einen kurzen Ueberblick über die Hauptepochen der
c h e m i s c h e n Wissenschaft, die durch den genialen
französischen Forscher Lavoisier gegen Ende des 18.
Jahrhunderts von den Fesseln der spekulativen For-

Unsere Welt 1913. 9

as knowledge of the same kind, but two prominent liberals gave him the benefit of the doubt: Martin Rade, editor of the leading journal of "cultural Protestantism," *Die Christliche Welt* (Christian world), and Georg Wobbermin, who had been inspired by the *Schöpfungsgeschichte* to study theology and become an influential writer on science and religion.[19] Haeckel's renegade student, the left-liberal, anti-Darwinist vitalist Hans Driesch, was peripherally involved.[20]

Battle lines were drawn. Haeckel was more exposed than ever, his latest pictures were newly available and topical, and an avid spreader of the forgery charges had dedicated an organization to fighting his science. But Dennert struggled to critique Haeckel's recent plates. For "the grim dragon [to] be lured out of his cave"[21] needed an antagonist able to bring the embryos into the limelight again.

Luring the Dragon

Arnold Brass (1854–1915) was an outsider like Hamann, the other zoologist on the Kepler League committee, but more qualified and influential. He had studied physical sciences at the Technical College in Hannover and natural sciences at the University of Leipzig, gaining a doctorate on the urogenital apparatus of marsupials with Rudolf Leuckart in 1879. Brass did some cell research and assisted Leuckart for a year, but then, it seems, they fell out. His academic career ended in Marburg, that hotbed of anti-Darwinism, when he was refused the qualification necessary to teach at a German university—because of his antievolutionism, he claimed.[22] As a private scholar of modest means Brass now earned money by writing textbooks and atlases. His outline of anatomy, physiology, and embryology—a concise, inexpensive summary of a kind that professors did not always appreciate—was recommended, for example, in Bonn and became, one student reported, the "book that all of my medical classmates also own."[23] By contrast, Brass's theoretical work was cranky: he imagined himself able to discover new laws and prove Goethe's theory of color.

In 1905 Brass invited Haeckel to a lecture at the Goethe Society in Weimar, having missed out through his own shyness on a meeting long before.[24] Haeckel politely declined and the rejected Brass wrote *Ernst Haeckel als Biologe und die Wahrheit* (Ernst Haeckel as biologist and the truth) for the same Protestant press

as Dennert's *Sterbelager*. In a more personal and dogmatic though less confident performance, Brass criticized Haeckel on issues raised by the *Welträtsel*, but was silent on fraud. He closed with the provocative declaration, "Would that at least *German* scientists feel that it is not reprehensible if for once we venture also to grant a natural scientific work the motto '*in majorem Dei gloriam!*'": "to the greater glory of God!"[25]

Brass helped Dennert found the Kepler League, but Dennert rejected only Darwinism, Brass also evolution; Dennert was awarded a professorial title, while Brass revealed himself as a scientific thug.[26] With no university zoologist willing to enroll, Dennert was nevertheless glad to have someone as competent. Brass joined the committee and took a position as lecturer, which was unpaid but obliged the league to underwrite his talks in winter 1907–8. One anti-Haeckel schoolmaster complained that Brass implausibly put everything down to God's personal intervention, asking after each of a jumble of examples: "And such a thing is supposed to be chance?" But he was a popular speaker, able to thwart the pictures of embryos with his own drawings, and willing to spice things up with a joke.[27]

On a Friday night in mid-April 1908 Brass repeated a lecture, "Primordial Man," that he had already given in eighteen towns,[28] for a big public meeting of the Christian Social Party. This packed the main ballroom of Carl Keller's Neue Philharmonie, a restaurant with function rooms on the Köpenicker Straße in Berlin. Brass made the case against human evolution, projecting "a large number of excellent slides" and stimulating a "very lively" discussion among a probably mainly new-middle-class audience more used to political speeches. They debated till one in the morning, and as the beer flowed, a few opponents failed to keep themselves "dignified and objective." *Das Reich* and its soul mate, the *Staatsbürger-Zeitung* (Citizen's paper), reported that Brass had argued that "some similarities in the embryo, which were maintained by Haeckel, rest on errors. Haeckel himself had had the bad luck to put a human head on an ape embryo and vice versa." Brass knew "from the most definite, personal experience" because he had himself made "the correct drawings" for Haeckel.[29]

Although the talk was only of error, this "*barefaced lie*," which also appeared in *Das Volk* (The people), the national daily of the Christian Socials, so outraged

Haeckel that he contemplated suing Brass for "malicious slander" and asked Wilhelm Breitenbach, now a monist publisher, to put a correction in his brand-new magazine *Neue Weltanschauung* (New worldview). The assertion was "an *audacious fabrication. I have never* 'put a human head on an ape embryo and vice versa.' Mr. Brass has *never* 'himself made' any 'drawings' for me." Haeckel had "no connection at all" to this "chairman of the so-called Kepler League," except having declined to attend a lecture.[30] Haeckel's lawyer required the newspapers that had published the story to print corrections too.[31]

Brass countered with statements presenting himself as the injured party and denying Haeckel's right to dodge an embarrassing scientific criticism by calling in a criminal judge. Brass had "never" said he drew for Haeckel (the confusion could have arisen because he had shown his own "original drawings"). At the same time he built momentum behind corrected charges: the first two rows on plates II and III of the *Menschen-Problem* pamphlet (figs. 14.4–14.5) were "quite miserably distorted, incorrect depictions as ... Haeckel ... alone has managed to repeat them for decades," and the second gibbon embryo looked suspiciously like a human specimen Brass had published, while the human embryo next to it had an ape's head and tail. Let Haeckel show photographs of his embryos, but Brass did not believe His Excellency would ever force a retraction.[32]

Haeckel again repudiated the "*deliberate and audacious falsehood.*" An artist had faithfully copied the ape from Selenka and the human embryo from "the consistent representations of Rabl, Keibel, His, etc." But by referring to the third row, not the second, Haeckel defended figures that Brass had not attacked. And the new information allowed Brass to assert that Haeckel had "committed the most serious crime" by taking Selenka's macaque, cutting down the tail and labeling it a gibbon.[33] Brass promised to prove everything in a published "comparison of original and distortion."[34]

To break into the national news it helped to have a fresh allegation about recently published pictures. The mental image of putting an ape head on a human embryo could not have been more potent. Yet Haeckel might not have reacted had the reported version sounded less outrageous and less easy to rebut, and without his response a local story would have sunk without trace.

Desecrating the Temple

Haeckel's invocation of the Kepler League gave them a golden opportunity, but a dangerous one, because Brass's extreme stance risked frightening cautious supporters and aiding the monist attack. Not even Dennert and Teudt would accept his book manuscript as it stood: poorly organized, with too many personal insults, it created the impression that worldview drove the argument and that he overestimated the significance of the "forgeries."[35] Rather than revise, Brass appears to have published *Das Affen-Problem* (The ape problem) himself for sale at just one mark (fig. 14.8).[36] It made monists sick.[37] Even Brass later regretted that he had "had to" take "mockery and ridicule" to such an extreme.[38]

Flaunting his Protestant nationalism, Brass sarcastically framed the plates in Haeckel's *Menschen-Problem* as part of an un-German complex of free thought, sexual enlightenment, and modern art. They must be the wall and ceiling décor promised for the Phyletic Museum. "If everything inside is made as nice as these offerings of 'pure reason,' then it will surely be a place of pilgrimage for many who for once would really like to poke fun and have a proper laugh."[39] Haeckel hid behind the artist he said had made the copies, but why then were his drawings always distorted to favor his own hypotheses? Too much effort had been expended to excuse them as schematic. He "should *creep away* into the darkest corner of the earth, for what he offers us *this time* is more serious than anything of which he has been accused before." If he or his cronies dared to slander Brass again, as he had for forty years insulted Rütimeyer, His, and others, Haeckel would "darken completely the twilight of your life"—because Brass would darken it for him.[40]

Brass now accepted the top row of sandal embryos as displaying difference, if also ignorance, but criticized the second as "sadly failed copies of irreproachable drawings by Keibel, Hubrecht, and perhaps (rabbit) Kölliker or O[scar] Schultze" (fig. 14.4). The pig embryo—appropriately, since it was based on Keibel's wax models—looked as if "a plasterer had formed it into part of the molding of a modern ornament. Perhaps it is indeed taken from the corner décor of some ceiling in the temple of the good, true, and beautiful.... The '*Sandalion*' of man is just as attractive; it is more a 'Skandalon.'" The plasterer had copied not a human,

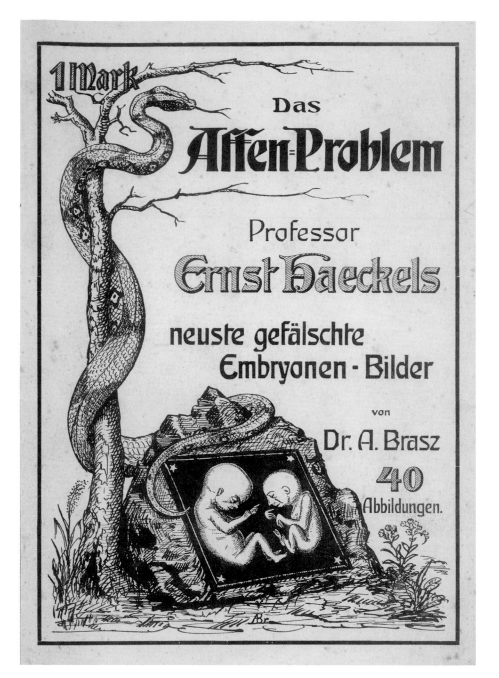

Fig. 14.8 The cover of the pamphlet in which Arnold Brass (here, unusually, Brasz) detailed his charges against the plates in Haeckel's *Menschen-Problem*. A plaque on a rock compares (right) a gibbon embryo (after Selenka) with (left) a thirteen-week human embryo (Brass's original), not the eight-week one Haeckel used, in order to make the point that the human brain is larger in proportion to the face. The tree with snake is presumably that of knowledge of good and evil, and could also refer to the barrenness of Haeckel's phylogenies. Carl Rabl complained that Brass had drawn a cover (signed "ABr.") that "appears calculated only to attract attention and pique curiosity," something an academic could then hold against a book ("Unsere 'Erklärung,'" *Frankfurter Zeitung*, 5 Mar. 1909). Brass 1908.

but a spectral tarsier. The third row was all distorted, especially the heads.[41]

Brass leveled his gravest charges against the older embryos (fig. 14.5), supported with plates that for the first time lined up Haeckel's figures with their alleged originals (figs. 14.9–14.11). It may seem astonishing, now that photographic comparisons are all over the press, that this step had not been taken before, but to be fully intelligible His's criticisms and counterimages had presupposed access to Haeckel's (more widely dis-

tributed) pictures. Exploiting photo-relief printing, Brass offered a less-informed audience all the evidence in one place. He could thus write, as His would never have done: "*I can and will leave the office of judge to the German people.*"[42] The plates were the most effective part of his book.[43]

Haeckel's first row showed the "fish-mammal embryos" that Brass said no one else had ever seen, but the second was worse (fig. 14.5). FII was a common bat miscopied and labeled as a horseshoe bat. MII

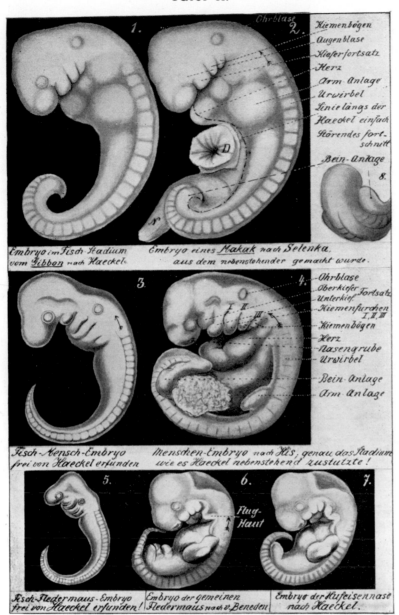

Tafel II.

Fig. 14.9 "The so-called fish stages of mammal germs, as Haeckel has dared to offer them for decades." Arnold Brass paired Haeckel's fish-stage gibbon embryo (1) with Selenka's macaque (2), from which Brass claimed it derived by removal of parts; Haeckel's "freely invented" fish-human embryo (3) with an illustration after His (4); and Haeckel's "freely fantasized together" fish stage of a horseshoe bat (5) with Eduard van Beneden's original (6) and Haeckel's copy of a later stage (7) to prove that Haeckel had copied this species and called it another. Brass 1908, plate II.

appeared to have been adapted from His by adding vertebrae to the tail and reducing the forebrain (fig. 14.9). Brass had joked in a lecture that it had an ape head; he now reckoned this at most that of a sheep (fig. 14.11). Had the specimen only lived, a millionaire freak-show exhibit might have developed,[44] he suggested, but he was really accusing Haeckel, a mere "*desk* embryologist," of lacking originals.[45] The most heinous crime was GII, to create which Haeckel had taken Selenka's drawing of a (tailed) macaque, short-

ened the tail by some fifteen vertebrae, and called it a (tailless) gibbon (fig. 14.10).[46]

Brass indicted Haeckel for a double offense, against the all-German "heroes of embryological research" and against "the German people," among whom freethinking lecturers ignorantly projected slides copied from such drawings. Haeckel insulted the conscience and honor of German researchers which had brought German culture the first place on earth and led people to speak of a "temple of science." This nationalist

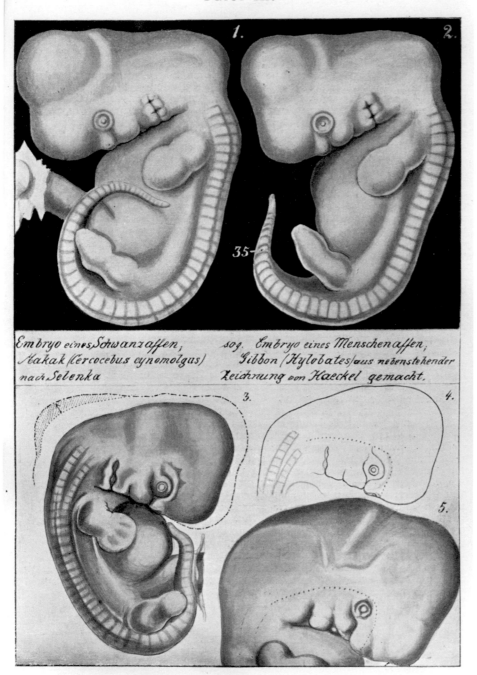

Tafel III.

Embryo eines Schwanzaffen,
Makak (Cercocebus cynomolgus)
nach Selenka

sog. Embryo eines Menschenaffen,
Gibbon (Hylobates) aus nebenstehender
Zeichnung von Haeckel gemacht.

Fig. 14.10 Critique of Haeckel's gibbon embryo by Arnold Brass. Selenka's drawing of a macaque (fig. 1) and the gibbon (fig. 2) that Haeckel made from it, with *35* marking the point where, according to Brass, the tail should in fact end. "Not only the specialist, but every layman will acknowledge that I am right." Figures 3–5 aimed to show that Haeckel also exaggerated the size of the head. Brass 1908, plate III.

Fig. 14.11 Critique of Haeckel's human embryos by Arnold Brass. Robert Bonnet's sheep (*1*) is more like Haeckel's "sadly distorted" drawing (*2*) than that drawing is to His's human specimen (*3*). Figures 4–*7*, after Brass's own specimens, claim to show human peculiarities. Figures 8 and 9 compare a 13-week human and corresponding gibbon to support the claim in figures 10 and 11 that when proper account was taken of the proportions of face and brain, apes moved closer to other mammals and further from humans. Brass 1908, plate IV.

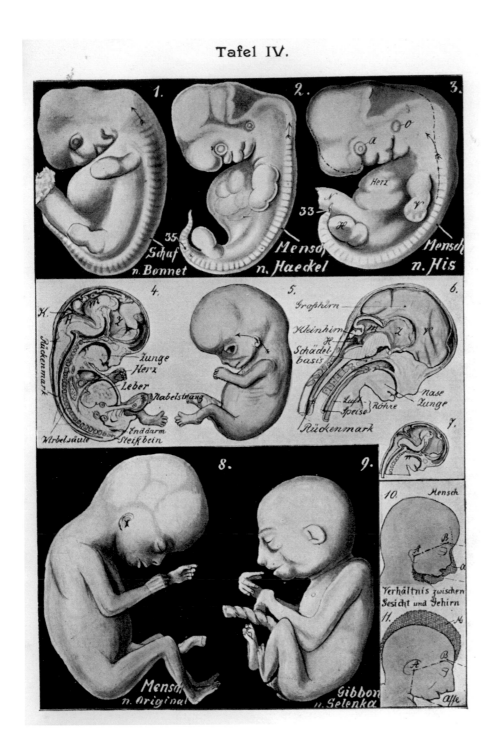

Tafel IV.

temple was built around a holy grail, *"the last ground of all being and becoming,"* "from which a never failing power radiates to all those who approach to serve and pure in heart." "Woe betide the knight who dedicated himself to its service and then sullies the shield which should guard the holy of holies, woe betide him who ever ignores the motto that adorns the edge of the shield … *In the service of the truth!*"[47]

Brass aimed new and sensational charges at Haeckel's pictures as atheist, liberal, modernist distortions of a national Christian tradition. He provided the first direct pictorial comparisons through which laypeople could see how Haeckel had cheated. But the booklet, off-putting in its language and not always easy to follow, needed publicity.[48]

Remorseful Confession?

Das Affen-Problem was published in November, and on 19 December 1908 the struggling but still prestigious *Allgemeine Zeitung* called Haeckel to account. Picking up Brass's subtitle, the very heading, "Haeckel's Pictures of Embryos," consolidated the independent status of the topic. A never-identified "Prof. Dr. X" demanded that Haeckel say where the original specimens were and how he had made the illustrations. The professor also challenged "the German embryologists" to go before "the German people" to remove "a disgraceful stain on German science."[49] This specialist group was thus first prominently invoked not in the name of a society or journal—the field was too weakly institutionalized for that—but as a court of experts summoned by public opinion.

The nasty Christmas present forced Haeckel to answer. Since his camp was appalled at the once-liberal newspaper's behavior, he favored the sympathetic, high-circulation *Berliner Volks-Zeitung* with a long letter (fig. 14.12).[50] This "polemical bequest" by "one of the greatest ornaments of modern science" framed the attack in the struggle between progressive monists and reactionary Kepler League, with Brass as an "older zoologist, gone off the rails," who for thirty years had flunked an academic career and was now trying for one through Jesuitical attacks.

Avoiding detail, Haeckel harked back to his general arguments, but a try at irony led to a serious tactical error:

> To make an end of the whole vile dispute, I want without further ado to begin immediately with the remorseful confession that a small part of my numerous pictures of embryos (perhaps 6 or 8 per cent) are really *"forged"* (in the sense of Dr. Brass)—all those, that is, for which the available observational material is so incomplete or insufficient that in the production of a connected chain of development we are *forced* to fill in the gaps with *hypotheses* and to reconstruct the missing links by *comparative synthesis*. What difficulties attend this task, and how easily the artist makes mistakes, only the specialist embryologist can judge.

Professor X—Haeckel dubbed him "Tartuffe" after Molière's religious hypocrite—might appear to make a reasonable demand, but the idea of a verdict from "the *German people*" was ludicrous and those "German embryologists" would never agree. In any case, the great majority of morphological, anatomical, histological, and embryological figures were "forged" in the same sense, because schematic rather than exact—and so hundreds would join him in the dock. The "poisoned arrows" thus flew back to strike Brass, Dennert & Co. and their "*natural philosophical forgers' league*." Mixing "the dogmas of the Judeo-Christian religious edifice ... with the empirical knowledge of modern natural science ... is itself the most splendid attempted *forgery*."[51]

From the moment Haeckel called his lawyer, Brass and the Kepler League perhaps saw that they just had to ratchet up the pressure and he would do the rest. But it had taken eight months and a chain of contingencies—Brass's lecture, the report in the *Staatsbürger-Zeitung* and *Das Reich*, Haeckel's corrections, Brass's rebuttals and pamphlet, the challenge from Professor X—to arrive at this point. Haeckel's statements of 1875 and 1891 had satisfied his fans but fed those flames; this time he faced an organization committed to keeping the argument going in a larger and more polarized arena, and was himself bigger game. He would regret that, having been ill and unable to think clearly, he felt pressured into shooting off a reply on Christmas Eve.[52] Widely reprinted, the "confession" became the story because it allowed his enemies to parade an admission of guilt.

The Christian right, Protestant and Catholic, had a field day. *Der Reichsbote* (The imperial messenger), a Berlin daily through which the German Conservative Party reached out beyond the nobility, East Elbian landowners, and traditionalists in the Prussian state church, reaffirmed its commitment to "creation by an omniscient and omnipotent God" and opposition to the "nonsense" of evolution. "A peculiar science! It demands absolute authority, but employs hypotheses, even in its pictures, and then founds its 'exact' conclusions on these trimmed representations." Haeckel was

Fig. 14.12 Front page of the *Berliner Volks-Zeitung*, 29 December 1908. "Forgeries of Science," Haeckel's ironic confession, takes up all the space, but typically, the pictures at issue were not reproduced; beyond the ads, weekday newspapers were still sparsely illustrated. Staatsbibliothek zu Berlin, © bpk.

No. 607. — 56. Jahrgang.

Berliner Volks-Zeitung

mit Täglichem Familienblatt und Illustriertem Sonntagsblatt

Morgen - Ausgabe

Dienstag, 29. Dezember 1908

Erscheint täglich zweimal: Sonntags nur morgens, Montags nur abends.

Abonnementspreis für Berlin:
75 Pf. monatlich
frei ins Haus, vierteljährlich M. 2.25
Abonnementspreis für auswärts
bei Bezug durch die Post:
monatlich M. 0.80, vierteljährlich M. 2.40

Insertionspreis für die Zeile 40 Pf.
Stellenangebote und Gesuche . . 30
Kleine Anzeigen: das Wort 30
Das fette Ueberschriftswort . . . 10

Redaktion: Jerusalemer Straße 46/49.
Für unverlangt eingesandte Manuskripte übernimmt die Redaktion keine Verantwortlichkeit.

Haupt-Expedition:
SW. Jerusalemer Straße 46/49.
Telephon: Amt I, Nr. 10131—10148.

Chef-Redakteur: Karl Vollrath, Berlin W.
Verlag u. Druck: Rudolf Mosse, Berlin SW.

Fälschungen der Wissenschaft.

Von Ernst Haeckel.*)

Jena, 24. Dezember 1908.

Durch zahlreiche Zuschriften aus den verschiedensten Bildungskreisen, sowie durch viele irrtümliche Mitteilungen aus Zeitungen der letzten Wochen, bin ich zu nachstehender Erklärung gezwungen. Sie betrifft in erster Linie den modernen Kampf zwischen Monistenbund und Keplerbund, in zweiter Linie die maßlosen Angriffe, welche der letztere neuerdings gegen mich, als einen der Ehrenpräsidenten des ersteren, gerichtet hat, und in dritter Linie die Frage der Fragen, das "Menschen-Problem".

Ziele des Monistenbundes. Als vor drei Jahren in Jena der Monistenbund gegründet wurde, stellte er sich zur Aufgabe die Förderung und Verbreitung einer einheitlichen Weltanschauung, welche als ihr sicheres Fundament lediglich die erfahrungsmäßig auf Beobachtung und Versuch gestützten Ergebnisse der modernen Naturforschung gelten läßt. Sie lehnt vollständig die sogenannte "Offenbarung" ab, jeden Glauben an "Wunder" und übernatürliche Geisterwelt. Der wichtigste moderne Fortschritt ist der Sieg des Entwickelungsgedankens, und namentlich der von Darwin reformierten Abstammungslehre oder Descendenztheorie; ihr bedeutungsvollster Folgeschluß bleibt die Anwendung derselben auf den Menschen, die Erkenntnis, daß auch der Mensch, gleich allen anderen Säugetieren, sich aus einer langen Ahnenreihe von niederen Wirbeltieren stufenweise entwickelt hat. Damit war nicht nur die "Frage aller Fragen" gelöst, sondern auch das alte Dogma von der "Unsterblichkeit" der persönlichen Seele widerlegt, sowie der weitverbreitete Glaube, daß ein persönlicher (menschenähnlich gedachter) Gott als "Schöpfer" alle einzelnen Dinge fabriziert habe und als "Vorsehung" leite.

Diese Grundgedanken des Monismus, die ich zuerst 1866 in meiner "Generellen Morphologie" eingehend zusammengefaßt hatte, haben später (1899) eine ausgedehnte Anwendung auf das Gesamtgebiet der Philosophie in meinem Buche über die Welträtsel gefunden. Sie sind jetzt bei der großen Mehrzahl der Naturforscher schon angenommen und finden ihre Fortbildung in zahlreichen Zeitschriften, so namentlich in dem Berliner "Monismus", Zeitschrift für monistische Weltanschauung und Kulturpolitik (Dr. H Koerber), in der Stuttgarter "Neuen Weltanschauung" (Dr. W. Breitenbach) und in der Zeitschrift für "den Ausbau der Entwickelungslehre" (Kosmos, Gesellschaft der Naturfreunde, Stuttgart).

Ziele des Keplerbundes. Naturgemäß stieß unsere monistische Naturphilosophie von Anfang an auf den heftigsten Widerstand der herrschenden christlichen Theologie und der mit ihr verbündeten dualistischen Schulphilosophie. Denn die alten Glaubenslehren des Christentums, die bisher als die festen Grundlagen des Kulturstaates gegolten haben, werden dadurch jede wissenschaftliche Geltung ab. Daher wurde vor einem Jahre in Frankfurt a. M. der sogenannte "Keplerbund" gegründet. Er setzte sich als höchstes Ziel die bedingungslose Anerkennung der übernatürlichen "Offenbarung" und des Wunders, des persönlichen Gottes und seines Ebenbildes, der unsterblichen Seele. Er stellte sich ferner die unlösbare Aufgabe, die Ergebnisse der modernen monistischen Naturerkenntnis mit den traditionellen dualistischen Glaubenslehren des Christentums zu versöhnen — das heißt dort betrachtet die Unterwerfung der ersteren unter die Letzteren durchzuführen. Alle konservativen und orthodoxen Kreise schenkten ihm ihre einflußreiche Unterstützung; insbesondere die reaktionären, ganz vom Geiste des Klerikalismus beherrschten Unterrichtsministerien von Preußen und Bayern. Mit reichen Mitteln ausgestattet begann im der Keplerbund im diesem Winter einen förmlichen Feldzug gegen den Monistenbund, wobei massenhafte Verteilung von Flugschriften und Abhaltung von populär-wissenschaftlichen Vorträgen durch Wanderredner eine ausgedehnte und nicht zu unterschätzende Wirksamkeit ausüben.

Der tätigste und unverfrorenste Wanderredner des Keplerbundes ist gegenwärtig Dr. Arnold Braß, ein entgleister älterer Zoologe, der sich seit 30 Jahren vergeblich bemüht hat, eine akademische Stellung zu gewinnen und der jetzt sein Ziel leichter und besser zu erreichen sucht durch Reden und Schriften gegen die Descendenztheorie, und besonders gegen deren meistgehaßten Folgeschluß, die "Abstammung des Menschen vom Affen". Dabei stützt er sich wohl, auf die unwiderleglichen Beweise für Letztere eingestanden, welche uns die Paläontologie und vergleichende Anatomie in die Hand gibt; aber so ausgiebiger benutzt er die ihm wohlbekannten Tatsachen der vergleichenden Ontogenie (oder Embryologie), um durch jesuitische Entstellung und willkürliche Verdrehung derselben ihre Wertlosigkeit für den Darwinismus darzutun. Als der passendste Weg dazu erscheint ihm aber eine Reihe der

*) Der berühmte naturwissenschaftliche Forscher und Bahnbrecher, eine der größten Zierden der modernen Wissenschaft, Ernst Haeckel in Jena, seit Jahren der Zielpunkt erbitterter Angriffe von wissenschaftlich und politisch-reaktionärer Seite, ist in der Zeit besonders gehässig beschimpft worden, zumal seine "Welträtsel" ihm großen Kummer seiner Gegner an zu Hunderttausenden von denkenden Männern und Frauen gefunden haben. In der vorstehenden, uns von dem großen Gelehrten überlassenen Darlegung erzählt Ernst Haeckel, welcher Wert in neuen Elaboraten seiner Widersacher beizumessen ist. Weil die Ausführungen bilden eine Art polemischen Verwächtnisses, das aus gröbsten Blüten und durchlöchert von Gift auf allem alten Boden entzieht. Darum bilden die vorstehenden Darlegungen ein wertvolles entwicklungsgeschichtliches Dokument.

Die Redaktion der "Berliner Volks-Zeitung".

heftigsten Angriffe gegen meine Person und meine Schriften. Schon vor zwei Jahren veröffentlichte Braß eine Broschüre: "Ernst Haeckel als Biologe und die Wahrheit" (96 Seiten); darin wird die Natürliche Schöpfungsgeschichte der schärfsten Kritik unterworfen, ihre Stammbäume werden als wertlose Hypothesen verworfen, das biogenetische Grundgesetz wird als ein eroliger Einfall lächerlich gemacht und die Gastraeatheorie "ein Zeugnis für Unkenntnis physiologischer Grundanschauungen" genannt. Ich habe auf dieses boshafte Pamphlet, wie auf viele ähnliche Schmähschriften nicht geantwortet.

Am 10. April dieses Jahres hielt Dr. Braß in einer Versammlung der Christlich-Sozialen Partei in Berlin einen Vortrag über das Thema "Der Mensch in der Urzeit", in welchem er die Lehre der Abstammung des Menschen vom Affen energisch bekämpfte und die Embryonenbilder, die ich zu deren Begründung vergleichend nebeneinandergestellt hatte als "wissenschaftliche Fälschung" brandmarkte. Er behauptet, ich habe dem Affenembryo einen menschlichen Kopf aufgesetzt und angepaßt und muß "hier als allergenauester persönlicher Kenntnis sprechen, da er die wichtigen Zeichnungen seinerzeit selbst für Haeckel hergestellt habe." Die unglaubliche Frechheit, mit der Braß diese und andere aus der Luft gegriffenen Behauptungen verbreitete, zwang mich zu einer öffentlichen Entgegnung, in der ich die dreiste Erfindung bezeichnete und hinzufügte: "Ich habe überhaupt zu Vorstande des sogenannten Keplerbundes gar keine Beziehungen, — ausgenommen, daß derselbe vor einigen Jahren mich aufforderte, bei ihm einem Vortrage, den er im Weimar über Goethes Farbenlehre hielt, zu unterstützen." (Vergleiche hierzu die Mitteilungen von Dr. W. Breitenbach in seiner Zeitschrift: "Neue Weltanschauung").

Das Affenproblem. Statt mir Unrecht einzugestehen und die boshaften gegen mich geschleuderten Verleumdungen zu widerrufen, veröffentlichte Braß vor einigen Wochen gegen mich eine Schmähschrift unter dem Titel: "Das Affenproblem. Professor Ernst Haeckels neueste gefälschte Embryonenbilder" (mit 46 Abbildungen, Biologischer Verlag, Leipzig). Die angeblichen Fälschungen befinden sich auf einigen Tafeln, welche ich teils 1905 in meinen Berliner Vorträgen über "den Kampf um den Entwickelungsgedanken" teils 1907 in meinem Vortrage über "das Menschenproblem und die Herrentiere vom Linné" veröffentlicht habe. Wohlgemerkt, sind dies Darstellungen, welche dazu dienen sollen, längst bekannte Tatsachen einem größeren Bildungskreise zugänglich zu machen. Braß hingegen sucht seine Leser glauben zu machen, daß es sich um "Erfindungen" handelt, durch welche ich dem "Publikum falsche Tatsachen vorspiegeln wolle. Dieses jämmerliche Pamphlet, 42 Seiten stark, ist so voll von falschen Angaben, absichtlichen Entstellungen meiner Schriften, heuchlerischer Versicherungen seiner Wahrheitsliebe und hämischer Angriffe auf meine Person, daß es einer seiner längeren Broschüre (von mindestens 400 Seiten) bedürfen würde, um sie in ein wahres Licht zu stellen.

Professor Tartüffe. Auch gegenüber diesen, wie vielen ähnlichen Angriffen, würde ich mein Schweigen bewahrt haben, wenn nicht vor acht Tagen ein Zwischenfall eingetreten wäre, der mich zu einer kurzen Antwort geradezu zwingt. In Nummer 38 der "Münchener Allgemeinen Zeitung" (vom 19. Dezember) — Internationale Wochenschrift für Wissenschaft, Kunst und Technik — erschien eine anonyme Mitteilung über "Haeckels Embryonenbilder" (S. 823). Die perfiden Ausführungen dieses Artikels, die sofort in viele deutsche und auswärtige Zeitungen übergegangen sind, erscheinen dazu bestimmt: "nicht nur die Forscheransehen und die Ehre eines bisher in weiten Kreisen hochangesehenen Mannes zu vernichten, sondern auch geradezu einen Schandfleck der deutschen Wissenschaft aufzudecken." Der anonyme Verfasser dieses Artikels, der nicht den moralischen Mut hat, seine Angriffe, diese "vernichtenden" Beschuldigungen mit seinem Namen zu decken, unterzeichnet sich "Professor Dr. X. Ich bezeichne ihn im Folgenden kurz als Professor Tartüffe, dem heuchlerischen Charakter seiner Mitteilung gemäß. Was meine "moralische und wissenschaftliche Vernichtung" betrifft, so kann ich ihn damit beruhigen, daß diese bereits längst vollzogen ist; seit mehr als dreißig Jahren lese ich in frommen und Gott wohlgefälligen Zeitschriften, daß ich "wissenschaftlich tot und gerichtet bin"; das Nähere darüber findet si unter anderem bei Professor Eberhard Dennert, dem geistigen Haupte des "Keplerbundes" und dem Kollegen von Dr. Braß, der gleich diesem "immer zote Wahrheit" predigt. Dennert spricht z. B. von der beständig vom Tode des Darwinismus und hat eine besondere Darstellung von dieses "Sterbelager" gegeben. Merkwürdig nur, daß die ganze moderne Literatur der Biologie vom Geiste dieser Entwickelungslehre durchdrungen ist!

"Die gefälschten Embryonenbilder." Um den ganzen wüsten Streite kurzerhand ein Ende zu machen, will ich mir gleich von vornherein zugestehen, daß wirklich, wie ich in dem ersten Teil meiner zahlreichen Embryonenbilder (vielleicht 6 oder 8 vom Hundert) wirklich "im Sinne von Dr. Braß "gefälscht" sind — alle sie nämlich, bei denen das vorliegende Beobachtungsmaterial so unvollständig oder ungenügend ist, daß man bei Herstellung einer zusammenhängenden Entwicklungskette gezwungen wird, die Lücken durch Hypothesen auszufüllen, und durch vergleichende Synthese die fehlenden Glieder zu rekonstruieren. Welche Schwierigkeiten und wie leicht der Zeichner dabei sehlgreift, kann nur der Embryologe von Fach beurteilen. Professor Tartüffe verlangt daher mit einem Schein von Recht:

Jetzt haben zunächst die deutschen Embryologen das Wort, sie müssen sich unbedingt dazu äußern. — Dann aber muß man vor allem dringend wünschen, daß Haeckel selbst eingehend und sachlich darlegt, auf welche Weise jene Bilder zustande gekommen sind, wo sich die Originalpräparate befinden usw. Jede andere Antwort Haeckels, selbst eine gerichtliche Klage, würde das deutsche Volk nicht verstehen können!" — Eine köstliche Idee, das deutsche Volk — oder selbst ein auserlesenes Kollegium von scharfsinnigen Juristen! — als Richter über den Wert von Embryonenbildern zu setzen, zu deren Verständnis und Beurteilung ein mehrjähriges Studium der vergleichenden Anatomie und Embryologie gehört. Und was unsere "deutschen Embryologen" kennt, mit ihren weit auseinander gehenden Zielen und Methoden, ihren widersprechenden allgemeinen Ansichten und Vorurteilen, der wird von vornherein von ihnen kein übereinstimmendes Urteil in dieser hochpeinlichen Gerichtsverhandlung erwarten können.

Exakte und schematische Bilder. Nun würde ich nach diesem belastenden Eingeständnis der "Fälschung" mich für "gerichtet und vernichtet" halten müssen, wenn ich nicht den Trost hätte, neben mir auf der Anklagebank Hunderte von Mitschuldigen zu sehen, darunter viele der zuverlässigsten Beobachter und der angesehensten Biologen. Die große Mehrzahl nämlich von allen morphologischen anatomischen, histologischen und embryologischen Figuren, welche in den besten Lehrbüchern und Handbüchern, in biologischen Abhandlungen und Zeitschriften allgemein verbreitet und geschätzt sind, verdienen den Vorwurf der "Fälschung" in gleichem Maße. Denn sie sind nicht exakt — in demselben mehr oder weniger "zurechtgestutzt", schematisiert oder "konstruiert". Dieses unvermeidliche Beiwerk ist vielmehr angelegt, um das Wesentliche in der Gestalt und Organisation klar hervortreten zu lassen.

Anthropogenie. Im Jahre 1874 habe ich unter dem Titel "Anthropogenie" den ersten Versuch gewagt, die bedeutungsvolle Entwickelungsgeschichte des Menschen in gemeinverständlichen wissenschaftlichen Vorträgen weiteren Bildungskreisen zugänglich zu machen. 30 Jahre später erschien dann die fünfte umgearbeitete Auflage in zwei Bänden (I. Band Keimesgeschichte, II. Band Stammesgeschichte, 1020 Seiten Text, mit 30 Tafeln, 500 Textfiguren und 60 genetischen Tabellen). Dieses mühsam konstruierte und mit großen Schwierigkeiten durchgeführte Werk ist der erste (und bisher einzige) Versuch, die Stammesgeschichte des Menschen durch seine Keimesgeschichte zu erklären — (und umgekehrt!) — das biogenetische Grundgesetz auf alle Organsysteme unseres Körpers anzuwenden, und unter kritischer Benutzung der drei großen "Urkunden" (Palaeontologie, Vergleichende Anatomie und Ontogenie) die "Frage aller Fragen" zu lösen. Schon damals (1874) erhob der Leipziger Anatom Wilhelm His (ein ausgezeichneter Beobachter und exakter Zeichner, aber höchst beschränkter Denker) gegen mich dieselben Vorwürfe, wie jetzt sein Genosse Braß. In dem Apologetischen Schlußwort zur vierten Auflage der Anthropogenie (Seite 857 bis 864) habe ich 1891 diese schweren Anschuldigungen von His, eine weit Kreise fanden, kritisch beleuchtet und widerlegt. Es ist sehr bezeichnend für den Charakter von Dr. Arnold Braß, daß er in seinen selben bübischen Schriften darüber schweigt, und die grundlegende Anthropogenie überhaupt nicht nennt, während er nur aus unbedeutenden, aber angeführten Vorträge zur Zielscheibe seiner gemeinen und unehrlichen Angriffe macht.

Der Fälscherbund. Die vergifteten Pfeile, welche der fromme Keplerbund (— von "christlicher Bruderliebe" überfließend —) gegen mich abschießt, und denen er wahrscheinlich sein großes Vorrat in Köcher hat, fliegen auf ihn selbst zurück. Ihm deshalb zu Gericht zu sitzen, wie viele Anhänger und Freunde von mir wünschen, darauf verzichte ich. Mögen die Herren Reinke, Dennert, Braß und Cie. fortfahren, mich auch fernerhin zu verleumden und zu verdächtigen, und gönne ich ihnen das Vergnügen den zahlreichen Geistlichen und Metaphysikern, Lizentiaten und Pfarrern, welche daraus ihren brennbaren Stoff für ihre Predigten und Apologetischen Vorträge entnehmen. Ihr Menschen, das Dogma des jüdisch-christlichen Religionsgebäudes zur kleineren Grundlage der von ihnen erstrebten dualistischen Weltanschauung zu gestalten und mit den empirischen Erkenntnissen der modernen Naturwissenschaft zu verschmelzen, ist selbst der großartigste Fälschungsversuch. In diesem Sinne kann der einflußreiche "Keplerbund" auch als der "naturphilosophische Fälscherbund" bezeichnet werden. Ich selbst stehe diesen fortgesetzten hässerlichen Angriffen mit völligem Gleichmut gegenüber und werde deshalb keine gerichtliche Klage anstrengen. Indem ich jetzt mein 75. Lebensjahr vollende und mein zoologisches, seit dem 48. Lebensjahre innegehabtes Lehramt niederlege, erwächst hier von mein öffentliches Leben der Wissenschaft mit dem Bewußtsein, meine Kräfte in langer und harter Lebensarbeit — unter großen Opfern — dem Dienste der Wahrheit erfolgreich gewidmet zu haben.

Das Sedanbild.

Das Schicksal des Angelo Jantschen Sedanbildes im Plenarsitzungssaale des Reichstags ist nunmehr definitiv entschieden: wie das "Berl. Tagebl." erfährt, wird das Bild, und zwar voraussichtlich noch vor Wiederaufnahme der Sitzungen, entfernt werden.

Der holländisch-venezolanische Konflikt beigelegt.

Aus dem Haag meldet das Reutersche Büro: Im Ministerium des Auswärtigen ist man der Ansicht, daß man beim jetzigen Stand der Dinge die Schwierigkeiten mit Venezuela vorläufig behoben sind.

like the Sicilian charlatan Alessandro Cagliostro, who put hypotheses in his magic hat to draw them out as science.[53] As readers learned in Paderborn, the "conjurer with pictures of embryos" had *made a complete fool of himself.*[54]

The high-circulation Protestant weekly *Sabbathklänge* (Sabbath chimes) explained that "it has now been clearly proved against this old man that he simply forged plates of pictures ... so that they fitted ... his theory of unbelief, but then of course acted as if the pictures were correct.... He has now been caught. How the god of this world hath blinded the minds of them which believe not (2 Cor. 4:4). The man stands at the end of his life. Only a very short span of time may now separate him from eternity. What an awakening there will be when he passes on!"[55] Few expected the people to awaken soon, even now "the *last* pioneer in the scientific *aping of man ... has been declared morally dead.*" The problem, asserted the conservative Catholic daily *Das Bayrische Vaterland* (The Bavarian fatherland), popular for blunt opposition to Prussia and any hint of liberalism, was that the people were aping their betters, as in clothing fashions so also in the "*intellectual mass epidemic*" of Darwinism.[56]

Dennert would claim that "the more or less right-wing papers described Haeckel's article as devastating for him or at least embarrassing, while the Marxist and freethinking-Jewish papers stood completely on his side."[57] It suited accusers to associate Haeckel with the "atheistic, radical-democratic *Berliner Volkszeitung*"[58] and defenders to marginalize attacks from the ultraconservative press, but moderates in fact played crucial roles, led by the biologically qualified writers who now covered life science for the liberal dailies of major cities. Several past and future authors of *Kosmos* supplements became reluctant critics, expressing dismay at the confrontational populism of the Kepler League, but also disappointment with a response that did not engage.

The Zurich-based journalist Adolf Koelsch wanted to throw Brass's pamphlet on the fire after the first page, but had looked at the plates, been astonished by the transformations Haeckel had wrought, and so read the book and his reply after all. Reviewers thus multiplied the effect of Brass's comparisons. For Bavaria's major liberal daily, the *Münchener Neueste Nachrichten* (Munich latest news), Koelsch saw Haeckel's statement as "*miserable.*" He was "ashamed for Haeckel" when he

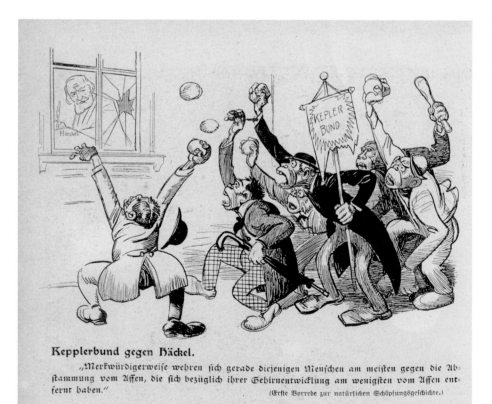

Kepplerbund gegen Häckel.

„Merkwürdigerweise wehren sich gerade diejenigen Menschen am meisten gegen die Abstammung vom Affen, die sich bezüglich ihrer Gehirnentwicklung am wenigsten vom Affen entfernt haben."

(Erste Vorrede zur natürlichen Schöpfungsgeschichte.)

Fig. 14.13 "Kepler League against Haeckel." The cartoon linked the league to a widely reported stone-throwing through the window of Haeckel's Jena study. The caption quoted his statement that the brains of those who most strongly resist descent from the ape have evolved least. Together these echoed Carl Vogt's comment, after suffering a similar attack when lecturing in the 1860s, that he had told his audience the previous day about Stone Age savages, and that his listeners would now realize that this age was not entirely over yet (W. Vogt 1896, 178). Caricature from *Lustige Blätter* 24, no. 5 (27 Jan. 1909): 4. Stadtbibliothek Hannover: Zs 212.

read his pretense that other biologists did the same. Psychologically, Haeckel was like the Englishman who failed to find a mountain and concluded that the landscape was wrong.[59] Ernst Teichmann, literature editor of the *Frankfurter Zeitung*, delivered an influential verdict. The former Protestant clergyman and assistant on *Die Christliche Welt*, with a doctorate in biology and a *Kosmos* supplement on "reproduction and generation" to his name, admitted that "Haeckel's procedure can hardly be considered irreproachable." Even had the schematics been identified as such, his alterations robbed them of any evidential power. But Teichmann more strongly condemned the Kepler League's unworthy polemic. Hounding Haeckel served no one, and it would not discredit evolution even if the drawings were forged (fig. 14.13).[60]

All saw Brass's appeal to the public as irresponsible. Otto Zacharias, now director of a research station and critic of Haeckel's *Welträtsel*, had written (on another topic) for Dennert's magazine *Unsere Welt* (Our world). But he told the high-circulation *Leipziger Neueste Nachrichten* (Leipzig latest news) that all biologists brought subjectivity into their drawings and it was hard to say where what he trusted was "unconscious 'forgery'" began. "In any case the 'German people' are *not* in a position to decide the matter by a plebiscite" and so, for all Brass's good intentions, Zacharias regretted his pamphlet.[61] For the *Stuttgarter Neues Tagblatt* (Stuttgart new daily news) Haeckel's reply gave the chemist and bacteriologist Adolf Reitz a glimpse into the "workshop of a fanatical hypothesis-smith." But Reitz judged the issue "*purely academic*…. It belongs before … competent scholars and not … in the daily press."[62] Invoking the people piled pressure on "the German embryologists" to express a view.

The German Embryologists and the Closed Club

By the 1890s more legitimation was expected from publicly funded research; that was the context for the row over Hensen's plankton expedition. This often meant press articles reporting the findings and claiming relevance,[63] but it could have a critical edge. The Kepler League kept the story going with media events such as open letters, pamphlets, questionnaires, and declarations. Working to break what it saw as an academic conspiracy of silence, it struck populist notes but also posed as a guardian of traditional schol-

arly values, professing respect while pushing biologists to take the stand. It built a stage for a theater of expertise.[64]

When Haeckel ignored a letter in the *Allgemeine Zeitung* requesting that he name researchers who made pictures in the same way, the league asked a hundred professors of anatomy and of zoology four questions: was Haeckel's gap-filling admissible; was it permitted to make schematic figures by altering originals and in part species names; did other researchers do this; and would the professor sign a statement that science handled schematic pictures differently from Haeckel? Of just fifteen replies—the league claimed junior scientists feared to speak out—two were rude and the rest rejected Haeckel's actions.[65]

Biologists' most important responses go back to Julius Schwalbe, the activist, moderately liberal editor of Germany's leading medical weekly, who argued that scientists must not leave the dispute to "the political press" or they would be accused of not daring to take Haeckel on.[66] "Some outstanding biologists" declined "for personal reasons," but two experts, Franz Keibel and Carl Rabl, agreed.[67] Keibel wrote authoritatively in Schwalbe's *Deutsche medizinische Wochenschrift*. Rabl, His's successor in Leipzig, joined with his zoologist colleague Carl Chun to organize a declaration of forty-six German-speaking biologists in the *Frankfurter Zeitung* and other papers.

Keibel applied the standards of the new vertebrate embryology to the plates in the *Menschen-Problem*. On the first he found the pig figures "very strongly schematized," KI "incorrect," MI "a bad copy," and MII–III "figments of fantasy" (fig. 14.4). So were FI and MI on plate III, while GI was a macaque labeled as a gibbon (fig. 14.5). Keibel did not like the way Haeckel had removed the belly stalks and yolk sacs, but accepted this as defensible if acknowledged. FII was an altered illustration of a different species of bat, not from the source Brass gave, but still renamed. GII was again a macaque turned gibbon, and Haeckel had shortened the tail; MII was "much changed" from His. So Keibel concluded

> that Haeckel in *many* cases either freely invented embryos or reproduced figures of other authors in significantly altered form, and not only in order to fill gaps through hypotheses, and also without indicating that these were schemata and hypothetical

forms.... In our good handbooks and textbooks we do not proceed in this way and ... such a procedure is ... quite unscientific. I regard it as at least equally improper to give such pictures in popular presentations. In the essential points, then, Brass was right to raise his objections.

But Keibel "would not like to call them 'forgeries' as Brass does, because Haeckel doubtless acted in good faith. The fantasy and fanaticism of the founder of a religion make him see things as he represents them."[68]

Keibel developed a larger argument about scientists' rights and responsibilities, but first tackled Brass, who "is also a fanatic, only he has much less brilliance and talent." There was no point discussing evolution with a scientist who regarded an *"act of creation"* as an *"explanation,"* but Keibel did criticize his cavalier approach. Brass did not know that human embryos could have as many as forty-three somites and dogmatically announced dubious "discoveries" alongside his polemic. "Haeckel and Brass mistake in the same way the essence and scope of natural scientific research. Natural science has nothing to say about value and purpose; its task is to determine the facts and the causal connection of facts." Scientists had no business making normative statements, and nor should morality and religion meddle in the theory of evolution. "The evolutionary theorist can nevertheless be deeply religious, indeed a true Christian, if such a person is not assumed to be characterized by rigidly literal belief." A typical imperial German science professor, Keibel, himself on the nationalist right, exchanged autonomy for limits.[69]

Rabl and colleagues avoided technicalities in a newspaper, tersely distancing science from procedures no specialist could condone, while defending it against outside interference. They declared (in full)

> that they do not approve of the kind of schematization practiced by Haeckel in some cases, but that in the interest of science and the freedom of teaching they condemn in the strongest possible terms the struggle waged by Brass and the "Kepler League" against Haeckel. They further declare that a few incorrectly reproduced pictures of embryos cannot detract from the concept of development, as it is expressed in the theory of descent.[70]

First the professors and directors rejected Haeckel's questionable methods, but mildly, because there was no evidence of bad faith, and most biologists set his achievement against his foibles. Second, they rebuffed the threat to scientific freedom from Brass's complaint that no German zoologist or anatomist took an openly Christian position, and protested more specifically against the Kepler League's attempt to "ostracize" Haeckel. Closing ranks to protect the aged prophet, the signatories were incensed that "a man such as Brass" dared to insult, "for all his faults, such an outstanding and meritorious researcher" as Haeckel, and at the age of seventy-five. Brass had been described as "a respected biologist"; Richard Hertwig wrote that his career had ended in failure long ago and Rabl that his later works "are not ornaments of science." "I frankly had to warn my pupils against his 'Atlas of embryology.'" Finally, since Brass opposed the theory of descent, it had seemed necessary to reassert its validity.[71]

Senior Jena-trained morphologists thus built a consensus. While specialist research had left the Haeckelian verities behind, no mainstream biologist, even those feuding with Rabl over the phylogenetic value of embryos versus adults, doubted that at certain stages vertebrates look similar because they are related by descent. No one justified Haeckel's actions, but since "absolutely *true to nature* pictures" or photographs would have proved his point "far *better* and more convincingly," few could see a motive for fraud.[72]

Rabl and Chun recruited full professors and museum directors, including many of the most respected German-speaking biologists. Strong support from Austria and Switzerland included Kollmann, now known for an embryological textbook and atlas. But the key measure was the proportion of imperial German full professors, and with twenty-four out of forty-three (fourteen of twenty-two anatomists and ten of twenty-one zoologists) they had just over half (table 14.1). From Berlin, Oscar Hertwig was conspicuously absent, but Wilhelm Waldeyer signed, even though he had asked Haeckel a few months before why his figures of human embryos did not match those on Keibel's normal plate.[73] The smaller Prussian universities also gave only partial backing, and Kiel, as expected, none at all. Richard Hertwig led Bavaria, apart from Fleischmann, to a full house. Bastions in the

TABLE 14.1 Full professors of zoology and of anatomy at the universities of the German Empire and the declaration of the forty-six

State	University	Name	Signed in 1909	Donated for 60th in 1894	Research in vertebrate embryology	Comments
Prussia	Berlin	Franz E. Schulze	Yes	Yes		
		Karl Möbius		Yes		
		Wilhelm Waldeyer	Yes	Yes	Yes	Research on ovary, placenta, and related topics
		*Oscar Hertwig**		Yes	Yes	
	Göttingen	Ernst Ehlers	Yes	Yes		
		Friedrich Merkel	Yes	Yes	Yes	Research, for example, on sections of fetuses
	Bonn	Hubert Ludwig				Student of Carl Semper; echinoderm embryologist
		Robert Bonnet	Yes	Yes	Yes	Mammalian embryologist
	Breslau	Willy Kükenthal*	Yes	Yes	Yes	Whale embryologist
		Carl Hasse	Yes			Criticized Haeckel more sharply in 1911
	Halle	Valentin Haecker		Yes		More interested in heredity than development
		*Wilhelm Roux**		Yes	Yes	*Allgemeine Zeitung* article more critical
	Greifswald	G. W. Müller				
		Erich Kallius	Yes		Yes	
	Kiel	Karl Brandt				Kiel was a bastion of anti-Haeckelism
		Walther Flemming		Yes		
	Königsberg	Max Braun				
		Ludwig Stieda			Yes	Known as a historian of embryology
	Marburg	Eugen Korschelt	Yes	Yes		Authority on invertebrate embryology
		Emil Gasser			Yes	Student and successor of Nathanael Lieberkühn
Bavaria	Munich	Richard Hertwig*	Yes	Yes		Haeckel's senior student
		Siegfried Mollier	Yes	Yes	Yes	
		Johannes Rückert	Yes	Yes	Yes	
	Würzburg	Theodor Boveri	Yes	Yes		
		Philipp Stöhr	Yes	Yes		
	Erlangen	Albert Fleischmann			Yes	Antievolutionist who clashed with Haeckel
		Leo Gerlach	Yes	Yes	Yes	Published on malformations
Baden	Heidelberg	Otto Bütschli				
		Max Fürbringer	Yes	Yes		Student of Carl Gegenbaur, organized 1894 event
	Freiburg	August Weismann	Yes	Yes		
		Robert Wiedersheim	Yes	Yes		[Franz Keibel was not a full professor]
The Reich	Strasbourg	Alexander Goette	Yes		Yes	Attacked by Haeckel in 1875
		Gustav Schwalbe	Yes	Yes		
Württemberg	Tübingen	Friedrich Blochmann		Yes		
		August von Froriep				
Hessen	Giessen	Johann Spengel		Yes		
		Hans Strahl			Yes	Student of Nathanael Lieberkühn
Saxony	Leipzig	Carl Chun	Yes	Yes		Co-organized the declaration
		*Carl Rabl**	Yes	Yes	Yes	Co-organized the declaration
Thuringia	Jena	Ludwig Plate	Yes			Used charges against Haeckel in 1919
		Friedrich Maurer	[Yes]	Yes		Gegenbaur student, supported Haeckel in article
Mecklenburg	Rostock	Hans Spemann			Yes	Appointed in 1908
		Dietrich Barfurth	Yes	Yes	Yes	

Note: Professors of zoology appear in roman type; professors of anatomy, in italics. *Considered himself a Haeckel student.

smaller states were, in addition to Leipzig and Jena,[74] Heidelberg and Freiburg in Baden and the Imperial University at Strasbourg—even Alexander Goette, whom Haeckel had attacked in 1875. Experts in vertebrate embryology tended to sign.

With few exceptions, the consensus held. Wilhelm Roux criticized Haeckel more strongly, while Carl Hasse, one of the forty-six, condemned his slur on other biologists, and Victor Hensen complained.[75] But Richard Hertwig declined a Protestant banker's invitation to dissociate himself from the declaration, and the combative Darwinist geneticist, Ludwig Plate, negotiating to become Haeckel's successor, told the *Illustrirte Zeitung* that opponents were exploiting "small inexactnesses and schematizations."[76]

Confident "the German embryologists" would not defend the indefensible, the Kepler League had forced them into an unedifying dispute, only to be condemned itself while Haeckel got off lightly. The leadership had paid the price for supporting "a man such as Brass" but still competed for the middle ground. The forty-six, Teudt argued, mistook a legitimate interest for interference. This explained the logical impossibility of condemning the struggle against a procedure of which they did not approve. The league would keep up the pressure, not to judge beyond its competence, but to lead the people it represented to science after Haeckel had put them off. "The times are past when scientific matters could be decided as if in a closed club." The public had the right to ask, "What are you up to there? And how are you doing your job?"[77]

In March the league declared that, while they themselves disapproved of Brass's tone, the experts had upheld his criticism. Thirty-seven professors signed a counterdeclaration: the league did not threaten scientific freedom; it was a matter of honor to intervene for truthfulness in science; and the struggle against Haeckel's methods had nothing to do with evolution, which many again said they endorsed.[78] The thirty-seven lacked specialist credibility. Astronomers, physicists, geologists, botanists, and surgeons were joined by scholars with even less expertise. They claimed that any reasonable academic could see Haeckel was wrong. Martin Rade went so far as to praise his fight for scientific independence from the church, and understood why biologists had not spoken out before, but objected that the forty-six had gone public only to combat criticism of harmful procedures.[79] The dominance of Dennert and Brass, however, led many to suspect a true agenda of rolling back evolutionism and bringing in religious tests.

Monists, Keplerians, and their scientist critics did not just reenact ancient battles over limits and freedom. As the natural sciences advanced, they faced more radical challenges in the polarized politics of the twentieth century, sometimes from the left, but more frequently from the right and often with a religious agenda.[80] Haeckel's misdemeanors allowed the Kepler League to take on the "closed club" in the name of both "the people" and its own *Volk*. Biology professors closed ranks against science by plebiscite.

The declaration of the forty-six ended the main phase of the debate, and Haeckel's biographers have given it the last word,[81] but it was not the last, even from several signatories, any more than Dennert's take on the "forgeries" represented his own settled opinion, let alone that of the Kepler League. With a more diverse press, the scope to cultivate group-specific interpretations had grown, and so had the competition to shape a dominant view. Haeckel would see his colleagues as intervening "in my favor" and "for me,"[82] while Catholic critics read them as rescuing German science from him. The Kepler League moved on to the wider issues, and lured Haeckel into another unwise defense. They might have lost the argument with the embryologists; they had shaped views of relations between natural science and Christian religion for many decades, and ensured that the allegations would dog his reputation for ever. His followers soon complained that forging pictures was the only thing most Germans knew he had done.

{ **15** }

A Hundred Haeckels

"A hundred Haeckels, grotesque in their unlikeness to each other, circulate in our midst to-day," wrote his English translator in 1906.[1] Neutrality was impossible as everyone constructed Haeckel in their own or their opponents' images.[2] German admirers at his shrine and archive in Jena negotiated the fraud charges as they recovered from the Brass affair and reconstructed national Haeckels for the late Empire, Weimar Republic, Third Reich, and postwar states.[3] Yet, as the Stanford entomologist Vernon Kellogg told *Popular Science Monthly*, "Haeckel is no longer merely the German champion of Darwinism and monism, but the world champion"; his "heresies … have penetrated all lands and circles of reading and thinking people."[4] Haeckel was so famous in the United States, which in the early 1900s began to overtake Germany as the powerhouse of science, that readers were expected to take an interest in the detail that an Austrian manufacturer sent him two "creation hats" every year.[5] Then the periodical press imported Brass's charges, and Americans pondered the possibility that the eminent foreign savant was a common "nature faker" after all.[6]

In the twentieth century Haeckel embodied the best and the worst of nineteenth-century biology and the scientist's role in German history: a hero of evolutionism and free thought; a visionary systematist whose categories shaped knowledge from *ecology* to *stem cell*; a shallow philosopher, a schematizer and propagandist; a fount of scientific racism, racial hygiene, euthanasia, and National Socialism; a pacifist but also a warmonger. Even supporters acknowledged that Haeckel had flaws, but they could never accept that he was a fraudster at heart. While religious and personal enemies kept the charges alive, especially in Germany, influential voices agreed that science needs

various types. Diligent civil servants were not always enough, and even a genius who violated basic norms might have a place.[7]

Monists and Jesuits

Some monists did not mind whether or not Haeckel "has told us the completely exact truth." "A tremendous personality" had taken "humanity" a good part of the way there. No one should complain if he took a false turning now and then.[8] An "officer's wife" thanked him for battling on,[9] but the attacks nevertheless hurt the young league, absorbed as it was in faction fights over his nature philosophy. Unprepared members, often responding to local newspaper articles about the forgery charges or announcing that Brass would visit, inundated Haeckel with letters like Tschirn had written years before: "You must show that the Haeckel of 1866 [the *Generelle Morphologie*] and 1899 [the *Welträtsel*] still lives! It is a matter here of your [very] existence among the people, which has until now honored you with reverence and love!"[10] A mining engineer who claimed to have won dozens for monism knew such an exact researcher as Haeckel would never forge anything; it must be a side-issue— but could he please explain?[11] When his accuser was expected in a Saxon textile town, the plea went out: "Since we are very keen to send Dr. Brass packing, may I ask if you would be so kind as to send me some material?"[12] From northern Switzerland, where Brass was beginning a tour, a zoological preparator wrote to say that although he was still reading Darwin, and had not reached Haeckel yet, no one more expert was available, so would Haeckel provide something to use and tell him where to attack?[13] University professors condescended, but Brass was a formidable opponent when the only zoologist in a room.

In spring 1909 Haeckel's assistant and Monist League general secretary Heinrich Schmidt, a former elementary-school teacher Haeckel had enabled to study biology,[14] explained that his childlike enthusiasm and the Keplerians' misuse of trivia had blurred the battle lines and allowed them to leave him for dead. "But lo! ... they shall kill him; and after three days he shall rise again."[15] Schmidt brought scattered documents together to make the case: authoritative quotations and pictures upheld the similarity of vertebrate embryos as evidence of common descent and

vouched for the complicating effect of individual variation. It was a "*Jesuitical trick*" to denounce schematics as forgeries for not being exact. Filling gaps was also correct; Schmidt dug out a telling passage in which Keibel explained why, lacking middle stages for a gibbon series, he had substituted those of the macaque. Haeckel's only mistake had been not always to identify particular illustrations as schematic.[16]

If monists could hope to neutralize the issue and build a little solidarity, Kepler League membership almost doubled to exceed theirs, with 8,400 in thirty-nine branches in 1909, courses, a building, and by 1914 a museum. In a rival document collection Teudt agreed with Brass, in a second edition of his book, that what mattered was control over science. As Brass put it, "The issue now is not only 'pictures of embryos'— these are in the end as irrelevant for the German people as a catastrophe in the constellation of Perseus— but how *research into nature is misused ... to push old views in all areas to one side!*" The people might not know embryology, but should judge its presentation to them.[17]

This league was a coalition too, with the orthodox wanting more positive content while Dennert struggled to keep liberal Protestants on board.[18] Georg Wobbermin condemned Haeckel's actions while not liking to label them forgery: Haeckel was "with subjective truthfulness objectively untruthful." Wobbermin supported the counterdeclaration of the thirty-seven while wishing for more distance from Brass.[19] But theological liberals were not all soft on Haeckel: a Hamburg orphanage director who left the league in protest against Dennert's defenses of Christianity approved of his updated Haeckel book, now in its twentieth thousand.[20]

Moderate Catholics had launched magazines that provided platforms for a subtler approach to evolutionism, and even to Haeckel, than the blanket rejection and character assassination of old. Some conceded his services to science and regretted the damage his failings would do the developmentalist cause. Wasmann argued more polemically that Haeckel had played a "sophistical game with the term 'schematic figure,'" but that his forgery of ideas was worse. Catholic commentators agreed that the declaration of the forty-six amounted to a veiled condemnation: obliged to disavow his actions, biologists had attacked the Kepler League to sugar the pill.[21]

The dispute was nevertheless dying down until Haeckel, dissatisfied that his "confession" had backfired, ignored good advice to keep quiet.[22] In 1910 he tackled Keibel for stressing differences without mentioning the more important similarity, and insisted that the fact of human evolution removed any limits on natural science.[23] Haeckel also authored a pamphlet that pitted "an honest researcher after truth" against "the *sophistry* of the Jesuits, smooth as an eel and slippery as a snake." For him they were all "Jesuits," whether they "wear the black monk's habit of the Catholic Thomas League [his collective term for various associations] or the black cassock of the Protestant Kepler League." The small book developed familiar defenses, and followed his critics into a little more detail.[24]

Named with the Greek for *sandal*, *Sandalion* concentrated on the first row of sandal embryos and especially the human one, the earliest observed (fig. 15.1). Haeckel compared his schematic with Kollmann's copy after the Kiel anatomist Count Spee, explaining that his own drawing omitted the extraembryonic membranes and made the germ symmetrical to give the true form "*more correctly,*" that is, more ideally, than the original. Comparison to a similar object represented by another anatomist showed that exact drawings varied too.[25] Yet Brass had all but accepted these figures by the time he wrote his book. Haeckel had again sidestepped most of the specific charges in favor of picking up the general argument that forgery had no motive when true-to-nature pictures would have made the point.[26] Even moderates found the pamphlet

Fig. 15.1 Cover of "Sandalion: A Frank Answer to the Jesuits' Accusations of Forgery," the pamphlet Haeckel was proud to have written in three weeks and had printed and published by the main free-thinking press in another two (note in his copy, EHH). A halftone reproduction of a drawing shows the eponymous embryo. Haeckel 1910c.

weak;[27] foes decried him as once more convicted by his own pen.[28]

Beneath the surface of monist approval and Christian denigration lurked freethinkers' nagging doubts and cries for help, Keplerians with reservations about calling Haeckel a forger, and devout readers expressing concern. Jeannette Connor asked from the Institute of Fermentation Industry in Berlin, "whether you really forged the pictures of embryos" and urged him to recant before he died. "I will pray for you," she promised.[29] Some claimed to have been disillusioned,[30] but few minds can have changed, least of all his own. When he cited the charges to justify joining a monist campaign to quit the churches, people were amazed he was still in.[31]

Romantic Genius

Condemning Haeckel was easy. Defending him was not hard. But excusing without condoning his actions took dexterity, as the sixtieth-birthday celebration had shown. Brass made it trickier still to settle the status of a researcher so widely vilified and admired. This status mattered, because as intellectual work became more a job than a calling, Haeckel represented an alternative that still appealed: natural science as encompassing all knowledge and replacing religion, with the scientist as prophet and priest. He was thus prominent among those exceptional scientists, those geniuses with their characteristic eccentricities, reflection on whom helped define the profession and its norms.[32]

Haeckel confessed great failings and many errors. Enthusiasm, "often criticized by my enemies as 'fanaticism,'" had combined with what friends called a "drive for completeness" to lead him to fill gaps by hypothesis and deduction. (It had also brought him to the nature philosophy he regarded as his most valuable contribution.)[33] He had long ago admitted sometimes schematizing too much, but considered the embryo comparisons, except for a few deductions and interpolations, regular schematics.[34] He likewise defended the *Kunstformen* as "true to nature" and "objective"; "of reconstruction, trimming, schematizing, or forgery there can be no question at all."[35]

A few biologists accepted this;[36] most forgave the pioneer of Darwinism while rejecting his pictures. Richard Hertwig had shown the way with his homage

to a Goethean "artistic nature."[37] As published watercolors and the *Kunstformen* made the artist better known (fig. 15.2), Haeckel's devoted student and colleague Arnold Lang compared his "daring constructions and genealogical hypotheses" to "giant paintings drafted by the hand of an artist full of fantasy" and "experience."[38] Haeckel, who had always set himself against "exact" physiology, won so many followers, especially in the literary world, in part precisely because he refused to separate beauty and truth. He embodied a synthetic alternative to the anatomist's dissections, the experimenter's vivisections and calculations, and physiologists' dismissal of Goethe's scientific pursuits.[39] For some, Haeckel was still not Romantic enough. When the dancer Isadora Duncan hosted him for a performance of Wagner's *Parsifal* at Bayreuth, she enjoyed the "perfume" of his intelligence, but found him "too purely scientific" to appreciate legends, and—echoing his own comments decades before—regretted that his painting "lacked the artist's imagination."[40] For most scientists, by contrast, the problem was insufficient respect for the difference between science and art.

Though not entirely complimentary, this argument referred to an innate trait and so exonerated Haeckel of deliberate fraud. Writing for many, Keibel had pointed to his fanaticism as driving an overdeveloped fantasy: he saw what he wanted, he took the theory for the reality, without intention to deceive.[41] Auguste Forel likened Haeckel to Alphonse Daudet's Tartarin de Tarascon, who having almost accepted a job in Shanghai, honestly told stories of his time there. The best researchers balanced fantasy with self-criticism, but many a genius did not. These "poets of science" nevertheless enriched knowledge far more than the "fact collectors," and a legion of "schoolmasters" soon corrected the errors.[42] In an address in 1918 Einstein would recognize the "many mansions" in the temple of science, and "how various indeed are they that dwell therein and the motives that have led them thither." He would be likened to a poet himself.[43]

In some ways Haeckel-worship participated in standard tropes of the genius, though it also helped to define these for the early twentieth century. On his eightieth birthday in 1914 the scientist contributors to a two-volume tribute saluted a visionary, a new Cuvier who could deduce wholes from parts (fig. 15.3). It was

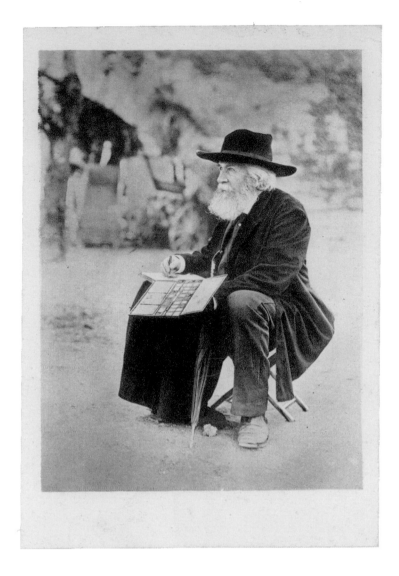

Fig. 15.2 Haeckel as an artist, on the beach at Rapallo on or near his seventieth birthday, 16 February 1904. W. Haeckel 1914, no. 20.

mean to criticize trivial slips.[44] Haeckel, in this view, combined a warrior's courage in his science with a childlike innocence in everyday life. This made a curiously unworldly figure of perhaps the highest-earning scientist author of the age and explained those missteps that had caused so much trouble. For Haeckel was a genius of a particular kind. Fresh from a study of "great men," the monist chemist Wilhelm Ostwald distinguished classical and Romantic types. The classical genius worked slowly on one or a few fiercely defended topics, aiming for a definitive solution, was often not cut out for teaching, and could initially underwhelm contemporaries. The Romantic genius attacked a wide range of subjects, published quickly, often revolutionized an immature field, inspired students, and was influential in his own time, but risked superficiality. Dar-

win was a pure classical and Haeckel a pure Romantic type.[45]

An honest accounting needed to face Haeckel's failings more frankly. His death freed Richard Hertwig to ask how a reformer who once had most scientists on his side made ever more enemies as he aged. The answer lay in his rejection of not just the physiological "levers and screws," but also modern morphological methods, and in an idiosyncratically artistic style. Haeckel's drive for generality prevented mental immersion in an individual specimen; he saw the typical only. He also represented imperfect preparations as he believed the animals must have looked in life. So his drawings were schematic; artists found the *Kunstformen* too stylized to serve as raw material. Worse, fantasy and passion led him to "actions which … greatly

Fig. 15.3 Cover of the "Book of Admiration and Gratitude" produced for Haeckel's eightieth birthday in 1914. The monist flame is flanked by marine invertebrates drawn by Hans Dietrich Leipheimer after Haeckel's research. Two volumes contain a biography and 122 tributes on the theme "What we owe Ernst Haeckel." This is one of 200 numbered, leather-bound copies over and above the regular run. H. Schmidt 1914, gift of Michael Cahn.

damaged his name." Hertwig mentioned the gibbon embryo, even as he claimed the right specimen would have looked more human-like. In the end, however, one had to take great men whole.[46]

Haeckel became a major, aberrant figure in anti-Darwinist histories of biology,[47] a prize exhibit in the sociology of scientific genius, and an extreme case in the social psychology of observation. Philosophical discussion of scientists' uses of necessary "fictions" cited the debates over his schematics. The Polish microbiologist Ludwik Fleck took the "biased illustrations appropriate for his theory" as exemplifying "creative fiction," "the liveliest stage of tenacity in systems of opinion."[48] Yet his theory cannot here have been much more specific than evolution itself, or twentieth-century biology books would not have used these textbook examples of the theory-ladenness of

observation to support rival theories of the relations of evolution and development.

For Hertwig, "the tendency to give a schematic drawing instead of an individual figure lay from the beginning in Haeckel's temperament [*Naturell*]" and just increased as he became more nature philosophical and wrote more popularly.[49] That may be so. But the image of the Romantic, artistic, Goethean genius was also made in his own lifetime, especially late in life, and after his death. Biographies have nurtured this Haeckel; some even grant him the title of genius as a descriptive accolade. This explains little, just as Hertwig's comment does not tell us why only some illustrations caused trouble, or why some of the first caused the most. German Darwinism was not a projection of Haeckel's psychology. He was effect as much as cause. But this Haeckel matters historically as an

outlier in the repertoire of scientific types and became influential to the extent that, with different emphases, it let his devotees agree.

National Legacy

Scientists typically appeal across political lines, but for a man so often decried as a dogmatic controversialist, Haeckel is remarkable for having drawn such diverse disciples into his orbit and maintained a presence through rapid changes of German regime. He benefited from the rise of evolutionism, in part thanks to his own efforts, and from his status as the national pioneer of Darwinism and free thought. His own politics were so much a part of the history of science in the country that they could be acknowledged and, if necessary, detached. But the few overtly political statements mattered less than his play of unpolitical neutrality: "Whether a monarchy or a republic be preferable, whether the constitution should be aristocratic or democratic, those are subordinate questions in comparison with the great and principal question: shall the modern civilized state be ecclesiastical or secular?"[50] As followers struggled over his legacy and fought off the forgery charges, they excused his politics and recruited him to theirs.

Defeat, revolution, and the founding of the democratic Weimar Republic realized Haeckel's worst fears. The country lurched toward economic crisis and near civil war, and he joined the ultranationalist Pan-German League. But among Jena Darwinists the left supported and the right attacked. Haeckel had chosen Ludwig Plate as his successor against friends' advice, evidence he was a poor judge of people, they said. The previously obsequious geneticist rudely asserted his authority, even reproaching Haeckel for stealing books. Just before and after Haeckel's death, Plate used the charges, reporting that "I am often asked by visitors if the Haeckelian pictures of embryos are …

in the [Phyletic] Museum, which did not happen, of course,"[51] and pronouncing it unpleasant to succeed a man "branded a forger by scholars of the first rank."[52] He contrasted himself, an "idealist, freethinking Christian, *völkisch* German, and anti-Semite," to the "crude materialist and atheist" celebrated by "social democracy and the Jews."[53] The doctor and writer Adolf Heilborn indicted Plate for martyring Haeckel, but lost the resulting court case on the second appeal. Heilborn's pamphlet reminded observers that Plate had signed the declaration of the forty-six; Schmidt reminded them that Plate had called the charges "*slander*" as late as 1911 (fig. 15.4). Was he now slandering Haeckel?[54] Yet even Plate, adapting Lang's analogy, acknowledged that Haeckel's vices were "only small disturbing marks

Fig. 15.4 Cover of Adolf Heilborn's pamphlet, "The Lear Tragedy of Ernst Haeckel." Hat, beard, and craggy features were essential ingredients of Haeckel's old-age image, here given an expressionist interpretation that heightened light and shade to represent a prophet cast out from his own creation, like Lear and Bismarck. After a woodcut by Eddy Smith, a member of the socialist November group of Berlin artists, from Heilborn 1920b.

on an otherwise splendid painting, rich in colors and figures."[55]

Social democrats took Haeckel's side, led by Schmidt and by Haeckel's last student, the theoretical biologist Julius Schaxel. Repulsed by Plate from the museum, Haeckel had founded a separate "Phyletic Archive" in his Villa Medusa.[56] The "Ernst Haeckel House," inaugurated in a ceremony to inter his ashes in 1920, became the center of biographical production. Schmidt, the first director, edited the collected popular works and some letters and authored a hagiography, but neither he nor his successors explored the genesis of the embryo plates (fig. 15.5).[57] Apart from the *Welträtsel*, Haeckel's books had lost momentum, but secular science flourished. *Kosmos* went from strength to strength, and the cultural organizations of the social-democratic and communist parties promoted science as part of a socially aware atheist worldview (fig. 11.6).[58] *Urania*, the "proletarian *Kosmos*" that Schaxel launched with the temporary stabilization in 1924, placed Haeckel, naïve politics and all, as the "last hero" of "bourgeois free thought."[59]

Meanwhile, men took over the still small Kepler League who wanted to stop fixating on Haeckel and draw a line under what they regarded as Dennert's ill-advised support for Brass. Dennert's successor Bernhard Bavink, also a schoolteacher, "rejected" the battle against Haeckel as "neither expedient nor always fair," and Brass as an "obsessive complainer," whose writings "could not be taken seriously."[60] Karl Hauser, who had assisted with the handbook *Natur und Bibel in der Harmonie ihrer Offenbarung* (Nature and Bible in the harmony of their revelation), stepped back from the accusation of "forgery" by accepting that the end justified the means: "With this word one always thinks of a crime like the document or currency forger commits in order to gain an illegal pecuniary advantage. For the psychological evaluation of a deed, however, the motive is decisive, and so it is unfair to put on the same level as the criminal forger the statesman who for diplomatic reasons shortens a dispatch by a few words or the scholar who, consumed by his conviction,

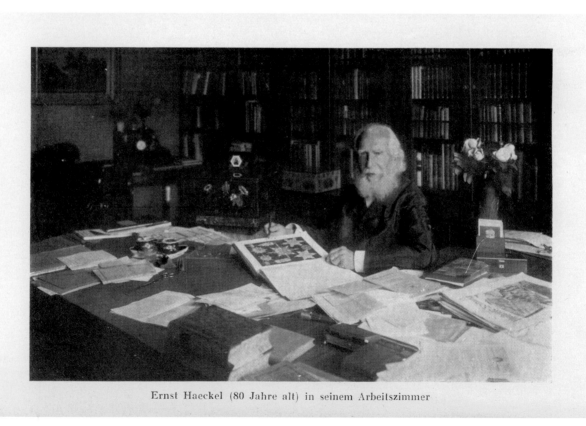

Ernst Haeckel (80 Jahre alt) in seinem Arbeitszimmer

Fig. 15.5 Haeckel in his study, aged eighty, a plate in Schmidt's biography. Old-age portraits often showed him with the *Kunstformen*, here open at the *Acanthophracta* radiolaria, or sometimes with his watercolors (fig. 1.3). Since Haeckel was no longer welcome in the Zoological Institute, views in his study became staples of the biographical literature. After his death the room was faithfully preserved. Halftone after photograph of 1914, from H. Schmidt 1926.

'shortens' a little embryo tail by a few vertebrae."[61] The reference to Bismarck's editing of the Ems telegram to provoke the Franco-Prussian War suited "the Bismarck of zoology."[62] Even Dennert, now an invalid penning conservative revolutionary tracts, biologistic but anti-Darwinist,[63] was impressed by Haeckel's character as constructed in a heavily edited selection of letters exchanged with a much younger noblewoman around 1900: wanting a lover like his first wife, but choosing duty to the second. "From the serene, calmer standpoint of age" Dennert would no longer call Haeckel's actions "forgery."[64] But the Christian stereotype of the atheist forger was standard still.[65]

Jena stayed loyal to the social democrats in the slump after the crash of 1929, but the Nazis joined the Thuringian state government in Weimar in 1930 and set about establishing the university as a center for racial biology.[66] Historian Daniel Gasman argued that Haeckel himself represented "the scientific origins of National Socialism,"[67] but exploiting his legacy after 1933 in fact posed a major challenge, not least because the left had fêted him most.

Nazification started with a burst of activity around Haeckel's hundredth birthday in 1934. Schmidt authored a new biography, stressing Haeckel's nationalism and racial character as a fair-skinned blond with Germanness in his blood. Schmidt ignored the forgery question, but Nazi racial hygienists had to counter allegations last prominently used, by Brass and Plate, on the right. Plate avoided repeating them as he praised the evolutionist zoologist while accepting that Haeckel the philosopher had flopped. In the official birthday speech Victor Franz, Ritter professor of phylogeny, party member since 1930, and soon Haeckel House director, pointed to Haeckel's worship of Bismarck, antisocialism, wartime propaganda, racial features, and eugenics. Haeckel could not be blamed if in his declining years political opponents had taken over the now banned Monist League. Franz admitted that Haeckel had given zoologists much to forgive, but the anthropologist and brownshirt Gerhard Heberer could explain the "grotesque" charges only as flowing from "boundless hate."[68]

In 1936 the major Nazi biography opened with a recollection by the senior Thuringian racial hygienist, health bureaucrat, and SS officer Karl Astel: "I learned in religion class Haeckel was a forger and fraudster, because he retouched pictures of human embryos in order to prove that man descended from the ape." Later Astel discovered that "the most excellent defenders of truth . . . are not infrequently slandered by the beneficiaries of lies and lovers of intellectual half-darkness as forgers, heretics, and atheists." Freed from this "slander, misleading, ignorance, envy, and pettiness," "the gigantic picture of Ernst Haeckel became visible" as *one of the most courageous and most significant pioneers of a state concept based on natural law . . .* and the most brilliant German biologist to date." The ideas of this "Aryan scientist" underlay such policies as ridding Germany of Jews.[69]

Yet in the next two years nazifying Haeckel became controversial as the party rejected attempts by scientists to align pet approaches with the new politics.[70] For the educationalist Ernst Krieck, finding forerunners was "nonsense." Franz Lenbach's Haeckel portrait hung in the "Great Germans" exhibition during the Berlin Olympics, but he was described as having failed "to sow eternal values."[71] Critics in the Nazi Party Office of Racial Policy worked to neutralize the threat to race constancy of his views on inheritance and adaptation.[72] For the Kepler League, of which leading lights were close to National Socialism even before 1933, the increasingly nonconformist Bavink protested against honoring Haeckel, who had opposed holistic biology, in what the *Führer* had ruled should be a Christian state.[73] A small Ernst Haeckel Society was nevertheless permitted under Astel's auspices in 1942.[74]

After the war the German Democratic Republic (GDR, or East Germany) returned to the socialist Haeckel. The key architect of the state, Walter Ulbricht, admired the *Welträtsel*, which he had studied in a school for socialist youth, and ensured the institutionalization of the Schaxel-Haeckel tradition of freethinking science as worldview (fig. 15.6).[75] It might have tested Haeckel's commitment to the religious question as "great and principal" that a Stalinist regime made Jena part of one of the most secular countries in the world, but he would have enjoyed the recognition. Despite his nationalism, this pioneer of scientific materialism had been "objectively positive" for the working class;[76] his "mistakes and hastiness" "cannot reduce the significance of his work."[77] The Haeckel House was initially mainly a center of Lysenkoism, and nearly became an institute for atheist propaganda, but Georg Uschmann, though disparaged by Marxist-Leninists as a positivist fact collector, took over in 1959 and turned

Walter Ulbricht und seine Gattin im Gespräch mit Jenenser Schülern vor dem Ernst-Haeckel-Museum · *Fotos: Zentralbild/„ND"-Archiv*

Kolloquium in der „Villa Medusa"

Walter Ulbricht besuchte das Ernst-Haeckel-Museum in Jena / Notizen von Dr. Harald Wessel

„Villa Medusa" hatte Ernst Haeckel jenes Haus genannt, das er sich im Jahre 1883 bauen ließ und in dem er bis zu seinem Tode im Jahre 1919 wohnte. Heute beherbergt die „Villa Medusa" in Jena das Ernst-Haeckel-Museum, mit dem Haeckel-Archiv und das Institut für Geschichte der Zoologie der Friedrich-Schiller-Universität. Hier ist in den letzten Jahren das Zentrum der Haeckel-Forschung entstanden. Hier wird der wissenschaftliche Nachlaß des großen deutschen Naturforschers gesammelt und ausgewertet. Hierher kommen Jahr für Jahr zahlreiche Besucher aus dem In- und Ausland, um sich ein anschauliches Bild vom Kämpferleben des Mannes zu machen, der dem Darwinismus in Deutschland zum Durchbruch verhalf.

Zuneigung der Jugend

Am frühen Donnerstagmorgen wurde es um das ein wenig verträumte und abseits liegende Haeckel-Haus lebendig. Viele Jenenser waren erschienen. Sie hatten erfahren, daß der Vorsitzende des Staatsrats der „Villa Medusa" einen Besuch abstatten werde. Pünktlich um neun Uhr fährt der Wagen vor. Walter Ulbricht, seine Gattin und Professor Hager werden herzlich begrüßt. Wie überall in der DDR, läßt auch hier insbesondere die Jugend ihre Zuneigung zu Walter Ulbricht erkennen. Junge Pioniere bestürmen ihn mit Blumen, Glückwünschen und Fragen. Da gibt es Gespräche unter vier Augen zwischen dem Staatsratsvorsitzenden und einigen Schülern. Der Inhalt der „Aussprache" sollte jedoch nicht lange „geheim"bleiben.

An der Tür des vor einigen Jahren gründlich renovierten Hauses empfangen Magnifizenz Prof. Dr. Schwarz und Dr. Uschmann, der Direktor des Instituts, die Gäste. Das geht ganz alltäglich zu, mit jener nüchternen Freundlichkeit, die bei uns selbstverständlich geworden ist. Und dennoch ist es für alle Haeckel-Kenner ein ungewöhnliches Ereignis. In dieses Haus war die wissenschaftliche Welt der Jahrhundertwende ein und aus gegangen. Aber die Staatsoberhäupter der deutschen Vergangenheit hatten das Heim des weltberühmten Naturforschers nicht betreten. So blieb es dem Repräsentanten des ersten deutschen Arbeiter-und-Bauern-Staates vorbehalten, durch seinen Besuch Ernst Haeckel, dem bis über den Tod hinaus von reaktionären Dunkelmännern geschmähten Wahrheitsfanatiker, die Ehre zu erweisen, die das deutsche Volk ihm schuldet.

Vorbild unserer Studenten

Dr. Uschmann führt die Gäste durch die einzelnen Räume, in denen vielfältige zeitgenössische Dokumente den Lebensweg Haeckels deutlich machen. Walter Ulbricht betrachtet die Schriftstücke, Bücher und Bilder mit größtem Interesse. Seine Frau macht er auf die Kolleghefte des Studenten Haeckel aufmerksam, die

dessen Bienenfleiß bezeugen. Da ist auch ein Entwurf jener Rede, die Ernst Haeckel auf der 38. Versammlung Deutscher Naturforscher und Ärzte hielt und die das erste flammende Bekenntnis eines deutschen Biologen zum Darwinismus darstellte.

Schmunzelnd liest Walter Ulbricht einen Originalbrief Darwins an Haeckel, in dem der Begründer der Abstammungslehre seinen energischen deutschen Verteidiger bittet, sich nicht zu sehr mit den Feinden des Darwinismus anzulegen. Man müsse die Persönlichkeit Haeckels, die Unerschrockenheit, Kompromißlosigkeit und Wahrheitsliebe dieses großen Menschen viel stärker bekanntmachen, bedeutet Walter Ulbricht den Mitarbeitern des Museums. Die Haltung und Weltanschauung Haeckels könnten den sozialistischen Studenten als Vorbild dienen.

Antikommunismus von damals

Neben vielen begeisterten Briefen, in denen Wissenschaftler, Studenten und einfache Menschen Haeckel ihre Sympathie und Zustimmung versichern, gibt es in der „Villa Medusa" auch Dokumente des Hexenwahns, der inquisitorischen Gehässigkeit und der gleichen klerikalen Geistesenge, die heute in Adenauers Staatswesen wieder Triumphe feiert. Jesuitische Pamphlete, Drohbriefe und Schimpfereien wie „Affenprofessor" und „Generalagent des Satans" bekunden nur zu deutlich, wie sehr sich politischer Klerikalismus und geistige Freiheit ausschließen. Walter Ulbricht kommentiert dieses Papier: „Das war der Antikommunismus von damals!"

An der Wand hängt eine Weltkarte, auf der die vielseitigen internationalen Verbindungen des Haeckel-Museums aufgezeichnet sind. Dr. Uschmann berichtet von der ganzen Zusammenarbeit mit Wissenschaftlern, Bibliotheken und Archiven in aller Welt. Walter Ulbricht stellt eine Zwischenfrage: „Und wie ist die Zusammenarbeit mit den westdeutschen Biologen?"

Da erfährt man, daß sich nur in Hamburg ein kleines Zentrum mit Fragen der Geschichte der Biologie befaßt. Das Erbe Haeckels wird im anderen deutschen Staat weitgehend vertuscht, verheimlicht oder verfälscht. Viele westdeutsche Biologen, die natürlich auch auf dem Boden des Darwinismus stehen, scheuen sich, die weltanschaulichen Konsequenzen ihrer Erkenntnisse offen zu behandeln. Andere bemühen sich, die philosophischen Unterwanderungsversuche der Jesuiten abzuwehren. Biologielehrer, die sich zum Materialismus bekennen, werden bedrängt und verfolgt. Walter Ulbricht schlußfolgert, daß die darwinistischen Naturforscher der DDR ihren westdeutschen Kollegen mehr als bisher helfen sollten.

Nach dem Rundgang durch das Museum setzt man sich zu einer zwanglosen Aus-

sprache zusammen. Es entwickelt sich ein wissenschaftliches Kolloquium über die Bedeutung Ernst Haeckels in unserer Zeit. Walter Ulbricht erzählt aus jenen Jahren, da er in die sozialistische Bewegung eintrat.

Haeckel und die Arbeiter

Damals, so berichtet er, hätten die jungen Genossen im gesellschaftswissenschaftlichen Zirkel das „Kommunistische Manifest" und „Zur Kritik der politischen Ökonomie" sowie im naturwissenschaftlichen Zirkel Haeckels „Welträtsel" studiert. Haeckel habe seinerzeit den Sozialisten den Weg zum Verständnis des Darwinismus und der Naturforschung überhaupt eröffnet. Heute würden anscheinend viele Genossen glauben, sie kämen mit gesellschaftswissenschaftlichen Kenntnissen aus. Die Naturwissenschaft werde oft noch unterschätzt. Und gerade der Darwinismus als Band unserer Naturforschung und unserer Weltanschauung müsse wieder viel stärker und breiter popularisiert werden.

Walter Ulbricht lobt die Forschungstätigkeit der Mitarbeiter des Haeckel-Museums. Es sei sehr wichtig und verdienstvoll, alle Zeugnisse von Haeckels Wirken zu sammeln und zu bewahren. Es habe seinen Grund, daß Ernst Haeckel heute nicht mehr so stark und massenwirksam an die Studenten und werktätigen Menschen herangetragen werde wie zu Beginn unseres Jahrhunderts. Weil heute die Entwicklung natürlich weiter sei als zu Haeckels Zeiten und weil Haeckel in bezug auf die Entwicklung der Gesellschaft irrige Vorstellungen hatte, habe man ihn einfach „in die Ecke gestellt". „Wenn wir in der DDR aber nicht genügend an die guten Traditionen der deutschen Naturforschung anknüpfen, dann überlassen wir reaktionären Mißdeutungen Einfluß. Deshalb ist die Bedeutung des Haeckelschen Erbes gar nicht zu überschätzen."

Hinweis für die Lehrer

Als Dr. Uschmann mitteilt, daß zahlreiche Schulklassen und Delegationen Tag für Tag das Haeckel-Museum besuchen, lüftet Walter Ulbricht das Geheimnis seiner Aussprache mit den Pionieren: Er habe die Jenenser Schüler vor dem Haus gefragt, ob sie schon einmal im Haeckel-Museum gewesen seien, und da hätten sie mit Nein geantwortet. Aus der Heiterkeit, die diese Enthüllung hervorruft, entwickelt sich eine Diskussion über den Biologieunterricht an unseren Zehnklassenschulen. Walter Ulbricht gibt zu bedenken, ob es richtig ist, die Abstammungslehre erst im letzten Schuljahr zu behandeln. Die Jugend habe heute doch schon viel früher weltanschauliche Interessen und könne einiges aus Haeckels Kampf um die wissenschaftliche Wahrheit schon mit 14 Jahren verstehen.

Professor Hager schlägt vor, daß sich die Lehrerweiterbildung einmal der Persönlichkeit und dem Schaffen Haeckels zuwenden soll. Insbesondere die neugegründete Biologische Gesellschaft in der DDR könne viel dazu beitragen, die modernen Erkenntnisse der Entwicklungslehre und ihre philosophischen Konsequenzen an die Lehrer und die Jugend heranzutragen. Der Präsident der Biologischen Gesellschaft, Prof. Dr. Schwarz, berichtet, daß die Gesellschaft bereits die ersten Schritte auf diesem Weg getan hat.

Schließlich präzisiert Walter Ulbricht die wichtigsten Aufgaben:

„Erstens sollte man einen Spielfilm über Leben und Werk Ernst Haeckels drehen. Solch ein Film über das dramatische Leben unseres größten Naturforscher ist längst fällig. Ich bin sicher, daß die Mitarbeiter des Haeckel-Hauses bei der Ausarbeitung eines Drehbuches beratend mithelfen werden. (Dr. Uschmann sichert Unterstützung zu.)

Zweitens ist es ein Fehler, daß wir bisher immer noch nicht die ‚Welträtsel' neu aufgelegt haben. Es müßte doch nicht zu schwer sein, ein würdigendes Vorwort und ein Nachwort zu schreiben, in dem die neueren Einsichten, die über Haeckel hinausgehen, vermerkt sind. (Professor Hager: ‚Das ist eine Aufgabe für unsere Philosophen.')

Von Haeckel bis Oparin

Und drittens brauchen wir unbedingt ein populärwissenschaftliches Buch über die moderne Entwicklungslehre. Darin müßte gezeigt werden, wie die neuen Erkenntnisse den Darwinismus und Haeckels materialistische Auffassungen bestätigen, ein Buch über den Darwinismus etwa unter dem Titel ‚Von Haeckel bis Oparin'."

Das sei, so betont der Vorsitzende des Staatsrates, die DDR dem Manne schuldig, der einen Umschwung im naturwissenschaftlichen Denken Deutschlands herbeigeführt und entscheidend dazu beigetragen habe, daß die Abstammungslehre heute Allgemeingut der Menschheit geworden ist. Walter Ulbricht empfiehlt den anwesenden Wissenschaftlern, Eigeninitiative zu entwickeln und nicht darauf zu warten, daß der Staatsrat etwas beschließt. Und lachend fügt er hinzu: „Sie sollten die Initiative ergreifen, selbst wenn Sie dabei Fehler machen. Große wissenschaftliche Leistungen verlangen schöpferisches Denken."

Das Kolloquium in der „Villa Medusa" hat ein Ende. Dr. Uschmann dankt noch einmal den Gästen für ihren Besuch und für die vielen Ratschläge. Auf Wunsch der Mitarbeiter des Ernst-Haeckel-Hauses trägt sich Walter Ulbricht ins Gästebuch ein. Er schreibt folgende Zeilen: „Ich danke den Mitarbeitern des Instituts für ihre bedeutende Arbeit zur Popularisierung der wissenschaftlichen Leistung Ernst Haeckels. Wir wünschen, daß die noch breitere Popularisierung der Entwicklungslehre erfolgt."

Ein Pionier der wissenschaftlichen Wahrheit

Auszug aus der Rede Walter Ulbrichts auf dem Festakt zum 15. Jahrestag der Neueröffnung der Friedrich-Schiller-Universität in Jena

it into an institute for history of science. The dominant accounts of the forgery charges toed Haeckel's own line.[78] Though Uschmann adopted a more critical approach—an encyclopedia article presented the schematization as "hardly justifiable from the specialist point of view"—his "biography in letters," successful in both Germanies, relied on the subject's own words and pictures, and omitted the accusations.[79]

GDR authors complained that while the Workers' and Peasants' State developed the pugnacious materialist's true legacy, in the Federal Republic (FRG, or West Germany) "political clericalism" contaminated biology with "idealist speculations."[80] Elementary and middle schools taught a religiously inflected respect for life.[81] Encyclopedia entries were mixed, but books on Haeckel supported him. At the University of Göttingen former *SS-Hauptsturmführer* Heberer continued Astel's rehabilitation project, complaining in much the same words that the forgery "is today still often the only thing that the average 'educated' person knows about Haeckel,"[82] and that the stupid and arrogant were still printing garbled versions of the charges.[83] Christian groups invoked Heberer's Göttingen colleague Erich Blechschmidt, who as a human embryologist, aficionado of Wilhelm His, antiabortionist, and antievolutionist attacked Haeckel on all fronts.[84]

From the late 1970s, historians of medicine and biology studied Haeckel in a research program on biologism that engaged with the hegemonic claims of the life sciences, including eugenics, in and since the nineteenth century. A dissertation by the dentistry student Reinhard Gursch unearthed rich printed evidence to conclude that Haeckel's pictures had weak points, he was provocative but no forger, and his opponents were less interested in the facts than in discrediting him.[85] This fed into a short, informative biography by Uschmann's student Erika Krauße, curator at the Haeckel House, but the issue was not a hot topic on reunification in 1989.[86] In the English-speaking world it was almost unknown.

World Champion?

Back in 1894 British magazines were amazed that Haeckel was only sixty, when "the comparisons of vertebrate embryos, the natural history of creation, and the blundering incapacity of those who doubted it, were no small part of the intellectual pabulum of our scientific youth." He had become "less of a moving force"[87]—until the *Riddle* moved even American journalists to trek to quaint old Jena to interview "Germany's greatest naturalist" and render his every action news (fig. 15.7).[88] *The Evolution of Man* had referred to "a charge of 'falsifying science,'"[89] but usable accounts of the accusations barely crossed the North Sea, let alone the Atlantic. A few biologists criticized Haeckel,[90] and sizeable communities read German, but the key documents went untranslated, *Popular Science Monthly* did not cover the story, and British and American critics rarely picked it up.[91] Encyclopedias warned darkly of "the dangers of artistic and speculative imagination."[92] What difference would the Brass affair make as the news reached interested readers not just in continental Europe,[93] but also in the British Empire from England and Ireland to India and Australasia,[94] and especially in the United States?

From the largest American city and financial hub, publishing capital and epicenter of evolutionism, the *New York Times* engaged in detail in early 1909. Lowering the cover price within reach of the aspirant and advertising decency—"All the News That's Fit to Print"—was creating "the world's most influential newspaper."[95] Readers knew of Haeckel as a scientific celebrity, and had been warned that "a large number" of his illustrations "at first sight seem to base his theories on the widest form of induction, but more carefully examined, a good many of these are rather diagram[m]atic than photographic."[96] Though scientists still often favored drawings or even diagrams, the

Fig. 15.6 Report of Walter Ulbricht's visit to the Ernst Haeckel House in 1960 in *Neues Deutschland* (New Germany), the organ of the Central Committee of the Socialist Unity Party. "Young pioneers bombarded him with flowers, congratulations, and questions," and the chairman of the State Council then entered Villa Medusa as the first German head of state to pay Haeckel, the "fanatic of the truth slandered by reactionary obscurantists," the respect owed him by the German people. Ulbricht celebrated Haeckel as a "pioneer of a new scientific truth" and for bringing science to the workers. His achievements mattered, not the "unscientific and reactionary social Darwinist attitudes" exploited by the bourgeoisie. Ulbricht specified such tasks as making a film about Haeckel and reprinting the *Welträtsel* and expressed sympathy for West German biologists prevented from following his work to its materialist conclusions. The photograph shows "Ulbricht and his wife in conversation with Jena students in front of the Ernst Haeckel Museum." *Neues Deutschland*, 25 Oct. 1960, 3.

A German Professor 153

there the individual is developed, he has great powers and responsibilities—the man is the unit. Who shall say how these great influences will work out?"

Speaking at another time **of** the beautiful and

Professor Haeckel lecturing in his Class Room

accurate pictures of animals and plants now obtainable where thirty years ago there were almost none, Professor Haeckel mentioned this as an instance of one of the lesser and yet important influences of modern life. Pictures convey ideas swiftly and accu-

Fig. 15.7 "Professor Haeckel lecturing in his Class Room," in the Zoological Institute, with charts on the wall behind, while (all male?) students listen and make notes. Ray Stannard Baker, an investigative journalist with *McClure's Magazine*, presented the best known "of all the distinguished company of German professors" as a fascinating and engaging companion whose achievements were made possible by a frugal, disciplined work regime. Haeckel highlighted the ready availability of beautiful and accurate pictures of organisms as "a new and powerful factor in education." Halftone of drawing by George Varian from R. Baker 1901, 153, by permission of the Syndics of Cambridge University Library.

Fig. 15.8 "Exterior Evidences of Kinship: Two 'Primates'": the "Roman Catholic Primate of All Ireland" and "The Bald-Headed Chimpanzee (Order Primates)." Halftone from Joseph McCabe, "Haeckel's Embryo-Drawings," in Haeckel 1911a, following 40. Courtesy Lilly Library, Indiana University, Bloomington, Indiana.

photograph was now the gold standard of evidence. The paper mentioned forgery, however, only when the "confession" was wired and wirelessed around the world.

"Prof. Ernst Haeckel Accused of Faking; Scientist Charged with Filching Photographs and Manipulating Them" ran the headline on an initial short item. The first allegation against "the eminent Darwinian scholar" was "plagiarism" of "a set of photographs of embryonic monkey life from the work of a foreign zoologist." This presumably interpreted criticism of inadequate labeling, hardly the main issue in Germany. Second, Haeckel was said to have "manipulat[ed] them, on the lines made familiar by the 'art departments' of the American yellow press, into pictures which would prove certain contentions of his own." The *Times* here invoked the fear that photographs could lie and specifically its own competition with the *New York World*.

"He Makes a Spirited Denial, but the German Press Demands a Rigid Investigation" to clear "the fair name of German science." A month later the Sunday magazine ran a more accurate long article on "'Man-Apes' the Subject of a War of Science," with translations from Haeckel and Brass, described as motivated by "conservative religious views" but nevertheless "a man of considerable repute."[97]

Yet the *Times* set no editorial line, and neither adjudicated nor followed up,[98] but let journalists develop the story as and when it linked to other news. Announcing Haeckel's retirement, the paper denied a connection and stressed the esteem in which he was held. One review even called him a "pedant" and "stickler for exact knowledge" within his own field.[99] But in November 1910, "Accused of Fraud, Haeckel Leaves the Church," his "lame and unsatisfactory" explanations having "injured irreparably his scientific standing."

EXTERIOR EVIDENCES OF KINSHIP.

ROMAN CATHOLIC PRIMATE OF ALL IRELAND.

Cardinal Logue, Archbishop of Armagh and chief dignitary of the Catholic Church in Ireland, posed for this photograph for the *North American* at the archiepiscopal residence yesterday.—*Philadelphia North American*, May 29, 1908.

TWO "PRIMATES."

THE BALD-HEADED CHIMPANZEE (Order Primates).

Anthropithecus calvus, described by Frank Beddard in 1897 as *Troglodytes calvus*, differs considerably from the ordinary *A. Niger* in the structure of the head, the coloring, and the absence of hair in parts.—*Haeckel's "Evolution of Man."*

"In spite of his life-long devotion to unselfish scientific pursuits," this "anti-Christ to a large number of devout believers" is "commonly represented by priests and ministers alike as the typical nature faker relying on forgeries to harm the Christian religion." "Nature faker" was the term popularized by president Theodore Roosevelt to belittle inventive, anthropomorphic, and sentimental natural history writing for the public. The *Times* distanced itself, however, by quoting the Darwinist Kellogg acknowledging charges against Haeckel's illustrations, but recommending that criticizing his philosophy would be "more to the point than the picking of flaws in the details of … embryologic description."[100]

Alongside the general press, international networks of Christians and freethinkers translated religious criticism, chiefly Wasmann's, and monist adulation. The *Catholic World* reviled Haeckel as "led astray by a fanatical hatred of Christianity" and explained that "you may crush error in Germany and it will continue to live and flourish in America and England. For that is where bad German science goes when it dies!"[101] Father Joseph Assmuth, who had been studying in Berlin and in contact with Wasmann during the Brass

affair,[102] directed Jesuits disputing the Rationalist Press Association in Bombay (now Mumbai). His book consolidated an anglophone tradition of exploiting the "frauds and forgeries" which continued in the anti-evolutionist movement that emerged with American Protestant fundamentalism in the 1920s.[103]

On the other side, the distinguished literary *North American Review* described a "colossus," a "silver-haired, blue-eyed Luther of Science" who had "realized immortality while still living." Top American research scientists typically took a more conciliatory approach to Christianity, but the freethinking "Truth Seeker Company" offered an abridged translation of *Sandalion* and added a provocative comparison (fig. 15.8). They put the "forgers … in the churches" and derided the "mess of malignant mendacity."[104] Edwin E. Slosson, the New York journalist (and leading science popularizer of the 1920s), warned against missing "the marvelous constructive genius of the man." "The mind of Haeckel has such high tension that it leaps over the gaps in a demonstration like a ten thousand volt current."[105] He was a hero to many, especially on the secular left.

Yet the anglophone press never forgave Haeckel's signature on the declaration justifying the German

military campaign against Belgium. Jules Duesberg, professor of anatomy in Liège and an associate of the Carnegie Department of Embryology, wrote to the *New York Times* to remind readers about the forgery.[106] When Haeckel died the *Times* of London introduced him as "familiar to the unlettered as a popular expounder of the theory of evolution in its crudest form, … notorious as a venomous protagonist of the German case," and a "clever" though unreliable artist.[107] But the *Riddle* kept selling, Watts reissued *The Evolution of Man* in 1923, and in the United States a clutch of cheap, progressive *Little Blue Books* found the author a new generation of readers.[108] Highbrows dismissed his philosophy as an embarrassment in part because "the unlettered" took him seriously still.[109] His science was harder to assess.

Having moved beyond Haeckel's recapitulationism, the dwindling band of comparative morphologists were losing out to experimental approaches, in embryology and elsewhere.[110] His stock fell further after World War II and the establishment of a "modern evolutionary synthesis" to replace his, by implication, old-fashioned one. Marginalized in evolutionism, past embryology was now dominantly seen through an experimentalist lens, and Haeckel as representing the speculative phylogenizing against which his students had had to revolt.[111] The house historian of developmental mechanics offered a psychopathologizing portrait of an evil genius who corrupted the science of the sainted von Baer,[112] and recapitulation was ritually slain again and again.[113] Even evolutionists presented Haeckel, one of the few characters routinely criticized in biology textbooks, as at best overzealous.[114] He appeared as careless and "somewhat unscrupulous,"[115] had "habitually perverted scientific truth," and had seen things in microscopic organisms "less visible to eyes devoid of that fire that burned within his own."[116]

To make matters worse, the 1971 book of Gasman's Chicago PhD updated the politically negative Anglo-American view common since 1914, and reinforced during World War II, by identifying Haeckel as the scientific progenitor of National Socialism. Haeckel had promoted biological racism, eugenics, and euthanasia and moved to the right; his Romantic modernism looked to have an affinity for Nazi ideas, which included elements of Darwinism; and some of his followers were Nazis. Gasman's argument thus cor-

rected uncritical accounts, but Haeckel today seems an unlikely "proto-Nazi," and his "Darwinist movement" not to be "fully understood as a prelude to the doctrine of National Socialism," not least because of the diversity reviewed here.[117] Curiously however, Uschmann, writing for the *Dictionary of Scientific Biography*, found space to mention the forgery accusations, neutralized by quoting the forty-six,[118] while Gasman left them out. Perhaps it was awkward that so many of the accusers were on the right. Or maybe the charges now accumulated against modern biology's most criticized historical figure were so serious that fraud—or was it really only "a certain carelessness"?[119]—seemed a lesser crime.

The Man and the Pictures

Memories of old Haeckels might fade, but new ones circulated through the twentieth century as events reshaped his reputation in each country and social group. In the German states the figurehead of evolutionism attracted greater religious opposition, which ensured more knowledge of the fraud allegations, but he was also more admired, and—in East Germany—from the very top. At the same time his American reputation declined. A poet might make a refreshing change from the technocrats and careerists, but the stain of Nazism would be hard to wash out of a Romantic German eugenicist. Americans defined experimental biology, modern evolutionism, sound politics, and moral conduct against him.

So Haeckel is one of the last scientists we might expect to have drawn standard textbook illustrations for the twentieth-century United States, even if "bad German science" did go there "when it died." Yet most of the English-speaking world knew only of his "artistic license"; the accessible biographical allusions to schematizing were too vague or coded to implicate particular pictures. The story of the ape-human embryo did not necessarily taint his most extensively reproduced figures, which were often not credited to him. So plates that in 1900 no competent scientist had defended for decades still had most of their career before them. Some of the most criticized scientific images were about to become some of the most widely seen.

The Textbook Illustration

From *Tennessee v. Scopes* over human descent to *Kitzmiller v. Dover* over intelligent design, from the trial of 1925 to the trial of 2005, textbooks have been at the heart of America's public battles over evolution. Some of the most storied intersections of science, the media, and the law concern the transmission of biology to schoolchildren.[1] But declare that in a tale of embryos, images, Darwinism, and fraud the most fascinating twist is how illustrations were copied in high-school and college texts, and people are liable to look at you with pity or disbelief. In the twentieth-century United States, textbooks became the main vehicles for science communication on an unprecedented scale. A multimillion-dollar business was regulated by governments and targeted by lobbying and reform campaigns as it played major roles in shaping knowledge. Yet textbooks suffer from the low status of teaching, and a poor press within it, and these negative stereotypes block inquiry.[2]

If anything is reckoned worth finding out, it is how rapidly texts contributed to the making of knowledge by recognizing discoveries, theories, and approaches,[3] or more rarely, pictures.[4] But a hundred-year-old diagram on the same page as the latest color photograph may present the bigger and more significant challenge. Everyone knows that rather than go back to the sources, busy authors tend to copy each other (or themselves), thus preserving outdated content and reproducing errors.[5] Having shown the insidious effects of copying icons of evolutionary progress, Stephen Jay Gould assumed that Haeckel's embryos were taken into "nineteenth-century textbooks" to survive by "mindless recycling" through the twentieth.[6] But "recycling" only describes what needs to be explained, while "mindless" merely invokes the sense of action by default. A proper explanation should reconstruct the general conditions for "content clon-

ing" within the industry and the field, and the specific factors which favored an image that was in some places intensely contested and everywhere threatened by major change.[7]

Because direct evidence is seldom available, these factors can be hard to reconstruct, but as for the earlier copying into evolutionary works, a survey by level and country will reveal patterns to explain.[8] American, but not German or British, schoolbooks introduced the Haeckel-Romanes grids as early as 1900. Elementary college texts followed soon, but more advanced courses several decades later. The contrasting trajectories—staying in Tennessee schools after Scopes, but entering embryology thirty years ago—point to passive constraints and active decisions. These will make sense in terms of the pressures on textbook publishers, including of antievolutionism and curriculum reform, authors' likely knowledge of and stances toward the forgery charges, disciplinary agendas, and, not least, the placing of the figures in chapters and on the page.

Starting School

In the early 1900s evolution books fairly often reproduced embryo grids. Haeckel's accompanied Darwinism into American schools, enriching zoology courses and gaining from the synthetic work that made biology a unified, principles-based science of life.[9] In Germany and Britain, by contrast, either authors, publishers, and government curriculum-setters did not consider evolving embryos suitable for young people, or criticism inhibited their inclusion.

The German campaign to upgrade biology teaching distanced the subject from Haeckel, who was blamed for the ban from the upper classes. Stressing the observational foundation and hostility to speculation, reformers achieved partial acceptance in 1908 and more recognition, though in practice still patchy, in 1925.[10] Frog development was already a staple illustration (fig. 11.1), and advanced pupils might learn about recapitulation,[11] but textbooks would hardly flaunt Haeckel's most notorious images. Critical pedagogues rather argued that pupils should start from available things, that pictures were overused, and that simpler drawings were better.[12]

Otto Schmeil's bestselling zoology texts had long integrated the ecological perspective into a traditional systematic organization. This imparted a good deal about evolution, but was unconducive to general discussion. In 1931, a less successful *Allgemeine Biologie* (General biology) safely illustrated recapitulation with eel development and the migration of the halibut eye.[13] In 1909, the second edition of the first postban biology text, by the Hamburg museum director Karl Kraepelin, a former teacher and one of the forty-six, added an unillustrated discussion of evolution, replete with the resemblance of mammalian and other vertebrate embryos, gill clefts, and vasculature as evidence for the biogenetic law. The third edition pictured these, but not after Haeckel.[14]

The Nazis met biologists' long-standing demand for two hours per week in each school year.[15] The greater emphasis on evolution was mainly in relation to genetics, anthropology, and racial hygiene, but included the embryological evidence, not least in the form of Richard Hesse's grid (fig. 12.7).[16] Haeckel's own turned up in a German schoolbook in 1951, when a posthumous edition of Schmeil's general biology borrowed an uncredited figure from an introductory course on evolution based on lectures Gerhard Heberer had given at the University of Jena.[17] The embryos had not come in earlier because, even when educators combined embryology and evolution, they saw these as off-limits.

In Britain the grids were less controversial, but evolution was similarly little taught, and then to the few. Leading the campaign for school science, in the 1870s T. H. Huxley had invented the influential "type system" of "elementary biology." Pupils began not with classification, but by working though some dozen "types," that is, representatives of the major plant and animal groups. Huxley left his Darwinism at the classroom door, and biology failed to compete effectively with botany and a bowdlerized physiology. As late as 1918 "elementary" zoology was almost exclusively for intending medics in boys' secondary schools.[18] The systematic textbooks increasingly opened or closed with short general sections that might introduce evolution, and even recapitulation, but usually did without illustrations.[19]

A unified biology was disadvantaged by the lack of a university model, by the weight accorded skills such as measurement, which physics and chemistry seemed more suited to teach, by discomfort about dissection and reproduction, and by the dearth of nonmedical

Fig. 16.1 Photomechanically reproduced illustrations in David Starr Jordan and Vernon Kellogg's *Animal Life*. *A*, Mary H. Wellman or James Carter Beard redrew several columns from the Romanes diagrams, with a wash shading that adapts them to the visual environment; *B*, photograph of pupation, as if capturing a moment in the life cycle; *C*, drawing by Beard of altricial nestlings, that is, young needing much parental nourishment and care. From D. Jordan and Kellogg 1901 (first published in 1900), 87, 94, 138, by permission of the Syndics of Cambridge University Library.

careers. Only in the 1930s did experimentalists begin to establish biology for all. Books for the school-certificate exam at age sixteen added principles to types, but most omitted evolution.[20] Advanced texts sometimes discussed the embryological evidence, but rarely with a picture; alternatives included a branching diagram and a chick, rabbit, and human trio.[21] It took the socialist sex educator Cyril Bibby, who made a career of promoting challenging topics, to put Haeckel's embryos in a schoolbook in 1942.[22]

American schools taught more evolution, though textbooks of zoology and of type-based biology ranged widely in the amount.[23] University professors wrote advanced texts for the few fourteen- to seventeen-year-olds who planned to go to college. In 1900 Haeckel's drawings debuted in *Animal Life* from Appleton, an important educational publisher. Embracing ecology and bringing "the principles of evolution … into relation with the facts of biology,"[24] Stanford ichthyologist (and founding president) David Starr Jordan and his entomologist colleague Vernon Kellogg provided less "a *basis* for an elementary course" and more "the best … supplementary reading."[25] Five columns redrawn from Romanes—with the focus on nonhuman animals, the rabbit stood for mammals—illustrated a section on divergent development as evidence for evolution (fig. 16.1A).

How could leading American biologists familiar with the German literature—Kellogg had studied with Leuckart—choose figures no German professor touched and the embryologist Minot had dismissed out of hand? Staunch Darwinists, Jordan and Kellogg rejected Haeckel's monism but embraced his (and Agassiz's) recapitulationism, which enjoyed strong support in the United States.[26] By 1910 Kellogg knew that Haeckel's "illustrations are accused of inaccuracies favorable to his argument," but objected to nit-picking.[27] When the book came out, improved grids were not yet available and the Brass affair was still several years off; Romanes had validated these plates.

As high-school attendance expanded after 1900, an alliance of teachers and publishers in New York

produced a unified biology to teach upwardly mobile immigrants to seize opportunities in industrial cities. Though "evolutionary to the core," and oriented toward human beings, this progressivist replacement for courses in botany, zoology, and physiology emphasized not "the history of life but … its present and future." The authors were as committed to Darwinism as sex education, but found both tricky in class, especially when the antievolution movement gained ground. They typically handled evolution obliquely, giving natural selection and eugenics more attention, often in a final chapter, than human descent.[28]

Several new textbooks excluded evolution; others, such as the dominant American Book Company's mar-

ket-leading *Civic Biology* by George W. Hunter, left out the embryological evidence,[29] but a few offered grids.[30] The most influential was Benjamin Gruenberg's *Elementary Biology* for Ginn & Co. of Boston. An ardent evolutionist and socialist with a genetics PhD from Columbia, Gruenberg had six chapters on "heredity and evolution" and indirectly promoted "the idea of progressive change in the organic world" throughout. The chapter on development used a full-page grid (fig. 16.2); the evolution chapter referred back.[31]

As the pressure to illustrate increased and the cost went down, Haeckel's drawings visualized a striking, still little-known fact and at the same time qualified as the "standard illustrations" that experienced edu-

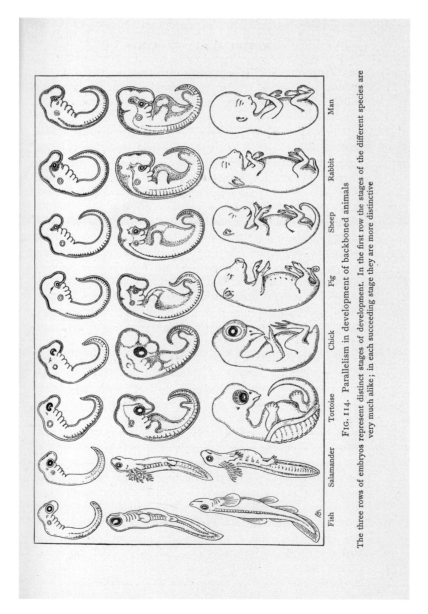

FIG. 114. Parallelism in development of backboned animals

The three rows of embryos represent distinct stages of development. In the first row the stages of the different species are very much alike; in each succeeding stage they are more distinctive

Fig. 16.2 Embryo grid in Benjamin C. Gruenberg's *Elementary Biology*, a high-school text used in eight out of the fifty-nine American cities with populations over 100,000 that responded to a survey (ten did not); only a botanical text, two books by Hunter, and Peabody and Hunt's *Elementary Biology* were more popular (O. Richards 1923, 144). Line drawings by F. Schuyler Mathews, probably directly after Haeckel, with the cow relabeled a sheep, illustrate "von Baer's Law of Recapitulation." Gruenberg 1919, 277.

cators preferred.[32] The embryos did not participate in the most exciting visual innovation, the reproduction of photographs as halftones,[33] but those could come out muddy. Shaded drawings looked almost equally photographic (fig. 16.1), and diagrammatic outlines reduced expectations of accuracy (fig. 16.2). At a time when publishers seldom prepared figures in-house, reuse was straightforward: some redrew, some received permission free; others may have done without.

So high-school texts in the United States adopted Haeckel's figures earlier and on a larger scale than their British and German counterparts, and the isolation of national school systems kept the books distinct. Evolution had a higher profile in the more open American system, and the forgery charges, less known, were less attached to pictures which, remarkably, would survive.

Bowdlerized

In early twentieth-century America, evolutionism was the common sense of biology and looked set for accommodation with Protestantism. Like *Deathbed Dennert*, most anti-Darwinists accepted the earth's antiquity and much organic development, while prominent Darwinists kept a role for divine intervention in human origins. Aggressive public debate alarmed conservatives, but many religious colleges taught theistic evolution. The situation polarized after 1920 with the rise of Protestant fundamentalism and the universalization of high-school education. Progressivist, urban, northern values now clashed with those of the rural South, and Darwinism was already blamed for German aggression in World War I. Fundamentalists launched a campaign against evolution and recruited the Presbyterian, thrice Democratic presidential candidate, former secretary of state, and antiwar campaigner William Jennings Bryan.[34]

Bryan made the usual point against *The Descent of Man*: "Probably nothing impresses Darwin more than the fact that at an early stage the foetus of a child cannot be distinguished from the foetus of an ape, but why should such a similarity in the beginning impress him more than the difference at birth and the immeasurable gulf between the two at forty? If science cannot detect a difference, *known to exist*,… it should not ask us to substitute the inferences, the presumptions, and the probabilities of science for the word of God."[35]

Queen Silver, a twelve-year-old socialist from California—she inspired Cecil B. DeMille's film *The Godless Girl*—countered with a much-reprinted lecture recommending Haeckel's *Evolution of Man* for the still "startling proof" that embryos look alike.[36]

Creationists used the charges to discredit this evidence. According to the preacher Harry Rimmer, whose "creation research" involved dissecting embryos in a shed,

> Almost every text-book of biology that deals with … embryology has a page of pictures with the various embryos in parallel columns, showing their striking similarity! … And in the pictures [they] do so closely resemble each other that the name at the top is essential to differentiation. *But in the picture only*: in life, the student or the scientist would not be confused…. For these pictures are all "schematized!" That is a wonderful word, coined by the chief priest and foremost prophet of the organic evolution cult, even the eminent Haeckel himself. After he was accused of falsifying the delineation of certain embryos he stated that he had "schematized" them to conform to his argument … and they have been "schematized" ever since! But an honest photograph, or the physical embryo itself, tells a far different story!

Yet Rimmer did not depend on this critique. He relied, like Bryan, on a "method by which any embryo may be classified according to its true species" even by "a child of six years of age. That method is *let it alone!* … The *embryo* … will always develop into just exactly what its parents and its ancestors always were!"[37]

Grievances over compulsory teaching and its content combined with fundamentalist agitation to push several states to enact antievolutionist laws, in part to smooth the passage of legislation expanding public education. In March 1925 Tennessee made it a crime to teach in the public schools "any theory that denies the story of the Divine Creation of man as taught in the Bible, and to teach instead that man has descended from a lower order of animals." The American Civil Liberties Union offered to defend any teacher prosecuted, and the trial of John Scopes has gone down as a Manichaean struggle between creationism and evolutionism, traditionalism and progress, religion and science.[38] A publicity stunt brought it to Dayton,

and a huge media circus kept it on the front pages for months. Scopes was found guilty, with the state-prescribed textbook, Hunter's *Civic Biology*, read as containing passages contrary to the act—even though it did not explicitly claim human descent from beasts.[39] But the long-planned appeal overturned the verdict on a technicality rather than allow the ACLU to pursue a more general challenge. Antievolutionist laws stayed on the books.

Historian Adam Shapiro has recently placed the trial in the political economy of textbook publishing. Several southern and western states had by this time introduced statewide adoption to combat publishers' price-fixing and their sales agents' corruption—not initially to control content. Tennessee still used *Civic Biology* in May 1925, when Scopes was indicted, only because the governor had delayed the next adoption

decision to save money. More recent books had already developed a strategy of accommodation and camouflage that might have avoided a trial.[40]

Tipped off by correspondence with Bryan himself, Ginn's chief editor had Gruenberg's new book pioneer evolutionism by stealth. *Biology and Human Life* presented the paleontological, comparative anatomical, and embryological evidence, explained natural selection, and discussed eugenics, but rigorously excluded the word *evolution*. The chapter "The Human Organism and Keeping It Fit" redeployed the grid with other evidence of homology, but cut the human column. The text still had the embryos start "very much alike" and then develop to "differ from each other more and more," but surrendered the conclusion about common ancestors. Gruenberg had not changed his mind— he would have agreed to testify in Dayton had Ginn

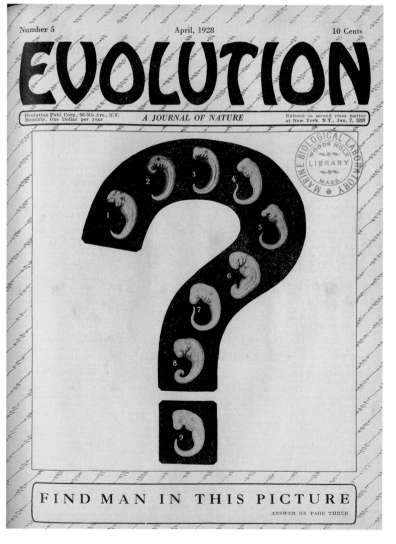

Fig. 16.3 Haeckel's embryos as a question mark on the front cover of a magazine founded to promote evolution teaching in the wake of the Scopes trial (Cain 2003). Since all these mammals (unusually copied from Haeckel 1908 [here, fig. 9.19]), "are almost like peas in a pod," only sequence and separation from the others pointed to the answer, number 9. The same issue profiled Haeckel as evolution's "knight in shining armor" without addressing the forgery charges. *Evolution* 1, no. 5 (Apr. 1928). MBLWHOI Library, Woods Hole, MA.

Fig. 16.4 "Embryos, showing three stages of development of typical vertebrates," in *Biology for Beginners*, the leading high-school biology book in the United States. The American Museum of Natural History often supplied third-party figures, but the illustration on the facing page was taken by a museum photographer in 1922, probably from a display. Moon and Mann 1933, 450–51, fig. 207 courtesy of American Museum of Natural History Library.

not warned him that this would kill his book in the South—but he took his editors' canny advice.[41]

Humans had been omitted before (figs. 12.3 and 16.1), but here it is clearer why. Ginn was probably not responding to specific attacks on Haeckel's "fraudulent photographs of imaginary embryos."[42] Advocates of evolution seem not to have realized what a question mark hung over the figures (fig. 16.3). Ginn was playing safe and it worked: Tennessee adopted Gruenberg's among other new books in June 1925 and 1931.[43] Author and publisher had saved the pictures—by sacrificing the most important drawings.

Modernized

American high-school textbooks of the 1930s to 1950s may have lost the confident progressivism of the previous generation, but they still presented more evolution than Britons learned.[44] They made the embryo grids standard, if generally in bowdlerized versions.[45] Holt's *Biology for Beginners*, which was founded by the New York State teacher Truman Moon, taken over by several other authors, and renamed *Modern Biology* in 1947, led the market for decades. Between 1926 and 1933 the book removed the word *evolution* along with references to human descent, but introduced the nonhuman columns (fig. 16.4). It was safe to deduce "common ancestry" for other vertebrates, but Moon's "racial development through the ages" stopped before humans, and his "development of man" started after we appeared.[46] The most frankly evolutionist editions of the next most popular postwar text, Ella T. Smith's *Exploring Biology* for Harcourt, Brace, included a Haeckel figure without a mammal (fig. 16.5).[47]

450 RACIAL DEVELOPMENT THROUGH THE AGES

parently starting out on its ancestral plan. The breast of the young robin is spotted like a thrush, as students of ornithology would expect, because of its known relationship to thrushes.

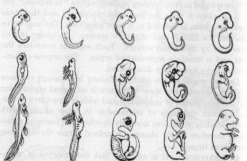

Courtesy of American Museum of Natural History

FIG. 206. — Embryos, showing three stages of development of typical vertebrates. Starting at left are shown fish, salamander, turtle, bird, and pig. Note the long tail and gill slits in the earliest stages, also other structural resemblances.

The presence of temporary teeth in the embryos of certain birds would imply descent from toothed ancestors. This can be checked from fossil evidence, as we know that the earliest true bird — the archaeopteryx — did possess teeth.

5. **Physiological Similarities.** Not only do the various classes of vertebrates resemble one another in structure, as the three preceding statements have portrayed, but in functions there is also marked similarity. For instance, internal secretions of mammals show a striking resemblance.

The digestive enzymes are so similar that many commercial products such as pepsin, extracted from cows, sheep, and pigs, are used in medicine. The tremendous use of insulin, thyroxin, adrenin, ductless products taken from animals for use in

ENVIRONMENT 451

human treatment, suggests relationship. The blood of the horse is successful material in immunity treatments for diseases like diphtheria, scarlet fever, pneumonia, etc. (see p. 629).

Courtesy of American Museum of Natural History

FIG. 207. — Song sparrows are affected by environmental conditions sufficient to produce different varieties. Note that those found along the coast are darker than those inland. Song sparrows in the dry southwest regions of the United States are particularly light colored. There are also observable differences in the size.

Two English scientists, Nuttall and Graham-Smith, have made extensive tests with blood to show the degrees of relationship between different animals. Many thousands of such experiments seem to point to a close relationship between all mammals. Blood tests of the reptiles indicate that lizards are related closely to snakes, and turtles to crocodiles. Birds are more nearly related to lizards and to snakes than to the other reptiles. Fossil evidence also corroborates this.

6. **Environment.** It is well known, from the writings of Darwin and many other investigators since his time, that

266 *Three stages in the development of the chick within the egg. (Left) Second day. (Center) Fifth day. (Right) Tenth day. (American Museum of Natural History)*

these four into eight, and so on until many millions of cells were produced. As these cells kept dividing, some cells became changed or differentiated into muscle cells, others into bone cells, others into blood cells, and so on. A baby chick grows from the fertilized egg by repeated cell divisions and by cell differentiation.

DEVELOPMENT OF A LANCELET

In the fertilized ovum of the lancelet (page 70) it is easy to see just how the embryo grows. First, the fertilized ovum

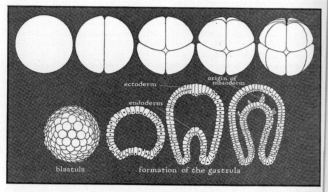

267 *Early stages in the development of the lancelet. The single cell (upper left) is the fertilized egg. All vertebrates pass through stages comparable to these.*

divides into two cells (Fig. 267). Each cell divides again, making four. These four cells cling together in a round cluster. The cells in the cluster continue to divide until they form a hollow ball of cells such as you may see in Fig. 267. The hollow inside the ball is filled with liquid, and the outside of the ball is one layer of cells. At this stage the lancelet embryo is called a *blastula* (blăs′tû lá).

Next, a strange thing happens to the blastula. It folds in on one side, much the way you might push in one side of a child's hollow rubber ball, until it forms a kind of cup instead of a ball. One side of the blastula folds inside the other as you see in Fig. 267. This cup-like stage of the embryo is called the *gastrula* (găs′trŏŏ lá). It reminds one of a jellyfish without its tentacles.

In a short time the gastrula elongates until it looks like a little worm. At first the wormlike stage is without rings or segments, but these features are soon added, so that the embryo now looks a little like a pygmy earthworm. From this point on it develops more and more of the normal lancelet structure. Thus the ovum grows into a young lancelet.

To summarize the stages briefly, we have: (1) the fertilized ovum which divides into 2 cells, then 4, 8, 16, 32, 64, etc., (2) blastula, (3) gastrula, (4) wormlike tube, (5) segmented stage, and (6) the lancelet.

VERTEBRATES

If these were the stages in the growth of the lancelet only, there would be no need to include them here, but these or similar stages occur in the growth of all vertebrates. Thus in the chick the early blastoderm stage corresponds to the blastula, and the three-layered stage corresponds to the gastrula. The chick then passes through these stages: a

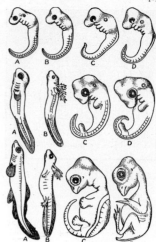

268 *Three stages in the development of the embryos of four vertebrates. A. Fish. B. Salamander. C. Tortoise. D. Chick. (American Museum of Natural History)*

wormlike tube, a segmented stage, and a fishlike stage with gill slits. In general the early stages of all vertebrate embryos are similar to those named, although there are differences whereby each may be recognized.

CELL DIVISION

IMPORTANCE OF CELL DIVISION

All many-celled organisms grow from fertilized ova by repeated cell divisions, and by cell differentiation. You yourself developed from a single cell in this way. Since cell division is the very basis

Fig. 16.5 Spread in Ella T. Smith's *Exploring Biology*, showing four embryo columns in the "Reproduction" chapter alongside photographs of chick eggs and diagrams of amphioxus development. The chick pictures date from before World War I and may originally have been French. E. Smith 1949, 404–5.

In the late 1950s, when 80 percent of fifteen-year-olds studied biology,[48] university biologists re-engaged with the curriculum, and the Sputnik crisis increased federal funding. Set up in 1958, the Biological Sciences Curriculum Study (BSCS) developed books to educate scientists and citizens who would support the science into which the government was sinking vast sums. Disagreement led to three different color-coded versions—molecular blue, ecological green, and yellow highlighting cells and processes of inquiry.[49] Franker coverage of human evolution, reproduction, and sexuality was an unevenly realized goal (fig. 16.6), but all

BSCS books offered embryo grids that put humans back in.

The blue and the green adapted the chart from the American Museum of Natural History (fig. 12.9), but beyond the injunction to study it "very carefully," the figure played no great role in the blue-book chapter on development, and in the green one it merely represented Darwin's interest in embryos.[50] The yellow version stands out for placing recapitulation in nineteenth-century science and critiquing "a classic series of drawings … in which the resemblances of the embryos of fish and man were remarkable. They were so

UNIT FOUR

Multicellular
Organisms:
New Individuals

Life seems to have evolved over many millions of years from a relatively simple condition to higher and higher levels of complexity. This evolution towards complex organization was due, to a major extent, to a distinctive characteristic of living things: reproduction. A specie's capacity to reproduce helps to assure its survival. The reproduction of single cells is a comparatively minor process when compared to the problems associated with the reproduction of multicellular organisms. The study of this reproductive process and the related area of development are among the most fundamental problems in biology.

261

A 40-day old human embryo embedded in maternal tissue. Mammalian adaptations for keeping and nourishing the embryo within the body of the mother insure the protection of the developing young.

Fig. 16.6 Unit opener in the BSCS blue book featuring a photograph of a forty-day human embryo by Chester F. Reather of the Carnegie Department of Embryology. BSCS 1963a, 260–61.

remarkable, in fact, that further investigation showed that overzealous artistry had indicated a few resemblances that did not quite exist!" There were similarities, but only "a certain amount of recapitulation." The field test included the American Museum figure, but perhaps in response to criticism the definitive grid substituted four new columns (fig. 16.7).[51]

Initially controversial, the BSCS books sold well through commercial publishers—who shifted over two million of the yellow version by the third edition[52]—but an evolutionized *Modern Biology* still accounted for 60 percent of sales in 1978.[53] Overall, evolution content rose, declined in response to creationist textbook-watching in the 1970s, and increased again from the late 1980s.[54] Authors lost status to production teams and control over illustrations that had to

impress selectors as fresh.[55] *Modern Biology* at first kept the old Romanes figure, but redrew and pared it down by 1973 to fish, bird, and, crucially, "man." The diagrams thus hung on long enough to share chapters with color photographs of human fetuses.[56]

Postwar British schools, by contrast, adopted the embryos only occasionally at advanced level. One of the earliest mainstream appearances was a discussion of recapitulation in a massive *Plant and Animal Biology* of 1959. Incongruous among detailed line drawings that "wherever ... possible ... have been constructed from actual specimens," Haeckel's "diagrammatic representations" lasted into a fourth edition, buried deep in volume 2.[57] In 1980–82 my class at a Norwich comprehensive used this book infrequently. Nuffield, the equivalent of the BSCS, provided our main texts, and

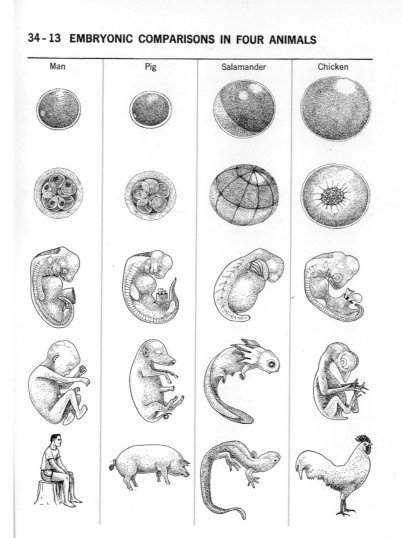

34-13 EMBRYONIC COMPARISONS IN FOUR ANIMALS

| Man | Pig | Salamander | Chicken |

DARWINIAN EVOLUTION **609**

Fig. 16.7 A redrawn grid in the BSCS yellow book. Strangely, the salamander separates the chicken from the other amniotes. BSCS 1963c, 609.

here modernization favored not just the topic, but also embryos credited to Haeckel's *Evolution of Man*.[58]

The pictures played little role in postwar Germany. GDR texts occasionally featured a redrawn grid.[59] In the FRG alternatives prevailed,[60] though a few books copied grids after the *Anthropogenie*.[61] These seem to have become more popular later,[62] perhaps in part as a reimport from American schoolbooks and developmental biology. Though marginal even among conservative Protestants, West German creationists, including the embryologist Blechschmidt, produced their own textbook, attacking Haeckel on human embryos, quoting His on the three clichés, and disputing the biogenetic law.[63]

Surviving College

In the United States embryo grids reached college zoology and biology around 1930 through a national peculiarity, the large elementary course. British biologists marveled at the scale. In 1924 Julian Huxley compared the approximately 60 out of 4,000 Oxford undergraduates "taking the Biological Preliminary," some 90 percent in preparation for medicine, with the 600 out of 3,000 he had found studying elementary biology at the State University of Texas. In America this was not "a door-mat for specialists," but "a proper and necessary part of general education" in which everywhere 10–25 percent enrolled.[64] British courses, longer

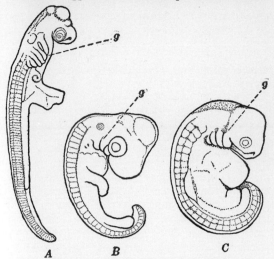

EVIDENCE FROM EMBRYOLOGY 63

while in the frog's egg the yolk is disseminated, though not uniformly, throughout the egg and in the mammalian egg, which is microscopic in size, there is

FIG. 5. Embryos in corresponding stage of development of Shark (*A*), Fowl (*B*), and Man (*C*). *g*, gill-slits.

no yolk. It is a very remarkable fact that all of the vertebrated animals, fishes, amphibians, reptiles, birds and mammals, however different their habits and modes of life, have a mode of ontogeny which is of even more characteristically and unmistakably the same plan than is the type of their adult struc-

Fig. 16.8 A group of vertebrate embryos in William Berryman Scott's *The Theory of Evolution*. Scott 1917, 63.

separated into botany and zoology, more organized around types than principles, allotted the embryological evidence of evolution less space. The traditional subjects were even more entrenched in German universities and Haeckel's figures usually beyond the pale.[65] How did they enter American texts and how did they survive?

Some authors chose alternatives, occasionally the redrawn grids,[66] more often accurate groups at a single stage. Produced by experts for evolution courses, three were most used. The Princeton paleontologist William Berryman Scott, who had researched vertebrate embryos under Balfour and Gegenbaur and saw Haeckel as a "charlatan" deficient in "regard for the truth," prepared a trio (fig. 16.8).[67] Bradley M. Patten transferred a quartet into his own embryology textbooks from his father's evolution lectures at Dartmouth College.[68] The

Chicago embryologist George W. Bartelmez assembled photographic "portraits."[69]

Copying from Romanes began inauspiciously into a pair of poorly reviewed books,[70] but successful authors soon took the diagrams up: the Yale paleontologist Richard Swann Lull's comprehensive *Organic Evolution* (1917), still reprinted after World War II although hopelessly out of date, and the Denison University entomologist and Lamarckian Arthur Ward Lindsey's *Textbook of Evolution and Genetics* (1929).[71] The breakthrough was adoption from around 1930 in most new, multiple-edition elementary texts of biology and zoology: Michael Guyer's *Animal Biology*, which balanced principles with an animal parade; James Watt Mavor's *General Biology* (from Lindsey), which did well although its illustrations "are not particularly distinctive and many of them are copied."[72] The 1940s opened with William C. Beaver's *Fundamentals of Biology* and Tracy I. Storer's *General Zoology*,[73] texts that reprinted the figure into the 1960s and beyond. The Romanes embryos were less dominant after 1945, but the most widespread new books used them too: Claude A. Villee's *Biology* (from Lindsey, apparently via Mavor) and *General Zoology*, both in print from the 1950s to the 1980s, and the second edition of Cleveland P. Hickman's *Integrated Principles of Zoology* (1961), still a market leader today.[74] The 1960s and 1970s saw major restructuring, but the pictures were featured in John W. Kimball's "good, solid, and dependable" *Biology* and William T. Keeton's acclaimed *Biological Science*.[75]

Strengths outweighed weaknesses for the few authors who expressed a view. A *General Biology* by Gairdner B. Moment of Goucher College, a regular reviewer of anatomy and embryology for the *Quarterly Review of Biology*, reprinted Haeckel's by this time (1942) "classic" embryos directly from *The Evolution of Man*, even though they were "(alas) slightly inaccurate." The Mount Holyoke zoologist Ann Haven Morgan selected the Romanes diagrams because "these figures originally after Haeckel lack detail and certain points of accuracy but ... excel in emphasizing essential agreements and ultimate differences."[76] The decision was bigger than any individual author, however, especially when student numbers surged in the 1960s. College now followed high-school publishing and shifted to mass-market production managed by large teams and including "illustration programs" over which authors had less control. Glossy packaging

differentiated otherwise similar products and eased adoption by teachers reluctant to embrace change that would mean extra work.[77]

A 1957 report had already deplored "the long-standing practice of uncritically borrowing illustrations from other sources, irrespective of their accuracy or appropriateness."[78] The maturity of college biology and the bureaucratization of the textbook industry increased both recycling and awareness of the problem. Experienced authors warned that lazy copying "is a big mistake."[79] But as texts grew to over a thousand pages, they kept established material,[80] and protests about specifics were rare. On the one hand, continuing large-scale use implies consultant and reviewer comfort on

seeing figures in edition after edition. On the other, general works cannot possibly satisfy all specialists, so tend to be insulated from their disdain. It became common to lament the difficulty of correcting errors.[81] If these were hard to remove, it would have been much tougher to cull "slightly inaccurate" and conveniently out-of-copyright figures when it was unclear what difference accuracy would make. Some pictures looked too complex or out of place; the embryo grids seemed to speak loud and clear. Alongside striking photographs, line drawings in the manner of *Scientific American* were used more. Adding background, boxes, arrows, labels, and color updated and adapted the style (fig. 16.9).

Fig. 16.9 Embryo grid in Harvard professor Claude A. Villee's college *Biology*. The figure appears in a typical "evidences" section. Villee 1962, 546.

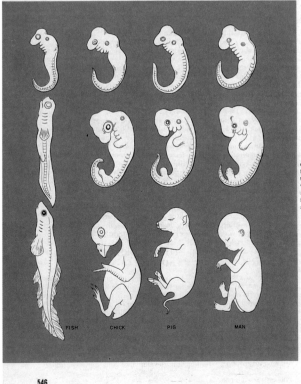

process. It is now clear that the embryos of the higher animals resemble the *embryos* of lower forms, not the adults, as Haeckel had believed. The early stages of all vertebrate embryos are remarkably similar (Fig. 35.1) and it is not easy to differentiate a human embryo from the embryo of a pig, chick, frog or fish.

In recapitulating its evolutionary history in a few days, weeks or months the embryo eliminates some steps and alters and distorts others. In addition, some new characters have evolved which are adaptive and enable the embryo to survive. Early mammalian embryos have many characteristics in common with those of fish, amphibia and reptiles but also have other structures which enable them to survive and develop within the mother's uterus rather than within an egg shell. These secondary traits may alter the original characters common to all vertebrates so that the basic resemblances are blurred. The concept of recapitulation must be used with due caution, rather than rigorously, but it does provide an explanation for many otherwise inexplicable events in development.

The concept of recapitulation is helpful in understanding such curious and complex patterns of development as those of the vertebrate circulatory or excretory systems. It is also useful, when not taken too literally, in getting a broad picture of the whole of development. The fertilized egg may be compared to the single-celled flagellate ancestor of all animals, and the blastula to a colonial protozoon or some spherical multicellular form which may have been the

Figure 35.1. Stages in the embryonic development of the fish, chick, pig and man. Note that the earlier stages of development (top row) are remarkably similar and that differences become more marked as development proceeds.

FISH CHICK PIG MAN

546 EVOLUTION

The diagrams thus benefited from inertia without succumbing to the critiques. But this does not fully explain how they survived major midcentury innovations that sank Haeckel's reputation still further: on the one hand, the reorganization of some life sciences around the modern (that is, non-Haeckelian) evolutionary synthesis of population genetics and Darwinism, and the consequent marginalization of embryos within evolutionism; on the other, the neglect of evolution and ritualized rejection of recapitulation within developmental biology.[82] Only disciplinary history and the details of deployment can show how textbooks provided niches where figures from a degenerating research program could shelter: use was stereotyped, uncoupled from Haeckel, in part historical, and immune from marginal critics.

Open a midcentury textbook at the chapter on evolution, find the section on "evidences," and turn to "comparative embryology." Chances are the Romanes diagrams will accompany a brief discussion as part of a fairly stable *imagetext*.[83] Stereotyping was incomplete; the figure might be slightly redrawn or taken from a different source,[84] and could come and go. In an extreme example, Villee's *Biology* began with the Romanes diagrams, borrowed an improved grid for the next two editions,[85] gave a less accurate version of Haeckel's columns in the fourth (fig. 16.9), and replaced this by photographs in the 1980s. Comparative embryology was not active enough for the details to matter, and this favored the most available existing illustrations.

The conflicted and confused legacy was hard to sum up. Books told of Haeckel's overzealous promotion of the biogenetic law, but salvaged a core of truth by stating that the similarity was to embryos, not adults, and was modified by larval adaptation. Against him authors celebrated Baer as the earlier, sounder discoverer of embryonic resemblance and its correct interpretation in terms of a divergence law.[86] Haeckel's pictures, which show differentiation more obviously than recapitulation, escaped tarring with the same brush. Credited to a secondary source, they could even demonstrate Baer's law on a page that criticized Haeckel as controversial, less accurate, or simply wrong.[87] His theory was rejected, but in a twist that would have had His and Keibel spinning in their graves, these figures now stood for the empirical content of comparative embryology.[88] Their power to represent the past increased as competing images disappeared.[89]

The pictures survived Haeckel's low reputation in part, but only in part, as explicitly historical. Among the evidences of evolution, sometimes presented in terms of what had convinced Darwin and his followers, classical examples were at home, and insulated from change after the modern evolutionary synthesis.[90] In the 1960s some textbooks confidently cut the evidences and with them the figure, but authors reinstated the proofs to counter creationist campaigns.[91] Chapters on animal development avoided evolution in favor of physiology, and generally chose more accurate pictures. But even here the grids endured among a diverse collection of line drawings, scanning electron micrographs, and color photographs; they typically concluded an account of early embryogenesis.[92]

Finally, criticism of Haeckel's embryos was marginal. No reviewer appears to have objected, even the few vertebrate embryologists.[93] Comments about "overzealous artistry" did not connect. Only creationists cultivated disapproval, it seems. For the Creation Research Society, promoter of the literalist deluge geology that from about 1970 was repackaged as "creation science," Wilbert H. Rusch, an ultraconservative Lutheran with a master's in biology, tackled Haeckel's pictures, going back to the first edition of the *Schöpfungsgeschichte* and even part-translating Rütimeyer's review (fig. 16.10). He targeted recent college texts that perpetuated "these distorted drawings," but took the "charitable view" that the authors were "unaware" of the accusations.[94]

Entering Embryology

All this time the vast majority of books devoted to embryology at any level excluded the grids.[95] In the United States as in Germany and Britain, this was more because the various kinds of embryo science ignored evolution as from any more specific hostility. The largest academic market was still noncomparative, nonevolutionary human embryology for medical students. The anatomists who taught it concentrated on presenting the development of the body in accurate drawings and photomicrographs.[96] "General" embryologies, that is, type-based treatments of vertebrate developmental anatomy, served medics too.[97] These dominantly

RARE BOOKS
Science and Religion Coll.
CA 15501
No. 667
V. 6
no. 1

Larry G Butle.

CREATION
RESEARCH SOCIETY

1969 ANNUAL

Haec credimus:

For in six days the Lord made heaven and earth,
the sea, and all that in them is and rested on
the seventh. — Exodus 20:11

VOLUME 6 JUNE, 1969 NUMBER 1

Fig. 16.10 Cover of the *Creation Research Society Annual* of 1969, containing Wilbert H. Rusch Sr.'s article, "Ontogeny Recapitulates Phylogeny." The symbol is the ancient christogram, consisting of the superimposed chi (X) and rho (P), the first two letters of "Christ" in Greek. Courtesy of *Creation Research Society Quarterly* and Department of Special Collections, Memorial Library, University of Wisconsin–Madison.

Fig. 16.11 A prominent use of a redrawn grid in Theodore W. Torrey's 1962 textbook of comparative embryology. Columns are shark, salamander, lizard, chicken, pig, rabbit, and "man." The corresponding text figure stayed through to the fifth edition (1991). Reproduced from Torrey 1962 with permission of John Wiley & Sons, Inc., © 1962.

anti-Haeckelian fields pushed comparative questions to the margins, while the few texts billed as "comparative" epitomized the failure to synthesize after World War I; they described the development of a small handful of vertebrates, one after another.[98]

How, if at all, were embryos visually compared? The main alternative was the group at a single stage (fig. 16.8). But Haeckel's egg-to-gastrula columns or the grids with added rows inspired books in embryology, as in general biology, occasionally to line up stages across the vertebrates and even the Metazoa.[99] Evolution was not necessarily the context for discussion of amounts of yolk or developmental themes. Versions of his own drawings featured, it seems, in only a couple of weak single-edition embryology books before 1980.[100]

Unusually, the Indiana zoologist Theodore W. Torrey, integrating comparative and developmental anatomy, confidently placed a redrawn grid across a title page (fig. 16.11). He accepted the "element of truth" in recapitulation, but described the figure, his closest to a "panorama," as "illustrating von Baer's principles."[101]

By the 1960s, experimental embryology, which had languished in the 1940s and 1950s after a burst of excitement in the 1930s, was making the running again. Like human embryologists, experimentalists traced a lineage to Wilhelm His and put comparison off. With the field reframed as *developmental biology*, the assumption of deep cellular, genetic, and molecular homologies across the animal kingdom and even the living world justified focusing on a few model

THEODORE W. TORREY
Department of Zoology
Indiana University

JOHN WILEY & SONS, INC.
NEW YORK · LONDON

MORPHOGENESIS
OF THE
VERTEBRATES

systems.[102] Teaching had long introduced a selection of types, while early textbooks exemplified developmental mechanisms in whichever system had been engineered for a particular job. Haeckel and his evolutionist speculations appeared, if at all, as obstacles the pioneers had overcome.[103]

Only in the mid-1980s did Haeckel's figures arrive in developmental biology, in part with a rekindling of interest in development and evolution, often among scientists with little training in the old vertebrate embryology. One might have expected to find the drawings in *Ontogeny and Phylogeny* (1977) by the invertebrate paleontologist Gould, but he avoided that issue although couching the general problem as how to go beyond Haeckel.[104] Gould would soon join a

move to engage with the visual languages of past science, but few anglophone historians of biology either took pictures seriously or knew what fraud, if any, was alleged.[105] A further milestone in developmental biologists' rediscovery of evolution, Rudolf A. Raff and Thomas C. Kaufman's advanced text on *Embryos, Genes, and Evolution* (1983), did include a grid from *The Evolution of Man*. Trained in biochemistry and developmental genetics, the authors worked on sea urchins and the fruit fly *Drosophila* respectively. They knew of Haeckel's "reputation for prettying up his drawings of invertebrates and protists for artistic effect," but not that he was accused of fraud.[106]

Other uses seem independent of the evolutionist revival. In the same year a team led by James D. Wat-

son, codiscoverer of the structure of DNA, produced Garland's landmark *Molecular Biology of the Cell*. Over several editions this visually innovative model of synthesis and clarity defined the new "superdiscipline" of molecular cell biology. In the chapter "Cellular Mechanisms of Development," primarily by the British scientists Julian Lewis and Cheryll Tickle, a Haeckel figure closed a section, "Gastrulation, Neurulation, and Somite Formation," with the achievement of a common vertebrate body plan. Pictures that had featured in the development chapters of general biologies now occupied an equivalent place in a more specialized text.[107]

Two years later, in 1985, the grids entered the soon-leading textbook of developmental biology itself.

The author, Scott F. Gilbert of Swarthmore College, probably first encountered Haeckel as a high-school student in a National Science Foundation precollege course and remained interested as an undergraduate studying biology and religion. As well as a PhD in pediatric genetics, he took a master's in history of science which included a history of embryology seminar. Gilbert imbibed positive appraisals of Baer and a negative view of Haeckel from the historians of biology Jane Oppenheimer and Dov Ospovat, as well as Gasman and Gould. "I wasn't yet aware of the forgery charges.... That he was wrong, racist, and possibly a proto-Nazi was bad enough."[108]

Gilbert's *Developmental Biology* aimed "to bridge the boundary between developmental biology and

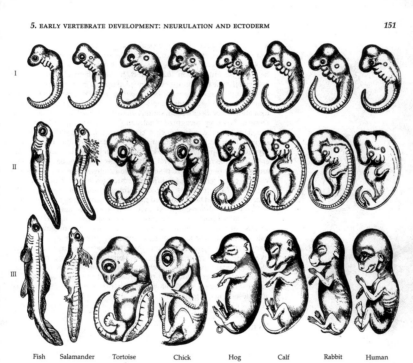

5. EARLY VERTEBRATE DEVELOPMENT: NEURULATION AND ECTODERM 151

Fish Salamander Tortoise Chick Hog Calf Rabbit Human

FIGURE 1
Illustration of von Baer's law. Early vertebrate embryos exhibit features common to the entire subphylum. As development progresses, embryos become recognizable as members of their class, their order, their family, and finally their species. (From Romanes, 1901.)

malian and other embryos diverge, none of them passing through the stages of the other.[2]

These conclusions were extremely important for Charles Darwin because evolutionary classification depended upon finding those similarities that demonstrated that certain diverse animals arose from a common ancestor. "Community of embryonic structure," wrote Darwin

[2]This work was largely ignored after Ernst Haeckel made a synthesis of German romanticism and Darwinism wherein "ontogeny [the development of an individual] recapitulated phylogeny [the evolutionary history of the species]." Here, the various stages of the human embryo were seen to correspond with the adult stages of "lower" organisms. Even though this view was scientifically discredited before it was even proposed, Haeckel had a gift for showmanship and his theory "explained" human progress. It caught on like wildfire throughout biology and the social sciences before it was shown to be based on false premises (see Gould, 1977).

Fig. 16.12 The Romanes embryos in the first edition of Scott Gilbert's developmental biology textbook. Figure 1.1 above shows the fifth (1997) edition. Gilbert 1985, 151.

evolution." Having discussed differences between groups in early development, the chapter on the ectoderm stressed the similarities (fig. 16.12). This was "to bring in some historical interplay between embryology and evolution" and to discuss vertebrate neurulation in general. As Gilbert remembered, "I wanted a picture that showed von Baer's idea of individuation with increasing development … and I also didn't want one associated with Haeckel.… I recalled seeing Romanes' picture somewhere and thinking that it would be a good illustration of what I wanted to show. I probably used the copy of *Darwin and After Darwin* that we have in our library here.… If I recall correctly, I didn't even know if Romanes had gotten the drawing from Haeckel or had made it himself; but it illustrated what

I wanted, and I could quote it as being from Romanes, not from Haeckel."[109] Like others, Gilbert criticized Haeckel on the same page.

Sources were legion; the change was the importation into more specialized books. Gilbert may have gone back to Romanes, but he also cited Raff and Kaufman and *Molecular Biology of the Cell*, which itself appears to have taken the figure from Nuffield's school biology course. General works here served as repositories of synoptic and synthetic knowledge on which scientists drew outside their immediate areas of expertise.[110] The inclusion of the pictures in Gilbert's prizewinning "giant" of a textbook[111] then licensed further borrowing,[112] even occasionally into human embryology (fig. 16.13).

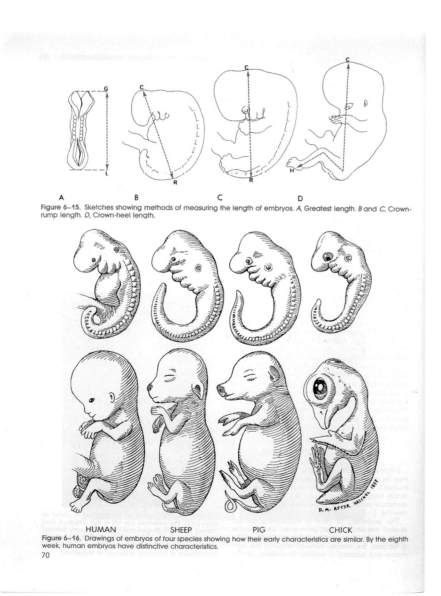

Figure 6–15. Sketches showing methods of measuring the length of embryos. *A*, Greatest length. *B* and *C*, Crown-rump length. *D*, Crown-heel length.

Figure 6–16. Drawings of embryos of four species showing how their early characteristics are similar. By the eighth week, human embryos have distinctive characteristics.

HUMAN SHEEP PIG CHICK

70

Fig. 16.13 Haeckel's embryos enter human embryology in the third edition of Keith L. Moore's *Before We Are Born*. The grid, significantly redrawn for the human embryos only, was even juxtaposed with diagrams of measuring methods. An end-of-chapter question gives a motive for its introduction: "I have heard that the human embryo could be confused with the offspring of many other species, e.g., a pig, mouse, or chick. Is this true?" The answer suggested, controversially, that "until the fifth week, human embryos resemble the embryos of several other species … but thereafter acquire characteristics that are distinctly human." Line drawings, the lower one by David Mazierski, with what is essentially Haeckel's rabbit labeled a sheep, from K. Moore 1989, 70, © Elsevier.

No reviewer objected[113] because, for all the wariness about Haeckel, few knew details of the accusations and the figures were not necessarily associated with him. Where the old comparative embryologists had despised blatant distortions, developmental biologists focused on deep similarities instead. With diagrams expected to idealize, Haeckel's perhaps also did not clash with the accurate figures the authors reproduced. Age may have contributed to a sense that they should not be taken too seriously. Having avoided his pictures for over a century, embryology imported them without debate.

Unexploded Ordnance

This special kind of novelty challenges the expectation that innovation flows down gradients of expertise. The grids entered American schools in the early 1900s, introductory college courses from about 1930, and developmental biology in the 1980s. The embryos also undercut any assumption that images and theories are linked so closely they must live and die together. Frequently dissociated from Haeckel, and even used against him, these of all figures provided neutral evidence for a theory opposed to his own. But then they never were merely illustrations of the biogenetic law.

General features of the industry and the field account for the phenomenon of recycling, but particular pictures arrive, stay, and leave for specific reasons. In this case these include a shortage of specialist engagement from a field in the doldrums, antievolutionist weakness, and the confused legacy of comparative embryology. Bowdlerization saved the grids in high schools, while in colleges they found a niche, protected by captioning, as a fairly stable imagetext. More evidence might allow more reconstruction of particular decisions, and so make clearer the agency not just of authors but also of editors, reviewers, salespeople, graphic artists, teachers, pupils, and school boards. Many people will have stories of use in class and at home. More could be said about transfers across the Atlantic; American books were published in Britain too. It is already evident that changing patterns of copying imply more or less mindful decisions that attention to disciplinary, pedagogical, and curricular agendas, as well as deployment within a book and on a page, can explain.

Copying in general textbooks kept the grids available to developmental biology in the 1980s. They soon littered the subject like so much unexploded ordnance in the fields after a forgotten war. No scientist a century before could have imagined the result: the figures once again framed a defining dispute in a fresh, young field. Now-powerful creationists ensured maximum damage when they blew up.

Iconoclasm

"This is one of the worst cases of scientific fraud," a British biologist told the *Times* of London in summer 1997.[1] Rising excitement about the relations of evolution and development, growing concern about ethics in science, and the repackaging of creationism as "intelligent design" fanned a firestorm from that flame.[2] The Discovery Institute, a conservative think-tank in Seattle, was soon drafting labels to stick in high-school texts: "WARNING. These pictures make vertebrate embryos look more similar than they really are."[3] The president of the National Academy of Sciences of the United States, as first author of *Molecular Biology of the Cell*, promised to remove Haeckel's grid.[4] Dwarfing the debate of 1909, this third big fight all but ended its textbook career.

Once again, during a politicized controversy over Darwinism and a major transformation in visual communication, now with the takeoff of the Internet, a scientist had sparked trouble by going public, and an organization trying to harmonize biology and Christianity fed the blaze.[5] Yet widespread use, and a role for the illustrations in a specialist dispute for the first time since 1875, shifted the focus from Haeckel's character to the integrity of the evolutionist community as a whole. This tragedy, repeated not a first but a second time as farce, abounded with the ironies of history and iconoclasm.[6] A sensational discovery turned out to be old hat and "the forgotten fraud" perhaps no forgery at all. Meanwhile, the image breakers forced the figures out of the textbooks, only to make these "ruined idols" more globally available than ever before.

Egg Timers and Hourglasses

After 1945, when most research on embryos proceeded without reference to evolution, comparative embryology survived on the margins of the expanding

biomedical and biological sciences. But from around 1980 dissatisfaction with the "modern evolutionary synthesis" of population genetics and Darwinism directed attention to developmental processes and constraints. A major issue was the adequacy of incremental, adaptive change to explain such "macroevolutionary" transformations as the origins of phyla or even the Metazoa.[7] Developmental biologists also returned to the question of stage conservation across the vertebrates, left open after World War I and considered only intermittently since then. This would lead them to Haeckel's grids.

Keibel had rejected conserved ancestral stages for mammals; heterochrony jumbled everything up. Even Haeckel had sometimes acknowledged the variety. But critical discussions going back at least to His had accepted a stage of vertebrate similarity, while suggesting that the animals converge from different beginnings before diverging again. From the 1930s the German embryologist Friedrich Seidel, an expert on insects (and later mammals), identified for several phyla a "stage of the basic body form" that in vertebrates was "very clear" (fig. 17.1).[8] Others made the same point more abstractly (fig. 17.2A), and an influential textbook

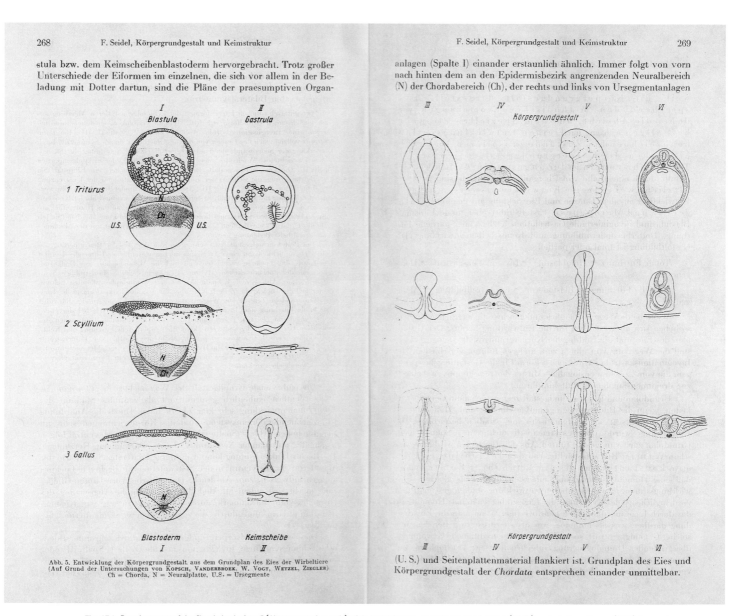

Fig. 17.1 Development of the "basic body form" (*Körpergrundgestalt*) of the vertebrates, seen in cross-sections (*IV, VI*) and whole embryos (*III, V*) for newt (*1*), dogfish (*2*), and chick (*3*). Friedrich Seidel drew similar diagrams for sponges, coelenterates, arthropods, molluscs, and echinoderms. Seidel 1960, 268–69, © Elsevier.

explained that embryos are most alike, because most constrained, during an intermediate period.[9] Developmental biologists taught that reproductive strategy determines early differences, such as the amount of yolk—and hence patterns of cleavage—and the membranes that adapt the embryo to development inside the mother.

Yet since introductory textbooks still played Baer off against Haeckel and early interference can have catastrophic effects, researchers lacking comparative experience assumed that the first stages are most conserved.[10] In 1976 William W. Ballard of Dartmouth College protested that only "semantic tricks and subjective selection of evidence" could make early vertebrates appear "more alike than their adults"; at most, this was true within a class. The problem was not just Haeckel but also Baer. For in reality evolution acted on every stage, and only one, Ballard's "pharyngula," looked roughly the same.

From very different eggs the embryos of vertebrates pass through cleavage stages of very different appearance, and then through a period of morphogenetic movements showing patterns of migration and

A of course, that the eggs of vertebrates, no matter how great their anat diversity may be, must certainly have a fundamental ground-plan in co and the discovery of this ground-plan is one of the principal agenda of e logical research; but we are concerned here with those tangible differer size, shape, composition, and developmental procedure which form the s matter of descriptive embryology.

B

TEXT-FIG. 1

What is the significance of the convergent phase of vertebrate developm causal embryology? My suggestion is that adaptive diversification dur convergent phase of vertebrate development has been made possible by a adaptive device, viz. the existence of *inductive relationships* between n the constituent parts of the embryo. For it is clear that the existence of an tive relationship between two parts allows the embryo a latitude of develo an extra degree of freedom, that is denied to parts which are rigidly dete in respect of their ultimate fates. Consider, for example, the inductive r ship between eye-cup and lens. In many species the lens is caused to for the ectoderm by the action of the eye-cup that underlies it. Presumpti

Fig. 3. The phylotypic egg-timer. This scheme illustrates the convergence of vertebrate developmental strategies towards the phylotypic progression, the acquisition of a stable Bauplan. This convergence may be imposed by the necessity to use a meta-*cis* regulatory mechanism whose intrinsic properties, linked to those of the genetic material, may considerably reduce the amount of evolution allowed within this narrow point (see the text). Such a mechanism may result in the progressive temporal activation of Hox genes along their complexes. The diagrams of embryos are schematic to illustrate the concept; it is not suggested that they give an exact description of vertebrate morphologies.

Fig. 17.2 Convergent and divergent development. *A*, illustration in an article in which the British biologist Peter Medawar suggested that inductive interactions allow the variety of vertebrate eggs to converge on "an axiate neurula of very uniform pattern." Later development diverged according to Baer. *B*, "The phylotypic egg-timer." Denis Duboule offered a molecular interpretation for "a neck of phylogenetic similarity and obligatory passage between two states of higher tolerance for variability." Drawing by Petra Riedinger (European Molecular Biology Laboratory), based on a magnifying glass and pictures supplied by Duboule (Duboule to author, 23 July 2011). Reproduced with permission from Medawar 1954, 173, and Duboule 1994, 139.

temporary structures unique to each class. All then arrive at a pharyngula stage, which is remarkably uniform throughout the subphylum, consisting of similar organ rudiments similarly arranged (though in some respects deformed in respect to habitat and food supply). After the standardized pharyngula stage, the maturing of the structures of organs and tissues takes place on diverging lines.

Baer's "generalities" applied, with "many exceptions," to this last phase.[11]

When "development and evolution" began its comeback biologists again asked why phyla were so conserved and how radical novelty might arise. In 1983 Klaus Sander, a German insect embryologist in the Seidel tradition, translated his concept as the "phylotypic stage," the first that "reveals the general characters shared by all members of that phylum." Earlier stages would differ wherever selection conserved characters without conserving the pathways that led to them.[12] Developmental biologists, wanting systems in which to investigate this problem, picked close relatives with impressive changes in mode of development: frogs that went from egg to adult without a tadpole and sea urchins that omitted the feeding-larva stage.[13]

Around this time some of the same people were bringing Haeckel's pictures—typically identified as his—into symposium volumes and reviews as well as textbooks. Recognizing early differences stimulated attempts less to question than to extend the grids. In a

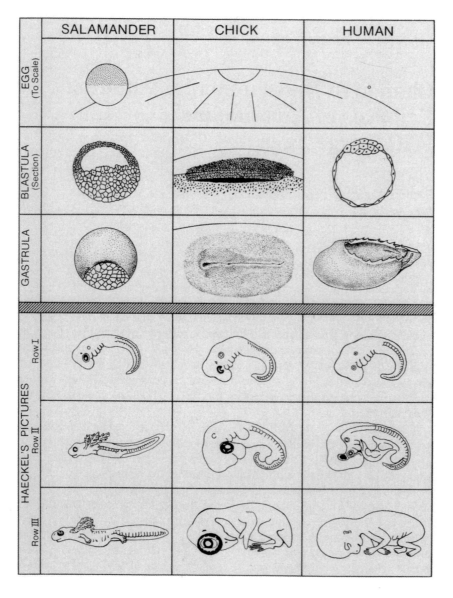

Fig. 17.3 "Haeckel Revisited." Richard Elinson based the lower half of the figure on the *Anthropogenie*; the upper half redraws embryos from two textbooks and a journal article to show that the early stages are "not at all similar." The caption notes that the eggs are drawn to scale to reveal the huge size differences, and that the jagged line indicates the removal of the amnion from the human gastrula. Elinson gave an artist "Xeroxes of Haeckel's pictures, as well [as] of cleavage and gastrulation stages from the cited sources, and asked for black and white line drawings" (Elinson to author, 12 May 2008). Reproduced from Elinson 1987, 2, with permission of John Wiley & Sons, Inc., © 1987.

The figure is a grid table. Column headers: SALAMANDER, CHICK, HUMAN. Row labels (left side): EGG (To Scale), BLASTULA (Section), GASTRULA, then a section labeled HAECKEL'S PICTURES with Row I, Row II, Row III.

1987 chapter about direct-developing frogs from South America and Puerto Rico, Richard Elinson, a Toronto developmental biologist trained at Johns Hopkins and Yale, followed Ballard but showed more sympathy for Haeckel, who "was fully aware of the differences in early development."[14] To his three stages Elinson added drawings of egg, blastula, and gastrula (fig. 17.3), and so echoed Frederic Lewis's note of 1907 (fig. 12.10).

Within developmental biology, evolution was still a minority pursuit. Genetics and biochemistry dominated, with the majority of laboratories focusing on single species,[15] most excitingly on uncovering cascades of regulatory genes that specify position in *Drosophila*. In the mid-1980s, however, the discovery that these genetic networks are highly conserved opened up new approaches to evolution as well. Research on homeotic genes that in fruit flies mutate to transform, for example, a head segment into thorax, identified a shared protein-coding region, the *homeobox*, in an ever wider variety of animals, including vertebrates. Individual *Hox* homologs turned out to belong to gene complexes with equivalent expression patterns and similar mutational effects along the anteroposterior axis. Remarkably, these correspond to the chromosomal order of the genes.[16]

As several rather different research programs began to coalesce into a field that some called *evolutionary developmental biology*, or *evo-devo*,[17] the molecular genetic evidence prompted a reassessment of the phylotypic stage. Based on the claim that *Hox* gene expression peaks then, or is clearest, in 1993 a commentary in *Nature* from the Department of Zoology at Oxford suggested that the spatial pattern, the "zootype," was common to all animals, and only them, and so should define what an animal is. Jonathan Slack would dismiss his own work as "dilettante-ish nonsense … written with sufficient panache to appeal to journalists." He joined critics of the high-impact-factor "fashion journals" *Nature*, *Science*, and *Cell* for preferring this to solid but unflashy research.[18] The paper still consolidated the phylotypic stage as a key problem in evo-devo.

Developmental biologists increasingly associated the stage with Haeckel's embryos, but distanced themselves more in the mid-1990s. A new edition of *Molecular Biology of the Cell* replaced the copy with a reproduction from the *Anthropogenie* and moved this to the introduction and a more historical role. Julian Lewis

recalled that he had become "a bit concerned" about its accuracy and wanted "to indicate that this was a quaint old set of pictures, perhaps not entirely trustworthy in detail, but making a valid conceptual point."[19] In a symposium volume the Geneva-based mouse researcher Denis Duboule argued that the phylotypic stage was better seen as "a *succession* of stages," which existed because disturbing the progression of *Hox* gene activation had such serious and multifarious effects. The accompanying "phylotypic egg-timer" used Haeckel drawings but explicitly as schematics (fig. 17.2B).[20] In *The Shape of Life* the evo-devo pioneer and sea urchin expert Rudolf Raff proposed, like Duboule only more generally, that the phylotypic stage is stable because gene modules then interact most. He adopted an "hourglass" model much like the egg timer. But having in 1983 copied Haeckel's diagrams unmodified, he now added Elinson's and discussed further limitations. These included the suggestion in a review Raff had just handled as an editor for the top American journal that they were inaccurate as well as incomplete.[21]

The author, Michael Richardson, a lecturer in anatomy and embryology at St. George's Hospital Medical School, London, had in 1990 completed a PhD on bird embryo pigment patterns with Lewis Wolpert, known for the "French flag" theory of pattern formation. The thesis work had raised the issue of when pigment develops in different vertebrates, and reading Gould fostered this interest.[22] Richardson surveyed data from a wider variety of sources than his colleagues had been in the habit of consulting, especially Keibel's normal plates, and found too much heterochrony for the "narrow timepoint" implied by the term *stage*. So that 1995 minireview in *Developmental Biology* challenged the idea that the phylotypic stage resists evolutionary change. Following Duboule's argument for a "progression," it was "more appropriate to speak of a phylotypic 'period.'" Like Oppel and Mehnert a hundred years before, but now with respect to gene expression data, Richardson lamented that most descriptions were too casual for rigorous comparison. He also took aim at Haeckel's "inaccurate and misleading" drawings.[23]

In Springer's lower-profile *Anatomy and Embryology*—where nonmolecular morphology was more at home—Richardson followed up two years later with a review that drew on visits to the Central Embryological Collection at the Hubrecht Laboratory, Utrecht

(fig. 10.11). An international team compared a wide range of vertebrate embryos, including lamprey, electric ray, lungfish, caecilian (a limbless amphibian), and scaly anteater. Differences in body size and plan and number of somites, as well as in timing and patterns of growth, were large enough, they concluded, to confirm Richardson's hypothesis: "There is no highly conserved embryonic stage in the vertebrates."[24]

Haeckel's drawings appeared here, too, because they "remain the most comprehensive comparative data purporting to show a conserved stage," were "still widely reproduced in textbooks and review articles, and continue to exert a significant influence on the development of ideas in this field." They had supported the true claim that species diverge as they develop, but also the false one to near identity early on. "Sedgwick (1894) and Richardson (1995) have argued that Haeckel's drawings are inaccurate," Richardson and colleagues stated, "and we have now provided persuasive evidence that this is indeed the case." Haeckel had "inexplicably omitted" several nonamniote groups and "fails to give scientific names, stages, or source"; his first row just repeated "a stylized amniote embryo." "These inaccuracies and omissions seriously undermine his credibility."[25]

Under attack in a hot new field, the stakes for Haeckel's pictures were now higher than at any time since the 1870s, and the possible audience far larger. Even in 1908–10 the charges crossed national boundaries to only a limited extent; now their very publication was international. Yet the journal articles, especially somewhere so unfashionable, were not going to make news on their own. (Brass's more inflammatory intervention had needed a press campaign.) And news counted: since the mid-1980s pressure had increased on scientists to publicize their research.[26]

A Famous Fake?

Convinced he was uncovering something "really, really interesting," Richardson lured the press with a forgery charge.[27] In August 1997, a month after publication, the *Times* based a story on his interview with the science editor Nigel Hawkes, who quoted him as saying, "It's shocking to find that somebody one thought was a great scientist was deliberately misleading. It makes me angry.... What [Haeckel] did was to take a human embryo and copy it, pretending that the salamander

and the pig and all the others looked the same at the same stage of development. They don't.... These are fakes."[28] It no longer mattered where the underlying article had been published. Other papers picked up the news,[29] and in early September it reached *Science* magazine,[30] one of the general weeklies that played the main role in mediating globally between specialist journals and wider publics.

But the story had already changed. In response to the letter objecting that he "tells us nothing new," Richardson began to repeat the creationist factoid about Haeckel's trial.[31] It seemed to fit with what historically aware colleagues were telling him about earlier attacks; Sander sent a photocopy of His's title page with the date underlined.[32] So *Science* headlined "Fraud Rediscovered" and the British *New Scientist* "Embryonic Fraud Lives On."[33] "Generations of biology students," *Science* began, "may have been misled by a famous set of drawings of embryos published 123 years ago" (fig. 17.4). Richardson was quoted as remarking, "It looks like it's turning out to be one of the most famous fakes in biology." He presumably meant that famous pictures had been faked, but by explaining that the news "might not have been so shocking to Haeckel's peers in Germany a century ago," Gilbert raised the possibility that they had once been famous as fakes.[34] By the winter Richardson reckoned the "strangest thing" that the accusations had been forgotten. Were textbook authors unaware of the controversy or seduced by "simplicity and visual impact"?[35]

Fraud had become a hot issue in America over the previous twenty years as a category of unethical behavior, the revelation of which fueled demands for regulation of rather autonomous professions. Big science measured quantity more easily than quality, and laboratory chiefs had been known to put their names on papers without having followed every detail of the research. Calls for ethical audit were most incendiary at the National Institutes of Health and in a long-running case centered on an (eventually exonerated) collaborator of the molecular biologist David Baltimore. The antiforgery campaign was problematic in several respects, but concern spread.[36] Just before the Haeckel story broke, the press uncovered the biggest fraud in postwar German science: a pair of cancer researchers had systematically fabricated dozens of publications with coauthors at several universities over a decade.[37]

DEVELOPMENTAL BIOLOGY

Haeckel's Embryos: Fraud Rediscovered

Generations of biology students may have been misled by a famous set of drawings of embryos published 123 years ago by the German biologist Ernst Haeckel. They show vertebrate embryos of different animals passing through identical stages of development. But the impression they give, that the embryos are exactly alike, is wrong, says Michael Richardson, an embryologist at St. George's Hospital Medical School in London. He hopes once and for all to discredit Haeckel's work, first found to be flawed more than a century ago.

Richardson had long held doubts about Haeckel's drawings because they didn't square with his understanding of the rates at which fish, reptiles, birds, and mammals develop their distinctive features.

group of animals. In reality, Richardson and his colleagues note, even closely related embryos such as those of fish vary quite a bit in their appearance and developmental path-

M. RICHARDSON

THE BODLEIAN LIBRARY, OXFORD

Artistic license. Photographs to scale *(top)* and Haeckel's drawings *(bottom)* of a salamander, human, rabbit, chicken, and fish embryo *(left to right).*

way. "It looks like it's turning out to be one of the most famous fakes in biology," Richardson concludes.

This news might not have been so shocking to Haeckel's peers in Germany a

century ago: They got Haeckel to admit that he relied on memory and used artistic license in preparing his drawings, says Scott Gilbert, a developmental biologist at Swarthmore College in Pennsylvania. But Haeckel's confession got lost after his drawings were subsequently used in a 1901 book called *Darwin and After Darwin* and reproduced widely in English-language biology texts.

The flaws in Haeckel's work have resurfaced now in part because recent discoveries showing that many species share developmental genes have renewed interest in comparative developmental biology. And while some researchers—following Haeckel's lead—like to emphasize the similarities among species, Richardson thinks studying the contrasts may be more interesting. Gilbert agrees: "There is more variation [in vertebrate embryos] than had been assumed." For that reason, he adds, "the Richardson paper does a great service to developmental biology."

–Elizabeth Pennisi

Fig. 17.4 "Fraud Rediscovered." *Science* magazine paired Richardson's photographs with the top row from Haeckel's *Anthropogenie*, which is credited to the Bodleian Library, the source for the 1994 edition of *Molecular Biology of the Cell* and for Richardson. From Pennisi 1997, with permission from AAAS; Bodleian Libraries, University of Oxford (1891? d. 25, plates IV–V); and Michael Richardson.

Antifraud campaigners, like other reformers, mobilized allegations of historic abuses reaching into or close to the present, many of them shocking, most of them complex to interpret in detail. The most notorious is the United States Public Health Service study of syphilis left untreated in African American men at Tuskegee, Alabama. In 1996 a case closer to Haeckel's embryos questioned the use of scientific images from the German-speaking world: the Austrian author and artists of a standard anatomical atlas had been Nazis and likely portrayed the bodies of people executed under National Socialism.[38] Fraudbusters invoked history primarily to establish prevalence and increase. If great scientists had sinned, how much more must lesser figures have trimmed and cooked their data, and how much greater must be the temptation under

the pressures of big science? Long-dead heroes turned into all-too-familiar rogues. Reformers revived the old story of Gregor Mendel's improbable pea ratios and used historical work showing the physicist Robert Millikan selecting data from his oil-drop experiment to bring him into disrepute. They blamed the system for facilitating deception, but tended to present alleged fraudsters from before World War II in isolation and to judge them anachronistically. Historians, by contrast, contextualized actions as appropriate in their own place and time.[39]

For Haeckel, unusually, the defenses were themselves old, but most available in Germany, where, as Richardson reported, it "upset" scientists "that their hero is under fire."[40] Newspapers quoted Sander as stating that Haeckel had gone too far but been proved

right.[41] In letters rebutting criticism, Sander's colleagues even suggested that recent research confirmed the biogenetic law and that Haeckel had schematized legitimately. The accusers' true aim was to discredit him and hence evolution, just as Brass had attempted and the forty-six biologists had resisted ninety years before. If only evolutionists would show as much backbone today.[42]

Creationist exploitation of his work embarrassed Richardson—a nonreligious Darwinian[43]—into explaining in *Science* that "on a fundamental level, Haeckel was correct." Embryology still supported evolution; the minor issue was the extent to which natural selection acted on the phylotypic stage. Sander and Roland Bender replied that Richardson should have foreseen what would happen, and not repeated the unfounded assertion about Haeckel's conviction—a "mistake" Richardson acknowledged while upholding the core charge.[44] Insisting that earlier critics' evidence was not "persuasive," he now provided an alternative grid (fig. 17.5). Photographs avoided suspicion of bias,[45] but the outlines were harder to see and laypeople risked being overly impressed by the visually prominent but biologically peripheral yolk sacs.[46] Those used to reading from left to right would also find development harder to follow.[47]

The first *Science* piece had quoted Gilbert praising Richardson's "great service." Richardson seemed to need defending against the mostly unwritten reproach of causing trouble for evolutionists at an already difficult time.[48] As the story gathered momentum Gould, himself scarred by creationist appropriation of punctuated equilibrium and under attack for not having highlighted the problems with Haeckel's pictures, weighed in with a column in *Natural History* magazine. His well-honed style and knowledge of primary sources separated Richardson's "good science" from its creationist misuse. "Careless reporting" and "media hype" had generated a tale that "a primary pillar ... of evolution" had finally "been revealed as fraudulent after more than a century of continuous and unchal-

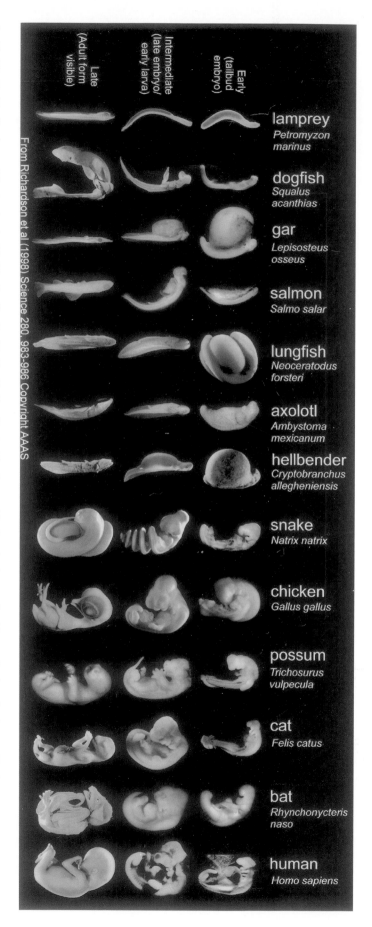

From Richardson et al (1998) Science 280, 983-986 Copyright AAAS

Fig. 17.5 A photographic grid. A good deal of the greater diversity is accounted for by the stronger emphasis on lower vertebrates than Haeckel's grids, which concentrated on amniotes, especially mammals. From Richardson et al. 1998, courtesy of Michael Richardson.

lenged centrality." In fact, Gould explained, experts had recognized Haeckel's "artistic license" immediately, but hard-pressed textbook authors recycled the figures from popular works. While Gould asserted that Richardson "never claimed originality in uncovering the fraud," Richardson confessed that he had said as much in interviews. But he shared the blame: if historians knew, why had they kept quiet?[49] The answer, for anglophone historians of biology, is probably that most did not know of the charges,[50] and that the few who did had not realized how much the embryos were still used; I had not thought about that myself.

Richardson had begun criticizing Haeckel almost as if he were a contemporary, by comparing old images to current specimens. He moved into history to contest contextualizing attempts to excuse the drawings as legitimate schematics. In *Nature* he now proposed a general method for identifying fraudulent illustrations: changes that bolstered an author's theory implied dishonest intent. So Haeckel was guilty as charged, and—a truly original claim—even His had produced "dubious" figures: his "specific physiognomies" were more advanced than Haeckel's first row and his deer embryo had cloven hooves, which a work published over thirty years later did not show.[51] Anachronism apart, Richardson ignored the inevitable theory-ladenness of observation. But he softened his stance the following year.

A long review in the end found only "some evidence of doctoring" in the grids.[52] This was too late to affect the mainstream reception. Haeckel had already joined the collections of fraudsters, swindlers, and charlatans that burgeoned as a nonfiction genre from the late 1990s, and so for most people the story ended with the rediscovery of fraud, sometimes including the repeated blocks.[53] The smaller audience of evo-devo aficionados debated the phylotypic stage for a further few years,[54] but now generally accept that this is a more extended period in vertebrates and accessible to evolution, while subject to internal constraints.[55] It is also respectable to maintain some role for recapitulation in development.[56]

A Policeman's Whistle

In Germany, a report in the highbrow, conservative *Frankfurter Allgemeine Zeitung* (Frankfurt general news) invited creationist responses by mentioning Erich Blechschmidt. Letter writers blamed Haeckel for abortion and Nazi racial hygiene, and fought over Blechschmidt's arguments for human uniqueness; for the creationist Reinhard Junker, Haeckel's manipulations were typical of scientists who first committed to evolution and then looked for proofs.[57] But creationism was stronger and the pictures were used more in the United States. Richardson acknowledged that "some Americans worry that criticising Haeckel will give [the creationists] ammunition," but he just wanted "to bring this into the open so it doesn't fester."[58]

The young-earth creationism of the Institute for Creation Research and Answers in Genesis flourished in the fundamentalist churches, Bible conferences, and broadcasting and publishing empires of America's conservative Christian subculture. Here humans had walked with dinosaurs, fossils dated to Noah's flood, and Darwinism seemed truly "a theory in crisis." But the National Academy of Sciences, the American Association of Biology Teachers, and almost all biologists were united around evolution, and the Supreme Court had ruled in 1987 that teaching "creation science" violated the constitutional ban on religion in the public schools. Some creationists responded by rebranding it "intelligent design" (ID), which in the mid-1990s gained a base at the Discovery Institute. Generally hiding their politics and the designer's identity, ID activists said little about their positive scientific beliefs. The founders, lawyer Phillip E. Johnson, author of the bestselling *Darwin on Trial*, and philosopher of science Stephen C. Meyer, concentrated instead on processes allegedly so complex that natural explanations fail. By attacking perceived weak points in Darwinism they aimed to drive in wedges that would kill the materialist tree. The demand was not necessarily that pupils study "creation science" but that schools "teach the controversy"—the controversy the Discovery Institute was manufacturing.[59]

Creationists already exploited the charges against Haeckel;[60] as antiabortionists, many also railed against the idea that the human embryo was ever like a fish.[61] The award-winning TV miniseries, *The Odyssey of Life*, based on photographs by Lennart Nilsson, aired in late 1996 on the Public Broadcasting Service (PBS) science flagship *Nova*. One program, "The Ultimate Journey," was an evolutionary epic featuring Haeckel-inspired comparative embryological series made by "morphing" photographs of human, pig, chick, and fish, some

Morphing Embryos

To view the video, choose a QuickTime or AVI file. You'll need the free QuickTime plugin to view the QuickTime files. Note: all of the clips are silent.

Human Embryo

QuickTime (2.9MB) | AVI (2.9MB)

Pig Embryo

QuickTime (1.5MB) | AVI (1.5MB)

Chicken Embryo

QuickTime (2MB) | AVI (2MB)

Fish Embryo

QuickTime (2.2MB) | AVI (2.2MB)

Fig. 17.6 "Morphing Embryos" on the website of the *Nova, Odyssey of Life* series. The site assembled stills from Lennart Nilsson's morphing videos into a Haeckel-style grid in 1996. Detail from http://www.pbs.org/wgbh/nova/odyssey/clips/.

of which had appeared in *Life* magazine. The then-new morphing technique undertook to revive the Nilsson brand, most associated with his fetus on the cover of *Life* in 1965, while the commentary traditionally promoted the photographs as replaying evolution. The series website carried downloadable versions of four separate morphing videos, fronted by stills in a Haeckel-style grid (fig. 17.6). It also hosted a "cyberdebate" between the anticreationist Catholic biologist Kenneth R. Miller and Johnson, who objected that "early stages of vertebrate development are actually radically dissimilar."[62]

This primed creationists to pick up the *Science* news. The Catholic biochemist and ID advocate Michael Behe pounced in December 1997 during a two-hour TV debate, also on PBS, over the motion "The Evolutionists Should Acknowledge Creation." In his opening statement Behe held up a copy of Haeckel's embryos and declared that because they were "fraudulent ... a big problem that Darwinism was thought to have solved, embryology, turns out not to have been solved after all" (fig. 17.7).[63] When Richardson and colleagues objected in *Science*, Behe responded that, having "for a century ... embraced a false description," Darwinists could not now say their approach was "'fully consistent' with either conserved or variable embryogenesis," for "then it is consistent with virtually any scenario and makes no predictions." Evolution supposedly failed to explain development.[64]

Behe had suggested on TV that students should be warned about the pictures, and this soon became a campaign.[65] In 1999 Jonathan Wells, a Discovery Institute fellow and minister in Sun Myung Moon's Unification ("Moonie") Church, took the lead. Convinced that Darwinism was "materialistic philosophy masquerading as empirical science," he had for years been determined "to destroy its dominance in our culture." He had taken a theology PhD from Yale, on nineteenth-century debates over Darwinism, and another from Berkeley in developmental biology, chosen because "embryology is the Achilles' heel of Darwinism."[66] Like Brass, Wells was trained in the field but supported by right-wingers hostile to the academic establishment. His first shot, in *American Biology Teacher*, argued that the figures "misrepresent the facts" but stayed studiously neutral about evolution. The grid, Wells averred, created a misleading effect in three ways: by omitting "groups that don't fit neatly

Fig. 17.7 Michael Behe holds up a copy of Haeckel's embryos during a *Firing Line* debate taped at Seton Hall University, South Orange, NJ, on 4 December 1997. William F. Buckley Jr., the conservative commentator and long-running program host, joined the team for the affirmative, with Kenneth Miller and Eugenie Scott among the opposition. The frame can be seen as reworking an antiabortionist tradition of displaying pictures of fetuses during debates (*Life* 68, no. 14 [17 Apr. 1970], 34). Firing Line Broadcast records, FLS203, "A Firing Line Debate: Resolved: That the Evolutionists Should Acknowledge Creation," at 29.55, Hoover Institution Archives.

into Haeckel's scheme"; by distorting the embryos he had selected, as Richardson had shown; and by leaving out the diverse earliest stages. So "it might be better to look elsewhere for evidence of evolution, at least in an introductory course."[67]

In 2000 Wells generalized the assault and made the larger argument, though not his religious agenda, explicit. *Icons of Evolution*, from "the nation's leading conservative publisher," promised to explain *Why Much of What We Teach about Evolution Is Wrong*. With an epigraph from Gould on "the evocative power of a well-chosen picture," Wells targeted ten textbook images, from peppered moths to fossil horses, that other biologists had criticized or qualified. He again attacked Haeckel's drawings as triply "faked" and like Behe concluded that, if the similarity of the earliest embryos had evidenced common descent, only the precommitted could find support in the hourglass too. The drawings had survived because, Wells contended, such icons *were* the evidence for evolution—and if that "best evidence" was "false or misleading, what does that tell us about the theory?"[68]

The book featured illustrations by Jody F. Sjogren, a zoologically trained medical artist who became an active creationist herself. She had previously produced a set of prints depicting "metamorphoses" from God-made birds to man-made warplanes, such as from the bald eagle, "America's symbol of national pride and strength," to that other "dominant raptor," Lockheed Martin's F-22 fighter.[69] Working with Wells—incidentally, a conscientious objector to the Vietnam War[70]—allowed Sjogren to pursue that fascination with design

in a countergrid of zebrafish, frog, turtle, chick, and human embryos. Evolutionists criticized it for exaggerating differences by using various views and scales and making much of the effects of yolk.[71]

Protesting against "dogmatic Darwinists that misrepresent the truth to keep themselves in power," Wells's book served as a primer for textbook activism. He rated texts from A to F. Even substituting photographs for the Haeckel drawings might score only a D. For an A, a book had, among other things, to "acknowledge" early dissimilarity "as an unresolved problem for Darwinian evolution" and consider "the possibility that Darwin's theory of vertebrate origins could be wrong."[72] With echoes of Virchow and Reinke, the publisher's blurb blew "a policeman's whistle, calling upon scientists to ... rid their textbooks of lies."[73]

Icons divided opinion more sharply even than had Brass in Germany ninety-two years before. American antievolutionists, for all that separated young-earth creationism from intelligent design, were more united against evolutionism than the Kepler League, which had both endorsed and distanced itself from Brass. With backing from within the neoconservative administration of George W. Bush, which many scientists held responsible for misusing, distorting, and suppressing research,[74] ID was also more powerful. Evolutionists likewise presented a more united front than "the German embryologists" ever had. Brass had shot at Haeckel, on whom even Darwinists were split, taunting him that his colleagues did not use his pictures. Wells questioned macroevolution, while implying dishonesty among biologists who had reproduced

the embryos, and so rallied the community against him.

The rise of the Internet shaped the rapid exchange of charge, rebuttal, and countercharge. Usenet groups took off in the late 1990s and blogging was soon established. Politicized issues drove science blogging, with *The Panda's Thumb*, *TalkOrigins* and the anticreationist National Center for Science Education (NCSE) confronting Answers in Genesis and Discovery Institute sites.[75] Minnesota developmental biologist, former Lutheran, and militant secularist P. Z. Myers named his top-ranked *Pharyngula: Evolution, Development, and Random Biological Ejaculations from a Godless Liberal* after Ballard's conserved stage and paid Haeckel's embryos close, expert attention from 2003.[76] As in 1909,

activists preached to the converted as they hurled charges of bad faith. Communication was faster and wider, but biological training at a premium still.

Evolutionists panned *Icons*. In *Science* the NCSE director, anthropologist Eugenie C. Scott, argued that individual sentences were "usually technically correct," but "artfully strung together to take the reader off the path of real evolutionary biology and into a thicket of misunderstanding."[77] Critics objected to Wells's treating "textbook examples" as "the best evidence."[78] "The fact that science … textbooks contain plenty of oversimplifications and inaccuracies, and occasionally even major conceptual errors, is not news to anybody and has always been decried by professional scientists and educators."[79] The embryos thus

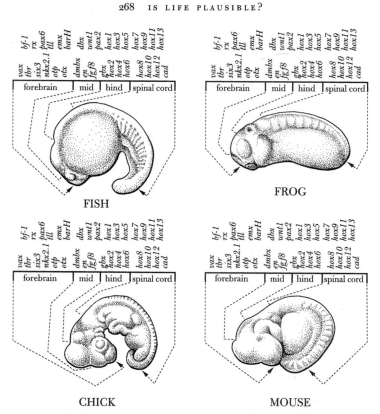

268 IS LIFE PLAUSIBLE?

Fig. 17.8 "Haeckel reconsidered." Vertebrate embryos and their *Hox* gene expression domains compared. These are the four main model systems, so the fish is zebrafish and the frog is *Xenopus*. Illustration © John Norton 2005 from Kirschner and Gerhart 2005, 268.

Figure 40 Haeckel reconsidered. Four embryos of different vertebrate classes are shown at their phylotypic stages, when they look most similar. Although their shapes are distinguishably different, they have the same map of compartments of selector gene expression (indicated by gene names above each drawing). The map has just formed at this stage. Extraembryonic tissues have been removed from the chick and mouse embryos.

differed from the other icons in Wells's "slick book of bogus science."[80] Myers conceded that "Haeckel was wrong. His theory was invalid, some of his drawings were faked, and he willfully over-interpreted the data to prop up a false thesis.... Wells is also correct in criticizing textbook authors for perpetuating Haeckel's infamous diagram without commenting on its inaccuracies or the way it was misused to support a falsified theory."[81]

Few evolutionists defended the figures,[82] but influential responses claimed (with some exaggeration) that textbooks had typically reproduced them in a historical context, and (justifiably) that authors used them to argue that Haeckelian recapitulation was wrong. Many already preferred more accurate drawings or photographs; all should now replace "cartoonish drawings."[83] More fundamentally, evolutionists underscored not just the striking similarities in internal anatomy, but also the deep molecular homologies beneath superficial differences in the earliest stages. As a book coauthored by Wells's PhD supervisor put it: "The real anatomy of the conserved phylotypic stage of vertebrates is not simply the overt shapes and bumps that Haeckel may have embellished, but a highly conserved map of compartments of expressed selector genes, whose functions can be tested individually by genetic experiments. An unbiased view of some of these embryos and the corresponding selector gene domains is shown in [fig. 17.8], where the anatomical similarities are still obvious."[84] Developmental biology had not "been finding growing disparities" but rather "showing us ... *greater* ... similarity between species than previously suspected."[85] Recent research had generated positive images galore, but ID proponents kept the focus on the most problematic.

Ruined Idols as Negative Icons

In 1908–9 the Kepler League tried to stop *Kosmos* lecturers using pictures that were then still far from mainstream. In 2000, with the target in children's textbooks, the Discovery Institute wanted Haeckel's embryos removed. Wells called on biologists "to clean their own house before the taxpaying public has to do it for them," with the risk that "a popular revolt against the Darwinian establishment" would "lower support for scientific research in general." *Icons of Evolution* also recommended action taxpayers could take.[86]

Some authors had acted already. Gilbert corrected the *Developmental Biology* website within a month and obtained photographs from Richardson for the next edition.[87] Kenneth Miller rewrote his and Joe Levine's introductory books and put a note on the website in December 1997. Drawing on Miller's *Nova* experience, the site offered a grid after the Nilsson stills (fig. 17.6) and the next edition "accurate drawings of the embryos made from [these] detailed photomicrographs."[88] Yet responses depended on revision schedules, competence, and views on illustration. Even developmental biologists hesitated over how best to update figures that had lasted so long because they "are a very attractive [and memorable] way of presenting a complex idea."[89] Some substituted Richardson's photographs (fig. 17.5); some worried that these could mislead laypeople by obscuring the similarities.[90] A few authors kept Haeckel's drawings despite his "liberties."[91]

The Discovery Institute hunted Miller and Bruce Alberts, academy president and activist for science education; *Molecular Biology of the Cell* cut the figure from the next edition.[92] ID advocates also went after Haeckel's embryos in state-level disputes over Wells's icons. They were weaponized in the 1999 battle over a decision to delete evolution from science standards in Kansas. An Arkansas bill of 2001 failed to force teachers to instruct students "to make a marginal notation that the statement is a false evidence," but in 2002 the Ohio Board of Education revised standards in response to an *Icons*-based lesson plan that it approved two years later.[93]

In 2003 Texas, the second-largest textbook purchaser (after California) and shaper of the national market, saw the biggest debate. Evolution teaching was mandatory, but the Board of Education had to ensure freedom from "factual errors" and uphold a standard that students should "analyze, review, and critique scientific explanations, including hypotheses and theories, as to their strengths and weaknesses using scientific evidence and information." The Discovery Institute with the affiliated Texans for Better Science Education used Wells's *Icons* as a catalogue of errors. Scientists mobilized to head off the threat to the state's massive biomedical investment.[94]

An elaborate review of eleven draft texts forced publishers to respond to written comments and oral testimony in public hearings.[95] Critics, if perhaps not lay experts in evolutionary biology, rated icons pro-

ficiently.[96] Haeckel's embryos loomed larger in the submissions than the books—several of these offered photographs already—and most willingly replaced the "old and inaccurate" drawings.[97] This counted among the top changes the Discovery Institute achieved,[98] but most publishers held the line against further concessions, and with minor corrections, every text passed. Where the pressure was less intense, the figures could persist, or even appear in new books.[99] Controversy kept on breaking out somewhere else.[100]

ID suffered a major defeat in 2005 with a (conservative Republican, Lutheran) federal judge's ruling in Dover, Pennsylvania, that since it "is a religious view, a mere re-labeling of creationism, and not a scientific theory," "it is unconstitutional to teach ID as an alternative to evolution in a public school science classroom."[101] Ohio rescinded its mandate to teach the "critical analysis of evolution" and the accompanying lesson plan.[102] Controversy died down, but the film *Flock of Dodos* by former marine biologist Randy Olson kept the historical debate alive. Olson has tried to educate scientists to communicate more effectively and so avoid the fate of the dodo. "There's a value to making a few mistakes and coming off like a human being," he has been quoted as saying, "instead of being 100 percent certain and coming off like a robot."[103] Pushing evolutionists to embrace spontaneity and humor, *Flock of Dodos* sided with them but gave their opponents equal time. In one scene a Kansas-based

promoter of ID failed to find Haeckel's embryos in his own biology books, and Olson asserted that texts stopped using them long ago.[104]

After the film showed at festivals, museums, and science centers in early 2006—it debuted on TV in May 2007—the Discovery Institute put out a counterblast on the video-sharing site YouTube, launched in 2005. *Hoax of Dodos* features an irate *Icons* customer arriving at the institute and demanding his money back because Wells's claim that Haeckel's pictures were in modern textbooks was false. A research fellow shows the visitor a 2002 text and a graphic superimposes the figures (fig. 17.9). The video ends with the customer wondering "what else in the movie is bogus." The institute said that Olson had not really checked, and had finally resorted to suggesting that the diagrams were just a "piece of teaching trivia … a crusty artifact from … science history."[105]

So people paid the images fresh attention in all kinds of places they had never been seen before. Cut from new textbooks, they became more visible in old ones. Rivals uploaded figures and discussed their use. The digital environment made the evidence easier to share and debate, but since the texts were still mostly unavailable online and libraries rarely hold multiple editions, no one had easy access to the full range.

As a "dead" icon turned into a controversial illustration to attack, discuss, and perhaps defend, copying surged. Richardson's own articles had had to include

Fig. 17.9 Still from the Discovery Institute video *Hoax of Dodos*. Institute fellow Casey Luskin is showing drawings based on Haeckel's in the 2002 edition of Peter H. Raven and George B. Johnson's *Biology* that his visitor has selected from his shelves. Luskin explains that "it has Haeckel's embryo drawings and what they've actually done is that they've colorized them, but they still have the same fraudulent data where Haeckel fudged the differences between the early stages of the embryos and made them look more similar than they actually are, in order to claim that they all share a common ancestor." Screen image captured with Grab from a video downloaded with TubeTV from YouTube and viewed in QuickTime, 7 Feb. 2007.

the figures he said should no longer be reproduced. Then other journals, newspapers, magazines, and TV programs displayed them for the first time. Crucially, the Discovery Institute endlessly copied the icon they branded a lie. It was not in creationists' interests to expunge all trace: "to vilify, it is also necessary to exhibit." Like the iconoclasts of the Protestant Reformation they deployed "the ruined idols ... as emblems of defeat,"[106] only these were not beheaded statues, but digital images commented and juxtaposed. The aim, going beyond Brass's comparisons, was to create a *negative icon*, a warning of Darwinist infamy that testified not for evolution, but to fraud in Darwin's name. Critics had turned scientists' pictures against them before; in the 1870s antivivisectionist magazines reproduced figures of experimental setups from physiology manuals as evidence of cruelty.[107] Now digital technology and the economics of mass customization enabled creationist networks to respond to individual online orders by printing the icons onto "intelligently designed merchandise" from mugs and aprons to T-shirts and tote bags.[108] Copying around the web distributed the pictures more broadly than ever before—now not despite the forgery charges, but because of them.

Déjà vu All Over Again?

The rediscovery of Haeckel's "fraud" was truly "déjà vu all over again," but also unlike the controversies of the 1870s and even 1908–10. The battle lines are familiar, with the initial complaint from within the biological community and the threat mainly from without, the Discovery Institute instead of the Kepler League. But the third phase of intense debate, possible only because biologists had forgotten or never learned about the first two, was both more historical and more contemporary. Haeckel's questions might be current again, but few outside Germany were now invested in his reputation, while vastly more were implicated in the drawings' suddenly controversial survival.

With news traveling faster and further, more scientists accused, and the pictures more widely used, the debate was longer and more distributed. Haeckel's embryos still troubled boundaries between research science and its communication, fraud and standards. Wells's "best evidence" might be dismissed as outdated, popular, cartoonish, teaching trivia, but leading textbooks and advanced reviews had validated these figures. More as in 1875 than 1908, they mediated between specialist research and general understandings not just for laypeople or even biologists in other fields, but also within developmental biology. Evolution was in no real trouble, but "good science" was hard to separate from "media hype" when a scientist had fed a journalist the story.

Image breaking changed the visibility of the embryos in contradictory ways. Mainly available as negative icons or in historical discussions, their own career seemed to be over. No longer trusted to teach embryology, they had gained the power to raise historical awareness, or at least to make authors temporarily wary of old illustrations. So though excluded from mainstream biology, they still shaped knowledge, either for the moment when people remembered not to use them or, more lastingly, in the debt to them of the reformed grids. But did Haeckel's own drawings have no future beyond creationism and history of science: was this really the end?

nature

THE INTERNATIONAL WEEKLY JOURNAL OF SCIENCE

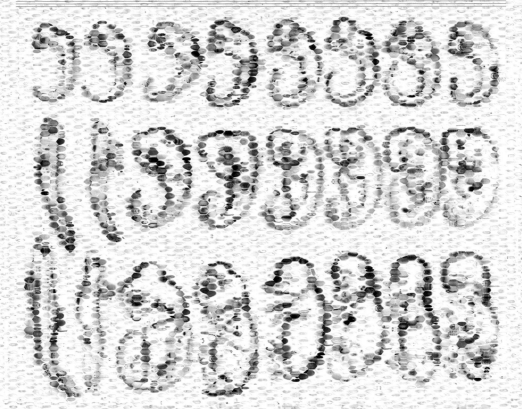

HOURGLASS FIGURES

Confirmation of developmental convergence updates classic of early embryology for the genomics age **PAGES 768, 811 & 815**

↻ **NATURE.COM/NATURE**

9 December 2010 £10

Vol. 468, No. 7325

9 770028 083095 49

{ 18 }

The Shock of the Copy

Haeckel's diagrams might seem too extraordinary—too controversial and too tenacious—to say anything general about how visual representations of knowledge succeed or fail, become taken for granted or cause trouble. In fact, the very different roles they have played— instructive, inaccurate, mysterious, forged, schematic, beautiful, classic, iconic—let them highlight various ways images can survive, stimulate debate, and continue to mold knowledge long after they were first produced. They reveal how consequential, contested, and creative copying can be. As I was writing this book I followed many a twist and turn, but the most recent copy still came as a shock.

By 2008 I assumed the embryos were so tainted they must finally be on their way out. They might hang on where distancing was understood, but their biological career was surely over. I underestimated the advantages of an image in possession of a field. Though still effectively banned from American high schools, in December 2010 a version of the 136-year-old picture occupied one of the most sought-after spaces in science publishing, the cover of *Nature*. A journal sometimes criticized for chasing the latest fashions "update[d]" the "classic of early embryology for the genomics age" (fig. 18.1). Not just associated with cutting-edge research, it was involved in visual innovation once again: this mosaic generated from a database of 66,579 images of gene expression patterns during *Drosophila* embryogenesis inspired the open-source software CoverMaker.[1]

The headline, "Hourglass Figures," played on an ideal female body shape, while the caption explained that the waist in question is the convergence of vertebrate development on a period of similar appearance, the phylotypic stage, before diverging again. The journal presented the mosaic, showing the second, diverging half of the hourglass, as Haeckel's popularization of Baer. Inside, a News

Fig. 18.1 Haeckel's embryos constructed from *Drosophila* embryo images on the cover of *Nature*. The fruit-fly embryos were stained for gene expression by histochemical RNA *in situ* hybridization. The mosaic might also be read as symbolizing the dominance of *Drosophila* in a field once owned by vertebrate embryologists; genomics is increasingly breaking down species barriers. The underlying image is after Romanes (Pavel Tomancak to author, 4 Aug. 2012), though credited to "Haeckel 1879." Image by Tomancak reprinted, by permission from Macmillan Publishers Ltd., from *Nature* 468, no. 7325 (9 Dec. 2010).

and Views piece introduced two papers from different Max Planck institutes as proving by comparative genomics what had rested on morphology alone. One group compared early gene expression in six *Drosophila* species to show that divergence reaches a minimum at the phylotypic stage, with genes involved in development following the hourglass pattern most closely. The other group, having divided zebrafish genes by the age of their emergence in evolution, found that the oldest are expressed most in the same interval, with younger ones making more of a contribution earlier and later. Putting the results together: "Genes expressed during the phylotypic stage are both evolutionarily older and more conserved across the genus than those expressed at other stages."[2] This fit with a near consensus in evo-devo on the hourglass and the stage—or, in vertebrates, period—even if debate continues over its capacity to resist evolutionary change.[3]

Researchers have for several decades competed to put their discoveries on covers. These still make news and can become iconic in their own right, but have less impact and may be more ephemeral now that journals are mostly read online. So it matters that the issue refers directly to Haeckel nowhere else, in part because *Nature* strictly limits numbers of references. Pavel Tomancak's group "did not want to annoy potential reviewers"; Diethard Tautz, the senior author

of the other paper, cited Gould's *Ontogeny and Phylogeny* as a summary account; and the News and Views authors, Benjamin Prud'homme and Nicolas Gompel from Marseille, focused on "what was new."[4] As if to "compensate," *Nature* chose the Haeckel figures for the cover from candidates submitted by both groups and presumably others. Tomancak, who knew that journals were eager for mosaics, had "worried" this one might be "too controversial," while hoping it would appeal as "truly iconic."[5] His group wanted it to stand for the work, and the others approved.

The checkered history did not matter, because for Tomancak the drawings "convey beautifully the idea of embryonic conservation as manifestation of common descent"; for Tautz the cover "was a beautiful graphic representation of the essence of our papers."[6] Aware of the forgery charges, both saw the critiques as exaggerated, a view that had been backed by Klaus Sander, one of Germany's most distinguished developmental biologists, and Robert J. Richards's sympathetic Haeckel biography from the University of Chicago Press.[7] Tomancak felt that "creationist propaganda has distorted Haeckel's scientific legacy and … I hoped to contribute [to] its restoration." For Tautz, his embryos were "not for teaching anatomy," but "convey[ed] a principle" that was "still fully correct." With only slightly different emphasis Prud'homme suggested that while

Fig. 18.2 "Evolutionary history can be a bit repetitive." Print-on-demand mug available since 2008, most recently mainly via Zazzle. Image on mug by Lucille S. Chang, Words & Unwords Store; photograph by Adrian Newman.

the image retained much truth, it had also become a "'textbook' example" of "falsification"; in some circumstances it might be important to point out that such idealization is unacceptable today.[8] But here Tomancak could play with a classic. Produced in Dresden by fruit-fly experts for a British international journal, and distanced as the historical inspiration for current research, the cover caused little trouble. In the United States biologists might not have been so relaxed, but even America shows signs of giving Haeckel's pictures a more complex future.

As after the controversies of the 1870s and 1909, highly informed, sharply divided opinions coexist with ignorance, indifference, and irony. This time embryologists are more tolerant, creationists exploit the issue more, and there is little immediate prospect of much classroom use. To the few still listening, the Discovery Institute objected in 2011 that, "Like a zombie that just won't die, these bogus drawings keep coming back." Rice University in Texas had asked students to arrange the individual figures in order, with the answer, the Romanes diagrams, labeled "Top secret! Only view at the end!"[9] Though not always secret, the pictures remain rare in high schools. Elsewhere they circulate in ways it can be hard to classify as knowing or naïve.

Since 2008 the grid has been available with a telling caption on such print-on-demand items as badges, mugs, key fobs, fridge magnets, mouse mats, bumper stickers, neckties, aprons, and, of course, pet T-shirts.[10] The advertising invites purchasers of "scientific geek humor gifts"[11] to consider the "infamous drawing" representing the "debunked" recapitulation theory as nevertheless "perfect" for "anyone who understands that 'evolutionary history can be a bit repetitive'" (fig. 18.2).[12] Haeckel's embryos compete with creationist alternatives to adorn mass-customized merchandise.[13] But would you bet against their eventual rehabilitation for a wider range of uses or their ever sparking a big controversy again? Repetition has an unpredictable power when images are copied and claims reiterated independently and these may then intersect.

Produced in an unsung rearrangement between editions, the first embryo grid was a node of creativity from which, by extracting, expanding, and substituting, copying then spawned a large and long-lived family. Pictures may be harder to appropriate than words,

but the survivors share with canonical texts a certain openness to interpretation.[14] Haeckel's succeeded to the extent that they formed a persuasive package within an evolutionist consensus, and were at the same time complex enough to invite reframing and reworking. Familarity then made that image either the obvious choice or the standard starting point from which to move on. Users treated the grid as a flexible resource, from a store of simpler, cheaper figures to a frame within which to supplant every cell, from outlines to trace to a mosaic to construct.[15]

Media and budgets constrain copying. Haeckel's embryos were favored by conditions as general as the invention of photomechanical methods for the ready reproduction of whole plates, and the tendency of mid-twentieth-century college textbooks to add content rather than replace it. The grid was protected more specifically by cutting parts, preservation as an imagetext in a stereotyped niche, and attribution to someone else. Because it also benefited from being out of copyright, I almost took the law for granted—until I needed permission to copy it myself in this book.[16]

To turn the *Science* news of "Fraud rediscovered" into figure 17.4 took three permissions—from the American Association for the Advancement of Science, the Bodleian Library, and Michael Richardson—all generously granted free of charge. Some research libraries offer an efficient, economical service—German universities are often exemplary—while some commercial textbook publishers do not. More remarkably, Jonathan Wells's illustrator refused permission because she judged "the thesis" of a previous publication of mine "in conflict with" that of Wells and would not allow a use that "supports Darwinism."[17] Having collaborated in tarnishing icons of evolution, she perhaps feared for her own drawing. Copyright is flouted all over the Internet, but to maximize revenue, ensure a flattering context, or take sides rights holders may restrict use. By contrast, scientists commit to free exchange, and artists make money from license fees (or waive them for academic publications). Both have an interest in the selection of their work, reproduced with due credit, for standard status.

By casting contemporaries into the shade, canonical illustrations structure what is and can be known. By obscuring the history of their own production and use, they reduce the chances of an effective challenge. Someone somewhere has surely repeated the charges

against Haeckel every year, if not every month, since 1868. Small-scale disputes continually flared up in clashes between representatives of different milieus. Meanwhile the allegations and the images circulated widely, often independently, and with different dynamics. This created complex, sometimes volatile, situations that generated repeated disagreement after long intervals of apparent indifference. Three times, in 1875, 1908, and 1997, Haeckel's embryos were catapulted into the national or international news.

The big controversies depended on chains of contingent events but shared some conditions: politicized struggles over Darwinism, a hostile biologist with relevant expertise, and a fresh or fresh-seeming claim that refracted the record through current concerns. Absolute novelty did not matter, only that fading memories, expanding audiences, and recent copies brought enough people to see the topic as important and new. The latest row started with an assertion about Haeckel that would not have surprised biologists a century ago. Yet the wide use of his pictures would have amazed many—especially after debates each faster and bigger than the one before.

Commentators in the 1870s marveled that Haeckel's books sold ten or twenty thousand. As reviewers and journalists filtered the charges, coverage stayed sporadic, with little international reach. In 1908, with millions reading Darwinism, a pressure group orchestrated a newspaper campaign which reverberated through a larger and more differentiated press to produce the clear sense of an unfolding plot and multiple, linked focuses of dispute. Even that seems halting compared with the global Internet-mediated spectacular that Richardson's *Times* interview sparked in 1997. Reported the next month in *Science*, the story was suddenly available internationally to creationists primed to exploit it, as they did on TV three months later, and then Wells's book made it easy to organize campaigns. In countless local confrontations and media outlets, the issue developed monthly, weekly, and on some blogs even hourly, and so forced change.

These controversies defined relations of trust and distrust between makers and spectators and explored moral qualities beyond the stereotype of the professor as servant of the state: Haeckel the "forger," but also the "genius" and "prophet" set against the "specialists" and "schoolmasters."[18] In more conciliatory moments the diversity expressed the realization that science might take all sorts. These types related in different ways to publics that had changed since Oken's "educated of all estates" and in the wake of Haeckel's critique of the "so-called educated." The Kepler League's appeal to "the people [*Volk*]" accelerated the breakdown of liberal dominance and the creation of a mass audience. More frequent invocation of "the German people" and "our people," and the occasional use of "his people [*Leute*]," showed how nationalistic and factionalized this public could be. Where Haeckel had once insisted on nonscientists' right to follow scientific disputes, the league's demand that the professors open the "closed club" has echoed through the Discovery Institute's agitation on behalf of "taxpayers" in the recent debate.

For some groups Haeckel was always the target, and attacking the embryos—"as irrelevant … as a catastrophe in the constellation of Perseus"[19]—just a means to this end. But sometimes his images emerged unscathed, or initially even benefited, from association with him, while at other times and elsewhere people used them without knowing they were his or rejected them for other reasons. We accept a picture less because we believe individual scientists or artists to whom we rarely have independent access than because a periodical, publisher, channel, or URL inspires trust. That is why textbook copying is so insidious, why researchers want their figure on the cover of *Nature*, and why journals now take extra steps to protect themselves from fraud.

Controversy has long stimulated the setting up of standards, such as normal plates, tables, and stages in embryology. Though relatively informal, these are used because communication has become impossible without them. But in a sign of expanding regulation and a presumption that the possibility of fraud must always be considered, in 2002 the *Journal of Cell Biology* adopted explicit rules to cope with the transition to electronic submission and reviewing: all figures in accepted papers are screened for evidence of manipulation. The nondetection of doctored photographs in the 2005 Korean stem-cell scandal promoted the generalization of these guidelines to safeguard the integrity of research data.[20]

The three debates over Haeckel's drawings display a trend, as reproduction became easier, for arguments over pictures to be fought out with pictures. Seeing became more explicitly comparative, and criticism no longer mainly inhibited copying but also promoted it.

In the 1870s critics had worried about the value and propriety of showing wood engravings and lithographs of embryos in public. Though His offered counterimages, he did not reproduce Haeckel's, and these and the charges largely excluded each other until 1908, when it was easier to print pictures and more important to show nonexperts what was at stake. Pamphlets now compared copies and originals on the same page. Around 2000, readers expected to see the evidence, and almost every discussion presented the embryos. Enemies worked to make these infamous, but meanings are not so easily controlled.

Textbook publication potentially signifies something different for a figure previously unpublished or carried over from numerous earlier editions, taken from a classic article—or an article that is thus made classic—or introduced via the latest commercial visual aid. Scientists may relate differently to pictures they first encountered at school or as products of recent research. In different places, at different times, and for different viewers, illustrations may be marked by their histories or treated as timeless. The visual world of knowledge is a cross-section through thousands of these trajectories, acknowledged or not, as modified by larger shifts in design practice and the communications industry, including availability from such repositories as libraries, museums, and image banks.

Haeckel's embryos did not merely survive the era of engravings and lithographs. The halftone process and digital photography allowed them respectively to join X-rays in the early twentieth century and stem cells in the early twenty-first as subjects of major debates. "The shock of the copy," like "the shock of the old,"[21] is not that scientific images last for long periods or even that they may reach furthest a century after they were first produced, but their repeated involvement in innovation. From the 1870s Haeckel's drawings goaded specialists to set up the technical standards of development that are still used today. In 1908, embryologists in Germany first gained a collective public identity (it seems) as the experts summoned to testify against him. But the grids did not begin to enter embryology books, advanced reviews, and specialized journals for another seventy-five years.

Copying usually passes without a word, framing knowledge subtly and silently. Sometimes it places visual representations in novel contexts that direct fresh eyes in new ways. Occasionally someone questions faithfulness, to nature or an existing illustration, and a contest ensues. But controversies are rarely conclusive. So while most images fail to establish themselves or gradually disappear, it can be almost impossible to wave a problematic but powerful picture goodbye.

ACKNOWLEDGMENTS

I began researching the history of embryo images in 1996, and this book started to take shape in 2003. At a time of ever more pressure to fit outputs to short funding cycles, I am very lucky to have been allowed to write it over a whole decade, and I owe an enormous debt of gratitude to institutions and people for patient support over so many years.

The Cambridge Department of History and Philosophy of Science has sustained me in countless ways under the leadership of the late Peter Lipton and then John Forrester. Tamara Hug and David Thompson have run an exemplary administration, and Jill Whitelock, Tim Eggington, Anna Jones, and Dawn Moutrey made the Whipple Library a gem of a collection and a delight to use. It has been a rare privilege to have as colleagues Simon Schaffer and Jim Secord, and I have fond memories of our evenings discussing seriality. Jim has taken a close interest in the book and been characteristically liberal with encouragement and advice from beginning to end. Nick Jardine, Tatjana Buklijas, and Ayako Sakurai shaped my understanding of nineteenth-century German science. Tatjana, with whom I curated the online exhibition *Making Visible Embryos*, Sarah Franklin, Martin Johnson, Salim Al-Gailani, Jesse Olszynko-Gryn, Dmitriy Myelnikov, and especially Tim Horder have taught me much about embryology. Tim has been a frequent and valued interlocutor about Haeckel and recapitulation. My interactions with Cambridge historians of medicine, mainly in the "Generation to Reproduction" program, have more often tempted me away from this book than helped me finish it, but I would not have had it any other way. As well as those already named, it has been a pleasure to work with, among others, Lauren Kassell, Rebecca Flemming, Peter Murray Jones, Richard Smith, Simon Szreter, Francis Neary, Soraya de Chadarevian, Sarah Wilmot, Karin Ekholm,

Michael Bresalier, Ayesha Nathoo, Nick Whitfield, Jenny Bangham, and Mary Fissell. I would also like to acknowledge the CRASSH-supported Cambridge Interdisciplinary Reproduction Forum and the Ischia Summer Schools on the History of the Life Sciences for facilitating intellectual exchange.

Just before Haeckel's embryos budded off from a still-planned history of visualizing human development, I was very fortunate to spend several months at the Max Planck Institute for the History of Science in Berlin. In the departments of Lorraine Daston and Hans-Jörg Rheinberger I did some of the key research and benefited from stimulating interactions, especially in the project "Common Languages of Art and Science." Karl Steinacker generously put a roof over my head and, before his untimely death, Rainer Zocher put many a Hefeweizen in my hand.

Archives and libraries deserve special thanks, in the first place the Ernst Haeckel House in Jena, where I have been welcomed since 1993 and the late director Olaf Breidbach kindly permitted me to research. I would have been lost without a great deal of expert advice from the curators, the late Erika Krauße and Thomas Bach, who has spent many hours helping me. In Jena I also thank Uwe Hoßfeld for all kinds of tips, Rüdiger Stutz and his family for hospitality, Gerta Puchert for showing me zoological wall charts, and Johanna Triebe of the Thüringer Universitäts- und Landesbibliothek for assistance with images. In Basel I worked happily in the Staatsarchiv, Universitätsbibliothek, and Anatomisches Museum, where Daniel Kress, Martin Steinmann, Hugo Kurz, and others gave friendly support, and Charles and Annick Thompson provided a place to stay. I further thank the staffs of the other institutions credited in the figure captions and references, above all the outstanding Cambridge libraries, for assistance with and permission to reproduce materials in their care. At the University Library I am particularly grateful to Julie Inwood and Alison Zammer for efficiently ordering a large number of interlibrary loans, and to Les Goody and Don Manning in Imaging Services.

I am indebted also to those who responded promptly and helpfully to my questions: Michael Richardson and Scott Gilbert, Lucille Chang, Richard Elinson, Nigel Hawkes, Julian Lewis, Benjamin Prud'homme, Nicolaas Rupke, Diethard Tautz, and Pavel Tomancak. For crucial pieces of advice, I thank Thomas Brandstetter, Troy Britain, Solveig Jülich, Ron Ladouceur, Nick Matzke, Signe Nipper Nielsen, Ron Numbers, Jesse Olszynko-Gryn, and Constance Sommerey, and for help with research materials, Rhiannon Baxter (BSCS), Eva Hürtgen (Domkapitel Aachen), Shelley Innes (Darwin Correspondence Project), Elizabeth Lockett (National Museum of Health and Medicine), Susan McGlew (Sinauer Associates), Klaus-Dieter Pett (Landesarchiv Berlin), Mai Reitmeyer (American Museum of Natural History), Robin Rider (University of Wisconsin–Madison), and Michael Venator.

Lengthy projects involving work abroad, very various and scattered materials, and the reproduction of many images do not come cheap, and this one would have been impossible without funding from the Wellcome Trust, through the research leave award in the history of medicine with which I began (grant number 063293), and the enhancement and strategic awards through which I continued and completed it (074298 and 088708). I greatly appreciate the support of the Trust and its staff, especially Clare Matterson, Tony Woods, Nils Fietje, Elizabeth Shaw, and David Clayton. By teaching so well while I was on leave, Sarah Hodges, Vanessa Heggie, and Richard Barnett let me focus on research.

The responses to over thirty talks have kept me going by convincing me the topic was of wide enough interest to justify my investment in it, and have shaped and reshaped the work. I enjoyed all the warm hospitality and learned much from constructive criticism in Cambridge, London, Oxford, Exeter, Aberystwyth, Manchester, Durham, Paris, Madrid, Basel, Vienna, Dresden, Berlin, Aarhus, Oslo, Chicago, Madison, Seoul, and Beijing. If I single out three experiences, it is because they came at critical stages. In Canterbury in 2003 Ulf Schmidt and Charlotte Sleigh gave the research specifically for this book its earliest outing and reacted positively to a very preliminary talk. I first presented the whole project in 2007 to an extraordinarily engaged audience at a seminar that Jonathan Topham hosted in Leeds. And in 2011 participation in the wonderful 6th European Spring School on the History of Science and Popularization, organized by Josep Simon and Alfons Zarzoso in Menorca, helped me see the work in a larger frame.

The writing has benefited from insightful feedback too, on an *Isis* article published in 2006, and then in

winter 2008–9, when the Cambridge Scientific Images Discussion Group run by Mirjam Brusius and Geoffrey Belknap devoted four meetings to draft chapters. Six people generously read the whole manuscript: Silvia De Renzi, Jim Secord, Tim Horder, Soraya de Chadarevian, and two readers for the press. I thank them all for their suggestions, especially Silvia, Jim, and Tim, who read parts of it more than once. For comments on individual chapters I am grateful to Christina Benninghaus, Scott Gilbert, and Adam Shapiro, who also gave me access to his important work at an early stage. I take responsibility for the errors that will inevitably remain.

Karen Merikangas Darling, my editor at the University of Chicago Press, has with great efficiency, enthusiasm, and just the right amount of patience steered text and images into a book. She and Susan Bielstein secured a grant from the Getty Trust for an enviable extent and quality of illustration that has allowed me to argue in pictures almost as much as in words. Abby Collier magicked many problems away. Carol Saller's sensitive editing materially improved the manuscript, and with Micah Fehrenbacher's and Tadd Adcox's effective marketing made everything run smoothly on the home straight. Bonny McLaughlin created the index. In Cambridge, Ian Bolton and Adrian Newman (Anatomy Visual Media Group) scanned images and prepared the figures with their usual good humor and expertise. Jenny Bangham skillfully constructed the graph.

Little of *Haeckel's Embryos* has been published before and none in its present form, but early versions of chapters 5–8 were summarized in "Pictures of Evolution and Charges of Fraud: Ernst Haeckel's Embryological Illustrations," *Isis* 97 (2006): 260–301 (© 2006 by The History of Science Society). A few paragraphs of chapter 9 use "Approaches and Species in the History of Vertebrate Embryology," in *Vertebrate Embryogenesis: Embryological, Cellular and Genetic Methods*, edited by Francisco J. Pelegri (New York: Humana Press, 2011), 1–20, with kind permission of Springer Science+Business Media (© 2011). Chapter 10 draws on research and arguments set out at greater length in "Producing Development: The Anatomy of Human Embryos and the Norms of Wilhelm His," *Bulletin of the History of Medicine* 74 (2000): 29–79 (© 2000 by The Johns Hopkins University Press); and "Visual Standards and Disciplinary Change: Normal Plates, Tables and Stages in Embryology," *History of Science* 43 (2005): 239–303.

Silvia, Lia, and our families in England and Italy have given most, through the time the book has taken me away from them, and the myriad ways in which they have tolerated my preoccupations, shown an interest, offered advice, and provided diversions. My parents nurtured my curiosity and taught me to turn it into projects. Their love and support mean more than I could ever say.

ABBREVIATIONS

AA	*Anatomischer Anzeiger*
AAPAA	*Archiv für Anatomie und Physiologie (Anatomische Abtheilung)*
AHPB	*Annals of the History and Philosophy of Biology*
AZ	*Allgemeine Zeitung*
BHM	*Bulletin of the History of Medicine*
BJHS	*British Journal for the History of Science*
BMJ	*British Medical Journal*
DMW	*Deutsche medizinische Wochenschrift*
DSB	*Dictionary of Scientific Biography*
EH	Ernst Haeckel
EHH	Ernst-Haeckel-Haus, Jena
FZ	*Frankfurter Zeitung*
HPLS	*History and Philosophy of the Life Sciences*
HS	*History of Science*
ID	Intelligent design
IJDB	*International Journal of Developmental Biology*
IZ	*Illustrirte Zeitung*
JGM	*(Schmidt's) Jahrbücher der in- und ausländischen gesammten Medicin*
JHB	*Journal of the History of Biology*
JLFM	*Jahresbericht über die Leistungen und Fortschritte in der gesammten Medicin*
MHJ	*Medizinhistorisches Journal*

NCSE National Center for Science Education
NSUB Niedersächsische Staats- und Universitätsbibliothek Göttingen
NYT *New York Times*
PB *Periodische Blätter zur wissenschaftlichen Besprechung der großen religiösen Fragen der Gegenwart*
QJMS *Quarterly Journal of Microscopical Science*
SBB Staatsbibliothek zu Berlin
UPNE University Press of New England
VWB Verlag für Wissenschaft und Bildung
ZwZ *Zeitschrift für wissenschaftliche Zoologie*

NOTES

Note: All translations are by the author, using English editions as guides where available. All emphasis is in the originals.

CHAPTER 1

1. Haeckel 1868, 240; 1874a, xiv.

2. A future geneticist, sent to take books for his father out of the citizens' club library in Frankfurt am Main, on the effect of Haeckel's illicitly borrowed *Natürliche Schöpfungsgeschichte*: Goldschmidt 1956, 34–36.

3. *100 Photographs That Changed the World* 2003; further on the X-ray: Glasser 1989; Cartwright 1995; on mushroom clouds: G. Paul 2006; further on news photographs: Hariman and Lucaites 2007; for an accessible overview of "superstar" icons: M. Kemp 2012; for stories about "key images in the history of science": Barrow 2008.

4. Cosgrove 1994; Poole 2008; Helmreich 2011; Duden 1993; Jülich 2011.

5. Daston and Galison 1992.

6. Monmonier 2004.

7. Sappol 2006.

8. Sassoon 2001; M. Kemp 2012, 140–65; further: Brzyski 2007.

9. Nelkin and Lindee 1995; de Chadarevian and Kamminga 2002; de Chadarevian 2003; Heßler 2007.

10. These edited books offer general entry points to the literature on the history of science and the visual: Lynch and Woolgar 1990; Jones and Galison 1998; Gugerli and Orland 2002; Latour and Weibel 2002; de Chadarevian and Hopwood 2004; Heßler 2006; Pauwels 2006; Shteir and Lightman 2006; Daston and Lunbeck 2011; N. Anderson and Dietrich 2012; see also Nikolow and Bluma 2008.

11. On the history of copying images: e.g., Haskell and Penny 1981; Beard 1994; Zorach and Rodini 2005; Kusukawa 2012, 64–69; on an early-modern classic, Albrecht Dürer's rhinoceros: F. Cole 1953; T. Clarke 1986.

12. Historians of books have followed the replication of texts, and the conditions for

stability or fragility, through print runs, editions, translations, excerpting, quotation, and discussion in conversation, but have relegated the increasingly dominant illustrations to a minority concern. For the history of science: Johns 1998; J. Secord 2000; Topham 2004; also, e.g., Turney 1998; Fissell 2003. Even histories of book illustration privilege techniques for taking drawings, paintings, and photographs into print over the transfers that have spread pictures from one printed book to another. For pictures on the page: Jussim 1983; P. Anderson 1991; Armstrong 1998; Beegan 2008; in the sciences: Pang 1994–95; Hentschel 2002; Hansen 2009; Prodger 2009; Kusukawa 2012.

13. See, in general: Brewer and Porter 1993; J. Secord 2000; Edgerton 2006; and for the nineteenth-century literary debate: Macfarlane 2007.

14. S. Gould 1991a, 168–81; 1991b, 23–52; 1997; further: Griesemer and Wimsatt 1989; for more on evolution images: Uschmann 1967; Barsanti 1992; Bouquet 1996; J. Smith 2006a; Clark 2008; Donald and Munro 2009; Kort and Hollein 2009; B. Larson and Brauer 2009; Prodger 2009; Voss 2010; on Darwin himself as icon: Browne 2001, 2009; J. Secord 2009.

15. D. Kaiser 2005.

16. Surveys of the changing representations of a phenomenon offer other advantages: e.g., Rudwick 1992; Mitchell 1998; Moser 1998; for a history of a visual motif: Ginzburg 2001.

17. Latour and Weibel 2002.

18. Pennisi 1997.

19. Though the literature on the case was already large, and expanded through the recent controversy, the only book in English is a Jesuit attack: Assmuth and Hull 1915; the only extended scholarly study is Gursch 1981.

20. On high-status embryological images: Gilbert 1991; Maienschein 1991b; Duden 1993, 2002; Hopwood 1999, 2000a, 2002, 2005, 2012; Tammiksaar and Brauckmann 2004; Buklijas and Hopwood 2008; Ekholm 2010; Wellmann 2010; Brauckmann 2012b; see also Landecker 2006.

21. On limits to Haeckel's popularity: Daum 1998, 307.

22. Fleck 1979, 111–25; Schaffer 1998, 221.

23. Hopwood 2000a.

24. For a survey: Buklijas and Hopwood 2008; on human embryos further: Petchesky 1987; Duden 1993, 1999, 2002; Hopwood 2000a, 2005, 2012; L. Morgan 2009; see also Wellmann 2010.

25. E.g., Seidler 1993; Usborne 2007; Dubow 2011.

26. Bölsche 1891a, 259.

27. Hopwood 2000a, 2005.

28. Bader, Gaier, and Wolf 2010; Hopwood, Schaffer, and Secord 2010.

29. Hopwood 2006.

30. The most influential survey: Broad and Wade 1982; for discussion of this issue: D. Kevles 1998, 107–10; Judson 2004, 43–98; for approaches to fraud in science further: Sapp 1990; Mackintosh 1995; Tucker 1997; Cook 2001; Spary 2003; Gliboff 2006; Hopwood 2006; Reulecke 2006.

31. While Haeckel's biographers fight over the essence of his Darwinism, e.g., Gasman 1971 (from the title of which the first quotation is taken); and R. Richards 2008, it may be more

helpful to understand him, and his drawing, as essentially contested: Hopwood 2000b; more generally on "metabiography": Fara 2002; Rupke 2008. The second quotation heads a report of a Walter Ulbricht speech in *Neues Deutschland*, 25 Oct. 1960, 3.

32. Richardson et al. 1997; also Oppenheimer 1987, 134; for a critique: Rupp-Eisenreich 1996, 2106–7.

33. E.g., Haeckel 1891, 2:857–64; Richardson and Keuck 2002; R. Richards 2008.

34. Daston 1999, 28–29; Daston and Galison 2007, 191–95.

35. Gursch 1981, 137–38; Sapp 1990, 16–22, with reference to the 1908–10 controversy. Sapp pioneered the application of sociology of scientific knowledge to histories of fraud, though the execution was flawed: Jonathan Harwood, *Annals of Science* 50 (1993): 493–95; Trevor Pinch, "Generations of SSK," *Social Studies of Science* 23 (1993): 363–73.

36. On the German debates: Kelly 1981; Weindling 1989a; Nyhart 1995; Bayertz 1998; Daum 1998; on eugenics, most recently: Bashford and Levine 2010; on Darwinism in Europe and the English-speaking world: Glick 1988; Numbers and Stenhouse 1999; Glick, Puig-Samper, and Ruiz 2001; Artigas, Glick, and Martínez 2006; Numbers 2006; E. Engels and Glick 2008; and esp. J. Secord 2010. Though Haeckel had huge international reach, and crops up in this literature, dedicated studies of import are rare: Krauße 1993; Aescht et al. 1998; Hoßfeld and Olsson 2003; Kyriakou and Skordoulis 2010; Nieto-Galan 2012.

37. Judson 2004, 52–58, 72–79, reviews these cases.

38. So complements work such as Haynes 1994; and Shapin 2008.

39. E.g., Kirschner and Gerhart 2005.

CHAPTER 2

1. Baer 1828, 221.

2. Darwin 1859, 439.

3. Haeckel 1872, xxxv.

4. Nathanael Lieberkühn, reported in Dennert 1901, 33.

5. Histories of ideas: Russell 1916; Toellner 1975; Lenoir 1989; R. Richards 1992.

6. Duden 1999, 2002; Hopwood 2000a, 2002, 2005; Buklijas and Hopwood 2008; Wellmann 2010; surveys of nineteenth-century embryology: Churchill 1994; Hopwood 2009a, 2011; more generally on seriality in nineteenth-century science: Hopwood, Schaffer, and Secord 2010.

7. E.g., Bischoff 1842c, 861–67.

8. Jardine 1991, 18–19; Barsanti 1992.

9. Lovejoy 1936, 242–87; Foucault 1970; most recently: Hopwood, Schaffer, and Secord 2010.

10. Haeckel 1868, 38–50, 89–95; Foucault 1970; Rudwick 2005, 388–92; Corsi 2011.

11. Appel 1987, 40–68; Rudwick 2005.

12. For a review: Hopwood 2009a, 287–91; further: esp. Roe 1981; Appel 1987; Hagner 1999; Duden, Schlumbohm, and Veit 2002.

13. Roe 1981; Roger 1997.

14. S. Gould 1977, 13–68; Lenoir 1989, 17–53; Jardine 1991, 12–55; Mengal 1993.

15. Jardine 1991, 37–50; Oken is quoted on p. 47.

16. Appel 1987; Desmond 1989.

17. Pagenstecher 1913, 20.

18. Hopwood 2000a; for working objects: Daston and Galison 1992, 85.

19. Wellmann 2010 contains some strong statements about pictures, but pp. 107–36 present the new view of development as primarily conceptual.

20. E.g., Albrecht von Haller and William Harvey: Adelmann 1966, vol. 2; most recently: Ekholm 2010.

21. Ecker 1859b.

22. W. His 1868, vii.

23. A survey: Buklijas and Hopwood 2008.

24. Fischer-Homberger 1983, 222–92; McLaren 1984, 113–44; Jordanova 1985; Duden 1989, 2002; "Unborn," in Buklijas and Hopwood 2008; see also Stolberg 2009, 106–16.

25. Duden 1999, 2002; Enke 2000, 81–110; 2002; "Development," in Buklijas and Hopwood 2008. That view needs extra justification since it has been argued that it is nothing of the kind, but merely a chronological tableau of isolated anatomical preparations, organized by size: Wellmann 2010, 283–91.

26. Soemmerring 2000, 170–73.

27. Ibid., 172–73.

28. Choulant 1852, on Koeck: Geus 1985.

29. Soemmerring 2000, 172–73. Since Soemmerring had too few specimens to achieve as complete a single-sex series, he unsurprisingly mixed preparations he identified as male and female; so did influential late nineteenth-century seriations, e.g., W. His 1885, 254.

30. On techniques for printing illustrations: Benson 2008.

31. Soemmerring 2000, 172–73; further: Fischer-Homberger 1983, 222–92; Duden 1999.

32. Wilhelm Heinse to Soemmerring, 31 Jan. 1796, quoted in Soemmerring 2000, 85.

33. McLaren 1984; Duden 1989; Seidler 1993.

34. Valentin 1835b, 357–58; Enke 2000, 104–10.

35. Bischoff 1842b, 122; 1842c, 867.

36. R. Wagner 1839a, 93; also Döllinger 1824, 12.

37. Adelmann 1966; Ekholm 2010.

38. Roe 1981, 79–83; Churchill 1994; Wellmann 2010.

39. A medical dissertation is the chief claim to fame even of a "forgotten pioneer": Beetschen 1995; more generally on research in and around the universities: Nyhart 1995, 2009; D. Phillips 2012.

40. Lenoir 1989, 65–71.

41. *Isis oder Encyclopädische Zeitung* 1 (1817): 1529–40, on 1529.

42. Malpighi, in Adelmann 1966, 2:937.

43. Pander 2003; 1817, 30. It is unclear how profound a shift this was; Wellmann 2010 makes it part of a new episteme of "rhythm."

44. Baer 1828, 5–7.

45. Pander 2003; further: Raikov 1984.

46. *Isis oder Encyclopädische Zeitung* 1 (1817): 1529–40, on 1528, 1539–40, 1533.

47. Pander 1817, 29–30; also "Entwickelung des Küchels," *Isis oder Encyclopädische Zeitung* 2 (1818): 512–24.

48. Baer to Woldemar von Ditmar, 10 July 1816, quoted in the standard biography, Raikov 1968, 91.

49. Baer 1886, 302.

50. W. His 1868; Haeckel 1875a.

51. Baer 1828, 3–8; further: Hopwood 2005, 245–47.

52. Baer 1828, xv–xvi; Tammiksaar and Brauckmann 2004; Wellmann 2010, 345–69.

53. Baer 1828; Lenoir 1989, 72–95.

54. Voss 2010, 89–102; for Baer's private tree: Brauckmann 2012a.

55. Baer 1827, 740.

56. "Ueber Entwickelungsgeschichte der Thiere," *Isis von Oken* 22 (1829): 206–12.

57. Baer 1956.

58. Lenoir 1989, 96.

59. Bischoff 1854, 11, with reference to deer uteri.

60. Kußmaul 1960, 106; further on Bischoff: "Selbstbiographie," Institut für Anatomie und Zellbiologie, Justus-Liebig-Universität Giessen; Giese 1990.

61. Bischoff 1842a, 140.

62. Bischoff to Vieweg, 29 Mar. 1842, Universitätsbibliothek Braunschweig, Vieweg-Archive: V1B:128.

63. Bischoff to Vieweg, 29 Mar. 1842, 13 Mar. 1841 (print run), ibid.; on Vieweg: R. O., "Deutsche Buchhändler, 15: Eduard Vieweg," *IZ* 54, no. 1386 (22 Jan. 1870): 59, 61–62.

64. Johannes Müller reported, via Carl Reichert, in Russell 1916, 138.

65. Lenoir 1989; Appel 1987; Nyhart 1995, 35–64; R. Richards 2002.

66. E. Clarke and Jacyna 1987; Hagner 2004.

67. Hopwood 2005, 247–48.

68. Agassiz 1849, 104; 1857, 1:84; on Agassiz: Lurie 1988.

69. Malpighi, in Adelmann 1966, 2:979.

70. Bischoff 1854, 3.

71. Rathke 1839, 1848, 1866; H. Menz 2000, 193–210.

72. Lurie 1988, 109; the phrase is Vogt's.

73. Agassiz 1849, 7; 1857, 84.

74. Rathke 1825; Lenoir 1989, 95–102; H. Menz 2000, 149–69.

75. E. Clarke and Jacyna 1987.

76. E.g., Bischoff 1842a, 46–80.

77. Oppenheimer 1967, 256–94; on Remak: Schmiedebach 1995.

78. Valentin 1835a, xi.

79. Bischoff 1842b, 159–60; also R. Wagner 1839a, 91; Erdl 1845, v; for the "species politics": Hopwood 2011.

80. E.g., Rathke 1861, 19–57.

81. Baer 1886, 362; for the plan: Baer to Karl vom Stein zum Altenstein, 22 June 1830, in H.-T. Koch 1981, 180. The reference suggests that Soemmerring's plate was not so obviously non-developmental.

82. Coste 1837, 1849.

83. Carus 1831.

84. See also Hopwood 2000a, 33–34.

85. Lurie 1988.

86. Agassiz 1849, 98; for "frivolity and inaccuracy" in some blackboard drawings: Oppenheimer 1986, 405–6.

87. Bidder 1959, 108–9, referring to the 1840s.

1. Haeckel 1874a, xi.

2. Tuchman 1993; on the universities further: Coleman and Holmes 1988; Cunningham and Williams 1992; Nyhart 1995; Lenoir 1997; on (British) courses: Jacyna 2001.

3. Hopwood 2002, 33–39.

4. On such collaborations: e.g., Hentschel 2002; Simon 2011, esp. 99–109.

5. Daum 1998; Nyhart 2009; "Historicizing 'Popular Science,'" focus section, *Isis* 100 (2009): 310–68.

6. On pictorial science: A. Secord 2002; more generally on the rise of printed pictures: e.g., P. Anderson 1991; Beegan 2008.

7. C. Vogt 1852, 208.

8. W. His 1868, 50; also Kölliker 1899, 9–10.

9. Antoine François de Fourcroy in 1794, quoted in Foucault 1994, 70.

10. Coleman and Holmes 1988; Cunningham and Williams 1992; Tuchman 1993, esp. 56–59, 76–77; Lenoir 1997.

11. Ecker 1886, 140; Gooday 1991; Jacyna 2001; on the challenges further: Schickore 2007.

12. Scheele 1981; Daum 1998, 43–64.

13. Goschler 2002, 207–11.

14. Lenoir 1997, 45–74.

15. Nyhart 1995, 65–102.

16. Ludwig, *JGM* 62 (1849): 341–43; Leuckart 1850; Lenoir 1989, 195–245; Nyhart 1995, 96–98; on the new physiology: Dierig 2006.

17. Lenoir 1997, 75–130.

18. Nyhart 1995, 90–102.

19. Hopwood 2009a, 292–94; a complaint about lack of funding: C. Vogt 1854, 629–30; for fish farming: Coste 1853; C. Vogt 1859; for legal medicine and obstetrics: Seidler 1993.

20. Bidder 1959, 65–66; for the lectures, see the almost unillustrated transcript, "Entwicklungsgeschichte der Wirbelthiere. Vorlesungen von Rathke im Wintersemester 1852/53," NSUB: Cod. Ms. E. C. Neumann 2a:6, based on similar notes to Rathke 1861; for seeing and drawing as better than books, also Erdl 1845, iii.

21. Tuchman 1993, 56–59; Otis 2007, 68–69.

22. Moleschott 1894, 196.

23. Kußmaul 1960, 106; also Kupffer 1884, 12; P. H. W., "Ein Besuch in Giessen," *Wiener medizinische Wochenschrift* 1 (1851): 521–24, 537–40, on 522–23; on the courses: Waldeyer 1899, 30–31, 49–50.

24. Kölliker 1899, 185.

25. Bardeleben 1906 ("Praeceptor Germaniae," as Wilhelm His called him); Sonderegger 1898, 16–17.

26. Ecker 1886, 140; also F. von Müller 1951, 41.

27. Kölliker 1899, 185.

28. On visual aids more generally: Hopwood 2002, 33–39.

29. Valentin 1835a, xiii.

30. Daum 1998, 269; D. Phillips 2012; Sakurai 2013.

31. Kelly 1981; Daum 1998; Wittmann 1999.

32. Humboldt 1849, 3–38; Schleiden 1848, 285–329; Kockerbeck 1997; Kleeberg 2005, 38–57.

33. H. Burmeister 1848, iii, referring to the (unillustrated) first edition in the (illustrated) third. The analogy points to the power of pictures stressed by A. Secord 2002, even as the success of the books shows what could be achieved without them; see further O'Connor 2007, 3–4.

34. Daum 1998, 33–41, 265–86.

35. On the techniques: Benson 2008.

36. For the place of this work in the British tradition: Gauld 2009, 124–26.

37. H. Burmeister 1848; Zimmermann 1855; A. Wagner 1857–58.

38. "Was wir wollen," *IZ* 1, no. 1 (1 July 1843): 1–2; on the *IZ*: Weise 2003; further on wood engraving for the periodical press: Beegan 2008, 47–71.

39. Daum 1998; Schwarz 1999.

40. "Vorwort," *IZ* 64 (1875): iii–iv; on the virtues of pictures, also "Vorwort," *IZ* 4 (1845).

41. Rudwick 1992; O'Connor 2007; J. Secord 2010, 40–41 (quotations).

42. R. Wagner 1839a, 60; Kölliker 1861, v.

43. A long-running complaint: Gooday 1991, 307; Kuhl 1949, 7.

44. On Wagner: Hagner 2004, esp. 140–54; Bayertz, Gerhard, and Jaeschke 2007a.

45. Wagner, *Göttingische gelehrte Anzeigen* 1853, no. 2: 705–14, on 706–7; also Bischoff, *JGM* 26 (1840): 231–41, on 240.

46. Erdl 1845, iii–vi; Hopwood 2007, 283–89. Erdl died in 1848 and a planned second volume, on organ development, never appeared.

47. Ecker to Wagner, 22 Jan. 1850, NSUB: Wagner Papers (the commission); F. A. Zenker, *JGM* 76 (1852): 108–13, on 108 (the figures); Hopwood 2002, 17–19; on Ecker: Ecker 1886; Foerster 1963.

48. Hopwood 2002, 15–31.

49. Ecker 1886, 141; further on charts: Bucchi 1998; Redi et al. 2002.

50. Ecker 1859a, preface. Johannes Müller's physiological handbook gave only a few simple cuts, mainly on development: J. Müller 1833–37; Wagner added figures after Bischoff to the third (1845) edition of his text, but the quality was poorer than English work: R. Wagner 1845; Günther, *JGM* 49 (1846): 342–46, on 343.

51. Kölliker 1861; 1899, 286–87; on Engelmann: *Jubiläumskatalog* 1911; Nyhart 1991.

52. Kölliker 1861, vi.

53. "Ehrerbietiges Gesuch des Zeichners C. Lochow um Anstellung an der Universität," 5 June 1862 and 11 Jan. 1865, Universitätsarchiv Würzburg: ARS 635.

54. E.g., *Reglements* 1872; F. von Müller 1951, 41; but see P. H. W., "Ein Besuch in Giessen," *Wiener medizinische Wochenschrift* 1 (1851): 521–24, 537–40, on 523, for Bischoff as a feared examiner of embryology.

55. Erdl 1845, vi; Czerny 1967, 221, with reference to Vienna in the mid-1860s.

56. D. Phillips 2012, 9.

57. Daum 1998.

58. H. Burmeister 1843, 284–99; 1848, 578 (a longer, more radical conclusion than in the first edition); Kleeberg 2005, 67–71; Rupke 2005, 147–48.

59. "In einem Genfer Landhause," *Die Gartenlaube* 15 (1867): 148–52; C. Vogt 1896; F. Gregory 1977, 51–79; Jansen 2007, 245–59. R. Richards 2008 underestimates Vogt's importance to Haeckel.

60. C. Vogt 1847, 206; for the run: Cotta, Geschäftsbücher/Druckereicalculationen, Deutsches Literaturarchiv Marbach: Cotta-Archiv (Stiftung der Stuttgarter Zeitung).

61. C. Vogt 1848, 1:104–5; Kockerbeck 1995.

62. C. Vogt 1848, 1:130–32.

63. Ibid., 16.

64. Quoted in Ackerknecht 1957, 11.

65. C. Vogt 1848, 1:129–30.

66. Jansen 2007, 246–51.

67. F. Gregory 1977.

68. Feuerbach 1990, 358.

69. Büchner 1856, 75–76.

70. J. Secord 2000; Rupke 2000.

71. Zimmermann 1855; Rudwick 1992, 135–36.

72. *Naturwissenschaftliches Literaturblatt* of *Die Natur*, no. 1 (7 Nov. 1856): 1.

73. Pfaff 1855; A. Wagner 1857–58, 1:xii.

74. F. Engels 1975, 332.

75. C. Vogt 1852, preface.

76. C. Vogt 1851; EH to his parents, 14 May 1853, in Haeckel 1921a, 51–53.

77. C. Vogt 1852, 451–52.

78. R. Wagner 1854a, 29; most recently on the "materialism conflict": Bayertz, Gerhard, and Jaeschke 2007a.

79. R. Wagner 1854b, iv.

80. Anderton 1993.

81. Daum 1998; D. Phillips 2012.

82. Kelly 1981; Daum 1998, 337–58; Belgum 1998; Graf 2003.

83. Baer 1837, 8.

84. E.g., Hagner 1997; Hopwood 2007, 304.

85. E.g., Oken 1843, 1–5; Poeppig 1848, 13, 16; Baumeyer 1857.

86. Rudwick 1992; O'Connor 2007.

87. "Die Fortpflanzung und der Nestebau der Fische," *IZ* 13, no. 315 (14 July 1849): 27–28.

88. Wundt 1921, 17.

89. König and Ortenau 1962; Altick 1978, 338–42; Oettermann 1992; M. Burmeister 2000.

90. Zeiller 1867, 47 (*alles Anstößigen*); Hopwood 2007, 302–4.

91. C. Vogt 1854, 436; 1851, 1:8 (prudery). Some such books were illustrated (e.g., see my fig. 7.2); on Britain and America: Brodie 1994, 87–203; Porter and Hall 1995; Fissell 2003.

92. C. Vogt 1852, 208; on politics of ovaries further, e.g., Simmer 1993.

93. *Die Natur* 6 (1857): 34–36.

94. C. Vogt 1854, 542.

95. C. Vogt 1851, 1:16.

96. C. Vogt 1861, xix–xx, and, e.g., 559, 565, 582.

97. On Zeiller: Hopwood 2007; on British debates about the effects of pictures: A. Secord 2002.

CHAPTER 4

1. EH to parents, 17 May 1855, in Haeckel 1921a, 133–37, on 137.

2. For the Romantic Haeckel: R. Hertwig in *Bericht* 1894, 3–7; R. Hertwig 1919, 1928; Ostwald 1914, 30; Gasman 1971; Lebrun 2004; Kleeberg 2005; Breidbach 2006; R. Richards 2008; for a corrective: Gliboff 2008; for other recent Haeckel biographies: Krauße 1984; Di Gregorio 2005; Lynn K. Nyhart, "Haeckel, Ernst," in *DSB*, vol. 21 (2008): 206–10; on his science and art further: Kockerbeck 1986; Krauße 1995.

3. On Haeckel's youth: Haeckel 1921a; Wedekind 1976; Kleeberg 2005.

4. For Haeckel's lecture attendance: Haeckel 1921a; for his relations to Müller: Otis 2007, 190–223.

5. Ludwig 1852–56; e.g., Alexander Ecker to Rudolf Wagner, 13 Dec. 1852, NSUB: Wagner Papers.

6. EH to parents, 6 Nov. 1852, in Haeckel 1921a, 8–10; on Haeckel and Kölliker: Uschmann 1974; on student attitudes to Kölliker: W. His 1965, 39–40.

7. EH to parents, 14 May 1853 and 17 May 1855, in Haeckel 1921a, 51–53, on 53; 133–37, on 137.

8. EH to father, 21 Dec. 1853, ibid., 87–91, on 88–89; for Jacob Henle in similar vein about muscles and bones: Otis 2007, 44.

9. EH to parents, 25 Dec. 1852, in Haeckel 1921a, 26–29, on 27.

10. EH to parents, 18 Aug. 1853 and 5 May 1855, ibid., 68 and 130–33, on 132.

11. EH to parents, 21 Dec. 1852, ibid., 25–26.

12. EH to father, 19 Nov. 1852, ibid., 14–15.

13. EH to parents, 31 Dec. 1853, ibid., 91–92. This letter is currently misplaced, so the sketch cannot be reproduced.

14. EH to parents, 4 May 1853, ibid., 50.

15. Kleeberg 2005, 94–97.

16. EH to parents, 14 May 1853, in Haeckel 1921a, 51–53; Kleeberg 2005, 73–79. Even after they fell out in the 1870s, Haeckel looked up to Vogt as a "teacher and writer" with whose "brilliant talents" he could not compete: EH to William Vogt, 8 Aug. 1896, in Kockerbeck 1999, 65.

17. EH to parents, 17 June 1855, in Haeckel 1921a, 140–46, on 146.

18. EH to parents, 17 May 1855, ibid., 136.

19. A testimonial of 1860, quoted in H. Schmidt 1934, 16.

20. EH to parents, 4 Aug. 1856, in Haeckel 1921a, 204–8, on 208.

21. Ibid., 206.

22. On Haeckel and Müller: Otis 2007, 190–223.

23. EH to Anna Sethe, 7 Aug. 1859, in Haeckel 1921b, 85–86.

24. EH to Allmers, 20 Jan. 1860, in Koop 1941, 38–41, on 38.

25. R. Hertwig 1919, 956.

26. EH to Anna Sethe, 16 Feb. 1860, in Haeckel 1921b, 155–58.

27. EH to Allmers, 5 Nov. 1860, in Koop 1941, 57–60, on 58–59.

28. Kleeberg 2005, 86, 101–2.

29. R. Richards 2008, 44–49.

30. EH to Allmers, 5 Nov. 1860, in Koop 1941, 57–60, on 58.

31. EH to Allmers, 14 May 1860, ibid., 44–50, on 45; for a Müllerian precedent: Otis 2007, 39.

32. Allmers to EH, 7 Jan. 1862, in Koop 1941, 79; for architects' and designers' uses of the radiolaria: Krauße 1995; R. Franz 1998; Binet 2007.

33. Haeckel 1862, xi.

34. Schultze, Leuckart (and an impressed Rudolph Wagner) in reviews quoted in H. Schmidt 1914, 1:64–67, which also mentions the prize; Darwin to EH, 3 Mar. 1864, EHH; see also H. Schmidt 1926, 164–65; for reference to letters of praise from Schultze, Leydig, and Thomas Henry Huxley: EH to parents, 5 Nov. 1862, in H. Schmidt 1929, 307–8.

35. On Carus: Kuhlmann-Hodick, Spitzer, and Maaz 2009a, 2009b; on Leuckart: Wunderlich 1978.

36. E.g., R. Hertwig 1919; Singer 1931, 480–81; on the "too perfect" radiolaria: Goldschmidt 1956, 32–33; for a defense: Lötsch 1998, 356–59. General critiques such as Hensen 1891 and R. Hertwig 1919 do not cite specific objections.

37. EH to Allmers, 1 June 1861, in Koop 1941, 71–73.

38. "Embryologie des Menschen," EHH: B102.

39. Gliboff 2008.

40. Haeckel 1862, 231–32; Di Gregorio 2005, 74–85.

41. Darwin 1859, 439.

42. Through the American botanist Asa Gray, the anatomist Jeffries Wyman told Darwin, "It is all gammon [nonsense] about Agassiz, not knowing to what class an *unticketed embryo* belonged. Agassiz denies that he ever said so." Huxley, who had translated the passage in the 1850s, may have revealed the source. Darwin admitted that "I have shamefully blundered but Von Baer is fully as good an authority; some would say better." Gray to Darwin, 23 Jan. 1860, and Darwin to Gray, [8–9 Feb. 1860], Darwin Correspondence Database, accessed 20 May 2013, http://www.darwinproject.ac.uk/entry-2663 and http://www.darwinproject.ac.uk/entry-2701.

43. Apparently via Huxley; this may have been among the "additional corrections" Darwin sent the German publisher in February 1860: Darwin to Bronn, 4 Feb. [1860], ibid., http://www.darwinproject.ac.uk/entry-2687.

44. Darwin 1859, 450; on embryology in the *Origin*: Nyhart 2008.

45. Kelly 1981; W. Montgomery 1988; T. Junker 1989; Nyhart 1995, 105–42; Bayertz 1998; Daum 1998; E. Engels 2000.

46. Nyhart 1995, 145.

47. Coleman 1976; Lenoir 1989, 195–245.

48. R. Hertwig 1928, 400.

49. Quoted in Uschmann 1959, 44.

50. Huxley 1863a, 71; 1863b, 64; and, e.g., Rolle 1863; Schleiden 1863; C. Vogt 1863.

51. "Die 38. Versammlung deutscher Naturforscher und Aerzte in Stettin," *IZ* 41, no. 1059 (17 Oct. 1863): 279.

52. *Amtlicher Bericht* 1864, 17.

53. Ibid., 17–18.

54. Ibid., 24, 28–29.

55. Ibid., 59–71, 75; "Die 38. Versammlung deutscher Naturforscher und Aerzte in Stettin," *IZ* 41, no. 1059 (17 Oct. 1863): 279.

56. Uschmann 1959, 34–72.

57. R. Richards 2008.

58. Haeckel 1866, 1:xv, 4.

59. Ibid., 1:19–20, 103, 2:291

60. Ibid., 2:xvii–xviii, with reference to Goethe on the metamorphosis of plants.

61. Cunningham and Jardine 1990; Gliboff 2008.

62. R. Richards 2008, 120.

63. Haeckel 1866, 1:46–49; Krauße 1995.

64. Haeckel 1866, 2:185–86; on recapitulation: S. Gould 1977; Mengal 1993.

65. *Amtlicher Bericht* 1864, 20; also Darwin 1859, 129–30.

66. EH to Huxley, 12 May 1867, in Uschmann and Jahn 1959–60, 11–12.

67. Oppenheimer 1987; S. Gould 1991a, 263–67; compare R. Richards 2008, 137–42, 158–62; further on trees: Uschmann 1967; Barsanti 1992; Bouquet 1996; Voss 2010, 61–126.

68. Haeckel 1866, 2:450.

69. Ibid., 436.

70. Gliboff 2008; R. Richards 2008; also Nyhart 1995; Bowler 1996.

71. EH to Allmers, 13 July 1860, in V. Franz 1944, 14–15; on Haeckel and Reimer, a family friend: my chap. 5.

72. Nyhart 1995, 137–38.

73. *Literarisches Centralblatt*, no. 25 (15 June 1867): 678–83, on 682.

74. *Allgemeiner literarischer Anzeiger für das evangelische Deutschland* 2 (1868): 42–46; see also Andreä 1868, 274–81.

75. E.g., Wilhelm Wundt, *Kritische Blätter für wissenschaftliche und praktische Medicin*, 1867, no. 2: 13–17, and no. 5: 41–45; Rudolf Leuckart, "Bericht über die wissenschaftlichen Leistungen in der Naturgeschichte der niederen Thiere während der Jahre 1866 und 1867 (Erste Hälfte)," *Archiv für Naturgeschichte* 33 (1867), pt. 2: 163–67; Carl Theodor von Siebold to Ernst Ehlers, 17 Feb. and 13 Mar. 1867, NSUB: Ehlers Papers; H. Schmidt 1926, 262–68.

76. EH to Huxley, 12 May and 28 June 1867 (truth), and Huxley to EH, 20 May 1867, in Uschmann and Jahn 1959–60, 11–14; EH to G. Reimer, 18 Sept. 1868 and 17 Jan. 1869 (quotation), SBB; Reimer to EH, 21 Jan. 1869 (sales), EHH.

77. Julius Römer, in H. Schmidt 1914, 1:380.

78. Uschmann 1959, 43–45, also for the quotations from letters from Haeckel to his parents.

79. EH to Huxley, 27 Jan. 1868, in Uschmann and Jahn 1959–60, 15–16.

80. Nordenskiöld 1929, 515.

81. But see Daum 1998, 291–92; Kleeberg 2005, 67–79.

82. Haeckel 1868, i, iii.

83. Goschler 2002, 202–3; the "Prospekt" on the inside wrappers of the first few issues gives the aims; further: Daum 1998, 136.

84. Haeckel 1868, 3

85. Ibid., iii–v.

CHAPTER 5

1. Haeckel 1868, iv, a claim expanded from Haeckel 1866, 2:xvii–xviii.

2. Hopwood 2006, 264–81, previewed this work; on the ar-

chive: Krauße and Hoßfeld 1999; for a register of 39,220 letters: Hoßfeld and Breidbach 2005; for an updated version containing 42,693: "Ernst Haeckel Online Briefedition," December 2013, haeckel-briefwechsel-projekt.uni-jena.de.

3. Compare Richardson and Keuck 2001; for difficulties with this approach: Judson 2004; Hopwood 2006, 262.

4. E.g., Julius Kollmann, "Die Anatomie menschlicher Embryonen von W. His in Leipzig," *Verhandlungen der Naturforschenden Gesellschaft zu Basel* 8 (1890): 647–71, on 665; Dennert 1937, 182.

5. By contrast, Haeckel's contemporary, the zoologist August Weismann, inspired diagrams of relations between the germ plasm and the somatic cells that acquired power by simplification: Griesemer and Wimsatt 1989.

6. Browne 2001; 2003a, 373–81; Bindman 2009.

7. Huxley 1863a; Voss 2010, 143–48. In some places application to transformism predated Darwinism: J. Secord 2010, 42, but I have not seen cartoons about Darwinism in the *Fliegende Blätter* till 1867.

8. Hooker to Darwin, [26 Feb. 1863], and St. George Jackson Mivart to Darwin, 25 Apr. 1870, quoted in Dawson 2007, 116–17.

9. Vogt is quoted in Desmond 1994, 317–18; Schleiden 1863, 52 reproduced one of the figures. The *Literarisches Centralblatt*, no. 52 (26 Dec. 1863): 1236 praised "the great calm and objectivity of the presentation."

10. Browne 2003a, 221–22.

11. Voss 2010, 143–45.

12. Darwin to Joseph Hooker, 14 Dec. [1859], and to Asa Gray, 10 Sept. [1860], Darwin Correspondence Database, accessed 20 May 2013, http://www.darwinproject.ac.uk/entry 2583 and http://www.darwinproject.ac.uk/entry 2910.

13. Huxley 1863a, 74.

14. Ibid., 80–81.

15. Ibid., 81.

16. E.g., Rolle 1863; Schleiden 1863; C. Vogt 1863.

17. For the encounters of Vogt and other German anthropologists with Darwin, see most recently Backenköhler 2008. Historians of ideas have stressed Vogt's conversion to evolutionism, but said little about how he promoted it; the lecture tours cry out for research.

18. For the place of the *Thierleben* in natural historical illustration: Gauld 2009; for examples, see my fig. 9.10.

19. Büchner 1868, 93; for underwhelming illustrations: Rolle 1866, 157.

20. EH to Huxley, 11 Aug. 1868, in Uschmann and Jahn 1959–60, 16.

21. The original numbers are shown in the diagram in my figure 5.11.

22. W. His 1874, 170.

23. Richardson and Keuck 2002, 521. Ecker described this specimen as five, not four, weeks old. See also Gursch 1981, 32.

24. EH to Carl von Siebold, 4 Jan. 186[9], EHH. Here is the whole passage, from which later in this chapter I translate more: "Was die von Bischoff gerügte zu große Ähnlichkeit der Embryonen von Mensch und Hund betrifft, so erklärt sich diese einfach daher, daß ich die beiderlei Embryonen auf meinen Tafeln (S. 240, b, c) auf gleiche Größe reducirt, in gleiche Stellung gebracht, und in gleicher Manier ausgeführt

habe. Im Übrigen sind die Formen derselben ganz genau theils nach der Natur copirt, theils aus allen, bisher über diese frühen Stadien bekannt gewordenen Abbildungen zusammengestellt. Dabei möchte ich Bischoff noch besonders darauf aufmerksam machen, daß die verschiedenen Abbildungen menschlicher Embryonen *von gleichem Alter* (aus der IV–VIII Woche) bei den *verschiedenen Autoren unter sich mehr* verschieden sind, als von den Hunde-Embryonen gleichen Alters! Dies kann man schon aus den Embryonen-Tafeln in Eckers 'Icones physiolog.' sehen! Übrigens wird Bischoff wohl selbst nicht läugnen wollen, daß in einem wenig früheren Stadium *geradezu gar keine* Unterschiede zwischen Mensch und Hund vorhanden sein können!"

25. Daston and Galison 1992, 88–98; for embryology: Hopwood 2005, 2006.

26. Bliedner 1901, 24–25.

27. Haeckel 1866, 1:xxi, 19, 66; Grimm and Grimm, *Deutsches Wörterbuch*, s.v. *genau*.

28. Haeckel 1875a, 37–38.

29. C. Vogt 1854, 10–11; fig. 3.16 herein.

30. Baer 1828, xv (fig. 2.6 herein); R. Wagner 1839b, vii, plate VII; Ecker 1859a; Kölliker 1861 (fig. 3.11B herein).

31. Rütimeyer 1863, 634, with reference to the work illustrated in my figure 6.3.

32. E.g., EH to Georg Reimer, 26 Mar. 1868, SBB.

33. Haeckel used charts for a lecture in Berlin later that year: EH to Agnes Haeckel, 19 Dec. 1868, in Huschke 1950, 56–57, but I do not know if the Darwin lectures in Jena did. The embryological ones that survive in the Jena Zoological Institute, including some from Haeckel's time, appear more recent than the 1860s (e.g., fig. 3.10 herein).

34. Oppenheimer 1986, 405–6.

35. EH to Siebold, 4 Jan. 186[9], EHH; Baer 1828, 4–6.

36. Haeckel 1891, 2:859–60.

37. EH to Siebold, 4 Jan. 186[9], EHH; Baer 1828, 221. Haeckel modified this view in the 1870s.

38. EH to Siebold, 4 Jan. 186[9], EHH.

39. On the Reimers: Virchow 1897; Ziesak 1999, 33–44.

40. Ernst Reimer to EH, 5 June 1868, EHH, with reference to the "Berlin church conflict" over a pastor who denied that the earth circles the sun; compare John Murray and Darwin's *Descent of Man*: Browne 2003a, 346–47.

41. E. Reimer to EH, 19 July 1878, EHH, on Haeckel and Virchow.

42. E.g., Pang 1994–95; Prodger 2009.

43. Haeckel 1868, 146, 242, 248.

44. Haeckel 1891, 2:861–62.

45. EH to G. Reimer, 26 Mar., 4 May, and 22 June 1868, SBB.

46. G. Reimer to EH, 27 Mar. 1868, EHH; G. Menz 1925, 75–82, on 78; Wogawa 2001.

47. EH to E. Reimer, 22 June 1868, SBB.

48. E. Reimer to EH, 5 June 1868, EHH; EH to E. Reimer, 22 June 1868, SBB. The smeared cuts were figs. 1–7, of which 5–7 are on my fig. 5.8.

49. EH to G. Reimer, 26 Mar. 1868, SBB; G. Reimer to EH, 27 Mar. 1868, EHH.

50. On Adolf Giltsch: Haeckel, "Adolf Giltsch. Ein Nachruf," *Altes und Neues aus der Heimat. Beilage zum Jenaer Volksblatt* 1911, no. 11.

51. The legends refer to rows (*Querreihen*), but not columns: e.g., Haeckel 1874a, 256.

52. Rudwick 1992, 84–87; O'Connor 2007, 364–66.

53. Lurie 1988, 256–64; Desmond and Moore 2010, 263–64.

54. Lavater's physiognomical fragments included a set of panels comparing the heads of a boy and a girl at different ages, every ten years: Lavater 1778, 363. On physiognomical developmental series: Clausberg 1997; Schögl 1999. For the argument that seventeenth- and eighteenth-century picture series for fencing, drilling, dancing, and gymnastics served as a model for the single series of early nineteenth-century embryology: Wellmann 2010, 197–265.

55. R. Richards 2008, 234, 240.

56. EH to G. Reimer, 26 Mar. 1868, SBB.

57. Rütimeyer, *Archiv für Anthropologie* 3, no. 3–4 (1869): 301–2. The volume is dated 1868, but the issue came out in mid- to late 1869.

58. EH to E. Reimer, 22 June 1868, SBB; Reimer to EH, 23 June 1868, EHH.

59. Di Gregorio 2005, 249–52, though applying Gegenbaur's criticism of a plate in the *Anthropogenie* to this one.

60. For Haeckel on race: Winau 1981; Hoßfeld 2005a, 92–97, 139–59; R. Richards 2008, 244–61, 269–76.

61. Baer 1837, 8; Haeckel 1868, 239–40.

62. Haeckel 1868, 147, 241.

63. Huxley 1863a, 79–80; Haeckel 1868, 249.

64. Haeckel 1868, 235.

65. Ibid., 252–53.

66. Ibid., 317, 543.

67. Ibid., 238–41.

68. Ibid., 534–35.

69. E.g., ibid., 113, 138, 159, 161–62, 172–73, 181–83.

70. Ibid., 241, 9, 239–40.

71. Beer 1983, 80–82.

72. Darwin to Gray, 10 Sept. [1860], Darwin Correspondence Database, accessed 20 May 2013, http://www.darwin-project.ac.uk/entry-2910.

73. Unlike the sainted Louis Pasteur against whom lack of candor was also alleged: Geison 1995.

CHAPTER 6

1. "German Literature," *Saturday Review*, no. 682 (21 Nov. 1868): 697–99, on 698.

2. T. H. Huxley, "The Natural History of Creation," *Academy* 1 (1869), no. 1 (9 Oct.): 13–14; and no. 2 (13 Nov.): 40–43, on 43; R. Richards 2008, 226.

3. Schleiden 1869, 276–77; also E. Schultze, *Philosophische Monatshefte* 3 (1869): 398–404.

4. *Allgemeiner literarischer Anzeiger für das evangelische Deutschland* 3 (1869): 372; and 4 (1869): 187–88.

5. On professorial reading and reviewing: J. Secord 2000, 222–60.

6. On the German debates: Engelhardt 1980; Kelly 1981; Weindling 1989a; Nyhart 1995; Bayertz 1998; Daum 1998; further: E. Engels and Glick 2008.

7. Blackbourn 1997, 270–83; Daum 1998, 300–23.

8. EH to Agnes Haeckel, 27 Aug. 1868, in Huschke 1950, 47–48.

9. Carl von Siebold to EH, 28 Dec. 1868, EHH.

10. Allmers to EH, 5 Oct. 1868, in Koop 1941, 124–27, on 126; on the museum: Hopwood 2007, 299–306.

11. A. Elsner 1972, 283–85.

12. Siebold to EH, 28 Dec. 1868, EHH; for strong criticism: Siebold to Ernst Ehlers, 17 Feb. and 13 Mar. 1867, NSUB: Ehlers Papers; Nyhart 1995, 186; on Siebold: Ehlers 1885; Körner 1967, 291–355; on relations with Haeckel, 324, 327–28.

13. EH to Siebold, 4 Jan. 186[9] and 30 Nov. 1869 (funds); Siebold to EH, 31 July 1870, 22 Feb. 1873 (first *Duzen*), and 14 Feb. 1874 (birthday), EHH; for Haeckel's Munich ambitions: Uschmann 1959, 81–82.

14. Siebold to EH, 22 Feb. 1873, EHH.

15. Bischoff 1867, 74–94, on 88–89.

16. Bischoff 1842c, 893; 1852, 7.

17. Siebold waited for daylight and used a magnifying glass to decipher the dark wood engravings in the *Anthropogenie*: Siebold to EH, 14 Feb. 1875, EHH.

18. S. Gould 2000, 46–48.

19. Hensen, "Generationslehre und Embryologie," *JLFM* 3.1 (1869): 56–65, on 58; Darwin 1990, 358. Victor Hensen rewarmed the accusations of fraud in 1891.

20. Darwin to Fritz Müller, 23 May 1865, quoted in E. Krause 1885, 152; on Rütimeyer: C. Schmidt 1896; Iselin 1897; E. His 1941, 202–12; Clifford M. Nelson, "Rütimeyer, Karl Ludwig," in *DSB*, vol. 12 (1975): 37–39; on anthropological empiricism: Zimmerman 2001; Backenköhler 2008.

21. EH to E. Reimer, 19 Oct. 1868, EHH. Haeckel either misjudged Rütimeyer's likely response or aimed to make it harder for him to attack.

22. Rütimeyer, *Archiv für Anthropologie* 3, no. 3–4 (1869): 301–2, with reference to Benoît de Maillet's *Telliamed* of 1748; for professors' overestimation of accessibility: Daum 1998, 307.

23. Rütimeyer 1898 [1868], 254.

24. Rütimeyer, *Archiv für Anthropologie* 3, no. 3–4 (1869): 301–2. Darwin made trees in private too: Voss 2010, 181–83.

25. *Pace* R. Richards 2008, 238, 279.

26. Rütimeyer, *Archiv für Anthropologie* 3, no. 3–4 (1869): 301–2, which does not explain how he supposed the woodcut had been misinterpreted.

27. Ecker 1886, 66.

28. EH to Darwin, 12 Oct. 1872, in *Correspondence of Charles Darwin*, vol. 20 (2013): 443–44, 632–34, in which Haeckel also likened the "pseudo-Darwinist" Rütimeyer to "a barking dog angered by the swift progress of a fast horse."

29. C. Schmidt 1896, 221; E. His 1941, 408–17; Gossman 2000, 8.

30. "Entwickelungsgeschichte" in winter 1868–69: "Inskriptionsbuch der Studenten von W. His, WS 1856/57 bis SS 1872," Universitätsbibliothek Basel: His Papers, 13.

31. On His: Hopwood 1999, 2012, and the cited biographies.

32. W. His 1965, 39; also 1882b, 64–68; 1895, 3–5.

33. Hopwood 1999; 2002, 41–49.

34. W. His 1868, 183–224, quotation on 212; for individual and sex differences: 217–18.

35. Ibid., 46, 61, 154.

36. Ibid., 87, 105.

37. Ibid., 56.

38. As stressed by Gliboff 2008, 196–98.

39. W. His 1870b, 35.

40. *Literarisches Centralblatt*, no. 19 (30 Apr. 1870): 521.

41. W. His 1868, 223–24; 1896.

42. W. His 1870b, 24.

43. Miescher's son, also Friedrich, discovered nucleic acid; he appears in the next chapter.

44. E. His 1941, 218–29, 408–17.

45. E.g., *Basler Nachrichten*, no. 75 (31 Mar. 1875), Beilage.

46. EH to G. Reimer, 30 Oct. 1869, SBB.

47. W. Montgomery 1988; T. Junker 1989; Nyhart 1995.

48. Blackbourn 1997, 270–83; Daum 1998.

49. G. Reimer to EH, 3 Nov. 1869, EHH.

50. Haeckel 1870, xxi–xxx.

51. C. L. Brace, *North American Review* 110, no. 227 (Apr. 1870): 284–99, on 293, where he accepted the embryo plates as "a much more convincing argument." See also *Allgemeiner literarischer Anzeiger für das evangelische Deutschland* 4 (1869): 187–88, for the frontispiece as an example of Darwinists trimming the facts to their theory, a practice the reviewer warned readers would increase. The replacement was tame also compared with Vogt's Raphael caricature: fig. 3.12 herein.

52. EH to Lyell, 27 Nov. 1868, Edinburgh University Library: Lyell Correspondence, 1798.

53. EH to A. Haeckel, 31 Aug. 1868, in Huschke 1950, 49; and to Huxley, 20 Oct. 1868, in Uschmann and Jahn 1959–60, 19.

54. EH to G. Reimer, 6 Nov. 1869, SBB.

55. Haeckel 1870, 170, 264–65, 271.

56. "Ernst Haeckels natürliche Schöpfungsgeschichte, 1. Die Abstammungslehre," *Das Ausland* 43, no. 29 (16 July 1870): 673–79, on 678; on Hellwald: Bayertz 1998, 244–46. The Austrian politician and philosopher Bartholomäus von Carneri told Haeckel the plates of embryos were among "the most interesting": von Carneri to EH, 12 Jan. 1871, in Jodl 1922, 1–2.

57. M[ichael] F[oster], "Haeckel's Natural History of Creation," *Nature* 3 (8 Dec. 1870): 102–3; on Foster's tour: Sykes 2001, 151–52; on looking back at *Vestiges*: J. Secord 2000, 471–514.

58. EH to the Hertwigs, 23 Feb. 1871, EHH (copy); Darwin 1871, 1:4; also EH to Darwin, 24 Feb. 1871, in *Correspondence of Charles Darwin*, vol. 19 (2012): 98–100, 752–54; for Haeckel's bad influence: Johannes Huber, "Wissenschaftliche Tagesfragen, I. Darwins Wandlungen und Häckels 'natürliche Schöpfungsgeschichte,'" *AZ*, no. 159 (8 June 1874), 2465–66; and no. 161B (10 June 1874), 2498–99, on 2465–66.

59. Darwin to Huxley, 20 June [1870], Imperial College London, College Archives: Huxley Papers, 5.269.

60. Darwin 1871, 1:14–16; R. Richards 1992, 158–64.

61. EH to Darwin, 24 Feb. 1871, in *Correspondence of Charles Darwin*, vol. 19 (2012): 98–100, 752–54.

62. Print runs: G. Reimer to EH, 3 Nov. 1869 (2nd ed.) and 7 Jan. 1874 (5th ed.); E. Reimer to EH, 1 Nov. 1871 (3rd ed.) and 8 Jan. 187[3] (4th ed.), EHH.

63. M[oritz] W[agner], "Neueste Beiträge zu den Streitfragen der Entwicklungslehre (Fortsetzung)," *AZ*, no. 93B (3 Apr. 1873), 1406–8, on 1408.

64. Julius Sponholz, "Häckel und seine Gegner," *AZ*, no. 294B (21 Oct. 1875), 4601–2.

65. He and Ernst Reimer agreed not to reinstate the plate in the fourth edition lest this push "pedantic owners of the 3rd" to demand one: E. Reimer to EH, 1 Feb. 1873, EHH.

66. E. Reimer to EH, 1 Feb. 1873 and 13 Dec. 1888, EHH.

67. Haeckel 1872, xxxiii–xxxvi.

68. Ibid.; on Bastian: Zimmerman 2001.

69. Darwin to EH, 2 Sept. 1872, EHH.

70. Uschmann 1959, 76–81.

71. Haeckel 1874c; Oppenheimer 1967, 256–94; Grell 1979.

72. EH to Karl Friedrich Zöllner, 30 Jan. 1873, in Zöllner 1883, Beilage 15; Meinel 1991, 34. Resenting Ludwig's palace, and then the money Louis Agassiz attracted for zoology in the United States, Haeckel claimed as well known "that the *scientific achievements of institutes stand in an inverse ratio to their size*": Haeckel 1875a, 84–85.

73. Du Bois-Reymond 1886, 105–40, on 130; Anderton 1993; Bayertz, Gerhard, and Jaeschke 2007b. Ludwig tried in vain to persuade Haeckel to attend the Leipzig meeting: Ludwig to EH, 11 Aug. 1872, EHH.

74. Zoologists' unease: Nyhart 1995, 168–206; praise for supporting morphology: Siebold to EH, 30 Oct. 1874, EHH; reservations about going public: Carl Vogt, "Apostel-, Propheten- und Orakelthum in der Wissenschaft, I," *FZ*, no. 74 (15 Mar. 1877), Morgenblatt, 1–3, on 2; direct attacks as advertising for the enemy: J. Secord 2000, 136.

75. The third (1867) German edition of the *Origin* carried Darwin's first portrait frontispiece: Browne 2003a, 273.

76. EH to G. Reimer, 13 Jan. 1873, SBB, probably with reference to Bock 1873, 711; for the rise of *Gartenlaube*: Belgum 1998, 16; and, on medicine in the magazine: Mildenberger 2012. Interest was international: the French translation of the *Schöpfungsgeschichte* (1874) had included a biography by Charles Martins; another appeared, with a portrait, in the United States. "Sketch of Professor Haeckel," *Popular Science Monthly* 6 (Nov. 1874): 108–9.

77. Otto Zacharias, "Ernst Heinrich Häckel," *IZ* 63, no. 1630 (26 Sept. 1874): 235–38; for Haeckel's help: EH to Zacharias, 21 Apr. 1874, in Nöthlich et al. 2006, 188–90; on Zacharias further: Thienemann 1917.

78. Huber, "Wissenschaftliche Tagesfragen, I. Darwins Wandlungen und Häckels 'natürliche Schöpfungsgeschichte,'" *AZ*, no. 159 (8 June 1874), 2465–66; and no. 161B (10 June 1874), 2498–99; the book version included the comments: Huber 1875, 8.

79. Bastian 1874, 8–9, 24.

CHAPTER 7

1. Appel 1987.

2. Influential accounts: S. Gould 1977, 189–93; Maienschein 1991a, 89–96; 1994, 43–46; my own earlier work: Hopwood 1999, 2006.

3. Daston 1999, 28–29; Daston and Galison 2007, 191–95.

4. Anderton 1993; Bayertz, Gerhard, and Jaeschke 2007b.

5. On the illustration strategies of Darwin's books: J. Smith 2006a; Prodger 2009; Voss 2010.

6. EH to E. Reimer, 3 Jan. 1873, SBB; Reimer to EH, 8 Jan. 187[3], EHH; Haeckel 1874a.

7. Haeckel claimed he had taught students of all faculties human embryology for twelve years (Haeckel 1874a, xv), but appears to have begun with medical and science students; for the inclusion of phylogeny, perhaps with a widening of the audience: Uschmann 1959, 46.

8. Haeckel 1874a, 295.

9. Ibid., 169, 6–9, xvi.

10. Ibid., 627, 52.

11. Blackbourn 1997, 261–63, 296–302; Goschler 2002, 244–46.

12. Haeckel 1874a, xii–xvi; for du Bois's responses and some further exchanges: du Bois-Reymond 1886, 198, 218–23, 237–38; on the speech and the conflict: Anderton 1993; Bayertz, Gerhard, and Jaeschke 2007b.

13. Haeckel 1874a, xi, xv–xvi; on Haeckel's style: Kelly 1981, 33; Daum 1998, 307.

14. Haeckel 1874a, xi.

15. Ibid., xvii.

16. E.g., Belgum 1998, 84–102; Jefferies 2003, 59–72.

17. R. Richards 2008, 140–42.

18. Haeckel 1874a, subtitles of lectures 16–19, 337, 340.

19. Ibid., 158, 106, 199; C. Vogt 1854, 542.

20. EH to G. Reimer, 13 Jan. 187[4], SBB. The Reimers published some of Haeckel's later books.

21. Haeckel borrowed also from Gegenbaur's comparative anatomy, Hermann von Meyer's human anatomy, and histologies by Heinrich Frey and Salomon Stricker.

22. For Darwin's problems with borrowed wood engravings: J. Smith 2006b.

23. Eliminating those I identified as copies left fifty-seven that could be new plus twenty-six repeats of these.

24. Kölliker 1861, 122–24.

25. Haeckel 1874a, 270–74; on the earlier history of the allantois: A. Meyer 1953; Adelmann 1966, 4:1550–602; Boyd and Hamilton 1970, 1–19.

26. Haeckel 1874a, 256, 712. He mentioned preparations of no other species, though he had some in Jena: Richard Fleischer to EH, 29 Apr. and 7 May 1874, EHH; none remains in the Phyletic Museum: Dietrich von Knorre, personal communication, 26 Aug. 2002.

27. Haeckel 1874a, 13.

28. Ibid., 253–55, 259–60, 262–66 (quotations: 263, 259). He acknowledged molecular differences (Haeckel 1868, 241–42), but did not draw attention to them here.

29. Haeckel 1874a, 253–54, 287.

30. W. His 1874, 2.

31. Hopwood 1999, 472–76, 487; Nyhart 1995, 193–204.

32. His to Friedrich Miescher-His, 8 May 1881, Universitätsbibliothek Basel: Miescher-His Papers. His's parablast theory was also unpopular: W. His 1873, 37–50.

33. Hohlfeld 1930. No publisher's archive is known, and most of His's was lost from Leipzig in World War II.

34. His to Antonie Miescher-His, 26 July and 15 Nov. 1874,

Staatsarchiv Basel-Stadt: PA 633, E 3-4; W. His 1897, 18.

35. Ramón y Cajal 1999.

36. Fick 1904, 179.

37. W. His 1874, ix, x, 75–76, 216; Hopwood 1999, 483 (also for comparison to Michael Foster and Francis Balfour's textbook); 2002, 41–49.

38. W. His 1874, 3–31; for the schematic, 27–28.

39. Ibid., 45–54.

40. Ibid., e.g., 64–65, 90, 96–99.

41. Ibid., 165–68. Perhaps to leave clear water between them, His had stopped calling his own growth law a *Grundgesetz* and avoided the social implications the monograph drew out.

42. Ibid., 177–91, drawing on research on Rhine salmon in Basel and marine species at the Naples Zoological Station. This is an antecedent of the "hourglass" model.

43. Ibid., 167.

44. Ibid., 201–3. Richardson and Keuck 2002, 518, pointed out that His presented stages too advanced to clinch his case; as far as I know, no one raised this objection in the 1870s, but see Keibel 1906, 153–54.

45. W. His 1874, 168.

46. Nyhart 1995, 168–206; Daum 1998.

47. W. His 1874, 168–69.

48. Ibid., 169–70. Though expressed in absolute terms, the point, *pace* R. Richards 2008, 286–87, was to accuse Haeckel, irrespective of scaling, of changing the proportions, as the internal comparisons of Ecker's embryo make especially clear. His's criticism does not consider the possibility of Haeckel's synthetic procedure, which was not made explicit but is documented in Hopwood 2006, 270–74, because His would have rejected it for illustrations presented as evidence.

49. W. His 1874, 170, 223.

50. Ibid., 170; Kölliker 1861, 124; Hopwood 2000a, 56–58.

51. W. His 1874, 170–71.

52. Ibid., 171.

53. Ibid. "Party leader" carried potentially negative connotations within the professoriate. A local concern with evidence of authenticity was also in play: His's brother, the silk-ribbon merchant and art connoisseur Eduard His-Heusler, contributed documents to authenticate one of two paintings attributed to a distant ancestor, Hans Holbein the Younger: Burckhardt-Werthemann 1907, 112–59; Bätschmann and Griener 1998.

54. W. His 1874, 129, 213–15.

55. Haeckel 1875a; Baer to EH, 29 Dec. 1875–10 Jan. 1876, EHH.

56. Haeckel 1875a, 40.

57. Ibid., 12–36, quotation on 27.

58. Ibid., 36.

59. Ibid., 36–37; W. Krause 1875; Hopwood 2000a.

60. Dennert 1901, 25, has a desperate Haeckel grab His's passing reference to schematics. On the move from research to demonstration: Wolf 2010, 264.

61. Haeckel 1875a, 37.

62. Ibid., 37–38.

63. For "schematic outlines" in the narrow sense: Haeckel 1866, 1:559; for general praise for "schematic figures" in the

Anthropogenie: Carl Hasse to EH, 19 Oct. 1874, EHH.

64. Haeckel 1875a, 38–39.

CHAPTER 8

1. Studies of visual culture in imperial Germany have paid paintings, monuments, museums, photographs, and advertising more attention than scientific illustrations: Jefferies 2003; research on science images has explored drawing and photography, especially in relation to Daston and Galison 1992, but I am not aware of historical work thematizing schematics, for which the Haeckel-His dispute appears to have been a defining episode.

2. The best account indicates simply that "in the meantime" the controversy had been discussed in the general press: Gursch 1981, 39. Though contemporaries were much exercised by reviewing practices in the face of rising output, e.g., Carl Vogt, "Wissenschaftliche und unwissenschaftliche Bücherei, I. Des Bücherlesers Klage," *FZ*, no. 19 (19 Jan. 1875), Morgenblatt, 1–3, these have not, to my knowledge, received sustained historical attention.

3. Anderton 1993; Bayertz, Gerhard, and Jaeschke 2007b; Schröder 2008.

4. T. W. Engelmann's addition to W. Engelmann to EH, 11 Sept. 1874, EHH.

5. W. Engelmann to EH, 4 Aug. 1874, EHH.

6. Otto Zacharias, "Ernst Heinrich Häckel," *IZ* 63, no. 1630 (26 Sept. 1874): 235–38; Zacharias, "Ernst Häckel's 'Anthropogenie,'" *IZ* 64 (1875), no. 1646 (16 Jan.): 42; no. 1647 (23 Jan.): 68–69; no. 1650 (13 Feb.): 119; and no. 1651 (20 Feb.): 140–42, on 42, 142; on the *IZ*: Weise 2003.

7. "Vorwort," *IZ* 64 (1875): iii–iv; in similar vein, "Die Illustration als Hebel der Volksbildung," *IZ* 51, no. 1305 (4 July 1868): 3–4.

8. Ernst Krause to EH, 19 Nov. 1875, EHH.

9. "Vorwort," *IZ* 64 (1875): iv.

10. Zacharias, "Ernst Häckel's 'Anthropogenie,'" *IZ* 64 (1875), no. 1650 (13 Feb.): 119; and no. 1651 (20 Feb.): 140–42, on 119, 142. The publisher asked if he could use the woodcuts elsewhere: Engelmann to EH, and *IZ* to EH, 28 Jan. 1875, EHH.

11. "Ultradarwinismus und Dilettantismus. Aus der Laienperspective," *AZ*, no. 105B (15 Apr. 1875), 1625–26.

12. F[riedrich] M[iescher], *Correspondenz-Blatt für Schweizer Aerzte* 5 (1875): 199–202; J. Rüedy to EH, 14 Oct. 1875, EHH, confirms the author's identity.

13. Engelmann to EH, 30 Oct. 1874, EHH.

14. Engelmann to EH, 19 (quotation) and 27 Nov. (England) 1874, EHH.

15. Michelis 1875, 74; on Michelis: Belz 1978.

16. P. H. Pye-Smith, "Haeckels Development of Man," *Nature* 11 (5 and 12 Nov. 1874): 4–5, 22–24; also Carl Hasse to EH, 19 Oct. 1874, EHH.

17. Hellwald to EH, 13 Oct. 1874, in Haeckel and Hellwald 1901, 14–15; Otto Zacharias, "Häckels Anthropogenie," *Das Ausland* 48 (1875): 210–13; on the difficulty of finding reviewers: J. Secord 2000, 133–34.

18. "Häckel's Entwickelungsgeschichte des Menschen,"

Weser-Zeitung, no. 9987 (11 Nov. 1874), Morgenausgabe, 1–2 (quotes); no. 9989 (13 Nov. 1874), Morgenausgabe, 1–2; and no. 9995 (19 Nov. 1874), Morgenausgabe, 1–2; also Hartmann 1875, 19–20.

19. [Hinrich] N[itsch]e, *Literarisches Centralblatt*, 1875, no. 40 (2 Oct.): 1291–93.

20. EH to Hellwald, 7 Feb. 1875, in Haeckel and Hellwald 1901, 21–22.

21. Vogt, "Wissenschaftliche und unwissenschaftliche Bücherei, II. Des Darwinisten Zweifel," *FZ*, no. 43 (12 Feb. 1875), Morgenblatt, 1–2. Vogt's comment predates a better-known quip that Haeckel's trees were "worth about as much as the pedigrees of Homeric heroes in the eyes of historical criticism": du Bois-Reymond 1886, 222.

22. "Ultradarwinismus und Dilettantismus. Aus der Laienperspective," *AZ*, no. 106B (16 Apr. 1875), 1643–45; on Darwinist "tricks" also H. Kemp 1873. The review could have quoted Rütimeyer from an excerpt Johannes Huber had given in the same paper that omitted the charges against the pictures. For ignorance construction of other kinds: R. Proctor and Schiebinger 2008.

23. Pye-Smith, "Haeckel's Development of Man," *Nature* 11 (5 and 12 Nov. 1874): 4–5, 22–24, on 5.

24. Karl Heider to EH, 11 Nov. 1891, EHH, referring to the mid-1870s.

25. Hasse to EH, 19 Oct. 1874; Gegenbaur to EH, 10 Nov. 1874, EHH.

26. Hasse to EH, 19 Oct. 1874; Gegenbaur to EH, 10 Nov. and 4 Dec. 1874, EHH; on Haeckel and Gegenbaur: Krauße 1994; Di Gregorio 2005. Gegenbaur wrote "41," but surely meant 42, which is original, while figure 41 is from Kölliker. Wilhelm His also objected to figures 42 and 83, but picked on a different aspect of figure 83. Ludwig Büchner recommended a better picture of the gorilla: Büchner to EH, 30 Mar. 1875, in Kockerbeck 1999, 143–45; Haeckel modified it slightly for the third edition, and the orang more.

27. W. von Kleist [Wilhelm Dilthey], "Literaturbriefe," *Westermanns Monatshefte* 40 (1876): 553–60, on 555; M[ichael] F[oster], "His on Morphological Causation," *Nature* 12 (26 Aug. 1875): 328.

28. The advertisement is in *Die Gegenwart* 7, no. 13 (27 Mar. 1875): 208; *Unsere Körperform* cost 5M. 50Pf., the *Anthropogenie* 14M.

29. Vogt, "Wissenschaftliche und unwissenschaftliche Bücherei, IV," *FZ*, no. 90 (31 Mar. 1875), 1–2; W[ilhelm] W[aldeyer], *Literarisches Centralblatt*, no. 32 (7 Aug. 1875): 1035–36.

30. *Basler Nachrichten*, no. 75 (31 Mar. 1875), Beilage; K[arl] M[üller], "Literatur-Bericht," *Die Natur*, n.s., 1, no. 23 (4 June 1875): 182–83; and further, K[arl] M[üller], "Literatur-Bericht," *Die Natur*, n.s., 2, no. 13 (25 Mar. 1876): 128.

31. Nitsche to Darwin, 18 Apr. 1871, Darwin Correspondence Database, accessed 20 May 2013, http://www.darwin-project.ac.uk/entry-7697; Prodger 2009, 138–41. Nitsche and Leuckart would produce celebrated wall charts: Bucchi 1998; Redi et al. 2002.

32. [Hinrich] N[itsch]e, *Literarisches Centralblatt*, 1875, no. 40 (2 Oct.): 1291–93.

33. Haeckel 1875a; copy of contract with Hermann Dufft, 18 Oct. 1875, EHH.

34. Hermann Müller to EH, 21 Nov. 1875, EHH; Büchner to EH, 26 Nov. 1875, in Kockerbeck 1999, 146; T. W. Engelmann to EH, 28 Dec. 1875, in Stürzbecher 1975, 132–35. Ludwig Overzier read His and still concluded that vertebrate embryos were almost identical: "Ueber die Darwin-Häckel'sche Auffassung der organischen Natur," *Gaea* 11 (1875): 357–63.

35. Krause to EH, 19 Nov. 1875, EHH; Carus Sterne, "Menschliche Erbschaften aus dem Thierreiche," *Die Gartenlaube* 23 (1875): 266–68, on 267; Zacharias, "Ziele und Wege der heutigen Entwickelungsgeschichte," *Das Ausland* 49 (1876): 29–32, on 30; for popularity among "the ladies": Reymond [1882], 4: 76; further on Krause: Daum 1995.

36. Siebold to EH, 24 Feb. 1876, EHH, and to Ernst Ehlers, 28 Nov. 1875, NSUB: Ehlers Papers, welcoming the attack on Ludwig and Agassiz; Gegenbaur to EH, 25 Nov. 1875, EHH, praising the polemic against His and Ludwig, but cross Haeckel had included Agassiz and Michelis.

37. Bischoff 1876; H. Schaaffhausen, *Archiv für Anthropologie* 9 (1876): 109–10; Balfour 1876, 521; Hensen 1876, 236.

38. Advertisement, *Die Gegenwart* 9, no. 1 (1 Jan. 1876): 16.

39. Semper 1876, 35–36; on Semper: Schuberg 1895; on relations with Haeckel and Gegenbaur: Semper 1874; EH to Zacharias, 31 Dec. 1875, in Nöthlich et al. 2006, 213–14.

40. "Häckel, Ernst, berühmter Naturforscher," in *Meyers Konversations-Lexikon*, 3rd ed., vol. 8. (1876): 409–10.

41. Kelly 1981, 123–41; Bayertz 1998, 253–65.

42. Dörpinghaus 1969; Kelly 1981, 75–99; F. Gregory 1992; Schröder 2008.

43. [Otto Zöckler], "Miscellen," *Der Beweis des Glaubens* 12 (1876): 198–200.

44. R. Steck, "Ein Darwinianer gegen den deutschen Darwin," *Protestantische Kirchenzeitung* 23, no. 4 (22 Jan. 1876): 74–77.

45. Wigand 1877, 235–89, quotations from 273, 275, 287, 289; on Wigand: T. Junker 1989, 190–228.

46. Dörpinghaus 1969, 43–48; but Haeckel was noticed earlier than this: Hagemann 1870, 137; on the Vatican and evolution: Artigas, Glick, and Martínez 2006.

47. Zollmann 1872, 137–38; Scheidemacher 1874, 369–70; Stöckl 1874, 174–75; Wieser 1875, 139–40; also Lange 1875, 712–14.

48. On Scheidemacher: Dörpinghaus 1969, 279; further biographical information kindly provided by Eva Huertgen, Domarchiv Aachen.

49. Carl Scheidemacher, "Häckels Ziele und Wege der heutigen Entwickelungsgeschichte," *PB* 5 (1876): 38–48, on 44.

50. Ibid., 40, 44, 48.

51. Scheidemacher 1876b, 710; further: 1875–76; 1876a.

52. Haeckel 1877a, xxv.

53. "*Anthropogenie*. Holzschnitte," EHH: B63; Haeckel revised, e.g., figure 83 and plate XI. Tucked away in an endnote to the legend, however, he no longer claimed to have drawn the human embryos after "preparations," which sat uneasily with the defense as schematics, and added the rider that there "is never real identity, but always only the very greatest similarity. Even the germs of different individuals of one species are never really identical." Haeckel 1877a, 748.

54. Haeckel 1876a; von Engelhardt 1980. A widely reviewed pirate edition of Agassiz's lectures on comparative embryology made clear how slender was the basis for Haeckel's claims: Agassiz 1875; for the piracy and a sense of the debate over Agassiz's reputation: Eichhorn 1876.

55. Rehbock 1975; also O'Brien 1970, 215–16, for an accusation of deliberately using inaccurate figures.

56. Vogt, "Apostel-, Propheten- und Orakelthum in der Wissenschaft," *FZ*, 1877, no. 74 (15 Mar.), 1–3; no. 75 (16 Mar.), 1–3; no. 81 (22 Mar.), 1–3; and no. 95 (5 Apr.), 1–3.

57. *Amtlicher Bericht* 1877, 14–22, 65–77, quotations on 66, 76.

58. Haeckel 1878, 73–74, 93; Vogt, "Papst und Gegenpapst," *Neue Freie Presse* (Vienna), no. 5053 (21 Sept. 1878), 1–3; von Engelhardt 1980; Kelly 1981, 57–60; Bayertz 1998, 253–65; Daum 1998, 66–71.

59. Wigand 1878, 49, 102.

60. Weiner 2003; "Piltdown Man: The Greatest Hoax in the History of Science?" Natural History Museum, 2013, http://www.nhm.ac.uk/nature-online/science-of-natural-history/the-scientific-process/piltdown-man-hoax/.

61. Gliboff 2006.

62. *Deutsches Biographisches Archiv*, s.v. "Reymond, Moritz"; Reymond 1880; Althaus 2002, 79–80; on songs and science: Jackson 2003; Smocovitis 2009.

63. Reymond 1877, 3–5, 15, 20.

64. Ibid., 142–43; 1878, 22–23; [1882], 2:2.

65. Michelis 1875, 51; Reymond 1877, 24–25; on *Fasnacht*: Back and Groeneveld 1988.

66. Szarota 1998, 150.

67. Haeckel 1874a, 429.

68. Reymond [1882], 4:73. On amphioxus: Hopwood 2014.

69. Ibid., 92.

70. Sterne 1878, 528.

71. Vernon L. Kellogg, "Evolution in Rhyme," *Science* 27 (15 May 1908): 791–92, assuming only anti-Haeckelian glee.

72. "Der moderne Prometheus," *PB* 6 (July 1878): 92–100.

73. For K[arl] M[üller], "Stylistische Mittheilungen. Der Humor in der Naturwissenschaft," *Die Natur*, n.s., 3 (1877): 80–81, "this food for the mind" complemented Christmas sweetness as perfectly as "herring salad with Spanish pepper … a stomach upset by marzipan." Alexander Ecker also stressed the corrective effect: Ecker 1886, 145.

74. K., "Die Abstammung des Menschen in Reimen," *Die Presse* (Vienna), no. 358 (29 Dec. 1876), Beilage.

75. W. Breitenbach in *Neue Weltanschauung* 5, no. 8 (1912), quoted in publisher's flyer for Reymond 1912 (practical); May 1909, 116 (pocket); "Geleitwort von Professor August Forel," flyer for Reymond 1912; for Haeckel's recommendation: E. A. Göldi, quoted in Reymond 1912, 251. Siebold had suggested students could revise from the book for exams: Siebold to EH, 15 Feb. 1877, EHH. Haeckel told a visiting naturalist it was "kollossal"; the American understood that a Jesuit had travestied Haeckel's lectures: "Reminiscences of John Sterling Kingsley," 1927, typescript copy, Bancroft Library, University of California, Berkeley: BANC MSS C-D 5057. Walther May organized singing from Reymond at a birthday celebration: *Trink-Lieder*

zur Feier des 70. Geburtstags Ernst Haeckel's in Karlsruhe, Baden am 4 März 1904; May in H. Schmidt 1914, 1:283.

CHAPTER 9

1. The turtle figures were North American to the extent that Haeckel based them on Agassiz's specimens; the first stage could have drawn on Rathke 1848.

2. On grids: Fahnestock 2003; and, perhaps less relevantly, R. Krauss 1985, 8–22; on the periodic table: Gordin 2004; Scerri 2007.

3. E.g., H. Schmidt 1914, 1:106–7.

4. For other changes see, e.g., Hoßfeld 2005a, 144–48; Reynolds and Hülsmann 2008; and R. Richards 2008, 244–55; on image families: e.g., Uschmann 1967; Griesemer and Wimsatt 1989; S. Gould 1997; for the expansion of the evolutionary edifice: Bowler 1996.

5. The practice is common; for an extreme example: S. Gould 1997, 65.

6. On edition sequences and authorial revision: J. Secord 2000, 151–52, 385–93, 492–93; on the publication history of Haeckel's books: Krauße 2002, 2005.

7. For translation as gain: S. Montgomery 2000.

8. E.g., Cartwright 1995; B. Kevles 1997; Beegan 2008.

9. Daum 1998. The first edition spelled the title *Welträthsel*.

10. Haeckel 1879a, xxiii; also 1891, 1:xxv.

11. E. Reimer to EH, 1 Feb. 1873, 6 Nov. 1878, and 13 Dec. 1888, EHH.

12. Haeckel 1879a, 689.

13. Emanuel Reinicke to EH, 28 Oct. 1891, EHH.

14. EH to Wilhelm Bölsche, 25 Aug. 1903, in Nöthlich 2002, 154–55.

15. EH to Oscar Hertwig, 27 Jan. 1891 (quotation); Reinicke to EH, 28 Oct. 1891 (honorarium), EHH.

16. O. Hertwig 1888; Max Fürbringer to EH, 23 Dec. 1890; Carl Rabl to EH, 31 Jan. 1891, EHH.

17. Reinicke to EH, 17 Oct. 1889 (the run), 26 Dec. 1889 (quotation), 8 July 1890 and 26 Oct. 1891 (price), and 30 Jan. 1893 (biologists), EHH. Haeckel had Reinicke order electrotypes of the available woodcuts and tipped the prints into the manuscript: EHH: B61–62, 64.

18. Haeckel 1899, 240, 398 (quotations).

19. Loofs 1900; Ziche 2000a; Dörpinghaus 1969, 65–68; Schröder 2008, 287–96.

20. Krauße 1994, 95.

21. Krauße 2005, 165–66.

22. Quoted in Krauße 1984, 108.

23. Krauße 1995; R. Franz 1998; further: Kockerbeck 1986; Breidbach 1998; Binet 2007. The anatomist Wilhelm Waldeyer reported that the *Kunstformen* "much interest the female part of my family as well. The beautiful installments … offer me a welcome opportunity to give the women a small zoological lecture course, which is made much easier with such excellent illustrations": Waldeyer to EH, 11 Nov. 1899, EHH.

24. Haeckel 1899, vi.

25. Haeckel 1902, xx–xxi; also 1898a, x–xi; 1889, xiii–xiv.

26. EH to Bölsche, 27 Nov. 1902, 30 Mar., and 4 Aug. 1903, in Nöthlich 2002, 148, 150–52; and to Fürbringer, 12 Aug. 1903, EHH.

27. EH to Bölsche, 25 Aug. 1903, in Nöthlich 2002, 154–55.

28. Haeckel 1903, 1:xxvi.

29. Haeckel 1891, 1:350–57; 1903, 1:375–83.

30. Haeckel 1898a, xi.

31. Haeckel 1889, 662; 1891, 2:576; counting orders according to Haeckel's scheme.

32. Haeckel 1903, 1:376.

33. For the rediscovery of the complexity of Haeckel's view: Elinson 1987, 3; Richardson and Keuck 2002, 506–7.

34. Of the last stage he made a contradictory claim—the human embryo is "not distinguishable from that of other mammals and in particular very similar to that of the rabbit": Haeckel 1903, 1:322.

35. Hopwood 2000a, 2005, 2011; also MacLeod 1994; Raff 1996, 1–4; B. Hall 2001; more generally on collecting: J. Elsner and Cardinal 1994; Heesen and Spary 2001.

36. Groeben and Müller 1975.

37. Balfour 1881; also Agassiz 1875.

38. Rathke 1839; Bischoff 1854.

39. W. Parker 1880; 1883, 263; Moseley 1892, 487–88; *Oxford Dictionary of National Biography*, s.v. "Parker, William Kitchen."

40. Selenka 1887, 101–6, on 106; on Selenka: Hubrecht 1903.

41. T. Parker 1891, 26–27; Dendy 1899, 2–4; on Dendy: Butcher 1999, 53; Stenhouse 1999, 79.

42. Kükenthal 1893; Semon 1896; Hubrecht 1903; E. Selenka and L. Selenka 1905, 45–54.

43. W. Parker 1880, 1; C. Thomson 1880.

44. Uschmann 1959, 150–65.

45. Kükenthal 1893, v–x, 234–35, plate XV, fig. 16.

46. Semon 1896, 166–75.

47. Semon 1894, 61.

48. Selenka 1903, 329; Hubrecht 1903, 8.

49. Semon 1896, 155–56, 246.

50. Ramstad et al. 2007.

51. Hopwood 2000a, 38–40; Fisher 2006, 26–75; Usborne 2007.

52. Brass 1908, 13; after Schultze 1897, 457.

53. Most authoritatively: Keibel 1909.

54. Haeckel 1891, 1:xxvi. The first edition had already given the second human embryo, at the stage in the *Schöpfungsgeschichte* that His would criticize, a larger brow and shorter tail. The top row of the new plates was more varied throughout: the pig had a smaller head than the human, just as His had said it should; the turtle and chick were more different at every stage (fig. 9.3 herein). Richardson and Keuck 2002, 513, note the shorter tale of the chick in GII, though also that Haeckel made the forelimb resemble that of the ostrich.

55. Haeckel 1891, 2:861. He collected vertebrate embryos in Java in 1900 (Haeckel 1901, 92), but there is no evidence that these significantly informed the figures introduced in 1903 and this is unlikely given the geographical ranges of most groups depicted: Hopwood 2009b, 866. The Phyletic Museum has few specimens of an appropriate age and none that Haeckel could

clearly have used for his plates: Dietrich von Knorre, personal communication, 26 Aug. 2002.

56. Rabl to EH, 31 Jan. 1891, EHH, mentioning "pictures of selachians (*Pristiurus*), amphibia (axolotl), reptiles (lizard), birds (chick), and mammals (rabbit, cat, sheep, and human)." For anatomists sending photographs of ape and human embryos: Julius Kollmann to EH, 15 Sept. 1892; and Ferdinand Hochstetter to EH, 7 Apr. 1892, EHH.

57. F[ranz] v[on] Wagner, *Biologisches Centralblatt* 12 (1892): 157–60, on 158.

58. Fürbringer to EH, 23 Dec. 1890; EH to Fürbringer, 21 Apr. 1903; Fürbringer to EH, 23 Apr. 1903, EHH.

59. Haeckel 1891, 2:859–60.

60. Haeckel 1908, 57, with reference to figures mostly first published on plates in *Schöpfungsgeschichte* and *Anthropogenie*.

61. Haeckel 1891, 2:859. Though sociologists have long explored diagram use in biology, e.g., Lynch 1991, we lack a history (as of the related schematics), but see: Griesemer and Wimsatt 1989.

62. Haeckel 1910c, 27; also R. Hertwig 1919, 953.

63. Haeckel 1891, 1:352; 1910c, 43–44.

64. Hopwood 2000a, 43; fig. 10.2B herein.

65. Richardson and Keuck 2002.

66. Haeckel 1903, 2:917; also 1908, 57; 1910c, 35.

67. Theunissen 1989.

68. In his books, that is; others released, replaced, or added to the embryo drawings.

69. Haeckel, "Fälschungen der Wissenschaft," *Berliner Volks-Zeitung*, no. 607 (29 Dec. 1908), Morgenausgabe; also 1910c, 37.

70. Haeckel was casual about species: figures could reappear under other names, e.g., the first two figures for koala in Haeckel 1898a and opossum in Haeckel 1891 are the same (my figs. 9.5 and 9.3).

71. Ernst Gaupp to EH, 30 Oct., 5 Nov., and 7 Dec. 1892, EHH.

72. H. Schmidt 1909, 88–89.

73. Historians of science increasingly study international knowledge transfer: e.g., Daum 2001; J. Secord 2010; we have yet to explore systematically the translation of illustrations, but see, e.g., Simon 2011.

74. H. Schmidt 1914, 1:107; but see also EH to Verlagsbuchhandlung Georg Reimer, 22 Apr. 1909, SBB, including for Haeckel's report that the first (1873) Russian translation was confiscated by the censor and burned.

75. While histories of translating evolutionism have emphasized export from Britain, including to Germany (Rupke 2000; Gliboff 2008), Britain, with America, was also an importer.

76. Howsam 2000; Daum 2001, 305–8; Johns 2009, 293–94.

77. Lester 1995, 37–38.

78. Johns 2009, 298.

79. Kegan Paul to EH, 8 Apr. 1876 (quotation); W. Engelmann to EH, 27 Nov. 1874; R. Engelmann to EH, 25 Aug. 1876; and for more complications: Van Rhyn to EH, 10 June and 19 and 26 Oct. 1874, EHH.

80. W. Engelmann to EH, 27 Nov. 1874 (on the difficulty of translating the names); R. Engelmann to EH, 22 Aug. 1876

(supplying electrotypes and plates) and 25 Aug. 1877 (electrotypes), EHH; Archives of Kegan Paul, Trench, Trübner & Henry S. King (microfilm): A1, 269; A2, 501–2; B7, 105–6 (costs of stereotyping and electrotyping).

81. P. H. P[ye-]S[mith], "Haeckel's History of Creation," *Nature* 13 (16 Dec. 1875): 121–23; James Sully, "Professor Haeckel's History of Creation," *Examiner*, 26 Feb. 1876, 237–38, but for this psychologist and philosopher, recently a student in Berlin, Haeckel offered "meagre proof" for "so large a proposition" as recapitulation.

82. The runs were half those of each German edition but more frequent. Archives of Kegan Paul et al.: London, 1899, 1906; New York, 1893, 1902, 1906, 1909, 1914, 1925. Library catalogues list several more Appleton editions between 1899 and 1913.

83. Archives of Kegan Paul et al.: London: 1883, 1901; New York: 1886, 1887, 1892, 1896, 1898, 1899–1900, 1903. This edition appears also to have been printed in 1906 (London) and 1897 and even 1920 (Appleton).

84. Also under the imprint of A. L. Fowle, New York; on Werner: M. Kahn 2011.

85. By contrast, the only French translation was from the second edition, while the only Italian one was of the fourth, with plates and apologia, as part of a multivolume collected works: Haeckel 1877b, 1895.

86. S. Montgomery 2000, 271.

87. But see Haeckel 1879b, 1:xxxv, 383. Translation into English of *Unsere Körperform* and *Ziele und Wege* is a major desideratum today.

88. Daum 2001.

89. Morse 1920, 267–68; further: F. Lewis 1916.

90. Minot 1877; also 1880, 249.

91. McCabe 1906b, 302.

92. McCabe in H. Schmidt 1914, 2:244; compare McCabe 1906b, 306–7; on McCabe: McCabe 1947; Cooke 2001.

93. Engelmann-Verlag to EH, 8 Mar. 1905 and 17 Aug. 1909 (Haeckel's having given permission to use all plates without the fee Engelmann had planned to charge), EHH. On Haeckel, Watts, and the RPA: F. Gould 1929, 28, 32; Whyte 1949, 35, 49; further: Lightman 2007, 264–65.

94. *Nature* 75 (22 Nov. 1906): 78 (quotation); J. P. McM[urrich], *Science*, n.s., 22 (4 Aug. 1905): 137–39. The "Pedigree of Man" and another genealogical tree were omitted in 1905, "on account of [the] impossibility of adapting them to English circulation" (Haeckel 1905b, 2:vii), but added in a 1910 printing, with "Myxine," a hag(fish), rendered as "Hog."

95. Ad on the back of J. Gregory 1930.

96. McCabe 1947, 42.

97. A short Turkish book that is considered a (highly abridged) translation contains as illustrations only some portraits not in the original and a tree: Haeckel [1911b]; Hanioğlu 2005, 71–72, 110.

98. Wilhelm Engelmann (Jr.) to EH, 24 Nov. 1906 and 16 Jan. 1912; and to Walther Haeckel, 10 Feb. 1921, EHH.

99. Haeckel 1912 (2nd ed., 1920); Krauße 2002, 140; on Reclam: Bode 1992. Haeckel's book was not in the first selection offered from the machines, but may have been added later.

100. W. Engelmann to EH, 28 and 30 Mar. 1916, EHH;

Krauße 2002, 140.

101. Walter de Gruyter to EH, 6 and 10 Jan., and 22 Feb. 1911; EH to de Gruyter, 8 and 20 Jan. 1911, SBB.

102. Heinrich Schmidt, "Vorwort zur zwölften Auflage," in Haeckel 1926, v; de Gruyter to EH, 2 and 24 June 1919; and EH to de Gruyter, 17 June 1919, SBB. Discussions about a people's edition went back at least to EH to de Gruyter, 17 Dec. 1907, SBB.

103. Haeckel 1924b: vols. 1–2.

104. For reference to an ancient copy: e.g., Neumann 1905, 65.

105. But see Keibel 1909; [Max] Hilzheimer, *Archiv für Rassen- und Gesellschafts-Biologie* 6 (1909): 544–46.

106. Haeckel 1905a sold 9,096 of 10,000 by the end of 1905: de Gruyter to EH, 10 Jan. 1911, SBB; the freethinkers' press in Frankfurt had printed 8,000 of Haeckel 1907 by 1910 and sold it for 1.50 marks: Haeckel 1910c, back cover. Haeckel 1905a did well in English too, with and then especially without the plates: Haeckel 1906b and, e.g., [*c.* 1922].

CHAPTER 10

1. Haeckel 1875a, 36–37; Hopwood 2000a.

2. Hopwood 2005.

3. E.g., Latour 1987, 250–54; O'Connell 1993; Kohler 1994; Wise 1995; Schaffer 1997; Zimmerman 2001, 86–107; Gradmann and Simon 2010.

4. For revisionist views of the "revolt": Maienschein 1991a, 1994; Nyhart 1995, 243–361; Hopwood 2009a, 298–304.

5. For more detailed accounts of the topics in this chapter: Hopwood 2000a, 2005.

6. E. Krause to EH, 5 Dec. 1876, EHH (receipt of the book); [Ernst] K[rause], *Kosmos* 1 (1877): 275–76.

7. Kölliker 1879, 306–7, 1013; W. Krause 1876, 204–7.

8. Ahlfeld 1876; Hensen 1877; Ebner 1877. Semper criticized Haeckel for ignoring Kölliker's reservations: Semper 1877, 27–28.

9. W. His 1880b, 407.

10. W. His 1880a, 68.

11. Ibid., 2, 4–5.

12. Karl Bardeleben, *DMW* 7 (1881): 44.

13. The midwives of Leipzig from whom he obtained twenty-two specimens were not named either; perhaps he paid cash instead.

14. Hopwood 2000a; for other discourses: Usborne 2007.

15. W. His 1880a, 6–10; for the photographs: Bardeleben, *DMW* 7 (1881): 44; for their projection: W. His 1879.

16. W. His 1870a; 1880a, 7–12; 1885, 3–5; 1887; Hopwood 1999; 2002, 40–49.

17. W. His 1880b; 1882a, 18–22; for skepticism about a woman's statement: His 1882a, 90–91; on overturning the dominant view: Holle 1984; further: Schlünder 2005.

18. W. His 1880a, 12–13; 1882a, 4–6.

19. W. His 1880a, 147.

20. *Pace* R. Richards 2008, 310.

21. W. His 1882a, 12–17.

22. W. His 1880a, 148–66; 1882a, 18–22.

23. W. His 1879.

24. W. His 1880a, 68–72.

25. Ibid., 169–73; W. His 1885, 222–26. Minot translated *Bauchstiel* as "body-stalk."

26. W. Krause 1880a, 1880b.

27. Fr. Ahlfeld, *Centralblatt für Gynäkologie* 4 (1880): 603 (but see also ibid., 223–25; and Fr. Merkel, "Entwickelungs-geschichte," *JLFM* 15.1 [1881]: 78–105, on 94); Ecker 1880; Balfour 1881, 224–26; for a rebuttal: W. Krause 1881a.

28. W. His 1880b, 410, 413–14, 420.

29. W. Krause 1881b, 1881c.

30. W. Krause 1880b, 133; W. His 1880b, 412.

31. *FZ*, no. 98 (8 Apr. 1882), Abendblatt, 2; Merkel 1891, 349–52; on the celebration: Waldeyer to Henle, 3 May 1882 and 29 Apr. 1883, in Hoepke 1976, 45, 47. Controversies over tailed people, with an embryological dimension which His addressed in the *Anatomie*, were widely reported: Zimmerman 2001, 77–79, 83; I am not aware that newspapers discussed the more esoteric dispute over the allantois.

32. Kölliker 1882; Hasse 1882; further: Merkel, "Entwickelungsgeschichte," *JLFM* 16.1 (1882): 94–118, on 103. Compare the role of the more public debate over the jaw of Moulin-Quignon in establishing norms in paleontology: C. Cohen 2006, 170–71.

33. Haeckel 1891, 1:371–73.

34. W. Krause, "Entwickelungsgeschichte," *JLFM* 22.1 (1888): 67–111, on 88. He does not appear to have had a scientific-political axe to grind, and anatomists later assisted his already blighted career: Hopwood 2000a, 58–59, 68–69.

35. W. His 1885, 6, 236–42.

36. Raff 1996, 1–4.

37. Haeckel 1874a, 634, 717; 1875b, 409–16; S. Gould 1977, 76–85. For the origin of the terms in pathology: Hopwood 2005, 243; for Haeckel's encounter with them in Virchow's lectures: EH to his father, 16 Nov. 1853, in Haeckel 1921a, 75–84, on 82.

38. S. Gould 1977, 167–206.

39. Nyhart 1995, 243–77.

40. Maienschein 1994; Nyhart 1995, 278–361; Mocek 1998.

41. Hopwood 2005, 244; 2009a, 298–304.

42. Hopwood 1999, 486–93; 2000a, 70–76; 2002, 50–67.

43. W. His 1886, 549–54.

44. Haeckel 1891, 1:xxii.

45. Oppel 1891; 1892, 683–86; on Oppel: Roux 1917.

46. Mehnert 1895, 430; for links to debate over the biogenetic law: S. Gould 1977, 174–75; Hopwood 2005.

47. Keibel 1895a, 75–78.

48. Keibel 1898, 731–36.

49. Keibel 1895b; he even approached Haeckel: Keibel to EH, 26 Oct. 1895, EHH.

50. Keibel 1896; for the standard run: Hopwood 2005, 270, 298; on Fischer: Lütge 1928.

51. Keibel 1897.

52. Kerr 1950.

53. Kerr 1901, 3; B. Hall 2001.

54. Hubrecht 1894; on Hubrecht: Keibel 1915.

55. Keibel and Elze 1908, 89.

56. Keibel 1906, 1.

57. Ibid., 153–74.

58. E.g., Keibel and Elze 1908, 152–62.

59. O'Rahilly 1988; Maienschein, Glitz, and Allen 2004; L. Morgan 2009.

60. Nieuwkoop 1961; Faasse, Faber, and Narraway 1999; Richardson and Narraway 1999.

61. Hopwood 2005, 273–84, also on the Carnegie department's different approach to ordering detailed reconstructions of thousands of human specimens.

62. Rupp-Eisenreich 1996, 2106–7.

63. E.g., Haeckel 1903, 1: plate V (SI–III), here fig. 9.9; 1910a.

64. Keibel 1909.

CHAPTER 11

1. Bölsche 1930, 252; on Bölsche: Kelly 1981; Berentsen 1986; Susen and Wack 2012; for adult workers' pub talk about science: Evans 1989, 167–81.

2. On self-development through reading: J. Secord 2000, 336–63.

3. On the power of images: Freedberg 1991; Mitchell 2005.

4. Kelly 1981, 74.

5. Haeckel 1874a, xi, xiv; on problems of propriety in nineteenth-century evolutionism: Dawson 2007. Ways of handling tricky images and objects had been developed, more or less respectably, in anatomy and anthropology museums: König and Ortenau 1962; Oettermann 1992; M. Burmeister 2000; Zimmerman 2001, 172–98.

6. On the milieus: Jefferies 2003, 25–41; for reform initiatives: Buchholz et al. 2001; on sex education: Sauerteig 1999b.

7. Depdolla 1941; Kelly 1981, 57–74; Scheele 1981; Nyhart 2009, 161–97, 293–322.

8. E.g., Julius Schaxel to EH, 9 Apr. 1906, in Krauße 1987, 41–42.

9. H. Schmidt 1914, 1:323, 2:15, 101, 150; for reading Vogt and Moleschott first: ibid., 2:224; for Büchner's Darwin lectures as introduction: ibid., 2:329.

10. E.g., ibid., 2:330.

11. Ibid., 2:143, 292; H. Windhorn to EH, 14 Nov. 1910, EHH.

12. E.g., H. Schmidt 1914, 2:15, 150.

13. Quoted in Rabl 1971, 251–52; see also Goldschmidt 1956, 34–36.

14. E.g., H. Schmidt 1914, 1:275–76, 2:182–83.

15. Ibid., 1:206–7; on Breitenbach: Nöthlich 2009.

16. E.g., Kelly 1981, 123–41; Weber 1991.

17. Most 1876, on 126, 131–33, 497, 508; "Haeckel," *Die Neue Welt* 2 (1877): 40, 48.

18. E.g., H. Schmidt 1914, 1:223–27, 228–29.

19. Depdolla 1941, 302–3; Kelly 1981, 60–65; Morkramer 2010.

20. H. Schmidt 1914, 1:326–27 (on Winterthur, Switzerland), 2:84–85.

21. Ibid., 1:357–59.

22. Bölsche 1891b, 1098.

23. H. Schmidt 1914, 1:328.

24. Neumann 1905, 65–66; Haeckel 1912; also H. Schmidt 1914, 2:154–55.

25. Dennert 1901, 7.

26. Dennert 1937, 95–105, on 105; further on Dennert: Selle 1986; Schröder 2008, 426–36.

27. Chaps. 12 and 16.

28. E.g., the embryology teacher in Graz around 1880: H. Schmidt 1914, 2:230. Thanking Haeckel for the first edition, Wilhelm Waldeyer looked forward, having already discussed the gastraea theory with his students, to basing his lectures on "your excellent new work": Waldeyer to EH, 12 Oct. 1874, EHH. That was before His's letters and Kölliker's second edition. Haeckel criticized Waldeyer for failing to discuss the *Anthropogenie* in an annual review: Haeckel 1875a, 74.

29. For the print runs: Weindling 1991a, 347.

30. A[rthur] M. M[arshall], "The Evolution of Man," *Nature* 45 (24 Mar. 1892): 482–83; on Marshall: Kraft and Alberti 2003.

31. J. A[rthur] T[homson], "Zoological Books from Germany," *Nature* 71 (19 Jan. 1905): 265–66; G[rafton] E[lliot] S[mith], "The Evolution of Man," *Nature* 87 (13 July 1911): 39–40; also J[ames] P. McM[urrich], *Science* 22 (4 Aug. 1905): 137–39.

32. F[ranz] v[on] Wagner, *Biologisches Centralblatt* 12 (1892): 157–60; J[ulius] Kollmann, *Globus* 86 (1904): 174–75.

33. H. Schmidt 1914, 2:285; also Escherich 1949, 14.

34. H. Schmidt 1914, 1:369–70; also 367. In theological terms, Tschirn appears here to favor traducianism, the doctrine that the soul is transmitted through generation, over creationism, the idea that souls are implanted in each body by God.

35. McCabe 1906b, 303.

36. E.g., Penzoldt 1923, 170; for divisions over Haeckel's reputation and effect on students also: Lubarsch 1931, 20–21; Stoeckel 1966, 30–31, 34.

37. Dennert 1901, 33; on Lieberkühn: "Nekrolog," *AA* 2 (1887): 296.

38. Hopwood 2000a, 68–69.

39. Julius Kollmann, "Die Anatomie menschlicher Embryonen von W. His in Leipzig," *Verhandlungen der Naturforschenden Gesellschaft in Basel* 8 (1890): 647–71, on 665; for less charitable views: Minot 1892, 355 ("hasty and unfounded speculation"); Fleischmann 1901, 246; Jamin 1986, 15.

40. "New Publications; Humanity's Origin," *NYT*, 16 June 1879, 3; Joseph Jacobs, "Man and Evolution: The Advance in Scientific Knowledge since Darwin's Day—Prof. Ernst Haeckel's Recent Books," *NYT*, 2 Sept. 1905, BR569.

41. Wundt 1921, 17.

42. Bischoff 1872, 33–35; on such arguments, most recently: Rowold 2010.

43. On the museums: König and Ortenau 1962; Oettermann 1992; on Fanny Zeiller, an early author outside academia: Hopwood 2007, 299–301; on the leading advice-book writer: M. Krauss 2010, 63–67.

44. Letter of 1874, quoted in Lester 1995, 38. Victorians marveled at what could be said in German without the protection of Latin or even Greek, but Pye-Smith approved of Lankester's plain English equivalents for anatomical and zoological terms: P. H. P[ye-]S[mith], "Haeckel's History of Creation," *Nature* 13 (16 Dec. 1875): 121–23; Dawson 2007, 36–38.

45. Reuter 1906, 302–7; Woodford 2012.

46. Engelmann to EH, 3 and 19 Nov. 1874, EHH.

47. Michler 1999, 167–71.

48. Henrich-Wilhelmi to EH, 16 Jan. 1875, EHH.

49. Quotation, referring to the Deutscher Frauen Klub in Berlin, from "A German Women's Club," *Hampshire Telegraph*, supplement, 22 Oct. 1898, 11.

50. Zöckler 1874; on Zöckler: F. Gregory 1992, 112–59; Schröder 2008, 200–220.

51. Working out from the abortion debate might reveal connections: Seidler 1993; Dienel 1993. Haeckel opposed the law, with the arguments that the egg cell is a part of the maternal body with which the woman may do as she wishes, and that even the newborn child has the mental development of a lower vertebrate: Haeckel 1904b, 375.

52. The boy, Walther May, later studied the essay more carefully and was inspired for life as a Darwinist, social democrat, and eventually zoologist: H. Schmidt 1914, 1:273–74; G. Mayer 1987.

53. Bölsche 1891a, 259.

54. Bölsche 1891b, 1100, using "physiological" in an old sense.

55. Bölsche 1891a.

56. "Nehmet Eure Kinder in Acht!" *Schwerter Zeitung*, no. 24 (24 Mar. 1877), reproduced in Morkramer 2010, 122.

57. Bumüller 1908, 138–57; the review: *Stimmen aus Maria-Laach* 78, no. 4 (21 Apr. 1910): 459–60.

58. Sauerteig and Davidson 2008.

59. Grazie 1909, 5–24, 34–41; Michler 1999, 396–447, which explains the complexities of her positions and points out that by this time evolution had more of a place in Austrian than German secondary schools.

60. Quoted in Wolff 1993, 17; information about the school from "Die Geschichte des Schulgebäudes der Friedrich-Bergius-Oberschule," Friedrich-Bergius-Oberschule, accessed 2 May 2013, http://www.friedrich-bergius-schule.de/Geschichte/Geschichte1.html; for a similar performance: Goldschmidt 1956, 35–36. Hodann's most famous clash came in 1928 when, as a socialist doctor and sex educator, he had a children's book banned and was put on trial.

61. Pesch 1884, 204.

62. The title of a regular section in the *PB*.

63. On the reception of Darwinism: Dörpinghaus 1969, esp. 43–48; of liberal newspaper readers: Reichensperger 1872.

64. Stöckl 1874, 174–75.

65. Scheidemacher 1875–76, 1876b; Pesch 1884, 204–7; for a moderate position: X, "Der Darwinismus und das Christenthum," *Deutscher Hausschatz* 9 (1882–83): 462–63.

66. F. Gregory 1992; Schröder 2008.

67. Zöckler 1879; "Vorwort," *Deutsch-evangelische Blätter* 1 (1876): 1–5; Zollmann 1878.

68. R. Steck, "Ein Darwinianer gegen den deutschen Darwin," *Protestantische Kirchenzeitung* 23, no. 4 (22 Jan. 1876): 74–77, on 76–77.

69. Zöckler 1879, 673–76; Schmid 1876, 60–65. Rudolf Schmid insisted, however, on individual differences, that recapitulation was no law, and that such indirect evidence could at most indicate the possibility of descent. Weygoldt 1878, 14–17, accepted embryonic similarity, but argued that "mere analo-gies" were not enough without proof of laws.

70. E.g., Wigand 1878; for an antievolutionist embryology: Linstow 1878, with the forgery charges after Semper on 76–78.

71. "Centrum u. Volkspartei in Württemberg," *Der Oberländer*, no. 103 (8 July 1890), 1; and no. 109 (19 July 1890), 1.

72. H. Schmidt 1914, 1:370–71; on organized free thought: Groschopp 1997; Simon-Ritz 1997.

73. Edward Elkan, "Sketches from My Life" (1983), 20, Wellcome Library, London: MS.9151. The book, identified from this description and the title, was the two-volume Guenther 1909, containing the embryo grid shown here in figure 12.8 as the last plate of volume 1.

74. Thus the subtitle of the English translation.

CHAPTER 12

1. Bölsche 1907 (first published 1898), 1:44, x; Heidler 1998, 672; further: Kelly 1981, 36–56; Berentsen 1986; Susen and Wack 2012.

2. On evolutionist imagery: Browne 2001, 2009; Clark 2008; Donald and Munro 2009; Kort and Hollein 2009; B. Larson and Bauer 2009; for X-rays and bacteria: e.g., Cartwright 1995; Hansen 2009.

3. Kusukawa 2012, 63–69; also Zorach and Rodini 2005.

4. On the law: M. Vogel 2001; on piracy: Johns 2009; neither pays illustrations much attention.

5. On photographic reproduction methods: Harris 1979; Jussim 1983; Weise 2003; Beegan 2008.

6. Periodicals are another story, and according to my unsystematic impression a smaller one, though with such major exceptions as are shown in figures 8.2 and 16.3. Unacknowledged copies have been identified by formal similarity.

7. On use and avoidance of problematic illustrations in a single work: J. Smith 2006b.

8. EH to G. Reimer, 5 Dec. 1872, SBB.

9. Chapman 1873, v. The book came out, with an 1873 title page, in 1872.

10. E.g., E. Krause to EH, 4 Apr. and 1 July 1876; Engelmann-Verlag to EH, 17 Aug. 1909, EHH.

11. Wilhelm, König von Preußen 1870, §§43–44; M. Vogel 2001.

12. Sterne 1876, 336; Gunning 1876, 233–35, 282–83; March 1883, plate; A. Wilson 1883, 181, 187–88; Laing 1885, 171; Clodd 1888, 162, 190–92; 1895, 109, 133–35; Romanes 1892, 152–53; J. Thomson 1892, 198; Bommeli 1898, 61–67; Headley 1900, 17–18; Hird 1903, 41–43; 1906–7, 2:102–3; Metcalf 1904, 197–98, plate 98; Herbert 1913, 77–81.

13. On encyclopedias: Jäger 2001; for print runs: "Meyers Lexikon Auflagen," *Lexikon und Enzyklopädie*, accessed 3 May 2013, http://www.lexikon-und-enzyklopaedie.de/Meyers-Konversations-Lexikon-Auflagen/.

14. *Illustriertes Konversations-Lexikon der Frau* 1900, 1: plate for article "Embryo"; Dennert 1900, 801–7, 1185–86.

15. Sedgwick 1894, 36–37 (quotation); Sedgwick, "Embryology," in *Encyclopaedia Britannica*, 10th ed., vol. 28 (1902): 137–48; on Sedgwick: Ridley 1985, 44–45.

16. J. Thomson, "Embryology," in *Chambers's Encyclopaedia*,

new ed., vol. 4 (1889): 317–22; 1892, 198; on Thomson: Bowler 2005. The embryos stayed through the 1924 edition.

17. Dedicated to Haeckel, Heilborn 1914, 9–13; and 1920a, 19, unusually included his pictures.

18. These are not present, e.g., in: Aveling 1887, 116–23; Marshall 1894, 78–115; Magnus 1908, 86–93; Whyte 1916, 153; Berndt 1924, 36–37. There is little embryology in the social-democratic Tschulok 1921, first published in 1912; a later, more academic book insisted on the embryological evidence of evolution, but rejected the biogenetic law: Tschulok 1922, 315.

19. A. Wallace 1889, 448–49, relied on the text of Huxley 1863a and for figures referred to Darwin 1871.

20. E.g., Zöckler 1874, 77–78; and perhaps Fiske 1874, 454–55.

21. E.g., Marshall 1894, 78–115; Shute 1899; Maas 1911; Baege 1913, 5–8 (a plan for a slide lecture produced by the Social Democratic Party); Berndt 1924, 36–37.

22. As a critic confirmed: Brass 1909b, 57–58.

23. Ranke 1886, v–vi, 140–42; on Ranke: Geus 1987.

24. Krause to EH, 9 July 1875, EHH.

25. Zacharias 1892, 145–58.

26. Zacharias 1883, 356; Nöthlich et al. 2006.

27. Zacharias to EH, 26 Apr. 1882, in Nöthlich et al. 2006, 237–39. As Zacharias launched the station at Plön he also temporarily collaborated with Haeckel's enemies at the nearby University of Kiel—who shared ecological interests—until they too fell out: Raf De Bont, *Stations in the Field: A History of Place-Based Animal Research, 1870–1930* (Chicago: University of Chicago Press, forthcoming).

28. Bölsche to EH, 31 Dec. 1897, in Nöthlich 2002, 79–80.

29. Decker 1990; Daum 1998, 184–91.

30. Heidler 1998, 465.

31. Bölsche 1904, 62; also 1894–96, 1:99–101; Bölsche to EH, 30 July, and EH to Bölsche, 4 Aug. 1892, in Nöthlich 2002, 45–46.

32. For the publication history, see chap. 9; rare uses of plates from later editions of the *Anthropogenie*: *Illustriertes Konversations-Lexikon der Frau* 1900, 1: plate for article "Embryo"; Heilborn 1914, 12 (two rows from one plate).

33. Quotation from Bommeli 1898, 3, a social-democratic natural history of animals, which invoked Haeckel as a freedom fighter of knowledge and reproduced the older dog-human pair from the *Schöpfungsgeschichte* and the first row of mammals from the fourth edition of the *Anthropogenie*; on Bommeli: G. Mayer 1988.

34. Gunning 1876, 233–35, 282–83; on Gunning: W. H. Larrabee, "The Scientific Work of W. D. Gunning," *Popular Science Monthly* 50 (1897): 526–30.

35. A. Wilson 1883, 188; on Wilson: "Dr. Andrew Wilson," *Cairns Post*, no. 1439 (14 Oct. 1912), 3.

36. March 1883.

37. This became a bowdlerizing strategy in mid-twentieth-century America.

38. Clodd 1888, 162, 190–92; 1895, 109, 133–35; Lightman 2007, 253–66. Samuel Laing, a railway owner and liberal politician who had anonymously redacted *Vestiges* for a newspaper in 1846 (J. Secord 2000, 136), used a dog-human pair from the *Schöpfungsgeschichte* in a plea for "Christianity without mira-

cles" that sold some 20,000 and then came out as a sixpenny reprint with Watts in 1902: Laing 1885, 171.

39. Thomson, "Embryology," in *Chambers's Encyclopaedia*, new ed., vol. 4 (1889): 317–22.

40. Headley 1900, 17–18.

41. As was done in the books by Sterne, Gunning, and Bommeli.

42. Less is known about how photomechanical processes changed book production than magazines, on which see: Weise 2003; Beegan 2008.

43. As the *Illustrirte Zeitung* at least planned: Engelmann to EH, and *IZ* to EH, 28 Jan. 1875, EHH.

44. Richardson et al. 1998.

45. On Hesse: Nyhart 2009, 345–51.

46. Wirén 1899, 304–12; Leche 1911, 168–75; on Leche: Hoßfeld and Olsson 2003.

47. Guenther 1909, i, 198.

48. Ibid., legend to plates 47–48.

49. Ibid., preface; on Guenther and Haeckel: Nöthlich 2006, 95–96. There was a second edition in 1912.

50. E. Wasmann, "Vom Urtier zum Menschen. Kritische Bemerkungen," *Literarische Beilage der Kölnischen Volkszeitung*, no. 27 (8 July 1909), 205–8; no. 31 (5 Aug. 1909), 237–40, on 240.

51. Edward Elkan, "Sketches from My Life" (1983), 20, Wellcome Library, London: MS.9151.

52. On the museum: Clark 2008.

53. By contrast, H. Wells, Huxley, and G. Wells 1934, 71, introduced a five-column, five-row grid into the separately published *Evolution* volume of their successful *Science of Life*, with a neurula as the very similar, but not identical, earliest stage.

54. Bischoff 1852; W. His 1874, 190–91.

55. F. L[ewis] 1907.

56. Chap. 16. Adaptations for invertebrates: Crampton 1931, 65; Lemke 1950, 127. Some one-offs changed format without increasing accuracy, e.g., in a "popular anatomy, biology, physiology, and embryology" of the industrial body for the publisher of *Kosmos*, the illustrator Fritz Kahn reproduced handbook figures corresponding to Haeckel's second row, which he showed developing from one "completely identical" egg into four adults, from a salamander to the *Apollo Belvedere*: F. Kahn 1922, plate XIX. See also Brightwell 1938, 33.

57. The figure in Sterne's *Werden und Vergehen* was not to my knowledge reproduced in other books.

58. American textbooks also made much use of Romanes; in Britain and the United States some favored groups of embryos at a single stage (fig. 16.8).

59. Romanes 1892, 10; *Oxford Dictionary of National Biography*, s.v. "Romanes, George John."

60. Romanes 1892, 154–55.

61. Especially figures that are separate in Le Conte 1888.

62. Metcalf 1904, plate 98; Hird 1906–7, 2:102–3; Herbert 1913, 80–81. Though *Darwin and After Darwin* was translated quickly, German authors, who hardly used Haeckel's embryos anyway, did not copy the embryos from it for a long time.

63. F. S. Lee, *American Naturalist* 27 (1893): 31–33. *Science* 20 (19 Aug. 1892): 109–10, acknowledged "numerous diagrams of fairly good quality," but Sedgwick 1894, 36–37, dismissed these

drawings "reproduced by Romanes and, for all that I know, other popular exponents of the evolution theory."

64. C. S. Minot, *Science*, n.s., 4 (20 Nov. 1896): 762–63; Haeckel's camp denied that he had: Dennert 1904, 112–15.

65. Metcalf 1904 and Herbert 1913 did not. The geologist, paleontologist, and sociologist Lester F. Ward commented that Metcalf, "who does not seem to be acquainted with Haeckel's work, borrowed it from Romanes": *American Anthropologist*, n.s., 7 (1905): 117–18.

66. Hird 1906–7, 2:211.

67. Hird 1903, 41–43.

68. Hird 1906–7, 1:vii, 2:vii.

69. Haeckel 1905a, translated as Haeckel 1906b, included an embryo plate based on later editions of the *Anthropogenie*.

70. For some indications: Burnham 1987; Bowler 2009, 42–48; but see, e.g., Gruenberg 1929, 130. Hird's *Picture Book* went into a posthumous fourth edition in 1948.

71. They are in Bibby 1942, 83.

72. Haeckel's celebrity has yet to be analyzed seriously; Darwin's is a hot topic: Browne 2001, 2003b, 2005, 2009; J. Secord 2009.

CHAPTER 13

1. Terry J. Hamblin, *Times* (London),18 Aug. 1997, 18.

2. Bowden 1977, 128; Sander and Bender 1998, 349; "Terry Hamblin," British Centre for Science Education, 17 Oct. 2007, http://bcseweb.org.uk/index.php/Main/TerryHamblin.

3. Haeckel 1891, 2:858–59 (quotation); Haeckel, "Fälschungen der Wissenschaft," *Berliner Volks-Zeitung*, no. 607 (29 Dec. 1908), Morgenausgabe; Haeckel 1910c, 44, 46–47.

4. Gursch 1981, 60, 74–79, noted the lack of new charges, except from the paleontologist Otto Jaeckel in a specialized journal, the *Neues Jahrbuch für Mineralogie, Geologie und Palaeontologie*, 1897, 1:386–95, against figures of fossil echinoderms.

5. Dennert 1901, 16.

6. Biographies of Haeckel have yet to thematize commemorative strategies during his lifetime; on memory practices in the sciences: Outram 1978; Graham, Lepenies, and Weingart 1983; Meinel 1992; Mehrtens 1994; Abir-Am and Elliot 1999; Browne 2003b, 2005, 2009; Richmond 2006.

7. Blackbourn 1997, 311–459.

8. H. Schmidt 1926, 413–23.

9. Hamann 1900, 342.

10. Heider 1919; further: H. Schmidt 1914.

11. E.g., Hensen 1891, 10; V. Franz 1934, 19. A student (later a critic), recalled Haeckel in his seminars as "quite the charming, refined gentleman, which he also always was in company. Only at his desk, it seems, did his temper run away with him" (Driesch 1951, 47–48).

12. Hensen 1890; Porep 1970, 1972; Lussenhop 1974; Mills 1989; see also Nyhart 2012.

13. Haeckel 1890, 10 (quotations), 99–100; Carus Sterne, "Die neueren Forschungen über den Stoffwechsel des Meeres. Schluß," *Tägliche Rundschau, Unterhaltungsbeilage*, no. 62 (14 Mar. 1891), 246–47.

14. Hensen 1891, 10–11.

15. Ibid., 5–6, 44, 55. The theme of nature as forger echoes Semper 1876, 35–36. Semper, a friend of Hensen, had taught him to fish with a net: Brandt 1925, 98.

16. Hensen 1891, 55, 64, 5.

17. Hensen had let pass Haeckel's first embryo plates, but criticized Wilhelm Krause's preparation and a picture of Haeckel's that showed sperm in the egg: Hensen, "Generationslehre und Embryologie," *JLFM* 3.1 (1869): 56–65, on 58; 1876; 1877.

18. Hensen 1891, 44.

19. Brandt 1925, 98; but see Mills 1989, 37.

20. Daum 2001, 286.

21. Quoted in Haeckel 1891, 2:887, 862.

22. Ibid., 858–59; for the monism: Kollmann to EH, 7 Jan. 1893, EHH; also Kollmann, *Globus* 86 (1904): 174–75.

23. Haeckel 1910c, 44, 46; also Haeckel, "Fälschungen der Wissenschaft," *Berliner Volks-Zeitung*, no. 607 (29 Dec. 1908), Morgenausgabe.

24. Haeckel 1891, 2:859–60.

25. On mechanical objectivity: Daston 1999, 28–29; Daston and Galison 2007, 191–95.

26. Hopwood 2006, 300.

27. Haeckel 1891, 2:859–60; W. His 1880a, 6; Hopwood 1999, 487–91; 2000a, 42–43.

28. Haeckel 1891, 2:861–63.

29. H. Schmidt 1914, 1:370–71.

30. Bölsche 1891b, 1100.

31. Bölsche 1900, 235–36.

32. Bölsche 1891b, 1100; 1930, 252 (*kalenderhaft roh*).

33. Bölsche 1891b, 1100.

34. Bölsche 1913, 314–19, on 315. *Palladium* refers to the image of the goddess Pallas (Athene) in the citadel of Troy, which was believed to guarantee the safety of the city.

35. Kollmann to EH, 20 Nov. 1891, EHH.

36. Carl Rabl to EH, 19 Nov. 1889; also, e.g., Johannes Rückert to EH, 18 Nov. 1891, EHH.

37. Specht 1894.

38. Karl von Bardeleben, in *Bericht* 1894, 22.

39. Ibid., 1–3, 11–13.

40. Ibid., 11–13, 25–36 (quotations on 11). Sedgwick 1894 has been prominent because it is in English. For the contributors among anatomists and zoologists still active in 1909: table 14.1, herein.

41. *Bericht* 1894, 3–7, on 5–6. On the art of the *éloge*, trickier in the subject's presence than after death: Outram 1978.

42. "Haeckel," *Natural Science: A Monthly Review of Scientific Progress* 4, no. 25 (Mar. 1894): 161–62, which also noted, "He is a dull man whom all speak well of."

43. Mivart was a more substantial and independent writer: *Oxford Dictionary of National Biography*, s.v. "Mivart, St. George Jackson."

44. Hamann to EH, 11 Feb. 1888, in "Der Ausgang des Prozesses Häckel-Hamann," *Freie Bühne für den Entwickelungskampf der Zeit* 4 (1893): 1131–37, on 1136.

45. Hamann 1892; on Hamann: Uschmann 1959, 117–20.

46. Haeckel 1893 (first published, 1892), 42–43.

47. "Der Darwinismus vor Gericht," *Freie Bühne für den Entwickelungskampf der Zeit* 4 (1893): 900–903.

48. Loening 1893; Uschmann 1959, 117–20, 155; Krauße

2005, 153. Hopwood 2006, 297, wrongly has Hamann fined more.

49. Hamann 1893; see also Brandt 1891, 204.

50. Kellogg 1907, 8; on Fleischmann: Stammer 1952.

51. Fleischmann 1898; Haeckel 1898b.

52. R. Hertwig to EH, 29 Nov. 1897, EHH; Isidor Rosenthal to EH, 26 Nov. 1897, quoted in Hoßfeld 2005a, 294.

53. Fleischmann 1901; Stammer 1952.

54. Fleischmann also challenged embryonic similarity in refuting the biogenetic law: Fleischmann 1901, 10–13, 244–47.

55. *Darwinismus und Socialdemokratie* 1895, 20–25.

56. Bölsche to EH, 10 Dec. 1898, in Nöthlich 2002, 86; Bölsche 1900. Sales topped thirty thousand, and an English translation did well.

57. "Auch ein Kompromiß," *Lustige Blätter* 15, no. 17 (26 Apr. 1900): 8; I have seen no earlier caricatures at the Haeckel House or reproduced in the literature.

58. Haeckel 1899, 61–80, on 75–76.

59. Vernon L. Kellogg drew attention to this "intemperate and unconvincing but interesting brief against ... the selection theories" by using it to frame his own defense: Kellogg 1907, 7.

60. Bowler 1983, 4; Numbers 2006, 52; for a revisionist view of Kellogg and the eclipse: Largent 2009.

61. Dennert 1901; on Dennert: Dennert 1937; Selle 1986; Schröder 2008, 426–36.

62. Dennert 1901, 34, though noting "really strongly idealized drawings" in the first rows.

63. Ibid., 16, with reference to H. Schmidt 1900, 62–63, a dismissal of a previous attack.

64. Breitenbach 1905, 115–18; Neumann 1905, 43–44; May 1909, 86–88.

CHAPTER 14

1. "Haeckel gesteht die Fälschungen ein," *Das Reich*, no. 4 (6 Jan. 1909), 1. Beilage; Haeckel, "Fälschungen der Wissenschaft," *Berliner Volks-Zeitung*, no. 607 (29 Dec. 1908), Morgenausgabe.

2. Klemm 1968, 221; Gursch 1981; Daum 1998, 235.

3. Rival document collections made this easier, but only sample the local reporting: H. Schmidt 1909; Teudt 1909. On science, the press, and the public sphere around 1900: Goschler 2000; Heesen 2006; Nikolow and Schirrmacher 2007; Hagner 2010, 151–72; on the press more generally: Grunewald and Puschner 2010, and other volumes in the series.

4. Bayertz 1998.

5. Rupke 1987; Buklijas 2008, 598–605; Sauerteig 1999a; Goenner 1993; see also Wazeck 2009. There are echoes of the Friedrich Zöllner affair: Meinel 1991.

6. On the uses of "the people" in the history of science: J. Secord 2000.

7. Gasman 1971; Simon-Ritz 1997; Groschopp 1997; Ziche 2000b; Nöthlich et al. 2007.

8. Nöthlich 2006, 83.

9. Haeckel 1905a, 9, 31–36; on Wasmann: Barantzke 1999; Lustig 2002; R. Richards 2008, 356–71, 385–90; on science for Christian audiences: Dörpinghaus 1969; Kelly 1981, 75–99;

Daum 1998; Schröder 2008.

10. Haeckel 1905a, 88, 105.

11. Wasmann 1906, 271–72, 464.

12. Daum 1998, 229–33.

13. Haeckel 1907, 6, 44, 49; on the museum: Fischer, Brehm, and Hoßfeld 2008.

14. Haeckel 1907, 28–29.

15. Ibid., 5.

16. In a draft defense Haeckel planned to claim that the changes corrected errors resulting from inadequate material: EHH: B84, fol. 64v.

17. Dennert 1908, 10; for slides of Haeckel's embryos in *Kosmos*-sponsored lectures: Brass 1908, 11; 1911, 1; on Dennert and the league: Dennert 1932, 1937; Schröder 2008, 426–36, 440–64.

18. The *Vossische Zeitung*, quoted in Dennert 1937, 202. Dennert met the accusation of promoting Christian science in part by claiming Jewish members: Schw., "'Christliche Naturwissenschaft,' Freiheit der Wissenschaft und Keplerbund," *Evangelische Kirchen-Zeitung* 82, no. 11 (15 Mar. 1908): 210–11.

19. R[ade], "Vom Kepler-Bund," *Die Christliche Welt* 22, no. 1 (2 Jan. 1908): 19–21; Wobbermin 1909; 1911, 4; on Rade: Nagel 1996; on Wobbermin: Schröder 2008, 464–69.

20. Driesch lectured at a members' meeting and shared opposition to "materialistic prejudices": "Dritte Mitgliederversammlung des Keplerbundes vom 8.–10. Oktober 1909," *Der Keplerbund*, no. 12 (Nov. 1909): i–v, on iii; further: Teudt 1909, 88–89; but also Driesch 1951, 71.

21. Adolf Reitz, quoted in H. Schmidt 1909, 27–30, on 29.

22. Brass 1906, 9–10; 1909a; Teudt 1909, 78–85.

23. Brass 1884; Ludwig Aschoff to his parents, 4 May 1885, in Aschoff 1966, 15–17, on 16.

24. Brass to EH, 10 Aug. 1883 and 8 Dec. 1905, EHH; see also record of meeting between representatives of the Reimer press and EH, 14 Apr. 1905, SBB.

25. Brass 1906, 94. The reception was mixed, e.g., H. M., *Hochland* 4, no. 2 (1907): 252; a "disappointed" Wasmann wanted "greater objectivity and depth": "Neuere Publikationen gegen die monistische Weltanschauung Ernst Haeckels," *Stimmen aus Maria-Laach* 73, no. 4 (1907): 439–46, on 444.

26. E.g., the letter quoted in H. Schmidt 1909, 45.

27. H. Schmidt 1909, 40–45; for praise: Ley 1908.

28. Brass 1911, 2.

29. "Berlin und Umgebung," *Das Reich*, no. 88 (12 Apr. 1908), 3; *Staatsbürger-Zeitung*, no. 88 (12 Apr. 1908), 3.

30. Breitenbach to EH, 15 Apr., and EH to Breitenbach, 17 Apr. 1908, in Nöthlich 2009, 326–27 (quotation from this version); see further Nöthlich 2009, 97–100, 325–29; W[ilhelm] B[reitenbach], "Haeckel-Feinde," *Neue Weltanschauung* 1 (1908): 152. Breitenbach sent Haeckel the article from the *Staatsbürger-Zeitung*; it is unclear if Haeckel already knew about this, as he did about *Das Volk*, or—until his press collection is opened to scholars—if he subscribed to a clippings service.

31. At least one of these is shorter and less inflammatory than Haeckel's: *Staatsbürger-Zeitung*, no. 94 (22 Apr. 1908), 3; perhaps the lawyer persuaded Haeckel to soften the tone and stick to the facts, perhaps the paper summarized the text.

32. Brass, "Der Mensch der Urzeit," *Staatsbürger-Zeitung*,

no. 97 (25 Apr. 1908), 1. Beilage.

33. Haeckel, "Berichtigung," in B[reitenbach], "Haeckel-Hetze," *Neue Weltanschauung* 1 (1908): 177–78; also, with Brass's "Erklärung," in "Braß contra Häckel," *Neue Preußische Zeitung*, no. 342 (23 July 1908), Abend-Ausgabe, 2; and Teudt 1909, 14–15.

34. Brass, letter to *Norddeutsche Allgemeine Zeitung*, no. 180 (2 Aug. 1908), Zweite (Morgen-)Ausgabe, which elicited a further, even less convincing response: "Häckel und seine Gegner," *Münchener Neueste Nachrichten*, no. 387 (20 Aug. 1908), Morgenblatt, 2.

35. Teudt 1909, 8–9; Dennert 1937, 208–9.

36. Library catalogues suggest that the Biologischer Verlag published no one else; H. G. Wallmann may have handled the distribution, as for later works by Brass.

37. H. Schmidt 1909, 10.

38. Brass 1909a, 7.

39. Brass 1908, 7; on clashes over art: B. Lewis 2003.

40. Brass 1908, 7–8, 20–21.

41. Ibid., 9. With this New Testament Greek for a stumbling block, hindrance, or offense Brass does not appear to have intended a serious theological point. For Keibel's models: Hopwood 2002, 111.

42. Brass 1908, 4.

43. E.g., Adolf Koelsch, in H. Schmidt 1909, 31–32.

44. Brass 1908, 15–17.

45. Ibid., 16, 13; after Schultze 1897, 457.

46. Brass 1908, 17–20, legend to plate III.

47. Ibid., 11, 22.

48. Not just reviews in the confessional press, e.g., B. Dieckmann, *Literarischer Handweiser zunächst für alle Katholiken deutscher Zunge* 46, no. 22/23 (1908): 896–98.

49. X, "Haeckels Embryonenbilder," *AZ*, no. 38 (19 Dec. 1908), 823; on the *AZ*: Zils 1913.

50. Haeckel 1910c, 20–22; Julius Schaxel to EH, 9 Feb. 1909, in Krauße 1987, 53–54; Richard Semon to EH, 9 Dec. 1910, EHH.

51. Haeckel, "Fälschungen der Wissenschaft," *Berliner Volks-Zeitung*, no. 607 (29 Dec. 1908), Morgenausgabe.

52. Haeckel 1910c, 22.

53. "Häckels Antwort," *Der Reichsbote*, no. 306 (31 Dec. 1908), 1. Beilage.

54. *Westfälisches Volksblatt* (Paderborn), no. 260 (9 Feb. 1909), quoted in Haeckel 1910c, 46.

55. Quoted in H. Schmidt 1909, 20–21.

56. Quoted ibid., 21–23.

57. Dennert 1937, 212; more mildly: 1932, 323.

58. "Häckels Antwort," *Der Reichsbote*, no. 306 (31 Dec. 1908), 1. Beilage.

59. Quoted in H. Schmidt 1909, 31–34.

60. Ernst Teichmann, "Wissenschaft und Weltanschauung," *FZ*, no. 26 (26 Jan. 1909), Erstes Morgenblatt.

61. Quoted in H. Schmidt 1909, 30–31.

62. Quoted ibid., 27–30.

63. Daum 1998, 330.

64. I owe this phrase to Jim Secord. See also Hilgartner 2000.

65. Teudt 1909, 40–42.

66. Keibel 1909, editor's note; on Schwalbe: Rüve 2009.

67. Schwalbe to EH, 12 Aug. 1910, EHH.

68. Keibel 1909.

69. Ibid.; Anderton 1993.

70. Quoted in H. Schmidt 1909, 50–51.

71. Quoted ibid., 58–67.

72. Rabl, quoted ibid., 66; also Friedrich Maurer, quoted in Haeckel 1910c, 54; on the feud: Nyhart 1995, 265–74. Chun counted as a Haeckel enthusiast, but Rabl had criticized his teacher's late work on phylogeny so sharply that a wounded Haeckel summarized his verdict: "'Do not write about things of which you understand nothing'!!": EH to Max Fürbringer, 21 May 1903; referring to Rabl to EH, 27 Sept. 1895, EHH; further: H. Schmidt 1914, 2:5; Krauße 1998, 396–99.

73. Waldeyer to EH, 28 Oct. 1908, EHH.

74. The anatomist Friedrich Maurer declared his solidarity later: Haeckel 1910c, 54.

75. Wilhelm Roux, "Braß contra Haeckel," *AZ*, 20 Feb. 1909, 175; C. Hasse, "Haeckels 'Sandalion,'" *Keplerbund-Mitteilungen*, no. 26 (Feb. 1911): 1–2; Hensen 1909. Karl Toldt Jr., an anatomist's son beginning a career as curator at the Natural History Museum in Vienna, revealed that an embryo both Haeckel and Maurer had described and depicted as that of a bear was in fact a hedgehog. Haeckel seems to have accepted that Toldt's motives were "purely factual": Haeckel 1903, 2:700; Toldt 1907–8; Toldt to EH, 10 May and 12 July 1909, EHH.

76. Wilhelm von Pechmann and Hertwig quoted in H. Schmidt 1909, 58–62; Plate quoted in H. Schmidt 1921, 25. This may go back to Plate's intention to accept an invitation from the *Wochenschrift*: Plate to EH, 9 Jan. 1909, in H. Schmidt 1921, 25.

77. Teudt 1909, 52.

78. Ibid., 52–53, 89–91. Dennert presented his league as the "conscience of German research into nature": "Das Ergebnis der Affäre Braß-Haeckel," *Der Keplerbund*, no. 6 (Mar. 1909): i–iv, on iv.

79. Rade, "Nachwort des Herausgebers," *Die Christliche Welt* 23, no. 16 (15 Apr. 1909): 376–77.

80. For challenges from the right, see the work cited in note 5; for some left-wing challenges: Hopwood 1996, 1997; Krementsov 2011.

81. Georg Uschmann, "Haeckel, Ernst Heinrich Philipp August," in *DSB*, vol. 6 (1972): 6–11, on 9; R. Richards 2008, 382–83. Sapp 1990, 16–22, argued that Haeckel won on forgery because he won on evolution; there is truth in that, but he was embattled even among biologists.

82. Haeckel 1910c, 23, 34, 46.

CHAPTER 15

1. McCabe 1906a, 10.

2. Hopwood 2000b.

3. For the Haeckel tradition in Jena: Uschmann 1959, 220–29; Penzlin 1994; Krauße and Hoßfeld 1999; Hoßfeld 2005b, 2005c; Hoßfeld and Breidbach 2007; Fischer, Brehm, and Hoßfeld 2008; for changing images of Alexander von Humboldt as a national figure: Rupke 2008.

4. Kellogg 1910, 137. For assurance of "full sympathy with

your position and writings" in a request for permission to reprint a (not used) photograph with the article: Kellogg to EH, 15 and 22 Nov. 1908, EHH.

5. R. Baker 1901, 133–57, on 135.

6. On earlier German-American exchange: Daum 2001; for other German imports: Cartwright 1995; Friedman and Donley 1985; on the "nature faker" debate: Lutts 2001.

7. On representations of scientists and their morals: Haynes 1994; Shapin 2008.

8. H.R., quoted in H. Schmidt 1909, 70–78, on 78.

9. Rosedore Kreissler to EH, 22 Aug. 1908, EHH.

10. Hermann Bauer to EH, 29 Dec. 1908, EHH.

11. H. Windhorn to EH, 14 Nov. 1910, EHH.

12. Johannes Fischer to EH, 10 Feb. 1909; further: Theodor Müller to EH, 12 Sept. 1908; Paul von der Porten to EH, 30 Sept. 1909, EHH.

13. Karl Stemmler-Vetter to EH, 22 Oct. 1909; further: physician Max Flesch to EH, 28 Nov. 1911, mentioning using the W. Krause embryo to defend Haeckel during lectures in Ludwigshafen; Oberstleutnant a. D. Lilie to EH, 13 and 18 Sept. 1918, EHH.

14. Hoßfeld 2005b.

15. H. Schmidt 1909, 6.

16. Ibid., 79–90.

17. Brass 1909b, 3 (quotation), 43; Teudt 1909, 52.

18. Dennert 1937, 203; Schröder 2008, 447–55.

19. Wobbermin 1909, 352 (quotation), 375–76; but he reckoned only scientists should sign: Wobbermin 1911, 80; further: Schröder 2008, 464–69.

20. Petersen 1911.

21. Joh. Bumüller, "Professorenkundgebungen zum Fall Haeckel-Braß," *Wissenschaftliche Beilage zur Germania*, 1909, 102–3; Wasmann 1909, 302–3; M[ax] E[ttlinger], "Naturwissenschaft," *Hochland* 6.2 (Apr. 1909): 116–18; *Stimmen aus Maria-Laach* 78, no. 3 (14 Mar. 1910): 358–60; Wasmann 1910, 62–67. Dörpinghaus 1969, 71, highlights the shift in attitudes to Haeckel.

22. Julius Schaxel to EH, 6 Oct. 1909, in Krauße 1987, 62–63.

23. Haeckel 1910a.

24. Haeckel 1910c, 14.

25. Ibid., 37–44, on 44.

26. Ibid., 37, but see 53–54 on the number of vertebrae. What appears to be a draft includes a more extensive though still mostly general discussion: EHH: B84.

27. E.g., Ernst Teichmann, "Ernst Häckel und seine Embryonen-Bilder. Ein Epilog zum vorjährigen Streit," *FZ*, no. 348 (17 Dec. 1910), 1. Morgenblatt, which was used by Max Ettlinger, "Haeckels Rechtfertigungsversuch," *Hochland* 8.1 (1911): 642–43.

28. E.g., "Ernst Haeckels neueste Verteidigungsschrift," *Stimmen aus Maria-Laach* 80, no. 2 (7 Feb. 1911): 238–40.

29. Connor to EH, 26 May 1914, EHH.

30. Hugo C. Juengst, quoted in Haeckel 1910c, 22–23.

31. Haeckel 1910b; on the campaign: Simon-Ritz 1997, 198–213.

32. Lassman and Velody 1989; Shapin 2008.

33. Haeckel 1910c, 49.

34. H. Schmidt 1909, 88, rejected any role for fantasy in the schematics.

35. Haeckel 1924a, 13–14; on these tricks: Judson 2004, 43–97.

36. E.g., Taschenberg 1919, 95–96.

37. *Bericht* 1894, 3–7.

38. C. Keller and Lang 1904, 37–38; also Ostwald 1914, 30.

39. Michler 1999, 439; on the physiologists: Daston and Galison 2007, 247; further: du Bois-Reymond 1886, 418–47.

40. Duncan 1928, 165–67.

41. Keibel 1909; also, e.g., Driesch 1951, 71.

42. A. Forel, "Ernst Haeckel und die Wissenschaften," *AZ*, 20 Feb. 1909, 173–75; also H. Schmidt 1909; 1914, 1:241–42. Alfred Greil, author of an embryological atlas, wrote of "schemata and summary pictures," to which only the "decades-long detailed work of a great community of embryologists could gradually add the details and round out the exact picture": H. Schmidt 1914, 2:214.

43. Quoted in Shapin 2008, 50–51, 63–64.

44. See esp. the chapters by Walther May, Gregor Antipa, Hans Gadow, Hugo Spitzer, Berthold Hatschek, and Rudolf Goldscheid in H. Schmidt 1914.

45. Ostwald 1914, 28–29; 1909, 371–88.

46. R. Hertwig 1919; also 1928; Goldschmidt 1956, 36–37. Heider 1919 invoked Jesus at the house of the pharisee: "Her sins, which are many, are forgiven; for she loved much."

47. Rádl 1909, 270–96, on 296; Nordenskiöld 1929, 505–6.

48. Vaihinger 1911, 37, 146; Fleck 1979, 32, 36.

49. R. Hertwig 1928, 407.

50. Haeckel 1899, 11.

51. Plate 1920; also 1919; on Plate: Levit and Hoßfeld 2006.

52. Letter of 6 Dec. 1920, quoted in H. Schmidt 1921, 10–11.

53. Plate, in "Arbeitsgemeinschaft deutscher Naturforscher zur Erhaltung reiner Wissenschaft e.V.," *Deutsch-völkische Monatshefte*, 1921, no. 1, 32–33.

54. H. Schmidt 1921, 24–27.

55. Plate 1920.

56. Krauße and Hoßfeld 1999.

57. H. Schmidt 1926, 295–302, 437–39. The book reproduced without comment one of Haeckel's original drawings for the embryo plates in the *Anthropogenie*.

58. Decker 1990; J.-C. Kaiser 1981; Zimmer 1984.

59. Schaxel 1931, 262; Hopwood 1996, 1997.

60. Bavink 1937, 65; on Bavink and the later history of the league: Hentschel 1993; Schröder 2008, 452–64.

61. Hauser 1920, 70.

62. As Haeckel said Huxley called him: Heilborn 1920b, 3.

63. Selle 1986.

64. Dennert 1937, 181; on the letters: Walther 1953, 41; for the complete edition, which presents a rather different picture: N. Elsner 2000.

65. E.g., in a standard Catholic encyclopedia: F[ranz] Sawicki, "Haeckel, Ernst," in *Lexikon für Theologie und Kirche*, vol. 4 (1932): 621.

66. Weindling 1991b; Hoßfeld et al. 2003.

67. Gasman 1971; for a revisionist account: Hoßfeld 2005a, 241–63, 280–339.

68. H. Schmidt 1934; Plate 1934; V. Franz 1934, 4, 11, 21;

Heberer 1934, 23; on Heberer: Hoßfeld 1997.

69. Astel, "Geleitwort," to Brücher 1936, 3–6; Hoßfeld 2005c.

70. Renneberg and Walker 1994.

71. Krieck 1937; Ganzer 1939, 365.

72. Hoßfeld 2005a, 332.

73. Bavink 1937, 71, 73.

74. Krauße and Hoßfeld 1999, 215–16; Hoßfeld 2005a, 252–61.

75. Hoßfeld and Breidbach 2007; Schmidt-Lux 2008.

76. *Biographien bedeutender Biologen*, 3rd ed., 1986, in *Deutsches Biographisches Archiv* III, 338:423–31.

77. *Deutsche Forscher aus sechs Jahrhunderten*, 1966, in *Deutsches Biographisches Archiv* III, 338:398–404.

78. Klemm 1968, 126–27, 222.

79. Uschmann 1983 (based on a collection first published in Jena in 1954); Uschmann, in *Philosophenlexikon*, 1984, in *Deutsches Biographisches Archiv* III, 338:410–22.

80. Klemm 1968, 241.

81. Maurer 1978; Keckstein 1980, 79.

82. E.g., Heberer in Walther 1953, 8, 113 (quotation), 148.

83. Heberer 1968, 524–25, citing Holzer 1964, 71–72, who had Haeckel forging a human skull. A paperback biography also defended Haeckel: Hemleben 1964, 129–36.

84. Blechschmidt 1968; on Blechschmidt: Hinrichsen 1992; Häußler 1992.

85. Gursch 1981; for the link to Gunter Mann's history of biologism: Armin Geus, the supervisor, to author, 20 Dec. 2007.

86. Krauße 1984, 79–80, 91–92, 101–2, 116–17.

87. "Haeckel," *Natural Science: A Monthly Review of Scientific Progress* 4, no. 25 (Mar. 1894): 161–62.

88. E.g., Williams 1900, 299.

89. Haeckel 1879b, 1:xxxv, 383.

90. Minot 1877; Sedgwick 1894; F. L[ewis] 1907.

91. E.g., Peek 1890 did not. A. Hall 1880, 370–76, critiqued the plates at length in apparent ignorance of the charges (and much else); Dennert 1904, 115–17, mentioned the three clichés as "one instance" of "forgery," but without making any accusations clear.

92. "Haeckel, Ernst Heinrich," in *Chambers's Encyclopaedia*, new ed., vol. 5 (1890): 498.

93. E.g., for Italy: Brass 1910, 1912; for France: Wasmann 1911. It seems likely that the charges were debated in Spain; see, most recently, Nieto-Galan 2012.

94. E.g., Gerard 1914, 14 (reference to a translation of Wasmann in the *New Ireland Review* of May 1909); Assmuth and Hull 1915; [John Urquhart?], "The Truth about Haeckel's Confession," *Bible Investigator and Inquirer* (Melbourne) 3, no. 1 (Mar.): 22–24; McCabe in Haeckel 1911a, 35.

95. Schudson 1978, 106–20, quotations on 112 and 107 (from Frank Presbrey in 1929).

96. Joseph Jacobs, "Man and Evolution: The Advance in Scientific Knowledge Since Darwin's Day—Prof. Ernst Haeckel's Recent Books," *NYT*, 2 Sept. 1905, BR569.

97. *NYT*, 3 Jan. 1909, C3; and 7 Feb. 1909, SM9; on photography: Tucker 1997; on the *Times* versus the *World*: Schudson 1978, 106–20.

98. Nor did British papers after initial reports: "An Academic Quarrel," *Aberdeen Journal*, 26 Dec. 1908, 5; "Professor Haeckel's Diagrams," *Observer*, 3 Jan. 1909, 10.

99. Irving Wilson Voorhels, "A Synopsis of Evolution," *NYT*, 2 July 1910, BR3.

100. "Accused of Fraud, Haeckel Leaves the Church," *NYT*, 27 Nov. 1910, SM11, quoting Kellogg 1910, 138; Lutts 2001.

101. Mangan 1909, 213, 223; also Brass 1910, 1912; A. Proctor 1910, 19–23; Wasmann 1911; Gerard 1914.

102. Wasmann 1909, 178.

103. Assmuth and Hull 1915; also Gillis 1925, 109–10.

104. Scheffauer 1910, 217–26, on 217–18; Joseph McCabe, in Haeckel 1911a, 42; on scientists' and others' defenses of evolution: Clark 2008, 41–68.

105. Slosson 1914, 283–84.

106. "Haeckel as an Authority," *NYT*, 23 Mar. 1916, 10. Duesberg made short work of another correspondent who played down the issue as a figure probably drawn by someone else in one book many years before: "Haeckel's Drawings," *NYT*, 28 Mar. 1916, 12. On Haeckel and the war: Di Gregorio 2005, 526–43; R. Richards 2008, 431–37.

107. "Ernst Haeckel: Popular Expositor of Darwinism," *Times* (London), 11 Aug. 1919, 14; further: [J. A. Thomson?], "Ernst Haeckel," *Nature* 103 (21 Aug. 1919): 487–88.

108. E.g., Haeckel [c. 1922]; Fenton 1924.

109. "Ernst Haeckel," *Lancet* 223 (10 Feb. 1934): 309, which summarizes Plate's assessment.

110. For a review: Churchill 2007.

111. Coleman 1977, 47–56, 162; Allen 1978, 21–72.

112. Oppenheimer 1967, 150–54; 1987.

113. Churchill 1980; Horder 2008, 124–27.

114. E.g., White 1933, 472; Winchester and Lowell 1961, 313.

115. "Haeckel, Ernst Heinrich," *Encyclopaedia Britannica*, vol. 10 (1970): 1105–6; also D. W. Ewer, "Haeckel, Ernst Heinrich," in *Chambers's Encyclopaedia*, vol. 6 (1966): 691.

116. Singer 1931, 480–81. For mention of Haeckel's altering illustrations of embryos in a context surprisingly critical even of Darwin: Thompson 1956, xv–xvi.

117. Gasman 1971, xiv; also Weikart 2004; for critiques: Weindling 1989b; Evans 1997, 63–68; Hoßfeld 2005a, 241–63, 280–339; R. Richards 2008.

118. Uschmann, "Haeckel, Ernst Heinrich Philipp August," in *DSB*, vol. 6 (1972): 6–11, on 9.

119. Kellogg 1910, 138.

CHAPTER 16

1. E. Larson 2003; Numbers 2006; on evolution in textbooks further: Grabiner and Miller 1974; Woodward and Elliott 1987; Skoog 2005; Ladouceur 2008; Shapiro 2013; on textbook illustrations of evolution: S. Gould 1991a, 168–81; 1997; Clark 2008. On anatomical illustrations, mostly in college texts: Lawrence and Bendixen 1992; L. Moore and A. Clarke 1995; on designing the cover of a developmental biology text: Gilbert and Howes-Mischel 2004, 387–89; for a sketch of shifts in high-school embryology coverage: Maienschein and Wellner 2013, 246–52.

2. Issitt 2004; but see Lundgren and Bensaude-Vincent 2000; García-Belmar, Bertomeu-Sánchez, and Bensaude-Vincent 2005; "Textbooks in the Sciences," focus section, *Isis* 103 (2012): 83–138.

3. E.g., Gaster 1990; Brush 2005.

4. D. Kaiser 2005 investigates both how textbooks promoted Feynman diagrams and how these survived.

5. E.g., D. Paul 1987; S. Vogel 1987; S. Gould 1991a, 155–67; Uhlik 2004.

6. S. Gould 1991a, 168–81; 1997; 2000, 44–45 (quotations).

7. Surveys of publishing economics, e.g., Elliott and Woodward 1990, say little about illustrations, though much research charts expansion and assesses effectiveness, e.g., Levin and Mayer 1993; Woodward 1993.

8. For general biology and zoology, the survey concentrated on multiedition market leaders but looked at many more titles; for embryology, it attempted near-comprehensive coverage. Only a small fraction of the books can be cited. On obstacles to such work: Brush 2005.

9. Caron 1988; Pauly 1991, 2002.

10. Kelly 1981, 71–74; Scheele 1981; Nyhart 2009, 161–97, 295–307.

11. Schoenichen 1903, 26–27.

12. Hoeller 1907a; but, in a proposed curriculum for elementary-school sex education lessons, the same author raised the possibility of comparing similar stages of embryos of different vertebrate classes: Hoeller 1907b, 34.

13. Schmeil, Schön, and Wefelscheid 1931, 212–13; on Schmeil: Schenk 2000; on general biology: Hopwood 1997, 378–80; Laubichler 2006.

14. Kraepelin 1909, 248–65, on 256–57; 1912, 283; on Kraepelin's textbooks: Nyhart 2009, 305–7. Haeckel's pictures are also absent from, e.g., Wossidlo 1886; and H. Otto and Stachowitz 1927.

15. Flessau 1977; Weiss 1994; 2010, 219–64.

16. Reinöhl 1940, 76–77; E. Meyer and Zimmermann [1941], 293; *Weg zur Reifeprüfung* 1943, 102.

17. Heberer 1949, 36; H. Koch, Steinecke, and Straub 1951, 297.

18. Jenkins 1979, 107–69.

19. Mostly rather advanced examples: Nicholson 1872, 93–95; H. Wells 1893, sections 43–46; T. Parker and Haswell 1897, 1:6–8, 2:608–10; Latter 1923, 321; N. Johnson 1933, 138–40.

20. The embryological evidence of evolution is not in, e.g., Shann and Gillespie 1931; Spratt and Spratt 1931; or Wyeth 1933; not directly illustrated in Shove 1931, 291; Hatfield 1938, 516–17; or Archer 1957, 330; and illustrated differently in Fox 1932, 303–4.

21. Wheeler 1947, 242–43; Wyeth 1952, 2:556.

22. Bibby 1942, 82–83; also 1968, 20.

23. E. Larson 2003, 7–27.

24. D. Jordan 1922, 1:444.

25. M. A. B[igelow], *American Naturalist* 36 (1902): 821–22.

26. D. Jordan 1894, lectures 15–16; 1898, 35–41; Kellogg 1907, 130–31; S. Gould 1977, 85–96; Largent 2009.

27. Kellogg 1910, 138. A Columbia histologist objected mildly to unspecified "doubtful statements" about the Haeckel drawings, not the figure itself: S[imon] H. G[age], *Science*, n.s.,

14 (26 July 1901): 147–48.

28. Hurd 1961; Pauly 1991, 663 (quotations); also E. Larson 2003, 7–27; Shapiro 2013.

29. Hunter 1907, 1914; Peabody and Hunt 1912, 1924; Hodge and Dawson 1918; Smallwood, Reveley, and Bailey 1924, 1934; others included the topic but used a different figure or none: Moon 1922, 322–23; Kinsey 1933, 120–21, 201; Holmes 1926, 348–52; A. Baker and Mills 1933, unit 14.

30. E.g., Bigelow and Bigelow 1911, 444–46; 1913, 399–400.

31. Gruenberg 1919, iv, 467–68; on Gruenberg: Pruitt 1966.

32. Bigelow and Bigelow 1913, vi–vii.

33. D. Jordan 1922, 1:444 highlights this feature of D. Jordan and Kellogg 1901.

34. E. Larson 1998, 2003; Numbers 2006; on Bryan: Kazin 2007.

35. Bryan 1922, 92–93.

36. Silver 1925, 11; on Silver: Clark 2008, 59–60.

37. Rimmer 1995 [1935], 17, 19, possibly referring to college texts; for other uses of the case, in the United States: McCann 1922, 153–62; Price 1924, 166–67; in Britain: Dewar 1931, 34–66, on 38–39; [Watts] 1936, 44; Rowcroft 1938, opposed by Beadnell 1938, the opening of a longer exchange; on Rimmer, George McCready Price, and Douglas Dewar: Numbers 2006.

38. Revisionist accounts: E. Larson 1998; Shapiro 2013.

39. Hunter 1914, 182, 194–96; Shapiro 2013, 108–10.

40. Shapiro 2010, 2013.

41. Gruenberg 1925, 285–86 (other comparisons still included "man"); Shapiro 2013, 84–85, 137–40.

42. Brewster 1925, lampooning Price.

43. Shapiro 2013, 85, 155.

44. Ladouceur 2008. In the 1946 edition of Spratt and Spratt "there is not so much as a hint that either heredity or evolution exist": Bentley Glass, *Quarterly Review of Biology* 23 (1948): 341.

45. The more advanced Wheat and Fitzpatrick 1929, 388–89, included human embryos in grids with the injunction, "Remember three words—ontogeny recapitulates phylogeny" (Frank M. Wheat had been Gruenberg's artist: Shapiro 2013, 57); human embryos are also in Benedict, Knox, and Stone 1938, 125–28; and Kroeber and Wolff 1938, 564–65 (a more accurate grid); E. Cole 1933, 486, put a mammal in a row of three.

46. Moon 1926; Moon and Mann 1933, 440–74, on 449–50.

47. E. Smith 1949; 1954, 466; Ladouceur 2008. Human embryos were also omitted from the grids in F. Curtis, Caldwell, and Sherman 1934, 589 (in which the lightly reworked calf is labeled a sheep) and 1940, 574 (in which it is called a dog); and Grant, Cady, and Neal 1948, 593.

48. Rudolph 2002, 144.

49. Hurd 1961; W. Mayer 1986; Rudolph 2002, 137–64; Ladouceur 2008.

50. BSCS 1963a, 307; 1963b, 578.

51. BSCS 1961, 779; 1963c, 608–10. The blue version later cut the first two rows and added the caveats that the sizes and timing of development differ for each animal: BSCS 1968, 358.

52. W. Mayer 1986, 490.

53. J. Young 1990, 71.

54. Skoog 2005; also Woodward and Elliott 1987. Though the creationist textbook J. Moore and Slusher 1970, 136, criti-

cized the recapitulation theory, it did not thematize Haeckel's pictures; also Morris 1988.

55. Squire and Morgan 1990; Young 1990; Follett 2002.

56. J. Otto and Towle 1973, 205.

57. Vines and Rees 1959, 1:vi; 2:709; 1972; the embryos are more accurate in Vines 1963, 191. The pictures are not in, e.g., Hankinson 1955; Brocklehurst and Ward 1958; Griffiths 1964; Humphrys 1966; Roberts 1973 (which my school, the Hewett, also used); Mackean 1978; Bunyan 1982.

58. 'O' level: Gliddon 1975, 225–26; 'A' level: Barker et al. 1986, 275–76.

59. E.g., Bach 1968, 45; Bach et al. 1968, 48.

60. E.g., Knodel, Bäßler, and Danzer 1971, 305–6, copied the Hesse grid, which is not in at least some earlier editions of this long-running text.

61. E.g., Stengel and Weise [c. 1955], 212; Grupe 1962, B72.

62. E.g., Hoff, Jaenicke, and Miram 1991, 334; Bayrhuber and Kull 1998, 406.

63. R. Junker and Scherer 1986, 117–28.

64. J. S. H[uxley], "The Teaching of General Biology," Nature 113 (1 Mar. 1924): 301–2.

65. But see Heberer 1949. By the 1970s, some evolution books used the drawings, such as the accessible Osche 1978, 29; some did not: Remane, Storch, and Welsch 1973, 54–59, 103–14. Britain and Germany need more study.

66. The grid from Guenther 1909 was part-copied in Ferris 1922, facing 62 (and later reprints); the American Museum version was reworked in Moody 1953, 44; 1970, 47.

67. Scott 1939, 110. The figure was copied into Scott 1921, 177; Woodruff 1922, 365–66; and Newman 1924, 417.

68. Patten 1951, 2; 1958, 8; Lindsey 1952, 66; Guthrie and Anderson 1957, 157; Browder 1980, 498. Perhaps Patten Jr. had drawn the figure himself.

69. Bartelmez 1926, 450 and facing plate; Romer 1933, 374. Other groups: Shumway 1927, 98; 1931, 233; Haldane and Huxley 1927, 76–77, 80–81, photographs of chick and human embryos, which were labeled and assembled into a pair in de Beer 1930, 46–47; de Beer 1928, 485 (five embryos).

70. McFarland 1910, 212–13; reviewed by Max W. Morse, "Elementary Biologies," Science 33 (17 Mar. 1911): 430–33; Smallwood 1913, 219–20. McFarland was the source for Atwood 1922, 18.

71. Lull 1917, 663–66; Lindsey 1929, 50–53.

72. Guyer 1931, 542; Mavor 1936, 660–62; Quarterly Review of Biology 12 (1937): 92 (quotation).

73. Beaver 1940, 706–8; Storer 1943, 204 (from Haupt). The pictures are in other books of more than one edition, e.g., Haupt 1928, 277–80; Wolcott 1933, 519–20 (from Guyer); Young, Hylander, and Stebbins 1938, 317–21 (from Lull); White 1933, 474–75; and Strausbaugh and Weimer 1938, 496.

74. Villee 1950, 512–15; Villee, Walker, and Smith 1958, 729–32; Hickman 1961, 704. See also Winchester 1947, 408–9; 1950, 712–14 (from Guyer); and W. Johnson, Laubengayer, and Delanney 1961, 567–69.

75. Kimball 1974, 705–6; Keeton 1967, 615–17; reviewed in J. T. Bonner, "Keeping Pace with Biology," Nature 308 (8 Mar. 1984): 128. For textbook uses in 1998–2000: J. Wells 2000, 249–50, 255; Gishlick 2002.

76. Moment 1942, 445–49; A. Morgan 1955, 786.

77. Whitten 1975; Coser, Kadushin, and Powell 1982, 55–57, 209–11, 269–82; Brock 1985, 59; D. Paul 1988; Follett 2002.

78. National Academy of Sciences—National Research Council 1957, 69. Such complaints were not new even then: e.g., Stopes 1920, 64–65.

79. Brock 1985, 61–62.

80. Blystone and Barnard 1988.

81. E.g., J. T. Bonner, "Keeping Pace with Biology," Nature 308 (8 Mar. 1984): 128; D. Paul 1987; S. Vogel 1987.

82. Churchill 1980; Gilbert, Opitz, and Raff 1996; Laubichler and Maienschein 2007; Horder 2008, 124–27; Hopwood 2009a, 306–12.

83. Mitchell 1994, 89.

84. E.g., Beaver 1940, 706–7, borrowed from Romanes directly, but the seventh edition (Beaver and Noland 1966, 511) took from the same publisher's Hickman 1961.

85. From Hunter and Hunter 1949, 695.

86. E.g., Villee 1950, 512–14; further: S. Gould 1977, 1–4; Churchill 1980, 114–15; Horder 2008, 124–27.

87. E.g., Gilbert 1985, 151. In Winchester and Lowell 1961, 313, 611, Haeckel was once of the "less scientific workers" when recapitulation was discussed in a chapter on starfish; the embryo grid, used among the general evidences of evolution, was not linked to him.

88. By contrast, changes in Weismann diagrams went hand in hand with conceptual change: Griesemer and Wimsatt 1989, 104. Feynman diagrams persisted through theoretical change thanks to visual affinity with realist representations of particle behavior: D. Kaiser 2005.

89. Hariman and Lucaites 2007, 11.

90. Embryos from the Anthropogenie (1891 edition) entered an illustrated edition of the Origin of Species; the caption explained that Darwin "correctly surmises" why the embryos reveal their identity only in the final stages, while Haeckel "formulated the misleading dogma" of recapitulation: Darwin 1979, 213.

91. Compare H. Curtis 1968 and 1983, which added a chapter on evidences for this reason (xxii), though without the Haeckel figure. This is in Dodson 1952, 58–59; and 1960, 46–47; a more mainstream text redrew the American Museum version: Moody 1953, 44; 1970, 47.

92. E.g., Keeton 1967, 617; for an earlier, high-school example: fig. 16.5 herein. The figure was sometimes presented historically here too, e.g., Hickman 1961, 704.

93. A former president of the British Society for Developmental Biology perhaps included Villee's figure in the "rather cavalier treatment of some important areas": D. R. Newth, "Animals Illustrated," Nature 314 (7 Mar. 1985): 32.

94. Rusch 1969, 34. A young Dutch geologist sent Rusch the review and other documents and advice: Nicolaas A. Rupke to Rusch, 24 Sept. 1966, Rupke Papers. On Rusch, the society, and Rupke (who later accepted evolution): Numbers 2006, 239–67, 306–8. Other creationist uses: Coffin 1969, 416–24; 1983, 353–65; Bowden 1977, 128–30; Hamblin 1981; Taylor 1984, 274–79. But a Newcastle botanist, writing as a Catholic about "evolution and Christians," employed Haeckel's figures as evidence: Fothergill 1961, 88–89.

95. Vertebrate embryologist authors of general biologies shunned them too: Wieman 1925; Shumway 1931.

96. Multiedition examples: McMurrich 1902; Dodds 1929; Frazer 1931; Hamilton, Boyd, and Mossman 1945. Embryology books for lay audiences mostly focused on human development; Bibby 1942 was unusual in dealing with evolution at all.

97. E.g., H. Jordan and Kindred 1926; Arey 1940; Patten 1958.

98. A. Richards 1931; Huettner 1941; Nelsen 1953. Richardson et al. 1997, 93–95, criticized this; see further: Wourms 2007. Comparative embryology was more broadly taught in German-speaking Europe: e.g., Siewing 1969; see esp. the diagram relating ontogeny and phylogeny on 15.

99. Haeckel 1877a, plates II–III; Selenka 1897, 1:19; Storer 1943, 128; R. Wallace 1978, 189–90; Ham and Veomett 1980, 16.

100. Manner 1964, 7; J. Phillips 1975, iii, 4.

101. Torrey 1962, 7–11.

102. On developmental biology: E. Keller 1995; for a review of species use: Hopwood 2011, 11–13.

103. E.g., Berrill 1971; Bellairs 1971; Karp and Berrill 1976; Browder 1980. Balinsky 1960 combined developmental anatomy and experimental analysis, but the illustrations were closer to the material than Haeckel's.

104. An endnote referred to His's "invective" over the repeated blocks but implied little interest in the details: S. Gould 1977, 430; though see his 1979; further: Laubichler and Maienschein 2007; and for a more critical perspective: Horder 2008. It is unclear why Gould avoided discussing the plates.

105. A standard textbook reproduced columns from Haeckel without commenting on this: Coleman 1977, 51; and one of Haeckel's most controversial grids featured silently on the cover of a history of ideas: R. Richards 1992; but see also Georg Uschmann, "Haeckel, Ernst Heinrich Philipp August," in *DSB*, vol. 6 (1972): 6–11, on 9.

106. Raff and Kaufman 1983, 11; Raff to author, 14 May 2008. Though based at Indiana, Raff and Kaufman did not use Torrey's textbook, because in this introductory chapter they aimed to go back to the sources: Raff to author, 14 May 2008.

107. Alberts et al. 1983, 825; for the authorship: Lewis to author, 12 May 2008; on the book: Serpente 2011, 407–8.

108. Gilbert to author, 6 April 2007; on Gilbert further: Mikhailov 2005.

109. Gilbert to author, 6 April 2007.

110. Fleck 1979, 111–25.

111. Claudio D. Stern, *Quarterly Review of Biology* 72 (1997): 76.

112. E.g., into Wolpert 1991, 184; W. Müller 1995, 108 (from Osche); 1997, 123; Collins 1995, 101 (an hourglass after Elinson 1987); Gerhart and Kirschner 1997, 328–29; Futuyma 1998, 653 (perhaps from Gilbert's book with the same press).

113. As far as I know; with help from Sinauer, I surveyed especially the many reviews of Gilbert's book.

CHAPTER 17

1. Nigel Hawkes, "An Embryonic Liar," *Times* (London), 11 Aug. 1997, 14.

2. On evolution and development: Laubichler and Maienschein 2007; on fraud: D. Kevles 1998; Judson 2004; on intelligent design: E. Larson 2003, 185–209; Numbers 2006, 373–98.

3. J. Wells 2000, 260.

4. James Glanz, "Biology Text Illustrations More Fiction Than Fact," *NYT*, 8 Apr. 2001, 32.

5. On media storms: e.g., Klausen 2009; Nathoo 2009, 111–46; on science, the media, and the Internet: e.g., Cox 2012.

6. Latour and Weibel 2002, esp. Koerner 2002.

7. Gilbert, Opitz, and Raff 1996; Laubichler and Maienschein 2007.

8. Seidel 1936, 1960; on Seidel: Sauer, Schwalm, and Moritz 1996. He also promoted the concept through a book first published in 1953.

9. Waddington 1956, 9; Horder 2008, 132–36.

10. Elinson 1987, 1–3.

11. Ballard 1976, 38; further: 1964.

12. Sander 1983, renaming the "phyletic stage" of J. Cohen 1979, 4–5. Sander studied with Seidel's student Gerhard Krause: Counce 1996.

13. Del Pino and Elinson 1983; Raff 2012, 201–15.

14. Elinson 1987, 3. Elinson even confirmed that Haeckel had depicted differences in vertebrate cleavage and gastrulation in the third edition of the *Anthropogenie*: Elinson to author, 12 May 2008.

15. For a review: Hopwood 2011, 11–13.

16. E. Keller 1996; Gehring 1998.

17. Laubichler and Maienschein 2007.

18. Slack, Holland, and Graham 1993; Slack 1999, 63–67.

19. Alberts et al. 1994, 33; Lewis to author, 12 May 2008; also, e.g., Gerhart and Kirschner 1997, 329; Arthur 1997, 39.

20. Duboule 1994, 139; on Duboule: Richardson 2009.

21. Raff 1996, 192–210; Richardson to author, 9 Nov. 2011.

22. Richardson to author, 9 Nov. 2011.

23. Richardson 1995, 412, 419, reproducing plates from the fourth edition (415) because this one came on interlibrary loan: Richardson to author, 9 Nov. 2011.

24. Richardson et al. 1997.

25. Ibid., 91, 104. Haeckel's more detailed plates had focused on amniotes.

26. To court the public was still to play with fire: Burchell, Franklin, and Holden 2009, 61–62.

27. Richardson to author, 9 Nov. 2011.

28. Nigel Hawkes, "An Embryonic Liar," *Times* (London), 11 Aug. 1997, 14. Hawkes to author, 15 Sept. 2011, gives his assessment: "From the newspaper's point of view it was rather an arcane topic.... Haeckel isn't a household name in this country." "Scientific fraud," by contrast, "does interest newspapers" and reports of several cases "had created ... an appetite.... That's why the story interested me."

29. E.g., the German newspapers cited later in this chapter and Robert Matthews, "Nice Stories, Pity They're All Codswallop," *Sunday Telegraph*, 14 Sept. 1997, 18; for Matthews's stance on evolution, see further his "It's Not Darwin Who's in the Wrong, It's His Supporters," ibid., 3 May 2001.

30. Pennisi 1997.

31. Terry J. Hamblin, *Times* (London), 18 Aug. 1997, 18.

32. Richardson showed me this in January 1998.

33. *New Scientist*, no. 2098 (6 Sept. 1997), 23.

34. Pennisi 1997.

35. Richardson 1997.

36. D. Kevles 1998; Judson 2004.

37. Ulrike Bartholomäus and Ulrich Schnabel, "Betrüger im Labor: Die deutsche Forschung hat ihren Fall. Wie schützt man sich vor Fälschern?" *Die Zeit*, no. 25 (13 June 1997); Abbott 1998; Finetti and Himmelrath 1999.

38. Reverby 2009; Nicholas Wade, "Doctors Question Use of Nazi's Medical Atlas," *NYT*, 26 Nov. 1996, C1; Hildebrandt 2006.

39. Broad and Wade 1982, which Terry Hamblin criticized for omitting Haeckel: "Lifting the Skirts of Science," *BMJ* 287 (3 Dec. 1983): 1699; Di Trocchio 1993; D. Kevles 1998, 107–10; Judson 2004, 98, and 52–58, 72–79, on Mendel and Millikan.

40. Nigel Hawkes, "An Embryonic Liar," *Times* (London), 11 Aug. 1997, 14.

41. Tina Baier, "Der Trick mit dem falschen Embryo," *Süddeutsche Zeitung*, 14 Aug. 1997, 34.

42. Roland Bender, "Von neuem bestätigte Grundgedanken Haeckels," *Frankfurter Allgemeine Zeitung*, no. 207 (6 Sept. 1997), 8; also Bender, "Nie behauptete Haeckel, der Embryo auf seinen Zeichnungen sei naturgetreu," *Frankfurter Rundschau*, 21 Nov. 1997, 33; Ulrike Arlt, "Zur Neuauflage der Fälschungsanklagen gegen Ernst Haeckel," *Frankfurter Rundschau*, 3 Dec. 1997, 27. Bender 1998 is more differentiated.

43. Richardson to author, 9 Nov. 2011.

44. Richardson et al. 1998; Sander and Bender 1998; Richardson 1998; Sander 2002, 529.

45. Raff to author, 18 May 2008.

46. Sander 2002, 532. The grid was reproduced in "Streit um Haeckels Thesen entschärft—Moderne Version der 'Embryonen-Tafel,'" *Frankfurter Allgemeine Zeitung*, no. 209 (9 Sept. 1998), N3.

47. Gilbert to author, 6 Apr. 2007; Gilbert found Haeckel's drawings, though no longer usable, aesthetically superior and clearer.

48. Pennisi 1997.

49. S. Gould 2000; Richardson 2000, which called for more history of ideas, when historians of biology rather needed to know more about pictures and practice.

50. Reproductions of the pictures without comment: Coleman 1977, 51; R. Richards 1992, cover.

51. Richardson and Keuck 2001.

52. Richardson and Keuck 2002, 522.

53. Finetti and Himmelrath 1999, 62–63; Fuld 1999, 99; Judson 2004, 82–83. Mainly in relation to the Brass controversy, Haeckel was already in Di Trocchio 1993, 254–62, and its German translation.

54. E.g., B. Hall 1997; 1999, 227–31; Sander 2002; Slack 2003; Horder 2008, 139.

55. Reviewed in Richardson 2012.

56. E.g., Horder 2008, 169–74.

57. Joachim Müller-Jung, "Angriff auf biologischen Anachronismus," *Frankfurter Allgemeine Zeitung*, no. 192 (20 Aug. 1997), N1; Leo Peters, "In einer Vorreiter-Rolle," ibid., no. 207 (6 Sept. 1997), 8; Reinhard Junker, "Evolutionslehre als Axiom," ibid., no. 215 (16 Sept. 1997), 15; Harald v. Sprock-hoff, "Haeckel stets wieder rehabilitiert," ibid., 15; Christian Ekowski, "Embryo ohne Kiemen," ibid., no. 222 (24 Sept. 1997), 16; on German creationism: Kutschera 2007; for the recent British creationist reception of Haeckel's embryos, e.g., Truth in Science, "Embryology," accessed 15 May 2013, http://www.truthinscience.org.uk/site/content/view/49/65/; more generally on global creationism: Numbers 2006, 399–431.

58. Nigel Hawkes, "An Embryonic Liar," *Times* (London), 11 Aug. 1997, 14.

59. E. Larson 2003, 156–209; Numbers 2006, 373–98.

60. Ham 1992; Major 1993. A creationist textbook put "precise photographs" "at odds with the idea of recapitulation," but did not attack Haeckel's drawings directly: Davis and Kenyon 1993, 128–29.

61. Grigg 1996.

62. "How Did We Get Here? (A Cyber Debate)," Nova Online, Odyssey of Life, 11 Nov.–9 Dec. 1996, on 19 Nov., http://www.pbs.org/wgbh/nova/odyssey/debate/; further: Solveig Jülich, "Morphing Fetal Evolution: Lennart Nilsson's Photographs and the Evolution-Creationism Controversy," manuscript; more generally on Nilsson's fetuses: Jülich 2011; for Miller's stance: Miller 2009; on *Nova*: LaFollette 2012, 121–35.

63. "A Firing Line Debate: Resolved: The Evolutionists Should Acknowledge Creation," Southern Educational Communications Association, taped 4 Dec., released for broadcast on public TV 19 Dec. 1997, transcript (available from http://hoohila.stanford.edu/firingline/programView2.php?programID=397), 11, 23–26.

64. Richardson et al. 1998; Behe 1998.

65. Grigg 1998 made a similar point.

66. Jonathan Wells, "Darwinism: Why I Went for a Second PhD," accessed 15 May 2013, http://www.tparents.org/library/unification/talks/wells/DARWIN.htm; "Jonathan Wells on Destroying Darwinism—and Responding to Attacks on His Character and Motives," 5 Nov. 2011, http://www.tparents.org/library/unification/talks/wells/Wells-111105.pdf.

67. J. Wells 1999; for responses: Freeman 2001 (invoking Blechschmidt); Blackwell 2001.

68. J. Wells 2000, vi, 8, 81–109; on the moths: Rudge 2006.

69. Metamorphosis Studios, Inc., "Metamorphosis: The Art of Jody F. Sjogren," accessed 8 Oct. 2012, http://www.met-studios.com/dominant_raptor.

70. "Jonathan Wells on Destroying Darwinism—and Responding to Attacks on His Character and Motives," 5 Nov. 2011, http://www.tparents.org/library/unification/talks/wells/Wells-111105.pdf.

71. J. Wells 2000, 95; Gishlick 2002, 29–40, on 34.

72. J. Wells 2000, 254–55.

73. Ibid., hardcover jacket.

74. For critiques: Mooney 2006; Shulman 2006.

75. Bora Zivkovic, "Science Blogs: Definition, and a History," *Scientific American*, 10 July 2012, http://blogs.scientificamerican.com/a-blog-around-the-clock/2012/07/10/science-blogs-definition-and-a-history/; on the NCSE: Park 2000.

76. P. Z. Myers, *Pharyngula*, http://freethoughtblogs.com/pharyngula/about/.

77. Eugenie C. Scott, "Fatally Flawed Iconoclasm," *Science* 292 (22 June 2001): 2257–58.

78. Ibid.

79. Massimo Pigliucci, "Intelligent Design Theory," *Bio-Science* 51 (2001): 411–14; also Jerry A. Coyne, "Creationism by Stealth," *Nature* 410 (12 Apr. 2001): 745–46.

80. Rudolf A. Raff, "The Creationist Abuse of Evo-Devo," *Evolution & Development* 3 (2001): 373–74.

81. P. Z. Myers, "Wells and Haeckel's Embryos: A Review of Chapter 5 of *Icons of Evolution*" (2003), TalkOrigins Archive, 15 Jan. 2004, http://www.talkorigins.org/faqs/wells/haeckel. html; further: Nick Matzke, "Icon of Obfuscation: Jonathan Wells's Book *Icons of Evolution* and Why Most of What It Teaches about Evolution Is Wrong" (2002–4), ibid., 23 Jan. 2004, http://www.talkorigins.org/faqs/wells/iconob.html.

82. Kardong 2002, 198–200.

83. Gishlick 2002, 39.

84. Kirschner and Gerhart 2005, 266–67.

85. P. Z. Myers, "Wells and Haeckel's Embryos: A Review of Chapter 5 of *Icons of Evolution*" (2003), TalkOrigins Archive, 15 Jan. 2004, http://www.talkorigins.org/faqs/wells/haeckel. html. See further, including for ID as a "loss-of-function mutant" showing "what science might be if it lost its respect for evidence and controls," Gilbert and the Swarthmore College Evolution and Development Seminar 2007, 41.

86. J. Wells 2000, 242–45.

87. Gilbert to author, 6 Apr. 2007.

88. Ken Miller, "Haeckel and His Embryos," 21 Dec. 1997, http://www.millerandlevine.com/km/evol/embryos/Haeckel. html; Solveig Jülich, "Morphing Fetal Evolution: Lennart Nilsson's Photographs and the Evolution-Creationism Controversy," manuscript.

89. Elinson to author, 12 May 2008. For an attempt to "molecularize" the Haeckel drawings: Elinson and Kezmoh 2010.

90. Sander 2002, 532.

91. Strickberger 2000, 44.

92. James Glanz, "Biology Text Illustrations More Fiction Than Fact," *NYT*, 8 Apr. 2001, 32. Wells acknowledged that Miller had provided better drawings, then photographs, but claimed it was still misleading to begin with a midpoint stage: Jonathan Wells, "There You Go Again: A Response to Kenneth R. Miller," Discovery Institute, 9 Apr. 2002, http://www.discovery.org/a/1144.

93. Michael J. Behe, "Teach Evolution—And Ask Hard Questions," *NYT*, 13 Aug. 1999, A21 (commenting on the Kansas decision that was reversed in 2001); Arkansas House Bill 2548, 2001, at http://web.archive.org/web/20070930225245/http://www.arkleg.state.ar.us/ftproot/bills/2001/htm/HB2548. pdf; Discovery Institute, "Ohio Praised for Historic Decision Requiring Students to Critically Analyze Evolutionary Theory," 10 Dec. 2002, http://www.discovery.org/a/1368; Nick Matzke, "'Critical Analysis of Evolution' Lesson Passed by Ohio BOE," NCSE, 10 Mar. 2004, http://ncse.com/news/2004/03/critical-analysis-evolution-lesson-passed-by-ohio-boe-00509.

94. Skip Evans, "Evolution: Still Deep in the Heart of Textbooks," NCSE, 2003, http://ncse.com/rncse/23/5-6/evolution-still-deep-heart-textbooks.

95. "Public Hearing on Textbooks," Transcript of Proceedings before the Texas State Board of Education, 9 July 2003,

previously at www.tea.state.tx.us/textbooks/adoptprocess/july03transcript.pdf.

96. On lay experts: Epstein 2008, 516–19.

97. Skip Evans (NCSE) reported in Holden 2003.

98. "Publishers Correct Some Factual Errors, But Now Textbooks Contradict Each Other," Discovery Institute, 30 Oct. 2003, http://www.discovery.org/a/1618.

99. Mayr 2001, 28; Martinez Arias and Stewart 2002 (in a historical introduction), 8; Prothero 2007, 110.

100. E.g., in London: "Haeckel's Embryos Live on at the Science Museum," *Truth in Science*, accessed 13 Nov. 2008, http://www.truthinscience.org.uk/site/content/view/210/63/.

101. Judge John E. Jones, "Memorandum Opinion," 20 Dec. 2005, available at http://ncse.com/files/pub/legal/kitzmiller/highlights/2005-12-20_Kitzmiller_decision.pdf; Numbers 2006, 394.

102. Jodi Rudoren, "Ohio Board Undoes Stand on Evolution: Intelligent Design Sustains 2nd Loss," *NYT*, 15 Feb. 2006, A14.

103. "Forward Thinkers: Randy Olson, An Evolutionary Biologist in Hollywood," by Eric Sorensen, *Conservation* 8, no. 1 (Jan.–Mar. 2007), http://www.conservationmagazine.org/2008/07/forward-thinkers/#Olson.

104. Olson 2006.

105. Jonathan Wells, "Flock of Dodos, or Pack of Lies?" *Evolution News and Views*, 9 Feb. 2007, http://www.evolutionnews.org/2007/02/flock_of_dodos_or_pack_of_fals_4003165.html.

106. Koerner 2002, 164, 179.

107. French 1975, 260–62; recent antivivisectionists have more often generated their own negative images by taking secret films. On antiabortionism: Petchesky 1987. In these cases opponents targeted procedures, while Haeckel's embryos represent results of science.

108. Offered by the Colorado-based Access Research Network through CafePress: "Intelligently Designed Apparel and Merchandise: Icons of Darwinism," accessed 15 Nov. 2008, http://www.cafepress.com/accessresearch/1341997.

CHAPTER 18

1. Pavel Tomancak, "Cover Maker," 7 Oct. 2012, http://fiji.sc/CoverMaker_plugin.

2. "About the Cover," *Nature* 468, no. 7325 (9 Dec. 2010), http://www.nature.com/nature/journal/v468/n7325/index.html (the print edition used a different caption); Prud'homme and Gompel 2010; Kalinka et al. 2010; Domazet-Lošo and Tautz 2010.

3. Richardson 2012.

4. Pavel Tomancak to author, 4 Aug. 2012; Diethard Tautz to author, 15 Oct. 2012; Benjamin Prud'homme to author, 25 Oct. 2012.

5. Tomancak to author, 4 Aug. 2012.

6. Ibid.; Tautz to author, 15 Oct. 2012.

7. Sander 2002; R. Richards 2008; also 2009.

8. Tomancak to author, 4 Aug. 2012; Tautz to author, 15 Oct. 2012; Prud'homme to author, 25 Oct. 2012.

9. Casey Luskin, "Haeckel's Embryo Drawings Make

Cameos in Proposed Texas Instructional Materials," *Evolution News and Views*, 17 June 2011, http://www.evolutionnews.org/2011/06/haeckels_embryos_make_multiple047321.html.

10. Lucille Chang (Words and Unwords Store) to author, 1 Aug. 2012.

11. "Words and Unwords Store," YouTube, 14 Feb. 2012, http://www.youtube.com/watch?v=_yIm3iX-C00.

12. "Evolutionary History Can Be a Bit Repetitive T Shirts," Zazzle, 17 Apr. 2009, http://www.zazzle.com/evolutionary_history_can_be_a_bit_repetitive_tshirt-235821379807813835.

13. "Intelligently Designed Apparel and Merchandise Brought to You by Access Research Network: Icons of Darwinism," CafePress, accessed 15 Nov. 2008, http://www.cafepress.com/accessresearch/1341997.

14. On classic books: J. Secord 2000, 516–17.

15. The practical lesson is not about predicting success, which is hard, however carefully authors and artists choose, label, examine, and revise, because designers only propose but users dispose (for advice: Tufte 1990; Frankel 2002). It is more to be wary of familiar items and to go back to the sources rather than pick up pictures secondhand.

16. On images in relation to economics and the law: e.g., Bruhn 2006; Dommann 2006.

17. Jody Sjogren to author, 7 Aug. 2012; the Creation Research Society gave permission for figure 16.10.

18. In Auguste Forel's reading; Wilhelm His criticized Haeckel for schoolmastering biology: W. His 1874, 214.

19. Brass 1909b, 3.

20. "About JCB," accessed 24 Apr. 2013, http://jcb.rupress.org/site/misc/about.xhtml; Rossner 2006; Kakuk 2009.

21. Edgerton 2006, with reference to Robert Hughes's BBC television series on modern art, *The Shock of the New* (1980).

REFERENCE LIST

Note: Newspaper articles, reviews of books and articles, editorials, all unsigned articles, individual webpages, and personal communications are cited fully in the notes and not included here.

MANUSCRIPTS

Germany

Ernst-Haeckel-Haus, Jena (EHH)

Letters to and from Haeckel.
Haeckel manuscripts.

> B63, "*Anthropogenie* III. Aufl. 1876."
> B64, "*Anthropogenie*. Notizen zur III. und IV. Aufl. 1891."
> B65, "*Anthropogenie*. Notizen zur V. Aufl. 1903."
> B74, "*Natürl[iche] Schöpfungsgeschichte*."
> B84, "Die Wahrheit. Eine offene Antwort an die katholischen und evangelischen Jesuiten."
> B102, "Embryologie des Menschen: Dr Haeckel: Jena: Sommer-Semester 1863."
> B286, "Kölliker. Embryologie. Würzburg 1853."

Staatsbibliothek zu Berlin—Preussischer Kulturbesitz (SBB)

Archiv Walter de Gruyter (Dep. 42).
> R1, R2, Gr: Haeckel, Ernst.

Universitätsbibliothek Braunschweig, Vieweg-Archive

Theodor Bischoff correspondence (V1B:128).

Institut für Anatomie und Zellbiologie, Justus-Liebig-Universität Giessen

Theodor Bischoff, "Selbstbiographie. Theodor Ludwig Wilhelm von Bischoff 28.10.1807–5.12.1882," typewritten transcription.

Niedersächsische Staats- und Universitätsbibliothek Göttingen (NSUB)

Ernst Ehlers Papers.
Rudolph Wagner Papers.
"Entwicklungsgeschichte der Wirbelthiere. Vorlesungen von Rathke im Wintersemester 1852/53" (Cod. Ms. E. C. Neumann 2a:6).

Universitätsarchiv Würzburg

Carl Lochow file (ARS 635).

Deutsches Literaturarchiv Marbach

Cotta-Archiv (Stiftung der Stuttgarter Zeitung).
Cotta, Geschäftsbücher/ Druckereicalculationen relating to Carl Vogt.

Switzerland

Staatsarchiv Basel-Stadt

Privatarchiv 633 (Ochs/His).

Universitätsbibliothek Basel

Papers of Wilhelm His-Vischer.
Papers of Friedrich Miescher-His.

Britain

Imperial College London, College Archives

Thomas Henry Huxley Papers.

University College London, Special Collections

Microfilm of *The Archives of Kegan Paul, Trench, Trübner & Henry S. King, 1853–1912.* Edited by Brian Maidment. Bishops Stortford: Chadwyck-Healey, 1973.

Wellcome Library, London

Edward Elkan, "Sketches from My Life" (1983), typescript (MS.9151) quoted by kind permission of Elkan's estate.

Edinburgh University Library, Special Collections Department

Charles Lyell correspondence.

United States

Bancroft Library, University of California, Berkeley

"Reminiscences of John Sterling Kingsley," 1927, typescript copy (BANC MSS C-D 5057).

PRINTED WORKS

100 Photographs that Changed the World. 2003. New York: Life.
Abbott, Alison. 1998. "German Oncology Research Shaken by Fraud Case." *Annals of Oncology* 9: 1–6.
Abir-Am, Pnina G., and Clark A. Elliot, eds. 1999. *Commemorative Practices in Science: Historical Perspectives on the Politics of Collective Memory. Osiris* 14.
Ackerknecht, Erwin H. 1957. *Rudolf Virchow. Arzt, Politiker, Anthropologe.* Stuttgart: Enke.
Adelmann, Howard B. 1966. *Marcello Malpighi and the Evolution of Embryology.* 5 vols. Ithaca, NY: Cornell University Press.
Aescht, Erna, Gerhard Aubrecht, Erika Krauße, and Franz Speta, eds. 1998. *Welträtsel und Lebenswunder: Ernst Haeckel—Werk, Wirkung und Folgen (Stapfia 56).* Linz: Oberösterreichisches Landesmuseum.
Agassiz, Louis. 1849. *Twelve Lectures on Comparative Embryology, Delivered before the Lowell Institute, in Boston, December and January, 1848–9.* Boston: Flanders.
———. 1854. "Sketch of the Natural Provinces of the Animal World and Their Relation to the Different Types of Man." In J. C. Nott and Geo. R. Gliddon, *Types of Mankind; or, Ethological Researches . . .,* lviii–lxxviii. Philadelphia: Lippincott.
———. 1857. *Contributions to the Natural History of the United States of America, First Monograph.* Vol. 1, pt. 1, *Essay on Classification*; pt. 2, *North American Testudinata.* Vol. 2, pt. 3, *Embryology of the Turtle.* Boston: Little, Brown.
———. 1875. *Der Schöpfungsplan. Vorlesungen über die natürlichen Grundlagen der Verwandtschaft unter den Thieren.* Leipzig: Quandt & Händel.
Ahlfeld, Fr. 1876. "Die Allantois des Menschen und ihr Verhältniss zur Nabelschnur." *Archiv für Gynäkologie* 10: 81–117, plate III, figs. 1–10.
Alberts, Bruce, Dennis Bray, Julian Lewis, Martin Raff, Keith Roberts, and James D. Watson. 1983. *Molecular Biology of the Cell.* New York: Garland.
———. 1994. *Molecular Biology of the Cell.* 3rd ed. New York: Garland.
Allen, Garland E. 1978. *Life Science in the Twentieth Century.* Cambridge: Cambridge University Press.
Althaus, Hans Peter. 2002. *Mauscheln. Ein Wort als Waffe.* Berlin: de Gruyter.
Altick, Richard D. 1978. *The Shows of London.* Cambridge, MA: Harvard University Press, Belknap Press.
Amtlicher Bericht über die acht und dreissigste Versammlung deutscher Naturforscher und Ärzte in Stettin im September 1863. 1864. Edited by C. A. Dohrn and Behm, 17–34. Stettin: Hessenland.

Amtlicher Bericht der 50. Versammlung deutscher Naturforscher und Aerzte in München vom 17. bis 22. September 1877. 1877. Munich: Straub.

Anderson, Nancy, and Michael R. Dietrich, eds. 2012. *The Educated Eye: Visual Culture and Pedagogy in the Life Sciences.* Hanover, NH: Dartmouth College Press.

Anderson, Patricia. 1991. *The Printed Image and the Transformation of Popular Culture, 1790–1860.* Oxford: Clarendon.

Anderton, Keith M. 1993. "The Limits of Science: A Social, Political, and Moral Agenda for Epistemology in Nineteenth-Century Germany." PhD diss., Harvard University.

Andreä, O. 1868. "Schöpfung oder Entwickelung?" *Der Beweis des Glaubens* 4: 257–84.

Appel, Toby A. 1987. *The Cuvier-Geoffroy Debate: French Biology in the Decades before Darwin.* New York: Oxford University Press.

Archer, Edward Thomas Stuart. 1957. *A Second School Biology.* London: University Tutorial Press.

Arey, Leslie Brainerd. 1940. *Developmental Anatomy: A Textbook and Laboratory Manual of Embryology.* 4th ed. Philadelphia: Saunders.

Armstrong, Carol M. 1998. *Scenes in a Library: Reading the Photograph in the Book, 1843–1875.* Cambridge, MA: MIT Press.

Arthur, Wallace. 1997. *The Origin of Animal Body Plans: A Study in Evolutionary Developmental Biology.* Cambridge: Cambridge University Press.

Artigas, Mariano, Thomas F. Glick, and Rafael A. Martínez. 2006. *Negotiating Darwin: The Vatican Confronts Evolution, 1877–1902.* Baltimore: Johns Hopkins University Press.

Aschoff, Ludwig. 1966. *Ein Gelehrtenleben in Briefen an die Familie.* Freiburg im Breisgau: Schulz.

Assmuth, J., and Ernest R. Hull. 1915. *Haeckel's Frauds and Forgeries.* Bombay: Examiner.

Atwood, Wm. H. 1922. *Civic and Economic Biology.* Philadelphia: Blakiston's Son.

Aveling, Edward B. 1887. *Die Darwin'sche Theorie.* Stuttgart: Dietz.

Bach, Herbert. 1968. *Biologie. Lehrbuch für Klasse 10. Vorbereitungsklassen.* Berlin: Volk und Wissen.

Bach, Herbert, Dieter Bernhardt, Wolfgang Crome, Rolf Löther, Helmut Nestler, and Martin Zacharias. 1968. *Biologie IV. Lehrbuch für die erweiterte Oberschule 12. Klasse. Die Lehre von der Evolution der Organismen.* Berlin: Volk und Wissen.

Back, Anita M., and Hermann Groeneveld. 1988. *Basler Fasnacht.* Dortmund: Harenberg.

Backenköhler, Dirk. 2008. "Only 'Dreams from an Afternoon Nap'? Darwin's Theory of Evolution and the Foundation of Biological Anthropology in Germany, 1860–75." In Engels and Glick 2008, 1:98–115.

Bader, Lena, Martin Gaier, and Falk Wolf, eds. 2010. *Vergleichendes Sehen.* Munich: Fink.

Baege, M. H. 1913. *Die Abstammungslehre und ihre Beweise. Entwurf für einen Vortrag mit 39 Lichtbildern.* Berlin: Zentralbildungsausschuß der sozialdemokratischen Partei Deutschlands, Abteilung Lichtbilder.

Baer, Karl Ernst von. 1827. "Beiträge zur Kenntniss der niedern Thiere, VII. Die Verwandtschafts-Verhältnisse unter den niedern Thierformen." *Verhandlungen der Kaiserlichen Leopoldinisch-Carolinischen Akademie der Naturforscher* 13, no. 2: 731–62.

———. 1828. *Über Entwickelungsgeschichte der Thiere. Beobachtung und Reflexion.* Pt. 1. Königsberg: Gebrüder Bornträger.

———. 1837. *Über Entwickelungsgeschichte der Thiere. Beobachtung und Reflexion.* Pt. 2. Königsberg: Gebrüder Bornträger.

———. 1886. *Nachrichten über Leben und Schriften des Herrn Geheimraths Dr. Karl Ernst von Baer mitgetheilt von ihm selbst.* 2nd ed. Braunschweig: Vieweg.

———. 1956. "On the Genesis of the Ovum of Mammals and of Man." Translated by Charles Donald O'Malley. Introduction by I. Bernard Cohen. *Isis* 47: 117–53.

Baker, Arthur O., and Lewis H. Mills. 1933. *Dynamic Biology.* New York: Rand McNally.

Baker, Ray Stannard. 1901. *Seen in Germany.* London: McClure, Phillips.

Balfour, Francis M. 1876. "The Development of Elasmobranch Fishes." *Journal of Anatomy and Physiology* 10: 517–70.

———. 1881. *A Treatise on Comparative Embryology.* Vol. 2. London: Macmillan.

Balinsky, B. I. 1960. *An Introduction to Embryology.* Philadelphia: Saunders.

Ballard, William W. 1964. *Comparative Anatomy and Embryology.* New York: Ronald.

———. 1976. "Problems of Gastrulation: Real and Verbal." *BioScience* 26: 36–39.

Barantzke, Heike. 1999. "Erich Wasmann (29.5.1859–27.2.1931)— Jesuit und Zoologe in Personalunion." *Jahrbuch für Geschichte und Theorie der Biologie* 6: 77–140.

Bardeleben, Karl. 1906. "Albert v. Koelliker. Nachruf." *DMW* 32, no. 4 (25 Jan.): 150–51.

Barker, John A., Grace Monger, Ianto Stevens, and T. J. King, eds. 1986. *Revised Nuffield Advanced Science, Biology: Study Guide.* Vol. 2, pt. 3, *Inheritance and Development*; pt. 4, *Ecology and Evolution.* Rev. ed. Harlow: Longman.

Barrow, John D. 2008. *Cosmic Imagery: Key Images in the History of Science.* London: Bodley Head.

Barry, Martin. 1837. "Further Observations on the Unity of Structure in the Animal Kingdom…." *New Edinburgh Philosophical Journal* 22: 345–64.

Barsanti, Giulio. 1992. *La scala, la mappa, l'albero: Immagini e classificazioni della natura tra Sei e Ottocento.* Florence: Sansoni.

Bartelmez, George W. 1926. "Man from the Point of View of His Development and Structure." In *The Nature of the World and of Man,* edited by H. H. Newman, 440–70. Chicago: University of Chicago Press.

Bashford, Alison, and Philippa Levine, eds. 2010. *The Oxford Handbook of the History of Eugenics.* Oxford: Oxford University Press.

Bastian, Adolf. 1874. *Offner Brief an Herrn Professor Dr. E. Häckel, Verfasser der "Natürlichen Schöpfungsgeschichte."*

Berlin: Wiegandt, Hempel und Parey.

Bätschmann, Oskar, and Pascal Griener. 1998. *Hans Holbein d. J. Die Darmstädter Madonna. Original gegen Fälschung.* Frankfurt am Main: Fischer.

Baumeyer, H. 1857. "Die Entwicklung des Hühnchens im Eie." *Die Natur* 6: 140–44, 156–58.

Bavink, B. 1937. "Haeckel redivivus." *Unsere Welt* 29: 65–73.

Bayertz, Kurt. 1998. "Darwinismus als Politik. Zur Genese des Sozialdarwinismus in Deutschland 1860–1900." In Aescht et al. 1998, 229–88.

Bayertz, Kurt, Myriam Gerhard, and Walter Jaeschke, eds. 2007a. *Weltanschauung, Philosophie und Naturwissenschaft im 19. Jahrhundert.* Vol. 1, *Der Materialismus-Streit.* Hamburg: Meiner.

———, eds. 2007b. *Weltanschauung, Philosophie und Naturwissenschaft im 19. Jahrhundert.* Vol. 3, *Der Ignorabimus-Streit.* Hamburg: Meiner.

Bayrhuber, Horst, and Ulrich Kull, eds. 1998. *Linder Biologie. Lehrbuch für die Oberstufe.* 21st ed. Stuttgart: Metzler.

Beadnell, Charles M. 1938. "The Evolutionary Theory." *BMJ* 1 (5 Mar.): 550.

Beard, Mary. 1994. "Casts and Cast-Offs: The Origins of the Museum of Classical Archaeology." *Proceedings of the Cambridge Philological Society* 39: 1–29.

Beaver, William C. 1940. *Fundamentals of Biology, Animal and Plant.* 2nd ed. St. Louis: Mosby.

Beaver, William C., and George B. Noland. 1966. *General Biology: The Science of Biology.* 7th ed. St. Louis: Mosby.

Beegan, Gerry. 2008. *The Mass Image: A Social History of Photomechanical Reproduction in Victorian London.* Basingstoke: Palgrave Macmillan.

Beer, Gillian. 1983. *Darwin's Plots: Evolutionary Narrative in Darwin, George Eliot, and Nineteenth-Century Fiction.* London: Routledge & Kegan Paul.

Beetschen, Jean-Claude. 1995. "Louis Sébastien Tredern de Lézérec (1780–18?): A Forgotten Pioneer of Chick Embryology." *IJDB* 39: 299–308.

Behe, Michael J. 1998. "Embryology and Evolution." *Science* 281 (17 July): 348.

Belgum, Kirsten. 1998. *Popularizing the Nation: Audience, Representation, and the Production of Identity in "Die Gartenlaube," 1853–1900.* Lincoln: University of Nebraska Press.

Bellairs, Ruth. 1971. *Developmental Processes in Higher Vertebrates.* London: Logos.

Belz, Willi. 1978. *Friedrich Michelis und seine Bestreitung der Neuscholastik in der Polemik gegen Joseph Kleutgen.* Leiden: Brill.

Bender, Roland. 1998. "Der Streit um Ernst Haeckels Embryonenbilder." *Biologie in unserer Zeit* 28: 157–65.

Benedict, R. C., Warren W. Knox, and George K. Stone. 1938. *High School Biology.* New York: Macmillan.

Benson, Richard. 2008. *The Printed Picture.* New York: Museum of Modern Art.

Berentsen, Antoon. 1986. *"Vom Urnebel zum Zukunftsstaat." Zum Problem der Popularisierung der Naturwissenschaften in der deutschen Literatur (1880–1910).* Berlin: Oberhofer.

Bericht über die Feier des sechzigsten Geburtstages von Ernst Haeckel am 17. Februar 1894 in Jena. 1894. Jena.

Berndt, Wilhelm. 1924. *Abstammungslehre.* Berlin: Ullstein.

Berrill, N. J. 1971. *Developmental Biology.* New York: McGraw-Hill.

Bibby, Cyril. 1942. *An Experimental Human Biology.* London: Heinemann.

———. 1968. *The Biology of Mankind.* London: Heinemann Educational.

Bidder, Friedrich von. 1959. *Aus dem Leben eines Dorpater Universitätslehrers. Erinnerungen des Mediziners Prof. Dr. Friedrich v. Bidder 1810–1894.* Würzburg: Holzner.

Bigelow, Maurice A., and Anna N. Bigelow. 1911. *Applied Biology: An Elementary Textbook and Laboratory Guide.* New York: Macmillan.

———. 1913. *Introduction to Biology: An Elementary Textbook and Laboratory Guide.* New York: Macmillan.

Bindman, David. 2009. "Mankind after Darwin and Nineteenth-Century Art." In Donald and Munro 2009, 142–65.

Binet, René. 2007. *From Nature to Form: With Essays by Robert Proctor and Olaf Breidbach.* Munich: Prestel.

Bischoff, Theodor Ludwig Wilhelm. 1842a. *Entwicklungsgeschichte des Kaninchen-Eies.* Braunschweig: Vieweg.

———. 1842b. *Entwickelungsgeschichte der Säugethiere und des Menschen.* Leipzig: Voss.

———. 1842c. "Entwicklungsgeschichte, mit besonderer Berücksichtigung der Mißbildungen." In *Handwörterbuch der Physiologie mit Rücksicht auf physiologische Pathologie,* edited by Rudolph Wagner, 1:860–928. Braunschweig: Vieweg.

———. 1845. *Entwicklungsgeschichte des Hunde-Eies.* Braunschweig: Vieweg.

———. 1852. *Entwicklungsgeschichte des Meerschweinchens.* Giessen: Ricker.

———. 1854. *Entwicklungsgeschichte des Rehes.* Giessen: Ricker.

———. 1867. *Ueber die Verschiedenheit in der Schädelbildung des Gorilla, Chimpansé und Orang-Outang, vorzüglich nach Geschlecht und Alter, nebst einer Bemerkung über die Darwinsche Theorie.* Munich: Verlag der k. Akademie.

———. 1872. *Das Studium und die Ausübung der Medicin durch Frauen.* Munich: Literarisch-artistische Anstalt (Th. Riedel).

———. 1876. "Ueber Unrichtigkeit der Angabe in Häckel's Anthropogenie in Bezug auf das Ei des Menschen und der andern Säugethiere (Sitzung vom 8. Jan.)." *Sitzungsberichte der Mathematisch-Physikalischen Classe der Königlich Bayrischen Akademie der Wissenschaften* 6: 1–2.

Blackbourn, David. 1997. *The Fontana History of Germany, 1780–1918: The Long Nineteenth Century.* London: Fontana.

Blackwell, Will H. 2001. "Don't Heckel Haeckel so Much." *American Biology Teacher* 63, no. 4 (Apr.): 230.

Blechschmidt, Erich. 1968. *Vom Ei zum Embryo. Die Gestaltungskraft des menschlichen Keims.* Stuttgart: Deutsche Verlags-Anstalt.

Bliedner, A. 1901. *Goethe und die Urpflanze.* Frankfurt am Main: Literarische Anstalt.

Blum, Ann Shelby. 1993. *Picturing Nature: American Nineteenth-Century Zoological Illustration*. Princeton, NJ: Princeton University Press.

Blystone, Robert V., and Kimberly Barnard. 1988. "The Future Direction of College Biology Textbooks." *BioScience* 38: 48–52.

Bock, [Carl Ernst]. 1873. "Von der Abstammungslehre." *Gartenlaube* 21: 698–99, 710–13.

Bode, Dietrich, ed. 1992. *Reclam, 125 Jahre Universal-Bibliothek 1867–1992. Verlags- und kulturgeschichtliche Aufsätze.* Stuttgart: Reclam.

Bölsche, Wilhelm. 1891a. "Der Jugendunterricht und die Thatsachen der Embryologie." *Freie Bühne für modernes Leben* 2: 257–61, 310–14.

———. 1891b. "Häckel's Anthropogenie in neuem Gewande. Aphorismen." *Freie Bühne für modernes Leben* 2: 1097–1101, 1217–21.

———. 1894–96. *Entwickelungsgeschichte der Natur.* 2 vols. Neudamm: Neumann.

———. 1900. *Ernst Haeckel. Ein Lebensbild.* Dresden: Reißner.

———. 1904. *Die Abstammung des Menschen.* Stuttgart: Franckh.

———. 1907. *Das Liebesleben in der Natur. Eine Entwickelungsgeschichte der Liebe.* 3 vols. Jena: Diederichs.

———. 1913. *Stirb und Werde! Naturwissenschaftliche und kulturelle Plaudereien.* Jena: Diederichs.

———. 1930. *Aus der Schneegrube. Der Geist im eisigen All.* Leipzig: Haberland.

Bommeli, R. 1898. *Die Thierwelt. Eine illustrirte Naturgeschichte der jetzt lebenden Thiere. . . .* Stuttgart: Dietz Nachf.

Bonnet, Charles. 1781. *Œuvres d'histoire naturelle et de philosophie.* Vol. 4, pt. 1, *Contemplation de la nature.* Neuchâtel: Fauche.

Bouquet, Mary. 1996. "Family Trees and Their Affinities: The Visual Imperative of the Genealogical Diagram." *Journal of the Royal Anthropological Institute*, n.s., 2: 43–66.

Bowden, M. 1977. *Ape-Men: Fact or Fallacy? A Critical Examination of the Evidence.* Bromley, Kent: Sovereign Publications.

Bowler, Peter J. 1983. *The Eclipse of Darwinism: Anti-Darwinian Evolution Theories in the Decades around 1900.* Baltimore: Johns Hopkins University Press.

———. 1996. *Life's Splendid Drama: Evolutionary Biology and the Reconstruction of Life's Ancestry, 1860–1940.* Chicago: University of Chicago Press.

———. 2005. "From Science to the Popularisation of Science: The Career of J. Arthur Thomson." In *Science and Beliefs: From Natural Philosophy to Natural Science, 1700–1900*, edited by David M. Knight and Matthew D. Eddy, 231–48. Aldershot: Ashgate.

———. 2009. *Science for All: The Popularization of Science in Early Twentieth-Century Britain.* Chicago: University of Chicago Press.

Boyd, J. D., and W. J. Hamilton. 1970. *The Human Placenta.* Cambridge: Heffer & Sons.

Brandt, Karl. 1891. "Häckel's Ansichten über die Plankton-Expedition." *Schriften des naturwissenschaftlichen Vereins für Schleswig-Holstein* 8: 199–213.

———. 1925. "Victor Hensen und die Meeresforschung." *Wissenschaftliche Meeresuntersuchungen, Abteilung Kiel*, n.s., 20: 49–103.

Brass, Arnold. 1884. *Grundriss der Anatomie, Physiologie und Entwickelungsgeschichte des Menschen.* Leipzig: Vogel.

———. 1906. *Ernst Haeckel als Biologe und die Wahrheit.* Stuttgart: Kielmann.

———. 1908. *Das Affen-Problem. Professor E. Haeckel's Darstellungs- und Kampfesweise sachlich dargelegt nebst Bemerkungen über Atmungsorgane und Körperform der Wirbeltier-Embryonen.* Leipzig: Biologischer Verlag.

———. 1909a. *Die Freiheit der Lehre und ihre Mißachtung durch deutsche Biologen.* Leipzig: Biologischer Verlag Wallmann.

———. 1909b. *Professor E. Haeckel's Darstellungs- und Kampfesweise sachlich dargelegt nebst Bemerkungen über Atmungsorgane und Körperform der Wirbeltier-Embryonen.* 2nd ed. Leipzig: Biologischer Verlag.

———. 1910. *L'origine dell'uomo e le falsificazioni di E. Haeckel.* Translated by Agostino Gemelli. Florence: Libreria Editrice Fiorentina.

———. 1911. "'Sandalion' ein Mißbrauch der 'Lehrfreiheit.'" *Keplerbund-Mitteilungen*, supplement to no. 27 (Mar.).

———. 1912. *Le falsificazioni di Ernesto Haeckel.* 2nd ed. Translated by Agostino Gemelli. Florence: Libreria Editrice Fiorentina.

Brauckmann, Sabine. 2012a. "Karl Ernst von Baer (1792–1876) and Evolution." *IJDB* 56: 653–60.

———. 2012b. "On Fate and Specification: Images and Models of Developmental Biology." In N. Anderson and Dietrich 2012, 213 34.

Brehm, A. E. 1876–79. *Brehms Thierleben. Allgemeine Kunde des Thierreichs* (Große Ausgabe). 10 vols. 2nd ed. Leipzig: Bibliographisches Institut.

Breidbach, Olaf. 1998. "Kurze Anleitung zum Bildgebrauch." In Ernst Haeckel, *Kunstformen der Natur*, edited by Breidbach, 7–16. Munich: Prestel.

———. 2006. *Visions of Nature: The Art and Science of Ernst Haeckel.* Munich: Prestel.

Breitenbach, Wilhelm. 1905. *Ernst Haeckel. Ein Bild seines Lebens und seiner Arbeit.* 2nd ed. Brackwede i. W.: Breitenbach & Hoerster.

Brewer, John, and Roy Porter, eds. 1993. *Consumption and the World of Goods.* London: Routledge.

Brewster, E. T. 1925. "Another Adult 'Howler.'" *Science* 61 (13 Feb.): 185.

Brightwell, L. R. 1938. "Evolution as the Clock Ticks." In *The Miracle of Life*, edited by Harold Wheeler, 25–50. London: Odhams.

Broad, William, and Nicholas Wade. 1982. *Betrayers of the Truth.* New York: Simon & Schuster.

Brock, Thomas D. 1985. *Successful Textbook Publishing: The Author's Guide.* Madison, WI: Science Tech.

Brocklehurst, K. G., and Helen Ward. 1958. *General School Biology.* London: English Universities Press.

Brodie, Janet Farrell. 1994. *Contraception and Abortion in Nineteenth-Century America.* Ithaca, NY: Cornell University Press.

Browder, Leon W. 1980. *Developmental Biology*. Philadelphia: Saunders College Publishing.

Browne, Janet. 2001. "Darwin in Caricature: A Study in the Popularization and Dissemination of Evolution." *Proceedings of the American Philosophical Society* 145: 496–509.

———. 2003a. *Charles Darwin: The Power of Place. Volume II of a Biography*. London: Pimlico.

———. 2003b. "Charles Darwin as a Celebrity." *Science in Context* 16: 175–94.

———. 2005. "Presidential Address: Commemorating Darwin." *BJHS* 38: 251–74.

———. 2009. "Looking at Darwin: Portraits and the Making of an Icon." *Isis* 100: 542–70.

Brücher, Heinz. 1936. *Ernst Haeckels Bluts- und Geistes-Erbe. Eine kulturbiologische Monographie*. Munich: Lehmann.

Bruhn, Matthias. 2006. "Der Markt als bildgebendes Verfahren." In Heßler 2006, 369–79.

Brush, Stephen G. 2005. "How Theories Became Knowledge: Why Science Textbooks Should Be Saved." In *Who Wants Yesterday's Papers? Essays on the Research Value of Printed Materials in the Digital Age*, edited by Yvonne Carignan, Danielle DuMerer, Susan Klier Koutsky, Eric N. Lindquist, Kara M. McClurken, and Douglas P. McElrath, 45–57. Lanham, MD: Scarecrow.

Bryan, William Jennings. 1922. *In His Image*. New York: Revell.

Brzyski, Anna, ed. 2007. *Partisan Canons*. Durham, NC: Duke University Press.

BSCS (Biological Sciences Curriculum Study). 1961. *Biological Science: An Inquiry into Life* [Yellow version, field test]. Boulder, CO: BSCS. (Held at BSCS.)

———. 1963a. *Biological Science: Molecules to Man* [Blue version]. Boston: Houghton Mifflin.

———. 1963b. *High School Biology* [Green version]. Chicago: Rand McNally.

———. 1963c. *Biological Science: An Inquiry into Life* [Yellow version]. New York: Harcourt, Brace & World.

———. 1968. *Biological Science: Molecules to Man* [Blue version]. Rev. ed. Boston: Houghton Mifflin.

Bucchi, Massimiano. 1998. "Images of Science in the Classroom: Wallcharts and Science Education, 1850–1920." *BJHS* 31: 161–84.

Buchhändler-Album. Portraits-Galerie verdienter und namhafter Buchhändler, Buchdrucker, Kunst- und Musikalienhändler aus älterer wie neuerer Zeit. Ser. 1, pt. 2. 1867. Leipzig: Schulz.

Buchholz, Kai, Rita Latocha, Hilke Peckmann, and Klaus Wolbert, eds. 2001. *Die Lebensreform. Entwürfe zur Neugestaltung von Leben und Kunst um 1900*. 2 vols. Darmstadt: Häusser.

Büchner, Ludwig. 1856. *Kraft und Stoff. Empirisch-naturphilosophische Studien. In allgemein-verständlicher Darstellung*. 4th ed. Frankfurt am Main: Meidinger.

———. 1868. *Sechs Vorlesungen über die Darwin'sche Theorie von der Verwandlung der Arten und die erste Entstehung der Organismenwelt. . . .* Leipzig: Thomas.

Buklijas, Tatjana. 2008. "Cultures of Death and Politics of Corpse Supply: Anatomy in Vienna, 1848–1914." *BHM* 82: 570–607.

Buklijas, Tatjana, and Nick Hopwood. 2008. *Making Visible Embryos*, an online exhibition, http://www.hps.cam.ac.uk/visibleembryos/.

Bumüller, Johannes. 1908. *Der Mensch. Ein anthropologischer Grundriß*. Kempten and Munich: Kösel.

Bunyan, P. T. 1982. *A First Biology Course*. Cheltenham: Thornes.

Burchell, Kevin, Sarah Franklin, and Kerry Holden. 2009. *Public Culture as Professional Science: Final Report of the ScoPE Project (Scientists on Public Engagement: From Communication to Deliberation?)*. London: BIOS, LSE.

Burckhardt-Werthemann, Daniel. 1907. "Eduard His-Heusler." *Basler Jahrbuch*, 112–59.

Burmeister, Hermann. 1843. *Geschichte der Schöpfung. Eine Darstellung des Entwicklungsganges der Erde und ihrer Bewohner*. Leipzig: Wigand.

———. 1848. *Geschichte der Schöpfung. Eine Darstellung des Entwickelungsganges der Erde und ihrer Bewohner. Für die Gebildeten aller Stände*. 3rd ed. Leipzig: Wigand.

Burmeister, Maritha Rene. 2000. "Popular Anatomical Museums in Nineteenth-Century England." PhD diss., Rutgers University.

Burnham, John C. 1987. *How Superstition Won and Science Lost: Popularizing Science and Health in the United States*. New Brunswick, NJ: Rutgers University Press.

Butcher, Barry W. 1999. "Darwin Down Under: Science, Religion, and Evolution in Australia." In Numbers and Stenhouse 1999, 39–60.

Cain, Joe. 2003. "Publication History for *Evolution: a Journal of Nature*." *Archives of Natural History* 30: 1–4.

Caron, Joseph A. 1988. "'Biology' in the Life Sciences: A Historiographical Contribution." *HS* 26: 223–68.

Cartwright, Lisa. 1995. *Screening the Body: Tracing Medicine's Visual Culture*. Minneapolis: University of Minnesota Press.

Carus, Carl Gustav. 1828. *Von den Ur-Theilen des Knochen- und Schalengerüstes*. Leipzig: Fleischer.

———. 1831. *Erläuterungstafeln zur vergleichenden Anatomie 3, enthaltend auf IX Kupfertafeln die Erläuterungen der Entwicklungs-Geschichte in den verschiedenen Thierklassen*. Leipzig: Barth.

Chadarevian, Soraya de. 2003. "Portrait of a Discovery: Watson, Crick, and the Double Helix." *Isis* 94: 90–105.

Chadarevian, Soraya de, and Nick Hopwood, eds. 2004. *Models: The Third Dimension of Science*. Stanford, CA: Stanford University Press.

Chadarevian, Soraya de, and Harmke Kamminga. 2002. *Representations of the Double Helix*. Rev. ed. Cambridge: Whipple Museum of the History of Science.

Chapman, Henry C. 1873. *Evolution of Life*. Philadelphia: Lippincott.

Choulant, Ludwig. 1852. *Geschichte und Bibliographie der anatomischen Abbildung nach ihrer Beziehung auf anatomische Wissenschaft und bildende Kunst*. Leipzig: Weigel.

Churchill, Frederick B. 1980. "The Modern Evolutionary Synthesis and the Biogenetic Law." In *The Evolutionary*

Synthesis: Perspectives on the Unification of Biology, edited by Ernst Mayr and William B. Provine, 112–22. Cambridge MA: Harvard University Press.

———. 1994. "The Rise of Classical Descriptive Embryology." In Gilbert 1994, 1–29.

———. 2007. "Living with the Biogenetic Law: A Reappraisal." In Laubichler and Maienschein 2007, 37–81.

Clark, Constance Areson. 2008. *God—or Gorilla: Images of Evolution in the Jazz Age*. Baltimore: Johns Hopkins University Press.

Clarke, Edwin, and L. S. Jacyna. 1987. *Nineteenth-Century Origins of Neuroscientific Concepts*. Berkeley: University of California Press.

Clarke, T. H. 1986. *The Rhinoceros from Dürer to Stubbs, 1515–1799*. London: Sotheby's.

Clausberg, Karl. 1997. "Psychogenese und Historismus. Verworfene Leitbilder und übergangene Kontroversen." In *Natur der Ästhetik. Ästhetik der Natur*, edited by Olaf Breidbach, 139–66. Vienna: Springer.

Clodd, Edward. 1888. *The Story of Creation: A Plain Account of Evolution*. London: Longmans, Green.

———. 1895. *A Primer of Evolution*. London: Longmans, Green.

Coffin, Harold G. 1969. *Creation, Accident or Design?* Washington, DC: Review and Herald Publishing Association.

———. 1983. *Origin by Design*. Washington, DC: Review and Herald Publishing Association.

Cohen, Claudine. 2006. "Vom 'Kiefer von Moulin-Quignon' zum 'Piltdown-Menschen.' Betrug und Beweis in der Paläanthropologie." In Reulecke 2006, 163–79.

Cohen, Jack. 1979. "Maternal Constraints on Development." In *Maternal Effects in Development*, edited by D. R. Newth and M. Balls, 1–28. Oxford: Pergamon.

Cole, Elbert C. 1933. *An Introduction to Biology*. New York: Wiley.

Cole, F. J. 1953. "The History of Albrecht Dürer's Rhinoceros in Zoological Literature." In *Science, Medicine and History: Essays on the Evolution of Scientific Thought and Medical Practice Written in Honour of Charles Singer*, edited by E. Ashworth Underwood, 1:337–56. London: Oxford University Press.

Coleman, William. 1976. "Morphology between Type Concept and Descent Theory." *Journal of the History of Medicine and Allied Sciences* 31: 149–75.

———. 1977. *Biology in the Nineteenth Century: Problems of Form, Function, and Transformation*. Cambridge: Cambridge University Press.

Coleman, William, and Frederic L. Holmes, eds. 1988. *The Investigative Enterprise: Experimental Physiology in Nineteenth-Century Medicine*. Berkeley: University of California Press.

Collins, Patricia, ed. 1995. "Embryology and Development." In *Gray's Anatomy*, 38th ed., edited by Peter Williams et al., 91–341. New York: Churchill Livingstone.

Cook, James W. 2001. *The Arts of Deception: Playing with Fraud in the Age of Barnum*. Cambridge, MA: Harvard University Press.

Cooke, Bill. 2001. *A Rebel to His Last Breath: Joseph McCabe and Rationalism*. Amherst, NY: Prometheus Books.

Corsi, Pietro. 2011. "Jean-Baptiste Lamarck: From Myth to History." In *Transformations of Lamarckism: From Subtle Fluids to Molecular Biology*, edited by Snait B. Gissis and Eva Jablonka, 9–18. Cambridge, MA: MIT Press.

Coser, Lewis A., Charles Kadushin, and Walter W. Powell. 1982. *Books: The Culture and Commerce of Publishing*. New York: Basic Books.

Cosgrove, Denis. 1994. "Contested Global Visions: *One-World*, *Whole-Earth*, and the Apollo Space Photographs." *Annals of the Association of American Geographers* 84: 270–94.

Coste, V. 1837. *Embryogénie comparée: Cours sur le développement de l'homme et des animaux, fait au Muséum d'Histoire Naturelle de Paris*. Paris: Amable Costes.

———. 1849. *Histoire générale et particulière du développement des corps organisés*. Paris: Masson.

———. 1853. *Instructions pratiques sur la pisciculture suivies de mémoires et de rapports sur le même sujet*. Paris: Masson.

Counce, Sheila J. 1996. "Biography and Contributions of Professor Klaus Sander, 1996 Recipient of the Distinguished International Award in Insect Morphology and Embryology." *International Journal of Insect Morphology & Embryology* 25: 3–17.

Cox, J. Robert. 2012. *Environmental Communication and the Public Sphere*. 3rd ed. Thousand Oaks, CA: SAGE.

Crampton, Henry E. 1931. *Coming and Evolution of Life: How Living Things Have Come to Be as They Are*. New York: University Society.

Cunningham, Andrew, and Nicholas Jardine, eds. 1990. *Romanticism and the Sciences*. Cambridge: Cambridge University Press.

Cunningham, Andrew, and Perry Williams, eds. 1992. *The Laboratory Revolution in Medicine*. Cambridge: Cambridge University Press.

Curtis, Francis D., Otis W. Caldwell, and Nina Henry Sherman. 1934. *Biology for Today*. Boston: Ginn.

———. 1940. *Everyday Biology*. Boston: Ginn.

Curtis, Helena. 1968. *Biology*. New York: Worth.

———. 1983. *Biology*. 4th ed. New York: Worth.

Czerny, Vincenz. 1967. "Aus meinem Leben," edited by Wilfried Willer. *Ruperto Carola* 14: 214–44.

Darwin, Charles. 1859. *On the Origin of Species by Means of Natural Selection, or The Preservation of Favoured Races in the Struggle for Life*. London: Murray.

———. 1871. *The Descent of Man, and Selection in Relation to Sex*. 2 vols. London: Murray.

———. 1979. *The Illustrated Origin of Species*, abridged and introduced by Richard E. Leakey. London: Faber and Faber.

———. 1990. *Charles Darwin's Marginalia*. Vol. 1. Edited by Mario A. Di Gregorio. New York: Garland.

Darwinismus und Socialdemokratie oder Haeckel und der Umsturz. Von einem denkenden Naturforscher. 1895. Berlin: Germania.

Daston, Lorraine. 1999. "Objectivity versus Truth." In *Wissenschaft als kulturelle Praxis 1750–1900*, edited by Hans Erich Bödeker, Peter Hanns Reill, and Jürgen Schlumbohm, 17–32. Göttingen: Vandenhoeck & Ruprecht.

Daston, Lorraine, and Peter Galison, 1992. "The Image of Objectivity." *Representations* 40: 81–128.

———. 2007. *Objectivity*. New York: Zone Books.

Daston, Lorraine, and Elizabeth Lunbeck, eds. 2011. *Histories of Scientific Observation*. Chicago: University of Chicago Press.

Daum, Andreas W. 1995. "Naturwissenschaftlicher Journalismus im Dienst der darwinistischen Weltanschauung. Ernst Krause alias Carus Sterne, Ernst Haeckel und die Zeitschrift *Kosmos*. . . ." *Mauritiana* (Altenburg) 15: 227–45.

———. 1998. *Wissenschaftspopularisierung im 19. Jahrhundert. Bürgerliche Kultur, naturwissenschaftliche Bildung und die deutsche Öffentlichkeit, 1848–1914*. Munich: Oldenbourg.

———. 2001. "'The Next Great Task of Civilization': International Exchange in Popular Science; The German-American Case, 1850–1900." In *The Mechanics of Internationalism: Culture, Society, and Politics from the 1840s to the First World War*, edited by Martin H. Geyer and Johannes Paulmann, 285–319. Oxford: Oxford University Press.

Davis, Percival William, and Dean H. Kenyon. 1993. *Of Pandas and People: The Central Question of Biological Origins*. 2nd ed. Dallas, TX: Haughton.

Dawson, Gowan. 2007. *Darwin, Literature and Victorian Respectability*. Cambridge: Cambridge University Press.

de Beer, Gavin. 1928. *Vertebrate Zoology: An Introduction to the Comparative Anatomy, Embryology, and Evolution of Chordate Animals*. London: Sidgwick and Jackson.

———. 1930. *Embryology and Evolution*. Oxford: Clarendon.

———. 1965. *Charles Darwin: A Scientific Biography*. Garden City, NY: Doubleday.

Decker, Herwig. 1990. "*Kosmos* (1904–1933). Die Anfangsjahre einer populärwissenschaftlichen Zeitschrift." Diploma diss., University of Munich.

Del Pino, Eugenia M., and Richard P. Elinson. 1983. "A Novel Development Pattern for Frogs: Gastrulation Produces an Embryonic Disk." *Nature* 306 (8 Dec.): 589–91.

Dendy, Arthur. 1899. "Outlines of the Development of the Tuatara, *Sphenodon* (*Hatteria*) *punctatus*." *QJMS* 42: 1–87, plates 1–10.

Dennert, Eberhard, ed. 1900. *Volks-Universal-Lexikon. Ein Nachschlage- und Belehrungsbuch für alle Fälle und Lagen des täglichen Lebens*. Berlin: Meyer.

———. 1901. *Die Wahrheit über Ernst Haeckel und seine "Welträtsel." Nach dem Urteil seiner Fachgenossen*. 2nd ed. Halle: Müller.

———. 1904. *At the Deathbed of Darwinism*. Translated by E. V. O'Harra and John H. Peschges. Burlington, IA: German Literary Board.

———. 1908. *Die Naturwissenschaft und der Kampf um die Weltanschauung. Ein Wort zur Begründung des Keplerbundes*. 2nd ed. Godesberg bei Bonn: Schloessmann.

———. 1932. "Die Anfänge des Keplerbundes." *Unsere Welt* 24: 321–26.

———. 1937. *Hindurch zum Licht! Erinnerungen aus einem Leben der Arbeit und des Kampfes*. Stuttgart: Steinkopf.

Depdolla, Philipp. 1941. "Hermann Müller-Lippstadt (1829–1883) und die Entwicklung des biologischen Unterrichts." *Sudhoffs Archiv* 34: 261–334.

Desmond, Adrian. 1989. *The Politics of Evolution: Morphology, Medicine, and Reform in Radical London*. Chicago: University of Chicago Press.

———. 1994. *Huxley: The Devil's Disciple*. London: Joseph.

Desmond, Adrian, and James Moore. 2010. *Darwin's Sacred Cause: Race, Slavery, and the Quest for Human Origins*. London: Penguin.

Dewar, Douglas. 1931. *Difficulties of the Evolution Theory*. London: Arnold.

Dienel, Christiane. 1993. "Das 20. Jahrhundert (I). Frauenbewegung, Klassenjustiz und das Recht auf Selbstbestimmung der Frau." In Jütte 1993, 140–68, 217–18.

Dierig, Sven. 2006. *Wissenschaft in der Maschinenstadt. Emil Du Bois-Reymond und seine Laboratorien in Berlin*. Göttingen: Wallstein.

Di Gregorio, Mario A. 2005. *From Here to Eternity: Ernst Haeckel and Scientific Faith*. Göttingen: Vandenhoeck & Ruprecht.

Di Trocchio, Federico. 1993. *Le bugie della scienza*. Milan: Mondadori.

Dodds, Gideon S. 1929. *The Essentials of Human Embryology*. New York: Wiley.

Dodson, Edward O. 1952. *A Textbook of Evolution*. Philadelphia: Saunders.

———. 1960. *Evolution: Process and Product*. New York: Reinhold.

Döllinger, Ignaz. 1824. *Von den Fortschritten, welche die Physiologie seit Haller gemacht hat. . . .* Munich.

Domazet-Lošo, Tomislav, and Diethard Tautz. 2010. "A Phylogenetically Based Transcriptome Age Index Mirrors Ontogenetic Divergence Patterns." *Nature* 468 (9 Dec.): 815–18.

Dommann, Monika. 2006. "Der Apparat und das Individuum: Die Verrechtlichung technischer Bilder (1860–1920)." In Heßler 2006, 347–67.

Donald, Diana, and Jane Munro, eds. 2009. *Endless Forms: Charles Darwin, Natural Science, and the Visual Arts*. Cambridge: Fitzwilliam Museum.

Dörpinghaus, Hermann Josef. 1969. "Darwins Theorie und der deutsche Vulgärmaterialismus im Urteil deutscher katholischer Zeitschriften zwischen 1854 und 1914." Dr. phil. diss., University of Freiburg im Breisgau.

Driesch, Hans. 1951. *Lebenserinnerungen. Aufzeichnungen eines Forschers und Denkers in entscheidender Zeit*. Munich: Reinhardt.

du Bois-Reymond, Emil. 1886. *Reden*. Vol. 1, *Litteratur, Philosophie, Zeitgeschichte*. Leipzig: Veit.

Duboule, D. 1994. "Temporal Colinearity and the Phylotypic Progression: A Basis for the Stability of a Vertebrate Bauplan and the Evolution of Morphologies through Heterochrony." *Development*, supplement, 135–42.

Dubow, Sara. 2011. *Ourselves Unborn: A History of the Fetus in Modern America*. New York: Oxford University Press.

Duden, Barbara. 1989. "Die 'Geheimnisse' der Schwangeren und das Öffentlichkeitsinteresse der Medizin. Zur

sozialen Bedeutung der Kindsregung." *Journal für Geschichte*, no. 1, 48–55.

———. 1993. *Disembodying Women: Perspectives on Pregnancy and the Unborn*. Translated by Lee Hoinacki. Cambridge, MA: Harvard University Press.

———. 1999. "The Fetus on the 'Farther Shore': Toward a History of the Unborn." In *Fetal Subjects, Feminist Positions*, edited by Lynn M. Morgan and Meredith W. Michaels, 13–25. Philadelphia: University of Pennsylvania Press.

———. 2002. "Zwischen 'wahrem Wissen' und Prophetie. Konzeptionen des Ungeborenen." In Duden, Schlumbohm, and Veit 2002, 11–48.

Duden, Barbara, Jürgen Schlumbohm, and Patrice Veit, eds. 2002. *Geschichte des Ungeborenen. Zur Erfahrungs- und Wissenschaftsgeschichte der Schwangerschaft, 17.–20. Jahrhundert*. Göttingen: Vandenhoeck & Ruprecht.

Duncan, Isadora. 1928. *My Life*. London: Gollancz.

Ebner, Victor von. 1877. "Ueber die erste Anlage der Allantois beim Menschen. Vortrag, gehalten in der Versammlung vom 28. Mai 1877." *Mittheilungen des Vereins der Aerzte in Steiermark*, 28–29.

Ecker, Alexander. 1859a. *Icones physiologicae. Erläuterungstafeln zur Physiologie und Entwickelungsgeschichte*. Leipzig: Voss.

———. 1859b. "Ueber plastische Darstellungen aus der Entwicklungsgeschichte des Menschen." In *Amtlicher Bericht über die vier und dreissigste Versammlung deutscher Naturforscher und Ärzte in Carlsruhe im September 1858*, edited by [Wilhelm] Eisenlohr and [Robert] Volz, 199. Karlsruhe: Müller.

———. 1880. "Beiträge zur Kenntniss der äusseren Formen jüngster menschlicher Embryonen." *AAPAA*, 403–6, plate XXIVA.

———. 1886. *Hundert Jahre einer Freiburger Professoren-Familie. Biographische Aufzeichnungen*. Freiburg im Breisgau: Mohr.

Edgerton, David. 2006. *The Shock of the Old: Technology and Global History since 1900*. London: Profile.

Ehlers, Ernst. 1885. "Carl Theodor Ernst von Siebold. Eine biographische Skizze." *ZwZ* 42: i–xxxiv.

Eichhorn, Nikolaus. 1876. "Louis Agassiz, der bestverleumdete unter den Naturforschern." *Die Gegenwart* 9, no. 17 (22 Apr.): 265–67; and no. 20 (13 May): 314–16.

Ekholm, Karin J. 2010. "Fabricius's and Harvey's Representations of Animal Generation." *Annals of Science* 67: 329–52.

Elinson, Richard P. 1987. "Changes in Developmental Patterns: Embryos of Amphibians with Large Eggs." In *Development as an Evolutionary Process: Proceedings of a Meeting Held at the Marine Biological Laboratory in Woods Hole, Massachusetts, August 23 and 24, 1985*, edited by Rudolf A. Raff and Elizabeth C. Raff, 1–21. New York: Liss.

Elinson, Richard P., and Lorren Kezmoh. 2010. "Molecular Haeckel." *Developmental Dynamics* 239: 1905–18.

Elliott, David L., and Arthur Woodward, eds. 1990. *Textbooks and Schooling in the United States*. Chicago: University of Chicago Press for the National Society for the Study of Education.

Elsner, Andreas. 1972. "Neue Perspektiven in Kulturpolitik und Wissenschaftsspezialisierung." In *Ludwig-Maximilians-Universität. Ingolstadt—Landshut—München 1472–1972*, edited by Laetitia Boehm and Johannes Spörl, 271–314. Berlin: Duncker & Humblot.

Elsner, John, and Roger Cardinal, eds. 1994. *The Cultures of Collecting*. London: Reaktion.

Elsner, Norbert, ed. 2000. *Das ungelöste Welträtsel. Frida von Uslar-Gleichen und Ernst Haeckel*. 3 vols. Göttingen: Wallstein.

Engelhardt, Dietrich von. 1980. "Polemik und Kontroversen um Haeckel." *MHJ* 15: 284–304.

Engels, Eve-Marie. 2000. "Darwin in der deutschen Zeitschriftenliteratur des 19. Jahrhunderts—Ein Forschungsbericht." In *Evolutionsbiologie von Darwin bis heute*, edited by Rainer Brömer, Uwe Hoßfeld, and Nicolaas A. Rupke, 19–57. Berlin: VWB.

Engels, Eve-Marie, and Thomas F. Glick, eds. 2008. *The Reception of Charles Darwin in Europe*. 2 vols. London: Continuum.

Engels, Friedrich. 1975. *Dialektik der Natur* [1925]. In *Karl Marx Friedrich Engels Werke*, 20:305–570. Berlin: Dietz.

Enke, Ulrike. 2000. "Soemmerrings Werk *Icones embryonum humanorum*." In Samuel Thomas Soemmerring, *Schriften zur Embryologie und Teratologie*, edited by Enke, 81–110. Basel: Schwabe.

———. 2002. "Von der Schönheit der Embryonen. Samuel Thomas Soemmerrings Werk *Icones embryonum humanorum* (1799)." In Duden, Schlumbohm, and Veit 2002, 205–35.

Epstein, Steven. 2008. "Patient Groups and Health Movements." In *The Handbook of Science and Technology Studies*, 3rd ed., edited by Edward J. Hackett, Olga Amsterdamska, Michael Lynch, and Judy Wajcman, 499–539. Cambridge, MA: MIT Press.

Erdl, M. P. 1845. *Die Entwickelung des Menschen und des Hühnchens im Eie zur gegenseitigen Erläuterung nach eigenen Beobachtungen zusammengestellt und nach der Natur in Stahlstichen ausgefuehrt*. Vol. 1, *Entwicklung der Leibesform*, pt. 1, *Entwicklung der Leibesform des Hühnchens*. Leipzig: Voss.

Escherich, Karl. 1949. *Leben und Forschen. Kampf um eine Wissenschaft*. 2nd ed. Berlin: Wissenschaftliche Verlagsgesellschaft.

Evans, Richard J., ed. 1989. *Kneipengespräche im Kaiserreich. Die Stimmungsberichte der Hamburger Politischen Polizei 1892–1914*. Reinbek bei Hamburg: Rowohlt.

———. 1997. "In Search of German Social Darwinism: The History and Historiography of a Concept." In *Medicine and Modernity: Public Health and Medical Care in Nineteenth- and Twentieth-Century Germany*, edited by Manfred Berg and Geoffrey Cocks, 55–80. Washington, DC: German Historical Institute.

Faasse, Patricia, Job Faber, and Jenny Narraway. 1999. "A Brief History of the Hubrecht Laboratory." *IJDB* 43: 583–90.

Fahnestock, Jeanne. 2003. "Verbal and Visual Parallelism." *Written Communication* 20: 123–52.

Fara, Patricia. 2002. *Newton: The Making of Genius*. London: Macmillan.

Fenton, Carroll Lane. 1924. *Ernst Haeckel: Evolutionist*. Girard, KS: Haldeman-Julius.

Ferris, Harry Burr. 1922. "The Natural History of Man." In *The Evolution of Man: A Series of Lectures Delivered before the Yale Chapter of the Sigma Xi during the Academic Year 1921–1922*, edited by George Alfred Baitsell, 39–79, 186–87. New Haven, CT: Yale University Press.

Feuerbach, Ludwig. 1990. "Die Naturwissenschaft und die Revolution." In *Gesammelte Werke*, vol. 10, *Kleinere Schriften III (1846–1850)*, 3rd ed., edited by Werner Schuffenhauer, 347–68. Berlin: Akademie-Verlag.

Fick, Rudolf. 1904. "Wilhelm His." *AA* 25: 161–208.

Finetti, Marco, and Armin Himmelrath. 1999. *Der Sündenfall: Betrug und Fälschung in der deutschen Wissenschaft*. Stuttgart: Raabe.

Fischer, Martin S., Gunnar Brehm, and Uwe Hoßfeld. 2008. *Das Phyletische Museum in Jena*. Jena: Institut für Spezielle Zoologie und Evolutionsbiologie mit Phyletischem Museum.

Fischer-Homberger, Esther. 1983. *Medizin vor Gericht. Gerichtsmedizin von der Renaissance bis zur Aufklärung*. Bern: Huber.

Fisher, Kate. 2006. *Birth Control, Sex and Marriage in Britain, 1918–1960*. Oxford: Oxford University Press.

Fiske, John. 1874. *Outlines of Cosmic Philosophy, Based on the Doctrine of Evolution, with Criticisms on the Positive Philosophy*. Vol. 1. London: Macmillan.

Fissell, Mary E. 2003. "Making a Masterpiece: The Aristotle Texts in Vernacular Medical Culture." In *Right Living: An Anglo-American Tradition of Self-Help Medicine and Hygiene*, edited by Charles E. Rosenberg, 59–87. Baltimore: Johns Hopkins University Press.

Fleck, Ludwik. 1979. *Genesis and Development of a Scientific Fact*. Translated by Fred Bradley and Thaddeus J. Trenn. Edited by Trenn and Robert K. Merton. Chicago: University of Chicago Press.

Fleischmann, Albert. 1898. *Lehrbuch der Zoologie. Nach morphogenetischen Gesichtspunkten*. Wiesbaden: Kreidel.

———. 1901. *Die Descendenztheorie. Gemeinverständliche Vorlesungen über den Auf- und Niedergang einer naturwissenschaftlichen Hypothese, gehalten vor Studierenden aller Fakultäten*. Leipzig: Georgi.

Flessau, Kurt-Ingo. 1977. *Schule der Diktatur. Lehrpläne und Schulbücher des Nationalsozialismus*. Munich: Ehrenwirth.

Foerster, Wolf-Dietrich. 1963. *Alexander Ecker. Sein Leben und Wirken*. Freiburg im Breisgau: Albert.

Follett, Robert J. R. 2002. "Textbook Publishing." In *Scholarly Publishing: Books, Journals, Publishers, and Libraries in the Twentieth Century*, edited by Richard E. Abel and Lyman W. Newlin, 95–105. New York: Wiley.

Fothergill, Philip G. 1961. *Evolution and Christians*. London: Longmans.

Foucault, Michel. 1970. *The Order of Things: An Archaeology of the Human Sciences*. London: Tavistock.

———. 1994. *The Birth of the Clinic: An Archaeology of Medical Perception*. New York: Vintage.

Fox, H. Munro. 1932. *Biology: An Introduction to the Study of Life*. Cambridge: Cambridge University Press.

Frankel, Felice. 2002. *Envisioning Science: The Design and Craft of the Science Image*. Cambridge, MA: MIT Press.

Franz, Rainald. 1998. "Stilvermeidung und Naturnachahmung. Ernst Haeckels 'Kunstformen der Natur' und ihr Einfluß auf die Ornamentik des Jugendstils in Österreich." In Aescht et al. 1998, 475–80.

Franz, Victor. 1934. *Das heutige geschichtliche Bild von Ernst Haeckel. Rede bei der Gedächtnisfeier der Universität Jena zu Haeckels 100. Geburtstag, in der Aula der Universität Jena gehalten am 16. Februar 1934*. Jena: Fischer.

———. 1944. "'Wem der große Wurf gelungen, eines Freundes Freund zu sein. . . .' Hermann Allmers und Ernst Haeckel in noch unbekannten Briefen." In *Ernst Haeckel. Eine Schriftenfolge zur Pflege seines geistigen Erbes*, edited by Victor Franz, 2:11–109. Jena: Gronau.

Frazer, J. E. 1931. *A Manual of Embryology: The Development of the Human Body*. London: Baillière.

Freedberg, David. 1991. *The Power of Images: Studies in the History and Theory of Response*. Chicago: University of Chicago Press.

Freeman, Brian. 2001. "Haeckel's Forgeries." *American Biology Teacher* 63, no. 8 (Oct.): 550–54.

French, Richard D. 1975. *Antivivisection and Medical Science in Victorian Society*. Princeton, NJ: Princeton University Press.

Friedman, Alan J., and Carol C. Donley. 1985. *Einstein as Myth and Muse*. Cambridge: Cambridge University Press.

Fuld, Werner. 1999. *Das Lexikon der Fälschungen: Fälschungen, Lügen und Verschwörungen aus Kunst, Historie, Wissenschaft und Literatur*. Frankfurt am Main: Eichborn.

Futuyma, Douglas J. 1998. *Evolutionary Biology*. 3rd ed. Sunderland, MA: Sinauer.

Ganzer, Karl Richard. 1939. *Das deutsche Führergesicht. 204 Bildnisse deutscher Kämpfer und Wegsucher aus zwei Jahrtausenden*. 3rd ed. Munich: Lehmann.

García-Belmar, Antonio, José Ramón Bertomeu-Sánchez, and Bernadette Bensaude-Vincent. 2005. "The Power of Didactic Writings: French Chemistry Textbooks of the Nineteenth Century." In *Pedagogy and the Practice of Science: Historical and Contemporary Perspectives*, edited by David Kaiser, 219–51. Cambridge, MA: MIT Press.

Gasman, Daniel. 1971. *The Scientific Origins of National Socialism: Social Darwinism in Ernst Haeckel and the German Monist League*. London: Macdonald.

Gaster, Barak. 1990. "Assimilation of Scientific Change: The Introduction of Molecular Genetics into Biology Textbooks." *Social Studies of Science* 20: 431–54.

Gauld, Nicola. 2009. "'What Is Meant by This System?' Charles Darwin and the Visual Re-ordering of Nature." In Donald and Munro 2009, 118–40.

Gehring, Walter J. 1998. *Master Control Genes in Development and Evolution: The Homeobox Story*. New Haven, CT: Yale University Press.

Geison, Gerald L. 1995. *The Private Science of Louis Pasteur*.

Princeton, NJ: Princeton University Press.

Gerard, John. 1914. *Professor Haeckel and His Philosophy*. London: Catholic Truth Society.

Gerhart, John, and Marc Kirschner. 1997. *Cells, Embryos, and Evolution: Toward a Cellular and Developmental Understanding of Phenotypic Variation and Evolutionary Adaptability*. Malden, MA: Blackwell Science.

Geus, Armin. 1985. "Christian Koeck (1758–1818), der Illustrator Samuel Thomas Soemmerrings." In *Samuel Thomas Soemmerring und die Gelehrten der Goethezeit. Beiträge eines Symposions in Mainz vom 19. bis 21. Mai 1983*, edited by Gunter Mann and Franz Dumont, 263–78. Stuttgart: Fischer.

———. 1987. *Johannes Ranke (1836–1916). Physiologe, Anthropologe und Prähistoriker*. Marburg: Basilisken-Presse.

Giese, Christian. 1990. "Theodor Ludwig Wilhelm von Bischoff (1807–1882). Anatom und Physiologe." Habilitation thesis, Justus Liebig University, Giessen.

Gilbert, Scott F. 1985. *Developmental Biology*. Sunderland, MA: Sinauer.

———. 1991. "Epigenetic Landscaping: Waddington's Use of Cell Fate Bifurcation Diagrams." *Biology and Philosophy* 6: 135–54.

———, ed. 1994. *A Conceptual History of Modern Embryology*. Baltimore: Johns Hopkins University Press.

———. 1997. *Developmental Biology*. 5th ed. Sunderland, MA: Sinauer.

Gilbert, Scott F., and Rebecca Howes-Mischel. 2004. "'Show Me Your Original Face Before You Were Born': The Convergence of Public Fetuses and Sacred DNA." *HPLS* 26: 377 94.

Gilbert, Scott F., John M. Opitz, and Rudolf A. Raff. 1996. "Resynthesizing Evolutionary and Developmental Biology." *Developmental Biology* 173: 357–72.

Gilbert, Scott F., and the Swarthmore College Evolution and Development Seminar. 2007. "The Aerodynamics of Flying Carpets: Why Biologists are Loath to 'Teach the Controversy.'" In *The Panda's Black Box: Opening up the Intelligent Design Controversy*, edited by Nathaniel C. Comfort, 40–62. Baltimore: Johns Hopkins University Press.

Gillis, James M. 1925. *False Prophets*. New York: Macmillan.

Ginzburg, Carlo. 2001. "'Your Country Needs You': A Case Study in Political Iconography." *History Workshop Journal* 52 (Autumn): 1–22.

Gishlick, Alan D. 2002. "Icons of Evolution? Why Much of What Jonathan Wells Writes about Evolution Is Wrong." NCSE, first posted 22 Nov., http://ncse.com/creationism/analysis/icons-critique-pdf.

Glasser, Otto. 1989. *Wilhelm Conrad Röntgen and the Early History of the Roentgen Rays*. San Francisco: Norman.

Gliboff, Sander. 2006. "The Case of Paul Kammerer: Evolution and Experimentation in the Early Twentieth Century." *JHB* 39: 525–63.

———. 2008. *H. G. Bronn, Ernst Haeckel, and the Origins of German Darwinism: A Study in Translation and Transformation*. Cambridge, MA: MIT Press.

Glick, Thomas F., ed. 1988. *The Comparative Reception of Darwinism*. Chicago: University of Chicago Press.

Glick, Thomas F., Miguel Angel Puig-Samper, and Rosaura Ruiz, eds. 2001. *The Reception of Darwinism in the Iberian World: Spain, Spanish America, and Brazil*. Dordrecht: Kluwer Academic.

Gliddon, Richard, ed. 1975. *Revised Nuffield Biology*. Rev. ed. Text 4: *The Perpetuation of Life*. London: Longman.

Goenner, Hubert. 1993. "The Reaction to Relativity Theory, I: The Anti-Einstein Campaign in Germany in 1920." *Science in Context* 6: 107–33.

Goldschmidt, Richard B. 1956. *The Golden Age of Zoology: Portraits from Memory*. Seattle: University of Washington Press.

Gooday, Graeme. 1991. "'Nature' in the Laboratory: Domestication and Discipline with the Microscope in Victorian Life Science." *BJHS* 24: 307–41.

Gordin, Michael D. 2004. *A Well-Ordered Thing: Dmitrii Mendeleev and the Shadow of the Periodic Table*. New York: Basic Books.

Goschler, Constantin, ed. 2000. *Wissenschaft und Öffentlichkeit in Berlin, 1870–1930*. Stuttgart: Steiner.

———. 2002. *Rudolf Virchow. Mediziner, Anthropologe, Politiker*. Cologne: Böhlau.

Gossman, Lionel. 2000. *Basel in the Age of Burckhardt: A Study in Unseasonable Ideas*. Chicago: University of Chicago Press.

Gould, Frederick James. 1929. *The Pioneers of Johnson's Court: A History of the Rationalist Press Association from 1899 Onwards*. London: Watts.

Gould, Stephen Jay. 1977. *Ontogeny and Phylogeny*. Cambridge, MA: Harvard University Press, Belknap Press

———. 1979. "Agassiz' Later, Private Thoughts on Evolution: His Marginalia in Haeckel's *Natürliche Schöpfungsgeschichte* (1868)." In *Two Hundred Years of Geology in America: Proceedings of the New Hampshire Bicentennial Conference on the History of Geology*, edited by Cecil J. Schneer, 277–82. Hanover, NH: UPNE.

———. 1991a. *Bully for Brontosaurus: Reflections in Natural History*. London: Hutchinson Radius.

———. 1991b. *Wonderful Life: The Burgess Shale and the Nature of History*. London: Penguin.

———. 1997. "Ladders and Cones: Constraining Evolution by Canonical Icons." In *Hidden Histories of Science*, edited by Robert B. Silvers, 37–67. London: Granta.

———. 2000. "Abscheulich! (Atrocious!): Haeckel's Distortions Did Not Help Darwin." *Natural History* 109, no. 3 (Mar.): 42–49.

Grabiner, Judith V., and Peter D. Miller. 1974. "Effects of the Scopes Trial: Was It a Victory for Evolutionists?" *Science* 185 (6 Sept.): 832–37.

Gradmann, Christoph, and Jonathan Simon, eds. 2010. *Evaluating and Standardizing Therapeutic Agents, 1890–1950*. Basingstoke: Palgrave Macmillan.

Graf, Andreas. 2003. "Familien- und Unterhaltungszeitschriften." In *Geschichte des deutschen Buchhandels im 19. und 20. Jahrhundert*, vol. 1, *Das Kaiserreich 1871–1918*, pt. 2, edited by Georg Jäger, 409–522. Frankfurt am Main: MVB.

Graham, Loren, Wolf Lepenies, and Peter Weingart, eds. 1983. *Functions and Uses of Disciplinary Histories*. Dordrecht: Reidel.

Grant, Charlotte L., H. Keith Cady, and Nathan A. Neal. 1948. *American High School Biology*. New York: Harper & Brothers.

Grautoff, Otto. 1901. *Die Entwicklung der modernen Buchkunst in Deutschland*. Leipzig: Seemann Nachfolger.

Grazie, M. E. delle. 1909. *Heilige und Menschen*. Leipzig: Breitkopf & Härtel.

Gregory, Frederick. 1977. *Scientific Materialism in Nineteenth-Century Germany*. Dordrecht: Reidel.

———. 1992. *Nature Lost? Natural Science and the German Theological Traditions of the Nineteenth Century*. Cambridge, MA: Harvard University Press.

Gregory, J. W., ed. 1930. *From Meteorite to Man: The Evolution of the Earth*. London: Watts.

Gregory, William K., and Marcelle Roigneau. 1934. *Introduction to Human Anatomy: Guide to Section I of the Hall of the Natural History of Man in the American Museum of Natural History*. New York: American Museum of Natural History.

Grell, Karl G. 1979. "Die Gastraea-Theorie." *MHJ* 14: 275–91.

Griesemer, James R., and William C. Wimsatt. 1989. "Picturing Weismannism: A Case Study of Conceptual Evolution." In *What the Philosophy of Biology Is: Essays Dedicated to David Hull*, edited by Michael Ruse, 75–137. Dordrecht: Kluwer Academic.

Griffiths, D. C. 1964. *A General Certificate Biology Course*. London: Pitman.

Grigg, Russell. 1996. "Ernst Haeckel: Evangelist for Evolution and Apostle of Deceit." *Creation* 18, no. 2 (Mar.): 33–36.

———. 1998. "Fraud Rediscovered." *Creation* 20, no. 2 (Mar.): 49–51.

Groeben, Christiane, and Irmgard Müller. 1975. *The Naples Zoological Station at the Time of Anton Dohrn*. Translated by Richard and Christl Ivell. Paris: Goethe-Institut.

Groschopp, Horst. 1997. *Dissidenten. Freidenkerei und Kultur in Deutschland*. Berlin: Dietz.

Gruenberg, Benjamin C. 1919. *Elementary Biology: An Introduction to the Science of Life*. Boston: Ginn.

———. 1925. *Biology and Human Life*. Boston: Ginn.

———. 1929. *The Story of Evolution: Facts and Theories on the Development of Life*. London: Chapman & Hall.

Grunewald, Michel, and Uwe Puschner, eds. 2010. *Krisenwahrnehmungen in Deutschland um 1900. Zeitschriften als Foren der Umbruchszeit im Wilhelminischen Reich*. Bern: Lang.

Grupe, Hans. 1962. *Biologie*. Hannover: Schroedel.

Guenther, Konrad. 1909. *Vom Urtier zum Menschen. Ein Bilderatlas zur Abstammungs- und Entwicklungsgeschichte des Menschen*. 2 vols. Stuttgart: Deutsche Verlags-Anstalt.

Gugerli, David, and Barbara Orland, eds. 2002. *Ganz normale Bilder. Historische Beiträge zur visuellen Herstellung von Selbstverständlichkeit*. Zurich: Chronos.

Gunning, William D. 1876. *Life-History of Our Planet*. Chicago: Keen, Cooke.

Gurdon, John B., and Nick Hopwood. 2000. "The Introduction of *Xenopus laevis* into Developmental Biology: Of Empire, Pregnancy Testing and Ribosomal Genes." *IJDB* 44: 43–50.

Gursch, Reinhard. 1981. *Die Illustrationen Ernst Haeckels zur Abstammungs- und Entwicklungsgeschichte. Diskussion im wissenschaftlichen und nichtwissenschaftlichen Schrifttum*. Frankfurt am Main: Lang.

Guthrie, Mary J., and J. Maxwell Anderson. 1957. *General Zoology*. New York: Wiley.

Guyer, Michael Frederic. 1931. *Animal Biology*. New York: Harper & Bros.

Haeckel, Ernst. 1862. *Die Radiolarien* (Rhizopoda radiaria). *Eine Monographie*. Berlin: Reimer.

———. 1866. *Generelle Morphologie der Organismen. Allgemeine Grundzüge der organischen Formen-Wissenschaft, mechanisch begründet durch die von Charles Darwin reformirte Descendenz-Theorie*. 2 vols. Berlin: Reimer.

———. 1868. *Natürliche Schöpfungsgeschichte. Gemeinverständliche wissenschaftliche Vorträge über die Entwickelungslehre im Allgemeinen und diejenige von Darwin, Goethe und Lamarck im Besonderen, über die Anwendung derselben auf den Ursprung des Menschen und andere damit zusammenhängende Grundfragen der Naturwissenschaft*. Berlin: Reimer.

———. 1870. *Natürliche Schöpfungsgeschichte.* . . . 2nd ed. Berlin: Reimer.

———. 1872. *Natürliche Schöpfungsgeschichte.* . . . 3rd ed. Berlin: Reimer.

———. 1874a. *Anthropogenie oder Entwickelungsgeschichte des Menschen. Gemeinverständliche wissenschaftliche Vorträge über die Grundzüge der menschlichen Keimes- und Stammes-Geschichte*. Leipzig: Engelmann.

———. 1874b. *Natürliche Schöpfungsgeschichte.* . . . 5th ed. Berlin: Reimer.

———. 1874c. "Die Gastraea-Theorie, die phylogenetische Classification des Thierreichs und die Homologie der Keimblätter." *Jenaische Zeitschrift für Naturwissenschaft* 8: 1–55, plate I.

———. 1875a. *Ziele und Wege der heutigen Entwickelungsgeschichte*. Jena: Dufft.

———. 1875b. "Die Gastrula und die Eifurchung der Thiere." *Jenaische Zeitschrift für Naturwissenschaft* 9: 402–508, plates XIX–XXV.

———. 1876a. *Die Perigenesis der Plastidule oder die Wellenzeugung der Lebenstheilchen. Ein Versuch zur mechanischen Erklärung der elementaren Entwickelungs-Vorgänge*. Berlin: Reimer.

———. 1876b. *The History of Creation; or, the Development of the Earth and Its Inhabitants by the Action of Natural Causes: A Popular Exposition of the Doctrine of Evolution in General, and of That of Darwin, Goethe, and Lamarck in Particular*. Translation revised by E. Ray Lankester. 2 vols. London: King.

———. 1877a. *Anthropogenie.* . . . 3rd ed. Leipzig: Engelmann.

———. 1877b. *Anthropogénie; ou, Histoire de l'évolution humaine. Leçons familières sur les principes de l'embryologie et de la phylogénie humaines*. Translated by Ch. Letourneau. Paris: Reinwald.

———. 1878. *Freie Wissenschaft und freie Lehre. Eine Entgegnung auf Rudolf Virchow's Münchener Rede über "Die Freiheit der Wissenschaft im modernen Staat."* Stuttgart: Schweizerbart.

———. 1879a. *Natürliche Schöpfungsgeschichte. . . .* 7th ed. Berlin: Reimer.

———. 1879b. *The Evolution of Man: A Popular Exposition of the Principal Points of Human Ontogeny and Phylogeny.* 2 vols. London: Kegan Paul.

———. 1889. *Natürliche Schöpfungs-Geschichte. . . .* 8th ed. Berlin: Reimer.

———. 1890. *Plankton-Studien. Vergleichende Untersuchungen über die Bedeutung und Zusammensetzung der pelagischen Fauna und Flora.* Jena: Fischer.

———. 1891. *Anthropogenie oder Entwickelungsgeschichte des Menschen. Keimes- und Stammes-Geschichte.* 4th ed. 2 pts. Leipzig: Engelmann.

———. 1893. *Der Monismus als Band zwischen Religion und Wissenschaft. Glaubensbekenntniss eines Naturforschers. . . .* 3rd ed. Bonn: Strauss.

———. 1895. *Antropogenia o storia dell'evoluzione umana. (Storia embriologica e genealogica) (Opere di Ernesto Haeckel 3).* Edited by Daniele Rosa. Turin: Unione tipografico editrice.

———. 1898a. *Natürliche Schöpfungs-Geschichte. . . .* 9th ed. 2 pts. Berlin: Reimer.

———. 1898b. "Aufsteigende und absteigende Zoologie." *Jenaische Zeitschrift für Naturwissenschaft* 31: 469–74.

———. 1899. *Die Welträthsel. Gemeinverständliche Studien über monistische Philosophie.* Bonn: Strauß.

———. 1901. *Aus Insulinde: Malayische Reisebriefe.* Bonn: Strauß.

———. 1902. *Natürliche Schöpfungs-Geschichte. . . .* 10th ed. 2 pts. Berlin: Reimer.

———. 1903. *Anthropogenie. . . .* 5th ed. 2 pts. Leipzig: Engelmann.

———. 1904a. *Kunstformen der Natur.* Leipzig: Bibliographisches Institut.

———. 1904b. *Die Lebenswunder. Gemeinverständliche Studien über Biologische Philosophie. . . .* Stuttgart: Kröner.

———. 1905a. *Der Kampf um den Entwickelungs-Gedanken. Drei Vorträge, gehalten am 14., 16. und 19. April 1905 im Saale der Sing-Akademie zu Berlin.* Berlin: Reimer.

———. 1905b. *The Evolution of Man: A Popular Scientific Study.* Translated by Joseph McCabe. 2 vols. London: Watts.

———. 1906a. *The Evolution of Man: A Popular Scientific Study.* Translated by Joseph McCabe. (Cheap reprint.) London: Watts.

———. 1906b. *Last Words on Evolution: A Popular Retrospect and Summary.* Translated by Joseph McCabe. London: Owen.

———. 1907. *Das Menschen-Problem und die Herrentiere von Linné. Vortrag gehalten am 17. Juni 1907 im Volkshause zu Jena.* Frankfurt am Main: Neuer Frankfurter Verlag.

———. 1908. *Unsere Ahnenreihe (Progonotaxis hominis). Kritische Studien über Phyletische Anthropologie. Festschrift zur 350-jährigen Jubelfeier der Thüringer Universität Jena und der damit verbundenen Übergabe des Phyletischen Museums am 30. Juli 1908.* Jena: Fischer.

———. 1910a. "Die Grenzen der Naturwissenschaft." *DMW* 36, no. 40 (6 Oct.): 1855–57.

———. 1910b. "Mein Kirchenaustritt." *Das Freie Wort* 10, no. 18 (Dec.): 714–17.

———. 1910c. *Sandalion. Eine offene Antwort auf die Fälschungs-Anklagen der Jesuiten.* Frankfurt am Main: Neuer Frankfurter Verlag.

———. 1911a. *The Answer of Ernst Haeckel to the Falsehoods of the Jesuits, Catholic and Protestant: From the German Pamphlet "Sandalion," and "My Church Departure." Being Haeckel's Reasons, as Stated by Himself, for his Late Withdrawal from the Free Evangelical Church, with Comments by Joseph McCabe and Thaddeus Burr Wakeman.* New York: Truth Seeker Company.

———. [1911b]. *Insanin menşei, nesl-i beşer.* Translated by Ahmed Nebil. Istanbul: Matbaa-i Nefaset.

———. 1912. *Natur und Mensch. Sechs Abschnitte aus Werken von Ernst Haeckel.* Edited by Carl W. Neumann. Leipzig: Reclam.

———. 1921a. *Entwicklungsgeschichte einer Jugend. Briefe an die Eltern 1852/1856.* Edited by Heinrich Schmidt. Leipzig: Koehler.

———. 1921b. *Italienfahrt. Briefe an die Braut 1859/1860.* Edited by Heinrich Schmidt. Leipzig: Koehler.

———. [c. 1922.] *Three Lectures on Evolution.* Girard, KS: Haldeman-Julius.

———. 1924a. *Die Natur als Künstlerin.* Edited by Franz Goerke. Berlin-Charlottenburg: Vita Deutsches Verlagshaus.

———. 1924b. *Gemeinverständliche Werke.* Edited by Heinrich Schmidt. 6 vols. Leipzig: Kröner.

———. 1926. *Natürliche Schöpfungs-Geschichte. . . .* Volksausgabe. Berlin: de Gruyter.

Haeckel, Ernst, and Friedrich von Hellwald. 1901. *Briefwechsel zwischen Ernst Haeckel und Friedrich von Hellwald.* Ulm: Kerler.

Haeckel, Walther, ed. 1914. *Ernst Haeckel im Bilde. Eine physiognomische Studie zu seinem 80. Geburtstage.* Berlin: Reimer.

Hagemann, G. 1870. "Mensch und Affe." *Natur und Offenbarung* 16: 29–37, 75–85, 135–45, 211.

Hagner, Michael. 1997. "Monstrositäten in gelehrten Räumen." In Alexander Polzin, *Abgetrieben*, edited by Sander L. Gilman, 11–30. Göttingen: Wallstein.

———. 1999. "Enlightened Monsters." In *The Sciences in Enlightened Europe*, edited by William Clark, Jan Golinski, and Simon Schaffer, 175–217. Chicago: University of Chicago Press.

———. 2004. *Geniale Gehirne. Zur Geschichte der Elitegehirnforschung.* Göttingen: Wallstein.

———. 2010. *Der Hauslehrer. Die Geschichte eines Kriminalfalls. Erziehung, Sexualität und Medien um 1900.* Berlin: Suhrkamp.

Haldane, J. B. S., and Julian Huxley. 1927. *Animal Biology.* Oxford: Clarendon.

Hall, Alexander Wilford. 1880. *The Problem of Human Life: Embracing the "Evolution of Sound" and "Evolution Evolved," with a Review of the Six Great Modern Scien-*

tists, *Darwin, Huxley, Tyndall, Haeckel, Helmholtz, and Mayer*. Rev. ed. New York: Hall.

Hall, Brian K. 1997. "Phylotypic Stage or Phantom: Is There a Highly Conserved Embryonic Stage in Vertebrates?" *TREE* 12: 461–63.

———. 1999. *Evolutionary Developmental Biology*. 2nd ed. Dordrecht: Kluwer.

———. 2001. "John Samuel Budgett (1872–1904): In Pursuit of *Polypterus*." *BioScience* 51: 399–407.

Ham, Kenneth. 1992. "The Smartest Man in America?" *Back to Genesis*, no. 48 (1 Dec.). http://www.icr.org/article/728/.

Ham, Richard G., and Marilyn J. Veomett. 1980. *Mechanisms of Development*. St. Louis: Mosby.

Hamann, Otto. 1892. *Entwicklungslehre und Darwinismus. Eine kritische Darstellung der modernen Entwicklungslehre und ihrer Erklärungsversuche mit besonderer Berücksichtigung der Stellung des Menschen in der Natur*. Jena: Costenoble.

———. 1893. *Professor Ernst Haeckel in Jena und seine Kampfweise. Eine Erwiderung*. Göttingen: Peppmüller.

———. 1900. "Die Welträthsel und ihr Verfasser Ernst Häckel in Jena." *Die Kultur* 1: 341–49.

Hamblin, T. J. 1981. "Fake!" *BMJ* 283 (19 Dec.): 1671–74.

Hamilton, W. J., J. D. Boyd, and H. W. Mossman. 1945. *Human Embryology*. Cambridge: Heffer.

Hanioğlu, M. Şükrü. 2005. "Blueprints for a Future Society: Late Ottoman Materialists on Science, Religion, and Art." In *Late Ottoman Society: The Intellectual Legacy*, edited by Elisabeth Özdalga, 27–116. London: RoutledgeCurzon.

Hankinson, John Trevor. 1955. *Biology for General Certificate: A Course for the Ordinary Level*. London: Blackie.

Hansen, Bert. 2009. *Picturing Medical Progress from Pasteur to Polio: A History of Mass Media Images and Popular Attitudes in America*. New Brunswick, NJ: Rutgers University Press.

Hariman, Robert, and John Louis Lucaites. 2007. *No Caption Needed: Iconic Photographs, Public Culture, and Liberal Democracy*. Chicago: University of Chicago Press.

Harris, Neil. 1979. "Iconography and Intellectual History: The Half-Tone Effect." In *New Dimensions in American Intellectual History*, edited by John Higham and Paul K. Conkin, 196–211. Baltimore: Johns Hopkins University Press.

Hartmann, Eduard von. 1875. "Ernst Haeckel." *Deutsche Rundschau* 4: 7–32.

Haskell, Francis, and Nicholas Penny. 1981. *Taste and the Antique: The Lure of Classical Sculpture, 1500–1900*. New Haven, CT: Yale University Press.

Hasse, Carl. 1882. "Erklärung über den Krause'schen Embryo." *AAPAA*, 203.

Hatfield, E. J. 1938. *An Introduction to Biology*. Oxford: Clarendon.

Haupt, Arthur W. 1928. *Fundamentals of Biology*. New York: McGraw-Hill.

Hauser, K. 1920. "Ernst Haeckel als zoologischer Forscher." In *Ernst Haeckel. Sein Leben, sein Wirken und seine Bedeutung für den Geisteskampf der Gegenwart*, edited by Hauser, 22–76. Godesberg bei Bonn: Naturwissenschaftlicher Verlag.

Häußler, Alfred. 1992. "Zum Tod von Prof. Dr. med. Erich Blechschmidt." *Medizin und Ideologie* 14 (Aug.): 12–14.

Haynes, Roslynn D. 1994. *From Faust to Strangelove: Representations of the Scientist in Western Literature*. Baltimore: Johns Hopkins University Press.

Headley, F. W. 1900. *Problems of Evolution*. London: Duckworth.

Heberer, Gerhard. 1934. *Ernst Haeckel und seine wissenschaftliche Bedeutung. Zum Gedächtnis der 100. Wiederkehr seines Geburtstages*. Tübingen: Heine.

———. 1949. *Allgemeine Abstammungslehre*. Göttingen: "Musterschmidt."

———, ed. 1968. *Der gerechtfertigte Haeckel. Einblicke in seine Schriften aus Anlaß des Erscheinens seines Hauptwerkes "Generelle Morphologie der Organismen" vor 100 Jahren*. Stuttgart: Fischer.

Heesen, Anke te. 2006. *Der Zeitungsausschnitt. Ein Papierobjekt der Moderne*. Frankfurt am Main: Fischer.

Heesen, Anke te, and Emma Spary, eds. 2001. *Sammeln als Wissen. Das Sammeln und seine wissenschaftsgeschichtliche Bedeutung*. Göttingen: Wallstein.

Heider, Karl. 1919. "Ernst Haeckel. Ein Wort der Erinnerung, gesprochen zur Eröffnung des Kollegs am 1. Oktober 1919." *Naturwissenschaften* 7: 945–46.

Heidler, Irmgard. 1998. *Der Verleger Eugen Diederichs und seine Welt (1896–1930)*. Wiesbaden: Harrassowitz.

Heilborn, Adolf. 1914. *Entwickelungsgeschichte des Menschen. Vier Vorlesungen*. Leipzig: Teubner.

———. 1920a. *Entwickelungsgeschichte des Menschen. Vier Vorlesungen*. 2nd ed. Leipzig: Teubner.

———. 1920b. *Die Leartragödie Ernst Haeckels*. Hamburg and Berlin: Hoffmann & Campe.

Helmreich, Stefan. 2011. "From Spaceship Earth to Google Ocean: Planetary Icons, Indexes, and Infrastructures." *Social Research* 78: 1211–42.

Hemleben, Johannes. 1964. *Ernst Haeckel in Selbstzeugnissen und Bilddokumenten*. Reinbek bei Hamburg: Rowohlt.

Hensen, Victor. 1876. "Beobachtungen über die Befruchtung und Entwicklung des Kaninchens und Meerschweinchens." *Zeitschrift für Anatomie und Entwicklungsgeschichte* 1: 213–73, 353–423, plates VIII–XII.

———. 1877. "Beitrag zur Morphologie der Körperform und des Gehirns des menschlichen Embryos." *AAPAA*, 1–8, plate I.

———. 1890. "Einige Ergebnisse der Plankton-Expedition der Humboldt-Stiftung." *Sitzungsberichte der Königlich Preussischen Akademie der Wissenschaften zu Berlin*, 1: 243–53.

———. 1891. *Die Plankton-Expedition und Haeckel's Darwinismus. Ueber einige Aufgaben und Ziele der beschreibenden Naturwissenschaften*. Kiel: Lipsius & Tischer.

———. 1909. "Die Wahrhaftigkeit in der Morphologie." *Unsere Welt* 1, no. 4 (4 Apr.): 199–204.

Hentschel, Klaus. 1993. "Bernhard Bavink (1879–1947). Der Weg eines Naturphilosophen vom deutschnationalen Sympathisanten der NS-Bewegung bis zum unbe-

quemen Nonkonformisten." *Sudhoffs Archiv* 77: 1–32.

———. 2002. *Mapping the Spectrum: Techniques of Visual Representation in Research and Teaching.* Oxford: Oxford University Press.

Herbert, S. 1913. *The First Principles of Evolution.* London: Black.

Hertwig, Oscar. 1888. *Lehrbuch der Entwickelungsgeschichte des Menschen und der Wirbelthiere.* Jena: Fischer.

Hertwig, Richard. 1919. "Haeckels Verdienste um die Zoologie." *Naturwissenschaften* 7: 951–58.

———. 1928. "Haeckel, Ernst." *Deutsches Biographisches Jahrbuch*, Überleitungsband 2, *1917–1920*, 397–412.

Hesse, Richard. 1902. *Abstammungslehre und Darwinismus.* Leipzig: Teubner.

Heßler, Martina, ed. 2006. *Konstruierte Sichtbarkeiten. Wissenschafts- und Technikbilder seit der Frühen Neuzeit.* Munich: Fink.

———. 2007. "Die 'Mona Lisa der modernen Wissenschaften.' Zur Doppelhelixstruktur als einer kulturellen Ikone." In *Konstruieren, Kommunizieren, Präsentieren. Bilder von Wissenschaft und Technik*, edited by Alexander Gall, 291–315. Göttingen: Wallstein.

Hickman, Cleveland P. 1961. *Integrated Principles of Zoology.* 2nd ed. St. Louis: Mosby.

Hildebrandt, Sabine. 2006. "How the Pernkopf Controversy Facilitated a Historical and Ethical Analysis of the Anatomical Sciences in Austria and Germany: A Recommendation for the Continued Use of the Pernkopf Atlas." *Clinical Anatomy* 19: 91–100.

Hilgartner, Stephen. 2000. *Science on Stage: Expert Advice as Public Drama.* Stanford, CA: Stanford University Press.

Hinrichsen, Klaus V. 1992. "In memoriam des Anatomen und Embryologen Erich Blechschmidt (1904–1992)." *Annals of Anatomy* 174: 479–84.

Hird, Dennis. 1903. *An Easy Outline of Evolution.* London: Watts.

———. 1906–7. *A Picture Book of Evolution.* 2 pts. London: Watts.

His, Eduard. 1941. *Basler Gelehrte des 19. Jahrhunderts.* Basel: Schwabe.

His, Wilhelm. 1868. *Untersuchungen über die erste Anlage des Wirbelthierleibes. Die erste Entwickelung des Hühnchens im Ei.* Leipzig: Vogel.

———. 1870a. "Beschreibung eines Mikrotoms." *Archiv für mikroskopische Anatomie* 6: 229–32.

———. 1870b. *Ueber die Bedeutung der Entwickelungsgeschichte für die Auffassung der organischen Natur. Rectoratsrede, gehalten den 4. November 1869.* Leipzig: Vogel.

———. 1873. *Untersuchungen über die erste Anlage des Wirbelthierleibes. Untersuchungen über das Ei und die Eientwickelung bei Knochenfischen.* Leipzig: Vogel.

———. 1874 [published in early 1875]. *Unsere Körperform und das physiologische Problem ihrer Entstehung. Briefe an einen befreundeten Naturforscher.* Leipzig: Vogel.

———. 1879. "Ueber jüngere menschl. Embryonen und über die Allantois des Menschen." In *Tageblatt der 52. Versammlung deutscher Naturforscher und Aerzte in Baden-Baden 1879*, 64–65. Baden-Baden: Hagen.

———. 1880a. *Anatomie menschlicher Embryonen.* Pt. 1, *Embryonen des ersten Monats.* Leipzig: Vogel.

———. 1880b. "Zur Kritik jüngerer menschlicher Embryonen."

Sendschreiben an Herrn Prof. W. Krause in Göttingen." *AAPAA*, 407–20.

———. 1882a. *Anatomie menschlicher Embryonen.* Pt. 2, *Gestalt- und Grössenentwicklung bis zum Schluss des 2. Monats.* Leipzig: Vogel.

———. 1882b. "Die Lehre vom Bindesubstanzkeim (Parablast). Rückblick nebst kritischer Besprechung einiger neuerer entwickelungsgeschichtlicher Arbeiten." *AAPAA*, 62–108.

———. 1885. *Anatomie menschlicher Embryonen.* Pt. 3, *Zur Geschichte der Organe.* Leipzig: Vogel.

———. 1886. "Die Entwicklung der zoologischen Station in Neapel und das wachsende Bedürfniss nach wissenschaftlichen Centralanstalten." *Biologisches Centralblatt* 6: 545–54.

———. 1887. "Über die Methoden der plastischen Rekonstruktion und über deren Bedeutung für Anatomie u. Entwickelungsgeschichte." *AA* 2: 382–94.

———. 1895. *Karl Ludwig und Karl Thiersch. Akademische Gedächtnisrede im Auftrage der medicinischen Facultät zu Leipzig am 13. Juli 1895 gehalten.* Leipzig: Vogel.

———. 1896. "Ludwig Rütimeyer." *AA* 11: 508–12.

———. 1897. "F. Miescher." In *Die histochemischen und physiologischen Arbeiten von Friedrich Miescher*, 5–32. Leipzig: Vogel.

———. 1965. *Lebenserinnerungen und ausgewählte Schriften.* Edited by Eugen Ludwig. Bern: Huber.

Hodge, Clifton F., and Jean Dawson. 1918. *Civic Biology: A Textbook of Problems, Local and National, That Can be Solved Only by Civic Cooperation.* Boston: Ginn.

Hoeller, Konrad. 1907a. *Das Bild im naturgeschichtlichen Unterricht. Eine pädagogische Studie, zugleich ein Ratgeber für Lehrer und Schulbehörden.* Leipzig: Nägele.

———. 1907b. *Die sexuelle Frage und die Schule nebst Versuch einer Eingliederung des zur sexuellen Aufklärung notwendigen Lehrstoffs in den Lehrplan einer achtstufigen Schule.* Leipzig: Nägele.

Hoepke, Hermann, ed. 1976. "Wilhelm Waldeyer. Briefe an Jakob Henle 1863–1885. Dritter Teil (1881–1885)." *Ruperto Carola* 57: 43–54.

Hoff, Peter, Joachim Jaenicke, and Wolfgang Miram. 1991. *Biologie heute 2 G. Ein Lehr- und Arbeitsbuch für das Gymnasium.* Hannover: Schroedel.

Hohlfeld, Johannes. 1930. *200 Jahre F. C. W. Vogel.* Leipzig.

Holden, Constance. 2003. "Texas Resolves War over Biology Texts." *Science* 302 (14 Nov.): 1130.

Holle, Stefanie. 1984. "Die Wiederlegung des Postulates von der Gleichzeitigkeit der Ovulation und Menstruation bei der Frau. Klinische und histologische Untersuchungen im frühen 20. Jahrhundert." Dr. med. diss., University of Erlangen-Nuremberg.

Hollmann, Sam[uel] Christian. 1783. *Nöthiger Unterricht von Barometern und Thermometern, Nebst zuverläßiger Nachricht von den seit 1743 und 1752 alhier verfertigten, beyden Arten.* Göttingen: Grapen.

Holmes, S. J. 1926. *Life and Evolution: An Introduction to General Biology.* New York: Harcourt, Brace.

Holzer, Josef. 1964. *Und Gott sprach. Biblischer Schöpfungsbericht*

und modernes Wissen. Würzburg: Arena.

Hopwood, Nick. 1996. "Producing a Socialist Popular Science in the Weimar Republic." *History Workshop Journal* 41 (Spring): 117–53.

———. 1997. "Biology between University and Proletariat: The Making of a Red Professor." *HS* 35: 367–424.

———.1999. "'Giving Body' to Embryos: Modeling, Mechanism, and the Microtome in Late Nineteenth-Century Anatomy." *Isis* 90: 462–96.

———. 2000a. "Producing Development: The Anatomy of Human Embryos and the Norms of Wilhelm His." *BHM* 74: 29–79.

———. 2000b. "Haeckel, Ernst." In *Reader's Guide to the History of Science*, edited by Arne Hessenbruch, 317–18. London: Fitzroy Dearborn.

———. 2002. *Embryos in Wax: Models from the Ziegler Studio, with a Reprint of "Embryological Wax Models" by Friedrich Ziegler*. Cambridge: Whipple Museum of the History of Science.

———. 2005. "Visual Standards and Disciplinary Change: Normal Plates, Tables and Stages in Embryology." *HS* 43: 239–303.

———. 2006. "Pictures of Evolution and Charges of Fraud: Ernst Haeckel's Embryological Illustrations." *Isis* 97: 260–301.

———. 2007. "Artist versus Anatomist, Models against Dissection: Paul Zeiller of Munich and the Revolution of 1848." *Medical History* 51: 279–308.

———. 2009a. "Embryology." In *The Cambridge History of Science*, vol. 6, *The Modern Biological and Earth Sciences*, edited by Peter J. Bowler and John V. Pickstone, 285–315. New York: Cambridge University Press.

———. 2009b. "Darwinism's Tragic Genius: Psychology and Reputation." *Isis* 100: 863–67.

———. 2011. "Approaches and Species in the History of Vertebrate Embryology." In *Vertebrate Embryogenesis: Embryological, Cellular, and Genetic Methods*, edited by Francisco J. Pelegri, 1–20. New York: Humana Press.

———. 2012. "A Marble Embryo: Meanings of a Portrait from 1900." *History Workshop Journal* 73 (Spring): 5–36.

———. 2014. "The Cult of Amphioxus in German Darwinism; or; Our Gelatinous Ancestors in Naples' Blue and Balmy Bay." *HPLS* 36, in press.

Hopwood, Nick, Simon Schaffer, and Jim Secord. 2010. "Seriality and Scientific Objects in the Nineteenth Century." *HS* 48: 251–85.

Horder, Tim J. 2008. "A History of Evo-Devo in Britain: Theoretical Ideals Confront Biological Complexity." *AHPB* 13: 101–74.

Hoßfeld, Uwe. 1997. *Gerhard Heberer (1901–1973). Sein Beitrag zur Biologie im 20. Jahrhundert*. Berlin: VWB.

———. 2005a. *Geschichte der biologischen Anthropologie in Deutschland. Von den Anfängen bis in die Nachkriegszeit*. Stuttgart: Steiner.

———. 2005b. "Haeckels 'Eckermann': Heinrich Schmidt (1874–1935)." In *"Klassische Universität" und "akademische Provinz." Studien zur Universität Jena von der Mitte des 19. bis in die dreißiger Jahre des 20. Jahrhunderts*, edited

by Matthias Steinbach and Stefan Gerber, 270–88. Jena: Bussert & Stadeler.

———. 2005c. "Nationalsozialistische Wissenschaftsinstrumentalisierung. Die Rolle von Karl Astel und Lothar Stengel von Rutkowski bei der Genese des Buches 'Ernst Haeckels Bluts- und Geistes-Erbe' (1936)." In *Der Brief als wissenschaftshistorische Quelle*, edited by Erika Krauße, 171–94. Berlin: VWB.

Hoßfeld, Uwe, and Olaf Breidbach. 2005. *Haeckel-Korrespondenz. Übersicht über den Briefbestand des Ernst-Haeckel-Archivs*. Berlin: VWB.

———. 2007. "Biologie- und Wissenschaftsgeschichte in Jena. Das Ernst-Haeckel-Haus der Friedrich-Schiller-Universität." In *Hochschule im Sozialismus. Studien zur Geschichte der Friedrich-Schiller-Universität Jena (1945–1990)*, edited by Uwe Hoßfeld, Tobias Kaiser, and Heinz Mestrup, 1:1181–206. Cologne: Böhlau.

Hoßfeld, Uwe, Jürgen John, Oliver Lemuth, and Rüdiger Stutz, eds. 2003. *"Kämpferische Wissenschaft." Studien zur Universität Jena im Nationalsozialismus*. Cologne: Böhlau.

Hoßfeld, Uwe, and Lennart Olsson. 2003. "Ernst Haeckel's Swedish Correspondents." *Uppsala Newsletter for the History of Science*, no. 34, 1–3.

Howsam, Leslie. 2000. "An Experiment with Science for the Nineteenth-Century Book-Trade: The International Scientific Series." *BJHS* 33: 187–207.

Huber, Johannes. 1875. *Zur Kritik moderner Schöpfungslehren, mit besonderer Rücksicht auf Haeckel's "Natürlicher Schöpfungsgeschichte."* Munich: Ackermann.

Hübinger, Gangolf, ed. 1996. *Versammlungsort moderner Geister. Der Eugen Diederichs Verlag—Aufbruch ins Jahrhundert der Extreme*. Munich: Diederichs.

Hubrecht, A. A. W. 1894. "Studies from the Zoological Laboratory in the University of Utrecht, IV. *Spolia nemoris*." *QJMS* 36: 77–125, plates 9–12.

———. 1903. "Emil Selenka 27. Februar 1842—21. Januar 1902. Ein Lebensbild." In Emil Selenka, *Studien über Entwickelungsgeschichte der Tiere 10 (Menschenaffen [Anthropomorphae]. Studien über Entwickelung und Schädelbau 5), Zur vergleichenden Keimesgeschichte der Primaten*, edited by Franz Keibel, 1–14. Wiesbaden: Kreidel.

Hubrecht, A. A. W., and Franz Keibel. 1907. *Normentafel zur Entwicklungsgeschichte des Koboldmaki (Tarsius spectrum) und des Plumplori (Nycticebus tardigradus)*. Jena: Fischer.

Huettner, Alfred F. 1941. *Fundamentals of Comparative Embryology of the Vertebrates*. New York: Macmillan.

Humboldt, Alexander von. 1849. *Ansichten der Natur, mit wissenschaftlichen Erläuterungen*. 3rd ed. Vol. 1. Stuttgart: Cotta.

Humphrys, L. G. 1966. *Life Is Exciting: An Introductory Biology Course for Schools*. London: Blackie.

Hunter, George William. 1907. *Elements of Biology: A Practical Text-Book Correlating Botany, Zoology, and Human Physiology*. New York: American Book Company.

———. 1914. *A Civic Biology: Presented in Problems*. New York: American Book Company.

Hunter, George W., III, and F. R. Hunter. 1949. *College Zoology*. Philadelphia: Saunders.

Hurd, Paul DeHart. 1961. *Biological Education in American Secondary Schools, 1890–1960*. Washington, DC: American Institute of Biological Sciences.

Huschke, Konrad, ed. 1950. *Ernst und Agnes Haeckel. Ein Briefwechsel*. Jena: Urania.

Huxley, Thomas H. 1863a. *Evidence as to Man's Place in Nature*. London: Williams and Norgate.

———. 1863b. *Zeugnisse für die Stellung des Menschen in der Natur*. Braunschweig: Vieweg.

Illustriertes Konversations-Lexikon der Frau. 1900. 2 vols. Berlin: Oldenbourg.

Iselin, L. E. 1897. *Carl Ludwig Rütimeyer*. Basel: Reich.

Issitt, John. 2004. "Reflections on the Study of Textbooks." *History of Education* 33: 683–96.

Jackson, Myles W. 2003. "Harmonious Investigators of Nature: Music and the Persona of the German *Naturforscher* in the Nineteenth Century." *Science in Context* 16: 121–45.

Jacyna, L. S. 2001. "'A Host of Experienced Microscopists': The Establishment of Histology in Nineteenth-Century Edinburgh." *BHM* 75: 225–53.

Jäger, Georg. 2001. "Der Lexikonverlag." In *Geschichte des deutschen Buchhandels im 19. und 20. Jahrhundert*, vol. 1, *Das Kaiserreich 1871–1918*, pt. 1, edited by Jäger, 541–74. Frankfurt am Main: Buchhändler-Vereinigung.

Jamin, Friedrich. 1986. *Briefe und Betrachtungen eines Arztes. Aus dem Nachlaß von Geheimrat Professor Dr. med. Friedrich Jamin weiland Ordinarius für Innere Medizin und für Kinderheilkunde an der Universität Erlangen*. Erlangen: in Kommission bei Palm & Enke.

Jansen, Christian. 2007. "'Revolution'–'Realismus'–'Realpolitik.' Der nachrevolutionäre Paradigmenwechsel in den 1850er Jahren im deutschen oppositionellen Diskurs und sein historischer Kontext." In Bayertz, Gerhard, and Jaeschke 2007a, 223–59.

Jardine, Nicholas. 1991. *The Scenes of Inquiry: On the Reality of Questions in the Sciences*. Oxford: Clarendon.

Jefferies, Matthew. 2003. *Imperial Culture in Germany, 1871–1918*. Basingstoke: Palgrave Macmillan.

Jenkins, E. W. 1979. *From Armstrong to Nuffield: Studies in Twentieth-Century Science Education in England and Wales*. London: Murray.

Jodl, Margarete, ed. 1922. *Bartholomäus von Carneri's Briefwechsel mit Ernst Haeckel und Friedrich Jodl*. Leipzig: Koehler.

Johns, Adrian. 1998. *The Nature of the Book: Print and Knowledge in the Making*. Chicago: University of Chicago Press.

———. 2009. *Piracy: The Intellectual Property Wars from Gutenberg to Gates*. Chicago: University of Chicago Press.

Johnson, Norman Miller. 1933. *An Elementary Biology for Schools*. Edinburgh: Oliver & Boyd.

Johnson, Willis H., Richard A. Laubengayer, and Louis E. Delanney. 1961. *General Biology*. Rev. ed. New York: Holt, Rinehart and Winston.

Jones, Caroline A., and Peter Galison, eds. 1998. *Picturing Science, Producing Art*. New York: Routledge.

Jordan, David Starr. 1894. *The Factors in Organic Evolution: A Syllabus of a Course of Elementary Lectures Delivered in Leland Stanford Junior University*. Boston: Ginn.

———. 1898. *Foot-Notes to Evolution: A Series of Popular Addresses on the Evolution of Life*. New York: Appleton.

———. 1922. *The Days of a Man: Being Memories of a Naturalist, Teacher, and Minor Prophet of Democracy*. 2 vols. London: Harrap.

Jordan, David Starr, and Vernon L. Kellogg. 1901. *Animal Life: A First Book of Zoology*. New York: Appleton.

Jordan, Harvey Ernest, and James Ernest Kindred. 1926. *A Textbook of Embryology*. New York: Appleton.

Jordanova, L. J. 1985. "Gender, Generation and Science: William Hunter's Obstetrical Atlas." In *William Hunter and the Eighteenth-Century Medical World*, edited by W. F. Bynum and Roy Porter, 385–412. Cambridge: Cambridge University Press.

Jubiläumskatalog der Verlagsbuchhandlung Wilhelm Engelmann in Leipzig 1811–1911. 1911. Leipzig.

Judson, Horace Freeland. 2004. *The Great Betrayal: Fraud in Science*. Orlando, FL: Harcourt.

Jülich, Solveig. 2011. "Fetal Photography in the Age of Cool Media." In *History of Participatory Media: Politics and Publics, 1750–2000*, edited by Anders Ekström, Jülich, Frans Lundgren, and Per Wisselgren, 125–41. New York: Routledge.

Junker, Reinhard, and Siegfried Scherer. 1986. *Entstehung und Geschichte der Lebewesen. Daten und Deutungen für den schulischen Bereich*. Giessen: Weyel.

Junker, Thomas. 1989. *Darwinismus und Botanik. Rezeption, Kritik und theoretische Alternativen im Deutschland des 19. Jahrhunderts*. Stuttgart: Deutscher Apotheker Verlag.

Jussim, Estelle. 1983. *Visual Communication and the Graphic Arts: Photographic Technologies in the Nineteenth Century*. New York: Bowker.

Jütte, Robert, ed. 1993. *Geschichte der Abtreibung. Von der Antike bis zur Gegenwart*. Munich: Beck.

Kahn, Fritz. 1922. *Das Leben des Menschen. Eine volkstümliche Anatomie, Biologie, Physiologie und Entwicklungsgeschichte des Menschen*. Vol. 1. Stuttgart: Kosmos, Gesellschaft der Naturfreunde.

Kahn, Miriam B. 2011. "Werner and His Empire: The Rise and Fall of a Gilded Age Printer." PhD diss., Kent State University.

Kaiser, David. 2005. *Drawing Theories Apart: The Dispersion of Feynman Diagrams in Postwar Physics*. Chicago: University of Chicago Press.

Kaiser, Jochen-Christoph. 1981. *Arbeiterbewegung und organisierte Religionskritik. Proletarische Freidenkerverbände in Kaiserreich und Weimarer Republik*. Stuttgart: Klett-Cotta.

Kakuk, Péter. 2009. "The Legacy of the Hwang Case: Research Misconduct in Biosciences." *Science and Engineering Ethics* 15: 545–62.

Kalinka, Alex T., Karolina M. Varga, Dave T. Gerrard, Stephan Preibisch, David L. Corcoran, Julia Jarrells, Uwe

Ohler, Casey M. Bergman, and Pavel Tomancak. 2010. "Gene Expression Divergence Recapitulates the Developmental Hourglass Model." *Nature* 468 (9 Dec.): 811–14.

Kardong, Kenneth V. 2002. *Vertebrates: Comparative Anatomy, Function, Evolution*. 3rd ed. Boston: McGraw-Hill.

Karp, Gerald, and N. J. Berrill. 1976. *Development*. New York: McGraw-Hill.

Kazin, Michael. 2007. *A Godly Hero: The Life of William Jennings Bryan*. New York: Anchor.

Keckstein, Rainer. 1980. *Die Geschichte des biologischen Schulunterrichts in Deutschland*. Bad Salzdetfurth: Franzbecker Didaktischer Dienst.

Keeton, William T. 1967. *Biological Science*. New York: Norton.

Keibel, Franz. 1895a. "Studien zur Entwicklungsgeschichte des Schweines (*Sus scrofa domesticus*), II." *Morphologische Arbeiten* 5: 17–168, plates II–VIII.

———. 1895b. "Normentafeln zur Entwickelungsgeschichte der Wirbeltiere." *AA* 11: 225–34.

———. 1896. "Mitteilungen über die 'Normentafeln zur Entwickelungsgeschichte der Wirbeltiere.'" *AA* 11: 593–96.

———. 1897. *Normentafel zur Entwickelungsgeschichte des Schweines (*Sus scrofa domesticus*)*. Jena: Fischer.

———. 1898. "Das biogenetische Grundgesetz und die Cenogenese." *Ergebnisse der Anatomie und Entwicklungsgeschichte* 7: 722–92.

———. 1906. "Die Entwickelung der äusseren Körperform der Wirbeltierembryonen, insbesondere der menschlichen Embryonen aus den ersten 2 Monaten." In *Handbuch der vergleichenden und experimentellen Entwickelungslehre der Wirbeltiere*, edited by Oskar Hertwig, vol. 1, pt. 2, 1–176. Jena: Fischer.

———. 1909. "Haeckel und Brass." *DMW* 35, no. 8 (25 Feb.): 350–51.

———. 1915. "A. A. W. Hubrecht. Ein Nachruf." *AA* 48: 201–8.

Keibel, Franz, and Curt Elze. 1908. *Normentafel zur Entwicklungsgeschichte des Menschen*. Jena: Fischer.

Keller, Conrad, and Arnold Lang. 1904. *Ernst Haeckel als Forscher und Mensch. Reden gehalten bei der Feier des 70. Geburtstages Ernst Haeckels*. Zurich: Müller.

Keller, Evelyn Fox. 1995. *Refiguring Life: Metaphors of Twentieth-Century Biology*. New York: Columbia University Press.

———. 1996. "*Drosophila* Embryos as Transitional Objects: The Work of Donald Poulson and Christiane Nüsslein-Volhard." *Historical Studies in the Physical and Biological Sciences* 26: 313–46.

Kellogg, Vernon Lyman. 1907. *Darwinism Today: A Discussion of Present-Day Scientific Criticism of the Darwinian Selection Theories, Together with a Brief Account of the Principal Other Proposed Auxiliary and Alternative Theories of Species-Forming*. New York: Holt.

———. 1910. "Ernst Haeckel: Darwinist, Monist." *Popular Science Monthly* 76 (Feb.): 136–42.

Kelly, Alfred. 1981. *The Descent of Darwin: The Popularization of Darwinism in Germany, 1860–1914*. Chapel Hill: University of North Carolina Press.

Kemp, Heinrich. 1873. "'Wissenschaftliche' Kunstgriffe der Darwinistischen Schule." *Stimmen aus Maria-Laach* 4: 448–66.

Kemp, Martin. 2012. *Christ to Coke: How Image Becomes Icon*. Oxford: Oxford University Press.

Kerr, J. G. 1901. "The Development of *Lepidosiren paradoxa*, Part II: With a Note upon the Corresponding Stages in the Development of *Protopterus annectens*." *QJMS* 45: 1–40, plates 1–4.

———. 1950. *A Naturalist in the Gran Chaco*. Cambridge: University Press.

Kevles, Bettyann Holtzmann. 1997. *Naked to the Bone: Medical Imaging in the Twentieth Century*. New York: Basic Books.

Kevles, Daniel J. 1998. *The Baltimore Case: A Trial of Politics, Science, and Character*. New York: Norton.

Kimball, John W. 1974. *Biology*. 3rd ed. Reading, MA: Addison-Wesley.

Kinsey, Alfred C. 1933. *New Introduction to Biology*. Philadelphia: Lippincott.

Kirschner, Marc W., and John C. Gerhart. 2005. *The Plausibility of Life: Resolving Darwin's Dilemma*. New Haven, CT: Yale University Press.

Klausen, Jytte. 2009. *The Cartoons That Shook the World*. New Haven, CT: Yale University Press.

Kleeberg, Bernhard. 2005. *Theophysis. Ernst Haeckels Philosophie des Naturganzen*. Cologne: Böhlau.

Klemm, Peter. 1968. *Ernst Haeckel, der Ketzer von Jena. Ein Leben in Berichten, Briefen und Bildern*. 2nd ed. Leipzig: Urania.

Knodel, Hans, Ulrich Bäßler, and Albert Danzer. 1971. *Hermann Linder Biologie. Lehrbuch für die Oberstufe*. 17th ed. Stuttgart: Metzler.

Koch, Hanns, Fritz Steinecke, and Joseph Straub. 1951. *Allgemeine Biologie für die Oberstufe der höheren Lehranstalten*. Heidelberg: Quelle & Meyer.

Koch, Hans-Theodor. 1981. "Karl Ernst von Baers (1792–1876) Korrespondenz mit den preußischen Behörden." *Wissenschaftliche Beiträge der Martin-Luther-Universität Halle-Wittenberg* 39: 169–91.

Kockerbeck, Christoph. 1986. *Ernst Haeckels "Kunstformen der Natur" und ihr Einfluß auf die deutsche bildende Kunst der Jahrhundertwende: Studie zum Verhältnis von Kunst und Naturwissenschaften im Wilhelminischen Zeitalter*. Frankfurt am Main: Lang.

———. 1995. "Zur Bedeutung der Ästhetik in Carl Vogts populärwissenschaftlichen Reisebriefen *Ocean und Mittelmeer* (1848)." *NTM* 3: 87–96.

———. 1997. *Die Schönheit des Lebendigen. Ästhetische Naturwahrnehmung im 19. Jahrhundert*. Vienna: Böhlau.

———, ed. 1999. *Carl Vogt, Jacob Moleschott, Ludwig Büchner, Ernst Haeckel. Briefwechsel*. Marburg: Basilisken-Presse.

Koerner, Joseph. 2002. "The Icon as Iconoclash." In Latour and Weibel 2002, 164–213.

Kohler, Robert E. 1994. *Lords of the Fly:* Drosophila *Genetics and the Experimental Life*. Chicago: University of Chicago Press.

Kölliker, Albert. 1861. *Entwicklungsgeschichte des Menschen und der höheren Thiere. Akademische Vorträge*. Leipzig: Engelmann.

———. 1879. *Entwicklungsgeschichte des Menschen und der höheren Thiere*. 2nd ed. Leipzig: Engelmann.

———. 1882. "Der W. Krause'sche menschliche Embryo mit einer Allantois. Ein Schreiben an Hrn Prof. His." *AAPAA*, 109–10.

———. 1899. *Erinnerungen aus meinem Leben*. Leipzig: Engelmann.

König, Hannes, and Erich Ortenau. 1962. *Panoptikum. Vom Zauberbild zum Gaukelspiel der Wachsfiguren*. Munich: Isartal.

Koop, Rudolph, ed. 1941. *Haeckel und Allmers. Die Geschichte einer Freundschaft in Briefen der Freunde*. Bremen: Geist.

Körner, Hans. 1967. *Die Würzburger Siebold. Eine Gelehrtenfamilie des 18. und 19. Jahrhunderts*. Neustadt an der Aisch: Degener.

Kort, Patricia, and Max Hollein, eds. 2009. *Darwin: Art and the Search for Origins*. Cologne: Wienand.

Kraepelin, Karl. 1909. *Einführung in die Biologie. Zum Gebrauch an höheren Schulen und zum Selbstunterricht*. 2nd ed. [of *Leitfaden für den biologischen Unterricht*]. Leipzig: Teubner.

———. 1912. *Einführung in die Biologie. Zum Gebrauch an höheren Schulen und zum Selbstunterricht*. 3rd ed. Leipzig: Teubner.

Kraft, Alison, and Alberti, Samuel J. M. M. 2003. "'Equal Though Different': Laboratories, Museums and the Institutional Development of Biology in Late-Victorian Northern England." *Studies in History and Philosophy of Biological and Biomedical Sciences* 34: 203–36.

Krause, Ernst. 1885. *Charles Darwin und sein Verhältnis zu Deutschland*. Leipzig: Günther.

Krause, Wilhelm. 1875. "Ueber die Allantois des Menschen." *Archiv für Anatomie, Physiologie und wissenschaftliche Medicin*, 215–16, plate VI.

———. 1876. "Ueber die Allantois des Menschen." *Archiv für Anatomie, Physiologie und wissenschaftliche Medicin*, 204–7.

———. 1880a. "Über einen frühzeitigen menschlichen Embryo." *Zoologischer Anzeiger* 3: 283–84.

———. 1880b. "Über zwei frühzeitige menschliche Embryonen." *ZwZ* 35: 130–40, plate IX.

———. 1881a. "Über die Allantois des Menschen." *Centralblatt für Gynäkologie* 5: 1–2.

———. 1881b. "Über die Allantois des Menschen." *Zoologischer Anzeiger* 4: 185.

———. 1881c. "Über die Allantois des Menschen." *ZwZ* 36: 175–79, plate IX.

Krauss, Marita. 2010. *Hope. Dr. Hope Bridges Adams Lehmann—Ärztin und Visionärin. Die Biografie*. 2nd ed. Munich: Volk.

Krauss, Rosalind E. 1985. *The Originality of the Avant-Garde and Other Modernist Myths*. Cambridge, MA: MIT Press.

Krauße, Erika. 1984. *Ernst Haeckel*. Leipzig: Teubner.

———, ed. 1987. *Julius Schaxel an Ernst Haeckel, 1906–1907*. Leipzig: Urania.

———, ed. 1993. *Haeckel e l'Italia: La vita come scienza e come storia*. Brugine: Centro internazionale di storia dello spazio e del tempo.

———. 1994. "Zum Verhältnis von Carl Gegenbaur (1826–1903) und Ernst Haeckel (1834–1919). Generelle und spezielle Morphologie." In *Miscellen zur Geschichte der Biologie. Ilse Jahn und Hans Querner zum 70. Geburtstag*, edited by Armin Geus, Wolfgang Friedrich Gutmann, and Michael Weingarten, 83–99. Frankfurt am Main: Kramer.

———. 1995. "Haeckel: Promorphologie und 'evolutionistische' ästhetische Theorie: Konzept und Wirkung." In *Die Rezeption von Evolutionstheorien im 19. Jahrhundert*, edited by Eve-Marie Engels, 347–94. Frankfurt am Main: Suhrkamp.

———. 1998. "Ernst Haeckels Beziehungen zu österreichischen Gelehrten—Spurensuche im Briefnachlaß." In Aescht et al. 1998, 375–414.

———. 2002. "Zur Popularisierung der Biologie unter dem Einfluß Ernst Haeckels." In *Popularisierung der Naturwissenschaften*, edited by Gudrun Wolfschmidt, 126–57. Berlin: GNT.

———. 2005. "Wege zum Bestseller. Haeckels Werk im Lichte der Verlegerkorrespondenz. Die Korrespondenz mit Emil Strauß." In *Der Brief als wissenschaftshistorische Quelle*, edited by Krauße, 145–70. Berlin: VWB.

Krauße, Erika, and Uwe Hoßfeld, 1999. "Das Ernst-Haeckel-Haus in Jena. Von der privaten Stiftung zum Universitätsinstitut (1912–1979)." In *Repräsentationsformen in den biologischen Wissenschaften . . .*, edited by Armin Geus, Thomas Junker, Hans-Jörg Rheinberger, Christa Riedl-Dorn, and Michael Weingarten, 203–32. Berlin: VWB.

Krementsov, Nikolai. 2011. *A Martian Stranded on Earth: Alexander Bogdanov, Blood Transfusions, and Proletarian Science*. Chicago: University of Chicago Press.

Kreß, O. [c. 1860.] *Die Geheimnisse der Zeugung und das Geschlechtsleben des Menschen*. Dresden: Wolf.

Krieck, Ernst. 1937. "Ernst Haeckel als Vorläufer des Nationalsozialismus." *Volk im Werden* 5: 164–66.

Kroeber, Elsbeth, and Walter H. Wolff. 1938. *Adventures with Living Things: A General Biology*. Boston: Heath.

Kuhl, Willi. 1949. *Das wissenschaftliche Zeichnen in der Biologie und Medizin*. Frankfurt am Main: Kramer.

Kuhlmann-Hodick, Petra, Gerd Spitzer, and Bernhard Maaz, eds. 2009a. *Carl G. Carus. Wahrnehmung und Konstruktion. Essays*. Berlin: Deutscher Kunstverlag.

———, eds. 2009b. *Carl G. Carus. Natur und Idee. Katalog*. Berlin: Deutscher Kunstverlag.

Kükenthal, Willy. 1893. *Vergleichend-anatomische und entwickelungsgeschichtliche Untersuchungen an Walthieren* (*Denkschriften der Medicinisch-naturwissenschaftlichen Gesellschaft zu Jena*, vol. 3). Jena: Fischer.

Kupffer, Carl. 1884. *Gedächtnissrede auf Theodor L. W. von Bischoff. . . .* Munich: Verlag der k. b. Akademie.

Kußmaul, Adolf. 1960. *Jugenderinnerungen eines alten Arztes*. Munich: Lehmann.

Kusukawa, Sachiko. 2012. *Picturing the Book of Nature: Image, Text, and Argument in Sixteenth-Century Human Anatomy and Medical Botany*. Chicago: University of Chicago Press.

Kutschera, Ulrich, ed. 2007. *Kreationismus in Deutschland. Fakten und Analysen*. Münster: Lit.

Kyriakou, Kyriakos, and Constantine Skordoulis. 2010. "The Reception of Ernest Haeckel's Ideas in Greece." *Almagest* 1: 84–103.

Ladouceur, Ronald P. 2008. "Ella Thea Smith and the Lost History of American High School Biology Textbooks." *JHB* 41: 435–71.

LaFollette, Marcel Chotkowski. 2012. *Science on American Television: A History*. Chicago: University of Chicago Press.

Laing, Samuel. 1885. *Modern Science and Modern Thought*. London: Chapman and Hall.

Landecker, Hannah. 2006. "Microcinematography and the History of Science and Film." *Isis* 97: 121–32.

Lange, Friedrich Albert. 1875. *Geschichte des Materialismus und Kritik seiner Bedeutung in der Gegenwart*. 2nd ed. Vol. 2, *Geschichte des Materialismus seit Kant*. Iserlohn: Baedeker.

Largent, Mark A. 2009. "The So-Called Eclipse of Darwinism." In *Descended from Darwin: Insights into the History of Evolutionary Studies, 1900–1970*, edited by Joe Cain and Michael Ruse, 3–21. Philadelphia: American Philosophical Society.

Larson, Barbara, and Fae Brauer, eds. 2009. *The Art of Evolution: Darwin, Darwinisms, and Visual Culture*. Hanover, NH: UPNE for Dartmouth College Press.

Larson, Edward J. 1998. *Summer for the Gods: The Scopes Trial and America's Continuing Debate over Science and Religion*. Cambridge, MA: Harvard University Press.

———. 2003. *Trial and Error: The American Controversy over Creation and Evolution*. 3rd ed. Oxford: Oxford University Press.

Lassman, Peter, and Irving Velody, eds. 1989. *Max Weber's "Science as a Vocation."* London: Unwin Hyman.

Latour, Bruno. 1987. *Science in Action: How to Follow Scientists and Engineers through Society*. Cambridge, MA: Harvard University Press.

Latour, Bruno, and Peter Weibel, eds. 2002. *Iconoclash: Beyond the Image Wars in Science, Religion, and Art*. Karlsruhe: ZKM.

Latter, Oswald H. 1923. *Elementary Zoology*. London: Methuen.

Laubichler, Manfred D. 2006. "Allgemeine Biologie als selbständige Grundwissenschaft und die allgemeinen Grundlagen des Lebens." In *Der Hochsitz des Wissens. Das Allgemeine als wissenschaftlicher Wert*, edited by Michael Hagner and Laubichler, 185–205. Zurich: Diaphanes.

Laubichler, Manfred D., and Jane Maienschein, eds. 2007. *From Embryology to Evo-Devo: A History of Developmental Evolution*. Cambridge, MA: MIT Press.

Lavater, Johann Caspar. 1778. *Physiognomische Fragmente zur Beförderung der Menschenkenntniß und Menschenliebe, Vierter Versuch*. Leipzig: Bey Weidmanns Erben und Reich.

Lawrence, Susan C., and Kae Bendixen. 1992. "His and Hers: Male and Female Anatomy in Anatomy Texts for U.S. Medical Students, 1890–1989." *Social Science & Medicine* 35: 925–34.

Lebrun, David. 2004. *Proteus: A Nineteenth-Century Vision*. Brooklyn, NY: First Run/ Icarus Films.

Leche, Wilhelm. 1911. *Der Mensch, sein Ursprung und seine Entwicklung. In gemeinverständlicher Darstellung*. Jena: Fischer.

Le Conte, Joseph. 1888. *Evolution and Its Relation to Religious Thought*. London: Chapman and Hall.

Lemke, Willi, ed. 1950. *Lehrbuch der Biologie für das 10. Schuljahr. Zoologie*. Berlin: Volk und Wissen.

Lenoir, Timothy. 1989. *The Strategy of Life: Teleology and Mechanics in Nineteenth-Century German Biology*. Chicago: University of Chicago Press.

———. 1997. *Instituting Science: The Cultural Production of Scientific Disciplines*. Stanford, CA: Stanford University Press.

Lerner, Reinhold. 1959. "Haeckel zeichnet Koelliker." *Mitteilungen aus dem Institut für Geschichte der Medizin an der Universität Würzburg*, no. 4: 1–4.

Lester, Joseph. 1995. *E. Ray Lankester and the Making of Modern British Biology*. Edited by Peter J. Bowler. Faringdon, Oxon: BSHS.

Leuckart, R. 1850. "Ist die Morphologie denn wirklich so ganz unberechtigt? Ein Wort der Entgegnung an Prof. Dr. Ludwig." *ZwZ* 2: 271–75.

Levin, Joel R., and Richard E. Mayer. 1993. "Understanding Illustrations in Text." In *Learning from Textbooks: Theory and Practice*, edited by Bruce K. Britton, Arthur Woodward and Marilyn R. Binkley, 95–113. Hillsdale, NJ: Erlbaum.

Levit, Georgy, and Uwe Hoßfeld. 2006. "The Forgotten 'Old-Darwinian' Synthesis: The Evolutionary Theory of Ludwig H. Plate (1862–1937)." *NTM*, n.s., 14: 9–25.

Lewis, Beth Irwin. 2003. *Art for All? The Collision of Modern Art and the Public in Late-Nineteenth-Century Germany*. Princeton, NJ: Princeton University Press.

L[ewis], F. T. 1907. "Specific Characters in Early Embryos." *American Naturalist* 41: 589–92.

———. 1916. "Charles Sedgwick Minot." *Anatomical Record* 10: 132–64.

Ley, W. 1908. "Ernst Haeckel—und die Wahrheit." *Deutsche Lehrer-Zeitung* 21, no. 16 (22 Feb.): 125–27.

Lightman, Bernard. 2007. *Victorian Popularizers of Science: Designing Nature for New Audiences*. Chicago: University of Chicago Press.

Lindsey, Arthur Ward. 1929. *Textbook of Evolution and Genetics*. New York: Macmillan.

———. 1952. *Principles of Organic Evolution*. St. Louis: Mosby.

Linstow, O. von. 1878. *Kurzgefaßte Uebersicht der Entwicklungsgeschichte der Menschen und Thiere. Zur Abwehr der Darwinistischen und materialistischen Lehren*. Hameln: Brecht.

Loening, Richard. 1893. "Der Prozeß Hamann gegen Haeckel." *Das Magazin für Litteratur* 62, no. 43 (28 Oct.): 681–85.

Loofs, Friedrich. 1900. *Anti-Haeckel. Eine Replik nebst Beilagen.* Halle: Niemeyer.

Lötsch, Bernd. 1998. "Gibt es Kunstformen der Natur? Radiolarien: Haeckels biologische Ästhetik und ihre Überschreitung." In Aescht et al. 1998, 339–72.

Lovejoy, Arthur O. 1936. *The Great Chain of Being: A Study of the History of an Idea.* Cambridge, MA: Harvard University Press.

Lubarsch, Otto. 1931. *Ein bewegtes Gelehrtenleben. Erinnerungen und Erlebnisse. Kämpfe und Gedanken.* Berlin: Springer.

Ludwig, Carl. 1852–56. *Lehrbuch der Physiologie des Menschen.* 2 vols. Leipzig: Winter.

Lull, Richard Swann. 1917. *Organic Evolution: A Textbook.* New York: Macmillan.

Lundgren, Anders, and Bernadette Bensaude-Vincent, eds. 2000. *Communicating Chemistry: Textbooks and Their Audiences, 1789–1939.* Canton, MA: Science History Publications.

Lurie, Edward. 1988. *Louis Agassiz: A Life in Science.* Baltimore: Johns Hopkins University Press.

Lussenhop, John. 1974. "Victor Hensen and the Development of Sampling Methods in Ecology." *JHB* 7: 319–37.

Lustig, A. J. 2002. "Erich Wasmann, Ernst Haeckel, and the Limits of Science." *Theory in Biosciences* 121: 252–59.

Lütge, Friedrich. 1928. *Das Verlagshaus Gustav Fischer in Jena. Seine Geschichte und Vorgeschichte. Aus Anlaß des 50-jährigen Firmenjubiläums.* Jena: Fischer.

Lutts, Ralph H. 2001. *The Nature Fakers: Wildlife, Science, and Sentiment.* Charlottesville: University Press of Virginia.

Lynch, Michael. 1991. "Science in the Age of Mechanical Reproduction: Moral and Epistemic Relations between Diagrams and Photographs." *Biology and Philosophy* 6: 205–26.

Lynch, Michael, and Steve Woolgar, eds. 1990. *Representation in Scientific Practice.* Cambridge, MA: MIT Press.

Maas, Otto. 1911. "Die Tatsachen der vergleichenden Anatomie und Entwicklungsgeschichte und die Abstammungslehre." In *Die Abstammungslehre. Zwölf Gemeinverständliche Vorträge über die Deszendenztheorie im Licht der neueren Forschung . . .*, 251–90. Jena: Fischer.

Mackean, D. G. 1978. *Introduction to Biology.* London: Murray.

Mackintosh, N.J., ed. 1995. *Cyril Burt: Fraud or Framed?* Oxford: Oxford University Press.

MacLeod, Roy. 1994. "Embryology and Empire: The Balfour Students and the Quest for Intermediate Forms in the Laboratory of the Pacific." In *Darwin's Laboratory: Evolutionary Theory and Natural History in the Pacific*, edited by MacLeod and Philip F. Rehbock, 140–65. Honolulu: University of Hawaii Press.

Macfarlane, Robert. 2007. *Original Copy: Plagiarism and Originality in Nineteenth-Century Literature.* Oxford: Oxford University Press.

Magnus, Rudolf. 1908. *Vom Urtier zum Menschen. Gemeinverständliche Darstellung des gegenwärtigen Standes der gesamten Entwicklungslehre.* Halle: Marhold.

Maienschein, Jane. 1991a. *Transforming Traditions in American Biology, 1880–1915.* Baltimore: Johns Hopkins University Press.

———. 1991b. "From Presentation to Representation in E. B. Wilson's *The Cell.*" *Biology and Philosophy* 6: 227–54.

———. 1994. "The Origins of *Entwicklungsmechanik.*" In Gilbert 1994, 43–61.

Maienschein, Jane, Marie Glitz, and Garland E. Allen, eds. 2004. *Centennial History of the Carnegie Institution of Washington.* Vol. 5, *The Department of Embryology.* Cambridge: Cambridge University Press.

Maienschein, Jane, and Karen Wellner. 2013. "Competing Views of Embryos for the Twenty-First Century: Textbooks and Society." *Science & Education* 22: 241–53.

Major, Trevor. 1993. "Haeckel: The Legacy of a Lie." *Firm Foundation* 108, no. 8 (Aug.): 9–11.

Mangan, Richard L. 1909. "Haeckel and His Methods." *Catholic World* 89, no. 530 (May): 213–23.

Manner, Harold W. 1964. *Elements of Comparative Vertebrate Embryology.* New York: Macmillan.

March, H. C. 1883. *Darwinism and the Evolution of Man.* 2nd ed. London: Clegg.

Marshall, Arthur Milnes. 1894. *Lectures on the Darwinian Theory.* London: Nutt.

Martinez Arias, Alfonso, and Alison Stewart. 2002. *Molecular Principles of Animal Development.* Oxford: Oxford University Press.

Maurer, Margarete. 1978. "Naturverständnis und Weltanschauung in Biologieschulbüchern." In *Natur in der Schule: Kritik und Alternativen zum Biologieunterricht*, edited by Ernst Busche, Brunhilde Marquardt, and Maurer, 57–130. Hamburg: Rowohlt.

Mavor, James Watt. 1936. *General Biology.* New York: Macmillan.

May, Walther. 1909. *Ernst Haeckel. Versuch einer Chronik seines Lebens und Wirkens.* Leipzig: Barth.

Mayer, Gaston. 1987. "Walther May (1868–1926). Freidenker, Sozialist, Zoologe und Historiker des Darwinismus." *Mitteilungen des badischen Landesverbandes für Naturkunde und Naturschutz*, n.s., 14: 483–95.

———. 1988. "Johann Rudolf Bommeli (1859–1926), Lehrer und Popularisator der Naturgeschichte." *Mitteilungen der thurgauischen naturforschenden Gesellschaft* 49: 7–11.

Mayer, William V. 1986. "Biology Education in the United States during the Twentieth Century." *Quarterly Review of Biology* 61: 481–507.

Mayr, Ernst. 2001. *What Evolution Is.* New York: Basic Books.

McCabe, Joseph. 1906a. Introduction to *Haeckel: His Life and Work*, by Wilhelm Bölsche, 9–13. Philadelphia: Jacobs.

———. 1906b. "The Crowning Years." In Wilhelm Bölsche, *Haeckel: His Life and Work*, 294–321. Philadelphia: Jacobs.

———. 1947. *Eighty Years a Rebel: Autobiography.* Girard, KS: Haldeman-Julius.

McCann, Alfred Watterson. 1922. *God—or Gorilla: How the Monkey Theory of Evolution Exposes Its Own Methods, Refutes Its Own Principles, Denies Its Own Inferences, Disproves Its Own Case.* New York: Devin-Adair.

McFarland, Joseph. 1910. *Biology, General and Medical.* Philadelphia: Saunders.

McLaren, Angus. 1984. *Reproductive Rituals: The Perception of*

Fertility in England from the Sixteenth Century to the Nineteenth Century. London: Methuen.

McMurrich, J. Playfair. 1902. The Development of the Human Body: A Manual of Human Embryology. Philadelphia: Blakiston's Son.

Medawar, P. B. 1954. "The Significance of Inductive Relationships in the Development of Vertebrates." Journal of Embryology and Experimental Morphology 2: 172–74.

Mehnert, Ernst. 1895. "Die individuelle Variation des Wirbelthierembryo. Eine Zusammenstellung." Morphologische Arbeiten 5: 386–444.

Mehrtens, Herbert. 1994. "Irresponsible Purity: The Political and Moral Structure of Mathematical Sciences in the National Socialist State." In Renneberg and Walker 1994, 324–38, 411–13.

Meinel, Christoph. 1991. Karl Friedrich Zöllner und die Wissenschaftskultur der Gründerzeit. Eine Fallstudie zur Genese konservativer Zivilisationskritik. Berlin: Sigma.

———. 1992. "August Wilhelm Hofmann—'Regierender Oberchemiker.'" In Die Allianz von Wissenschaft und Industrie—August Wilhelm Hofmann (1818–1892). Zeit, Werk, Wirkung, edited by Meinel and Hartmut Scholz, 27–64. Weinheim: VCH.

Mengal, Paul, ed. 1993. Histoire du concept de la récapitulation: Ontogenèse et phylogenèse en biologie et sciences humaines. Paris: Masson.

Menz, Gerhard. 1925. Deutsche Buchhändler. Vierundzwanzig Lebensbilder führender Männer des Buchhandels. Leipzig: Lehmann.

Menz, Heike. 2000. Martin Heinrich Rathke (1793–1860). Ein Embryologe des 19. Jahrhunderts. Marburg: Basilisken-Presse.

Merkel, Fr. 1891. Jacob Henle. Ein deutsches Gelehrtenleben. Braunschweig: Vieweg.

Metcalf, Maynard M. 1904. An Outline of the Theory of Organic Evolution, with a Description of Some of the Phenomena Which It Explains. New York: Macmillan.

Meyer, Arthur W. 1953. "The Elusive Human Allantois in Older Literature." In Science, Medicine and History: Essays on the Evolution of Scientific Thought and Medical Practice Written in Honour of Charles Singer, edited by E. Ashworth Underwood, 1:510–20. London: Oxford University Press.

Meyer, Erich, and Karl Zimmermann. [1941.] Lebenskunde. Lehrbuch der Biologie für höhere Schulen. Vol. 4, Klassen 6, 7 und 8 der Oberschulen für Jungen. Erfurt: Stengen.

Michelis, Fr. 1875. Haeckelogonie. Ein akademischer Protest gegen Häckel's "Anthropogenie." Bonn: Neusser.

Michler, Werner. 1999. Darwinismus und Literatur. Naturwissenschaftliche und literarische Intelligenz in Österreich, 1859–1914. Vienna: Böhlau.

Mikhailov, Alexander T. 2005. "Putting Evo-Devo into Focus: An Interview with Scott F. Gilbert." IJDB 49: 9–16.

Mildenberger, Florian. 2012. Medizinische Belehrung für das Bürgertum. Medikale Kulturen in der Zeitschrift "Die Gartenlaube" (1853–1944). Stuttgart: Steiner.

Miller, Kenneth R. 2009. Only a Theory: Evolution and the Battle for America's Soul. New York: Penguin.

Mills, Eric L. 1989. Biological Oceanography: An Early History, 1870–1960. Ithaca, NY: Cornell University Press.

Minot, Charles Sedgwick. 1877. "Criticisms of Haeckel." American Naturalist 11: 368–71.

———. 1880. "A Sketch of Comparative Embryology." American Naturalist 14: 96–108, 242–49, 479–85, 871–80.

———. 1892. Human Embryology. New York: Wood.

Mitchell, W. J. T. 1994. Picture Theory: Essays on Verbal and Visual Representation. Chicago: University of Chicago Press.

———. 1998. The Last Dinosaur Book: The Life and Times of a Cultural Icon. Chicago: University of Chicago Press.

———. 2005. What Do Pictures Want? The Lives and Loves of Images. Chicago: University of Chicago Press.

Mocek, Reinhard. 1998. Die werdende Form. Eine Geschichte der Kausalen Morphologie. Marburg: Basilisken-Presse.

Moleschott, Jac. 1894. Für meine Freunde. Lebens-Erinnerungen. Giessen: Roth.

Moment, Gairdner B. 1942. General Biology for Colleges. New York: Appleton-Century.

Monmonier, Mark. 2004. Rhumb Lines and Map Wars: A Social History of the Mercator Projection. Chicago: University of Chicago Press.

Montgomery, Scott L. 2000. Science in Translation: Movements of Knowledge through Cultures and Time. Chicago: University of Chicago Press.

Montgomery, William M. 1988. "Germany." In The Comparative Reception of Darwinism, edited by Thomas F. Glick, 81–116. Chicago: University of Chicago Press.

Moody, Paul Amos. 1953. Introduction to Evolution. New York: Harper.

———. 1970. Introduction to Evolution. 3rd ed. New York: Harper & Row.

Moon, Truman J. 1922. Biology for Beginners. New York: Holt.

———. 1926. Biology for Beginners. Rev. ed. New York: Holt.

Moon, Truman J., and Paul B. Mann. 1933. Biology for Beginners. New York: Holt.

Mooney, Chris. 2006. The Republican War on Science. Rev. ed. New York: Basic Books.

Moore, John N., and Harold Schultz Slusher, eds. 1970. Biology: A Search for Order in Complexity. Grand Rapids, MI: Zondervan.

Moore, Keith L. 1989. Before We Are Born: Basic Embryology and Birth Defects. 3rd ed. Philadelphia: Saunders.

Moore, Lisa Jean, and Adele E. Clarke. 1995. "Clitoral Conventions and Transgressions: Graphic Representations in Anatomy Texts, c. 1900–1991." Feminist Studies 21: 255–301.

Morgan, Ann Haven. 1955. Kinships of Animals and Man: A Textbook of Animal Biology. New York: McGraw-Hill.

Morgan, Lynn M. 2009. Icons of Life: A Cultural History of Human Embryos. Berkeley: University of California Press.

Morkramer, Michael. 2010. "Der 'Lippstädter Fall': Hermann Müller und der Kampf um die Lippstädter Schule." In Hermann Müller-Lippstadt (1829–1883). Naturforscher und Pädagoge. Beiträge eines Symposiums am Ostendorf-Gymnasium in Lippstadt im 125. Todesjahr Hermann Müllers 2008, edited by Heinrich Münz and

Morkramer, 112–29. Rangsdorf: Basilisken-Presse im Verlag Natur und Text.

Morris, Henry M. 1988. "The Heritage of the Recapitulation Theory." *Impact* 183: i–iv.

Morse, Edward S. 1920. "Biographical Memoir of Charles Sedgwick Minot, 1852–1914." *National Academy of Sciences of the United States of America, Biographical Memoirs* 9: 263–85.

Moseley, H. N. 1892. *Notes by a Naturalist: An Account of Observations Made during the Voyage of H.M.S. "Challenger" round the World in the Years 1872–1876. . . .* Rev. ed. London: Murray.

Moser, Stephanie. 1998. *Ancestral Images: The Iconography of Human Origins.* Ithaca, NY: Cornell University Press.

Most, Julius. 1876. "Der Mensch." *Die Neue Welt* 1: 40–42, 58–59, 69–70, 125–26, 131–33, 234–35, 243, 343, 351–52, 363, 374–75, 485–87, 496–500, 507–10.

Müller, Friedrich von. 1951. *Lebenserinnerungen.* Edited by Hedi Kloiber, née Müller. Munich: Lehmann.

Müller, Johannes. 1833–37. *Handbuch der Physiologie des Menschen für Vorlesungen.* 2 vols. Koblenz: Hölscher.

Müller, Werner A. 1995. *Entwicklungsbiologie. Einführung in die klassische und molekulare Entwicklungsbiologie von Mensch und Tier.* Stuttgart: Fischer.

———. 1997. *Developmental Biology.* New York: Springer.

Nagel, Anne Christine. 1996. *Martin Rade—Theologe und Politiker des sozialen Liberalismus. Eine politische Biographie.* Gütersloh: Kaiser.

Nathoo, Ayesha. 2009. *Hearts Exposed: Transplants and the Media in 1960s Britain.* Basingstoke: Palgrave Macmillan.

National Academy of Sciences—National Research Council, Committee on Educational Policies of the Biology Council, Subcommittee on College Education. 1957. *Improving College Biology Teaching.* Washington, DC: National Academy of Sciences—National Research Council.

Nelkin, Dorothy, and M. Susan Lindee. 1995. *The DNA Mystique: The Gene as a Cultural Icon.* New York: Freeman.

Nelsen, Olin E. 1953. *Comparative Embryology of the Vertebrates.* New York: McGraw-Hill.

Neumann, Carl W. 1905. *Ernst Haeckel. Der Mann und sein Werk.* Berlin: Gose & Tetzlaff.

Newman, Horatio Hackett. 1924. *Outlines of General Zoölogy.* New York: Macmillan.

Nicholson, H. Alleyne. 1872. *Introduction to the Study of Biology.* Edinburgh: Blackwood.

Nieto-Galan, Agustí. 2012. "A Republican Natural History in Spain around 1900: Odón de Buen (1863–1945) and His Audiences." *Historical Studies in the Natural Sciences* 42: 159–89.

Nieuwkoop, P. D. 1961. "'L'Institut International d'Embryologie' (1911–1961)." *General Embryological Information Service* 9: 265–69.

Nieuwkoop, P. D., and J. Faber, eds. 1956. *Normal Table of Xenopus laevis (Daudin): A Systematical and Chronological Survey of the Development from the Fertilized Egg till the End of Metamorphosis.* Amsterdam: North-Holland.

Nikolow, Sybilla, and Lars Bluma. 2008. "Science Images between Scientific Fields and the Public Sphere: A Historiographical Survey." In *Science Images and Popular Images of the Sciences*, edited by Bernd Hüppauf and Peter Weingart, 33–51. New York: Routledge.

Nikolow, Sybilla, and Arne Schirrmacher, eds. 2007. *Wissenschaft und Öffentlichkeit als Ressourcen füreinander. Studien zur Wissenschaftsgeschichte im 20. Jahrhundert.* Frankfurt am Main: Campus.

Nordenskiöld, Erik. 1929. *The History of Biology: A Survey.* Translated by Leonard Bucknall Eyre. London: Kegan Paul, Trench, Trubner.

Nöthlich, Rosemarie, ed. 2002. *Ernst Haeckel—Wilhelm Bölsche. Briefwechsel 1887–1919.* Berlin: VWB.

———, ed. 2006. *Ernst Haeckel—Wilhelm Bölsche. Kommentarband zum Briefwechsel (1887–1919).* Berlin: VWB.

———. 2009. *Wilhelm Breitenbach (1856–1937). Zoologe, Verleger und Monist. Eine Analyse seines Wirkens.* Berlin: VWB.

Nöthlich, Rosemarie, Heiko Weber, Uwe Hoßfeld, Olaf Breidbach, and Erika Krauße. 2007. "Weltbild oder Weltanschauung? Die Gründung und Entwicklung des Deutschen Monistenbundes." *Jahrbuch für Europäische Wissenschaftskultur* 3: 19–67.

Nöthlich, Rosemarie, Nadine Wetzel, Uwe Hoßfeld, and Lennart Olsson. 2006. "'Ich acquirirte das Schwein sofort, ließ nach dem Niederstechen die Pfoten abhacken u. schickte dieselben an Darwin.' Der Briefwechsel von Otto Zacharias mit Ernst Haeckel (1874–1898)." *AHPB* 11: 177–248.

Numbers, Ronald L. 2006. *The Creationists: From Scientific Creationism to Intelligent Design.* Expanded ed. Cambridge, MA: Harvard University Press.

Numbers, Ronald L., and John Stenhouse, eds. 1999. *Disseminating Darwinism: The Role of Place, Race, Religion, and Gender.* Cambridge: Cambridge University Press.

Nyhart, Lynn K. 1991. "Writing Zoologically: The *Zeitschrift für wissenschaftliche Zoologie* and the Zoological Community in Late Nineteenth-Century Germany." In *The Literary Structure of Scientific Argument: Historical Studies*, edited by Peter Dear, 43–71. Philadelphia: University of Pennsylvania Press.

———. 1995. *Biology Takes Form: Animal Morphology and the German Universities, 1800–1900.* Chicago: University of Chicago Press.

———. 2008. "Embryology and Morphology." In *The Cambridge Companion to the "Origin of Species,"* edited by Michael Ruse and Robert J. Richards, 194–215. Cambridge: Cambridge University Press.

———. 2009. *Modern Nature: The Rise of the Biological Perspective in Germany.* Chicago: University of Chicago Press.

———. 2012. "Voyaging and the Scientific Expedition Report, 1800–1940." In *Science in Print: Essays on the History of Science and the Culture of Print*, edited by Rima D. Apple, Gregory J. Downey, and Stephen L. Vaughn, 65–86. Madison: University of Wisconsin Press.

O'Brien, Charles F. 1970. "*Eozoön Canadense*: 'The Dawn Animal of Canada.'" *Isis* 61: 206–23.

O'Connell, Joseph. 1993. "Metrology: The Creation of Univer-

sality by the Circulation of Particulars." *Social Studies of Science* 23: 129–73.

O'Connor, Ralph. 2007. *The Earth on Show: Fossils and the Poetics of Popular Science, 1802–1856.* Chicago: University of Chicago Press.

Oettermann, Stephan. 1992. "Alles-Schau. Wachsfigurenkabinette und Panoptiken." In *Viel Vergnügen. Öffentliche Lustbarkeiten im Ruhrgebiet der Jahrhundertwende*, edited by Lisa Kosok and Mathile Jamin, 36–56, 294–302. Essen: Pomp.

Oken, Lorenz. 1843. "Einleitung" [Vögel] to *Abbildungen zu Oken's allgemeiner Naturgeschichte für alle Stände*, 1–26. Stuttgart: Hoffmann.

Olson, Randy. 2006. *Flock of Dodos: The Evolution–Intelligent Design Circus.* Los Angeles, CA: Prairie Starfish Productions.

Oppel, Albert. 1891. *Vergleichung des Entwicklungsgrades der Organe zu verschiedenen Entwicklungszeiten bei Wirbeltieren.* Jena: Fischer.

———. 1892. "Dritter Theil: Entwicklungsgeschichte. Zweiter Abtheilung: Entwicklungsgeschichte der Wirbelthiere." *Jahresbericht über die Fortschritte der Anatomie und Physiologie* 20, section 1: 608–747.

Oppenheimer, Jane M. 1967. *Essays in the History of Embryology and Biology.* Cambridge, MA: MIT Press.

———. 1986. "Louis Agassiz as an Early Embryologist in America." In *Science and Society in Early America: Essays in Honor of Whitfield J. Bell, Jr.*, edited by Randolph Shipley Klein, 393–414. [Philadelphia]: American Philosophical Society.

———. 1987. "Haeckel's Variations on Darwin." In *Biological Metaphor and Cladistic Classification: An Interdisciplinary Perspective*, edited by Henry M. Hoenigswald and Linda F. Wiener, 123–35. London: Pinter.

O'Rahilly, Ronan. 1988. "One Hundred Years of Human Embryology." In *Issues and Reviews in Teratology*, vol. 4, edited by Harold Kalter, 81–128. New York: Academic Press.

Osche, Günther. 1978. *Evolution. Grundlagen—Erkenntnisse—Entwicklungen der Abstammungslehre.* 9th ed. Freiburg im Breisgau: Herder.

Ostwald, Wilhelm. 1909. *Grosse Männer.* Leipzig: Akademische Verlagsgesellschaft.

———. 1914. *Ernst Haeckel. Festrede gehalten bei der Feier von Ernst Haeckels 80. Geburtstag in Hamburg am 19. Februar 1914.* Leipzig: Unesma.

Otis, Laura. 2007. *Müller's Lab.* Oxford: Oxford University Press.

Otto, Hermann, and Werner Stachowitz. 1927. *Biologie für höhere Schulen.* Pt. 2, *Pflanze, Tier und Mensch als Lebewesen. Ihr Bau, ihre Lebenserscheinungen und ihre Entwicklung.* Frankfurt am Main: Diesterweg.

Otto, James H., and Albert Towle. 1973. *Modern Biology.* New York: Holt, Rinehart and Winston.

Outram, Dorinda. 1978. "The Language of Natural Power: The 'Eloges' of Georges Cuvier and the Public Language of Nineteenth-Century Science." *HS* 16: 153–78.

Pagenstecher, C. H. Alexander. 1913. *Aus gärender Zeit.*

Lebenserinnerungen 1816–1850. Pt. 1, *Als Student und Burschenschaftler in Heidelberg von 1816 bis 1819.* Edited by Alexander Pagenstecher. Leipzig: Voigtländer.

Pander, Christian. 1817. *Beiträge zur Entwickelungsgeschichte des Hühnchens im Eye.* Würzburg.

———. 2003. "Dissertation inaugurale établissant l'histoire de la métamorphose que subit l'œuf au cours des cinq premiers jours d'incubation" [Latin original, 1817]. In *Les textes embryologiques de Christian Heinrich Pander (1794–1865)*, translated and edited by Stéphane Schmitt, 61–94. Turnhout: Brepols.

Pang, Alex Soojung-Kim. 1994–95. "Victorian Observing Practices, Printing Technology, and Representations of the Solar Corona." *Journal for the History of Astronomy* 25: 249–74; 26: 63–76.

Park, Hee-Joo. 2000. "The Politics of Anti-Creationism: The Committees of Correspondence." *JHB* 33: 349–70.

Parker, T. Jeffery. 1891. "Observations on the Anatomy and Development of *Apteryx*." *Philosophical Transactions of the Royal Society of London*, series B 182: 25–134, plates 3–19.

Parker, T. Jeffery, and William A. Haswell. 1897. *A Text-Book of Zoology.* 2 vols. London: Macmillan.

Parker, William Kitchen. 1880. "Report on the Development of the Green Turtle (*Chelone viridis*, Schneid.), Part I: The Cranium, Face, and Cranial Nerves." In *Report of the Scientific Results of the Voyage of H.M.S. "Challenger" during the Years 1873–1876 . . . : Zoology*, vol. 1, pt. 5, 1–58, plates I–XIII. London: HMSO.

———. 1883. "On the Structure and Development of the Skull in the Crocodilia." *Transactions of the Zoological Society of London* 11: 263–310, plates LXII–LXXI.

Patten, Bradley M. 1951. *The Early Embryology of the Chick.* 4th ed. New York: McGraw-Hill.

———. 1958. *Foundations of Embryology.* New York: McGraw-Hill.

Paul, Diane B. 1987. "The Nine Lives of Discredited Data." *The Sciences* 27, no. 3 (May–June): 26–30.

———. 1988. "The Market as Censor." *PS: Political Science and Politics* 21, no. 1 (Winter): 31–35.

Paul, Gerhard. 2006. "'Mushroom Clouds.' Entstehung, Struktur und Funktion einer Medienikone des 20. Jahrhunderts im interkulturellen Vergleich." In *Visual History. Ein Studienbuch*, edited by Paul, 243–64. Göttingen: Vandenhoeck & Ruprecht.

Pauly, Philip J. 1991. "The Development of High-School Biology: New York City, 1900–1925." *Isis* 82: 662–88.

———. 2002. *Biologists and the Promise of American Life: From Meriwether Lewis to Alfred Kinsey.* Princeton, NJ: Princeton University Press.

Pauwels, Luc, ed. 2006. *Visual Cultures of Science: Rethinking Representational Practices in Knowledge Building and Science Communication.* Lebanon, NH: UPNE for Dartmouth College Press.

Peabody, James Edward, and Arthur Ellsworth Hunt. 1912. *Elementary Biology: Animal and Human.* 2 vols. New York: Macmillan.

———. 1924. *Biology and Human Welfare.* New York: Macmillan.

Peek, Francis. 1890. *Reason, Revelation, and Faith*. London: Ibister.

Pennisi, Elizabeth. 1997. "Haeckel's Embryos: Fraud Rediscovered." *Science* 277 (5 Sept.): 1435.

Penzlin, Hans. 1994. *Geschichte der Zoologie in Jena nach Haeckel*. Jena: Fischer.

Penzoldt, Franz. 1923. "Franz Penzoldt." In *Die Medizin der Gegenwart in Selbstdarstellungen*, vol. 2, edited by L. R. Grote, 169–86. Leipzig: Meiner.

Pesch, Tilmann. 1884. *Die grossen Welträtsel. Philosophie der Natur*. Vol. 2, *Naturphilosophische Weltauffassung*. Freiburg im Breisgau: Herder.

Petchesky, Rosalind Pollack. 1987. "Foetal Images: The Power of Visual Culture in the Politics of Reproduction." In *Reproductive Technologies: Gender, Motherhood and Medicine*, edited by Michelle Stanworth, 57–80. Cambridge: Polity.

Petersen, Johannes. 1911. "Der Keplerbund und Dennerts Apologetik." *Die Christliche Welt* 25, no. 44 (2 Nov.): 1043–51.

Pfaff, Friedrich. 1855. *Schöpfungsgeschichte, mit besonderer Berücksichtigung des biblischen Schöpfungsberichtes*. Frankfurt am Main: Heyder & Zimmer.

Phillips, Denise. 2012. *Acolytes of Nature: Defining Natural Science in Germany, 1770–1850*. Chicago: University of Chicago Press.

Phillips, Joy B. 1975. *Development of Vertebrate Anatomy*. St. Louis: Mosby.

Plate, Ludwig. 1919. "Berichtigung bezüglich der Entstehung des Phyletischen Museums in Jena." *Mitteilungen des Deutschen Monistenbundes* 4, no. 4–5 (15 May): 57–58.

———. 1920. "Die Wahrheit über Ernst Haeckels Verhalten gegen seinen Amtsnachfolger." *Die Umschau* 24: 109–11.

———. 1934. "Zum 100 jährigen Geburtstag Ernst Haeckels." *Forschungen und Fortschritte* 10, no. 4 (Feb.): 51–52.

Poeppig, Eduard Friedrich. 1848. *Illustrirte Naturgeschichte des Thierreichs*. Vol. 2, *Naturgeschichte der Vögel*. Leipzig: Weber.

Poole, Robert. 2008. *Earthrise: How Man First Saw the Earth*. New Haven, CT: Yale University Press.

Porep, Rüdiger. 1970. *Der Physiologe und Planktonforscher Victor Hensen (1835–1924). Sein Leben und sein Werk*. Neumünster: Wachholtz.

———. 1972. "Methodenstreit in der Planktologie—Haeckel contra Hensen: Auseinandersetzung um die Anwendung quantitativer Methoden in der Meeresbiologie um 1890." *MHJ* 7: 72–83.

Porter, Roy, and Lesley Hall. 1995. *The Facts of Life: The Creation of Sexual Knowledge in Britain, 1650–1950*. New Haven, CT: Yale University Press.

Price, George McCready. 1924. *The Phantom of Organic Evolution*. New York: Revell.

Proctor, A. Edward. 1910. *Science and the Evolution of Man*. London: Catholic Truth Society.

Proctor, Robert N., and Londa Schiebinger, eds. 2008. *Agnotology: The Making and Unmaking of Ignorance*. Stanford, CA: Stanford University Press.

Prodger, Phillip. 2009. *Darwin's Camera: Art and Photography in the Theory of Evolution*. Oxford: Oxford University Press.

Prothero, Donald R. 2007. *Evolution: What the Fossils Say and Why It Matters*. New York: Columbia University Press.

Prud'homme, Benjamin, and Nicolas Gompel. 2010. "Genomic Hourglass." *Nature* 468 (9 Dec.): 768–69.

Pruitt, Clarence M. 1966. "Benjamin Charles Gruenberg, 1875–1965." *Science Education* 50: 83–89.

Rabl, Rudolf. 1971. "Carl Rabl (1853–1917)." *Jahrbuch des Oberösterreichischen Musealvereines, Gesellschaft für Landeskunde* 116, pt. 1: 249–92.

Rádl, Em. 1909. *Geschichte der biologischen Theorien*. Pt. 2, *Geschichte der Entwicklungstheorien in der Biologie des XIX. Jahrhunderts*. Leipzig: Engelmann.

Raff, Rudolf A. 1996. *The Shape of Life: Genes, Development, and the Evolution of Animal Form*. Chicago: University of Chicago Press.

———. 2012. *Once We All Had Gills: Growing Up Evolutionist in an Evolving World*. Bloomington: Indiana University Press.

Raff, Rudolf A., and Thomas C. Kaufman. 1983. *Embryos, Genes, and Evolution: The Developmental Genetic Basis of Evolutionary Change*. New York: Macmillan; London: Collier-Macmillan.

Raikov, Boris Evgen'evič. 1968. *Karl Ernst von Baer, 1792–1876. Sein Leben und sein Werk*. Translated by Heinrich von Knorre (*Acta historica Leopoldina* 5). Leipzig: Barth.

———. 1984. *Christian Heinrich Pander. Ein bedeutender Biologe und Evolutionist. An Important Biologist and Evolutionist, 1794–1865*. Translated by W. E. von Hertzenberg and P. H. von Bitter. Frankfurt am Main: Kramer.

Ramón y Cajal, Santiago. 1999. *Advice for a Young Investigator*. Translated by Neely Swanson and Larry W. Swanson. Cambridge, MA: MIT Press.

Ramstad, Kristina M., N. J. Nelson, G. Paine, D. Beech, A. Paul, P. Paul, E. W. Allendorf, and C. H. Daugherty. 2007. "Species and Cultural Conservation in New Zealand: Maori Traditional Ecological Knowledge of Tuatara." *Conservation Biology* 21: 455–64.

Ranke, Johannes. 1886. *Der Mensch*. Vol. 1, *Entwickelung, Bau und Leben des menschlichen Körpers*. Leipzig: Bibliographisches Institut.

Rathke, Heinrich. 1825. "Kiemen bey Säugthieren." *Isis von Oken*, no. 6: 747–49.

———. 1839. *Entwickelungsgeschichte der Natter* (Coluber natrix). Königsberg: Gebrüder Bornträger.

———. 1848. *Ueber die Entwickelung der Schildkröten. Untersuchungen*. Braunschweig: Vieweg.

———. 1861. *Entwickelungsgeschichte der Wirbelthiere*. Leipzig: Engelmann.

———. 1866. *Untersuchungen über die Entwickelung und den Körperbau der Krokodile*. Edited by Wilhelm von Wittich. Braunschweig: Vieweg.

Raven, Peter H., and George B. Johnson. 2002. *Biology*. 6th ed. New York: McGraw-Hill.

Redi, Carlo Alberto, Silvia Garagna, Maurizio Zuccotti, Ernesto Capanna, and Helmut Zacharias. 2002. *Visual Zoology: The Pavia Collection of Leuckart's Zoological*

Wall Charts (1877). Como: Ibis.

Reglements über Prüfung, Approbation und Ausübung des Gewerbes für A. Aerzte (Augenärzte, Wundärzte I. Klasse), Zahnärzte und Thierärzte . . . vom 25. September 1869. . . . 1872. Berlin: Heymann.

Rehbock, Philip F. 1975. "Huxley, Haeckel, and the Oceanographers: The Case of *Bathybius haeckelii.*" *Isis* 66: 504–33.

Reichensperger, August. 1872. *Phrasen und Schlagwörter. Ein Noth- und Hülfsbüchlein für Zeitungsleser.* 3rd ed. Paderborn: Schöningh.

Reinöhl, Friedrich. 1940. *Abstammungslehre.* Öhringen: Hohenlohe'sche Buchhandlung.

Remane, Adolf, Volker Storch, and Ulrich Welsch. 1973. *Evolution. Tatsachen und Probleme der Abstammungslehre.* Munich: Deutscher Taschenbuch Verlag.

Renneberg, Monika, and Mark Walker, eds. 1994. *Science, Technology, and National Socialism.* Cambridge: Cambridge University Press.

Reulecke, Anne-Kathrin, ed. 2006. *Fälschungen. Zu Autorschaft und Beweis in Wissenschaften und Künsten.* Frankfurt am Main: Suhrkamp.

Reuter, Gabriele. 1906. *Aus guter Familie. Lebensgeschichte eines Mädchens.* 15th ed. Berlin: Fischer.

Reverby, Susan M. 2009. *Examining Tuskegee: The Infamous Syphilis Study and Its Legacy.* Chapel Hill: University of North Carolina Press.

Reymond, Moritz. 1877. *Das neue Laienbrevier des Haeckelismus. Genesis oder die Entwickelung des Menschengeschlechts. Nach Häckel's Anthropogenie in zierliche Reimlein gebracht.* Bern: Frobeen.

———. 1878. *Das neue Laienbrevier des Häckelismus.* Pt. 1, *Genesis oder die Entwickelung des Menschengeschlechts. Nach Häckel's Anthropogenie in zierliche Reimlein gebracht.* 3rd ed. Bern: Frobeen.

———. 1880. *Wo steckt der Mauschel? oder Jüdischer Liberalismus und wissenschaftlicher Pessimismus. Ein offener Brief an W. Marr.* 4th ed. Bern: Frobeen.

———. [1882.] *Fünf Bücher Haeckel. Ein Reimbrevier der modernen Naturphilosophie.* Leipzig: Glaser & Garte.

———. 1912. *Laienbrevier des Haeckelismus. Jubiläumsausgabe 1862–1882–1912.* Munich: Reinhardt.

Reynolds, Andrew. 2008. "Ernst Haeckel and the Theory of the Cell State: Remarks on the History of a Bio-Political Metaphor." *HS* 46: 123–52.

Reynolds, Andrew, and Norbert Hülsmann. 2008. "Ernst Haeckel's Discovery of *Magosphaera planula:* A Vestige of Metazoan Origins?" *HPLS* 30: 339–86.

Richards, Aute. 1931. *Outline of Comparative Embryology.* New York: Wiley.

Richards, Oscar W. 1923. "The Present Status of Biology in the Secondary Schools." *School Review* 31: 143–46.

Richards, Robert J. 1992. *The Meaning of Evolution: The Morphological Construction and Ideological Reconstruction of Darwin's Theory.* Chicago: University of Chicago Press.

———. 2002. *The Romantic Conception of Life: Science and Philosophy in the Age of Goethe.* Chicago: University of Chicago Press.

———. 2008. *The Tragic Sense of Life: Ernst Haeckel and the Struggle over Evolutionary Thought.* Chicago: University of Chicago Press.

———. 2009. "Haeckel's Embryos: Fraud Not Proven." *Biology and Philosophy* 24: 147–54.

Richardson, Michael K. 1995. "Heterochrony and the Phylotypic Period." *Developmental Biology* 172: 412–21.

———. 1997. "The Forgotten Fraud." *Physiological Society Magazine* 29 (Winter): 30–31.

———. 1998. "Haeckel's Embryos, Continued." *Science* 281 (28 Aug.): 1285.

———. 2000. "Historians Need Scientists." *Natural History* 109, no. 4 (May): 10.

———. 2009. "The Hox Complex: An Interview with Denis Duboule." *IJDB* 53: 717–23.

———. 2012. "A Phylotypic Stage for All Animals?" *Developmental Cell* 22: 903–4.

Richardson, Michael K., James Hanken, Mayoni L. Gooneratne, Claude Pieau, Albert Raynaud, Lynne Selwood, and Glenda M. Wright. 1997. "There Is No Highly Conserved Embryonic Stage in the Vertebrates: Implications for Current Theories of Evolution and Development." *Anatomy and Embryology* 196: 91–106.

Richardson, Michael K., James Hanken, Lynne Selwood, Glenda M. Wright, Robert J. Richards, Claude Pieau, and Albert Raynaud. 1998. "Haeckel, Embryos, and Evolution." *Science* 280 (15 May): 983.

Richardson, Michael K., and Gerhard Keuck. 2001. "A Question of Intent: When Is a 'Schematic' Illustration a Fraud?" *Nature* 410 (8 Mar.): 144.

———. 2002. "Haeckel's ABC of Evolution and Development." *Biological Reviews* 77: 495–528.

Richardson, Michael K., and Jennifer Narraway. 1999. "A Treasure House of Comparative Embryology." *IJDB* 43: 591–602.

Richmond, Marsha L. 2006. "The 1909 Darwin Celebration: Reexamining Evolution in the Light of Mendel, Mutation, and Meiosis." *Isis* 97: 447–84.

Ridley, Mark. 1985. "Embryology and Classical Zoology in Great Britain." In *A History of Embryology,* edited by T. J. Horder, J. A. Witkowski, and C. C. Wylie, 35–67. Cambridge: Cambridge University Press.

Rimmer, Harry. 1995. "Embryology and the Recapitulation Theory [1935]." In *The Antievolution Pamphlets of Harry Rimmer,* edited by Edward B. Davis, 1–22. New York: Garland.

Roberts, M. B. V. 1973. *Biology: A Functional Approach.* London: Nelson.

Roe, Shirley A. 1981. *Matter, Life, and Generation: Eighteenth-Century Embryology and the Haller–Wolff Debate.* Cambridge: Cambridge University Press.

Roger, Jacques. 1997. *The Life Sciences in Eighteenth-Century French Thought.* Translated by Robert Ellrich. Edited by Keith R. Benson. Stanford, CA: Stanford University Press.

Rolle, Friedrich. 1863. *Ch[arle]s Darwin's Lehre von der Entstehung der Arten in Pflanzen- und Thierreich in ihrer Anwendung auf die Schöpfungsgeschichte.* Frankfurt am

Main: Hermann.

———. 1866. *Der Mensch, seine Abstammung und Gesittung im Lichte der Darwin'schen Lehre von der Art-Entstehung und auf Grundlage der neuern geologischen Entdeckungen.* Frankfurt am Main: Hermann (Suchsland).

Romanes, George John. 1892. *Darwin and After Darwin: An Exposition of the Darwinian Theory and a Discussion of Post-Darwinian Questions.* Vol. 1, *The Darwinian Theory.* London: Longmans, Green.

Romer, Alfred Sherwood. 1933. *Man and the Vertebrates.* Chicago: University of Chicago Press.

Rossner, Mike. 2006. "How to Guard against Image Fraud." *The Scientist* 20, no. 3: 24.

Rowcroft, G. F. 1938. "The Evolutionary Theory." *BMJ* 1 (26 Feb.): 497.

Rowold, Katharina. 2010. *The Educated Woman: Minds, Bodies, and Women's Higher Education in Britain, Germany, and Spain, 1865–1914.* New York: Routledge.

Roux, Wilhelm. 1917. "† Albert Oppel." *Archiv für Entwicklungsmechanik der Organismen* 42: 261–66.

Rudge, David W. 2006. "Myths about Moths: A Study in Contrasts." *Endeavour* 30: 19–23.

Rudolph, John L. 2002. *Scientists in the Classroom: The Cold War Reconstruction of American Science Education.* Basingstoke: Palgrave.

Rudwick, Martin J.S. 1992. *Scenes from Deep Time: Early Pictorial Representations of the Prehistoric World.* Chicago: University of Chicago Press.

———. 2005. *Bursting the Limits of Time: The Reconstruction of Geohistory in the Age of Revolution.* Chicago: University of Chicago Press.

Rupke, Nicolaas A., ed. 1987. *Vivisection in Historical Perspective.* London: Croom Helm.

———. 2000. "Translation Studies in the History of Science: The Example of *Vestiges.*" *BJHS* 33: 209–22.

———. 2005. "Neither Creation nor Evolution: The Third Way in Mid-Nineteenth-Century Thinking about the Origin of Species." *AHPB* 10: 143–72.

———. 2008. *Alexander von Humboldt: A Metabiography.* Chicago: University of Chicago Press.

Rupp-Eisenreich, Britta. 1996. "Haeckel: La querelle des embryons." In *Dictionnaire du darwinisme et de l'évolution,* edited by Patrick Tort, 2:2090–114. Paris: Presses Universitaires de France.

Rusch, Wilbert H., Sr. 1969. "Ontogeny Recapitulates Phylogeny." *Creation Research Society Annual* 6, no. 1 (June): 27–34.

Russell, E. S. 1916. *Form and Function: A Contribution to the History of Animal Morphology.* London: Murray.

Rütimeyer, Ludwig. 1863. "Beiträge zur Kenntniss der fossilen Pferde und zur vergleichenden Odontographie der Hufthiere überhaupt." *Verhandlungen der naturforschenden Gesellschaft in Basel* 3: 558–696, plates I–IV.

———. 1898. "Die Grenzen der Thierwelt. Eine Betrachtung zu Darwin's Lehre. Zwei in Basel gehaltene Vorträge, 1868." In *Gesammelte kleine Schriften allgemeinen Inhalts aus dem Gebiete der Naturwissenschaft. Nebst einer autobiographischen Skizze,* edited by Hans G. Stehlin, vol. 1, *Autobiographie. Zoologische Schriften,* 225–88. Basel: Georg.

Rüve, Gerlind. 2009. "Vom 'personal mouthpiece' zur medizinischen Fachzeitschrift. *Münchener Medizinische Wochenschrift, BMJ* und *The Lancet* in sich wandelnden Öffentlichkeiten vom 19. zum 20. Jahrhundert." In *Das Medium Wissenschaftszeitschrift seit dem 19. Jahrhundert. Verwissenschaftlichung der Gesellschaft— Vergesellschaftung von Wissenschaft,* edited by Sigrid Stöckel, Wiebke Lisner, and Rüve, 45–70. Stuttgart: Steiner.

Sakurai, Ayako. 2013. *Science and Societies in Frankfurt am Main.* London: Pickering & Chatto.

Sander, Klaus. 1983. "The Evolution of Patterning Mechanisms: Gleanings from Insect Embryogenesis and Spermatogenesis." In *Development and Evolution,* edited by B. C. Goodwin, N. Holder, and C. C. Wylie, 137–59. Cambridge: Cambridge University Press.

———. 2002. "Ernst Haeckel's Ontogenetic Recapitulation: Irritation and Incentive from 1866 to Our Time." *Annals of Anatomy* 184: 523–33.

Sander, Klaus, and Roland Bender. 1998. "Embryology and Evolution." *Science* 281 (17 July): 349.

Sapp, Jan. 1990. *Where the Truth Lies: Franz Moewus and the Origins of Molecular Biology.* Cambridge: Cambridge University Press.

Sappol, Michael. 2006. *Dream Anatomy.* Bethesda, MD: US Dept of Health and Human Services, National Institutes of Health, National Library of Medicine.

Sassoon, Donald. 2001. *Mona Lisa: The History of the World's Most Famous Painting.* London: HarperCollins.

Sauer, Helmut W., Fritz E. Schwalm, and Karl B. Moritz. 1996. "Morphogenesis, Seidel's Legacy for Developmental Biology and Challenge for Molecular Embryologists." *IJDB* 40: 77–82.

Sauerteig, Lutz. 1999a. *Krankheit, Sexualität, Gesellschaft. Geschlechtskrankheiten und Gesundheitspolitik in Deutschland im 19. und frühen 20. Jahrhundert.* Stuttgart: Steiner.

———. 1999b. "Sex Education in Germany from the Eighteenth to the Twentieth Century." In *Sexual Cultures in Europe: Themes in Sexuality,* edited by Franz X. Eder, Lesley A. Hall, and Gert Hekma, 9–33. Manchester: Manchester University Press.

Sauerteig, Lutz, and Roger Davidson, eds. 2008. *Shaping Sexual Knowledge: A Cultural History of Sex Education in Twentieth-Century Europe.* London: Routledge.

Scerri, Eric R. 2007. *The Periodic Table: Its Story and Its Significance.* Oxford: Oxford University Press.

Schaffer, Simon. 1997. "Metrology, Metrication, and Victorian Values." In *Victorian Science in Context,* edited by Bernard Lightman, 438–74. Chicago: University of Chicago Press.

———. 1998. "The Leviathan of Parsonstown: Literary Technology and Scientific Representation." In *Inscribing Science: Scientific Texts and the Materiality of Communication,* edited by Timothy Lenoir, 182–222, 399–406. Stanford, CA: Stanford University Press.

Schaxel, J. 1931. "Haeckels Naturgeschichte des Lebens." *Urania* 7: 258–62.

Scheele, Irmtraut. 1981. *Von Lüben bis Schmeil. Die Entwicklung von der Schulnaturgeschichte zum Biologieunterricht zwischen 1830 und 1933*. Berlin: Reimer.

Scheffauer, Herman. 1910. "Haeckel, a Colossus of Science." *North American Review* 192: 217–26.

Scheidemacher, Carl. 1874. "Ueber den Stand des Darwinismus. 10. Artikel. Kritik der Abstammung des Menschen." *PB* 3: 362–71.

———. 1875–76. "Ueber den Darwinismus." *Deutscher Hausschatz* 2: 342–46.

———. 1876a. "Neue Beiträge zum Häckel'schen Schwindel in der sogen. Culturwissenschaft mit Randglossen." *PB* 5: 135–42.

———. 1876b. "Ueber das Schicksal E. Haeckels vor dem Forum der fachgenössischen Wissenschaft." *Natur und Offenbarung* 22: 646–55, 705–14.

Schenk, Anette. 2000. *Otto Schmeil: Leben und Werk*. Heidelberg: Palatina.

Schickore, Jutta. 2007. *The Microscope and the Eye: A History of Reflections, 1740–1870*. Chicago: University of Chicago Press.

Schleiden, M. J. 1848. *Die Pflanze und ihr Leben. Populäre Vorträge*. Leipzig: Engelmann.

———. 1863. *Das Alter des Menschengeschlechts, die Entstehung der Arten und die Stellung des Menschen in der Natur. . . .* Leipzig: Engelmann.

———. 1869. "Ueber den Darwinismus und die damit zusammenhängenden Lehren." *Unsere Zeit: Deutsche Revue der Gegenwart. Monatsschrift zum Conversations-Lexikon*, n.s., 5, pt. 1: 50–71, 258–77, 606–30.

Schlünder, Martina. 2005. "Die Herren der Regel/n? Gynäkologen und der Menstruationskalender als Regulierungsinstrument der weiblichen Natur." In *Maß und Eigensinn. Studien im Anschluß an Georges Canguilhem*, edited by Cornelius Borck, Volker Hess, and Henning Schmidgen, 157–95. Munich: Fink.

Schmeil, Otto. 1907. *Lehrbuch der Zoologie für höhere Lehranstalten und die Hand des Lehrers, sowie für alle Freunde der Natur. Unter besonderer Berücksichtigung biologischer Verhältnisse*. 19th ed. Leipzig: Nägele.

Schmeil, Otto, Franz Schön, and Gustav Wefelscheid. 1931. *Allgemeine Biologie. Ein Hilfsbuch für den biologischen Unterricht auf der Oberstufe höherer Lehranstalten und zum Selbststudium. . . .* 3rd ed. Leipzig: Quelle & Meyer.

Schmid, Rudolf. 1876. *Die Darwin'schen Theorien und ihre Stellung zur Philosophie, Religion und Moral*. Stuttgart: Moser.

Schmidt, Carl. 1896. "Ludwig Rütimeyer." *Verhandlungen der Schweizerischen Naturforschenden Gesellschaft* 78: 213–56.

Schmidt, Heinrich. 1900. *Der Kampf um die "Welträtsel." Ernst Haeckel, die "Welträtsel" und die Kritik*. Bonn: Strauss.

———. 1909. *Haeckels Embryonenbilder. Dokumente zum Kampf um die Weltanschauung in der Gegenwart*. Frankfurt am Main: Neuer Frankfurter Verlag.

———, ed. 1914. *Was wir Ernst Haeckel verdanken. Ein Buch der Verehrung und Dankbarkeit*. 2 vols. Leipzig: Unesma.

———. 1921. *Ernst Haeckel und sein Nachfolger Professor Dr. Ludwig Plate*. Jena: Volksbuchhandlung.

———. 1926. *Ernst Haeckel. Leben und Werke*. Berlin: Deutsche Buch-Gemeinschaft.

———, ed. 1929. *Anna Sethe. Die erste Liebe eines berühmten Mannes in Briefen*. Dresden: Reissner.

———. 1934. *Ernst Haeckel. Denkmal eines großen Lebens*. Jena: Frommann.

Schmidt-Lux, Thomas. 2008. *Wissenschaft als Religion. Szientismus im ostdeutschen Säkularisierungsprozess*. Würzburg: Ergon.

Schmiedebach, Heinz-Peter. 1995. *Robert Remak (1815–1865). Ein jüdischer Arzt im Spannungsfeld von Wissenschaft und Politik*. Stuttgart: Fischer.

Schögl, Uwe. 1999. "Vom Frosch zum Dichter-Apoll. Morphologische Entwicklungsreihen bei Lavater." In *Das Kunstkabinett des Johann Caspar Lavater*, edited by Gerda Mraz and Uwe Schögl, 164–71. Vienna: Böhlau.

Schoenichen, Walther. 1903. *Die Abstammungslehre im Unterrichte der Schule*. Leipzig: Teubner.

Schröder, Tilman Matthias. 2008. *Naturwissenschaften und Protestantismus im Deutschen Kaiserreich. Die Versammlungen der Gesellschaft Deutscher Naturforscher und Ärzte und ihre Bedeutung für die Evangelische Theologie*. Stuttgart: Steiner.

Schuberg, August. 1895. "Carl Semper †." In C. Semper, *Reisen im Archipel der Philippinen*, pt. 2, *Wissenschaftliche Resultate*, supplement, vii–xxi and portrait. Wiesbaden: Kreidel.

Schudson, Michael. 1978. *Discovering the News: A Social History of American Newspapers*. New York: Basic Books.

Schultze, Oscar. 1897. *Grundriss der Entwicklungsgeschichte des Menschen und der Säugethiere für Studirende und Ärzte*. Leipzig: Engelmann.

Schulze, Elke. 2004. *Nulla dies sine linea. Universitärer Zeichenunterricht. Eine problemgeschichtliche Studie*. Stuttgart: Steiner.

Schwarz, Angela. 1999. *Der Schlüssel zur modernen Welt. Wissenschaftspopularisierung in Großbritannien und Deutschland im Übergang zur Moderne (ca. 1870–1914)*. Stuttgart: Steiner.

Scott, William Berryman. 1917. *The Theory of Evolution, with Special Reference to the Evidence upon Which It Is Founded*. New York: Macmillan.

———. 1921. "Critique of the Recapitulation Theory." In *Readings in Evolution, Genetics, and Eugenics*, edited by Horatio Hackett Newman, 173–82. Chicago: University of Chicago Press.

———. 1939. *Some Memories of a Palaeontologist*. Princeton, NJ: Princeton University Press.

Secord, Anne. 2002. "Botany on a Plate: Pleasure and the Power of Pictures in Promoting Early Nineteenth-Century Scientific Knowledge." *Isis* 93: 28–57.

Secord, James A. 2000. *Victorian Sensation: The Extraordinary Publication, Reception, and Secret Authorship of "Vestiges of the Natural History of Creation."* Chicago: University of Chicago Press.

———. 2009. Introduction to focus section on "Darwin as a Cultural Icon." *Isis* 100: 537–41.

———. 2010. "Global Darwin." In *Darwin*, edited by William Brown and Andrew C. Fabian, 31–57. Cambridge: Cambridge University Press.

Sedgwick, Adam. 1894. "On the Law of Development Commonly Known as von Baer's Law; and on the Significance of Ancestral Rudiments in Embryonic Development." *QJMS* 36: 35–52.

Seidel, Friedrich. 1936. "Entwicklungsphysiologie." *Fortschritte der Zoologie*, n.s., 1: 406–59.

———. 1960. "Körpergrundgestalt und Keimstruktur. Eine Erörterung über die Grundlagen der vergleichenden und experimentellen Embryologie und deren Gültigkeit bei phylogenetischen Überlegungen." *Zoologischer Anzeiger* 164: 245–305.

Seidler, Eduard. 1993. "Das 19. Jahrhundert. Zur Vorgeschichte des Paragraphen 218." In Jütte 1993, 120–39, 215–17.

Selenka, Emil. 1887. *Studien über Entwickelungsgeschichte der Thiere* 4, pt. 1, *Das Opossum* (Didelphys virginiana). Wiesbaden: Kreidel.

———. 1897. *Zoologisches Taschenbuch für Studirende zum Gebrauch bei Vorlesungen und praktischen Übungen.* Leipzig: Georgi.

———. 1903. *Studien über Entwickelungsgeschichte der Tiere* 10 (*Menschenaffen [Anthropomorphae]. Studien über Entwickelung und Schädelbau* 5), *Zur vergleichenden Keimesgeschichte der Primaten.* Edited by Franz Keibel. Wiesbaden: Kreidel.

Selenka, Emil, and Lenore Selenka. 1905. *Sonnige Welten. Ostasiatische Reiseskizzen. Borneo. Java. Sumatra. Vorderindien. Ceylon. Japan.* 2nd ed. Wiesbaden: Kreidel.

Selle, Olaf. 1986. *Antidarwinismus und Biologismus. Naturwissenschaft, Weltanschauung und Politik im Werk Eberhard Dennerts (1861–1942).* Husum: Matthiesen.

Semon, Richard. 1894. *Zoologische Forschungsreisen in Australien und dem Malayischen Archipel.* Vol. 2, *Monotremen und Marsupalier I* (*Denkschriften der Medicinisch-naturwissenschaftlichen Gesellschaft zu Jena*, vol. 5). Jena: Fischer.

———. 1896. *Im australischen Busch und an den Küsten des Korallenmeeres. Reiseerlebnisse und Beobachtungen eines Naturforschers in Australien, Neu-Guinea und den Molukken.* Leipzig: Engelmann.

Semper, Carl. 1874. "Kritische Gänge." *Arbeiten aus dem zoologisch-zootomischen Institut in Würzburg* 1: 73–82, 208–38.

———. 1876. *Der Haeckelismus in der Zoologie. Ein Vortrag gehalten am 28. October 1875 im Verein für Kunst und Wissenschaft zu Hamburg, unter dem Titel "Der neue Glaube und die moderne Zoologie."* Hamburg: Mauke's Söhne.

———. 1877. *Offener Brief an Herrn Prof. Haeckel in Jena.* Hamburg: Mauke's Söhne.

Serpente, Norberto. 2011. "Cells from Icons to Symbols: Molecularizing Cell Biology in the 1980s." *Studies in History and Philosophy of Biological and Biomedical Sciences* 42: 403–11.

Shann, E. W., and A. S. Gillespie. 1931. *School Certificate Biology.* London: Arnold.

Shapin, Steven. 2008. *The Scientific Life: A Moral History of a Late Modern Vocation.* Chicago: University of Chicago Press.

Shapiro, Adam R. 2010. "State Regulation of the Textbook Industry." In *Education and the Culture of Print in Modern America*, edited by Adam R. Nelson and John L. Rudolph, 173–90. Madison: University of Wisconsin Press.

———. 2013. *Trying Biology: The Scopes Trial, Textbooks, and the Antievolution Movement in American Schools.* Chicago: University of Chicago Press.

Shove, R. F. 1931. *Plant and Animal Life: An Introduction to the Study of Biology.* London: Methuen.

Shteir, Ann B., and Bernard Lightman, eds. 2006. *Figuring It Out: Science, Gender, and Visual Culture.* Hanover, NH: UPNE for Dartmouth College Press.

Shulman, Seth. 2006. *Undermining Science: Suppression and Distortion in the Bush Administration.* Berkeley: University of California Press.

Shumway, Waldo. 1927. *Vertebrate Embryology: A Text Book for Colleges and Universities.* New York: Wiley.

———. 1931. *Textbook of General Biology.* New York: Wiley.

Shute, D. Kerfoot. 1899. *A First Book in Organic Evolution.* London: Kegan Paul, Trench, Trübner.

Siewing, Rolf. 1969. *Lehrbuch der vergleichenden Entwicklungsgeschichte der Tiere.* Hamburg: Parey.

Silver, Queen. 1925. *Evolution from Monkey to Bryan.* Inglewood, CA: Queen Silver's Magazine.

Simmer, Hans H. 1993. "Rudolf Virchow und der Virilismus ovarioprivus." *MHJ* 28: 375–401.

Simon, Josep. 2011. *Communicating Physics: The Production, Circulation and Appropriation of Ganot's Textbooks in France and England, 1851–1887.* London: Pickering & Chatto.

Simon-Ritz, Frank. 1997. *Die Organisation einer Weltanschauung. Die freigeistige Bewegung im Wilhelminischen Deutschland.* Gütersloh: Kaiser, Gütersloher Verlagshaus.

Singer, Charles. 1931. *A Short History of Biology: A General Introduction to the Study of Living Things.* Oxford: Clarendon.

Skoog, Gerald. 2005. "The Coverage of Human Evolution in High School Biology Textbooks in the 20th Century and in Current State Science Standards." *Science & Education* 14: 395–422.

Slack, J. M. W. 1999. *Egg & Ego: An Almost True Story of Life in the Biology Lab.* New York: Springer.

———. 2003. "Phylotype and Zootype." In *Keywords and Concepts in Evolutionary Developmental Biology*, edited by Brian K. Hall and Wendy M. Olson, 309–18. Cambridge, MA: Harvard University Press.

Slack, J. M. W., P. W. H. Holland, and C. F. Graham. 1993. "The Zootype and the Phylotypic Stage." *Nature* 361 (11 Feb.): 490–92.

Slosson, Edwin E. 1914. *Major Prophets of Today.* Boston: Little, Brown.

Smallwood, W. M. 1913. *A Text-Book of Biology for Students in Medical, Technical and General Courses.* Philadelphia: Lea & Febiger.

Smallwood, W. M., Ida L. Reveley, and Guy A. Bailey. 1924. *New Biology*. Boston: Allyn and Bacon.

———. 1934. *New General Biology*. Boston: Allyn and Bacon.

Smith, Ella Thea. 1949. *Exploring Biology*. 3rd ed. New York: Harcourt, Brace.

———. 1954. *Exploring Biology*. 4th ed. New York: Harcourt, Brace.

Smith, Jonathan. 2006a. *Charles Darwin and Victorian Visual Culture*. Cambridge: Cambridge University Press.

———. 2006b. "Picturing Sexual Selection: Gender and the Evolution of Ornithological Illustration in Charles Darwin's *Descent of Man*." In Shteir and Lightman 2006, 85–109.

Smocovitis, Vassiliki Betty. 2009. "Singing His Praises: Darwin and His Theory in Song and Musical Production." *Isis* 100: 590–614.

Soemmerring, Samuel Thomas. 1799. *Icones embryonum humanorum*. Frankfurt am Main: Varrentrapp und Wenner.

———. 2000. "Icones embryonum humanorum." In *Schriften zur Embryologie und Teratologie*, translated by Ferdinand Peter Moog, edited by Ulrike Enke, 165–89. Basel: Schwabe.

Sonderegger, L. 1898. *Dr. L. Sonderegger in seiner Selbstbiographie und seinen Briefen*. Edited by Elias Haffter. Frauenfeld: Huber.

Spary, Emma. 2003. "Forging Nature at the Republican Muséum." In *The Faces of Nature in Enlightenment Europe*, edited by Lorraine Daston and Gianna Pomata, 163–80. Berlin: Berliner Wissenschafts-Verlag.

Specht, August. 1894. "Ernst Häckels 60. Geburtstag." *Menschenthum. Organ für deutsches Freidenkerthum* 23, no. 9 (4 Mar.): 33–34.

Spratt, E. R., and A. V. Spratt. 1931. *Biology for Schools: A Textbook Suitable for Certificate and Similar Examinations*. London: University Tutorial Press.

Squire, James R., and Richard T. Morgan. 1990. "The Elementary and High School Market Today." In Elliott and Woodward 1990, 107–26.

Stammer, H.-J. 1952. "Albert Fleischmann. Ein Nachruf." *Sitzungsberichte der Physikalisch-medizinischen Societät zu Erlangen* 75 (1943–51): xx–xxxv.

Stengel, Erich, and Kurt Otto Weise, eds. [c. 1955.] *Lebendige Natur VII: Allgemeine Biologie*. Stuttgart: Klett.

Stenhouse, John. 1999. "Darwinism in New Zealand, 1859–1900." In Numbers and Stenhouse 1999, 61–90.

Sterne, Carus [Ernst Krause, pseud.]. 1876. *Werden und Vergehen. Eine Entwicklungsgeschichte des Naturganzen in gemeinverständlicher Fassung*. Berlin: Borntraeger.

———. 1878. "Ernst-Haeckel's Gasträa-Theorie." *Die Gartenlaube* 26: 527–30.

Stöckl, [Albert]. 1874. "Der Darwinismus." *Der Katholik* 54.2: 37–50, 172–92, 284–307.

Stoeckel, Walter. 1966. *Erinnerungen eines Frauenarztes*. Edited by Hans Borgelt. Munich: Kindler.

Stolberg, Michael. 2009. *Die Harnschau. Eine Kultur- und Alltagsgeschichte*. Cologne: Böhlau.

Stopes, Marie Carmichael. 1920. *Married Love: A New Contribution to the Solution of Sex Difficulties*. 9th ed. London: Putnam's.

Storer, Tracy I. 1943. *General Zoology*. New York: McGraw-Hill.

Strausbaugh, Perry D., and Bernal R. Weimer. 1938. *General Biology: A Textbook for College Students*. New York: Wiley.

Strickberger, Monroe W. 2000. *Evolution*. 3rd ed. Sudbury, MA: Jones and Bartlett.

Stürzbecher, Manfred, ed. 1975. *Deutsche Ärztebriefe des 19. Jahrhunderts*. Göttingen: Musterschmidt.

Susen, Gerd-Hermann, and Edith Wack, eds. 2012. *"Was wir im Verstande ausjäten, kommt im Traume wieder": Wilhelm Bölsche 1861–1939*. Würzburg: Königshausen & Neumann.

Sykes, Alan H. 2001. *Sharpey's Fibres: The Life of William Sharpey, the Father of Modern Physiology in England*. York: Sessions.

Szarota, Tomasz. 1998. *Der deutsche Michel. Die Geschichte eines nationalen Symbols und Autostereotyps*. Translated by Kordula Zentgraf-Zubrzycka. Osnabrück: fibre.

Tammiksaar, Erki, and Sabine Brauckmann. 2004. "Karl Ernst von Baer's 'Ueber Entwickelungsgeschichte der Thiere II' and Its Unpublished Drawings." *HPLS* 26: 291–308.

Taschenberg, Otto. 1919. "Ernst Haeckel." *Leopoldina* 55: 84–96.

Taylor, Ian T. 1984. *In the Minds of Men: Darwin and the New World Order*. Toronto: TFE Publishing.

Teudt, W. 1909. *"Im Interesse der Wissenschaft!" Haeckels "Fälschungen" und die 46 Zoologen etc.: Die wichtigsten Dokumente zum Fall Brass-Haeckel nebst Erläuterungen und Ergebnis*. Godesberg: Naturwissenschaftlicher Verlag des Keplerbundes.

Theunissen, Bert. 1989. *Eugène Dubois and the Ape-Man from Java: The History of the First Missing Link and Its Discoverer*. Dordrecht: Kluwer.

Thienemann, August. 1917. "Otto Zacharias †. Ein Nachruf." *Archiv für Hydrobiologie und Planktonkunde* 11: i–xxiv.

Thompson, W. R. 1956. Introduction to *The Origin of Species*, by Charles Darwin, vii–xxv. London: Dent.

Thomson, Sir C. Wyville. 1880. "Notice." In *Report on the Scientific Results of the Voyage of H.M.S. "Challenger" during the Years 1873–1876 . . . : Zoology*, vol. 1:61–62. London: HMSO.

Thomson, J. Arthur. 1892. *The Study of Animal Life*. London: Murray.

Toellner, Richard. 1975. "Der Entwicklungsbegriff bei Karl Ernst von Baer und seine Stellung in der Geschichte des Entwicklungsgedankens." *Sudhoffs Archiv* 59: 337–55.

Toldt, Carl, Jr. 1907–8. "Studien über das Haarkleid von *Vulpes vulpes* L. Nebst Bemerkungen über die Violdrüse und den Haeckel-Maurerschen Bärenembryo mit Stachelanlagen." *Annalen des k. k. Naturhistorischen Hofmuseums Wien* 22: 197–269, plates V–VII.

Topham, Jonathan R. 2004. "Scientific Readers: A View from the Industrial Age." *Isis* 95: 431–42.

Torrey, Theodore W. 1962. *Morphogenesis of the Vertebrates*. New York: Wiley.

Tschulok, Sinai. 1921. *Entwicklungstheorie (Darwins Lehre)*. Stuttgart: Dietz Nachfolger.

———. 1922. *Deszendenzlehre (Entwicklungslehre). Ein Lehrbuch auf historisch-kritischer Grundlage.* Jena: Fischer.

Tuchman, Arleen Marcia. 1993. *Science, Medicine, and the State in Germany: The Case of Baden, 1815–1871.* New York: Oxford University Press.

Tucker, Jennifer. 1997. "Photography as Witness, Detective, and Impostor: Visual Representation in Victorian Science." In *Victorian Science in Context*, edited by Bernard Lightman, 378–408. Chicago: University of Chicago Press.

Tufte, Edward R. 1990. *Envisioning Information.* Cheshire, CT: Graphics Press.

Turney, Jon. 1998. *Frankenstein's Footsteps: Science, Genetics and Popular Culture.* New Haven, CT: Yale University Press.

Uhlik, Kim S. 2004. "Midnight at the IDL: Student Confusion and Textbook Error." *Journal of Geography in Higher Education* 28: 197–207.

Ulbricht, Justus H., and Meike G. Werner, eds. 1999. *Romantik, Revolution und Reform. Der Eugen Diederichs Verlag im Epochenkontext 1900–1949.* Göttingen: Wallstein.

Usborne, Cornelie. 2007. *Cultures of Abortion in Weimar Germany.* New York: Berghahn.

Uschmann, Georg. 1959. *Geschichte der Zoologie und der zoologischen Anstalten in Jena 1779–1919.* Jena: Friedrich-Schiller-Universität.

———. 1967. "Zur Geschichte der Stammbaum-Darstellungen." In *Gesammelte Vorträge über moderne Probleme der Abstammungslehre*, vol. 2, edited by Manfred Gersch, 9–30. Jena: Fischer.

———. 1974. "Über die Beziehungen zwischen Albert Koelliker und Ernst Haeckel." *NTM* 11: 80–89.

———. 1983. *Ernst Haeckel: Biographie in Briefen.* Leipzig: Urania.

Uschmann, Georg, and Ilse Jahn, eds. 1959–60. "Der Briefwechsel zwischen Thomas Henry Huxley und Ernst Haeckel. Ein Beitrag zum Darwin-Jahr." *Wissenschaftliche Zeitschrift der Friedrich-Schiller-Universität Jena, Mathematisch-Naturwissenschaftliche Reihe* 9: 7–33.

Vaihinger, Hans. 1911. *Die Philosophie des Als Ob. System der theoretischen, praktischen und religiösen Fiktionen der Menschheit auf Grund eines idealistischen Positivismus* Berlin: Reuther & Reichard.

Valentin, G. 1835a. *Handbuch der Entwickelungsgeschichte des Menschen mit vergleichender Rücksicht der Entwickelung der Säugethiere und Vögel. Nach fremden und eigenen Beobachtungen.* Berlin: Rücker.

———. 1835b. "Foetus." In *Encyclopädisches Wörterbuch der medicinischen Wissenschaften*, edited by D. W. H. Busch, C. F. v. Gräfe, C. W. Hufeland, H. F. Link, and J. Müller, 12:355–89. Berlin: Veit.

Villee, Claude A. 1950. *Biology: The Human Approach.* Philadelphia: Saunders.

———. 1962. *Biology.* 4th ed. Philadelphia: Saunders.

Villee, Claude A., Warren F. Walker Jr., and Frederick E. Smith. 1958. *General Zoology.* Philadelphia: Saunders.

Vines, A. E. 1963. *An Introduction to Living Things.* London: Pitman.

Vines, A. E., and N. Rees. 1959. *Plant and Animal Biology.* 2 vols. London: Pitman.

———. 1972. *Plant and Animal Biology.* 4th ed. 2 vols. London: Pitman.

Virchow, Rudolf. 1859. *Die Cellularpathologie in ihrer Begründung auf physiologische und pathologische Gewebelehre.* ... 2nd ed. Berlin: Hirschwald.

———. 1897. "Nachruf an Ernst Reimer." *Archiv für pathologische Anatomie und Physiologie und für klinische Medicin* 150: 388–90.

Vogel, Martin. 2001. "Die Entwicklung des Urheberrechts." In *Geschichte des Deutschen Buchhandels im 19. und 20. Jahrhundert*, vol. 1, *Das Kaiserreich 1870–1918*, pt. 1, edited by Georg Jäger, 122–38. Frankfurt am Main: Buchhändler-Vereinigung.

Vogel, Steven. 1987. "Mythology in Introductory Biology." *BioScience* 37: 611–14.

Vogt, Carl. 1847. *Physiologische Briefe für Gebildete aller Stände.* Stuttgart: Cotta.

———. 1848. *Ocean und Mittelmeer. Reisebriefe.* 2 vols. Frankfurt am Main: Literarische Anstalt.

———. 1851. *Zoologische Briefe. Naturgeschichte der lebenden und untergegangenen Thiere, für Lehrer, höhere Schulen und Gebildete aller Stände.* 2 vols. Frankfurt am Main: Literarische Anstalt.

———. 1852. *Bilder aus dem Thierleben.* Frankfurt am Main: Literarische Anstalt.

———. 1854. *Physiologische Briefe für Gebildete aller Stände.* 2nd ed. Giessen: Ricker.

———. 1859. *Die künstliche Fischzucht.* Leipzig: Brockhaus.

———. 1861. *Physiologische Briefe für Gebildete aller Stände.* 3rd ed. Giessen: Ricker.

———. 1863. *Vorlesungen über den Menschen, seine Stellung in der Schöpfung und in der Geschichte der Erde.* 2 vols. Giessen: Ricker.

———. 1896. *Aus meinem Leben. Erinnerungen und Rückblicke.* Stuttgart: Nägele.

Vogt, William. 1896. *La vie d'un homme: Carl Vogt.* Paris: Schleicher.

Voss, Julia. 2010. *Darwin's Pictures: Views of Evolutionary Theory, 1837–1874.* Translated by Lori Lantz. New Haven, CT: Yale University Press.

Waddington, C. H. 1956. *Principles of Embryology.* London: Allen & Unwin.

Wagner, Andreas. 1857–58. *Geschichte der Urwelt, mit besonderer Berücksichtigung der Menschenrassen und des mosaischen Schöpfungsberichtes.* 2nd ed. 2 pts. Leipzig: Voss.

Wagner, Rudolph. 1839a. *Lehrbuch der Speziellen Physiologie.* Leipzig: Voss.

———. 1839b. *Icones physiologicae. Tabulae physiologiam et geneseos historiam illustrantes. Erläuterungstafeln zur Physiologie und Entwickelungsgeschichte.* Leipzig: Voss.

———. 1845. *Lehrbuch der Speziellen Physiologie.* 3rd ed. Leipzig: Voss.

———. 1854a. *Menschenschöpfung und Seelensubstanz. Ein anthropologischer Vortrag, gehalten in der ersten öffentlichen Sitzung der 31. Versammlung deutscher Naturforscher und Aerzte zu Göttingen am 18. September 1854.* Göttingen:

Wigand.

———. 1854b. *Ueber Wissen und Glauben mit besonderer Beziehung zur Zukunft der Seelen. . . .* Göttingen: Wigand.

Wakeman, Geoffrey. 1973. *Victorian Book Illustration: The Technical Revolution.* Detroit: Gale Research.

Waldeyer, Wilhelm. 1899. *Zur Geschichte des anatomischen Unterrichts in Berlin. . . .* Berlin: Schade.

Wallace, Alfred Russel. 1889. *Darwinism: An Exposition of the Theory of Natural Selection, with Some of Its Applications.* 2nd ed. London: Macmillan.

Wallace, Robert A. 1978. *Biology: The World of Life.* 2nd ed. Santa Monica, CA: Goodyear.

Walther, Johannes. 1953. *Im Banne Ernst Haeckels. Jena um die Jahrhundertwende.* Edited by Gerhard Heberer. Göttingen: "Musterschmidt."

Wasmann, Erich. 1906. *Die moderne Biologie und die Entwicklungstheorie.* 3rd ed. Freiburg im Breisgau: Herder.

———. 1909. "Alte und neue Forschungen Haeckels über das Menschenproblem." *Stimmen aus Maria-Laach* 76, no. 2 (8 Feb.): 169–84; no. 3 (15 Mar.): 297–306; and no. 4 (21 Apr.): 422–38.

———. 1910. *Entwicklungstheorie und Monismus. Die Innsbrucker Vorträge von Erich Wasmann am 14., 16. u. 18. Okt. 1909.* Innsbruck: Tyrolia.

———. 1911. *La probité scientifique de Ernst Haeckel dans la question de la descendance simienne de l'homme hier et aujourd'hui.* Paris: Bloud.

[Watts, Newman.] 1936. *Why Be an Ape? Observations on Evolution.* London: Marshall, Morgan & Scott.

Wazeck, Milena. 2009. *Einsteins Gegner. Die öffentliche Kontroverse um die Relativitätstheorie in den 1920er Jahren.* Frankfurt am Main: Campus.

Weber, Thomas. 1991. "Zur Rezeption der Lehren Ernst Haeckels durch die deutsche Sozialdemokratie. Ein Beitrag zur Herausbildung ihres Weltbildes vor dem Ersten Weltkrieg." *Ethnographisch-Archäologische Zeitschrift* 32: 23–44.

Wedekind, Kurt. 1976. "Die Frühprägung Ernst Haeckels." *Wissenschaftliche Zeitschrift der Friedrich-Schiller-Universität, Mathematisch-Naturwissenschaftliche Reihe* 25: 133–48.

Weg zur Reifeprüfung. Pt. 5, Naturwissenschaften, Biologie-Chemie–Physik. 1943. Breslau: Hirt.

Weikart, Richard. 2004. *From Darwin to Hitler: Evolutionary Ethics, Eugenics, and Racism in Germany.* New York: Palgrave Macmillan.

Weindling, Paul. 1989a. *Health, Race, and German Politics between National Unification and Nazism, 1870–1945.* Cambridge: Cambridge University Press.

———. 1989b. "Ernst Haeckel, Darwinismus and the Secularization of Nature." In *History, Humanity and Evolution: Essays for John C. Greene,* edited by James R. Moore, 311–27. Cambridge: Cambridge University Press.

———. 1991a. *Darwinism and Social Darwinism in Imperial Germany: The Contribution of the Cell Biologist Oscar Hertwig (1849–1922).* Stuttgart: Fischer.

———. 1991b. "'Mustergau' Thüringen. Rassenhygiene zwischen Ideologie und Machtpolitik." In *Medizin und Gesundheitspolitk in der NS-Zeit,* edited by Norbert Frei, 81–97. Munich: Oldenbourg.

Weiner, J. S. 2003. *The Piltdown Forgery.* Oxford: Oxford University Press.

Weise, Bernd. 2003. "Aktuelle Nachrichtenbilder 'nach Photographien' in der deutschen illustrierten Presse der zweiten Hälfte des 19. Jahrhunderts." In *Die Eroberung der Bilder. Photographie in Buch und Presse (1816–1914),* edited by Charles Grivel, André Gunthert, and Bernd Stiegler, 62–101. Munich: Fink.

Weiss, Sheila Faith. 1994. "Pedagogy, Professionalism, and Politics: Biology Instruction during the Third Reich." In Renneberg and Walker 1994, 184–96, 377–85.

———. 2010. *The Nazi Symbiosis: Human Genetics and Politics in the Third Reich.* Chicago: University of Chicago Press.

Wellmann, Janina. 2010. *Die Form des Werdens. Eine Kulturgeschichte der Embryologie 1760–1830.* Göttingen: Wallstein.

Wells, Herbert George. 1893. *Text-Book of Biology. Pt. 1, Vertebrata.* London: University Correspondence College Press.

Wells, Herbert George, Julian Huxley, and G. P. Wells. 1934. *Evolution: Fact and Theory.* London: Cassell.

Wells, Jonathan. 1999. "Haeckel's Embryos & Evolution: Setting the Record Straight." *American Biology Teacher* 61, no. 5 (May): 345–49.

———. 2000. *Icons of Evolution: Science or Myth? Why Much of What We Teach about Evolution Is Wrong.* New York: Regnery.

Weygoldt, G. P. 1878. *Darwinismus, Religion, Sittlichkeit. . . .* Leiden: Brill.

Wheat, Frank M., and Elizabeth T. Fitzpatrick. 1929. *Advanced Biology.* New York: American Book Company.

Wheeler, W. F. 1947. *Essentials of Biology: An Introductory Textbook for Secondary Schools.* London: Heinemann.

White, E. Grace. 1933. *A Textbook of General Biology.* London: Kimpton.

Whitten, Phillip. 1975. "The Changing World of College Textbook Publishing." In *Perspectives on Publishing,* edited by Philip G. Altbach and Sheila McVey, 247–58. Philadelphia: American Academy of Political and Social Science.

Whyte, Adam Gowans. 1916. *The World's Wonder Stories for Boys and Girls.* London: Watts.

———. 1949. *The Story of the R.P.A., 1899–1949.* London: Watts.

Wieman, Harry Lewis. 1925. *General Zoology.* New York: McGraw-Hill.

Wieser, Johann. 1875. *Mensch und Thier. Populär-wissenschaftliche Vorträge über den Wesensunterschied zwischen Mensch und Thier, mit Rücksicht auf die Darwin'sche Descendenzlehre.* Freiburg im Breisgau: Herder.

Wigand, Albert. 1877. *Der Darwinismus und die Naturforschung Newtons und Cuviers. Beiträge zur Methodik der Naturforschung und zur Speciesfrage.* Vol. 3. Braunschweig: Vieweg.

———. 1878. *Der Darwinismus ein Zeichen der Zeit.* Heilbronn: Gebr. Henninger.

Wilhelm, König von Preußen. 1870. "Gesetz, betreffend das Urheberrecht an Schriftwerken, Abbildungen, musikalischen Kompositionen und dramatischen Werken. Vom 11. Juni 1870." *Bundes-Gesetzblatt des Norddeutschen Bundes*, no. 19: 339–53.

Williams, Henry Smith. 1900. "Today's Science in Europe, II: Professor Ernst Haeckel and the New Zoology." *Harper's Monthly Magazine* (European Edition) 100: 297–312.

Wilson, Andrew. 1883. *Chapters on Evolution*. London: Chatto & Windus.

Wilson, Edward A. 1907. "Aves." In *National Antarctic Expedition, 1901–1904*, section 1, *Natural History*, vol. 2, *Zoology (Vertebrata: Mollusca: Crustacea)*. London: British Museum.

Winau, Rolf. 1981. "Ernst Haeckels Vorstellungen von Wert und Werden menschlicher Rassen und Kulturen." *MHJ* 16: 270–79.

Winchester, A. M. 1947. *Zoology: The Science of Animal Life*. New York: Van Nostrand.

———. 1950. *Biology and Its Relation to Mankind*. New York: Van Nostrand.

Winchester, A. M., and Harvey B. Lowell. 1961. *Zoology*. 3rd ed. Princeton, NJ: Van Nostrand.

Winkler, Heinrich August. 1988. *Der Schein der Normalität. Arbeiter und Arbeiterbewegung in der Weimarer Republik 1924 bis 1930*. 2nd ed. Berlin: Dietz.

Wirén, A. 1899. *Zoologiens grunddrag*. Vol. 1. Stockholm: Bonnier.

Wise, M. Norton, ed. 1995. *The Values of Precision*. Princeton, NJ: Princeton University Press.

Wittmann, Reinhard. 1999. *Geschichte des deutschen Buchhandels*. 2nd ed. Munich: Beck.

Wobbermin, Georg. 1909. "Der Keplerbund und der Kampf um Haeckels Embryonenbilder." *Die Christliche Welt* 23, no. 14 (1 Apr.): 317–22; no. 15 (8 Apr.): 349–52; and no. 16 (15 Apr.): 374–76.

———. 1911. *Monismus und Monotheismus. Vorträge und Abhandlungen zum Kampf um die monistische Weltanschauung*. Tübingen: Mohr.

Wogawa, Frank. 2001. "'Zu sehr Bürger …'? Die Jenaer Verleger- und Buchhändlerfamilie Frommann im 19. Jahrhundert." In *Bürgertum in Thüringen. Lebenswelt und Lebenswege im frühen 19. Jahrhundert*, edited by Hans-Werner Hahn, Werner Greiling, and Klaus Ries, 81–107. Rudolstadt: Hain.

Wolcott, Robert H. 1933. *Animal Biology*. New York: McGraw-Hill.

Wolf, Falk. 2010. "Demonstration. Einleitung." In Bader, Gaier, and Wolf 2010, 263–72.

Wolff, Wilfried. 1993. *Max Hodann (1894–1946). Sozialist und Sexualreformer*. Hamburg: von Bockel.

Wolpert, Lewis. 1991. *The Triumph of the Embryo*. Oxford: Oxford University Press.

Woodford, Charlotte. 2012. "Bertha von Suttner's *Die Waffen nieder!* and Gabriele Reuter's *Aus guter Familie*: Sentimentality and Social Criticism." In *The German Bestseller in the Late Nineteenth Century*, edited by Woodford and Benedict Schofield, 206–23. Rochester, NY: Camden House.

Woodruff, L. L. 1922. *Foundations of Biology*. New York: Macmillan.

Woodward, Arthur. 1993. "Do Illustrations Serve an Instructional Purpose in US Textbooks?" In *Learning from Textbooks: Theory and Practice*, edited by Bruce K. Britton, Woodward, and Marilyn R. Binkley, 115–34. Hillsdale, NJ: Erlbaum.

Woodward, Arthur, and David L. Elliott. 1987. "Evolution and Creationism in High School Textbooks." *American Biology Teacher* 49, no. 3 (Mar.): 164–70.

Wossidlo, Paul. 1886. *Leitfaden der Zoologie für höhere Lehranstalten*. Berlin: Weidmann.

Wourms, John P. 2007. "The Relations between Comparative Embryology, Morphology, and Systematics: An American Perspective." In Laubichler and Maienschein 2007, 215–66.

Wunderlich, Klaus. 1978. *Rudolf Leuckart. Weg und Werk*. Jena: Fischer.

Wundt, Wilhelm. 1921. *Erlebtes und Erkanntes*. 2nd ed. Stuttgart: Kröner.

Wyeth, F. J. 1933. *Elementary General Biology*. 2 vols. London: Bell.

———. 1952. *A New School Biology*. 2 pts. London: Bell.

Young, Clarence Whitford, Clarence John Hylander, and G. Ledyard Stebbins. 1938. *The Human Organism and the World of Life: A Survey in Biological Science*. Hamilton, NY: Harper & Brothers.

Young, Jean M. 1990. "The Textbook Industry: Writing and Editing Textbooks." In Elliott and Woodward 1990, 71–85.

Zacharias, Otto. 1883. "Charles R. Darwin, der wissenschaftliche Begründer der Descendenzlehre." *Westermanns Monatshefte* 54: 341–67.

———. 1892. *Katechismus des Darwinismus*. Leipzig: Weber.

Zeiller, Paul. 1867. *Führer durch das anthropologische Museum enthaltend eine einfache, möglichst volksthümliche Erklärung….* Munich: Franz.

Ziche, Paul. 2000a. "Die 'Scham' der Philosophen und der 'Hochmut der Fachgelehrsamkeit.' Zur fachphilosophischen Diskussion von Haeckels Monismus." In Ziche 2000b, 61–79.

———, ed. 2000b. *Monismus um 1900. Wissenschaftskultur und Weltanschauung*. Berlin: VWB.

Ziegler, Friedrich. 1893. *Prospectus über die zu Unterrichtszwecken hergestellten Embyologischen Wachsmodelle von Friedrich Ziegler (vormals Dr. Adolph Ziegler)*. Freiburg in Baden: Atelier für wissenschaftliche Plastik.

Ziesak, Anne-Katrin. 1999. *Der Verlag Walter de Gruyter, 1749–1999*. Berlin: de Gruyter.

Zils, Wilhelm. 1913. "Münchener Verleger und Presse." In *Geistiges und künstlerisches München in Selbstbiographien*, edited by Zils, 407–39. Munich: Kellerer.

Zimmer, Jochen, ed. 1984. *Mit uns zieht die neue Zeit. Die Naturfreunde. Zur Geschichte eines alternativen Verbandes in der Arbeiterkulturbewegung*. Cologne: Pahl-Rugenstein.

Zimmerman, Andrew. 2001. *Anthropology and Antihumanism in Imperial Germany*. Chicago: University of Chicago Press.

Zimmermann, W. F. A. [C. G. W. Vollmer, pseud.] 1855. *Die Wunder der Urwelt. Eine populaire Darstellung der Geschichte der Schöpfung. . . .* Berlin: Hempel.

Zöckler, Otto. 1874. "Die Darwinsche Entwicklungstheorie, ihre Anhänger und ihre Kritiker." *Daheim* 11: 14–15, 26–31, 42–46, 75–79, 108–11, 119–21, 135–37.

———. 1879. *Geschichte der Beziehungen zwischen Theologie und Naturwissenschaft, mit besondrer Rücksicht auf Schöpfungsgeschichte*. Pt. 2, *Von Newton und Leibniz bis zur Gegenwart*. Gütersloh: Bertelsmann.

Zollmann, Theodor. 1872. *Bibel und Natur in der Harmonie ihrer Offenbarungen*. 3rd ed. Hamburg: Agentur des Rauhen Hauses.

———. 1878. "Darwinismus und Christenthum." *Deutsch-evangelische Blätter* 3: 242–61.

Zöllner, Johann Carl Friedrich. 1883. *Über die Natur der Cometen. Beiträge zur Geschichte und Theorie der Erkenntnis*. 3rd ed. Leipzig: in Commission bei L. Staackmann.

Zorach, Rebecca, and Elizabeth Rodini, eds. 2005. *Paper Museums: The Reproductive Print in Europe, 1500–1800*. Chicago: Smart Museum of Art.

INDEX

Page numbers in italics refer to illustrations.